Medieval Art

MARILYN STOKSTAD

ICON EDITIONS

1817

HARPER & ROW, PUBLISHERS, New York
Cambridge, Philadelphia, San Francisco, London, Mexico City
São Paulo, Singapore, Sydney

MEDIEVAL ART. Copyright © 1986 by Marilyn Stokstad. All rights
reserved. Printed in the United States of America. No part of this
book may be used or reproduced in any manner whatsoever
without written permission except in the case of brief quotations
embodied in critical articles and reviews. For information address
Harper & Row, Publishers, Inc., 10 East 53rd Street, New York,
N.Y. 10022. Published simultaneously in Canada by Fitzhenry &
Whiteside Limited, Toronto.

REPRINTED WITH CORRECTIONS, 1988

Designed by Ruth Bornschlegel
Maps by Frank Ronan
Index by Edmée Reit

Library of Congress Cataloging in Publication Data

Stokstad, Marilyn, 1929–
 Medieval art.

 (Icon editions)
 Bibliography: p.
 Includes index.
 1. Art, Medieval—History. I. Title.
N5970.S75 1986 709'.02 84-48522
ISBN 0-06-438555-8 96 97 98 HAL 10 9 8 7 6 5 4 3
ISBN 0-06-430132-X (pbk) 93 HAL 10 9

CONTENTS

Color plates follow page 162.

ILLUSTRATIONS

The number in italics refers to the
page on which the illustration appears.

[CHAPTER VIII]
Romanesque Art in Western Europe

[CHAPTER XI]
National Styles in Gothic Art

[CHAPTER XII]

Late Gothic Art

COLOR PLATES
(following page 162)

1. Baptistery of the Orthodox, Ravenna, mosaic, c. 450–60. Photo: Art Resource.
2. Eagle-shaped fibulae, Spain, sixth century. The Walters Art Gallery, Baltimore. Museum photo.
3. Woman clothed with the sun, Beatus manuscript (M. 644), Spain, 940–45. The Pierpont Morgan Library, New York. Library photo.
4. *The Tree of Jesse* (detail), west window, Chartres Cathedral, mid-twelfth century. Photo: Jacques Nestigen, Éditions Flammarion.
5. Charlemagne window (detail), Chartres Cathedral, thirteenth century. Photo: Jacques Nestigen, Éditions Flammarion.
6. North rose and lancet windows, Chartres Cathedral, thirteenth century. Photo: Wim Swaan.
7. *Windmill Psalter* (M. 102), England, 1270–80. The Pierpont Morgan Library, New York. Library photo.
8. Rogier van der Weyden, *St. George and the Dragon*, c. 1432. Ailsa Mellon Bruce Fund, National Gallery of Art, Washington, D.C. Museum photo.

PREFACE

ike those Celtic saints who confidently set sail for parts unknown on ships of millstones or cabbage leaves, I have accepted a strange mission and a challenge—the survey of over a thousand years in the history of western art and architecture, from ancient Rome to the age of exploration. The Celtic sailor-saints, beset by flying fish, giant cats, and deep-sea monsters, made their way to new lands, to the very mouth of Hell, to the Blessed Isles, and back home again, forever changed. This book, subject to a closer scrutiny than those ancient tales, suggests an intellectual voyage no less challenging and certainly just as enlightening.

Medieval Art, like most books by college professors, began as a set of notes, which changed over the years in response to the interests and background of students and the critiques of colleagues. My purpose in writing *Medieval Art* has always been to introduce the lay reader, the museum visitor, and the student to this period of extraordinary historical and geographical extent. To those art historians accustomed to concentrating on a single master or the cultural life of a single decade, *Medieval Art* may seem a mere survey of the territory. I recognize the difficulty, but my goal was to bring some sense of coherence to the history of this art—to find and demonstrate continuity, draw some parallels, all within the constraints of limited pages and illustrations. The diverse minor arts of the Middle Ages, as well as the monumental arts of architecture and sculpture, have to be studied within the social, religious, political, and intellectual framework of lands as varied as France and Denmark, Spain and Germany.

Great empires rose and fell; the arts flourished or decayed with them. Nevertheless, over the centuries, from the terrors and enthusiasms of humanity, the institutions of the modern world emerged. The old world view changed; values crumbled. Do not the Middle Ages, a period of cataclysmic changes—unsettling, terrifying, and challenging—speak more profoundly to the fears and hopes of people in the last years of the twentieth century than does the self-confident, optimistic, exuberant post-Medieval world?

Medieval Art includes the art and building of what is now Western Europe from the second to the fifteenth centuries. Although to Renaissance scholars the Middle Ages was a single dark period, a vast black hole in the triumphant development of western philosophy and science from the Greeks and Romans to their own enlightened days, the period is not one but many. It is diverse geographically and culturally, widespread in time and place. What do the painters of catacomb images have in common with artists of the imperial Byzantine court, or indeed with stone carvers in Ireland or builders of Gothic cathedrals? One would first say: a devotion to and sponsorship by the Christian church, whether the Latin church led by the Pope in Rome or the Orthodox church led by the Patriarch in Constantinople. However, even the supposed immutability of the Christian tradition was subject to constant revision and development, and the impact of non-Christian cultures influenced the form, if not the content, of the art. With all respect for the continuing influence of the pagan, Jewish, and

Islamic religions and cultures, we will see that Christian religious art provides continuity for this book. Of course, one may note that art in the service of the church has survived, while secular art and architecture has largely vanished. In any event the emphasis of this study is on Christian religious art.

The reader will also note the inclusion of some less traditional work. This probably stems from my interest in the art of northern Europe, an interest which led me, as a student, back in time from the paintings of Edvard Munch to the art of the Vikings. Perhaps I have continued to follow those Viking hordes, exploring coasts and rivers of Western Europe, thus giving this book a slightly peninsular and insular focus. The inclusion of Scandinavian, British, or Spanish art may sometimes be at the expense of a more traditional focus on France, Italy, and Germany. Even the added attention paid to the so-called decorative arts might be attributed by the fanciful reader to my admiration for the brilliant, sparkling, and exquisite work of northern goldsmiths.

The great cultures of Eastern Europe, of the Orthodox Church, and of Islam have been given far less attention than they deserve. These great arts, worthy of independent studies, have been used primarily as foils—as sources of influence and inspiration—for the art of the West. Late Medieval art has also been given a more cursory treatment than I would wish. This material, however, is usually included in books on Northern Renaissance art or, in the case of Italian art, as a prelude to the Renaissance. The fourteenth and fifteenth centuries have been covered in excellent, thoughtful detail by teacher-scholars such as Charles Cuttler, James Snyder, and Frederick Hartt.

In a limited and highly selective text many favorite monuments—be they cathedrals or jewels—have been omitted. I have often chosen my own favorites to be discussed and illustrated. When possible I have used works now in America, hoping to encourage study in local collections. Photos have been acquired over the years, many from original owners.

This book has gone through many transformations, and the present text bears little resemblance to the one read by colleagues many years ago. The project— to summarize and define the styles found in a thousand years of art and architecture—was twice abandoned, but finally, with the encouragement of family and friends (Karen and Anna Leider, Harold and Alice Wethey, Edward and Inge Maser, Charles and Jane Eldredge, Chu-tsing and Yao Wen Li, Elizabeth Broun, Katherine Giele, Ralph T. Coe, Irving Sandler, Rose Weil, and Minerva Navarette) and the enthusiastic support of Lucy Adelman and Cass Canfield, Jr., the manuscript was rewritten and at last completed.

Three medievalists worked very hard with me on this text: the ever-optimistic Franklin Ludden, William Clark, and Ann Zielinski. My heartfelt thanks to them and to all those other friends and colleagues who have read parts of the manuscript at different times and in various stages, especially Dale Hayward, Thomas Lyman, Walter Cahn, Per Jonas Nordhagen, John Hoag, Frank Horlbeck, Sheila Schwartz, and Dan Wheeler. Other medievalists were spared this burden but nevertheless over the years have given me more than they may realize: William Wixom, John Williams, George Forsythe, Robert Van Nice, Patrick de Winter, the stained-glass trio of Hayward, Raguin, and Caviness, the late Anders

Bugge and Hans Peter L'Orange in Norway, John Beckwith and Neil Stratford in England, Madeleine Gautier in France, the late Jesus Carro Garcia in Galicia, and the late Eduardo Junyent, Jusep Gudiol and Santiago Alcolea in Catalonia.

Anna Leider, as a student at Amherst, and Nancy Dinneen, Professor of Spanish at Washburn University, Topeka, gave me the benefit of the intelligent layperson's view, and several generations of students have read and criticized the text. For help in assembling photographs and references I would like to thank visual resources librarians Sara Jane Pearman (Cleveland Museum of Art), Ruth Philbrick (National Gallery of Art), Mary Heck and John Blum (University of Kansas), Nancy De Laurier (University of Missouri, Kansas City), Montserrat Blanch (Barcelona), and Pamela Jelley (New York), and librarians Susan Craig (Murphy-Ahmanson Art Library, Kansas), Stanley Hess (Nelson-Atkins Museum of Art), Caroline Backlund (National Gallery), Karen Leider (Trinity College, Washington). Thanks, too, to the staff members of the Instituto Amattler in Barcelona, the National Gallery in Washington, the Victoria and Albert Museum in London, Dumbarton Oaks in Washington, and the Kenneth Spencer Research Library in Lawrence, Kansas, where much of this text was written. The Center for Research in the Humanities at the University of Kansas and the Franklin D. Murphy Travel Fund of the Kress Department of History of Art at the University of Kansas assisted the preparation of the manuscript.

CHRONOLOGICAL TABLE

0-499

THE ARTS

Colosseum completed, 80
Arch of Titus, Rome, 81
Column of Trajan, 113
Rebuilding of Pantheon, 115–127
Catacomb paintings and sarcophagi, Rome
Christ-Helios mosaic, Vatican
Christian house, synagogue, Dura-Europos, before 256
Diocletian's Palace, Split, 300–305
Arch of Constantine, Rome, 312–315
Church of St. Peter, Rome, 319–337
Church of the Holy Sepulchre, Jerusalem, c. 325
Imperial Palace and churches, Constantinople, before 337
Church of San Lorenzo, Milan, 355–375, 390
Sarcophagus of Junius Bassus, Rome, c. 359
Church of Sta. Costanza, Rome, after 359
Missorium of Theodosius, 388
Walls of Constantinople, 408–413
Mausoleum of Galla Placidia, Ravenna, c. 425
Sta. Maria Maggiore, Rome, 432–440
Church of St. John, Ephesus
Baptistery of the Orthodox, Ravenna, c. 450
Church of Hagios Giorgios (formerly Mausoleum of Galerius)
Church of St. Paul Outside the Walls, Rome, after 440

PEOPLE & EVENTS

Crucifixion of Jesus, 30/33
Romans invade Britain, 43
Nero, Emperor, 54–68
First persecution of Christians, 64
Eruption of Vesuvius, destruction of Pompeii, 79
Titus, Emperor, 79–81
Trajan, Emperor, 98–117; greatest extent of the Roman Empire
Hadrian, Emperor, 117–138
Marcus Aurelius, Emperor, 161–180
Goths cross the Danube, 238; invade Gaul, 280s
Christianity made a "permitted religion," 260
Diocletian, Emperor, 284–305
Persecution of Christians, 303–311
Constantine, Emperor, 306–337; Battle of Milvian Bridge, 312
Edict of Milan, 313; religious toleration
Founding of Constantinople, 324
Huns invade Europe, c. 350
St. Ambrose, Bishop of Milan, 373–397

Theodosius I, Emperor, 379–395
Christianity made official religion of the Empire, 380
St. Jerome translates the Bible into Latin, 382–405
St. Augustine, Bishop of Hippo, 393–430
Honorius moves western capital to Ravenna, 402
Roman legions withdraw from Britain, 400–410
Goths under Alaric sack Rome, 410
St. Augustine writes *City of God*, 413–426
Visigoths conquer Spain, 416–418
St. Patrick in Ireland, 432–461
Pope Leo I, 440–461
Attila, King of the Huns, 433–453, destroys Milan, 450, spares Rome, 452
Theodoric, King of Ostrogoths, 471–526; founds kingdom in Italy, 493
Romulus Augustulus, last western Roman emperor, 475–476
Clovis, King of the Franks, 481–511, accepts Christianity, 496

500-599

THE ARTS

Tomb of Theodoric, Ravenna, 526
Church of S. Apollinare Nuovo, Ravenna, 526–549
Church of Hagia Sophia, Constantinople: 532–537; dome rebuilt, 558
Church of S. Apollinare in Classe, 532/36–559
Church of Holy Apostles, Constantinople, rebuilt 536–550
Church of S. Vitale, Ravenna, 547
Church of St. Catherine, Mt. Sinai: mosaic, 548
Rabbula Gospels, c. 506

PEOPLE & EVENTS

Pseudo Dionysius (Dionysius the Areopagite), c. 500
St. Benedict of Nursia (d. 543) founds Benedictine Order at Monte Cassino, 529
Justinian, Byzantine emperor, 527–565
Justinianic law code, 529–534
Lombards establish kingdom in northern Italy, 568; accept Christianity
Muhammad, prophet of Islam, c. 570–632
Pope Gregory the Great, 590–604
St. Augustine to England, 596

600-699

THE ARTS

Sutton Hoo treasure
Votive crown of Recceswinth, before 672

Book of Durrow, c. 675
Sarcophagus of Agilbert, Jouarre, c. 685

PEOPLE & EVENTS
Consecration of the Pantheon as a Christian church, 609
Caliph Omar, 634–644, captures Jerusalem, 638
St. Aiden founds monastery at Lindisfarne, 635
Recceswinth, king of Visigoths, 649–672
Synod of Whitby, 664, decides in favor of Roman
 liturgy
The Venerable Bede, 673–735

700–799

THE ARTS
Franks Casket, c. 700
Echternach Gospels (Gospels of St. Willibrord)
Lindisfarne Gospels
Ardagh Chalice
Church of Sta. Maria-in-Valle, Cividale
Sacramentary of Gelasius, c. 750
Abbey Church, Fulda, 744–751, 790
Abbey Church of St. Denis, 754–775
Godescalc Gospels, 781–783
Great Mosque, Cordova, begun 785
Palatine Chapel, Aachen, begun 790

PEOPLE & EVENTS
Beowulf, c. 700–730
Muslim conquest of Visigothic Spain, 711
Iconoclastic controversy, 726–843
Muslim invasion turned back in France by Charles
 Martel, 732
Pepin crowned King of the Franks at St. Denis, 754
Caliphate of Cordova, independent Muslim state, 755
Charlemagne, 769–814, conquers Langobard kingdom,
 773–774
Defeat of Roland at Roncevalles, 778
Council of Nicaea, 787, rejects iconoclasm
Vikings destroy Lindisfarne, 793

800–899

THE ARTS
Book of Kells, c. 800
Ada Gospels, c. 800
Oseberg ship, 800–850
Easby Cross
Crypt of St. Germain, Auxerre: murals
Coronation Gospels, before 814
Lorsch Gospels, ivory cover, c. 800
First church, Santiago de Compostela, after 813
Ebbo Gospels, 816–835
Plan of ideal monastery, St. Gall, c. 817

Church of Hagia Sophia, Constantinople: apse mosaic,
 867
Lindau Gospels, cover, c. 870

PEOPLE & EVENTS
Charlemagne crowned emperor, Rome, 800
Discovery of tomb of St. James in Galicia, 813
Louis the Pious, 814–840
Muslims invade Sicily, 827; capture Palermo, 831
Charles the Bald, 840–875
Council of Constantinople, 843, ends the iconoclastic
 controversy
Vikings destroy Centula, 845; Tours, 853; lay siege to
 Paris, 885–886
Danish kingdom established in York, 866
Alfred the Great of England, 871–899
Anglo-Saxon Chronicle begun, 891

900–999

THE ARTS
First church at Cluny, 900–911
Beatus manuscripts
Second church at Cluny, 940–960, ded. 981
New Minster Charter, Winchester, 966
Gero crucifix, Cologne, c. 970
Reliquary of St. Foy, Conques
Cross of Muiredach, Monasterboice, Ireland

PEOPLE & EVENTS
Cluniac Order founded, 910
Charles the Simple of France, 898–923, cedes
 Normandy to Rollo the Viking, 911
Otto the Great, 936–973, crowned emperor, 962
Exeter Book, Anglo-Saxon poetry, c. 970
Otto II, 973–983, marries Byzantine princess Theophano,
 972
Otto III, 983–1002 (regents: Theophano, d. 991;
 Adelaide, d. 999)
Arabic numerals adopted in West
Hugh Capet, French king, 987–996
Vikings colonize Greenland

1000–1099

THE ARTS
Harley 603 (copy of *Utrecht Psalter*), c. 1000
Gospels of Otto III, c. 1000
Church of St. Michael, Hildesheim, 1001–1015, 1033
Bronze doors, Hildesheim, c. 1015
Liber Vitae of New Minster, 1020
Cathedral, Speyer, 1030–1061
Abbey church, Jumieges, 1037–1067
Church of St. Mark, Venice, after 1063

Cathedral of Pisa, begun 1063; alter cons., 1118
Church of St. Etienne, Caen, 1064–1087; vaulted, 1120s
Bayeux Tapestry, after 1066
Church of St. Sernin, Toulouse, begun 1060s?; cons.,
1096
Cathedral of Santiago de Compostela, begun 1070s;
south portal, c. 1117
Church of St. Foy, Conques
Byzantine ivories
Church of San Clemente, Rome
Church of San Ambrogio, Milan, 1080, vaulted after
1117
Cathedral of Durham, begun 1093
Cathedral of Modena, 1099–1106

PEOPLE & EVENTS

Leif Ericson reaches North America, 1000–1002
Canute, 1014–1035, ruler of Denmark, England, and
Norway
Normans arrive in Sicily, 1016
William the Conqueror, 1035–1087: Duke of Normandy,
after 1066 King of England
Final break between Roman and Byzantine churches,
1054
Pope Alexander II, 1061–1073
Norman conquest of England, 1066–1071
Pope Gregory VII (Cluniac monk Hildebrand), 1073–
1085
Investiture controversy between Papacy and German
emperors, 1075–1122
Gregory VII confronts Henry IV at Canossa, 1077
St. Bruno founds Carthusian Order, 1084
Christians take Toledo, 1085
Pope Urban II, 1088–1099
First Crusade, 1095–1099, founding of Latin Kingdom of
Jerusalem
Robert of Molesmes founds Cistercian Order, 1098

1100–1199

THE ARTS

Wiligelmo, sculpture, Cathedral of Modena, c. 1100
Cloister, Moissac, c. 1100; portal 1115–1131
Gloucester Candlestick, 1104–1113
Albani Psalter, early 12th century
Rainier de Huy, baptismal font, Liège, 1107–1110
Abbey church, St. Savin-sur-Gartempe: murals, c. 1115
Church of San Clements, Tahull: murals, 1123
Church of St. Lazare, Autun, 1120s; cons., 1146
Church of the Madeleine, Vézelay, rebuilt after 1120
Priory chapel, Berzé-la-Ville: murals, 1109?–1140?
Abbey church of St. Denis, 1135–1144
Cathedral of Sens, 1130s–1180s
Cathedral of Chartres: west facade, 1140s
Abbey church of St. Gilles: west facade, 1140s

Church of St. Trophime, Arles, 1150s
Cathedral of St. Pierre, Poitiers, begun 1162
Cathedral of Notre-Dame, Paris, begun 1163; nave,
1180–1200
Cathedral of León, begun c. 1165; facade begun c. 1190
Cathedral of Senlis: west facade, c. 1170
Cathedral of Worms, 1170s
"Leaning Tower," Cathedral of Pisa, begun 1174
Cathedral of Canterbury, rebuilt after fire of 1174
Nicolas of Verdun: enamels, Klosterneuberg, 1181
Cathedral of Wells, begun 1184
Cathedral of Chartres, rebuilt after fire of 1194
Cathedral of Bourges, begun 1195

PEOPLE & EVENTS

St. Bernard, abbot of Clairvaux, 1115–1153
Suger, abbot of St. Denis, 1122–1151
Moses Maimonides, Jewish philosopher, 1135–1204
Eleanor of Aquitaine, French queen, 1137–1152, English
queen, 1154–1189, dies, 1204
Louis VII, King of France, 1137–1180
Second Crusade, 1146/47–1149
Frederick Barbarossa, German king, 1152–1190
Henry II Plantagenet, King of England, 1154–1189
Thomas à Becket, Archbishop of Canterbury, 1162–1170
Pope Alexander III establishes rules for canonization,
1170
Saladin, 1170–1193, captures Jerusalem, 1187
Richard the Lion-Hearted, King of England, 1189–1199
Third Crusade, 1189–1192, frees Jerusalem
Universities founded in Bologna, Paris, Oxford

1200–1299

THE ARTS

Cathedral of Bourges, 1195–1225
Cathedral of Reims burns 1210, rebuilding begins 1211,
facade by 1260
Cathedral of Amiens, 1218–1288; sculpture, 1220–1230;
south portal, c. 1260
Cathedral of Burgos begun 1221
Cathedral of Worms: western choir, 1220s
Church of St. Francis, Assisi, 1228–1253
Cathedral of Naumberg: choir and screen, c. 1240–1260
Ste.-Chapelle, Paris, 1243–1248
Cathedral of Salisbury, 1220–1258
Westminster Abbey, after 1245
Cathedral of Cologne begun 1248, finished 19th century
Cathedral of León begun 1254; west portal sculpture,
1270–1280
Cathedral of Lincoln: Angel Choir, 1256–1280
Nicola Pisano: Pisa baptistery, pulpit, 1260
Church of St. Urbain, Troyes, 1262–1265; rebuilt after
1266

Cathedral of Exeter begun c. 1270
Windmill Psalter, 1270–1280
Cathedral of Strasbourg: new west facade design, 1277
Giovanni Pisano: Siena Cathedral facade, 1284
Cathedral of Barcelona begun 1298

PEOPLE & EVENTS

Fourth Crusade, Sack of Constantinople, 1201–1204;
 Latin Kingdom in Byzantium, 1204–1261
St. Dominic, 1170–1221, founds Dominican Order, 1206
St. Francis, 1182–1226, founds Franciscan Order, 1209;
 confirmed, 1226
Frederick II crowned king at Aachen, 1212; emperor at
 Rome, 1220; dies, 1250
Magna Carta, 1215; reissued, 1217, 1225
Bartholomaeus Anglicus, *On the Nature of Things,* 1225–
 1230
Hanseatic League, 1241
Seventh Crusade, led by Louis IX, 1248–1254
Sorbonne founded, 1254/57
House of Commons established in England, 1258
Byzantines retake Constantinople, 1261
St. Thomas Aquinas (d. 1274): *Summa Theologica,* 1266–
 1273
Roger Bacon (d. 1290): *Opus Maius,* 1266; imprisoned
 for heresy, 1277
Marco Polo travels to China and India, 1271–1295
Albertus Magnus (d. 1280), scientist and philosopher
Dante Alighieri (d. 1321): *La Vita Nuova,* 1290
Turks drive Christians from Holy Land, 1291
Louix IX canonized, 1297

1300–1399

THE ARTS

Giotto: Arena chapel, Padua, murals, after 1305
Duccio: Maesta altarpiece, 1308–1311
Queen Mary Psalter, c. 1310
Heinrich and Peter Parler: Church of the Holy Cross,
 Swäbisch Gmünd, 1317, 1351
Cathedral of Ely: Octagon, 1328–1347
Tomb of Edward II, Gloucester, 1329–1334
Virgin of Jeanne d'Evreux, 1339
Avignon: walls, papal palace, murals, 1335–1352
Gloucester Cathedral: choir, 1337; cloister, 1351–1412
Cathedral of Prague, 1353–1385
Frauenkirche, Nürnberg, 1355
Simone Martini: *Angel of the Annunciation*
Angers Apocalypse, tapestry, 1376–1381
Claus Sluter: Well of Moses, Chartreuse de Champmol,
 1395–1406
Jacques de Baerze: Dijon altarpiece, sculpture, 1390–
 1391
Melchior Broederlam: Dijon altarpiece, wings, 1394–
 1399

PEOPLE & EVENTS

Papacy moves from Rome to Avignon—"Babylonian
 Captivity," 1309–1378
Dante Alighieri (d. 1321): *Divine Comedy,* 1314–1321
Hundred Years War between France and England,
 1337–1453
Black Death, 1347–1350
Boccaccio (d. 1375): *Decameron,* 1348–1353
Papacy returns to Rome, 1378; Great Schism, 1378–
 1417
Dukes of Burgundy become rulers of Flanders, 1384
Chaucer (d. 1400): *Canterbury Tales,* 1387–1400
Henry IV of Lancaster, King of England, 1399–1413

1400–1499

THE ARTS

Cathedral of Seville, 1402–1517
Limbourg Brothers: *Très Riches Heures* of Duc de Berry,
 1411–1416
Donatello: *David,* 1430–1432
Rogier van der Weyden: *St. George and the Dragon,*
 c. 1432
Jan van Eyck: *The Annunciation,* c. 1435
Stefan Lochner: *Madonna of the Rose Garden,* c. 1440
King's College, Cambridge, chapel, 1446–1515
Petrus Christus: *The Holy Family,* 1472
Bellini: *St. Francis in Ecstacy,* c. 1480
Tilmann Riemenschneider: Virgin and Child, c. 1499
Chapel of Henry VII, Westminster Abbey, London,
 1503–1519
Leonardo da Vinci, *Last Supper,* 1495–1497; *Mona Lisa,*
 1503
Cathedral of Chartres: north spire, 1507
Michelangelo: Sistine Chapel ceiling, 1508–12
Veit Stoss: *The Annunciation,* St. Lorenz, Nürnberg, 1518

PEOPLE & EVENTS

Council of Constance, 1414–18, ends Great Schism
John Hus burned at stake for heresy, 1415
Henry V of England defeats French at battle of
 Agincourt, 1415
Joan of Arc burned at Rouen, 1431
Henry V marries Catherine of France, 1420
Johann Gutenberg (d. 1468) invents printing with
 movable type, 1440
King's College, Cambridge, founded by Henry VI, 1441
Wars of the Roses in England, 1455–1485
Turks capture Constantinople, 1453
William Caxton prints Chaucer's *Canterbury Tales,* 1484
Ferdinand and Isabella of Spain, 1479–1504
Papal bull against witchcraft and sorcery, 1484
Fall of Moorish capital of Granada to Christians, 1492
Columbus discovers America, 1492

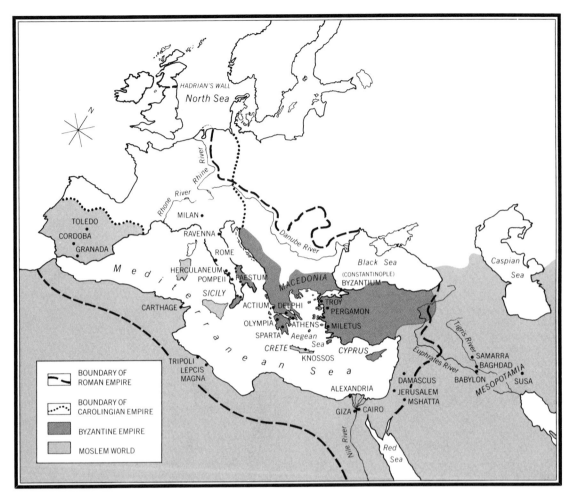

The Ancient and Early Medieval World
from about A.D. 200 to A.D. 900

Medieval Europe
(*opposite*)

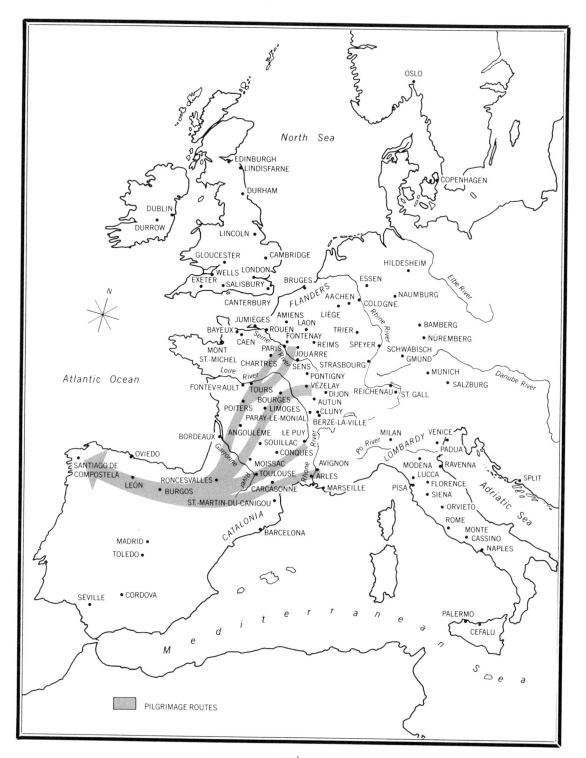

⟦ CHAPTER I ⟧

Art in the First Centuries of the Christian Era

*T*he Middle Ages. Exuberantly self-confident Renaissance scholars looked back on a thousand years of history as an interlude, and considered the centuries after the fall of Rome as a dark age, enlightened only by the presence of the Church—a middle age because the period fell between the Classical age of Greece and Rome and their own time. Today, with greater historical perspective, the "dark" Middle Ages appear as a brilliant period out of which emerged the modern world with its rival nations; its different philosophical, political, and economic systems, and its varied forms of art and architecture. The period extends over more than a thousand years: from the battle of the Milvian Bridge, when Constantine's troops conquered Rome bearing the monogram of Christ on their standards, to the Hundred Years War, which saw the end of feudal armies and battles fought by armored knights; from the writing of a universal Christian creed at the Council of Nicaea to the beginning of the Protestant Reformation; from the miracles of Christ and the apostles to the beginnings of modern science.

When did the ancient world end and the medieval world begin? Not with the birth of Christ, as the system of dating events B.C. (before Christ) or A.D. (*anno Domini*) suggests, for the Roman Empire reached the height of its power in the first centuries of the Christian era [1]. Do the Middle Ages begin, then, with Constantine's toleration of Christianity in 313

or his establishment of a new capital in Constantinople in 324. Or do such events as the Council of Nicaea in 325, or the last Olympic games in 394, or Emperor Theodosius' partition of the Empire in 395 mark the end of the ancient world? Historians do not agree. Certainly life, and art, had changed long before Rome fell to the Goths in 410.

For more than a thousand years the ideals and precepts of Christianity dominated European thought. Today, even in a secular age, when sacred texts are studied as history or literature, when church rites are seen as music or drama, when Christian beliefs are studied as only one philosophy among many seeking to explain the meaning of life, Medieval art and architecture maintain their hold on the imagination. Medieval art is essentially Christian art. Even in its secular manifestations its forms are dominated by the forms developed around Christian worship; therefore, we must begin a discussion of Medieval art first with the historical situation in which it evolved and then with the religion which was its motivating force.

Early Christian art can be seen as a phase of Late Roman art, distinguishable as Christian only by its subject matter. The study of imperial Roman and Late Antique art is fascinating in itself, but it cannot be treated here with the care and depth it deserves. The examination of a few examples of Roman sculpture must suffice to establish a context for the earliest Christian art.

1

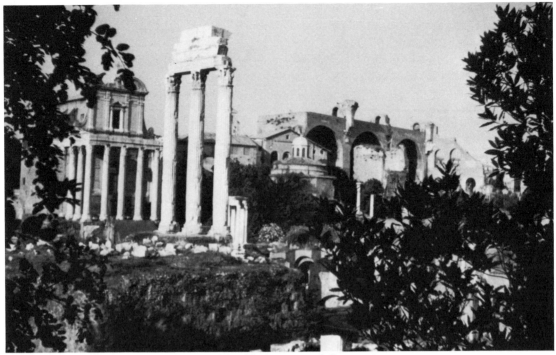

1. The Roman Forum with ruins of the Basilica of Maxentius and Constantine.

2. The spoils of Jerusalem, Arch of Titus, Rome, A.D. 81. Approximately 7' high.

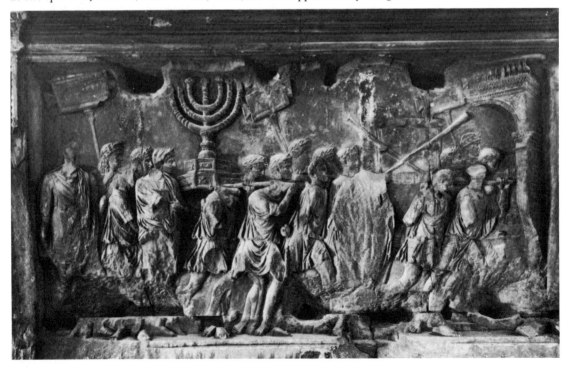

First, the term "Classical" needs definition. It may refer to Greco-Roman art in general, or, more specifically, it may be applied to the idealized representation of human beings and nature originating in Greece in the fifth century B.C. Classical art was anthropocentric and idealistic, but as adapted by Roman artists it became more realistic and more concerned with spatial environment. Artists achieved an illusion of material reality through subtle modeling that created varied textures and effects of light playing over tangible forms. They recorded and interpreted nature in its perfect moments with great skill and imagination; thus, the peak of achievement or moment of perfect harmony in any artistic mode has also come to be referred to as "classic." The change from the Classical style to the abstract and expressionistic mode characteristic of Medieval art began without reference to Christianity. The two styles—realistic and abstract—could exist side by side; sometimes one, sometimes the other gained ascendancy, depending on political, social, and economic as well as religious factors.

Three public monuments erected to celebrate imperial military victories dramatize the change taking place in Roman art during the first and second centuries A.D.—the Arch of Titus and the columns of Trajan and Marcus Aurelius. In all three, the sculptors carefully recorded the Roman army in action and celebrated the military prowess of the emperor. Such records of specific historical events, represented with well-observed detail, are an important contribution by the Romans to the history of art.

The Arch of Titus, erected in A.D. 81 to commemorate his Palestine campaign, is a sturdy barrel vault supported on massive piers and decorated with an applied ornament of columns, entablature, and an attic story carrying the inscription [2]. Panels sculptured in relief on the inner faces of the piers depict the actual triumphal procession. Soldiers march through an arch carrying the spoils from the Temple in Jerusalem, including the seven-branch candlestick, while the Emperor Titus, crowned by a winged victory, rides in a four-horse chariot. Not only have the artists carefully reproduced figures and objects, but they have also achieved a sense of place by the remarkable device of the curved background plane which eliminates the distinct cast shadows of the frame and produces an illusion of atmospheric space. The sculptors also varied the height of the relief, carving figures in the foreground in high relief and those farther away progressively lower. The entire procession moves along a curving path—out toward the spectator and then away through an arch set at an angle. The artists have tried to create the illusion of a window through which a spectator looks on an actual event.

This accurate depiction of specific events in a sensible, rational world on the Arch of Titus was continued by the sculptors of Trajan's Column (105–113). The column [3] stood in the heart of Rome in a complex of public buildings, forum, and markets built by Trajan. From the base, which eventually served as Trajan's tomb, to the statue of the emperor at the top, a spiral frieze 656 feet long represented the history of Trajan's Dacian campaigns.

3. Column of Trajan, Rome, 113.

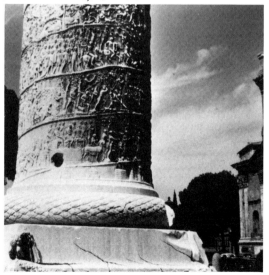

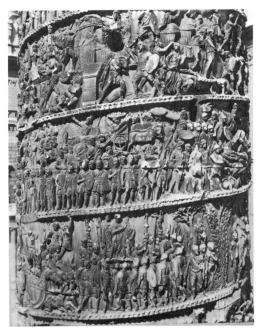

4. Column of Marcus Aurelius, Rome, 193.

Whether as a victorious commander on the battlefield or a conqueror and judge of his enemies, Trajan is always represented as a man, not a god—a man among men, and a great leader. The column is a brilliant example of imperial propaganda as well as of Roman historical relief. The activities of the Roman troops and the barbarians—life on the march and in the camps, the battles, the pursuit and slaughter of the Dacians—are vividly recorded in a continuous narrative winding around the column so that one episode leads naturally on to the next. In an effort to clarify events, the artists compressed space and action by tilting the ground upward so that the activities of the multitude could be seen and by reducing the architecture or landscape to a few well-chosen elements. In order to create a space through which the figures move easily and naturally as actors on a stage, the sculptors varied the height of the relief and suggested perspective in the architecture. They modeled the individual figures as subtly as had the sculptors of the Arch of Titus, but they tried

to enhance the carrying power of forms by slightly undercutting the forms. The cast shadows produced by undercutting sharpened outlines and made the narrative more intelligible at a distance. Gradually the artists began to think in terms of light and shade rather than of solid figures in a defined space, a change in focus that naturally led to a change in style.

The new style can be seen in the reliefs on the Column of Marcus Aurelius [4]. This monument, erected after the emperor's death in 180, superficially is similar to the Column of Trajan and also depicts the emperor's campaigns against the barbarians. The change in style is reflected in the technique of carving. Instead of carefully modeling forms with chisels, the sculptors drilled a series of holes or continuous grooves to produce deep shadows and strong highlights. At a distance the image could be strikingly dramatic; when seen close at hand, however, the two-dimensional pattern of drill work tends to destroy the organic quality of the form. This change in technique signaled a change in attitude toward nature and the representation of the material world, as artists sought to create an illusion of substance rather than tangible form. The complete work of art depends here on elements that are outside the work of art itself—that is, on the effects of light and the imagination of the spectator. By the end of the third century, these changes led to a break with the Classical tradition. The rational, self-reliant, and anthropocentric Greco-Roman world gave way to a world that was filled with supernatural beings.

The transition in sculpture from the depiction of actual events aimed at creating an illusion of reality to an art of geometric forms abstracted from nature and symbolizing intellectual concepts took place by the end of the third century. In portraying the tetrarchs, for example, the sculptors tried to create a symbol of the equality and unity of their rule and the enduring power of the Roman Empire rather

than the individual physical appearance of four men [5]. The political situation described in the sculpture of the four men is as follows: Diocletian had reorganized the government into workable administrative units by establishing a tetrarchy—a four-man rule—with himself as Augustus of the East and his old friend Maximian as Augustus of the West, and then, to provide for an orderly succession of rulers, the two *augusti* each had a caesar as heir and second in command. In this image the sculptors used the timeless quality inherent in geometric forms to express the tetrarchs' eternal authority. Worldly attributes of power such as crowns and swords seem less important than the psychological force expressed in the hypnotic, staring eyes. Even the material from which the image is carved—porphyry— implied imperial dignity; an extremely hard, purple stone from Egypt, where it had long been used for statues of the pharaohs, porphyry was reserved for imperial use. The rulers wanted to be thought of as beings with awesome power rather than flawed and fragile human beings; the tetrarchs, in their portrait, no longer belong to the material world of

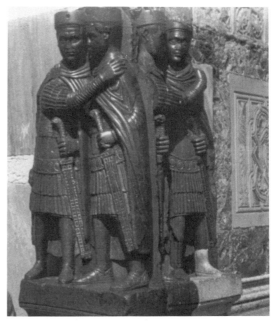

5. Tetrarchs, St. Mark's Square, Venice, 305. Porphyry, 4′ 3″ high.

specific images but to an invisible world of symbols.

Diocletian's palace at Split [6] tells as much about the Late Roman Empire as his portrait.

6. Diocletian's Palace at Split, 300–05. Reconstruction by E. Hebrard.

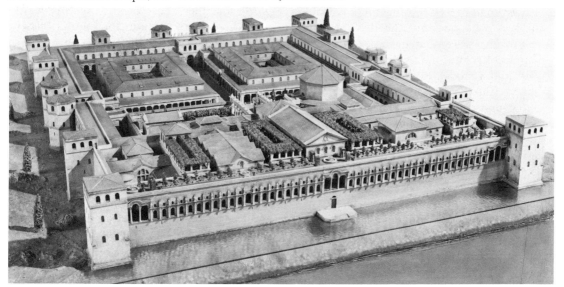

He and Maximian resigned in 305, as planned, and Diocletian retired to a palace designed like a Roman army camp, a rectangular walled enclosure fortified by towers and divided by colonnaded avenues into quadrants. On the main axis stood the imperial audience hall preceded by a peristyle; on the cross axis, Diocletian's mausoleum and a temple to Jupiter faced each other. Imperial apartments lay to the south; servants and bodyguards lived in the northern quadrants. An arcaded gallery opening toward the sea provided the only amenity. The peristyle formed the center of the complex, just as in an army camp the headquarters were placed at the juncture of the two main streets. The rhythmic progression of columns, arcade, and entablature in the peristyle and across the sea-front gallery were punctuated by arcuated lintels and gables framing doors where the emperor made official appearances. This motif—the arcuated lintel and gable—became a symbol of a palace and, by extension, of imperial authority. The huge size and driving axial plan made the palace more than a secure retirement retreat; it became another symbol of imperial power.

Diocletian's grand scheme for a revitalized Roman Empire died with him, but even after the Empire had ceased to function as a viable political or economic entity, the idea of Roman unity and imperial grandeur, as expressed in Roman architecture and sculpture, remained an ideal and a model. Roman practicality and efficiency, functional planning, excellent engineering, and creative use of strong, inexpensive materials were a major contribution to the development of later architecture. In the Forum Romanum, the great brick and concrete walls and vaults tower over the columns and friezes of temples and basilicas, a constant demonstration of engineering skill to be emulated when Western builders tried again to cover large spaces with a vault. Roman secular basilicas, audience halls, and peristyles provided models for Christian churches. The Roman Pantheon, rededicated to the Virgin Mary in the Middle Ages, and Roman imperial mausolea reinforced the idea of using centrally planned, domed buildings as churches or baptisteries. Finally, Roman buildings, even in ruins, helped to keep alive the concept of international dominion, a concept adopted by the Christian Church and emulated time and again by later political leaders.

Christianity and the Early Christian Church

At first few Romans would have been aware of the Christians, people who followed Jesus of Nazareth, the Jewish carpenter who performed miracles of healing and who claimed to be the son of God and the Messiah of the Jews. Jesus had commanded His disciples, "Love thy God with all thy heart and soul and mind; and thy neighbor as thyself." He preached that worldly matters have no importance and urged His followers to consider life on earth merely a preparation for life everlasting in Heaven. By His death on the Cross, Jesus offered Himself as a sacrifice to atone for the sins of all mankind. The Christians said that Jesus had returned to His Father in Heaven, but He would return to judge the world and then those deemed worthy would be received by Him into the eternal bliss of Heaven. This message of faith, hope, and love soon gained adherents, especially among the lower classes and women.

The central body of Christian belief is contained in the New Testament, which together with the Jewish texts, called by the Christians the Old Testament, form the Bible. The four Gospels, attributed to St. Matthew, St. Mark, St. Luke, and St. John, provide four versions of the life and teachings of Jesus, and St. Paul's letters to the new Christian communities and the Acts of the Apostles record the establishment of Christianity as an organized religion. These books and St. John's Revelation of the Apocalypse form the New Testament. The sacred texts of the Jews, the Old Testa-

ment, provided a historical context for the central mystery of the Incarnation; Old Testament events and people were seen as prefigurations of Christianity; for example, the deliverance of Jonah became a prototype of the Resurrection, and the shepherd of the Twenty-Third Psalm could be identified with Christ the Good Shepherd. At the end of the fourth century, St. Jerome edited and translated the Bible into Latin; his edition is known as the Vulgate.

Christianity began as a religion with a simple doctrine of love and a belief in eternal life through faith in its divine founder, Jesus Christ; however, increasing public recognition, the growing number of adherents with widely differing points of view, and even increased wealth created the need for formalized doctrines and an administrative hierarchy. Christianity owed its success as an organized religion to the efforts of St. Paul (d. A.D. 64), an efficient and practical organizer as well as an inspired apostle. St. Paul urged the belief in individual salvation through Christ's sacrifice and resurrection and the acceptance of Christ's divinity on faith.

The form of Christian worship was at first very simple. When Christ gathered with the apostles for the Jewish Feast of the Passover and defined the bread and wine as His own body and blood, He established the sacrament of Holy Communion.

And he took bread, and gave thanks, broke it, and gave unto them, saying, This is my body which is given for you: this do in remembrance of me. Likewise also the cup after supper, saying, This cup is the New Testament in my blood, which is shed for you. (Luke 22:19–20)

Thus a new concept, that of Christian commemoration, was added to the original Jewish rite of thanksgiving for divine intervention and salvation. This ceremony has remained the core of the Mass.

At first the Christians gathered in the homes of members of the congregation to reenact the Last Supper by taking a full meal together. Later this meal became formalized into a ritual (the Mass, or Eucharistic rite) performed by a priest, in which bread and wine miraculously became the flesh and blood of Christ (transubstantiation). Eventually the supper table became an altar; and the house where the Last Supper was reenacted became known as the House of the Lord—*Domus Dei*—the Church.

As a more elaborate service developed in the fourth century, elements of Jewish worship—reading from sacred books, collective prayer, and song—were incorporated into the Christian ritual, although the Christians substituted readings from the Gospels and the Epistles for the Law and the Prophets. The service was divided into two parts—one open to all, and a second part reserved for initiates. In the public part of the service the clergy and people invoked the saints and praised the Lord with hymns. Then catechumens and penitents had to leave while the Lord's Supper was celebrated by initiates alone. During the central mystery, the Mass of the Faithful, the priests consecrated the bread and wine, and asked God to intervene and transform the bread and wine into the body and blood of Christ, and to accept the offering at the heavenly altar. Then followed a complicated ceremony of the breaking of bread and taking of wine. The service ended with collective prayers of thanksgiving and a formal dismissal, "Ite, missa est," (Go, you are sent forth), from which the term for the service, the Mass, is derived.

The second important rite in the early church was the initiation ceremony, baptism. The simple washing away of sins and the gift of the Holy Spirit by the laying on of hands mentioned in the New Testament became an elaborate and formal ritual presided over by the head of the Christian community, the bishop. During Lent the initiate was exorcised and instructed in his new faith. The actual initiation—a personal rebirth—took place the

Saturday evening before Easter, the time of Christ's Resurrection. The baptismal rites consisted of a profession of faith, followed by triple immersion in which the sins were washed away and the initiate "died" and was reborn in Christ. The new Christian was robed in white and anointed, received the Holy Spirit through the touch of the bishop, and was then accepted into the full Christian community at the Mass of the Faithful. Baptism of large numbers of adults by immersion required a special building, which was equipped with a tank, fountains, and robing rooms. The ritual death and rebirth suggested the architectural symbolism of the tomb for the baptistery, just as the Lord's Supper could appropriately be taken in a house-church.

Other religions at this time also revolved around the concept of death and rebirth. In its early years, Christianity must have seemed to many Romans to be just another of the cults which originated in the eastern part of the Empire and which appealed particularly to the underprivileged members of society. Many of these religions grew out of ancient fertility cults—for example, the Egyptian cult of Isis and Osiris, the Roman cult of the Earth Mother, Demeter (the Eleusinian mysteries), or the Greek cult of Bacchus (the Orphic mysteries). Ecstatic in tone and highly individual in their appeal, the mystery religions had elaborate, secret, and sometimes orgiastic rites in which music, incense, lighting, and sacred images gave dramatic, sensuous urgency to the believers. Christians incorporated some of these elements into their liturgy, to enhance the emotional intensity and immediacy of worship. The idea of powerful secrets open only to the initiate, ensuring eternal life through union with a Man-God-Savior, appeared in Christianity as early as the writing of St. Paul.

Monotheistic cults—the *Summus Deus*, the Neo-Platonic One, Zoroaster and Mithras, and *Sol Invictus*—had spread through the Empire by the third century. The triumphant sun (*Sol Invictus*) had a cult associated with the Roman emperors. Even Constantine, for all his support of the Christian cause, gave up his devotion to and identification with the sun only on his deathbed, if at all. The designation of Sunday as the Christian sacred day rather than the Jewish Sabbath, Saturday, and the choice by the Christians of December 25 (the festival of the sun and of Mithras) as the feast of the Nativity suggest the influence of sun cults on Christian practice.

As Christianity became a major religion within the Roman Empire, it needed an organized administrative structure and a coherent philosophy. The first it took from the Romans and the second from the Greeks. As a political and economic institution, Christianity adopted the Roman imperial model—provincial governments under a central ruler, an international bureaucracy, a system of taxation, and even elaborate records and archives. To create a rational system for the justification of intuitive belief—essential in order to appeal to the educated classes—Christians turned to Greek philosophy, although the Greek belief in man as a rational being contrasted vividly with the Christian acceptance of religious dogma on faith alone. The Platonic cosmology, further refined by Plotinus and the Neo-Platonists, conceived of a Universal Soul which radiated through the universe and animated the world of matter. Human beings participated in both the world of the soul and the world of matter but their ultimate goal was the reunion with the Universal Soul, the One. St. Augustine (354–430) in the West and St. Gregory of Nazianzus (329–389) in the East sought to adapt elements of this philosophy to Christianity. The educated Greek or Roman could understand that the Universal Soul was another way of describing the Christian God.

The Christians had been given limited official status in the Empire, first by Septimius Severus in 202, who made it permissible to be a Christian but not to try to convert others, and later by Gallienus (253–268), who made

Christianity a "permitted religion" (*religio licite*). This easy situation changed under the tetrarchy. In an attempt to bring religious as well as political stability to the Empire, Diocletian identified himself with Jupiter, and in 303 he issued an edict requiring sacrifices to Jupiter as proof of allegiance not only to the god but also to the state and the emperor. Christians and Jews who tolerated no God but their own were imprisoned and sometimes executed.

After Diocletian's retirement and the failure of the tetrarchy, the Empire was split by contending factions until Constantine established a strong central government. In a series of edicts culminating in the Edict of Milan (313), Constantine confirmed the toleration of Christianity. Imperial capital cities—Constantinople in the East and Rome in the West—became the new Christian capitals. The emperor and his family became patrons of Christian art; imperial Roman art became Christian art. Ultimately the Church supplanted the Roman Empire as a unifying force in the Western world.

Christian Art Before Constantine

Social factors worked against the creation of Christian art before the fourth century. The early Christians had inherited from Judaism a prejudice against the representation of divinity; furthermore, in these first centuries Christians were concerned with disassociating themselves from pagan religious practices, including the creation and veneration of images of gods. The austerity of actual poverty as well as the Christians' denial of worldly goods as irrelevant, if not downright evil, also played a part in the rejection of art and monumental architecture by some segments of the Christian community.

In short, the study of Christian art from the first three centuries A.D. depends on the chance survival of monuments and on funerary art. One of the most striking provincial sites is Dura-Europos, a city on the Euphrates River

in Mesopotamia destroyed by the Persians in 256. In Dura-Europos archeologists have found a wide variety of places of worship: temples of Zeus Theos, Bel, and Mithras; a Christian house-church; and a Jewish synagogue. The Christian house had the date 231 scratched in the plaster of one of the walls and was buried when the city wall was strengthened as part of the fortification preceding the attack in 256. The house is an ordinary, modest home with rooms arranged around a courtyard. Except for the baptistery, which had a rectangular font set in a niche framed by columns at one end of the hall, none of the rooms has any special Christian features, although the rooms must have served as sanctuary, dining hall, and storage rooms. The owner of the house may have lived on the second floor. The oldest places of worship in Rome and other great cities also were private homes, often with an upstairs room set aside for services.

In the Christian house at Dura, paintings depicting the fall of man and salvation through Christ, a recurrent theme in Christian art, survive on the walls of the baptistery. Behind the font the artist drew figures of Adam and Eve, representing the Fall of man, and the Good Shepherd representing salvation [7]. On the walls he depicted Christ's miracles and the Holy Women at the Tomb. The paintings are hasty, clumsy sketches in which crude figures are scattered irregularly over a light, neutral background. The painter ignored the physical beauty of human beings and denied the spatial relationships of the material world, for the paintings were not intended to recall visual appearances or to decorate the room but were meant to carry an important, cryptic message. In the image of the Good Shepherd, a pagan would see a man carrying a sheep; a Jew might interpret the painting as the shepherd of Psalm 23. Only the Christian knew the correct interpretation of the picture—that is, the promise of salvation through Christ described in the parable of the lost sheep (Luke 15:3–7) and restated by Christ: "I am

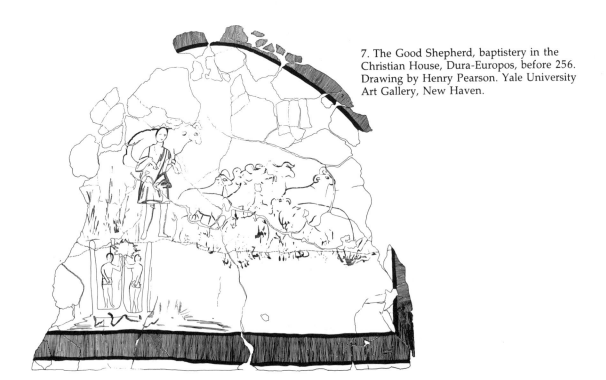

7. The Good Shepherd, baptistery in the Christian House, Dura-Europos, before 256. Drawing by Henry Pearson. Yale University Art Gallery, New Haven.

the Good Shepherd, the Good Shepherd lays down his life for the Sheep...." (John 10: 11–16). The Good Shepherd together with the Adam and Eve may be read as a promise of salvation affirmed by Paul to the Corinthians: "For just as in Adam all die, so in Christ shall all be made to live" (I Cor. 15:22). Early Christian art is an art of more or less disguised symbols intended to state and reinforce Christian doctrine.

The Jewish community at Dura-Europos also remodeled a private house into a synagogue to provide space and facilities for worship. A large hall with a niche for the Torah (the Law, or the Pentateuch—the first five books of the Old Testament) was splendidly decorated with scenes from the life of Isaac, Jacob, and Moses. Decorative frames divide the walls into rectangular panels whose size depends on the space necessary for the depiction of the story rather than on a preconceived architectural scheme. In this abstract Near Eastern style, forms are reduced to simplified geometric shapes created by strong outlines filled with flat, bright colors. Figures are frontal, stare straight ahead at the viewer, and are hieratic in scale—that is, their size depends on their importance rather than on their relationship in space. Either a sharply rising plane or superimposed registers indicate space in depth. Occasional references to three-dimensional, spatial compositions can be found—for example, the foreshortening of the ox team in the destruction of the pagan temple at the approach of the Ark. In contrast to the animals, the broken statues, vases, and candlesticks lie scattered over the picture plane, and the temple becomes a two-dimensional assemblage of columns and pediment. This abstract style is an important alternative to Roman realism. Furthermore, if painting of such clarity and vigor flourished in an outpost like Dura-Europos, then surely a fully developed Jewish pictorial tradition must have existed to provide models for later artists recording Old Testament stories. An abstract art representing anti-material religious beliefs became widespread in the third century.

In the heart of the Roman Empire and in Rome itself funerary art provides most of the evidence for Early Christian art: the paintings in the underground cemeteries known as catacombs and the sculpture of large stone coffins, or sarcophagi. Catacombs consisted of street-like tunnels with loculi (niches in the walls) to hold the dead. Cubicula (chambers) provided additional space for loculi and for simple funeral rites. With increasing demand for space, a catacomb became a complex maze of passages and chambers on many levels, a veritable necropolis, or city of the dead. Catacombs were not necessarily Christian burial places—pagans and Jews used catacombs, too—nor were they secret. Commemorative services and funeral banquets took place in halls built above ground.

The Cubiculum of the Good Shepherd in the so-called Flavian Hall of the Catacomb of Domitilla on the Via Appia, where the paintings probably date from the early third century, illustrates the typical arrangement of the paintings and the adaptation of secular ornament to Christian use [8]. The creamy white ceiling was divided into symmetrical fields by black, red, and green lines. Four lunettes surround a central medallion and create a shape that suggests a dome of heaven permitting a vision of paradise through a central round window [9]. The central medallion, or oculus, frames the Good Shepherd, an idealized youth effortlessly bearing a sheep on his shoulders and standing in a landscape between two more sheep. Doves standing among flowers and leaves fill the lunettes and rectangular panels on the walls. The artist has copied the typical secular wall decoration of foliage, birds, and flowers set in fanciful painted architectural frames found in fine Roman houses; however, in the context of the catacomb the painting suggests the Christian soul in the gardens of paradise.

In the decoration of the underground chambers, the Christian artists worked in a hasty and often careless version of the current illu-

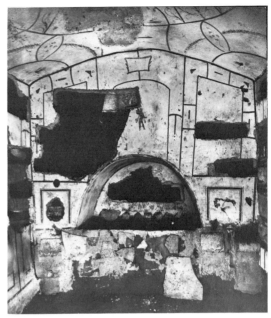

8. Cubiculum of the Good Shepherd, Catacomb of Domitilla, Rome, early third century.

9. The Good Shepherd, Cubiculum of the Good Shepherd, Catacomb of Domitilla, Rome, early third century.

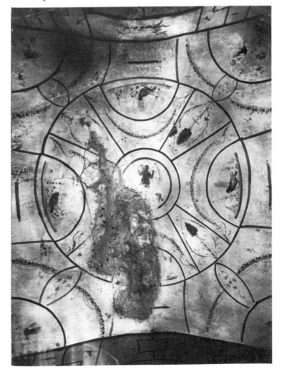

sionistic style. Master painters created naturalistic forms through the elimination of detail, color changes, and subtle modeling. Although the final effect of illusionistic painting is one of spontaneous, fluid ease, the technique actually required great control, care in execution, and thoughtful composition. In the hands of lesser artists it could all too easily become a sketchy, even crude, shorthand, as is apparent in the painting of the baptistery at Dura-Europos and in many catacombs. The distinction between pagan and Christian art is all too often one of quality and certainly one of iconography—that is, subject matter and its interpretation. The abstract quality inherent in Roman illusionism, developed in Late Antique imperial art and characteristic of Near Eastern art (such as the Dura synagogue paintings) could also be turned into an effective instrument for the expression of a new anti-materialistic vision of the world.

In the catacombs many memorable images successfully expressed the new religious beliefs and aspirations. Artists used both allegorical narratives and single symbolic images to convey their message. The Catacomb of Priscilla, in the Via Salaria, usually dated at the end of the third century, is a veritable gallery of Early Christian painting, in which themes of salvation and the protection of the faithful dominate the narratives. Many paintings in the catacombs could have been inspired by Judeo-Christian prayers which enumerated examples of God's intervention in behalf of His people.

Deliver, O Lord, the soul of thy servant as thou didst deliver Noah in the flood . . . Isaac from the sacrificing hand of his father . . . Daniel from the lion's den . . . the three children from the fiery furnace. . . .

The Hebrew Children in the Fiery Furnace (Daniel 3), in the Persian dress associated with Mithras or Zoroaster, stand with hands raised in the ancient gesture of prayer as the flames whip around them. The figures are merely green shapes touched by yellow; hands, faces, and flames are sketched in with a few strokes of red and orange [10]. Yet, in spite of the simplification of the forms and the economy of the brushwork, the story and its message would have been clear to the initiate. The presence of the Holy Ghost, in the form of a dove bearing foliage which could be either the palm of victory or the olive of peace, indicates that the flames were powerless to harm the believers. As persecution of Christians increased in the third century, such stories of faith and deliverance had an immediacy for the Christian community; nevertheless, the mood of the catacomb paintings remains hopeful and even joyous. Christians waited confidently for the release of death, for salvation, and for the eternal bliss of paradise.

Single images, as well as narratives, held disguised Christian meanings. The palm was an emblem of victory whether given to a victorious athlete or to a Christian martyr who died for his faith and triumphed over death as an "athlete of God." The dove indicated the presence of the Holy Ghost. The anchor became a symbol of hope. The cross, however, was usually disguised as the mast of Jonah's ship, a tau cross, or an Egyptian looped cross (the ankh, symbol of life). Only in the fourth century did the cross become the principal Christian symbol, first in combination with the initials of Christ to form the sacred monogram and then alone, after St. Helena's discovery of the True Cross.

The most common and important early Christian symbol was the fish. The fish had several meanings; it signified Christ, for the word "fish," as a cryptogram on the Greek word *ichthus*, spelled out the first letters of the phrase "Jesus Christ, Son of God, Savior." Christ had called on the apostles to be "fishers of men," and thus the fish stood for the Christian soul swimming in the water of baptism, to be caught and saved by the Fisher of Souls. Christ fed the multitude with fish (bap-

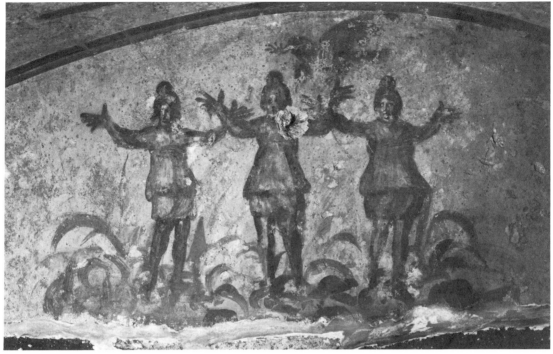

10. Three Children in the Furnace, Catacomb of Priscilla, Rome, third century. Fresco, 20″ × 30″.

tism) and loaves (the Eucharist). Christ was also represented as a teacher, a philosopher, the Good Shepherd, or the Lamb of God. Complexity of associational references of apparently simple objects became characteristic of Christian iconography.

Some images speak directly to the observer and interpretation seems superfluous. In the Catacomb of Priscilla the nurturing theme of mother and child can be interpreted as the earliest representation of Mary and Jesus [11]. A man pointing to a star may be the Prophet Isaiah foretelling the birth of Christ (Isa. 7: 14). A skillful artist has captured the squirming

11. Mother and Child, Catacomb of Priscilla, Rome, third century.

child and protective mother; however, the reduction of illusionistic modeling to blocks of color touched with brilliant highlights—a technique having the effect of the use of the drill in sculpture—suggests the dematerialization of form typical of Late Antique art.

Most Early Christian sculpture, like painting, was made for funeral rites. The carved sarcophagi commissioned from fine sculptors by wealthy members of the community provide abundant examples of Christian sculpture. Since most of these sarcophagi remained in public view in surface cemeteries, the iconography is often ambiguous and certainly not inflammatory. The carvers adapted pagan themes for their Christian patrons and, even more strikingly than in the case of painting, sometimes only the context identifies the work as Christian. A shepherd in a landscape, as we have seen, could be Christ but might be Orpheus or Mercury, both of whom were depicted as shepherds. A harvest scene with putti did not necessarily convey the image of the Vineyard of the Lord and the wine of the Eucharist but might also have been interpreted as the wine of Bacchus. A fisherman, a flock of sheep, an anchor, a female orant, a seated figure, a shepherd, a seated philosopher: none of the figures has overtly Christian meaning and yet each is found in clearly Christian contexts in the catacombs, where they can be identified with the Fisher of Souls, the Good Shepherd, Christ the teacher, the congregation of faithful Christians, and symbols of hope and prayer.

On a late-third-century sarcophagus with the story of Jonah, the sculptor used the continuous narrative technique seen in Roman historical reliefs to tell Jonah's story of salvation [12]. Jonah embarks, is cast into the sea, swallowed by the monster, and spit out on the shore, and he finally rests like a sleeping Endymion or Dionysus under the gourd, a symbol of paradise. Christ pointed to Jonah as an allegory of His own death and Resurrection (Matt. 12:39–40). Other miracles from the Old and New Testaments—Christ raising Lazarus, Moses striking water from the rock, Noah in his Ark (the Ark is reduced to a little square box)—attest to God's power and protection, while the seascape provides an excuse to disguise the Fisher of Souls as part of a genre scene: a man surrounded by birds, reptiles, and fish. The curling body of the sea monster, repeated twice, dominates the panel and provides continuity and compositional focus. The awkward insertion of additional scenes placed on independent base lines in the upper part of the panel breaks the continuity of the landscape but heralds a new design for sarcophagi with two registers of narration. The sculptural technique is excellent; the relief is so high that elements such as legs and Jonah's vine are actually free from the background. Although most of the work was done with the chisel, the sculptor used the running drill to create tiny pockets of shadow and thus produced a lively pattern of light and shade that is just as effective as that on the Column of Marcus Aurelius.

The Jonah story is told again in a remarkable series of statuettes now in the Cleveland Museum of Art [13]. Freestanding sculpture from the Early Christian period is rare, and these figures illustrate the difficulty of assigning a date and place of origin for many works of art. Scholars now suggest that they are the product of a workshop active in the third quarter of the third century somewhere in Asia Minor where Classical Hellenistic influence remained strong. Even the function of the figures is unclear—they could have come from a tomb or a baptistery; Kitzinger has suggested that they might have been fountain ornaments in a private home. In two of the statuettes, the sea monster swallows and spews forth Jonah with a vigor that recalls the intricate baroque compositions of later Greek sculpture. A third statue illustrates Jonah reclining under the vine like a Classical hero. The figures are highly finished, and the details of heads, hair, and human and monster anat-

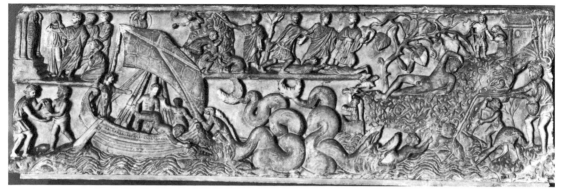

12. The Jonah sarcophagus, Vatican Cemetery, late third century. Marble. Approximately 2′ × 7′. Vatican City, Museo Pio Cristiano.

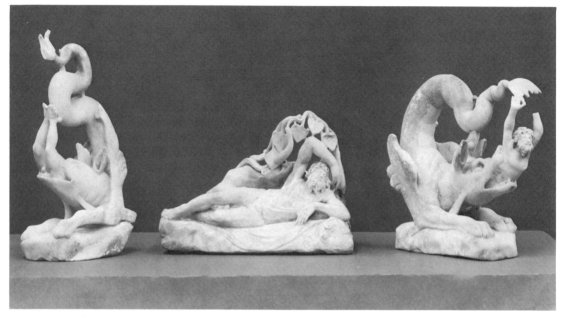

13. The story of Jonah, Asia Minor, third century. Marble. Jonah swallowed, 20 5/16″ high; Jonah under the gourd, 12 5/8″ high; Jonah cast up, 16″ high. The Cleveland Museum of Art.

omy are skillfully treated. The sculptor, unlike so many Early Christian artists, had clearly not lost contact with his Classical heritage and could, when called upon, break free of the restraint imposed by a Christian patron to create remarkably expressive idealized figures.

If Christian sculpture in the round is rare in the third century, mosaic—the monumental and expensive medium which was to become one of the glories of Early Christian and Byzantine art—is even rarer. The earliest mo-

saic with Christian subjects known today was found in the Mausoleum of the Julii under St. Peter's basilica in Rome and is dated to the end of the third century [14]. Like so much Early Christian art, the mosaic at first appears to have a pagan subject: the vineyard of Bacchus and a charioteer, from whose nimbed head stream beams of light, like Helios crossing the sky in his chariot. On the walls of the mausoleum, however, outlines of tesserae can still be seen, and three scenes have been

identified—Jonah, the Fisher of Souls, and the Good Shepherd. Thus the vine in the surviving mosaic becomes the symbol of salvation through the Eucharistic wine, and the charioteer is none other than Christ ascending to Heaven. In the Near East the charioteer had come to symbolize the cosmic power of the ruler through his identification with the astral bodies, and in pagan Rome the heavenly charioteer carried the Emperor into the heavens at the time of his deification, or apotheosis. He could also represent the Victorious Sun,

14. Christ/Helios, Mausoleum of the Julii, third century. Mosaic, 78" × 64". Vatican City, Rev. Fabbrica de S. Pietro.

Sol Invictus. The triumphant equation of Christ as Light of the World with Helios and cosmic power, and His Resurrection with an imperial apotheosis, indicates the growing strength and confidence of the Christian community. In this mausoleum, at least, the Christian owners and the artist adopted the most imposing imperial symbolism for their image of God.

If Christ/Helios appears stiff or overly simplified, the frozen quality of the style is due in part to the medium itself. A mosaic is made of cubes of stone, called tesserae, set in a bed of plaster or concrete. A skilled artist working with small tesserae of many shades can imitate the illusionistic effects of painting, and Roman mosaicists had learned to reproduce natural forms, usually in strong colors against a light background. Nevertheless, the nature of the medium lends itself to simplification and abstraction, for repeated geometric patterns are easy to set and produce handsome decorative effects. In the modeling of the charioteer's cloak and tunic or in the horses, for example, shadows and highlights are exaggerated and repeated so that they begin to form independent patterns, much as do the highlights produced by drilling in sculpture. Techniques begun as rapid, easy ways to achieve an illusionistic effect, through repetition and even misunderstanding, eventually led to a new style. When this abstract mode also served to express a new definition of reality—when abstract form and spiritual content coincided—then a new Medieval style emerged.

Christian art flourished when people who were from a level of society that was accus-tomed by wealth and education to patronize the arts began to enter the Church in large numbers. These cultured Romans commissioned painting and sculpture in the current local style, changing only the interpretation of the subject matter.

By the end of the third century, art and architecture were evolving without a break with the pagan past. The development of a style is not a self-conscious act. The earliest artists working for Christian patrons represented new subjects in the style in which they were accustomed to work. They tried to convey the divine nature of Christ and the mystical power of the apostles by adapting the traditional methods of portraying gods and rulers. The Late Antique style current throughout the Roman Empire combined with increasingly strong influence from the Near East, often handled without understanding, gradually became an art in which the physical appearance of figures and objects and their three-dimensional spatial relationships were unimportant. Artists denied the physical world and conveyed the essence of the scene through expressive eyes and gestures, symbolic settings, and almost naïvely direct narration. Late Antique art was abstract and expressionistic before it was Christian, but artists working for Christians enhanced and consciously developed these tendencies until painting, sculpture, and mosaic approached the ideal described by Plotinus—"an appropriate receptacle . . . seeming like a mirror to catch an image of [the Soul]."

[CHAPTER II]

The Art of the Triumphant Christian Church

onstantine the Great, revered by Christians throughout the Middle Ages as the first Christian emperor, became the patron of the Christians and Christian art almost by chance, or, as he declared, through the will of the Christian God. Constantine claimed the imperial throne through his father, who had ruled the West after Diocletian's abdication in 305. Although the army proclaimed Constantine his father's rightful successor, the Eastern ruler, Maximian, had designated his own son, Maxentius, as Western Caesar. In the bitter struggle that ensued, Constantine ultimately defeated Maxentius in 312 at the battle of the Milvian Bridge, near Rome. On the eve of the battle, Constantine had a dream in which he saw a flaming cross bearing the words: "In this sign thou shalt conquer." He ordered each soldier to place on his shield Chi Rho (XP), the monogram of Christ. However much the battle may have been determined by Maxentius' tactical blunders, Constantine believed that it was the Christian God who had granted his army victory. Now uncontestedly Western Augustus, Constantine felt a gratitude that in time would change the entire course of European civilization.

Constantine immediately began to undo the wrongs that his predecessors had visited upon the Christians. First he issued a decree whereby Christians would be tolerated and their confiscated property restored. Then in 313 he recognized Christianity as a lawful religion.

In a crucial pronouncement known as the Edict of Milan, issued in concert with the Eastern Augustus, Licinius, Constantine formalized his earlier decrees. The text of the edict, a model of religious toleration, allowed not only to Christians but to the adherents of every other religion the choice of following whatever form of worship they pleased. Giving freedom to Christian and pagan alike should have assured the Emperor a reign unhampered by civil strife. Having secured his authority in the West, Constantine sought absolute supremacy in the East as well. His struggle with Licinius lasted for ten more years, but Constantine emerged victorious.

But if Constantine expected the Christians to unite behind his government as a pious, harmonious people with a single belief, he was disappointed. Christian theologians debated the nature and meaning of Christ and Christianity, attacking each other with the same vigor that they directed toward unbelievers. A critical problem in the fourth century was the very definition of the nature of Christ. To most Christians indivisible equality of Christ's human and divine natures was essential to the dogma of salvation; all the while he lived and died on the Cross as a man, He remained the Son of God. Nevertheless Arius (d. 336), a Libyan priest in Alexandria, claimed that Christ had one, supernatural nature neither wholly human nor totally divine, and furthermore, that the three persons of the Trinity, while similar, did not have identical

natures. The Arian position was challenged by Athanasius (d. 373), who claimed that the three persons of the Trinity were one. In 325 Constantine called a Church council at Nicaea in an effort to establish a uniform Christian doctrine for his Empire. The council accepted the Trinitarianism of Athanasius as the basis for the Nicaean Creed and declared Arius' doctrine heretical; nevertheless, Arianism continued to flourish and to plague the Christian world. Unfortunately for the Christians and the Empire, the barbarian Goths had been converted to the Arian Christian heresy.

Official Art Under Constantine

Diocletian's experiment with four-man rule had ended with Constantine's victory over Licinius and the reestablishment of a single political authority. Ever the pragmatist, Constantine determined to establish new administrative headquarters in a secure part of the Empire; he chose a superbly defensible site, Byzantium, a Greek port of the Bosporus at the eastern end of the Mediterranean. There, in 330, Constantine dedicated a magnificent imperial residence, which soon caused the city to be called Constantinople, although the Emperor himself named it the New Rome.

For the next seven years, until his death in 337, Constantine commissioned works of art and architecture for every part of the Roman Empire. Pervading these monuments is an ecumenical spirit that reflects the emperor's calculated willingness to be all things to all people, the universal toleration explicitly stated in the Edict of Milan. Since Constantine recognized the propaganda value of great public works of art, he employed art and architecture as a means to impress his ecumenical piety upon the citizenry. For his forum at Constantinople, he ordered a colossal statue of himself—a full-length, freestanding portrait incorporating objects revered by his peoples. Now lost, it combined pieces of pagan sculpture with Jewish, Christian, and pagan relics

in a monument that enabled every citizen to regard Constantine as the defender of his or her own faith. A bronze figure of Apollo was turned into an image of Constantine by replacing the pagan god's head with a portrait of the emperor. Crowning the imperial brow was a diadem which had in it one of the nails discovered by Constantine's mother, the Empress Helena, when she found the Cross. The statue stood on a porphyry column, which in turn rested upon a hollowed-out base containing a marvelous collection of sacred objects: for Jews, an adz used by Noah to build the Ark and the rock from which Moses struck water in the desert; for Christians, crumbs from the loaves of bread with which Christ miraculously satisfied five thousand faithful, fragments from the crosses of the two thieves whom the Romans crucified with Jesus, and the jar of spices and ointment used by the Holy Women to prepare Christ's body for the tomb; for good Roman citizens, the standard that had been carried to Rome by its mythical founder, the Trojan prince Aeneas. The monument typified Constantine's cosmopolitan, syncretic vision.

Contemporary sources record that Constantine commissioned many other colossi, but since not one survives intact, we must imagine their awe-inspiring majesty from the pieces of a gigantic seated figure once placed in the basilica of Maxentius and Constantine in the Roman Forum [1]. The head alone is 8½ feet high; thus, before its dismemberment, the statue must have risen to a height of more than 30 feet—over five times life size—in the apse of the basilica. It served as the commanding *lauratron*, a symbol of imperial presence without which business could not be legally conducted in the emperor's absence. Even if its symbolic function escaped notice, the style alone set the figure in a world apart. The portrait radiates Heaven-sent sovereignty through aggrandized, abstracted features. In the geometric forms of the face, only a massive jaw and a hawk nose suggest Constantine's

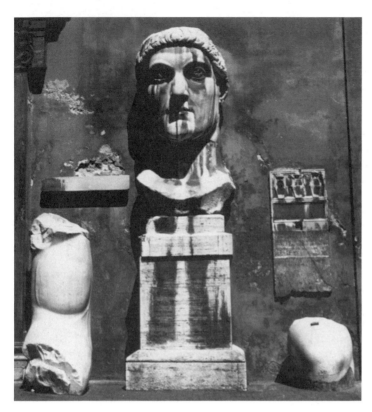

1. Head, knee, and upper arm, colossal figure of Constantine, early fourth century. Marble. Head, approximately 8′ 6″ high. Palazzo dei Conservatori, Rome.

individual characteristics, while rigid frontality, huge size, and absolute immobility create an otherworldly appearance. Although the deeply drilled eyes look upward, the regular, repeated arcs of the eyelids and the eyebrows deny even this slight sense of movement. These immense staring eyes, almost a foot high, fix on the spiritual source of the emperor's rule, for Constantine directs his sight upward to the gods acknowledged by his reign, be they Christian or pagan. No longer the portrait of a mortal man, the colossal head of Constantine personifies ordained majesty in eternal communion with the heavens.

Constantine's imperial triumph is recalled by the triple arch erected by the Roman Senate to celebrate his victory at the Milvian Bridge [2]. As if to assert Constantine's place in the succession of great Roman emperors, the builders incorporated fragments of sculpture from monuments of Trajan, Hadrian, and Marcus Aurelius, recarving the imperial like-

ness with Constantine's features. Reliefs carved for the arch, like the imperial portrait, break decisively with the realistic style and continue the anti-Classical tendencies already apparent more than a century before on the Column of Marcus Aurelius, where figures began to lose their three-dimensional character through a chiseled and drilled pattern of light and dark. Now every part of the relief—not only its composition but also the carving of individual figures—reflects the artists' will to depict the emperor as a symbol, an imperial presence dispensing wisdom, justice, and alms [3]. In contrast to depictions of Titus or Marcus Aurelius with his troops, Constantine is shown seated at the precise center of the composition, the only figure unconfined by the horizontal registers. His frontal position removes him from the world, since the frontality isolates him physically and psychologically from his petitioners and retainers, who are consistently rendered as short, dumpy figures with enor-

mous heads. Whether the figures dispense charity or petition for it, their repeated forms and gestures and their round, heavy-jawed heads generate a symmetrical pattern. Four identical galleries house indistinguishable officials, all bestowing the emperor's largesse upon similar recipients; thus alms-giving is represented as an immutable feature of Constantine's rule rather than as the pictorial recollection of one specific act of generosity.

The illusionistic space of earlier Roman art has given way in the Constantinian reliefs to

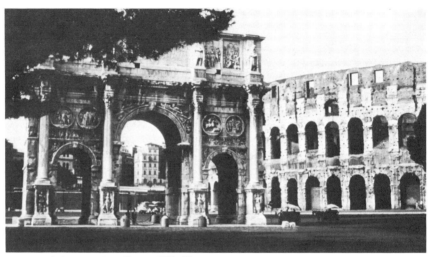

2. Arch of Constantine, Rome, 312–15.

3. Dispensing largesse, Arch of Constantine, Rome, 312–15. Frieze, approximately 40″ high.

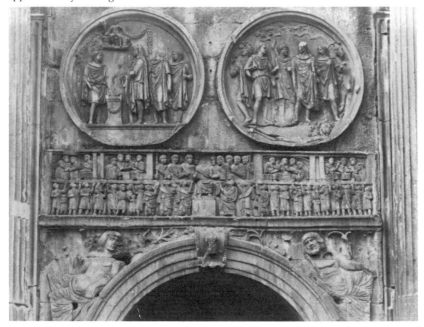

a flat background aligned parallel with the relief surface: architecture does not establish any illusion of three-dimensional space; crowds are represented by the ancient convention of superimposed registers. Compounding this lack of implied depth is the actual overall flatness of the modeling. A transparent plane seems to press against the figures, cutting off any projection into the spectator's space. Figures are simplified to geometric essentials: drapery folds are reduced to patterned linearity; legs are like a row of tree stumps. Extensive drill work produces sharp contours and patterns of light and shadow, exaggerating the style of the Marcus Aurelius column. Finally, the composition is dominated by the strict rectangularity of the panel's shape—a "sovereignty of the frame." If we regard this new symbolic mode not from the point of view of Roman naturalism but from that of the Middle Ages, it emerges, like all of Constantinian art, as an omen for the future.

Theodosius and Official Art in the Later Fourth Century

The *Pax Romana* envisioned by Constantine faded with his own passing. Not until the accession of Theodosius I in 379 were decisive steps taken to stabilize the Empire. With the barbarian threat more ominous than ever, Theodosius determined to unify his subjects by eradicating all trace of pagan worship. In a series of momentous edicts, he proclaimed Christianity for the first time to be the sole religion of the Empire. By the time he died in 395, Theodosius had irrevocably transformed the Roman Empire into a thoroughly Christian state.

Theodosius, like Constantine, had continued for reasons of safety to make his capital at Constantinople. Meanwhile, the city of Rome suffered political and economic decline. Although the city remained the administrative center of the Western Church, the secular government in the West, to meet the threat posed by the barbarians, moved northward first to Milan, which flourished under its great bishop, St. Ambrose, and then, at the beginning of the fifth century, to the safer retreat of Ravenna on the Adriatic coast. In 410 the Visigothic chieftain Alaric lay siege to Rome and finally entered its gates. Rome had fallen to the barbarians; the new age had begun.

In spite of the weakness of imperial rule in the West and in spite of Christian doctrine, official art in the second half of the fourth century continued to portray the emperor as a superhuman being. Theodosius, while condemning paganism, did not repudiate the imperial glorification of the emperor that paganism fostered. His artists intensified the formal principles developed earlier in the century—abstraction of natural forms, insistent frontality, rigid symmetry, and hieratic scale. In a stark and uncompromisingly symbolic manner they depicted the emperor as an omnipotent, divinely inspired sovereign.

A silver plate (*missorium*) made in 388 to mark the tenth anniversary of Theodosius' accession portrays the emperor looming over an official to whom he presents a commission [4]. The artist has made hierarchic distinctions visible and explicit; the emperor—rigid, frontal, and twice the size of any other man—is flanked by his nephew Valentinian, the senior Western ruler, holding a scepter and orb, and by his son Arcadius. Halos circle all three heads to indicate imperial majesty. The guards are smaller still and shown in three-quarter view. The emperor's achievements and the prosperity of his reign are symbolized by a personification of Earth, who reclines at his feet, bearing the cornucopia of abundance and surrounded by plants and putti bearing offerings. Theodosius is majestically enthroned under an arcuated lintel and gable that also serve to isolate him and emphasize his position. The material vestiges of the Classical heritage—idealized faces, personifications, architectural forms—appear in a space made

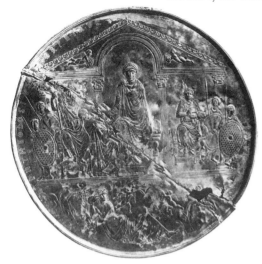

4. *Missorium* of Theodosius, found in Estremadura, Spain, 388. Repoussé and engraved silver. Diameter, 29 1/8″. Academy of History, Madrid.

set out to represent Jesus as the Divine King with a court of apostles and saints.

Christian Art of the Fourth Century

A reluctance to raise the visual arts to a position of prominence persisted among fourth-century Christians, despite the privileged station accorded to Christianity by the Constantinian and Theodosian edicts. Only the practical value of art as an instrument of instruction and the inherited taste for monumental commemoration gave license for images that would otherwise have been considered too worldly, too ostentatious, and too reminiscent of pagan idolatry. Sculpture in the round was particularly vulnerable to the charge of idol worship, since it encouraged association with the gods of the pagan world. Thus, except for portrait busts or small figures of the Good Shepherd, Christianity encouraged sculpture only on sarcophagi.

When the Roman prefect Junius Bassus died in 359, he was interred in a sarcophagus displaying a complex narrative program [5]. Ten scenes from the Old and New Testaments occupy two horizontal registers and are set forth as if in tabernacles, framed by ornamental columns supporting an architrave or alternating shells and gables. The central episodes

immeasurable and irrational by the flatness of the depiction. The men exist in no physical space, nor have they the familiar attributes of the living. Their bodies disappear beneath stiff ceremonial robes or behind decorative shield patterns, while their masklike boyish faces with stylized hair and jeweled headdresses seem to exist only to frame immense, staring eyes. Not surprisingly, the style and symbolism of these secular imperial works provided a fitting model for Christian artists when they

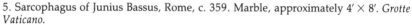

5. Sarcophagus of Junius Bassus, Rome, c. 359. Marble, approximately 4′ × 8′. *Grotte Vaticano.*

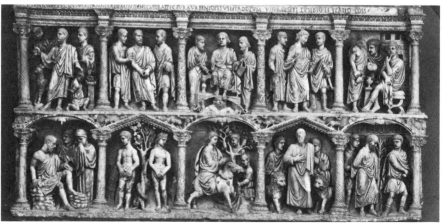

depict Jesus as the divine lawgiver who triumphed over the sin of Adam and Eve in order to save humankind. In the upper central panel, a youthful Christ, enthroned like an emperor in hieratic frontality and larger than the Apostles, dispenses the divine law to SS. Peter and Paul, just as the emperor commissioned an administrator. Christ's dispensation expresses worldwide sovereignty, for His left foot rests on the veil of Heaven upheld by the personified Cosmos. Below, the triumphal theme continues in the Lord's entry into Jerusalem.

The top right scenes amplify the narrative of the Passion; Christ appears to answer the charges made against Him before Pontius Pilate, who is about to wash his hands of all complicity. Analogous to the Crucifixion are the martyrdoms of the Apostles in Rome. Since the reliefs depict Jesus' trial and condemnation, but not His Crucifixion, SS. Peter and Paul, as if still emulating their master, appear at the moment of their arrests by the Roman soldiers. The remaining scenes suggest relationships between events of the Old and New Testaments. Adam and Eve hiding their nakedness after the Fall remind us of the need for salvation; Job on his dung heap, the prophet Daniel in the lions' den, and Abraham's sacrifice of Isaac all refer to faith, sacrifice, and God's protection, and they prefigure redemption in Christ.

The composition of the Junius Bassus reliefs is controlled by the architectural elements, which repeat the flat, rectangular shape of the sarcophagus. The evenly disposed columns, gables, and entablature impose a symmetry enhanced by the narratives. For example, the sculptor has matched at one diagonal extreme the seated, inward-facing figures of Pilate and Job, and at the other the outward-turning standing Abraham and St. Paul. The nude Adam and Eve would have balanced a nude Daniel (the toga-clad figure is a replacement). The figures completely fill the available space and act on a narrow stage in which the neutral background with tiny trees and buildings suppresses the illusion of measurable space. Although the figures have heavy proportions, they are muscular actors who move beneath form-revealing drapery, and their gestures are both dramatic and convincing. The very conflict between the human images and their unreal, stagelike environment testifies to the lingering appeal that Classical forms still held for wealthy Christian Romans.

Far more aggressively Christian, despite the solid substantiality of each figure, are the sarcophagi carved entirely with scenes from the Passion—the climactic and sacrificial episodes in the life of Christ. In the Passion Sarcophagus from the Catacomb of Domitilla [6], symbol and narrative—two facets of Early Christian art first seen in catacomb paintings—

6. Passion Sarcophagus, Catacomb of Domitilla, Rome, second half of the fourth century.

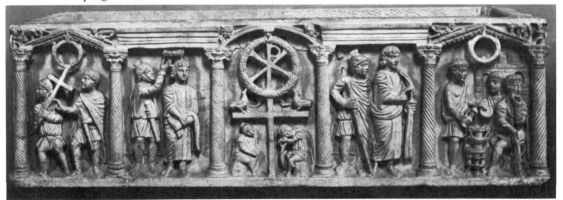

have been harmoniously merged into a new emblematic form. As in the Sarcophagus of Junius Bassus, to which the Passion Sarcophagus is stylistically akin, an architectural frame breaks up the surface into flat, evenly measured units. Each of the four scenes from the Passion functions as an abstract emblem. Christ is arrested and brought before Pilate, who by his symbolic washing of hands leaves the Lord's fate to the will of the multitude. At the left the Roman soldiers mockingly crown Christ with a wreath of thorns, and then Simon of Cyrene seeks to lighten Jesus' burden by carrying His cross, an act indicating the obligation of every Christian metaphorically to bear the cross after Christ. The Crucifixion and Resurrection are represented not as a story but as an abstraction. A cross fills the central panel. Doves, symbols of peace and purity, perch on the arms while overhead hangs the laurel-wreathed Chi Rho seen by Constantine and thus understandable as an allusion to the triumph of the Church. However, the most striking innovation, combining symbol and narrative as never before, is the inclusion of the two sleeping figures. Sent to guard Jesus' tomb, they are the soldiers who watched in vain, unaware of the miracle of the Resurrection. Their presence reminds us that the Chi Rho stands for Christ in His victory over death—the moment when the Lord triumphantly rose from the sealed tomb. With Jesus appearing not in human guise but under the sign of His Holy Name, we enter the symbolic world of the Middle Ages.

Christian Architecture in the Fourth Century

The modest arrangements that had adequately provided for the simple Early Christian service seemed inappropriate once Constantine recognized Christianity as one of the state religions. Throughout the fourth century, Constantine and his successors built churches to vie with pagan temples and to dignify Christianity as one of the official religions, and ultimately as the only official religion, of the Empire.

The ever-present symbolic focus of Christianity demanded that the Church signify both the house and the tomb of the Lord. This heavenly mansion on earth had to house the entire Christian community, and the building had to be majestic, worthy of the King of Heaven. In their efforts to create an imposing architecture, Early Christian architects first emulated imperial building types. Naturally, they avoided Classical religious architecture and turned to secular buildings—the basilica and tomb—for models. Roman basilicas were large, rectangular buildings that served as places for public gatherings: law courts, markets, schoolrooms, army drill halls, reception rooms in imperial palaces. The building could be a simple hall with a trussed timber roof, or it might be extended by aisles covered with shed roofs abutting the walls at lower levels and allowing the upper wall of the central aisle, or nave, to be pierced with windows (the clerestory). Some basilicas also had second-story galleries over the aisles. In addition, a basilica could have one or more semicircular apses projecting beyond the walls. The apse of a civil basilica provided an imposing site for a judge's seat, an emperor's throne, or the *lauratron* of the emperor. Christians adapted the basilican form to their own purposes: at the end of the hall a single apse housed the altar, while the hall served the congregation. The entrance was placed opposite the apse so that, on entering, the worshiper's attention was immediately focused on the sanctuary. This longitudinal orientation of the building also provided space for liturgical processions. Thus, both conceptually and functionally, the basilican hall fulfilled the congregational needs of the Early Christian Church. Most Constantinian basilicas have been rebuilt or remodeled; however, the appearance of these churches can be visualized from St. Paul's Outside the Walls as it was recorded by Piranesi in the eighteenth century [7].

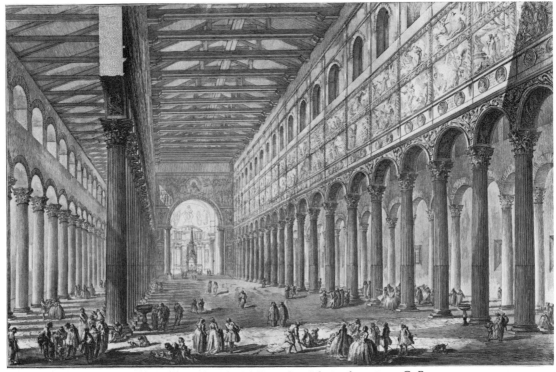

7. Interior of the Church of St. Paul Outside the Walls in the eighteenth century. G. B. Piranesi, 1749.

As early as 313 Constantine donated the Palace of the Laterani to the Christians to serve as a residence for their bishop. The church built next to the palace is still the Cathedral of Rome—that is, the church in which the bishop (in Rome, the Pope) presides and has his cathedra, or throne. The Lateran basilica (originally dedicated to Christ but now to St. John, S. Giovanni in Laterano) was the first Christian transformation of the basilican form. Although the building was remodeled in the seventeenth century, contemporary records, together with sixteenth-century depictions and modern investigations of the structure, enable us to re-create the appearance of the Constantinian church.

The construction and decoration of the apse and the housing of the altar within it provided a focal point for the celebration of the Mass. The basilica, entered now from the narrow gable end, was a vast rectangular space divided by four rows of columns into a wide nave flanked by two side aisles. The colonnade and entablature accentuated the longitudinal focus of the nave, a system stressing the direct path to the sanctuary, a path illuminated by clerestory windows. At the end of the nave, the juncture of the apse and the end wall formed a triumphal arch. In the Christian church, the triumphal arch came to signify the triumph of Christ—the triumph symbolically about to take place at the altar. In this sense the arch marked a dividing line between the worldly nave and aisles and the sanctified apse beyond.

Passing through the portals, the worshiper must have been stunned by the brilliance of the interior. Light and color filled the space, for no expense had been spared on glittering veneers and fine furnishings. Gold foil covered the simple timber roof, picking up the red, green, and yellow veining of the marble columns, while more than a hundred chandeliers and sixty candlesticks, all of gold and silver, produced a shimmering light that was reflected

off seven golden altars and silver statues of Christ and the apostles. Although inspired by the pomp of the imperial court, the magnificence did not constitute worldly ostentation but rather an attempt to re-create on earth the splendor of the House of the Lord in Paradise.

If the church building had been oriented solely around a congregation assembled to participate in the Mass, the basilica would have provided a model wholly satisfactory to later architects, but the organization and devotional character of Christianity had grown remarkably complex. Just as the Mass had developed from a simple commemorative meal shared in a private home to an intricate ritual performed within the sanctified space of a church, so too Christian devotions came to encompass the saints and martyrs who sacrificed their lives as witnesses to their faith. ("Martyr" comes from the Greek word *martys,* meaning "witness.")

To aid them in their prayers for intercession, Christians wanted to associate themselves with a saint, to possess a relic of the saint, or, if a relic was not available, a strip of linen which had touched the relic. Eventually the inclusion of relics transformed every altar into a tomb as well as into the sacred table of the Mass. Whereas an altar or a small shrine initially marked a burial or holy place, when thousands of pilgrims began to visit, churches known as martyria had to be erected to accommodate the crowds and to protect the relics. Cemeteries became crowded not only with tombs but with facilities for funeral and commemorative banquets and shrines of the martyrs—that is, funeral basilicas and martyria.

When in 258 the Romans martyred St. Lawrence by roasting him on a grid for refusing to hand over the valuables of the Church, the community buried him in a cemetery outside the city walls. By the fourth century an underground martyrium and then a funeral basilica, S. Lorenzo Fuori le Mura—outside the walls—were constructed at the site. The funeral basilica combined the features of a covered cemetery, a banquet hall, and a church where commemorative banquets could end with the celebration of the Mass. To enable the congregation to approach the altar and to pass by the relics, the builders projected the side aisles into an ambulatory, an aisle encircling the apse. This ambulatory permitted passage around the altar, at the same time protecting it from the possibility of desecration. Thus, a new type of church developed in response to the practical requirements of the veneration of martyrs and the dead.

The tomb, or mausoleum, joined the basilica in the expanding repertory of Christian architectural types. (The term derives from the tomb built for the Greek King Mausolus in the fourth century B.C.) The ancient mausoleum was a tall burial chamber, square, polygonal, or circular in plan, and often covered by a symbolic dome of Heaven [8]. The mausoleum built for Constantine's daughter, Constantina, who died about 354, stands in the

8. Plan, Church of Sta. Costanza, Rome, c. 350. Diameter, 62″ × 74″.

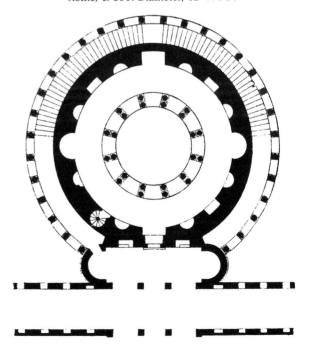

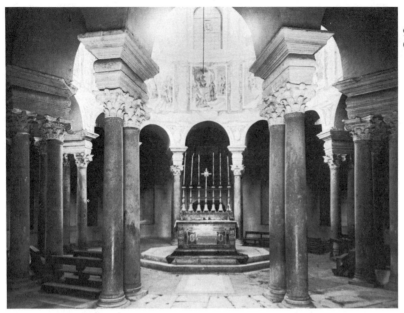

9. Interior, Church of Sta. Costanza, Rome, c. 350.

10. Vintaging putti, Church of Sta. Costanza, Rome, c. 350. Mosaic in ring vault.

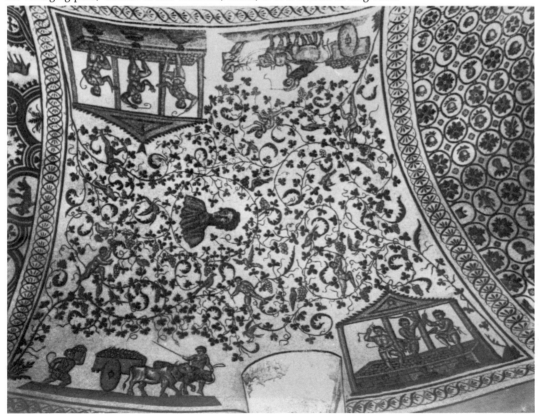

cemetery adjoining the martyrium of St. Agnes. (It was later consecrated as the Church of Sta. Costanza, another form of the princess's name.) The circular building, or rotunda, follows the antique tradition of funerary architecture with its domed centralized structure and simple, unadorned exterior. Twelve pairs of columns support the dome on an arcade and clerestory wall; they also form the inner limits of the circular ambulatory, here covered with an annular (or ring) barrel vault [9]. Four niches faced by four slightly wider intercolumniations suggest the form of a cross, and the twelve windows may represent the twelve apostles. The decoration of the dome, ring vault, and niches combined Christian and secular themes. The mosaics, with their pagan motifs and Late Antique style, clearly stem from the syncretic milieu of the Constantinian court [10]. In the dome, Biblical scenes appeared above a river filled with marine life. In the ring vault a host of cupids, libation vessels, assorted birds, foliage, and the ever-present grapevine come together in a Bacchic celebration appropriate for the floor of a triclinium (dining room), where such mosaics were often located in a Roman house. Fully modeled objects and figures are depicted against a light background laced with ornamental frames and foliage; cupids and nymph-like females fill medallions formed by a continuous circular interlace. Putti work enthusiastically in a vineyard, but although Christians had appropriated the popular images of Bacchus and the vine leaf to allude to the wine of the Eucharist, any overt sign for Christ, such as we saw in the Tomb of the Julii, is absent. The program at Sta. Costanza still suggests the coexistence of Christianity and paganism found in Rome.

The most important mausoleum built during the reign of Constantine was the long-since destroyed shrine in Constantinople where the emperor himself planned to lie. Constantine, with characteristic boldness, ordered his tomb to be housed in a church dedicated to the Holy Apostles, from whom it received its Greek name, Apostoleion. Eusebius described this building in his *Life of Constantine.* At first only cenotaphs (symbolic tombs) of the apostles surrounded Constantine's tomb in the center of the building. The implicit elevation of the emperor to the role of Christ's thirteenth apostle eventually seemed excessive, even in an age accustomed to extravagant imperial propaganda. Thus, when the apostles' relics were transferred to the church in 356–357, the remains of Constantine were moved to an adjoining circular mausoleum. The Church of the Holy Apostles—precisely because it was a major imperial commission—had far-flung consequences for Christian architecture. In plan, the Apostoleion had the form of an equal-armed Greek cross. The entire church, then, represented the Cross, and the altar where Christ's sacrifice was reenacted stood with the tomb at the junction, or crossing, of the four arms. So symbolically rich was this plan that within the next century builders adapted it for major martyria, and echoes of the scheme resounded throughout the Middle Ages.

The centrally planned building, although symbolically appropriate for a martyrium, had serious functional disadvantages as a church. The building could accommodate relatively fewer people than a basilica; furthermore, when worshipers gathered around the altar, the visual impact of the ceremonies was reduced. The need to accommodate vast crowds of pilgrims and simultaneously give added focus to the altar resulted in a new kind of church, one that achieved a compromise between the symbolic mausoleum and the functional basilica. Under the patronage of Constantine, and later of Theodosius, architects sought to merge these divergent forms, to fuse meaning and structure. Their first efforts turned to two of the most important pilgrimage churches in all of Christendom: the Church of the Holy Sepulchre in Jerusalem and the Basilica of St. Peter in Rome. Although each

solved in a different way the problem of housing thousands of pilgrims, both structures as they finally evolved combined the martyrium and the congregational basilica in designs whose influence on church architecture would endure through the Middle Ages.

The fourth-century Church of the Holy Sepulchre is lost to us, for it was remodeled, destroyed, and rebuilt many times [11]. Construction of the original building began shortly after Constantine's mother, the Empress Helena, later canonized as St. Helena, visited Jerusalem in 325. She was taken to the hill of Golgotha, where pilgrims revered the site of the Crucifixion and a rock tomb as the Holy Sepulchre; and there she discovered the True Cross. Over this most sacred of all sites associated with Jesus, Constantine ordered his architects to raise "a basilica more beautiful than any other." The complex included not only a martyrium over the Lord's tomb but also a sanctuary around Calvary as well as a basilica dedicated to the Resurrection over the place where St. Helena had found the True Cross.

The Holy Sepulchre stood apart from other churches, oriented toward a single shrine. Architects responded to the problems of sheltering three sacred sites by integrating the basilica with a traditional mausoleum and an outdoor shrine with an atrium so that for the first time these hitherto distinct structures formed one architectural unit. The builders cut away the cliff and leveled the area around the tomb, and raised a canopy over it surrounded by twelve columns to symbolize the twelve apostles. The Rock of Calvary, protected by a simple pavilion, was connected to the Sepulchre by a colonnaded courtyard. A basilica extending from Calvary provided a setting for the celebration of Mass. Eusebius tells us that a central nave, flanked by double, columned aisles and surmounted by galleries, led to a domed apse, nearly adjacent to the Rock of Calvary. An atrium and a monumental gateway, suggestive of imperial presence, sep-

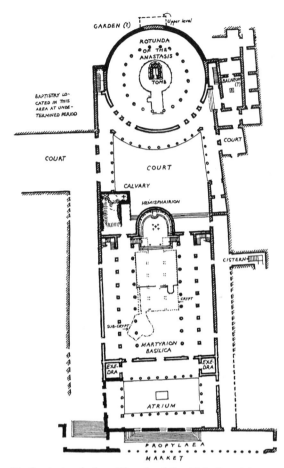

11. Conjectural plan, Church of the Holy Sepulchre, Jerusalem, mid-fourth century.

arated the basilica from the street. Later Theodosius II erected a monumental jeweled cross on Golgotha, a feature that appears in such later depictions of the Holy Sepulchre as the apse mosaic in Sta. Pudenziana, Rome.

The diverse architectural elements of the Church of the Holy Sepulchre were united by the liturgy, as the pilgrims were led through the basilica, to Calvary, into the Holy Sepulchre, and back again in the basilica—a pious circuit through the most venerable sites in Christendom. Thus, architects at the Holy Sepulchre managed to accommodate a large congregation in a martyrium, their method being to erect separate architectural units con-

solidated not by their structures but by the liturgy within.

Just before mid-century, in the first of many reconstructions, a rotunda was built over the tomb of Christ, known as the Anastasis Rotunda, from the Greek word for "resurrection." The rotunda surrounded the tomb and baldacchino with an ambulatory aisle similar to Constantina's mausoleum in Rome. Since this most sacred of all martyria drew more pilgrims than practically any other site in the Christian East, the builders added a second-story gallery for the benefit of additional crowds, and above that an encircling row of clerestory windows to light the tomb. Exactly what kind of dome rose over the Sepulchre remains a mystery. Whether it was conical or formed a hemisphere, the rotunda would have been recognized as a building exalting Christ, the Divine King.

Representations of the Anastasis Rotunda vary in structural details but evoke the symbolic type. An ivory panel carved about 400 represents the Holy Women confronted by an angel at the tomb of Christ, while in the upper right the Savior ascends to Heaven [12]. Perceiving that the Anastasis Rotunda was modeled on imperial mausolea, artists combined the basic elements of the Christian structure with the familiar features of the pagan tomb type: a round dome resting on a drum and columnar arcade, with medallion portraits in the spandrels of each arch. Thus, they ultimately represented, for all those without personal knowledge of the Holy Land, the idea that the tomb at Jerusalem both recalled and surpassed imperial funeral monuments of ancient Rome.

In the greatest pilgrimage church of the West, the faithful converged on only one site—the shrine of St. Peter [13]. The Roman church commissioned by Constantine, possibly as early as 319/322 and nearly completed by his death in 337, was built near the Circus of Nero over a spot which the Christian community had long venerated as the burial place

of St. Peter. When construction began, a small second-century aedicular shrine—a niche flanked by two columns and surmounted by a pediment—identified either the tomb or the site of martyrdom. This shrine took on political as well as religious importance when St. Peter's successors as Bishop of Rome—the Popes—claimed authority over their fellow bishops and insisted that Rome must be acknowledged as the primary seat of all Christendom. The church of the Prince of Apostles not only had to be larger and more splendid than any other, it also had to give special emphasis to the tomb of the saint whose unique mission and

12. Holy Women at the Tomb and the Ascension, Church of the Holy Sepulchre, early fifth century. Ivory, 7 3/8″ × 4 1/2″. Bayer. National Museum, Munich.

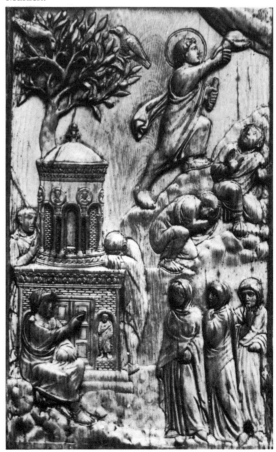

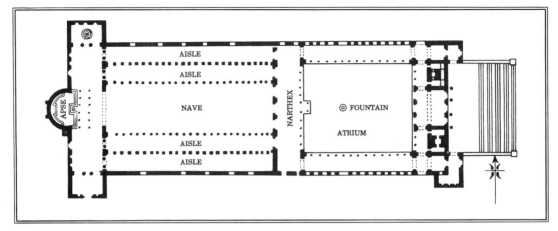

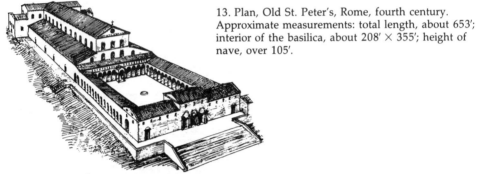

13. Plan, Old St. Peter's, Rome, fourth century. Approximate measurements: total length, about 653'; interior of the basilica, about 208' × 355'; height of nave, over 105'.

appointment by Christ justified the primacy of the Roman see. Renaissance prelates claimed even this huge Constantinian church inadequate and unworthy of the saint and ordered it rebuilt; therefore the Early Christian church is now known as "Old St. Peter's" to distinguish it from its Renaissance successor.

Modern excavations have revealed the extraordinary topographical obstacles overcome by the Constantinian architects in order to situate the church over the memorial shrine. First, the cemetery was disturbed, since the site's sloping hillside had to be completely leveled by cutting and filling, building up foundations under the southern walls by some 25 feet, and excavating on the northern side by an equal amount. Then a five-aisled basilica preceded by an atrium rose on these foundations, and with a total inner length of 368 feet the church could contain a congregation even larger than that provided for at the

Lateran. With a procession of columns supporting a straight entablature, clerestory windows, and a trussed timber roof (with a span of 72 feet), Old St. Peter's would seem at first a typical Christian basilica; however, in keeping with its central importance in Christendom, the architects expanded its size by adding a new feature, the transept.

Old St. Peter's had been designed so that the second-century shrine would lie just in front of the apse. There a baldacchino, or ciborium, recalling by its shape a rising centralized tomb, provided the focal point of the vista down the nave. St. Peter's was "occidented" rather than "oriented"; the apse was at the west so that during the celebration of the Mass, the priest faced east, the rising sun of the Resurrection, and the congregation. The nave remained congregational space and functioned as a funeral basilica. Clearly the space in even a large apse was not sufficient to

accommodate both a large clergy and throngs of pilgrims. The architects solved the problem by adding a transept, a continuous transverse hall as wide and high as the nave and projecting beyond the aisles. Transept and nave together had the form of a tau cross. The nave and aisles opened into the transept but were separated from it by the triumphal arch and by screens. This space between the nave and the apse could be given over to pilgrims or used by the clergy, depending on their needs. Here again, an unprecedented kind of structure emerged in response to new issues perceived and mastered by the architects of Christianity's first monumental buildings. Transept and apse provided ample space for the liturgical functions of a church which was the goal of thousands of pilgrims; the nave provided space for the congregation.

As we shall find throughout the history of Medieval art, these first artistic experiments constituted a process of appropriation and transformation. Once pagan edifices had been appropriated—the basilica, the audience hall, and the mausoleum—they were then transformed into a new architecture suitable for the special needs of the Christian community.

Construction of St. Peter's Church progressed slowly; the atrium was finished by about 390, and the interior decoration by midfifth century. In contrast to the austere exterior, the interior of the basilica was light and colorful [14]. Marble, alabaster, and gilt adorned the walls; a mosaic of Christ flanked by SS. Peter and Paul decorated the apse; and the transept held an extensive narrative cycle of the life of St. Peter. Drawings and written interpretations made immediately before the destruction of Old St. Peter's in the sixteenth century, as well as medieval copies and ad-

14. Interior of Old St. Peter's in the sixteenth century. S. Martino ai Monti, Rome. Fresco.

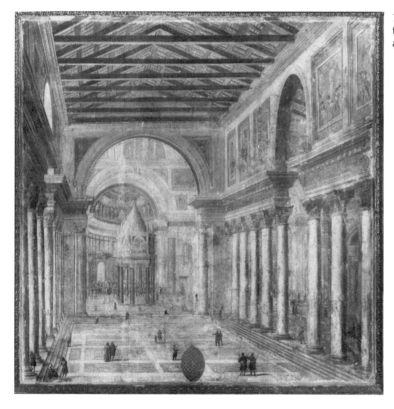

aptations, exist to suggest the appearance of the original interior.

In a sense, the apse mosaic and the pictorial life of St. Peter can be viewed as the natural descendants of two Classical models. Since the *lauratron* of the emperor had stood as surrogate for his presence in the apses of basilican civil courts, it followed that an image of Christ, the King of Kings, should be similarly located in a basilican church. As for the decoration of an interior with a narrative cycle, precedent existed in both pagan domestic architecture and Jewish synagogues, as we saw at Dura-Europos.

The direct stimulus for the inclusion of figural decorations in Old St. Peter's came from ecclesiastical politics—the urgent need to assert the primacy of the Roman see in the church dedicated to its first bishop. The transept illustration of the life of St. Peter documented his ordination as the chosen Apostle. Further, the apse mosaic of Christ with SS. Peter and Paul created a symbolic background for the baldacchino over the martyrium, for it alluded to the dramatic moment when Jesus singled out St. Peter—and consequently the

bishopric of Rome—to be the foundation of the Christian Church. The theme is known as the *traditio legis*, "the handing down of the law." Catacomb paintings suggest that a new type of Christ may have appeared at St. Peter's. Earlier, Jesus had been represented as a clean-shaven youth; by the fifth century He is a regal, older man with long hair and full beard, a type that may have originated in the Near East, where it appears in Syrian manuscripts. The emphasis of Christ's manifestation as the imperial, omnipotent ruler accords with the more transcendental spirit of Christianity found in the Eastern Empire.

After Constantine moved the imperial capital to his New Rome, Milan developed into the administrative and commercial capital of Italy. St. Ambrose, who became bishop of Milan in 373, transformed the city into the foremost ecclesiastical center of the West. The Church of S. Lorenzo, built at this time and variously dated 355–374 and 390, could have been the palace church or the cathedral, but it has also been called a martyrium and an army church [15]. The questions arising over its date and function demonstrate the problems confronting

15. Plan, Church of San Lorenzo, Milan, late fourth century.

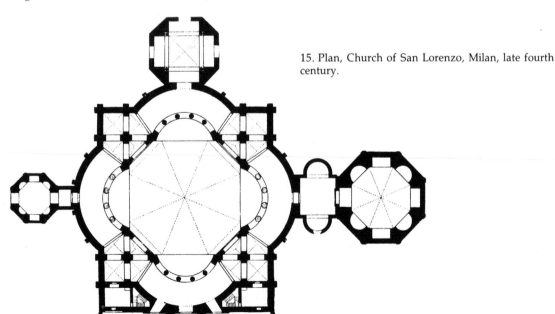

scholars who study this period. Even the source of building funds is unknown; however, such an imposing structure must have had imperial support. Local masons must have been employed, for the brick masonry is typical of northern Italy. The tetraconch form (see below) of the church derives from pagan architecture, but historians do not agree on its specific sources. S. Lorenzo and the building complex of which it is a part pose many scholarly problems but they also provide a vivid impression of fourth-century imperial architecture.

The church was preceded by a colonnaded atrium entered through a propylaeum composed of reused Corinthian columns and supporting an arcuated lintel, long associated with imperial architecture. Behind this monumental entry the church rose in a series of geometric masses: a central square tower over lower curved walls encompassed by four rectangular towers. In contrast to the austere exterior, colored marble veneer and stucco reliefs decorated the interior. Most of this sumptuous decoration vanished in remodelings undertaken in the twelfth and sixteenth centuries.

The centralized plan of S. Lorenzo was a quatrefoil based on a 78-foot square. The forms that appear as four lobes in plan rise into two-storied, semicircular recesses called exedrae, covered by half domes known as conches because of their shell-like shape. Since there are four of these conched recesses and since aisles and galleries repeat the form of the inner space, the building type is known as an aisled tetraconch. The structural elements delimiting the spaces at S. Lorenzo retain a Classical Roman clarity and monumentality. The massive piers flanking each exedra originally supported either a pyramidal or domical wooden roof or a groined vault buttressed by the corner towers. (A groined vault is created by two identical barrel vaults intersecting one another at right angles.) Radiating from this high central space, the four exedrae create

semicircular spaces in which the verticality of the piers is balanced by the horizontality of the two arcades. S. Lorenzo is a very early example of the aisled tetraconch church, but the type was widely used from Italy and North Africa to Mesopotamia, Armenia, and the Balkans. The tetraconch created a complex interior space that had important consequences in later Byzantine architecture.

Early Christian art reached beyond the Alps to the farthest outposts of the Empire in the fourth century. Even in distant Britain Roman landowners constructed villas having the luxuries of Rome itself—extensive gardens and vineyards, baths, rooms with painted walls, and mosaic floors. Some of these Romans had accepted Christianity. The fourth-century villa at Hinton St. Mary belonged to a Christian owner who commissioned an artist to re-create the composition of a catacomb ceiling or dome in a floor mosaic [16]. Christ is clearly identified in the central medallion and four male figures in the corners must be the four evangelists, however inappropriate such imagery might seem for a pavement. The geometric disposition of the motifs undoubtedly appealed to native craftsmen, and the arrangement of the colored tesserae into patterns

16. Floor mosaic, Roman villa at Hinton St. Mary, England, fourth century. The British Museum, London.

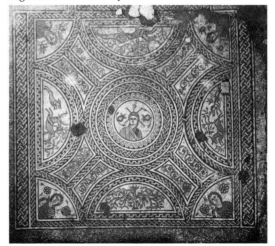

was not unlike a jeweler's setting of garnets and enamel. In fact, the three-strand interlace around the borders of the mosaic as well as the simpler cable directly inside it and the notched key design framing the lunettes were readily adopted by northern artists as ornament on jewelry and weapons.

The Fifth Century

In 395, Theodosius I divided his Empire into two equal and cooperating units ruled by his sons. Arcadius remained in Constantinople, while his younger brother Honorius took up residence at Ravenna. Safe in the new, defensible capital, Honorius and his successors could disregard the havoc being wrought in the south. By the end of the century, however, Ravenna too was lost. It was taken by Theodoric the Great (King of the Ostrogoths by 471, vice-regent of the Byzantine West, 497, d. 526). In spite of the barbarian invasions, Rome remained the spiritual center of the Western Empire, and in the course of the fifth century the Popes grew ever more powerful in the absence of civil administrators. Under the leadership of Sixtus III (432–440) and Leo I (440–461), the Church assumed an ever greater role in both political and economic matters.

The Eastern Empire, meanwhile, was ruled from Constantinople, where Arcadius and his son Theodosius II (408–450) created an effective bureaucracy and stable government in a period of civil peace and prosperity. The Eastern Church, however, was not at peace, for debates over the nature of Christ and the role of the Virgin Mary continued. Two heresies spread throughout the East. The first, Nestorianism, denied Mary the title "Mother of God" (*Theotokos*, or "God-bearer"), by claiming that while Jesus' divine nature came from the Father, the Virgin bore Him solely as a man. In 431 a Church council at Ephesus attempted to settle the controversy by decreeing that Christ had two distinct natures, human

and divine, inseparably joined in His one person. Another heresy developed out of a reaction to Nestorianism. Monophysitism, or belief in a "single nature," held that Jesus was wholly divine. A Church council at Chalcedon in 451 attempted to destroy Monophysitism, but, as before, the bishops' doctrinal assertions only clarified theological issues, doing little to end the strife that attended the debate. Syria and Egypt remained bastions of Monophysitism; thus, as the century progressed, the divisive controversy persisted. So strong was the Monophysite sect that in 482 Pope Simplicius excommunicated the entire Eastern Church. With this action he initiated a schism that grew wider and wider during the Middle Ages.

A historical overview of the fifth century, therefore, reveals the Empire beset by dangers from within and from without as the Mediterranean world split apart. The West remained spiritually unified under the Pope but fragmented by military invasions. Meanwhile, the East, although politically unified under the emperor at Constantinople and free from the immediate threat of invasion, found itself rent by internecine religious wars. As if to escape the turmoil of their own time, people looked with nostalgia to the early Roman Empire. The fourth century had been a period of experimentation as well as intermittent Classical revival, a time when architects and artists evolved new forms befitting the special requirements of Christianity. The fifth century, particularly in Rome and Constantinople, became an era of consolidation and retrospection, while in regional centers, such as Thessalonika, Milan, and Ravenna, artists worked in a variety of styles, adapting the classicizing style of Rome and Constantinople to suit the peculiarities of local tradition.

Rome in the Fifth Century

The purest form of the Classical revival flourished in Rome itself, the center of the

Sixtine Renaissance, so called for Pope Sixtus III. Although partly the product of the Pope's own refined tastes, the invocation of ancient Rome also lent an aura of stability and grandeur to Christian art. Christian artists underplayed the materialistic aspects of pagan Classicism, as though they sensed that a style proper to one kind of image might be incongruous when applied to another. The result, however, was that the Classical revival simply appeared in a more veiled manner. For example, the ivory representing the Ascension and the Holy Women at Christ's tomb seen earlier (see page 31), carved in Rome or northern Italy about 400, reflects the artistic milieu of Rome. The image is based on the apocryphal Gospel of James, an extended description of James and Peter witnessing the Ascension, rather than the brief account in Acts 1:9–12. Compared to the Passion Sarcophagus (see page 24), the figures have more natural proportions, which free them from the stockiness that characterized the sarcophagus reliefs.

Moreover, they move dramatically within an illusionistic environment. Again, legs and feet extrude beyond the frame to thrust the figures forward into the viewer's space, but space within the frame is also indicated, for the figures are foreshortened, and the lumpy earth provides a continuous landscape setting and suggests an atmospheric space through which Christ triumphantly strides up to grasp the hand of God in Heaven. Although a less elegant canon of form and proportion prevails, the style remains richly evocative of Classical standards.

This Classical heritage appears in ever-changing guises. In an ivory with a Crucifixion scene [17], the proportions of the figures have become stocky, the heads large, and the musculature stylized in a style reminiscent of the fourth century, although the ivory was probably carved in Rome, c. 420–430. At the left, the tree, instead of gracefully receding through a gradual lowering of the height of relief, as in the Ascension ivory, stands isolated against

17. The Crucifixion and the suicide of Judas, Rome or southern Gaul, 420–30. Ivory, 3″ × 4″. The British Museum, London.

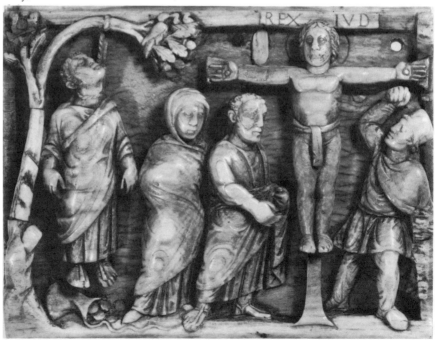

a flat ground—so much so that it describes not a real space but a symbolic one. However, the Classical heritage surfaces here in the narrative concept. At the right, the Roman centurion Longinus shields his eyes in reference to the miracle of his sight. On the other side of the cross stand Mary and either St. John or—because the figure is bearded—Joseph of Arimathaea, the pious Christian who would later place the body of the Savior in his own tomb. In the tree above a bird feeds its young, a reference to the eternal life promised by Christ. In contrast to these positive images of salvation, Judas swings lifelessly from a tree while telltale silver coins spill out of a bag at his feet. By representing two separate moments within a single frame, instead of dividing events by columns or other confining devices, the artist imitated the tradition of continuous narrative popular in im-

perial Roman reliefs. The portrayal of the protagonists also establishes the dramatic element. The rigid posture, open eyes, and idealized anatomy of Christ on the cross characterize His sacrifice as triumphant. The letters above His head read "REX IUD," King of the Jews. The heroic image of Christ contrasts with the body of Judas, which, as if to echo his denigration, dangles limply from the tree. This concern for narration and drama belongs more to the ancient tradition of Roman realism than to the hieratic mode seen in the Sculpture of the Arch of Constantine.

The most monumental evidence of the Classical revival appears in Roman churches, for it was there that the suggestive association with imperial grandeur and the advocacy of the papal see could be made public. Churches had been spared during the fifth-century pillaging of Rome, thanks to the Goths' and

18. Church of Sta. Maria Maggiore (nineteenth-century reconstruction of the interior), Rome, 432–40.

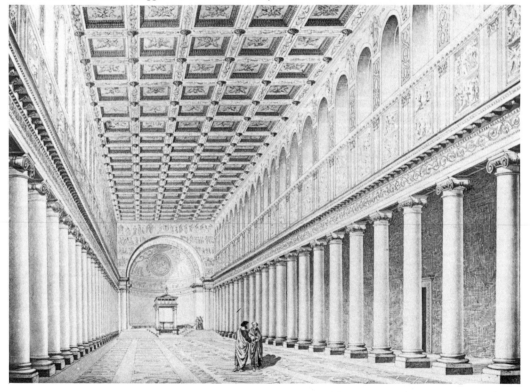

Vandals' own Arian Christianity. The heretics' presence in Rome, however, provided another reason for the assertion of pontifical authority. The Popes had not only claimed primacy over the patriarchs of Constantinople, but also had to prove that their condemnation of Arianism was binding throughout the Empire. The building of churches like Sta. Sabina on the Aventine Hill and the decoration of the basilicas of Sta. Maria Maggiore, St. Peter, and St. Paul became important projects for Popes Sixtus III (432–440) and Leo the Great (440–461).

The majestic basilican Church of Sta. Maria Maggiore [18], the single most important project of Pope Sixtus' reign, recaptures the past in faithfully copied Classical forms and proportions. The wide nave is separated from the side aisles by an Ionic colonnade supporting a Classical Corinthian entablature. The upper

wall is enriched with pilasters and friezes ornamented with a rinceau, or scroll pattern of foliage, in the purest Classical manner. Thus in proportion and detail the architecture of Sta. Maria Maggiore recalls the finest buildings of ancient Rome. The church has undergone extensive repairs, restorations, and remodelings: the mosaics were restored as early as the ninth century; in 1290 a transept was added and the apse rebuilt; and in the fifteenth century architects rebuilt the roof and ceiling. Restored once again in the twentieth century, the church provides crucial evidence of fifth-century decorative programs.

At Sta. Maria Maggiore an extensive series of mosaics covered the nave wall, triumphal arch, and apse [19]. The nave mosaics, located in the panels directly below the clerestory windows, illustrate the Old Testament stories of Abraham, Jacob, Moses, and Joshua, the

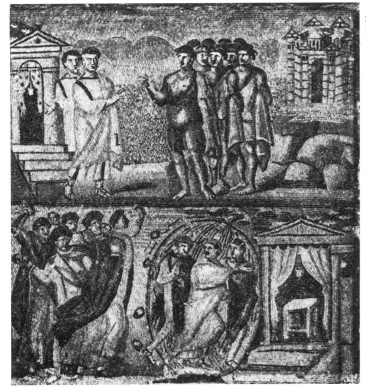

19. Rebellion against Moses, Church of Sta. Maria Maggiore, Rome 432–40. Mosaic in the nave.

patriarchs and heroes who in word or deed prefigured the Incarnation. Only twenty-seven of the original forty-two mosaics remain of this decoration, the earliest surviving narrative cycle in Roman Christian art. The mosaics reveal that the penchant for narrative and dramatic rendering inherited from Classical art operated in concert with the Christian stress on the emblematic and the miraculous. The panel reproduced here depicts the rebellion of the Jews against Moses as described in the Old Testament (Num. 13:25–31 and 14: 10). Led by Moses out of Egypt, the Jews journeyed through the desert seeking the Promised Land. In the upper register, the spies return from Canaan, and in the lower register the Israelites angrily stone Moses, Joshua, and Caleb, who are protected by the glory of the Lord. The artist has rendered the scene as accurately as possible. At the left, the people throw stones; at the right appears the tabernacle; and at the center the stones bounce off the "glory" surrounding Moses and his lieutenants. The undescribable presence of God is represented by His hand and the mandorla—an almond-shaped halo, or aureole, of light symbolic of divinity.

The otherworldly foundation of Christian faith underlies this visualization of the miraculous, but it is here merged with the narrative tradition of Classical art probably transmitted by illustrated manuscripts. An illusionistic style lingers on in the landscape background of rolling hills and blue sky at the horizon, in the city walls and tabernacles rendered in perspective, in the figures' solid muscularity and energetic gestures, and in the modeling itself, since each form as material substance is fully modeled by means of graduated color. Nevertheless, strong outlines encompassing shoulders, arms, and much of the architecture tend to flatten the forms, and gold tesserae are used in the background. This incipient abstraction marks a shift from the Late Antique style to the intentional immateriality of Medieval art.

As we move from the Old Testament scenes in the nave to the New Testament mosaics of the triumphal arch, the symbolic mode grows noticeably stronger [20]. Here, gold radiates from every available surround, and the figures have lost that lively mobility of gesture which gave dramatic force to the nave mosaics. Instead, they stand stiffly disposed across the front plane, filling the entire vertical and horizontal space; and since their heads nearly touch the top of each register, they block an illusionistic view into the background. It has been suggested that the new style of the triumphal arch may have developed because artists imitated illustrations in manuscripts; however, the more hieratic presentation suits the location on the triumphal arch and the message contained in the subject matter. Underlying the New Testament narrative of the early life of Christ is another theme, which reasserts the papal condemnation of Nestorianism at the Council of Ephesus. The events depicted proclaim the eternal divinity of Christ and the role of the Virgin as *Theotokos*. Mary's lofty position as Queen of Heaven and receptacle of divinity is emphasized by her enthronement, her regal costume, and the attentive presence of guardian angels. Moreover, Jesus appears not as a baby in His mother's lap, as in the early catacomb paintings, but as a miniature adult. In the Adoration of the Magi, the Zoroastrian priests, symbolizing the Gentiles, approach bearing gifts while the youthful Savior sits isolated on a throne and reigns as King of Heaven with His angelic court. At the crest of the arch, all the implicit references to Christ's divinity converge upon a single symbol: in a medallion flanked by SS. Peter and Paul and the emblems of the four evangelists, an imperial throne supports a cross, a crown, and the apocalyptic lamb—all three together symbolizing Christ's triumphant Second Coming. Beyond the arch, the original apse mosaic had an image of the Virgin, crowned as Queen of Heaven; thus, at the visual climax of the church, she was raised to

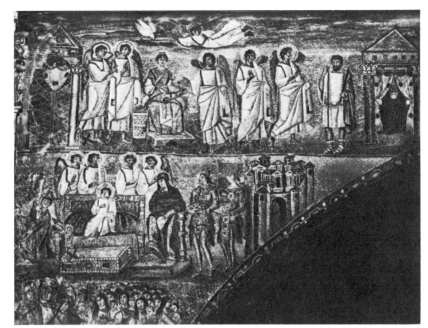

20. Infancy of Christ, Church of Sta. Maria Maggiore, Rome, 432–40. Mosaic on the triumphal arch.

an exalted state suitable only for the *Theotokos,* the Mother of God.

Through the affirmation of Mary as *Theotokos* in the Church of Sta. Maria Maggiore, Pope Sixtus refuted Nestorianism and defended the Roman prerogatives challenged by the Council of Ephesus. His successor, Leo the Great, made a similar claim for absolute authority when the Council of Chalcedon met to condemn Monophysitism. Like the pontiffs of the fourth century, Pope Leo supported this claim by glorifying St. Peter and St. Paul in a campaign of church decoration. Leo's efforts can only be imagined, for little remains of the work completed during his pontificate.

The apse mosaic of Old St. Peter's, as we have observed, depicted Christ dispensing the law to his two Roman apostles, while paintings in the transept narrated the life of St. Peter. Pope Leo, perhaps inspired by Sixtus' program at Sta. Maria Maggiore, now decided to extend the decoration to the nave. He commissioned a double row of Old and New Testament scenes for the nave wall and, below them, resting on the architrave, roundels with portraits of all his predecessors, beginning with St. Peter. These images of the Popes attest to the deliberate exaltation of the papacy, for they formed a symbolic progression down the nave to the apse, where Christ was shown ordaining their illustrious predecessor.

Pope Leo also ordered the decoration of the Basilica of St. Paul Outside the Walls (see page 26), the church over St. Paul's shrine, constructed in the last quarter of the fourth century as an imitation of Old St. Peter's. A fire in 1823 devastated St. Paul's, and although the building has been reconstructed to preserve the original's size, plan, and proportions, the Early Christian decorations are lost. An eighteenth-century view reveals that the decorative program as well as the architecture duplicated Old St. Peter's with only minor variations. Scenes from the life of St. Paul joined the Biblical events on the nave wall. Despite these differences, the appearance of St. Paul's gives us a good indication of Old St. Peter's nave and of the magnificent effect both basilicas must have made. In paying homage to the two founders of Christian Rome, Pope Leo

gave moving testimony of the divinely pre-
scribed heritage of the Roman bishops and
the primacy of their apostolic see.

Fifth-Century Architecture and Decoration Outside Rome

Churches built outside Rome were often
elaborations on the familiar basilican plan;
but in response to local materials and methods
of construction, as well as to slightly differing
ceremonial practices, regional church architec-
ture manifested a variety of structures and
styles. Builders might raise towers, elaborate
upon the simple square atrium courtyard, or
even add a second narthex or entrance porch.
On the interior, architects often rethought the
design of the transept area, increased the
number of aisles or added galleries, as in
Greek basilicas. Because of the requirements
of the Eastern rite, rooms might be added to
the narthex or, most frequently, flanking the
apse. Two of the chambers played an impor-
tant practical role; in the prothesis, the clergy
prepared and stored the consecrated Host,
while the diaconicon, or sacristy, housed the
archives, treasury, and clerical vestments.

Apart from these variations, the overall
design of fifth-century churches was most
profoundly affected by two Constantinian
types: the Roman or Greek basilica and the
Apostoleion in Constantinople. When fifth-
century builders had to build a martyrium,
they usually adapted the Greek-cross plan of
the Apostoleion. Later architects felt free to
alter details and proportions in order to fit
individual devotional requirements. The Church
of St. John at Ephesus, in Asia Minor, exem-
plifies one variation. According to legend, St.
John the Evangelist died in this Aegean port
city during the reign of the Emperor Trajan
(98–117). By 300 a martyrium, probably a
tetrapylon with four supporting piers and a
vaulted canopy, rose over the site of the
apostle's tomb. By the early fifth century the
faithful were flocking to Ephesus in such

numbers that a church was built with the
tomb as a nucleus, from which radiated four
basilical arms making a cross plan. The north,
south, and west arms were each divided into
three aisles, the better to accommodate wor-
shipers, but the eastern extension, which shel-
tered the sanctuary and apse, was widened
into a five-aisled basilica. The broad propor-
tions of the fourth arm suggest that St. John's
had a large clergy to attend the martyrium.
Meanwhile, the western arm of the church
underwent modifications that distinguished it
as an entryway. One narthex, or possibly two,
preceded the main portal, and led the way
into a basilica that now was longer than the
other three, thus setting off the hall as the
nave of the church. In the sixth century,
Emperor Justinian enlarged St. John's and, in
the process, destroyed the original martyrium.

The later Western capital, Milan, had been
a center of experimental church architecture,
as we saw in the tetraconch structure of S.
Lorenzo. In 402 Honorius moved the capital
again, this time to Ravenna, a port on the
Adriatic coast. After Honorius' death in 423,
his sister Galla Placidia ruled as regent for her
young son, Valentinian III. The empress soon
embarked on a campaign of church construc-
tion, the results of which reflect the style of
the previous capital at Milan, as well as that
of the court of Constantinople.

One of the first foundations erected under
the regent's patronage in Ravenna was the
palace Church of Sta. Croce, known for the
small mausoleum [21] and martyr's chapel
dedicated to St. Lawrence that adjoined its
narthex. The architects adopted the cross-
shaped plan, which they probably knew both
from the Apostoleion and from fourth-century
Milanese churches. Even the fabric of the
mausoleum—not masonry or typical Roman
brick but thick bricks with narrow mortar
joints—denotes the participation of north Ital-
ian craftsmen. The present-day appearance of
the overall structure is deceptive, for the
ground level of Ravenna has risen during

succeeding centuries, resulting in a reduction of the mausoleum's initially attenuated proportions. The four wings abut the sides of a higher central block, and all are capped by pediments and tiled roofs. Blind arcades strengthen and enliven the faces of these outer walls. Narrow windows are filled with alabaster panels.

On the interior the original vertical proportions of the chapel are apparent. Rising over the lower, barrel-vaulted arms and giving the effect of a soaring space within the tiny building, the tall crossing rises into a dome continuous with the pendentives (those spherical triangular sections that provide the transition from a square to a circular plan). The atmosphere of luxury in the dark interior is created by an expanse of brightly colored decoration. The walls are veneered in veined marble; ornamental and figurative mosaics glisten on the walls and vaults. A carpet of star shapes composed of white and gold tesserae against a blue ground turns the vaults and pendentive dome into a symbolic sky—a dome of Heaven.

This allusion to the celestial realm accords with the iconographic program of the mosaics, since each of the four lunettes at the terminals of the cross arms contains a scene that alludes to salvation through Christ: the Good Shepherd, stags symbolizing Christian souls drinking the waters of paradise, and the martyr St. Lawrence.

The mosaic depicting St. Lawrence also has a bookcase and a burning grill, which, read together, represent two possible vehicles of deliverance available to the pious Christian. The Word of the Lord is symbolized by the four Gospels resting on the shelves at the left. The gridiron on which St. Lawrence was tortured and St. Lawrence himself carrying a cross signify redemption through the intercession of martyred saints. The images do not, then, unfold in narrative fashion, as do those in Roman churches, but rather stand forth as separate emblems for a mystical doctrine.

The heavenly, or supernatural, focus of the chapel's decorative scheme affected the style of the mosaics. All material forms decompose

21. Interior, mausoleum of Galla Placidia, Ravenna, 425–50.

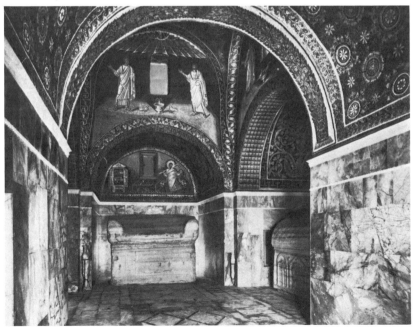

into linear designs. As vigorous and lively as St. Lawrence appears, the underlying musculature necessary to activate his striding posture is effectively denied, since the covering drapery falls unnaturally in a series of abstract patterns. Moreover, the visual isolation of the book cabinet, the gridiron, and the saint against a flat, blue ground and the rendering of each of these elements from a different point of view confound any attempt to establish the space in depth. The respective independence of the three forms negates that compositional unity so essential to the representation of a believable natural environment. Thus, the tradition of spatial illusionism inherited from antiquity has once again given way before the spiritual priorities of Christian art.

This pictorial emphasis on salvation through

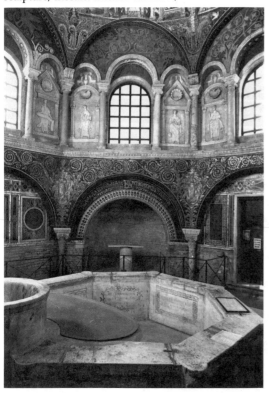

22. Baptistery of the Orthodox, Ravenna, late fourth century, remodeled mid-fifth century. Stucco sculpture; mosaic. Interior diameter, 36' 10" × 37' 7".

Christ and his saints reappears in the nearby Baptistery of the Orthodox (so called to distinguish it from the Arian baptistery) [22]. Not unexpectedly, the program also refers specifically to the role of baptism in redemption. The sacrament of baptism, we recall, symbolizes not only the cleansing of the soul but also the death of the sinful self and the initiate's rebirth in Christ. The implicit association with death and spiritual resurrection caused architects to erect baptisteries on the central plan common to pagan mausolea and Christian martyria and to vault them with the symbolic dome of heaven. Builders soon modified this plan in order to provide for the requirements of the ritual and to lay greater stress on the significance of baptism. Because the rite was performed only at Easter by the bishop, provision had to be made for crowds of hopeful neophytes and a large font. Then, instead of retaining the circular or square form of ancient tombs, patrons transformed the plan into an octagon, for in the context of Early Christian numerology, eight was the number of regeneration. It was on the eighth day after Creation that the world began, and Jesus arose from the dead on the eighth day of the Passion.

The Orthodox Baptistery, built early in the fifth century, is just such an octagonal building with four shallow niches and central font. The decoration of the interior with marble, stucco, and mosaic is well preserved, although at the lowest level it has been reworked and restored. About 450–60 Bishop Neon replaced the original wooden ceiling with a light pendentive dome constructed of concentric rings of tubular tiles set in concrete. The lightweight construction did not require rebuilding the walls. Bishop Neon also commissioned an elaborate program of mosaic and stucco decoration. Simply stated, baptism is the first step in the divine scheme of salvation, which began when Christ appeared as the Messiah prophesied in the Old Testament and accepted the purifying waters of the Jordan from St. John. While the

expression of this doctrine on the walls and dome of the Orthodox Baptistery is the most complex we have yet seen, the visual exposition does not progress logically from zone to zone, and this loose organization is surely an indication that such symbolic planning was at an early stage of development.

The program begins with the frames around the lower niches, which are inscribed with passages from the Psalms and Gospels that relate to baptism. At the next level, most of the stucco figures in the aediculae flanking the windows represent the Hebrew prophets who foretold the advent of a Messiah. The references continue in the three concentric rings of the dome mosaic [23]. Four altars, each of which supports a Gospel, alternate with draped thrones standing under baldacchinos. The prepared thrones symbolize the Second Coming of Christ (*Hetoimasia*). Next

the twelve apostles make a procession around the dome, offering the wreathed crowns that are the prize of their martyrdom. In the center of the dome the baptism of Christ reminded the initiates that, by accepting the sacrament, they repeated a moment in Christ's life on earth that would assure them a place with Him in paradise.

The style of the Orthodox Baptistery mosaics rejects the realities of the visible world, the better to concentrate on the mysteries of salvation through baptism. Vestiges of antique illusionism do appear—for example, in the architectural and landscape settings—and the Classical world is even more specifically recalled by the river god who personifies the Jordan. The baptism, however, takes place against a golden Heaven, not a blue sky. The ambiguity between a three-dimensional rendering and an abstract presentation continues

23. Baptism of Christ, dome of the Baptistery of the Orthodox, Ravenna, mid-fifth century (c. 450–60). Mosaic.

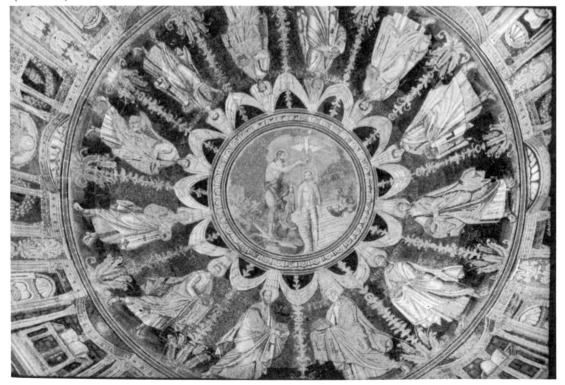

in the middle zone. The apostles' solid forms may cast dark shadows as they step across light-green grass, but their garments fall into repeated layers of schematic folds, while the colors alternate with precise regularity between jewel-like gold and white tesserae. Below the apostles the niched porticoes, niches, and garden walls constructed of shimmering gold tesserae suggest paradisaical architecture.

In Greece, too, artists designed mosaic cycles with uncommon sophistication and recondite visual references. In Thessalonika, a rotunda had been constructed as a mausoleum by Galerius (305–311) but transformed about 450 into a church. The mosaic decorations of Hosios Giorgios illustrate the expressive, symbolic mode in Early Christian art [24]. (The mosaics have been dated as early as 390 and as late as the sixth century; however, current scholarly opinion suggests a date in the second half of the fifth century and attributes them to a team of workers from Constantinople.) The surviving mosaic frieze of saints or donors ringing the lower zone of the dome once formed part of a large composition that may have depicted the Second Coming of Christ. In the center of the cupola the Savior was borne heavenward by angels, accompanied by a phoenix, another symbol of Resurrection. In keeping with the visionary subject, the artists produced a mosaic in which the representation of natural forms in tangible space gives way to abstract symbols and patterns. A fantastic architecture of porticoes, niches, canopies, and bejeweled columns creates an unreal setting for the figures. Whereas in earlier architectural painting Roman artists had united a variety of imaginary buildings into a richly illusionistic backdrop through the ingenious use of perspective, the artists at Hosios Giorgios compressed every element into a glistening surface design generated by the bright gold tesserae used both for background and for architectural elements. Consequently, what in Roman painting had appeared as a solid structure in a measurable space becomes a pattern of glittering forms

that lack all material substance. Never before had artists so demonstrably negated the reality of space with the very elements used by another age to render space in a deceptively natural way. Set against this shining fantasy, the orants begin to lose their corporeal substance. Some faces are modeled with subtle chiaroscuro, but the bodies disappear beneath voluminous drapery arranged in symmetrical linear patterns. Out of the inherent conflict between Classical standards and the anti-natural Christian ideals, artists created a mystical realm befitting the saints who, no longer of this world, intercede for the salvation of humankind.

Apocalypse imagery fills the apse of the church known today as Hosios David. The church was initially an oratory, or small chapel, attached to a monastery. The apse mosaic, of about 470, combines a theophany, the visionary appearance of God to man, with the vision of Ezekiel [25]. In a theophany the Lord, represented in human form, emanates from a radiant glory in a celestial setting. At the center of the conch in Hosios David, a youthful, blessing Savior sits on the crest of a rainbow within an aureole of light. A lion, an ox, an eagle, and a man with eye-studded wings emerge from behind the glory. Below, at Christ's feet, the four rivers of paradise stream down from a hilltop. Ancient tradition held that four sacred rivers in paradise issued from a single rock and that these rivers symbolized the four Gospels that flow from Christ. An inscription at the bottom of the mosaic explains that Jesus is the "spring of living water" at which the faithful quench their spiritual thirst. Two old men sit at each side of paradise. The man at the left, raising his hands to his face as if blinded by the light of the Word, is surely Ezekiel, the Hebrew prophet whose vision of the four winged creatures (Ezek. 1:10) came to be interpreted as a prefiguration of Matthew, Mark, Luke, and John. The man meditating on the right has been identified as either the prophet Ha-

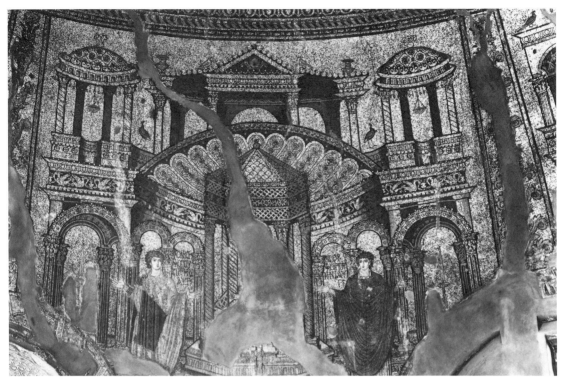

24. Orants, Hoşios Giorgios, Thessalonika, Greece, fifth century. Mosaic in dome.

25. Christ in Glory, the vision of Ezekiel, Hosios David, Thessalonika, Greece, c. 470. Apse mosaic.

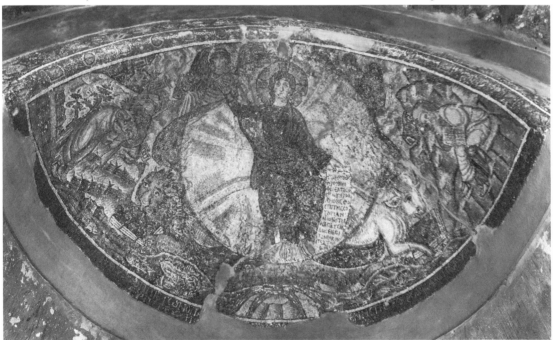

bakkuk or St. John the Evangelist. It was to St. John that God revealed a vision of glory.

Immediately I came under the Spirit's power and saw a throne standing in heaven, and one seated on the throne ... And a rainbow that looked like an emerald encircled the throne. (Rev. 4:2, 3)

Around the throne on each side, there were four living beings full of eyes in front and behind: the first living being was like a lion; the second, like an ox; the third, with a man-like face; and the fourth like a flying eagle. Each of the four living beings had six wings and each living being was full of eyes all around and within. Neither by day nor by night do they cease saying, "Holy, holy, holy, Lord God Almighty, who was and who is and who is coming." (Rev. 4:6–8)

The mosaicists inserted the tesserae with such calculated irregularity that no form seems to be stably affixed to the curving surface. This visual fluctuation must have been designed to remove the celestial apparition from all contact with the tangible, mundane world below, for it makes the whole apse glitter. In the individual figures, an illusion of real substance is achieved through a careful gradation of hues. At the same time, the use of heavy contours and internal patterns—for example, in the draperies—effectively denies a semblance of corporeality. Nor is there any definable, illusionistic space, although hints of architectural and landscape backgrounds rise behind the heads of Ezekiel and his counterpart. Ultimately, the shining glory of the Lord in Heaven dominates the entire composition.

By the end of the fifth century, the vestiges of Classical naturalism still present in early catacomb painting had been thoroughly subjugated. While Christians may have shared a mystical outlook with the pagan populace, the growing abstraction of their art was more fundamentally generated by the Gospel's doctrine of redemption. The Lord took on human form in order to redeem the sinful world; yet, He remained God. The art that gave visual testimony to this precept, therefore, had to be firmly dissociated from the ephemeral substance of earthly existence.

The pictorial themes and architectural designs expressive of this aesthetic evolved during the third, fourth, and fifth centuries, with the result that a potentially great and innovative art was created out of the heritage of ancient Mediterranean civilization. The political triumph of Christianity brought with it the inducement to raise ecclesiastical buildings on a monumental scale befitting the Church's role as an official state religion. The simple, domestic house of worship had to become the visible embodiment of the entire Christian community, a civic as well as religious center. Architects responded to this challenge by successfully transforming two totally different architectural types—the basilica with its longitudinal axis and the centralized scheme of Classical mausolea—into a number of complex, richly symbolic designs. The desire to adorn the building as an additional sign of triumph was irresistible, while the instructional value of paintings, mosaics, and sculpture further justified the impulse to embellish the interior. Moreover, since the church was above all the house of the Lord and the tomb of Christ or a saint, it deserved the most elaborate and serious enrichment.

The resulting decorative programs provide a striking demonstration of the change from a realistic to an abstract style. In the course of the first centuries after Christ, Mediterranean society underwent a complete spiritual reorientation, and this revolution required the development of a unique aesthetic for its effective expression. Ultimately, several styles evolved throughout Christendom, but all shared a common body of iconography and an anti-realistic, anti-materialistic focus. The medieval artist seemed determined to reproduce a visionary world in which angels were as real as human beings and, because they were closer to the One, even more worthy of artistic representation.

⟦ CHAPTER III ⟧

The Golden Age of Byzantium

hen Constantine moved the government of the Roman Empire to the small Greek port of Byzantium, he could hardly have imagined that the city would eventually give its Greek name to an entire civilization. Constantinople/Byzantium (today's Istanbul) survived in part because of its strategic location on a narrow peninsula protected by the waters of the Bosporus and the bay called the Golden Horn. The city commanded the overland trade routes between Europe and the East, as well as the shipping lanes leading to and from the Black Sea and the Mediterranean. In the fourth and fifth centuries, as Rome declined, Constantinople flourished. The political power, military strength, and economic prosperity of Constantinople generated more than mere physical growth. From the accession of Theodosius II in 408 until the arrival of the usurper Phocas in 602, the city was the nucleus of a brilliant civilization, one that historians admiringly refer to as the "Golden Age of Byzantium."

The "New Rome" grew into a beautiful metropolis laid out, like its ancient ancestor, with colonnaded avenues, open squares, and marketplaces, and splendid public buildings. The governmental center, with the emperor's palace, the Senate, and the Hippodrome, was on the site of the former Greek acropolis, a low hill at the eastern end of the peninsula. The palace Church of Hagia Sophia (Holy Wisdom) was erected on the highest point, facing the palace across the imperial forum.

From this complex of structures two avenues stretched inland to the gates in the defensive land wall. Near these western ramparts Constantine built his mausoleum, dedicated to the Holy Apostles.

Justinian (527–565), an emperor as remarkable in his own way as Constantine, led the Eastern Empire to new heights. With the help of brilliant advisers he achieved the earlier imperial goals of a revitalized, unified Empire. His closest adviser was his wife, Theodora, a beautiful, intelligent woman whose cunning no doubt derived in part from her early years as a performer in the circus. Justinian appointed Belisarius and Narses as generals; they stopped the barbarian threats and won new territories for the Empire. He called upon John of Cappadocia, an administrative genius, to help reorganize the government, revise its tax structure, and set up an efficient civil service. He ordered the scholar Tribonianus to sort out the maze of complex, contradictory, and often unjust laws and to direct the writing of a new code, the *corpus jurus civilis*, or "body of civil law," now known as the Justinianic Code. Byzantine law became the basis of many modern legal systems in the West.

With an exceptionally fine bureaucracy to administer clear and just laws, Justinian would seem, in the words of his biographer, Procopius, to have "wedded the whole state to a life of prosperity," but in reality Justinian's reign was never as prosperous or as benevolent as his understandably prejudiced historian

would have us believe. The Monophysites, still a formidable sect in the Eastern Empire, grew ever more discontent with Justinian's avowed orthodoxy. Meanwhile, the revised taxation system permitted the emperor to increase assessments whenever he deemed necessary, and taxes in Constantinople rose to the point where they became an intolerable burden on the populace. In 532 the citizenry, spurred on by the Monophysites, revolted against Justinian in the Nika rebellion, so called from the rioters' cheer, "Nika" (victory). Within a few days the insurgents destroyed half the city, including the imperial Church of Hagia Sophia. Justinian panicked and his ministers begged him to flee. Theodora alone stood firm, saying that she preferred death as the empress to flight and life as a fugitive. As she is reported to have said, "Purple makes a fine shroud." Taking courage from the empress, Justinian remained in Constantinople and, with the aid of Belisarius, put down the rebellion. The rebuilding of the city and of the churches began at once, as did a campaign of reconquest throughout the Mediterranean. Justinian extended the Empire as far as Spain, recaptured Italy from the Goths, and restored Ravenna to its former role as the Western Byzantine capital.

Justinian did not forget that religious factionalism had been partially responsible for the Nika rebellion in Constantinople; therefore, he tried to unify the Empire by enforcing the pronouncements of the fifth-century councils of Ephesus and Chalcedon. He began by making Rome, under the Pope, the spiritual capital of Christendom, while at the same time relegating the patriarch of Constantinople—a leader always subject to Monophysite influence—to the role of senior bishop. Like Constantine and Theodosius I before him, Justinian convened a Church council in an attempt to reconcile the quarrelsome religious sects. Although the Second Council of Constantinople (553) was only marginally successful, the emperor emerged as the political head of the Church. Such an exercise of temporal and religious authority, clearly reminiscent of both earlier Roman and Christian sovereigns, is called "caesaropapism." The term is eminently applicable to Justinian, a secular emperor who nevertheless ruled as a sacred monarch, living in a sacred palace, and surrounded by elaborate rituals that reaffirmed his identification with divinity.

Byzantine Architecture

The great age of Byzantine architecture began with a military project—the building of a new city wall [1]. Between 408 and 413 Theodosius II constructed a second wall about a mile beyond the fourth-century defenses. The new fortifications were an absolute necessity in order that the city could grow, secure from barbarian tribes who now began to challenge the Eastern Empire as they had the West. These Theodosian walls provided effective protection for more than a thousand years. They held back every threat to the city until 1453, when elite troops of the Turkish sultan, using cannon and outnumbering the defenders twenty to one, finally broke through the fortifications [2].

That the ramparts stood firm for a millennium was due to the inventiveness of the imperial engineers. (Their work provided a model for builders of fortifications throughout the Middle Ages, and the finest castles of the twelfth and thirteenth centuries are only refinements and variations on the Theodosian system.) The site itself was well chosen, and although sea walls were built around the peninsula, the emperor could rely on his navy to defend the city against attacks from the sea. The Golden Horn could be closed to ships by drawing a giant iron chain across its entrance. Danger lay on the land side of the peninsula, and here the engineers created a whole defensive system rather than a single wall. This system, four and a half miles long and about 180 feet wide, was composed of

1. Land walls, Constantinople, fifth century.

2. Tower and land walls, Constantinople, fifth century.

five separate barricades, each part of which was an independent fortification. The inner fortifications commanded and protected the outer; the inner wall, 36 feet high and 16 feet thick, towered over a terrace and a second lower wall. A 60-foot stone-lined moat, reinforced with an additional earth embankment, formed an outer defense. The inner wall was strengthened by battlements, fortified gates, and 96 huge towers 80 feet high, which projected beyond the wall on their outer side so that their roofs could be used as firing platforms. The defenders could unleash a raking cross fire against intruders along any part of the wall. Moreover, since every tower was physically independent of its neighbor, the enemy would theoretically have to make an individual attack on each one. The only inherent weaknesses in the scheme were at the gateways leading into the city, but to reduce this liability the defenders flanked each of the openings with a pair of towers. The principal entryway was the so-called Golden Gate, an impressive structure covered with marble revetment and closed with gilded bronze doors. The outer gate opened only into a courtyard in front of the city gate, surrounded by towers so that an invading party breaching the outer defenses would find itself trapped under a

barrage of fire from soldiers in the inner towers.

The builders of the Theodosian walls adopted an ancient eastern Mediterranean masonry system in which alternating courses of stones and bricks faced a solid core of concrete and rubble. In the tower rooms thin bricks set in thick mortar formed light, strong vaults. Here engineers and masons gained practical experience in vaulting techniques, which was to stand them in good stead when the emperor demanded even more elaborate monumental structures.

Secure behind the Theodosian walls a century later, Justinian embarked on a building campaign that not only changed the city but demonstrated the imperial largesse and perpetual presence throughout the state. The court historian Procopius devoted an entire treatise, *On Buildings*, to Justinian's works. According to Procopius, the emperor sponsored more secular architecture than he did religious building; however, the secular buildings have been destroyed or remodeled. Churches, on the other hand, were often preserved out of respect for tradition; hence, the accomplishments of Byzantine architects can be viewed today primarily in religious buildings. Hagia Sophia and the Church of the Holy Apostles in Constantinople, as well as the churches in the provincial capital of Ravenna, attest to the brilliance of the Byzantine court and to the lasting achievement of its artists.

No sooner had Justinian subdued the rebellious citizens in 532 than he set out to erect a new Hagia Sophia on the site of the old Constantinian church [3]. Construction progressed so rapidly that the project was completed in the short space of five years—clear testimony to the emperor's overriding concern for the project. Surely Justinian's personal interest spurred the builders on, to create one of the most original monuments in the history of architecture, a church that fulfilled all the aesthetic, symbolic, and functional needs of the Byzantine church. That the finest structure in the long history of Byzantine architecture was created at the very outset of this period rather than after generations of experimentation may seem remarkable, but Justinian was a patron of unusual learning and sophistication. Only such a discerning mind would have been inspired to select as architects two theoretical scientists who had never confronted the problems of erecting an actual building. Anthemius of Tralles approached the construction of Hagia Sophia from the studied vantage of a Greek mathematician—a specialist in geometry and optics. To complement Anthemius' abstract talents, Justinian chose Isidorus of Miletus, a professor of physics at the universities of Alexandria and Constantinople, who was an academic expert in the mechanics of thrust and support and the author of a scholarly commentary on a treatise on vaulting. In his extraordinary perceptiveness, the emperor foresaw that the Church of Hagia Sophia, in order to rise as the perfect embodiment of imperial power and Christian aspirations, had to be designed by men whose theoretical knowledge could transcend the limits of contemporary architectural practice.

Justinian's architects succeeded in integrating the longitudinal and centralized schemes of early Christian churches in a manner inconceivable to Constantinian architects [4]. When fourth- and fifth-century architects attempted to merge the two building types into a church that was both functional and symbolic, they did so merely by attaching one part to the other, as we have seen at the Holy Sepulchre in Jerusalem, St. Peter's in Rome, and St. John's at Ephesus. Early Christian churches remained additive structures, formed of discrete architectural units. The extraordinary Byzantine achievement was to consolidate the basilica and the martyrium into one logical and indivisible whole.

The inspiration to fuse the disparate plans seems to have come from the liturgical and symbolic requirements of Byzantine ritual. In

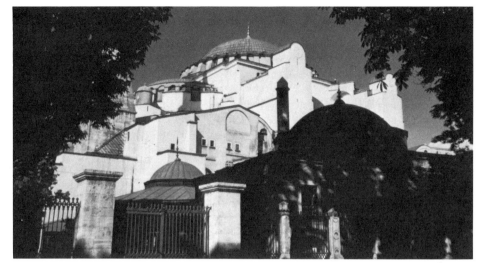

3. Anthemius of Tralles and Isidorus of Miletus, Church of Hagia Sophia, Constantinople, 532–37.

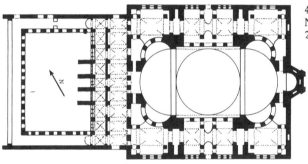

4. Plan, Hagia Sophia (after drawings by Van Nice and Antoniades). Body of building, 226' 7" × 244' × 8".

the Byzantine rite, the Gospel and the Host remained in or near the sanctuary at all times, and, unlike the Roman rite, the Eucharistic procession no longer followed the longitudinal direction of the nave, but formed a circuit moving around the apse and its adjoining rooms—the diaconicon and the prothesis—into the nave, and back again. In order to make the structure at one with ceremony, therefore, Byzantine architects turned to the dome, that ancient hemispherical symbol of the canopy of Heaven. Indeed, the very word "Byzantine" today conjures up visions of rising domes and vaults covered with shimmering mosaics. The dome is a shape that encourages the eye to circle upward, seeking the crown of the vault. In marked contrast to the driving

longitudinal force of a basilica, movement in a domed building revolves around a central vertical axis. One can even draw a striking parallel between the two structural types and their characteristic decorations. In architectural terms, the basilica is to the narrative scheme what the dome is to the symbolic image, in that the first suggests active life while the second induces contemplation.

In order to vault large spaces, Justinian's builders gave the dome on pendentives its definitive form. Pendentives had appeared as early as the second century, and we have seen a pendentive dome over the central crossing in Galla Placidia's mausoleum, but the Byzantine architects made extensive use of the form. (A pendentive, it will be recalled, is a spherical

triangular section of masonry that makes a structural transition from a square plan to a circular one.) Moreover, they reduced the weight on the load-bearing walls by substituting a brick and mortar construction, similar to that found in the towers of the land walls, for the traditional stone or concrete fabric. In so doing, the architects managed to raise ever larger domes, while supporting them with fewer and lighter abutments.

Such was the structural and visual adaptability of the dome on pendentives that it could be applied to several different plans. Eventually we will find domed basilicas, domed octagons, and domed Greek-cross churches. Even the number of domes employed remained variable, so that in the course of the sixth century two major types of domed architecture evolved. In one, a single dome covered a central area expanded by aisles and galleries; and in another, several domes enclosed nave and transept. Although the multidomed building had a wider and more lasting influence than did buildings roofed with only one dome, it was the single-domed church, developed by Justinian's architects and perfected at Hagia Sophia under his special patronage, that generated the most imaginative aesthetic and structural forms. The designers converted the dome on pendentives into a canopy that not only covered an extensive space and mirrored the circular path of the Eucharistic ceremony, but also served to integrate the forms and spaces of the entire fabric into an indissoluble unity.

The greatness of Anthemius and Isidorus lay in their ability to reconcile the inherent conflict in the Christian Church between the desire for a symbolic, upward-soaring space and the need for a directional focus on the altar. From afar, the Church of Hagia Sophia commands the whole of Constantinople. If we block out the four minarets—those slender towers added by the Muslim Turks—Hagia Sophia ascends from an earth-hugging mass into a man-made mountain. The dome that

crowns the upward-surging exterior also dominates the interior [5]. Through a series of niches (exedrae) and half domes rising to the main dome, the architects infused the inevitable horizontal movement from entrance to altar with a dramatic upward sweep, a unique integration of the basilica and the central-domed building. In theory (not in actual construction), they began with the gigantic dome, measuring 108 feet in diameter, supported on four enormous piers and pendentives. Then, in order to expand the church's longitudinal dimensions while accentuating the all-important rising effect of the central canopy, the architects added half domes at the eastern and western sides of the nave. These half domes were in turn supported by conch-covered niches. The apse at the east and an atrium and double narthex at the west, vaulted side aisles, and galleries on the north and south further extended the basilica-like plan. Nevertheless, the dome remained the unifying, form-giving element in the design, drawing together sanctuary and nave into a centralized space known in Byzantine architecture as the naos (from Greek, meaning "interior"). Anthemius and Isidorus defined the longitudinal space of the nave primarily with circular shapes: from the relatively low level of the narthex, the rising movement leads the eye from vaulted aisle to conch to semidome to dome and on down again to the altar. This slow, sweeping movement was originally even more fluid and continuous than it appears today, since the original dome had a shallower curve than the present one. Building techniques, however, could not match the architect's bold imagination, and in 558 the dome partially collapsed, but was replaced with a ribbed dome 20 feet higher than the first.

The central dome, even with its steeper profile, is an amazing achievement. This solid brick and mortar structure seems to levitate, as if it were truly the visionary dome of heaven. This floating sensation results from a dramatic passage of light; indeed, Byzantine

architects designed their churches with as much attention to illumination as to structural or functional necessities. The dome is pierced along the entire rim by forty windows. By opening the circumference of the dome to the skies, the architects created a luminous aureole which dematerializes the real substance of the support. Procopius remarked that the golden dome seems to be "suspended from Heaven." Modern scholars share Procopius' amazement at the dome's apparent hovering suspension. Careful examination of the fabric has revealed that, structurally, this central core of the church is a relatively independent unit, standing like a giant baldacchino. The weight of a dome, just like that of an arch, exerts a dynamic thrust from the keystone outward at an angle, the greatest outward movement occurring at the haunch. The higher the curvature of the dome, the less outward thrust and the more stable the structure. The weight is directed downward to be carried by the walls, pendentives, and piers, and abutted by galleries and semidomes. The dome needs continuous support at the rim (sometimes it is literally tied with chains). The architects at Hagia Sophia defied gravity by building a dome so low in curvature that it exerted a powerful outward thrust, by piercing its rim with windows, and by setting the structure above the abutting vaults. Even the second, steeper, dome was balanced precariously; hence it has required extensive repairs—once in 989, when the western section fell, and again in 1346, when the eastern half had to be strengthened. Apart from the decorations added after 1453 by the Turkish conquerors of Constantinople, the vault still retains its sixth-century appearance.

The wonder of Hagia Sophia's physical fabric was more than equaled by the spectacle of its decoration, for Byzantine planners understood the architectural interior as an arena for a resplendent display of precious materials, vivid colors, and patterns of light [6]. Hagia Sophia's dome glistened with gold mosaic while the walls and the columns had a lustrous

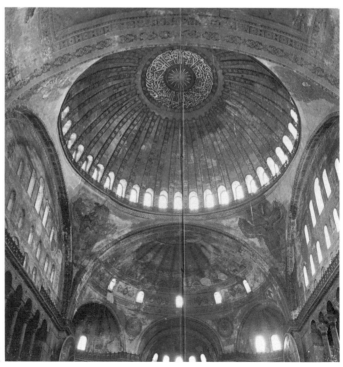

5. Hagia Sophia, interior of dome.
Height of dome, 184'.

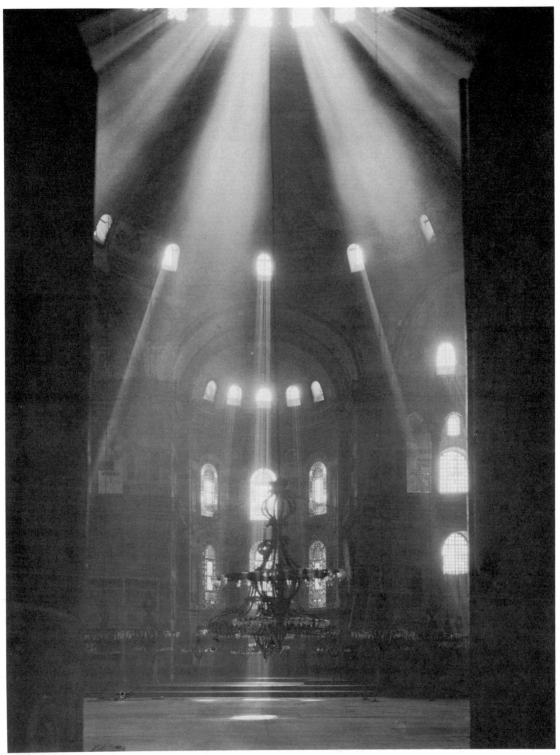

6. Hagia Sophia, interior.

veneer of green, white, and purple marble. The windows transmitted light through panes of colored glass. Against such a background, the effects of the constantly shifting shafts of illumination must have elevated worshipers to a state of spiritual exaltation in which they felt themselves truly to be in the presence of the divine. Justinian was devoutly moved by the magnificence of his new church. Upon entering Hagia Sophia for the dedication, Justinian is said to have exclaimed, "Solomon, I have surpassed thee!"

Hagia Sophia, as the palace church, was a testament of unending praise to the emperor as well as to God, and Justinian took full advantage of the symbolic possibilities of the liturgical ceremony enacted within its walls. Indeed, the Eucharistic service is telling evidence of the Byzantine Emperor's caesaropapism, for among laymen only Justinian had the privilege of participating directly in the lengthy and elaborate ritual. The solemnities were partially screened from the congregation by railings and curtains. The ceremony began with a double entrance as the patriarch and his clergy moved into the sanctuary and the emperor arrived with his court. Thereafter the courtiers watching from distant aisles and galleries saw only a series of circular processions moving out and into the sanctuary. The great entrance, a procession of the clergy bringing the bread and wine from the prothesis to the altar, the appearance of the emperor and patriarch to exchange the kiss of peace, and finally the emperor's entrance to receive Communion demonstrated Justinian's claim to equality with the patriarch and favored the emperor with divine blessing. Throughout the ceremony the emperor and the patriarch were sheltered by the dome of Heaven.

Hagia Sophia was never copied. Neither its unusual structure nor its perfect fusion of architecture and symbolic ritual suited a church where the emperor was not in attendance. Nor, given the high cost of such perfection, could the imperial patron again risk bank-rupting the Empire for his personal glorification of God. Nevertheless, Hagia Sophia did set a standard of architectural excellence throughout the Byzantine world.

Perhaps the finest among these provincial sixth-century buildings is the Church of S. Vitale in Ravenna, founded by Bishop Ecclesius (521–532) while that city was still the seat of the Ostrogothic Empire [7]. The church's construction probably began after 540, when Justinian's armies recaptured Ravenna and again turned the Adriatic port town into the Western Byzantine capital. Archbishop Maximianus dedicated the church to the city's patron saint, S. Vitale, in 547. The designers of the Church of S. Vitale gave the familiar central plan, associated with a palace church as well as martyria, new complexity and sophistication.

S. Vitale is a double-shell octagon—that is, a domed octagon encompassed by an ambulatory and gallery. Eight piers support squinches that in turn support the dome. Seven galleried niches press out from the core, while a rectangular choir, an apse, and flanking rooms project from the eastern face. Even so, an exterior view of the building discloses a clarity uncommon in Constantinopolitan buildings but characteristic of the West. The apse, the choir, and the gallery roof all ascend to the roof over the dome in a series of distinct yet interlocking polygonal forms [8]. Such a lucid disposition of exterior shapes contrasts with the complexity of spaces within the church.

Because the worshiper originally entered S. Vitale through a shallow narthex placed at an angle to the main axis, two entirely different vistas are presented. One leads into the niched bay opposite the apse, and a second line of sight moves through the adjacent bay on the right; however, neither view carries the eye directly to the sanctuary. This spatial ambiguity extends throughout the building, since the semicircular exedrae, opened as they are by arcades at two levels, cause space to seem to flow unbroken between naos and the outer

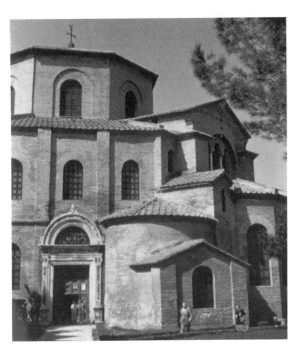

7. Church of S. Vitale, Ravenna, 547.

9. Interior, Church of S. Vitale.

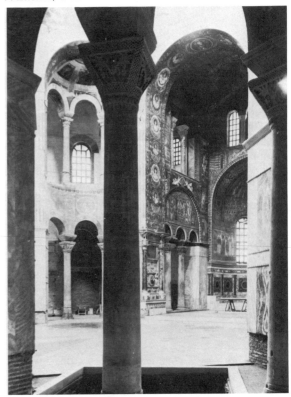

8. Plan, Church of S. Vitale. Diameter about 111'.

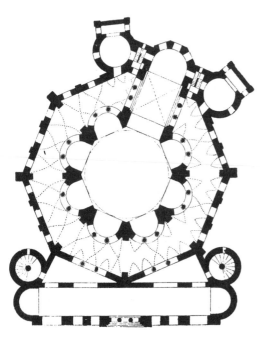

aisles. The arcades create identical semicircular figurations and rise into half-domed niches [9]. The architects provided additional structural stability to the slender columns by inserting downward-tapered blocks, known as impost blocks, between the column capitals and the arcade above, thereby concentrating the weight at the center of the column. A lighter wall was made possible by constructing the dome of ceramic tubes and mortar, a technique used in the Orthodox Baptistery. The steep dome and attenuated supporting structures created an effect of rising space. In the worshiper's experience of the building, such verticality helps to bind all the parts into one soaring fabric. As light pours in from the large windows of the ambulatory, galleries, and dome, it forms a halo of illumination around the tall central core. In its own way S. Vitale is as remarkable a building as Hagia Sophia.

Although the single-domed churches built under Justinian—Hagia Sophia and S. Vitale—are the architectural marvels of Byzantium's Golden Age, their designs were too sophisticated and too closely allied with the ceremony of the imperial court to remain workable concepts for most regional foundations. To satisfy symbolic and devotional needs, Byzantine planners turned to the multidomed church. Here, the rounded forms of the covering vaults continued to reflect the Byzantine fascination with the dome, and, even more important, the design emulated another famous structure—the newly reconstructed Church of the Holy Apostles. By the sixth century, the Constantinian Church of the Holy Apostles needed repair, and in 536 Justinian, moved by a reverence for the apostles, rebuilt the martyrium. The new Apostoleion, dedicated in 550, was so easily imitated and so well suited to the needs of Eastern churches that it served as a model for Byzantine architecture for the next thousand years.

Although the sixth-century Apostoleion was razed in 1469 to make room for a mosque, we can reconstruct its appearance from Procopius' description and from churches inspired by the plan, such as St. Mark's in Venice (chapter VI) [10]. The emperor's architects chose not to alter significantly the symbolic Greek-cross scheme of the Constantinian original, but the builders did completely transform the shrine's roofing system. Instead of merely repairing the flat ceilings covering the basilican arms, Justinian's designers built a central dome over the crossing, surrounded by four lower domes over the arms of the cross. Furthermore, they inserted a ring of windows around the rim of the main dome only, thereby, creating an emphatic vertical pull at the crossing through a flood of light. The upward-surging spaces inside the church reflected the ancient symbolism of the centrally planned martyrium. Moreover, the renovated Apostoleion was easy to understand and to build, because of its modular composition of repeating units, each one of which was a square surmounted by a dome on pendentives. The very simplicity of the design facilitated both imitation and endless variation.

A frequent modification of the Apostoleion's five-domed Greek-cross plan was the six-domed Latin-cross structure. This means that the builders added another square, domed bay to the western arm to form a long nave. When Justinian's architects rebuilt the Church of St. John at Ephesus at the emperor's command, they maintained the old plan, enlarged the total dimensions of the church, and reconstructed it as a six-domed Latin cross, further extended by a narthex and a large, colonnaded atrium. In order to increase the surrounding congregational space, the architects constructed barrel-vaulted aisles at ground level and similarly covered galleries on the second story.

A view of St. Mark's Church in Venice enables us to compare the relative success of single-domed and multidomed buildings. The single, expanded dome of Hagia Sophia created a sense of flowing, interpenetrating spaces. In contrast, the spatial development of the mul-

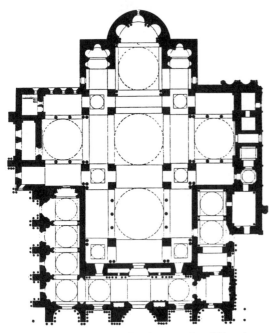

10. Typical multidomed Greek-cross plan (Church of St. Mark, Venice), inspired by the sixth century Apostoleion, Constantinople (destroyed 1469).

tidomed church is the product of individual units multiplied to form a coherent whole. Such a discontinuous ordering of spaces seems unsatisfactory if measured against Hagia Sophia, since the very repetition of the dome reduces and diffuses its dramatic effect. Too, the progression of vertical axes in a multidomed structure creates a conflict with the horizontal movement of space down the long arm of the nave. In a sense, however, the negative comparison is unjustified because the single-domed church evolved out of the special needs of the imperial court. When we consider the multidomed building as an independent architectural conception, its almost bewildering organization of spaces emerges as a rich and complex scheme of unending fascination.

In spite of the challenging possibilities offered by domed buildings, the ancient basilican

11. Nave, Church of S. Apollinare Nuovo, Ravenna, sixth century.

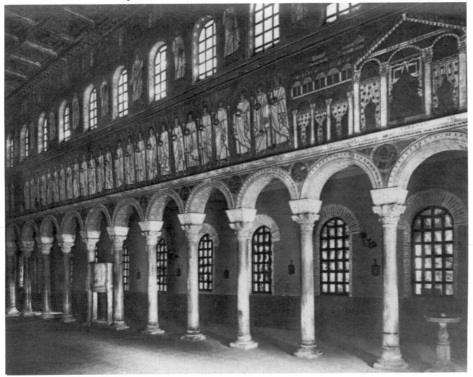

plan continued to be popular. In Ravenna, for example, S. Vitale remained the only domed church in a city filled with trussed-roof basilicas. Ravennate basilicas, nevertheless, adopted aspects of the Byzantine aesthetic even while they perpetuated the venerable Western tradition. The Church of S. Apollinare Nuovo, originally dedicated to St. Martin, was built at the end of the fifth century by the Arian Gothic ruler Theodoric (see chapter IV) as his palace church [11]. The original basilica, dedicated to St. Apollinaris, in Ravenna's seaport, Classe, had been begun between 532 and 536 by a wealthy banker named Julianus Argentarius. The church was completed, however, only in 549, a few years after the reconquest of the city by Justinian's armies. St. Apollinaris' relics were transferred to the redecorated St. Martin's Church in town, which thus became the "new" S. Apollinare. Both churches are three-aisled basilicas, but they differ from Roman basilicas in proportion and detail. Side rooms flanking the apse reflect the architects' Eastern heritage, although these rooms may have served simply as chapels rather than as the Byzantine diaconicon and prothesis. Furthermore, the apse has an Eastern form, polygonal on the exterior and semicircular on the interior. The proportions of the naves are wider than in typical Roman basilicas, and large windows in the outer walls flood the aisles and lower part of the nave with light, which emphasizes the lateral extension in space. Thus the directional emphasis so characteristic of the Western basilica gives way to a feeling of expansiveness in the Ravennate type.

Byzantine Mosaics

In both the basilicas raised to honor St. Apollinaris, the most noticeably Eastern feature is the style and the organization of the mosaics. Indeed, the Ravenna mosaic cycles give us precious information about the lavish programs that once decorated the churches built in Constantinople under imperial patronage.

They reveal that artists coupled high standards of craftsmanship with an extraordinary spirit of innovation to produce church interiors of a quality that more than equaled the architectural sophistication of the structure. Of course not all provincial buildings were so richly decorated.

Byzantine mosaicists had to create sumptuous interiors worthy of both the imperial and the heavenly courts. To achieve this awesome goal, artists augmented colored stones with glass tesserae, and since glass could be manufactured in almost any hue, the variety and intensity of colors could be increased. For the gold so vital to Byzantine sensibilities, dazzling tesserae were created by encasing a layer of gold leaf in the clear glass. Ultimately, artists came to prefer a color scheme composed of brilliant gold, deep blue, green, and purple, all enhanced by touches of red, yellow, and white. With these imperial colors they turned each wall into a light-refracting plane. Craftsmen spaced tesserae widely and often painted the exposed mortar or plaster bed red, thereby achieving a rich yet subdued background color. As they set them, the mosaicists also tilted the tesserae toward the ground at irregular angles, which had the effect of heightening the play of glittering reflections. Finally, Byzantine designers created mosaics that seemed truly to float over walls and vaults, as if with a separate reality independent of the supporting structural framework. No longer were images conceived of as windows opening into the world of matter. On the contrary, a Byzantine mosaic had to transcend matter and capture the intangible world of the spirit.

Unlike their Early Christian predecessors, Justinian's craftsmen worked within a well-formulated aesthetic theory, grounded in the Greek philosophy of Neoplatonism. By the sixth century, the Neoplatonic ideal had so pervaded the Eastern Empire that it became the intellectual basis for the period's entire scheme of pictorial arts. Neoplatonism emphasized a hierarchical order of the universe;

thus, the most sacred figures were placed in the upper zones, the earthly scenes in the lower register. Although most of the examples of the schema were destroyed during a period of puritanical revulsion against images in the eighth and ninth centuries, the decoration of later Byzantine churches, such as Hosios Loukas in Greece, suggests the earlier program of imagery. Later, Western artists would also turn to Neoplatonism for an aesthetic theory.

The theoretical formulations underlying Neoplatonic aesthetics derived from the third-century Greek philosopher Plotinus, whose writings, known as the *Enneads*, were familiar to the Byzantine world through the interpretations of his fifth-century disciple Proclus. Plotinus postulated a cosmology of creation and divinity based on a hierarchical order of abstract beings. At the pinnacle is the incomprehensible, all-sufficient One, a unity perfect in truth, beauty, and goodness. Through a process known as emanation, the One gives rise to and is reflected in Divine Reason, an intelligence then made manifest in the Universal Soul, which in turn animates the material world. Matter, however, lies at the nether end of Plotinus' scale. Since the One is the only reality, all else being an ever-weakened reflection of that unknowable perfection, material things have no existence except as they are given spiritual life by the Universal Soul. Earthly objects and beings appear as faint echoes of the One. Although humans belong to the world of matter, they also participate in the higher realm because they have intellect. Each person, theoretically, can achieve a mystical union with the One by means of meditation, and the arts provide a vehicle for contemplation. In the words of the philosophers, then, art as a reflection of beauty becomes a mirror that catches the image of the Universal Soul. Pictures should represent the essence of objects rather than superficial, outward appearances, for only in this way can art transmit the knowledge of infinite beauty to man's highly imperfect intelligence.

In order to make such a system viable, artists and viewers, in effect, had to agree to a series of conventions—that is, they had to create an artistic language which would be understood to communicate unseeable reality.

The most important artistic convention evolved from Plotinus' theory of light and vision. Since all objects, the philosopher contended, interrelate and interpenetrate as they share in the oneness of Divine Reason, they are, ideally, transparent. Hence, in order to remove a depicted figure from the false reality of its setting, the artist had to eliminate matter and attempt to evoke the diaphanous nature of material presences. He achieved the required effect by concentrating on light and color, while ignoring aspects of darkness and shadow—those features, in other words, that lent three-dimensionality to forms. With the image thus separated from mundane appearances, the viewer could meditate on art not with the physical but with the "inner eye" and, in so doing, intuitively grasp the reflections of beauty and perfect goodness emanating from the One through the Universal Soul.

None of these metaphysical speculations about art would have influenced Byzantine imagery had not Neoplatonism found adherents among Christian thinkers. In the late fifth century, the anonymous Greek theologian known as Dionysius the Pseudo-Areopagite, reinterpreted Plotinus' theories in Christian terms. Whereas Plotinus perceived the One as the ultimate perfection in the cosmological hierarchy, Pseudo-Dionysius saw God as the culmination of the same order. Moreover, the Christian philosopher justified the use of images as a step toward mystical communion with the Divine. Like Plotinus, Pseudo-Dionysius believed that light—and, consequently, the colors through which it is transmitted—plays an essential part in the contemplative process. As the immaterial element in material things, light links the world of matter with the higher realm of the spirit. Hence, light is the most important of all natural phenomena.

In sum, Neoplatonic aesthetics required that art glow with light and color in order to make the perfect beauty of the invisible world intelligible and visible to the ordinary person.

Byzantine artists had to satisfy another societal and imperial need. The Eastern emperors wanted to rule in the glorious tradition of imperial Rome. Assisted by the educated taste of the court advisers, they encouraged a revival of Classical culture, ceremonial etiquette, and art. In reconciling the earthy realism of ancient art with the spiritual goals of Neoplatonism, sixth-century artists developed the first truly medieval style. In order to capture the intangible reflection of divinity, be it Christ or the emperor, court artists adapted the hieratic, abstract style of the neighboring Near East. Thus two different but equally respected modes of perception—Roman illusionism and Late Antique abstraction—underlie the Byzantine style.

The shift from illusionistic vision to thoroughly abstract imagery is nowhere more evident than in the mosaics covering the interiors of Byzantine churches. This is not surprising since religious art was regarded as an aid to meditation and had to be rendered so that the worshiper could suspend belief in sensory experience, the better to partake of the spiritual world. For this purpose, the static, timeless quality of an image took precedence over any narrative element. Furthermore, if the required emphasis on light and color permitted an intellectual ascent to immaterial beauty, it also served to glorify Church and state by creating a brilliant environment for the celebration of the Mass. Hagia Sophia must have offered the most resplendent setting of all. Unfortunately, much of the church's original decorations have been damaged or destroyed; but in Ravenna, despite changing political fortunes and religious controversies, sixth-century mosaics survive in remarkable numbers.

At S. Apollinare Nuovo, the mosaics show a conscious effort to reject narrative development in favor of abstract, hieratic imagery [12]. The panels above the clerestory windows, probably completed before Theodoric's death

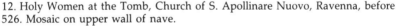

12. Holy Women at the Tomb, Church of S. Apollinare Nuovo, Ravenna, before 526. Mosaic on upper wall of nave.

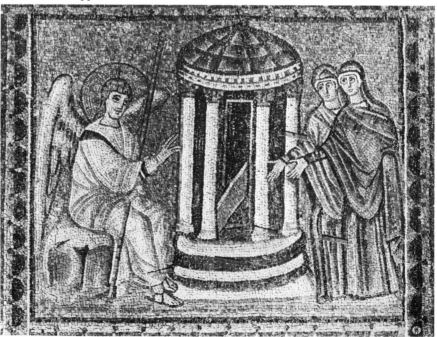

in 526, form the earliest surviving mosaic cycle of the miracles and the Passion of Christ. Comparison with fourth- and fifth-century mosaics shows the shift in pictorial conception. The individual image is no longer understood as part of a lively, illustrative account, but rather as an eternal, self-sustaining symbol. The dark outlines, only barely visible around the figures at Sta. Maria Maggiore, for example, have become prominent in the S. Apollinare Nuovo representation of the Holy Women at the Tomb. Such strong contouring, along with the use of bright, flat colors, facilitates a reading of the image from the distant nave floor. That the sixth-century mosaicists carefully considered the worshiper's relationship to the panel is further demonstrated by the general simplification of the design. Gone are the genre details and the profusion of small figures that gave many earlier mosaics an anecdotal character. Instead, the Byzantine artists have reduced the number and enlarged the size of the remaining figures.

Still, making the image visible to the spectator was not the only motivation for the artist's simplified design. When looking at the picture, the worshiper also had to grasp its symbolic content in order to see the reflection of divinity mystically present in the material substance of the mosaic. For this reason, the designers ordered each composition symmetrically and eliminated all landscape and architectural details, except for the few elements essential to the identification of the subject. Thus, a rock and some green lines refer to, but do not describe, the site of the tomb. Moreover, these vestiges of nature appear against a glimmering golden background rather than against the blue sky found even in the New Testament mosaics on Sta. Maria Maggiore's triumphal arch. The use of gold at S. Apollinare Nuovo disassociates the scene from a tangible environment, and thereby enables the viewer to focus attention solely on the dominant, central sepulchre. Unlike the Early Christian ivory that rendered the same mo-

ment, the Byzantine mosaic tells no story. In the fifth-century relief, sleeping soldiers and the confrontation between the Holy Women and the angel lend drama to the depiction of a specific moment. Here the auxiliary figures have disappeared. The divine messenger and the pious witnesses, all three rigid in posture and staring outward, simply gesture toward the tomb between them, where the open door reveals the raised lid of the empty sarcophagus. By means of this pictorial abbreviation, the S. Apollinare Nuovo mosaic presents the faithful not with the temporal narrative of Christ's ascent from the tomb, but with the miracle of the Resurrection willed by God.

Although created for the decoration of an Arian church, the scenes from the life of Christ manifested no heretical views, and the later orthodox conquerors left them untouched. Below the clerestory windows, however, Theodoric's artists had placed a procession of Arian saints. The Byzantines transformed these secular figures to a more appropriate gathering of saints. On the north side of the nave, the three Magi lead a procession of female martyrs toward the Virgin and Child; on the south, male martyrs leave the palace to follow St. Martin, the original patron of the church, to the enthroned Christ. Since the figures repeat the verticality and regular rhythm of the nave columns, they enhance the directional movement toward the sanctuary, and as a result of the visual interrelation between the mosaics and the architecture, the martyrs' existence as real figures is reduced. Barely distinguished from one another in physiognomy, and in no way individualized by dress or gesture, the toga-clad men become patterns of color, oblong white shapes overlaid with blue and green lines. In comparison with these still and frontal figures, the apostles in the Orthodox Baptistery dome (color plate I) seem vigorous and even classicizing. Once again, the contrast can be explained by the new urgency to exclude the material world from pictorial representation. Whereas the apostles in the Orthodox Baptis-

tery cast dark shadows as they stride forth on firm green ground, the S. Apollinare Nuovo martyrs quite literally do the reverse, for an aureole of bright yellow tesserae surrounds their feet. Rather than just eliminate shadows in response to Neoplatonic theories, the Ravenna mosaicists have willfully inverted the natural order of optical experience—and thus denied its very existence.

In the Church of S. Vitale, we find a more highly developed version of the same pictorial mode [13]. Only the mosaics of the sanctuary survive, still surrounded by elegant columns, carved capitals, intricate moldings, and a rich encrustation of marble veneer. Sheer splendor, however, is only one aspect of the decorative program, for in the hallowed space of the apse, the artists finally rejected every trace of continuous narration in favor of pure symbolism. Greco-Roman forms are thoroughly amalgamated with the spiritual rendering demanded by Christian Neoplatonism. Each mosaic is related to the others not by a narrative theme but by a symbolic one—the theme being either the Eucharist or the history of S. Vitale. In the conch, Christ sits enthroned on a celestial orb and offers a crown of martyrdom to the soldier-patron St. Vitalis, at the same time that he accepts a model of the church from Bishop Ecclesius, its founder. On one of the walls below, Justinian rules the material world as Christ's vicar. The emperor, attended by courtiers and Archbishop Maximian, holds his gift to the church, a Eucharistic plate (paten). Across the sanctuary, but represented as if in the narthex, Theodora and her guards and ladies complement Justinian's action by offering a chalice [14]. Although neither Justinian nor Theodora ever visited Ravenna, the imperial couple eternally participate in the

13. Sanctuary with mosaics, Church of S. Vitale, Ravenna, 525–47.

14. Empress Theodora and her court, Church of S. Vitale, Ravenna.

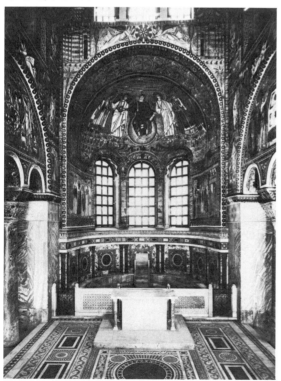

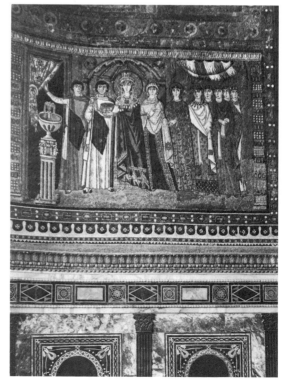

celebration of Mass at the altar. In the lunettes of the choir, just in front of the apse, two Old Testament scenes refer to the sacrifice of Christ, perpetually reenacted in the miracle of transubstantiation during the Eucharistic service. The patriarch Abraham entertains three angels, symbols of the Trinity, with meal cakes incised with crosses, prefigurations of the bread of the Host. At the right, the hand of God reaches out to stay Abraham's obedient sacrifice of his son Isaac, an event typologically associated with the Crucifixion. As if to make explicit the analogy between the Old and the New Testaments—between the sacrifice of Isaac and of Jesus—two angels hovering above the lunette support a cross wreathed by a victor's laurel.

The dedicatory mosaics of Justinian and Theodora provide an instance of the union of styles found in the best Byzantine art of the period. Pictorial abstraction has made the imperial presences a timeless reflection of the celestial order. Justinian, Theodora, and their entourage thus cast yellow "shadows," a space-denying device appropriate to the ethereal, substanceless bodies. Indeed, the men's garments, like those at S. Apollinare Nuovo, are arranged as flat white rectangles articulated by tubular folds and interrupted by patterns of black lines. Meanwhile, the multicolored, bejeweled robes and headdresses of the female figures and soldiers create an even more dazzling, otherworldly appearance. In contrast, all the faces—especially those of the imperial couple and their closest attendants—are rendered as lifelike portraits, thereby evoking the Greco-Roman tradition emulated by court artists. The images may in fact be based on official portraits made in Constantinople. Ultimately, the combination of two distinct pictorial modes in the S. Vitale dedicatory panels suggests that at the very moment the mosaicists sought to represent the divinely blessed nature of emperor and empress, they also wanted to leave future generations in no doubt about the monarchs' identity.

The S. Vitale artists employed another device to qualify traditional illusionism and bring the eye back to the surface: the book and fountain, and the chalice and paten, are rendered in reverse perspective—that is, the lines diverge from each other as they recede, and objects appear to tip up and grow larger. Two factors, both grounded in Neoplatonic philosophy, are responsible for the use of this method in Byzantine art. First, the object had to be presented as completely as possible in order to permit the viewer's eyes to wander over it, seeking the divine essence. Second, Plotinus considered the zone between the observer and the work of art to belong to the picture. The spectator did not look into an image but was confronted by it. Any space depicted, therefore, had to extend forward, toward the viewer, not backward into the wall. Rather than merely negate or suppress naturalistic effects, as their predecessors had done, sixth-century artists accepted the notion that objects exist in space. They simply inverted the "illusionism" of the setting so that space would project forward into the atmosphere between the image and the observer.

In the Theodora mosaic many individual elements recall the Classical heritage—the shell-like niche, the fluted pedestal, the open door, and the overhanging draperies—but since Theodora and her companions neither stand in a rational space nor have material substance, the architecture and the curtains cannot function, as they had in the Greco-Roman world, as space-creating elements. Instead, they simply allude to a bygone visual tradition, and in so doing suggest the glorious lineage of the Byzantine imperial house. The remarkable feat of the S. Vitale artists, therefore, was to integrate Classical art into an irrationally ordered composition.

The substitution of symbolic image for narrative or visual realism, so pervasive at S. Vitale, reaches a climax in the two great apse mosaics found in the Monastery of St. Catherine at the foot of Mount Sinai [15] and in

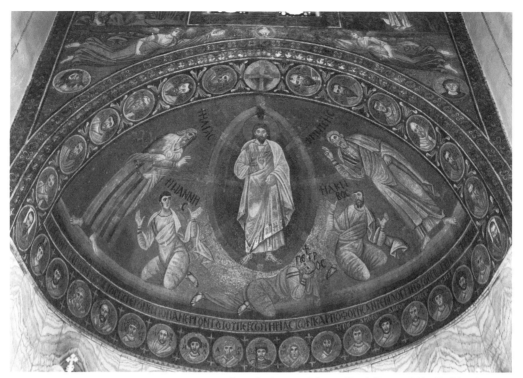

15. The Transfiguration, Monastery Church of St. Catherine, Mount Sinai, Egypt, 560–65. Mosaic.

S. Apollinare in Classe. Both depict the Transfiguration. Although geographically distant, both works reflect aspects of the court style in Constantinople in the second half of the sixth century. The Church of St. Catherine was built at Justinian's command between the death of Theodora in 548 and the emperor's own death in 565. In the apse, Classical forms appear in a new context in order to turn a narrative event into a symbol. The Transfiguration of Christ—the moment, that is, when Jesus temporarily shed his earthly, human form and appeared to Peter, James, and John as the shining divinity (Matt. 17:13, Mark 9:1–13)—illustrates a Biblical event and the dogma of the two natures of Christ, human and divine. As the voice of God said, "This is my beloved Son," the Savior emerged as a theophany in a mandorla, flanked by the standing figures of Moses and Elijah. In the mosaic, the awestruck apostles crouch at His feet. A comparison with the mosaic at Hosios David (chapter II) demonstrates the extent to

which sixth-century artists have moved in the direction of pure symbol. The apse mosaic in the Greek church is packed with landscape details, although the evangelists are depicted as the four beasts beheld by Ezekiel. The Sinai artists, in contrast, rendered only human forms but nevertheless presented a far more visionary scene because they eliminated everything belonging to the natural world and filled in the conch with glittering, gold glass tesserae. The prophets and apostles thus seem to levitate in a golden Heaven, barely touching the green and yellow bands at the base of the conch that signify the earth. Even the figures' active, exaggerated gestures, and their three-dimensional forms so carefully described by close-fitting garments, serve here to accentuate rather than to mitigate the abstract design. Too, the Byzantine figures are proportionately larger than were their fifth-century counterparts, and therefore have a more powerful impact on the distant observer.

In the mosaic that fills the apse of S. Apol-

linare in Classe (dedicated in 549) the Transfiguration is depicted almost entirely through symbols: a jeweled cross afloat in a blue, star-spangled sky represents the incarnate Christ, who is seen only as a tiny, pearl-framed face [16]. In the upper zone, the hand of God extends toward the cross. Half-length figures of Moses and Elijah emerge from the clouds, but the apostles who witnessed the miracle are shown as three sheep. Below the cross St. Apollinaris, the first bishop of Ravenna, whose relics originally lay under the altar, acts as intercessor for his congregation, depicted as a flock of twelve sheep around the base of the conch. A sinopia (preparatory drawing) discovered under this lowest zone shows the original scheme to have been a cross flanked by plants, birds, and baskets of grapes, all traditional emblems of paradise. In the final version, the landscape of paradise becomes a

16. The Transfiguration with St. Apollinaris, Church of S. Apollinare in Classe, 549. Mosaic. Approximately 38′ 5″.

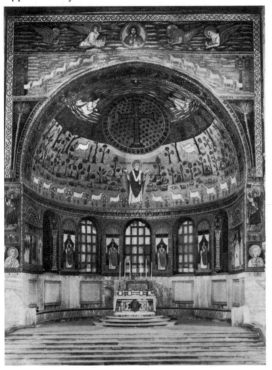

meadow filled with bushes, trees, flowers, and rocks. These landscape elements are symmetrically arranged, each transformed into an isolated and independent decorative unit. As a result, the garden has undergone an astonishing metamorphosis. By rejecting an illusionistic rendering of solid figures in a deep, natural landscape in favor of a mystical vision, the mosaicists captured the timeless quality of a divine miracle.

The Sumptuary Arts

When we turn from architecture and monumental decoration to the other arts, we are at once reminded that the Byzantine court held the sumptuary arts in high regard. Goldsmiths were installed in the imperial palace and even enjoyed favored seating at festivals and in the hippodrome. Objects and images fashioned from precious materials delighted and edified a wealthy, cultivated, intellectual elite. As a result, craftsmen excelled in working with ivory, silver, gold, and semiprecious stones. Panel painting and manuscript illuminations, too, took on a jeweled, highly wrought character, although the minor arts also reflect the style of large-scale mosaic cycles.

Ivory sculpture illustrates the debt of the Byzantine artists to the Greco-Roman heritage; however, not unexpectedly, Classical forms are imbued with symbolic content. Superb examples of this Byzantine classicizing style are two ivories made in Constantinople: one of the archangel Michael [17] and another of the emperor, Justinian, as defender of the faith. In churches throughout the East, ivory diptychs (panels joined in pairs) served as memorial tablets, on which were inscribed the names of people for whom prayers were to be said during the Mass. On one such panel, St. Michael appears as a divine messenger holding an imperial orb with a cross. His youthful face conforms to a Classical ideal and his well-proportioned figure is revealed

by clinging tunic and pallium. The archangel seems more like a young Greek hero or a Roman orator than an invisible celestial spirit. So strong is the antique cast of the work that it has been dated to the fourth and fifth centuries; current scholarship, however, places it in the first third of the sixth century. The Byzantine sculptor's debt to Classical art is nowhere more striking than in this relief; nevertheless, features of the panel disclose its Byzantine character. The architectural framework, for example, is not arranged in a rational space; St. Michael's feet rest on the back steps of a staircase that recedes from the pedestals and columns in the foreground, but since the angel's arms and wings project in front of the columns, the upper part of his body would appear to be in the foremost plane. Hence, there is spatial ambiguity between figure and setting, an ambiguity that denies the carefully wrought realism of the individual details. The Byzantine artist has suspended the physical world's laws of optics and gravity, and, in the process, created a fitting environment for a Heaven-sent messenger. The tablet with the Greek inscription reads, "Receive these gifts, and having learned the cause. . . ." The quality of the sculpture suggests that the ivory was made in the imperial workshop, and the right-hand leaf of the diptych might have had a representation of the emperor.

In the fifth century, complex imperial ivories, composed of several panels, were made. Four of the five panels of such a relief make up the so-called Barberini ivory [18]. An idealized emperor clad in Roman armor sits astride a rearing horse. So lively and three-dimensional are the figures that scholars have long held the image to be an echo of a towering equestrian statue of Justinian once set up in Constantinople in emulation of similar Roman monuments. In the ivory, antique emblems mingle comfortably with religious allusions in that mixture of pagan and Christian iconography familiar in Constantinian and Theodosian art and still serving the sixth-century

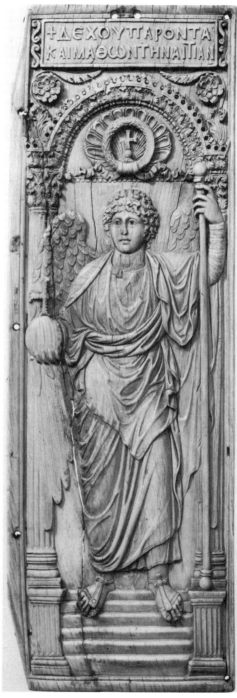

17. St. Michael, early sixth century. Ivory diptych, right leaf, 16 7/8" × 5 5/8". The British Museum, London.

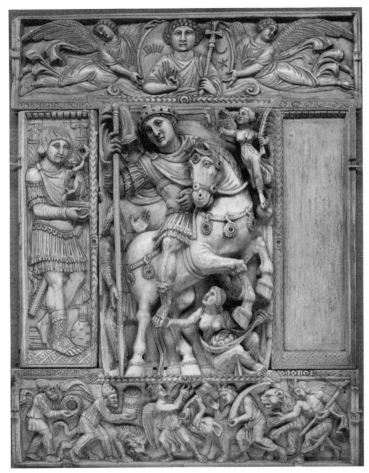

18. The emperor victorious: the Barberini ivory, sixth century. The Louvre, Paris.

court as a means of clothing the emperor in the mantle of divinity. A personification of earth supports Justinian's foot, while a winged Victory bearing a palm cheers the emperor on. To the left, a general offers a statue of Victory bearing a wreath. Still another flying Victory, surrounded by tribute-bearing representatives of the subjugated territories, reaches up to Justinian from the center of the lower frieze. The full, rounded modeling and the complex poses of conquered barbarians and wild animals suggest that the sculptor turned to Roman battle scenes for inspiration. The emperor himself, although seated on a rearing horse, appears as an ideal, superhuman ruler. As in the colossal portrait of Constantine, his impassive, masklike face seems to look beyond the earthly realm. Lest the focus of Justinian's

vision, as well as the source of his authority, go unnoticed, a blessing Christ emerges from a halo at the top. Moreover, the Savior's portrait is held up by two winged angels who, in a thoroughgoing conflation of pagan and Christian motifs, are completely indistinguishable from classical Victories. The two-dimensional carving of this upper panel contrasts with the vigorous high relief of the imperial image.

The rich variety of styles current in the Byzantine Empire can be seen in a single work, the justly famous throne of Archbishop Maximianus in Ravenna, which Justinian may have given to the archbishop at the time of the consecration of S. Vitale in 547 [19]. The symbolic function of the cathedra, as a bishop's throne is called, accords well with the subjects

selected for the ivory panels that cover the small wooden chair. On the curved back, the sculptors depicted scenes from the life of the Virgin and the early life of Christ, depending on stories from the apocryphal Gospels for details. The arms and the sides hold scenes from the story of Joseph, who, as an Old Testament patriarch, served as a model for the Christian bishop. Also, Joseph in his imprisonment in the well prefigured Christ's death and Resurrection, an important baptismal theme. Vine scrolls inhabited by stags, peacocks, and other paradisaical images reinforce the promise of salvation. On the front face of the seat, standing portraits of the four evangelists flank a figure of St. John the Baptist, who holds a medallion with the sacrificial Lamb of God. Above the Baptist's head, Maximianus' monogram affirms the succession of priestly authority from the one who baptized Christ to the bishop who reenacted the rite in the Lord's name.

The throne is an eclectic work in which several artists followed different models. The inhabited vine scroll is a masterful adaptation of Late Antique ornament, and the Joseph stories also show their debt to Roman art, especially to narrative sculpture. To be sure, the grace and elegance of true Classical forms have given way to angular, heavily proportioned bodies with large heads, but all the figures are energetic participants in narratives filled with genre details. A different combination of Roman art and the Byzantine hieratic mode characterizes St. John the Baptist and the evangelists. Remarkably expressive faces, carved in high relief, surmount wraithlike bodies disguised by drapery falling in symmetrical linear patterns. The projection of feet and hands in front of the columns implies that the figures stand in an earthly space, but the surrounding architecture is carved in such low relief that it becomes ornamental rather than space-defining. Scenes from the life of the Virgin also form dense compositions of interlocked figures and architecture in sharply

19. Throne of Archbishop Maximianus, Constantinople?, 545–47. Ivory over wood, 4′ 11″ high. Ravenna, Archepiscopal Museum.

rising planes. This integration of realistic and abstract styles in Byzantine art emphasized the immaterial nature of material things.

Manuscripts

Early Christian and Byzantine manuscript illumination, an art form so important in later periods of Medieval art, can be studied only through isolated examples. (In spite of the Herculean efforts of Kurt Weitzmann and his students, the paucity and mere chance survival of manuscripts make any systematic history of the early stages of the art impossible.) The Romans illustrated their scrolls with portraits of the authors and depiction of events in the text, and the Late Antique style lingered tenaciously into the sixth century in Byzantine painting. An encyclopedia of medicinal herbs compiled in the first century by the Greek

physician Dioscorides, and known as the *Materia Medica*, has survived in a sixth-century copy made in Constantinople for the Princess Anicia Juliana (it is now in Vienna and therefore is known as the *Vienna Dioscorides*). Since in a scientific treatise the illustrations were intended to clarify, not merely to ornament, the text, the artists naturally transferred aspects of the Late Antique style along with the pictorial compositions. The illustrations combine careful observation of nature with great delicacy in painting. The scene with Dioscorides and his assistant at work not only follows the established tradition of including a portrait of the author of the book but makes abundantly clear the intention to record nature faithfully [20]. Dioscorides is represented as a scholar seated with an open book on his lap, inspired by Epinoia, the Power of Thought, who holds a mandrake root, which an assistant copies. The assistant studies the model as he records it on a large sheet of vellum fastened to his easel. Such realistic details contrast with the idealized background of colonnade and niche. (Weitzmann has suggested that such architectural backgrounds for author portraits were inspired by the decoration of Roman theaters.) The complex poses of the figures, the refined modeling in light and dark tones, and the perspective rendering of the setting suggest that the *Vienna Dioscorides* is a skillful rendering of its Greco-Roman model.

The antique pictorial style seen in the Dioscorides treatise also influenced the illustration of religious texts with Christian subjects. Artists who worked in the imperial scriptoria (workshops for the production of books) created luxurious manuscripts worthy of their patrons. First, they dyed the light-colored vellum a deep purple, the color reserved for the use of the imperial court. (In the first century, long papyrus rolls began to be replaced by codices made up of individual leaves, as in a modern book; by the fourth century, the codex was the usual form of a book.) Then the scribes wrote out the texts in silver or gold. Finally,

the painters illustrated the narrative, often turning to Classical sources as they worked.

One of the most sumptuous manuscripts to survive from the sixth century is part of the Book of Genesis, now in the National Library in Vienna, and consequently known as the *Vienna Genesis*. Twenty-four folios (forty-eight pages) survive, each with a half-page illustration. Although the division of the *Vienna Genesis* into pages facilitated reading, the artist did not fully adapt to the modern arrangement, for he often illustrated the events as a continuous narrative. Thus, in the story of Rebecca (Gen. 24), the heroine, with a jug on her shoulder, journeys out of the walled city and down to a stream [21]. That a lightly draped nymph leaning on a jar appears as a personification of water further attests to the influence of a Classical model. The narrative then turns to the right and presents Rebecca again, charitably offering water to Eliezar and his camels—a shift in pictorial direction which suggests that the illuminator was self-consciously following the scroll format. The figures themselves are equally reminiscent of an earlier, Classical style. Even though the flat purple ground removes the scene from the material world, the individual figures are full-bodied and seem to move easily and naturally in their limited space.

Not all Byzantine manuscripts were imperial purple codices. Many were made for private patrons and for churches and monasteries in the provinces as well as the capital. Such a book is a Gospel copied in 586 by a calligrapher named Rabbula at the Monastery of St. John in Zagba, Syria, and illustrated by anonymous painters.

The artists worked in brilliant colors on the natural light vellum, using a sketchy illusionistic technique for the background and a strong outline drawing for the well-modeled figures. The accurate proportions, expressive poses and gestures, and the illusionistic setting suggest Late Antique models. Some of the full-page paintings in the code may have been

20. LEFT: Portrait of the author at work with an assistant, and Inspiration, Dioscorides, *Materia Medica,* Constantinople, 512. 15″ × 13″. Österreichische Nationalbibliothek, Vienna.

21. BELOW: Rebecca at the well, *Vienna Genesis,* Constantinople, sixth century. Purple vellum, 13 1/4″ × 9 7/8″. Österreichische Nationalbibliothek, Vienna.

inspired by monumental apse decorations in the churches of the Holy Land. The scene of Christ's Ascension is conflated with the same apocalyptic imagery described by Ezekiel that we have already encountered at Hosios David. In the *Rabbula Gospels,* however, the depiction of the four evangelists as symbolic beasts emerging from eye-studded wings and wheels of fire adheres more strictly to the scriptural source than does the fifth-century mosaic. Christ, although borne heavenward in a mandorla by the beasts, wheels of fire, and angels, raises His hand in blessing and steps forward like an ancient orator [22]. Below the celestial apparition angels direct the apostles' wondering gaze to the miracle of the Ascension. Yet, however lively and descriptive the narrative may be, and however deep the space suggested by the hills on the horizon, the visual focus of attention falls on the Virgin. The Mother of the Lord does not share in the apostles' excitement; instead, she stretches out her arms like an orant, as if praying for the faithful who will come before her Son on the Day of

22. The Ascension, *Rabbula Gospels,* Zagba, Syria, c. 586. 13 1/4″ × 10 1/2″. Biblioteca Medicea Laurenziana, Florence.

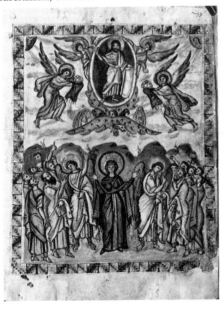

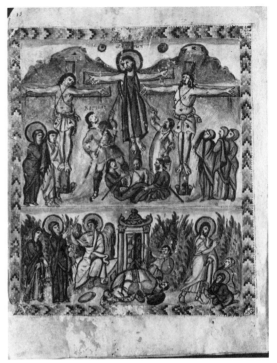

23. Crucifixion and Holy Women at the Tomb, *Rabbula Gospels,* Zagba, Syria, c. 586. 13 1/4″ × 10 1/2″. Biblioteca Medicea Laurenziana, Florence.

Judgment, on that awesome day already alluded to in Ezekiel's vision.

The many episodes in the story of the Crucifixion have been organized into a symmetrical composition in two registers that would have effectively filled the apse at Golgotha [23]. Christ is a mature, regal figure, alive and triumphant on the cross. He wears a *colobium,* or long, sleeveless, purple robe, in the modest and dignified tradition of the Eastern Church. Good and bad thieves, the centurion Longinus and Stephaton the sponge bearer, the mourning Virgin, St. John, and the Holy Women flank the Savior. Below the cross indifferent Romans fulfill the prophecy (Matt. 27:35) by casting dice for Jesus' clothes. In the lower register the artist depicted later episodes: the Holy Women at the empty, guarded tomb and the appearance of Jesus to the two Marys to reaffirm His Resurrection

(Matt. 28:9–10). This wealth of narrative detail gave historical validity to Christ's sacrifice and presented in visual terms the Orthodox answer to the heretical Monophysites, who, believing the Lord to be totally divine, denied the reality and the necessity of the Crucifixion.

Icons and Iconoclasm

The very heresy that the artist of the *Rabbula Gospels* sought to counter indirectly caused one of the greatest traumas of Byzantine civilization. If Christ was an exclusively divine manifestation, the Monophysites argued, then no anthropomorphic form could describe Him. Pictures that attempted to represent the godhead were blasphemous. This position, also advocated by those Christians who upheld the Old Testament ban on imagery, diametrically opposed the popular use of art as an aid to instruction and meditation. In the sixth and seventh centuries the condemnation of religious images increasingly focused on icons— hence the designation of the resulting crisis as iconoclasm, or "image-breaking."

Icons were small portraits of Christ, the Virgin, or the saints, designed, like the pagan imperial *lauratrons*, to serve as proxies for the divine presences. In order to avert charges of idolatry, theologians carefully pointed out that in venerating an icon one paid respect not to the image but to the person depicted. Thus, St. Basil explained that "the honor rendered to the image passes to the prototype." By this process the icon provided a Neoplatonic channel of communication between the worshiper and the divinity, a channel through which could emanate a mystical reflection of God.

The main distinction between icons and secular *lauratrons* was that the original Christian images were believed to have been fabricated under miraculous circumstances, without human intervention. The column of the flagellation, for example, bore Christ's form, while the cloth (the sudarium) with which St. Veronica wiped the Lord's face on the way to Calvary was stained with his portrait. Legend held that other images were painted by St. Luke, or even by angels. Because of these supernatural origins, the faithful often credited the icon itself with marvelous powers. In 626 and again in 717 icons of Christ and the Virgin, taken to the gates of Constantinople, saved the city, first from another Persian onslaught and then from an Arab assault. Naturally, the number of miraculously wrought images was limited; consequently, ordinary mortals began to copy the sacred icons, in the hope that even a facsimile of the holy form would in some way partake of its sanctity. Monasteries became important centers for the manufacture and sale of these reproductions, because they kept most of the existent icons in protective custody. Icons could be fashioned in mosaic, ivory, or precious metals, but the monks preferred painted images, which enabled them to avoid that three-dimensional likeness so uncomfortably reminiscent of pagan idols.

Very few icons survived the victory of the iconoclasts in the eighth century, for although the triumph was short-lived, it resulted in the destruction of countless art objects. In the Monastery of St. Catherine, however, far away in the deserts of the Sinai Peninsula, an unusually large collection of icons has been preserved.

Among the earliest is a sixth-century image of the Virgin and Child [24]. The Byzantine preference for linear or geometric shapes determines the severely frontal figures of the enthroned Virgin and Child and the attendant saints. The Virgin herself becomes a throne for the Christ Child through her hieratic posture, while a rich brocade transforms the bodies of St. Theodore and St. George into flat, attenuated and equally architectonic designs. Moreover, the ovoid shape of the faces of Mary and the saints, along with the repetition and the sheer size of the heavy halos, also reduces their tangibility. Nevertheless, the two angels behind the throne, and to

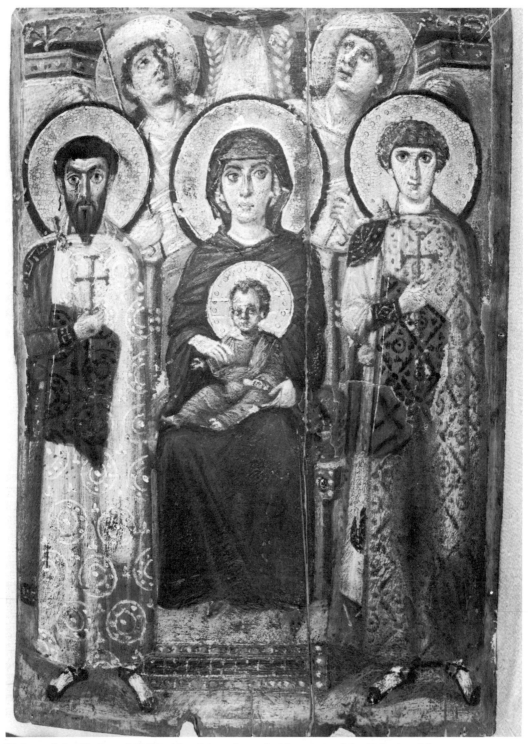

24. Icon of the Virgin and Child with saints and angels, Monastery of St. Catherine, Mount Sinai, Egypt. Encaustic painting, 27″ × 19 6/16″, Constantinople, sixth century.

some extent the Infant Himself, seem inspired by Classical art. The contrast may be due to the participation of more than one artist or to the use of different models for the different figures, but whatever the explanation, no more pointed example could be brought forth to reveal the two stylistic worlds that constitute the universe of Byzantine art.

By the eighth century the opposition to icons had grown formidable. Because the images were taken into private homes for domestic use, it was feared, with some justification, that their holiness would be abused, and indeed the powers attributed to such icons did seem dangerously close to magic. In 726 Emperor Leo III, a passionate iconoclast, removed all religious pictures from the palace, and four years later he issued a decree prohibiting the making or the veneration of icons. Leo's successor, Constantine V (741–775), held even more extreme views and persecuted those who continued to venerate icons. Thoughtful theologians rose to the defense of images, at great risk to their personal safety. St. John of Damascus contended that if "God created man in His own image" (Gen. 1:27), and further chose to make His divinity visible through the Incarnation of Christ, then representations had to be permissible, for they reflected the perfect truth and beauty of God. Despite St. John's efforts, however, iconoclasm remained the imperial policy until the accession of Empress Irene. In 787 she convened a second Church council at Nicaea, which affirmed the efficacy of images. Nevertheless, the controversy erupted once more in 815, iconoclasm having been reintroduced by the newly crowned Emperor Leo V. Not until twenty-eight years later did another council meet to officially restore the cult of images, and on March 11, 843, a great new liturgical feast—the Feast of Orthodoxy—was solemnly inaugurated. Iconoclasm may have troubled the Byzantine East but it never became official policy again.

The iconoclastic interlude resulted in irrep-arable losses, since the ban against pictures spread to any image that contained human figures, thereby condemning to destruction mosaics, sculpture, and other paintings as well. As a result, what little Constantinopolitan art survives from the eighth and ninth centuries tends to be purely abstract or decorative. Great nonfigurative pictorial traditions, however, also existed in northern Europe and the Near East, and as the barbarians adopted the Christian faith, their art began to enrich the artistic vocabulary of the Christian world.

Byzantine art served both the Church and the Empire. By perfecting a centralized, dome-covered architecture, Byzantine architects effectively fulfilled the needs and captured the essence of the Eastern liturgy and established a form of religious architecture which has survived in the Orthodox Church to this day. While theologians and philosophers expounded a philosophy of art to justify an abstract otherwordly style, the artists represented the Christian story and message in pictorial terms, using the human figure as the vehicle for communication. They perfected techniques of composition and craft—from monumental wall decoration to miniature work in ivory carving, manuscript painting, and enamel. The artists preserved and transmitted both the Classical idealism of Greece and Rome and the abstract art of the Near East, combining these impulses to form a visionary and transcendental style. In style, theme, and technique Byzantine artists were prepared to fulfill the imperial ideals in buildings and accouterments. Patronage of the arts by the emperor as well as by the Church continued the ancient ideal of imperial largesse. The Byzantine court and its artists—while attempting to create the splendors of Heaven in earthly terms for mortal eyes—established a standard of excellence and opulence which the barons and prelates of the medieval West could only envy even as they emulated.

[CHAPTER IV]

Barbarian Art

The barbarian tribes whose incursions irrevocably altered the history of the Roman and Byzantine Empires were far more than nomadic bands of brutal warriors. Although the Greeks and Romans referred to these people as *barbari*—that is, those who lived so far outside the civilized world that they could only "barble" the Greek and Latin languages—the barbarians, too, had an ancient cultural heritage and a developed artistic tradition. They were hunters, shepherds, and farmers with a tribal organization and an oral tradition, but without a written history or literature. Uncultivated as they may have seemed to Greeks and Romans, the barbarians had achieved a high level of technical accomplishment as early as the second millennium B.C., the era known as the European Bronze Age. They engaged in those crafts most common to migratory cultures: pottery, textiles, and wood-working, and they excelled in fashioning metals into jewelry, armor, and tools.

Modern historians can identify many different groups, among which the most important were the Celts in Western Europe and the Scandinavians north of the Baltic Sea. Between the eighth and the sixth centuries B.C. the Celtic population of Europe underwent a rapid technological and cultural expansion. The widespread adoption of iron advanced agricultural productivity, a development that led, in turn, to a higher standard of living and increased population. In search of yet more land, the tribes moved toward the Mediterranean and to the Black Sea. Through migration

and trade, a very creative group, the La Tène Celts (as they are now called, after a site in Switzerland where extensive remains have been found), came into contact with Mediterranean art and culture. As a result, La Tène craftsmen invented a brilliant artistic style that combined the Classical palmette and vine with their native geometric decoration.

A bronze fibula, the ancestor of the safety pin, illustrates the La Tène artist's ability to turn a functional object into a spirited work of art [1]. The straight pin and coiled spring establish taught linear motifs which merge with bow and safety-catch plate to produce a highly abstracted serpentine form infused with energy. Compass-drawn circles decorate the catch plate and an equally symmetrical geometric pattern, the bow; however, as the artist bends the oval pattern over the curve of the semicircular form, the underlying symmetry of the individual motif disappears. This penchant for surprise and disguise, for structure not apparent to the casual observer, is the conceptual foundation of La Tène art. So powerful was this imaginative Celtic style that it survived in the British Isles well into the Christian era.

While the La Tène Celts were developing their distinctive style, the Scyths, a tribe originating in Sino-Siberia, were creating a style based on animal forms [2]. By the fifth century B.C. the Scyths had established themselves in what is now southern Russia, where, despite frequent encounters with Classical Greek civilization, their own work is, in a sense, the

last vestige of the art of the Paleolithic hunters. As in prehistoric cave painting, they represented remarkably realistic animals, with legs folded under as if lying down or bound, or animal and bird combats. In a rectangular buckle a craftsman depicted a horned beast attacked by wolves, framed by ropes and braids. He emphasized the sinuous body and massive neck and meat-bearing flanks, while transforming the horns and tails, claws and jaws, into patterns that show the power and viciousness of the animals, as well as their usefulness as a source of food and clothing.

Still another animal style, dominated by

1. ABOVE: Fibula, Celtic, La Tène, 300–275 B.C. Bronze. Museum of Art and Archaeology, University of Missouri, Columbia.

2. RIGHT: Buckle with animal combat, Sino-Siberian, seventh–fifth centuries. Bronze 4 1/8″ wide. Museum of Fine Arts, Boston.

imaginary reptiles, emerged from the imagination of Scandinavian craftsmen [3]. The contours of ceremonial razors from Skivum, Denmark, dating about 700 B.C., trail off into a spiral that suggests a zoomorphic form, and similar spirals incised on the body of the razors culminate in a dragon head. The whole sinuous creature floats above a ship whose planks curl at either end into the tail and head of a second monstrous serpent. The Norse dragon is fanciful and intellectualized, like no beast ever stalked. It is an animal style created by artists, not hunters.

The Goths, Germanic tribesmen who settled in former Scythian territories in the second and third centuries and then gradually began to displace the Celts—and ultimately the Romans—added another kind of geometric ornament to the barbarian repertory of forms. They enriched their jewelry and weapons with colored stones, especially Indian garnets, mounted within strips of gold in a technique known as cloisonné, or "partition" work. The earliest craftsmen simply polished and set the gems, but later artists became master gem cutters. They employed geometric shapes such as lozenges, stepped patterns, and circles, into which they sometimes inserted recognizable animals and birds. Ultimately, in the Visigothic eagle brooches, the artists achieved a truly polychromatic effect by combining gold, blue, and green stones, pieces of ivory or bone, and red garnets. The term "gem style" has been used to describe the glittering pieces. In sum, the barbarian artists in Europe at the beginning of the Christian era worked in three separate although occasionally interdependent styles: the Celtic spiral style; the animal style; and the polychrome, or gem, style.

As the Roman Empire reached the apogee

3. Razors with ships and serpents, Skivum, Denmark,
c. 700 B.C. Bronze. Nationalmuseet, Copenhagen.

of its power and grandeur, the ever-restless
barbarian tribes began to cross imperial fron-
tiers, lured there by the attractiveness of Ro-
man civilization—its relative security, its cul-
tivated land, its stable life. At first the barbar-
ians claimed only territories that had originally
been theirs. The Romans, after all, had ex-
tended the Empire into the regions inhabited
by the Celtic peoples, initially through Caesar's
campaigns in Gaul (58 B.C.), then through
Augustus' establishment of the Danube fron-
tier (20–10 B.C.) and Claudius' conquest of
Britain (A.D. 43), and finally through Trajan's
subjugation of the area that constitutes modern
Rumania (A.D. 107). Sculptors recorded the
Roman victories in the reliefs on the Columns
of Trajan and Marcus Aurelius. After dem-
onstrating the strength of the imperial armies,
the Romans often turned the indigenous pop-
ulation into *foederatii*, or "federates," and
charged them with the defense of the newly
established borders. The barbarians, in return,
received military aid and lands, as well as the
privilege of associating with the mighty Em-
pire.

The transplantation of Mediterranean art
and architecture to the north by the Roman
conquerors and settlers introduced the indig-
enous populations to a new repertory of visual
forms and materials. Imperial architects, fol-
lowing on the heels of victorious battalions,
introduced stone and brick construction to a
people accustomed to building in wood and
thatch. Moreover, the sculpture, paintings,
and mosaics with which the Romans decorated
the new structures displayed a Classical sim-
plicity and a formal regularity that must have
seemed strange to the barbarians. Equally
strange subjects appeared—such as the human
heads, flowers, fruits, and vines in the mosaic
at Hinton St. Mary—along with ornamental
motifs such as the interlace, which undoubt-
edly appealed to the native craftsmen.

Christianity did not at first provide a uni-
fying force in Europe. Unfortunately for the
stability of the Empire, by the middle of the
fourth century the Goths had been converted
to Arian Christianity, and they were followed
by other tribes. In the eyes of Rome and
Byzantium, therefore, many barbarians had
simply renounced paganism for heresy.

Increasing violence marked the fifth century
as the tempo of migration accelerated under
new pressure from the Huns, a savage tribe
from Mongolia. The Huns drove the Goths
across the Danube frontier into the Roman
Empire. The Eastern Ostrogoths established a
kingdom in northern Italy, while the Visigoths,
or Western Goths, led by Alaric, made a brief
foray to the south and in 410 captured and
sacked Rome itself. They moved on into France
and founded a capital at Arles. Other Germanic
tribes, who had already pushed the Celts to
the western edges of the continent as they
moved into Western Europe, were themselves
displaced. The Burgundians settled in Swit-
zerland and eastern France; the Franks occu-
pied Germany, France, and Belgium. Mean-
while the Vandals, whose name has come to
mean senseless destruction, swept across
France and Spain, crossed over into Africa,
and established themselves around Carthage.
In 455 they too sacked Rome.

Once more the Huns attacked. On the move
again under their ruthless leader Attila—
known to Christians as the "scourge of God"—
the Huns raided Western Europe from 444

until Attila's death in 453. France and Germany were devastated. The Visigoths escaped to Spain, where they took over the Vandal kingdom; other displaced tribes migrated to Italy. By 476 a barbarian ruled as king of Italy under the nominal authority of the emperor in Constantinople, a reign cut short by Theodoric, king of the Ostrogoths, who captured Milan in 493 and then, as we have seen, set up his capital at Ravenna.

While Theodoric was leading his Arian Ostrogoths to victory, Clovis, the king of the Franks, accepted orthodox Christianity on behalf of all his people. His conversion was to have far-reaching consequences for the history of Western Europe. Meanwhile, across the Channel, the British outposts of the Roman Empire were left undefended in 408 by the recall of the imperial troops. The Picts and Scots breached the old Roman walls in the north, and the Saxons—along with the Angles and Jutes from Denmark—began to cross the seas and settle the southeastern part of Britain. The Celts finally took refuge in Cornwall, Wales, and Ireland.

This migration period seems bewildering, yet out of this confusion Europe as we know it began to take shape. By the end of the fifth century the Ostrogoths were settled in Italy, the Visigoths in Spain, the Franks in the region constituting present-day France, Switzerland, the Netherlands, and parts of Germany. The Anglo-Saxons ruled Britain, while the Celts, Picts, and Scots lived in Ireland and Scotland. Scandinavia became the province of the Norsemen, also of Germanic stock, and, far to the south, the Vandals commanded north Africa. One more major shift of the tribal populations occurred in the sixth century, when Justinian and his general Belisarius reconquered some of the Mediterranean territories for the Byzantine Empire. The African kingdom of the Vandals was destroyed in 534–535, and Ravenna fell in 540, ending the Ostrogothic reign. Yet even these victories, commemorated on such triumphant propa-

ganda pieces as the Barberini ivory, did not guarantee the Byzantine frontiers. Indeed, the pagan Langobards invaded Italy in 568 and laid siege to Rome itself before finally settling in northern Italy, thereafter named Lombardy.

The term "barbarian," when applied to the sixth-century tribes, is something of a misnomer. The peoples thus described were not only warriors and peasants but, in addition, the heirs of a great cultural tradition. As the Christian Roman Empire suffered an ever-greater decline, the barbarians stepped in to revitalize the arts and the social framework of Europe. Although the *foederatii* assimilated Roman customs, their society rested on an intricate system of blood relationships. Each man swore fealty to the leader of his tribe, promising to fight with and for him. The king, in return, vowed to protect his men, avenge their deaths, and generously share the spoils of war. The tribal organization, therefore, depended less on the administration of a government than on the execution of moral obligations founded on personal oaths of loyalty. Herein lay the roots of the feudal system that was to govern the European Middle Ages. Here too is the reason for the barbarians' warlike reputation, even after they accepted the spiritual authority of the Church.

During the sixth century, the Christian Church began to emerge as the dominant force in Europe. Roman Christianity gained ascendance with the conversion of the Franks in 496 and with the defeat of the Vandals and the Ostrogoths. By about 650 the Visigoths, the Anglo-Saxons, and the Langobards had all adopted Christianity and acknowledged the spiritual authority of the Pope in Rome. No sooner had the barbarians been assimilated than two new powers threatened the stability of European civilization. With missionary zeal, the armies of Islam attacked Constantinople, moved across Africa, invaded Europe through Spain and, in 711, easily subjugated the Visigoths. In 732 Frankish forces led by Charles Martel finally turned back the Muslim ad-

vances at Tours. Hardly more than a half-century later, however, the Vikings, sailing in their long boats from Scandinavia, began their harrying expeditions around Europe and out into the North Atlantic.

No matter how intensely the wars raged, artists never ceased to create prized possessions for the people, the regalia of kings, and magnificent objects to decorate the sanctuaries of deities. The very nature of nomadic society required that artistic production focus on portable items designed for personal adornment and daily use, and ultimately for burial with their owners. Even after the barbarians had settled down, the craftsmen continued to concentrate on weapons for the men and utilitarian equipment and jewelry for both sexes. The barbarians' love of abstraction and patterns was conceptually akin to the dematerializing tendencies of Late Roman, Early Christian, and Byzantine art; however, the abstract elements in the barbarians' art stemmed from vastly different spiritual sources. Even after they accepted Christianity, the barbarian artists did not forget their ancestors' worship of the forces of nature and creation—of the life-giving power of the sun, of the earth as a fertile mother goddess, and of the physical strength and energy of wild animals. Thus, they continued to use solar disks, trefoils, swastikas, and spirals—motifs that had been inspired by their forebears' pantheistic religion. The spiral winding in and out of itself remained a sign of the ever-recurring seasons, a life cycle encompassing death and regeneration. The soaring eagle with an upturned head and disklike body remained an ancient reference to the sun, and the slithering serpent represented evil, darkness, and death. Hawks, boars, stags—the strongest and most ferocious beasts in the animal kingdom—once employed as tribal totems became personal insignia. When the time came to transfer allegiance to the Christian god, and to fashion objects whose themes did not offend the new spiritual masters, artists simply adapted the primal motifs

to a changed context. In so doing, they laid the foundation for that extraordinary fusion of the barbarian and the Mediterranean styles which resulted in Western Medieval art.

The Art of the Goths

Theodoric established the capital of his short-lived kingdom in the western Roman capital city, Ravenna. In his mausoleum, no less than in his palace and in the royal church of S. Apollinare Nuovo, Theodoric's architects consistently sought to emulate and adapt Christianized Classical forms. Theodoric's mausoleum follows the domed rotunda scheme familiar from imperial Roman tombs and Christian martyria [4]. Moreover, in contrast to the brick used elsewhere in Ravenna, the stone construction of the mausoleum conforms to Roman practice. A ten-sided lower story, articulated on the exterior with deep, blind arcades, housed the sarcophagus and a circular second level served as the funeral chapel. The most astonishing feature of the Ostrogothic tomb is the enormous single slab of stone, weighing 470 tons, that serves as ceiling and roof. Around its circumference are set twelve rectangular loops inscribed with the apostles' names. These strange projections may have served as handles to lift the block, and once the covering was in place they became bases for now lost statues of the apostles. Nothing about the mausoleum strikes us as especially barbarian in character except for the ornamental frieze around the dome. Composed of bird heads like pincers, the design repeats a standard motif of Ostrogothic jewelry. Clearly, the Ostrogoths, lacking an architectural tradition of their own, copied Western structures, but when it came to decorative patterns, they needed no foreign models, having been masters of ornamental art for centuries.

The composition of Ostrogothic jewelry developed from the polychrome style of the migrating tribes. Given the utilitarian function of much barbarian art, it is not surprising to

4. Tomb of Theodoric, Ravenna, c. 526. Frieze.

find among the best pieces fibulae, or "safety pins," generally made in pairs and used to fasten cloaks and other garments [5]. By the fifth and sixth centuries, the form had become quite elaborate, with a head plate, covering the spring, joined by an arched bow to a foot plate that concealed the catch. Made in silver and gilt, set with garnets or enriched with niello or chip carving, the enlarged foot and head plates often have projections in the form of bird or animal heads whose design recalls the frieze of Theodoric's tomb. The ornament

5. Fibulae, Gothic, sixth century. Gilt, bronze. Museum of Art and Archaeology, University of Missouri, Columbia.

falls into a symmetrical pattern reminiscent of provincial Roman and Early Christian art, such as we saw at Hinton St. Mary. The Ostrogothic craftsmen did not remain untouched by the pictorial mode of the lands they conquered. Indeed, barbarian artists even incorporated Western figures as well as abstract motifs into their repertory of ornament.

Farther west, the Iberian Peninsula flourished under Visigothic rule. When King Reccared converted from Arianism to orthodoxy (587), his people joined the religious and intellectual mainstream of Europe. The work of St. Isidore, Bishop of Seville from 599 until his death in 636, exemplifies the extraordinary scholarly achievement of the Visigoths. Not only did Isidore document the movement of the tribes in his *History of the Goths*, but he also collected and organized all human knowledge into an encyclopedia known as the *Etymologies.* So comprehensive and learned was this study that it became the most frequently consulted source book throughout the Middle Ages, making its author the patron saint of historians.

In the sixth century the Visigothic metalworkers, like their Ostrogothic contemporaries, created weapons and jewelry combining poly-

chrome and animal styles. In a magnificent pair of eagle brooches (color plate II), the artist rendered the entire figure, with its outspread wings and tail, in a profile view of the head with curved beak and large round eyes around a disklike body [6]. The brooches also display a rich assortment of gems. Besides the red garnets interspersed with blue and green stones, the circles that represent the eagles' bodies have cabochon (polished but unfaceted) crystals at the center, while round amethysts in a meerschaum frame form the eyes. Pendant jewels originally hung from the birds' tails, accentuating the lavish polychrome effect. The eagle remained one of the most popular motifs in Western art, no doubt because it assumed a twofold significance, as the ancient pagan sun symbol and later as the emblem of St. John the Evangelist.

In sculpture and architecture, the Iberian Visigoths succumbed to the powerful influence of the art of both Byzantium and Rome. Their churches, such as S. Juan de Baños and Quintanilla de las Viñas, suggest a knowledge of Byzantine architecture, perhaps resulting from Justinian's occupation of the southern coast of Spain. Low, broad basilicas have three rectangular rooms as the sanctuary, recalling the

6. Eagle-shaped fibulae, Spain, sixth century. Gilt, bronze, crystal, garnets, and other gems. Height, 5 5/8". The Walters Art Gallery, Baltimore.

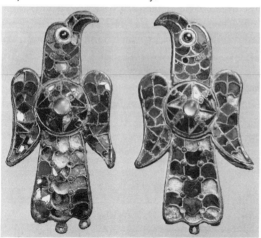

triple divisions of apse, diaconicon, and prothesis found in Eastern churches. The fine masonry construction, however, belongs to the indigenous Roman tradition. Only the compartmentalized treatment of space and the short, wide proportions of the buildings seem to be genuinely Visigothic in character.

Along with creating their own version of Byzantine churches, the Visigothic kings consciously copied Eastern court ceremonial. Justinian had presented votive crowns to Hagia Sophia—that is, crowns designed to hang over the altar in testament to the emperor's piety and ecclesiastical authority. Once the Visigoths had converted from Arian to Orthodox Christianity, their monarchs, too, ordered jeweled crowns and crosses as royal offerings to the churches. The crown given by King Recceswinth (649–672), part of the treasure hoard found at Fuente de Guarrazar near Toledo, is the most magnificent example of these symbolic donations [7]. In a wide band of gold, three rows of thirty large sapphires alternate with pearls, all set in gold and joined by an openwork surface punched with palmlike motifs. The narrow strips girding the upper and lower edges are decorated with interlaced tangent circles, a Late Antique design often called "Constantinian" and a widespread decorative theme in the fifth through the seventh centuries. From the base of the crown hang inlaid letters spelling out the Latin phrase "Reccesvinthus rex offeret" (offered by King Recceswinth), while each character supports a pendent sapphire and a pearl. Four golden chains of pierced, heart-shaped palmettes suspend the crown from an exquisite floral terminal of gold and rock crystal. The jeweler enhanced the borders of these palmettes with granulation, a process whereby beads of gold are affixed to the golden ground. The very setting of precious stones and pearls within gold frames recalls a Byzantine design; the crown marks both the end of the Classical tradition and the beginning of a new Western style.

7. Votive crown of Recceswinth, Fuente de Guarrazar, seventh century. Gold, sapphires, pearls. Diameter, 8 1/2". National Archaeological Museum, Madrid.

"The churches have been reduced to rubble and the priests murdered; the cities have become deserts and the people destroyed. Where once were the homes of the people, today is the domain of wild beasts" (Paulus Diaconus, *Historia gentes Langobardorum*, II, 317). At the beginning of the seventh century the kingdom, ruled by Queen Theodelinda and her consort, King Agilulf, had become a microcosm of the religious beliefs dividing the Western world. Although the majority of the Langobards were Arian Christians, some had remained pagan. The queen herself was a loyal follower of the Roman Pope, Gregory the Great; nevertheless, she permitted the Celtic monks to establish a monastery in her realm. St. Columban founded a monastery at Bobbio in central Italy, which not only served as a link between the Celtic and the Langobard peoples but became one of the foremost scriptoria and intellectual centers of the early Middle Ages.

Agilulf and Theodelinda were great builders and patrons of the arts. Their churches are lost, but enough carved and jeweled objects still exist to prove that, like the Goths, the Langobard rulers sought to emulate the art of Rome and Byzantium. On the frontal plaque of King Agilulf's helmet, fashioned in gilt copper relief, the artist tried to evoke a scene of imperial triumph [8]. As in the *missorium* of Theodosius, the king appears enthroned and hieratically larger than his retainers. In the same spirit of Caesaropapism, Agilulf holds a scepter in one hand and raises the other in blessing or command. Flanking the monarch stand warriors in full armor, winged Victories carrying standards and cornucopias, and, at the outermost edges of the plaque, tribute bearers and suppliants. Despite the Classical allusions, however, the composition remains symmetrical and static, with all the figures

The Art of the Langobards

During the sixth and seventh centuries artists in Italy did not enjoy the relatively peaceful existence permitted their Spanish counterparts. The violence that marked the Langobards' invasion of 568 continued unabated even after the tribe had conquered and settled the region. Paul the Deacon, an eighth-century scholar whose *History of the Lombard People* recounts the wanderings of the tribe, describes with horror the devastation wrought by the armies:

isolated against a neutral background. So disjointed is the vigorous action of the running Victories and the petitioners that their postures seem almost comic. Also, the Langobard translation of three-dimensional modeling produces frontal heads punctuated by wide eyes, sullen mouths, and pudgy cheeks. The sculptor merely attempted to reproduce a model that he did not understand, rather than integrate the earlier elements into a new whole. The relief on Agilulf's helmet is indeed a barbarization of a Byzantine triumph.

The Langobards attained the height of their power during the reign of King Luitprand (712–744), a great patron of the arts who restored and endowed churches, monasteries, and palaces. So extensive was his sponsorship that the term "Lombard" has been adopted to designate the style and the building technique used throughout northern Italy. While few of Luitprand's projects still stand, the skills developed by his masons became forever part of the local tradition, with the result that in the tenth century the Lombard masters profoundly influenced the formation of the Romanesque style.

Luitprand no doubt commissioned many buildings for Cividale, the political and religious heart of his kingdom. Of those that survive, the Tempietto, or "little church," of Sta. Maria-in-Valle is the most remarkable, for its resplendent interior display of marble revetment, painting, mosaics, and carved stucco [9]. As with other works of sculpture and architecture produced by the heirs of the barbarian invaders, the decoration of the entrance wall resounds with echoes of the Byzantine style. Indeed, the six standing female saints and the ornamental moldings may even have been done by itinerant Eastern artists rather than local craftsmen. In either case, the floral, vine, palmette, and interlace patterns around the door and across the wall re-create in a somewhat stylized fashion the Byzantine designs seen in the architectural details of the archangel Michael diptych. Even the figures—four crowned saints in richly embroidered cloaks, and two dressed in nuns' habits—show their Greek ancestry. Static in pose, elongated in proportion, with small heads sitting on attenuated bodies, the Cividale martyrs could well be granddaughters of the Empress Theodora and her retinue at S. Vitale. The Lombard sculptor intensified the cubic regularity of the faces and the nearly unbroken fall of parallel lines that form the garment folds. Nevertheless, in the context of eighth-century Italy, this overly conservative version of the Byzantine style remains unique in its bold and competent three-dimensional modeling.

The creative potential underlying Sta. Maria-in-Valle was never to be realized, because the Langobard kingdom did not endure long after

8. Helmet of Agilulf, Turin?, early seventh century. Gilt copper. The Bargello, Florence.

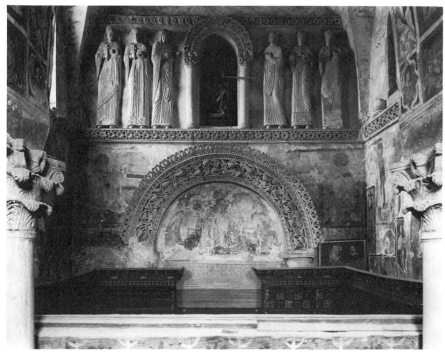

9. Sta. Maria-in-Valle, Cividale, eighth century. Stucco, relief sculpture.

Luitprand's reign. Although the king, for reasons of political expediency, had maintained relatively cordial relations with Charles Martel, later Langobard rulers were not so astute. In 751 they conquered Rome, but this action forced the Pope to appeal to the Franks for aid. The two armies battled for control of Italy until 774, when the Franks, under Charlemagne, decisively defeated the Langobards and in the process ushered in a new phase of Medieval art.

Merovingian Art

During the fifth and sixth centuries the Salian Franks of the Merovingian dynasty—so called after their semilegendary founder, Merovech—occupied Gaul and successfully vanquished, drove out, or incorporated into their kingdom the Huns, Burgundians, Alemanni, and Visigoths. If we are to believe the account of Bishop Gregory of Tours (538–594), the Merovingians achieved these victories because, although they had adopted Chris-

tianity, they remained ruthless and greedy, and still tied to the barbarian past, well into the sixth century.

The Franks had converted to Christianity during the reign of Clovis I (481–511), partly through the efforts of Queen Clotilda. In the midst of battle, the king called on the Christian God for help, and his troops immediately carried the day; thus Clovis, like Constantine, adopted Christianity in order to ensure victory. The conversion immediately put the Franks on the side of the Roman Church, and in the process of successfully defending the papacy, the Franks had emerged by the eighth century as the prevailing military force in Europe.

While the warriors struggled for control of the continent, Merovingian goldsmiths also exercised their talents. Understandably, the first Frankish art reflects its Germanic, tribal, origins, with jewelry and weapons in both the polychrome and animal styles being the principal objects. The craftsmen had ample opportunity to study the art of other migratory peoples, partly as a result of trade between

10. Circular brooch, St. Germain-en-Laye, seventh century. Filigree and garnets.

the tribes and the exchange of gifts, but primarily because hoards of precious jewelry and armor constantly circulated throughout Europe as booty taken and given by people forever at war with one another [10].

The skills of the metalworkers soon were employed in the service of Christianity. Frank-

11. Medallion with bust of Christ, Frankish, second half of eighth century. Cloisonné enamel on copper. Diameter, about 2". The Cleveland Museum of Art.

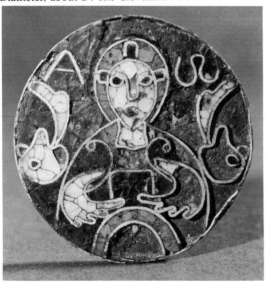

ish artists copying the objects and themes favored by Rome and Byzantium satisfied their patrons' love of brilliant display and their own taste for abstract design. A medallion with Christ holding the Bible placed above the arc of the heavens, flanked by alpha and omega (the beginning and the end) and mysterious animalistic heads (the winds?), remains in essence a Christian eighth-century adaptation of the early polychromatic gem style [11]. In cloisonné enamel, images are formed by gold wires soldered to a plate. These partitioned areas are filled with colored glass and fired to form a brilliant, nearly luminous surface. The artist could work with dazzling colors and glittering surfaces without incurring the expense of precious stones. The medium lends itself to abstraction, for in the early enamels forms are simplified and colors limited to emerald green, dark and light blues, red, yellow, and white.

When the Merovingians began to build churches, they necessarily embraced Western architectural techniques and structural forms. Gregory of Tours tells of large and lavishly decorated basilicas and baptisteries. The Church of St. Martin at Tours, erected in 466–470 to house the relics of the fourth-century apostle to Gaul, must have resembled superficially an Early Christian basilica, but, unlike its prototypes, the Merovingian church had a defense tower over the western entrance and a bell tower, perhaps inspired by a martyrium, over the crossing of transept and nave. The towers gave a vertical accent to the horizontal hall, a feature that was to play a significant role in the development of later Medieval architecture. Inside the Frankish churches, according to Gregory of Tours, were extensive painted decorations on marble veneer and rich ornaments; one patron brought a book from which she read to the painters "the histories of ancient times they were to represent on the walls."

While nothing remains of these Merovingian pictorial cycles, some excellent masonry walls,

columns, and capitals can be seen in the Crypt of St. Paul at Jouarre in northern France [12]. In 630 St. Adon, at the suggestion of St. Columban, had established a monastery there. About fifty years later Adon's nephew, Bishop Agilbert, erected a church on the site, intending the foundation to serve as a family mausoleum. Only a crypt, or burial vault, dedicated to the fourth-century saint known as Paul the Hermit, was left untouched during later restorations. The Frankish architects used indigenous structural types, even to the extent of pilfering columns from local Gallo-Roman buildings. To fit these shafts, the Franks ordered capitals from workshops in southern Aquitaine, where marble carvers never ceased to use Classical compositions and techniques.

Capitals that so carefully adapt Roman designs lead us to presume a Late Antique style in other sculpture. Such expectations are confirmed by the reliefs on the sarcophagus of St. Theodochilde (d. 662), the sister of Bishop Agilbert and the first abbess of Jouarre. Only

a first-hand knowledge of Mediterranean art could have inspired the vine scroll with leaves and grapes adorning the cover and the two rows of scallop shells and precise inscription decorating the side of the marble tomb. The austere simplicity of the design, with its delicate carving and finely adjusted proportions, suggests contact with Byzantine art. Another sarcophagus, believed to be that of Bishop Agilbert, which also rests in the Jouarre crypt, reinforces this supposition, for it has on the end panel a Christ in majesty surrounded by symbols of the four evangelists [13]. The evangelist symbols are not fantastic beasts but rather respectably naturalistic renderings of an ox, an eagle, a lion, and a man; moreover, the Frankish Savior is a three-dimensional figure with feet extending beyond the mandorla's frame to suggest illusionistic space. The very iconography of the panel harks back to a Byzantine type. The Jouarre Christ has a youthful, beardless face, while the evangelists—in a mode peculiar to Eastern art, seen

12. Sarcophagus of Theodochilde, Crypt of St. Paul, Abbey of Notre Dame, Jouarre, France, seventh century.

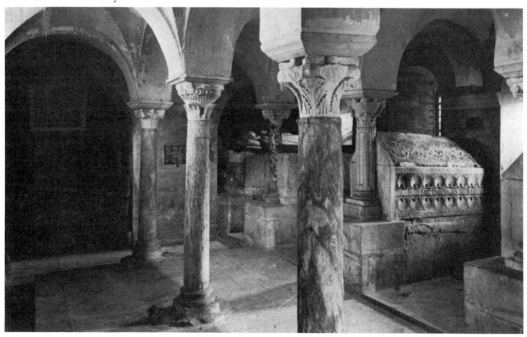

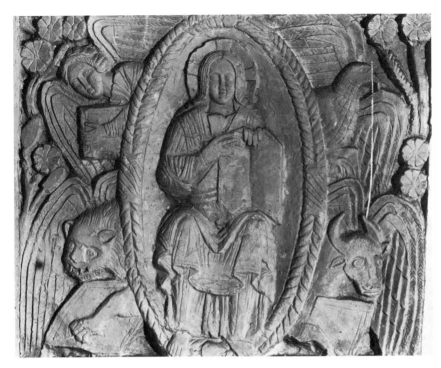

13. Christ in majesty, Sarcophagus of Agilbert (plaster cast), Jouarre, France, c. 685.

earlier at Hosios David in Thessalonika (chapter II)—face away from the Lord. Even the strange flowers filling the interstices may be a vestige of paradisaical landscapes, like those in Hosios David (page 47) and in the apse of S. Apollinare in Classe. Clearly, the carver of Agilbert's sarcophagus either traveled in the East or had before him Eastern models, indicating that Frankish sculptors received whatever remained of the Classical tradition through the intermediary of Byzantine art.

Monasteries such as that at Jouarre were missionary outposts and educational establishments where an important duty was to copy books. Missionary activities depended upon the accessibility of the Bible and the writings of the Church Fathers. From the seventh century onward, the writing and decoration of manuscripts was a flourishing enterprise in Merovingian scriptoria. The natural desire of an expert scribe to glorify the text with art caused words and letters themselves to be so elaborated that the first word on a page often took on the semblance of an enlarged ornament. It was but a step from the decorated initial to the addition of pictures. Inspired by Early Christian and Byzantine manuscripts, Frankish illuminators inserted an author portrait at the beginning of each evangelist's Gospel and frequently turned canon tables (concordances of the four Gospels), cross pages, and incipits (the introductory words of the text) into folio-size designs.

Scribes delighted in adopting traditional motifs for their manuscripts, just as craftsmen employed the decorative patterns invented for swords and fibulae to adorn chalices and patens. One of the most popular conceits derived from the Roman practice of converting birds and fish into readable letters. Knowledge of this custom was surely acquired through the Gaulish monasteries that remained in close contact with Italy—Luxeuil, for example, founded by St. Columban, and the seventh-century foundation at Corbie. Nowhere did a Merovingian artist more beautifully interpret the animal alphabet than in the *Sacramentary of Gelasius*, probably made at Corbie about 750 [14]. Named for the fifth-century pope who organized it, the sacramentary is a liturg-

ical service book containing the celebrant's part of the Mass. The second section literally opens with an ornamental portal. Suspended in the gateway is a large cross hung with alpha and omega, the Greek characters, fashioned solely of fish. On the next page another cross introduces the words "Incipit liber secundus" (here begins book two), and this time roundels inhabited by animals form the arms of the cross while the Lamb of God appears at the center, and two birds hovering below the alpha and the omega nibble at the pendent letters. The last words on the page are made up entirely of small fish and birds. These creatures, although at first glance rendered in natural proportions, are ingeniously composed of compass-drawn arcs. Their distinctive Merovingian eyes—round and white with a black dot exactly in the center for the pupils—repeat

14. *Sacramentary of Gelasius,* France, mid-eighth century. Manuscript illumination, 10 1/4″ × 6 7/8″. Vatican Library.

the circular motif. The cross, the roundels, the foliate motifs are laid out with geometric precision. The barbarian love of ornament is dominant. However much the illuminator of the sacramentary erred in his depiction of Classical architecture, he produced a magnificent ornamental folio.

Art in Scandinavia

Trade contacts enabled Mediterranean art and culture to reach those tribes that had remained in Scandinavia, which explains the appearance of Byzantine and Near Eastern vessels and coins in northern graves, as well as the native craftsmen's familiarity with the Classical world. Despite such encounters, the Scandinavian style in the early Middle Ages followed a path independent of the rest of Europe, for the artists and designers never lost their love of abstract animal forms. Indeed, Scandinavia, where the Bronze Age lasted well into the fourth century A.D. and where the people continued to worship pagan deities until the tenth and eleventh centuries, was the last stronghold of the animal style.

About the time of Constantine, the Norsemen, like their Germanic cousins, began to transform the simple "safety pin" into magnificent fibulae. Instead of using polychrome garnet inlays and cloisonné enamel, Norse artists covered the surface of their jewelry with chip-carving, a kind of faceting technique derived from wood carving and designed to catch and refract light. In the fifth and sixth centuries a taste for three-dimensional effects resulted in chip-carved rosettes, checkers, and spirals, such as those on the head plate and arched bow of a silver-gilt fibula found at Gummersmark on the Danish island of Zealand. Even more impressive than the geometric motifs is the intricate wealth of animal and anthropomorphic forms that crouch, crawl, and snarl their way around and through the entire brooch [15]. Scandinavian craftsmen invented fantastic beasts by exaggerating and

recombining components until natural shapes metamorphosed into symbols of sheer energy. Yet, for all the complexity of the concept, the integral parts of the creatures can usually be distinguished.

In the Gummersmark brooch the head plate is divided into two sections by an animal seen from above, whose backbone is continued as a center ridge in the bow and whose head lies in the center of a bird-head border. When the animal is seen from above, his beaded spine bisects a symmetrical arrangement of ribs, pear-shaped hips, shoulder joints, and slender legs and paws. Two crouching beasts seem to sprout from either side of the bow to define the upper limits of the foot plate. Below them a pair of profile heads link up with elongated quadrupeds, whose snapping tongues spiral out to delimit the bottom of the plate. This spread of animal forms from one compartment to another discloses a basic principle of north-

15. Square-headed brooch with animal and human ornament, Gummersmark, Zealand, Denmark, sixth century. Silver gilt. Height, 5 3/4". Nationalmuseet, Copenhagen.

ern design: although each animal is a complete being, each also interlocks with its neighbor in order to establish the form of the fibula.

In one important respect the Gummersmark carver broke away from the exclusively geometric and animal shapes of traditional nomadic decoration: human figures emerge between the beaded volutes of the foot plate and again below the chip-carved coils on the head piece. The artist has reduced anatomical parts to generalized shapes and compressed them into physically contorted but artistically elegant patterns. Only a pointed oval eye, an oblong nose, and a down-turned mouth describe the head, while the roll that represents hair rests directly on top of the shoulders, and a single ornamented band indicates clothing. The Scandinavian jeweler's loyalty to the animal as a source of inspiration is demonstrated by hands and fingers so emphatically outsized as to resemble paws and claws. What a striking contrast there is between this Norse artist's conception of the human form and that of the Merovingian, Visigothic, or even Langobard artists. Spiritually and aesthetically, no less than geographically, the distance between the Scandinavian tribes and the Mediterranean region seems very great.

At the end of the sixth century and through the seventh century, a second style dominated Scandinavian art—a style widely diffused through northern Europe. The royal burial mounds excavated at Vendel and Valsgarde in Sweden have yielded treasures so distinctive in aesthetic sensibility that archaeologists have named both the period (600–800) and the style Vendel, after the site of the first major discoveries. Vendel chieftains were interred in longboats and fully equipped with horses, hounds, weapons, and supplies necessary for their final trip across the seas to Valhalla, the hall of heroes and gods. Cast-bronze mounts decorated shields, swords, and helmets [16]. Here, the compact, crouching animals and men of the Gummersmark fibula have given way to sinuous, serpentine beasts that weave

16. Harness mount with animal ornament, Vallstenarum, Gotland, Sweden, sixth or seventh century. Gilt bronze, 4 1/2″ × 1 1/8″. Statens historika museum.

through intricate interlaces. To be sure, the interlace motifs may have come to Scandinavia from the Continental tribes, but the composition is different: an imaginary diagonal divides the panel, and the pattern develops as a triangular mirror image. The Vendel ribbon animals, cut and drawn on the surface rather than modeled, thread their way across a two-dimensional field. The northern artist has affixed small heads to the ends of the ribbons in an interlace, thus transforming each band into a serpent. Although the beasts' circular eyes, heavy "eyebrows," pointed "chins," and pear-shaped joints demonstrate an affinity with the work of Langobard craftsmen, the Scandinavian artist almost always represented the complete animal. No matter how complex the interlace becomes, or how freely the dragon seems to dissolve into a coiling contour, the creature's head, body, and limbs all share in the pattern's formation. The finest Vendel art has a quality of transparency, elegance, and intellectual control. The style began to make an impact on the rest of Europe at the end of the eighth century, when Viking explorations and invasions shook the foundations of the settled world.

The Migration Art of the British Isles

The Jutes, Angles, and Saxons, who in the fifth century replaced the Romans as rulers of that part of the British Isles to which the Angles gave their name—England—introduced Germanic art forms: the animal style and the polychrome style. Their Scandinavian

ancestry left its imprint on the objects found at one of the most important sites in Britain—Sutton Hoo. In 1938 and 1939 archaeologists excavating a burial mound at Sutton Hoo, in East Anglia, uncovered the vestiges of a longboat measuring 86 feet. Numismatic evidence dates the find to the second quarter of the seventh century. Although the wood had disintegrated over the centuries, the outlines of nails and planks had remained in the soil and were clear enough to permit the reconstruction of a vessel bearing a striking resemblance to ninth-century Viking boats. Indeed, the notion of a ship as a vehicle for transporting royal dead to the great beyond was one of the oldest themes in Scandinavian lore, going back to the prehistoric "razor people." The Sutton Hoo bark evidently served only as a cenotaph, for the site yielded no human bones. As in the case of the Vendel graves, the Sutton Hoo boat contained treasures and practical equipment, the better to establish the credentials of the deceased and give him provisions for the next world. What differentiates the Anglo-Saxon cenotaph from the Vendel tombs is the rich variety of styles found in the grave goods. Not only Norse influences but Celtic and Continental ones as well determined the design of the warrior's weapons, his jewelry, and even his cooking utensils.

A gold belt buckle of Anglo-Saxon workmanship attests to the strong stylistic connections between the English craftsmen and their Scandinavian cousins [17]. Three circular bosses and two hawk heads in profile punctuate a crawling mass of serpents and dragons,

all rendered in the two-dimensional Vendel mode. Thirteen animals in all inhabit the buckle, among them crocodile-headed beasts who chew on their neighbors and whose slender legs interlock with pairs of snakes, and two gnashing dragons attacking a little dog at the base of the terminal boss.

In contrast to the belt buckle, the hinged gold clasps from the Sutton Hoo hoard owe more to the Jutish and Continental polychrome style than to the Scandinavian animals [18]. In the main rectangular fields, stepped-pattern compartments are alternately filled with garnets over diapered foil and blue *millefiori*, a "thousand flowers," enamel—an enamel produced by fusing rods of different-colored glass into the desired disk or cube and then slicing off thin cross sections to set within the field. Yet, however much the stepped cells, garnets, and checkers may dominate the central composition, in the outer borders the Anglo-Saxon artist paid tribute to the northern animal style. Framing the large rectangles, S-shaped ser-

pents incised in gold and formed of garnet contort their slithering forms in order to snap back at their own bodies. Each curved end of the clasp is decorated by a pair of boars accurately described from tusks to curling tails. These boars intersect on the same two-dimensional plane to give a final effect of flat, symmetrical pattern.

All three great barbarian styles—the Continental polychrome, the Norse animal, and the insular version of La Tène—can be traced at Sutton Hoo. Into this mix the Anglo-Saxon traders or raiders introduced the art of the Christian East and West in the form of Byzantine silver bowls and Merovingian coins, buried with the funeral ship. The influx of such spoils as these into Britain slowly created a new artistic climate, in which the descendants of the barbarian invaders, inspired by new themes and ceremonial requirements, ultimately developed a great northern Christian art.

Christian Art in the British Isles

The conversion of two tribes, the Picts in northern Scotland and the Celtic Scots in Ireland and southern Scotland, began as early as the fourth century, for in 397 St. Ninian established a church in Scotland and thirty-five years later St. Patrick did the same in Ireland. Although the Pope nominally controlled these foundations, the relative isolation of Ireland allowed the people we may now begin to call the Irish to evolve distinctive liturgical practices, a different calendar of feasts and saints, and an administration that operated out of individual monasteries. The local autonomy thereby achieved was nurtured by the Irish preference for locating monastic centers in inaccessible regions. As described by the eighth-century Anglo-Saxon historian Bede, they were "among craggy and distant mountains, which looked more like lurking places for robbers and retreats for wild beasts, than habitations for men."

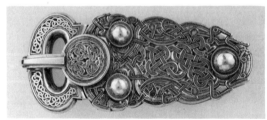

17. Buckle, Sutton Hoo, England, second quarter of the seventh century. Gold, 5" long. The British Museum, London.

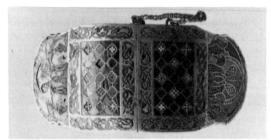

18. Clasp with boars, Sutton Hoo, England, early seventh century. Gold, garnets, colored glass. The British Museum, London.

Despite the Celtic monks' affection for re-mote surroundings, their monasteries became centers of learning and of book production. The earliest manuscript to survive is the sixth-century psalter fragment called the *Cathach,* or "champion," of St. Columba. Written in Irish majuscule, a script composed of capital letters, each psalm begins with an initial char-acter larger than the rest, and is ornamented by dots, pothooks, and spirals. According to legend, the Irish scholar St. Columba (c. 521–c. 597) copied the psalter without the permis-sion of its owner and then refused to relinquish his copy. War was declared over the book and the saint fled in exile to Iona, an island off the western coast of Scotland. From this base Columba converted the mainland Scots in 563 and, having done so, left Iona for the northern lands still held by the Picts. When he bested the pagan priests by driving off the Loch Ness monster with the sign of the cross, the Pictish king accepted Christianity in the name of the whole tribe. The legend serves as a reminder of the high regard in which books were held and of their vital role in missionary activities.

Although St. Columba's efforts were con-fined to the British Isles, his successors made an impact on the Continent. St. Columban, for instance, left Ireland at the end of the sixth century and founded important monas-teries at Luxeuil and Jouarre in Gaul, St. Gall in Switzerland, and Bobbio under the protec-tion of the Langobard Queen Theodelinda in Italy. Wherever Celtic monasteries appeared, active centers of book production arose and scholarship flourished.

The Irish monks, however, also brought with them a desire for self-rule and an idio-syncratic form of Christianity not entirely wel-comed by the Roman Church. Pope Gregory the Great therefore decided to deal with the problem at its heart by sending his own missionaries to complete the conversion of the British Isles. In 596 St. Augustine of Canter-bury (not to be confused with the early Church Father, St. Augustine of Hippo) arrived in Kent at the Anglo-Saxon court of King Ethel-bert. Influenced by his Christian wife, Bertha, the monarch accepted Christianity, and St. Augustine established his church and admin-istrative center at Canterbury. By Eastertide in 627, St. Paulinus of York, a follower of St. Augustine, baptized the Northumbrian King Edwin and all of his court and so completed the conversion of England.

While missionaries like St. Paulinus moved north from Canterbury, Irish monks traveled east and south from their base at Iona. In 635 one group of Celts, led by St. Aidan, set up a monastery at Lindisfarne, an island off the coast of Northumbria. Since the Irish met with greater success in these northern regions than did the disciples of St. Augustine, Lindisfarne soon rivaled Canterbury as a religious center in the British Isles. The conflict between the Celtic and the Roman Church had to be settled; hence, a Church synod, held at Whitby in 663–664, resolved the issues in favor of the papal party. Beyond the political ramifications of the agreement, the establishment of su-premacy had significant artistic consequences. The synod of Whitby, by strengthening British ties to Rome, quickened the flow of Mediter-ranean painting and sculpture to the north. At the end of the seventh century Benedict Biscop, an English scholar and ecclesiastical administrator, made five trips to Rome, each time returning with paintings, reliquaries, and other precious objects with which to decorate the churches under his direction. As the his-torian Bede wrote,

All who entered the church, even if they could not read, might have before them the loving counte-nances of Christ and his saints.

Bede's account demonstrates that Anglo-Saxon artists could draw upon the rich store of Roman and Byzantine narrative and emble-matic imagery as they tried to tell the stories of their new religion, or to cast the legends and myths of the north in visual form.

The Franks Casket, a small whalebone box

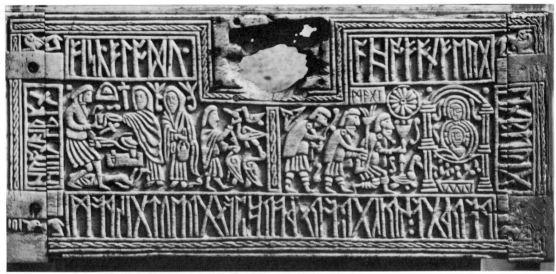

19. Weyland the Smith and the Adoration of the Magi, the Franks Casket,
Northumbria, c. 700. Whalebone. The British Museum, London.

usually dated about 700, exemplifies the complex visual heritage of northern England [19]. (The name refers to Sir Augustus Franks, not to the Frankish people.) Scenes from Roman history and legend, Scandinavian mythology, and the Christian story decorate the four sides of the casket. Framing each figurative panel, runic inscriptions—that is, twiglike letters used by the northern people—comment on the action; they tell of a terrible storm and a stranded whale, from which the craftsman acquired material for the box. The wealth of detail, no less than these explanatory devices, points up one consistent characteristic of the representational arts in this period: however divergent the stylistic and iconographic sources, vivid storytelling and didactic clarity were the primary concerns of the artist. On the front of the Franks Casket, for example, the sculptor depicted the Adoration of the Magi, juxtaposed, curiously enough, with events from the life of the Norse hero Weyland the Smith. The Weyland narrative is a typical pagan tale. Forced against his will to work for a king, the smith murdered the king's sons and turned their heads into drinking vessels. As if this were not adequate revenge, Weyland also raped the king's daughter, and then, to

escape the king's wrath, he flew to freedom on magic wings fashioned from goose feathers. The casket's sculptor chose to render the tale by showing Weyland forging a skull-cup while the princess looks on and, at the left, Weyland's brother Egil catching geese to make wings. Similarly descriptive is the scene of the Magi where the three gift-giving Persians, identified by the runes "MFXI" (MAGI), follow a rosette star to the Virgin and Child. The use of human forms in a logical narrative sequence surely came to the Anglo-Saxon craftsman from the Mediterranean, and the frontal, hieratic positioning of the Infant and His Mother must have been modeled on a Byzantine icon. At the same time, the way in which Jesus' head also serves as the Virgin's body recalls the Celtic fondness for interpenetrating and changing shapes. Moreover, the twisting, biting quadrupeds in the corners of the casket look as if they had migrated from animal-style jewelry.

Such a diversity of decorative sources is also discernible on the stone crosses of Northumbria, Scotland, and Ireland. Contrary to present usage, these large, freestanding crosses did not necessarily designate a gravesite. In Ireland they could define the boundaries of a

monastery, while in Northumbria the crosses also commemorated events and individuals, or marked a consecrated spot for the outdoor celebration of the Mass. In addition, the crosses, carved with scenes from the scriptures and the lives of the saints, served to educate the populace.

On the Ruthwell Cross in Scotland, runic inscriptions in the Northumbrian dialect frame sculptured panels with quotations from the Old English poem *The Dream of the Rood*. The rood, or cross, speaks out and describes the Crucifixion from its point of view: "I held the High King, the Lord of Heaven. I dared not bow. . . . They mocked us both. I was wet with blood from the Hero's side." The reliefs contained within the engraved verses do not, however, give visual form to the poem, for in effect the cross itself provides the only necessary illustration. The sculptors must have known Byzantine and Roman art of the kind brought north by Benedict Biscop, but the underlying concept of a column-like cross situated in the open air belongs to the barbarian tradition. The crosses suggest a Christian adaptation of those monolithic sky pillars and sword temples erected by the pagan peoples.

The high crosses of Ireland, while they share in this pagan inheritance, differ from the Northumbrian monuments. They have broader proportions and, in addition, wheels joining the four arms to create a motif variously interpreted as a stylization of the braces on wooden processional crosses, a three-dimensional version of engraved, compass-traced crosses, or a reference to some ancient sun symbol. Whatever its origin, the wheel cross became the characteristic Celtic form. Interlaces and spirals decorate the early crosses, in obvious imitation of metalwork, but increasingly sculptors added panels with scenes from the Old and New Testaments. The most famous of these crosses, the Cross of Abbot Muiredach at Monasterboice [20], although a late example of the type (tenth century), is outstanding both for its elaborate iconographical program

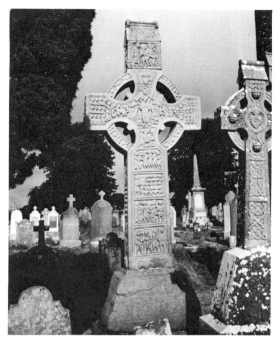

20. Cross of Muiredach, Monasterboice, Ireland, early tenth century.

21. The Last Judgment, Cross of Muiredach.

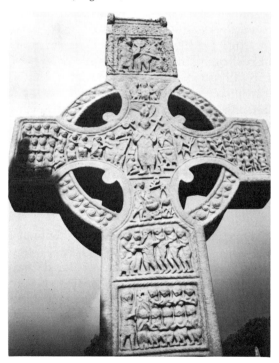

and for the effectiveness of its didactic figure sculpture. The cross, eighteen feet high, stands on a truncated pyramidal base and has a cap stone carved in the shape of a church with the desert saints Paul the Hermit and Anthony Abbot, patrons of monasticism. The Crucifixion is represented on the west face and the Last Judgment on the east face. In the Last Judgment, Christ holds a cross and a flowering staff as symbols of His Resurrection, while directly below Him St. Michael is weighing souls—the earliest sculptural representation of this important theme [21]. The blessed and the damned, already separated, fill the arms of the cross. On the side of the elect, a trumpeter and a harpist sound the call to judgment, while on the side of the damned energetic demons kick and stomp the souls into hell. Below this dramatic representation are scenes emphasizing the power of faith (Moses bringing forth water from the rock; David and Goliath) and the universal dominion of the established church (the Adoration of the Magi). At the bottom of the cross, the origin of sin with Adam and Eve, and its consequences in Cain and Abel, make clear the need for Christ's sacrifice. The emphasis on sin, faith, and salvation is reminiscent of Early Christian art, and some scholars see the iconographical program of the high crosses in Ireland as an indication of the continued contact of the Celtic church with the conservative Coptic church of Egypt. The attractiveness of themes emphasizing the power of Christ and the Church must have been reassuring to the Christian community under Viking attack (chapter VI), as they had been to the Early Christians.

The tradition of fine goldsmithing continued in Ireland, as it did elsewhere, and ecclesiastical metalwork can be studied in the Ardagh Chalice [22]. With generations of craftsmen behind him, the artist was understandably adept at fashioning liturgical vessels, objects which required no representational elements and therefore allowed free rein to his inherited

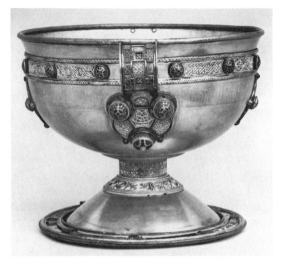

22. Ardagh Chalice, Ireland, early eighth century. Silver, gilt bronze, gold, glass, enamel. National Museum of Ireland, Dublin.

love of intricate abstract patterns. The chalice, a masterpiece of eighth-century metalwork, presents a summary of the decorative vocabulary used in the British Isles during this period, a repertory of motifs that so thoroughly blends Celtic, Norse, and Roman designs as truly to formulate a new visually cohesive style. The clean, unbroken lines of the chalice and its smooth silver surface, inscribed with the apostles' names, are enhanced by a subtle application of gold and enamel ornament. Enameled bosses in step-shaped cells are coupled with flat interlaces, just as we have seen in barbarian jewelry. The artist did not permit his craftsman's skill to overwhelm the massive, simple contours of the vessel, and he limited filigree and enamel to panels around the circumference of the chalice and on the handles. Whereas earlier metalworkers made their scrolls and interlaces out of single gold thread soldered to gold foil, and the most sophisticated goldsmiths created even richer designs with triple ribbons, the master of the Ardagh Chalice used even more complex methods. In some panels, he formed a thread out of twisted wires and then ran a beaded strand over it, while in others he hammered a beaded wire

flat and soldered a second thin ribbon on top, thereby generating a string of tiny circles framed by a notched border in low relief. His technical virtuosity is rivaled only by the equally remarkable illuminated books being produced for use and display with the chalice on the altar.

The Hiberno-Saxon school of manuscript illumination, faithful to the barbarian legacy although respectful of Mediterranean models, created a genuinely distinctive style of painting in the British Isles. ("Hibernia" was the ancient name for Ireland; works produced in Ireland, Scotland, and northern England have so many features in common that the area is treated as a single cultural province, called Hiberno-Saxon.) Luxurious Gospel books, among the glories of Christian art, document the development of this style. The *Book of Durrow,* produced in Iona about 675, is the earliest. In each Gospel the saint's emblem, is followed by a carpet page—that is, a purely decorative folio, named for its resemblance to an intricately patterned textile [23]. The painter's loyalty to the ornamental tradition of his ancestors overrode other criteria. Consequently, it is on the carpet pages, where neither man nor beast need be represented, that abstract and animal patterns burst into a brilliant display of decorative invention. Because the Durrow artist executed the individual elements with broad interlaced bands, the animal ornament is relatively easy to read. Against a dark ground, weaving strands of red, yellow, and green form serpentine beasts who, like their cousins on the Vendel bronze mount and the Sutton Hoo buckle, seem wont to bite anything within reach. The creatures' vicious appetites are made all the more apparent by the fact that their heads and legs, as well as the borders of their ribboned bodies, remain uncolored; each one is thus projected as an independent unit. In the gold-framed circle, an abundance of multicolored interlace replaces the animals, as do the three disks filled with a cloisonné-like stepped pattern. At the exact center of the field, nearly hidden by the densely clustered bands, rests a minute, equal-armed cross. Finally, the four outer corners of the page expand into complex knots. By pushing the drawing, in this way, beyond the established borders of the composition, the artist initiated a practice that came to characterize Hiberno-Saxon manuscript illumination.

Only slightly later than the *Book of Durrow* are the *Gospels of St. Willibrord,* carried by the missionary to the pagan Frisians at the end of the seventh century and then deposited in the Luxembourg monastery of Echternach [24]. (For this reason, the manuscript is more generally known as the *Echternach Gospels.*) The designer here obviously preferred clean, open, geometric lines to his Durrow kinsman's tightly locked monsters. But, despite this absence of ornamental animals, Norse influence can be discerned in the diagonally balanced disposition of the colored strips, which recalls the formal concept developed in Vendel art. At the head of St. Mark's Gospel, the evangelist's symbol, the *imago leonis* (image of a lion), has been drawn with the aid of a compass. Surely the svelte, leaping lion is one of the most elegant beasts in Medieval art—with an elegance in no small part due to the rectangular background pattern, which controls his ascent through space while it binds him to the confines of the page.

In the *Lindisfarne Gospels* and the *Book of Kells* decorative invention reaches its height. The *Lindisfarne Gospels* provide us with an unusual record of the history of a medieval book [25]. In the tenth century Aldred, then prior of Lindisfarne, added a colophon at the back of the manuscript to document the efforts of his predecessors: written by Eadfrith, Bishop of Lindisfarne (698–721); bound by Ethelwald; adorned with ornaments of gold and jewels by Billfrith; and glossed in English by Aldred. The *Lindisfarne Gospels* remain almost as complete as they were in Aldred's time, with prefaces, canon tables, and commentaries. Each Gospel text is preceded by the author's portrait

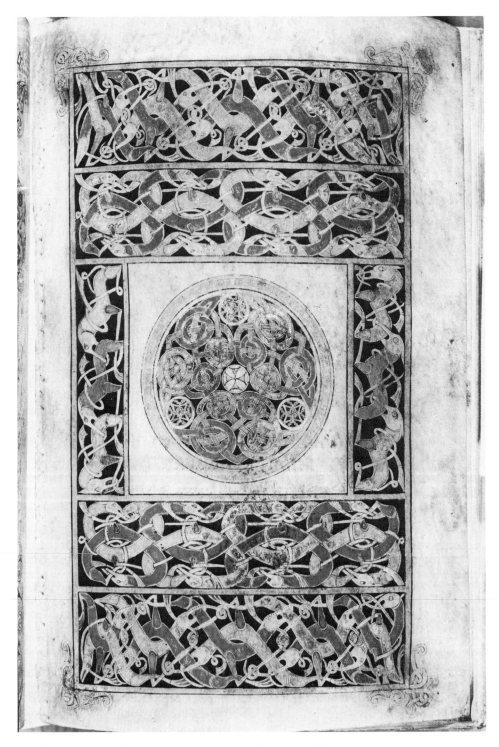

23. Carpet page, *Book of Durrow,* Iona, late seventh century. Manuscript illumination, 9 5/8″ × 6 1/8″. Trinity College, Dublin.

24. Lion, *Echternach Gospels (Gospels of St. Willibrord)*, Northumbria, eighth century. Manuscript illumination, 12 3/4″ × 10 3/8″. Bibliothèque Nationale, Paris.

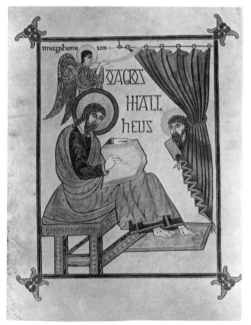

25. St. Matthew, *Lindisfarne Gospels*, Lindisfarne, Northumbria, early eighth century. Manuscript illumination, 13 1/2″ × 9 3/4″. The British Library, London.

and a cruciform carpet page. For the image of St. Matthew, Eadfrith adopted a Byzantine author portrait (the figure of Ezra from the *Codex Amiatinus* [26] provides an example of the type) for the evangelist—the profile view, the book, the cushioned seat and footstool, and the inspiring genius. Even the inscription, "Hagios Mattheus," in Greek rather than Latin, is self-consciously copied. The saint's symbol hovering over his head, a figure for which the Byzantine illumination offered no analogue, is identified in Latin—"imago hominus" (the image of man). Despite the obvious inspiration, Eadfrith rejected the Roman illusionistic perspective and cast shadows and the Byzantine reverse perspective and otherworldly lights in order to create a portrait in the two-dimensional mode to which he was accustomed. The treatment of head and draperies has much in common with the provincial Roman mosaic at Hinton St. Mary in its use of a heavy outline and the reduction of garments

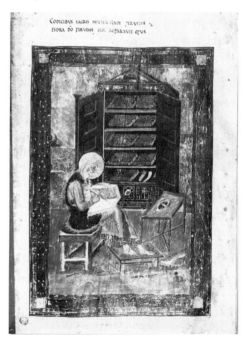

26. The scribe Ezra, *Codex Amiatinus*, Northumbria, early eighth century. Manuscript illumination. Biblioteca Medicea Laurenziana, Florence.

and hair to a repeated linear pattern. Although the receding bench and the figure peering in from behind the curtains suggest some space, a flat, uniformly colored background denies the effect of depth, as do the outlines, the compass-traced circles, and the flat, colorful patterns. What better way for the artist to signal his indifference to naturalistic representation than by completely eliminating the legs of the stool, so that the solid foot-rest becomes a levitating rug. The frame itself becomes a thin strip, twisting, like that in the *Book of Durrow*, into corner knots.

The artist's inherently abstract aesthetic assumes full command in the cross carpet page [27]. Here, with stunning complexity yet total control, the painter displays an extensive repertory of barbarian motifs, as if the painted page were really a bejeweled plaque spread with golden filigree and enameled interlace. If Eadfrith had any model in mind when he adorned this page, surely it was a contemporary piece, such as the Ardagh Chalice. Within the spiral and trumpet patterns derived from earlier insular art, the illuminator set pairs of hounds who snap at birds of alternate colors. These peacock-like creatures seem to be Eadfrith's own invention. So thorough is the integration of birds and ornament that the brilliantly feathered tails and wings are themselves the interlace, while the long, craning necks create the spirals. Still, this outpouring of animals remains subservient to the cross, for the animals are carefully shaped to fit the contours of the four arms. The semicircles and the central orb, meanwhile, are filled with twisting quadrupeds, their ribbon-like bodies and their gold interlacing legs surrounding small, white-framed crosses. Since this inner ornament is as dense as the knots of birds and dogs, the cross and its outer fields appear as a single surface. The artist, in other words, like the Scandinavian and Anglo-Saxon goldsmiths, denied the concept of foreground and background and substituted pure geometry— a method revealed by the lines and pinpricks

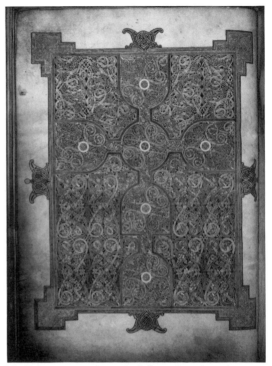

27. Cross, carpet page, *Lindisfarne Gospels*, Lindisfarne, Northumbria, early eighth century. Manuscript illumination. The British Library, London.

still visible on the folio. A series of parallel and diagonal lines and circles orders the layout of the page, and once this underlying logic is perceived the potentially frantic and wild energy of the elements falls into a satisfying rhythm. Everything is in motion, and yet all moves with the precision of clockwork. Thus, the *Lindisfarne Gospels,* the work of a scholarly monk captivated by complex visual abstractions, mark the classic moment of a style, a moment when intellectual control and decorative lavishness are held in perfect balance.

The *Lindisfarne Gospels* exemplify the classic phase of Hiberno-Saxon art; the *Book of Kells* is the largest and most richly illuminated Celtic manuscript preserved. "The chief relic of the Western world," as the *Book of Kells* was described as early as the eleventh century, was begun by Connachtach, an eminent scribe and the abbot of Iona. After he died in the

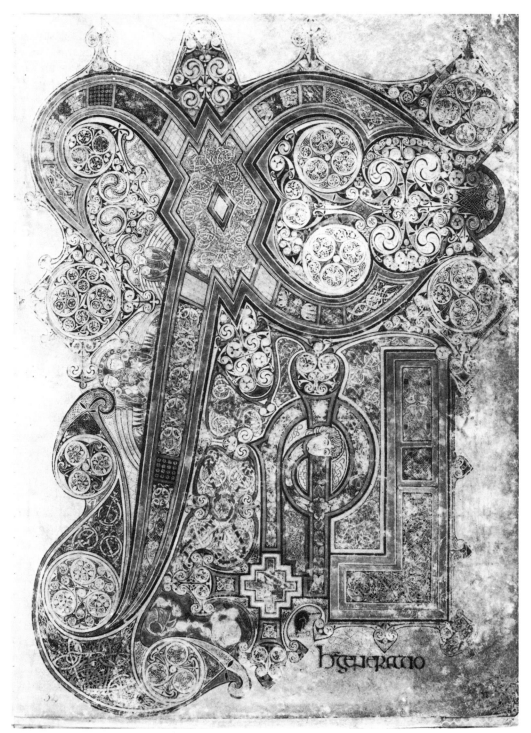

28. Monogram of Christ, *Book of Kells,* Iona and Kells?, early nınth century. Manuscript illumination, 13″ × 9 1/2″. Trinity College Library, Dublin.

Viking attacks of 802, the fleeing monks carried the Gospel book to the Irish monastery of Kells, where at least four other artists and a number of assistants completed it. The Chi Rho monogram is perhaps the most celebrated of the Kells images [28]. The three Greek letters, XPI, represent both the sacred monogram and the beginning of the text: "Christi autom generatio." So elaborate are the characters of this Incarnation initial that only two words could be fitted on the page. With good reason, therefore, Françoise Henry named the painter "the Goldsmith," for he has translated into line and color the artistry of the Ardagh Chalice.

The *Book of Kells* is distinguished by the sheer variety of the Goldsmith's design components. The painter subdivided letters into panels filled with interlaced animals and snakes as well as extraordinary spiral and knot motifs, then filled the spaces between the letters with equally complex ornamental fields. Despite this profusion of ornament, every line can be traced as a single thread and the individual parts of every beast easily discovered. The Kells illuminator also used human figures as shapes in the overall pattern; for example, a male head terminates the undercurve of the rho and at the same time it "dots" the iota. In the midst of these abstractions the artist inserted astute pictorial observation and commentary. Near the bottom of the page, just above and to the left of the word "generatio," he painted an otter holding a fish in its jaws. Has this image symbolic meaning, or is it merely observation of the natural world? To the right of the chi's tail, two cats pounce on a pair of mice as the tiny creatures nibble a Eucharistic wafer. Is this scene an allegory on good and evil?

To the painter whom Henry called "the Official Portraitist" is attributed the painting of Christ flanked by angels and peacocks [29]. For such primarily figural compositions this artist, like his colleague at Lindisfarne, no doubt had recourse to Early Christian or Byz-antine prototypes. Only a model would account for the broadly draped mantle folds, the hieratic immobility of the Savior, and his truly monumental, almost hypnotically impressive, appearance. The Portraitist even integrated Classical ornament with insular motifs. Vine scrolls, for example, sprout out of vases at Christ's shoulders, and the square panels breaking through the serpentine interlace of the surrounding frame bear a pattern that closely resembles a spread of architectural volutes. Yet, far more than in the *Lindisfarne Gospels,* the illuminator here reaffirmed his Celtic ancestry. He did so not merely by an abundance of geometric and animal decoration irrepressibly bursting forth from all sides of the border, but particularly in the design and ambiguous disposition of the figures. Is Christ standing or seated? The throne behind him suggests a seated posture and the large triangular sections of drapery at his knee do little to counter this interpretation. The four angels attending Jesus, moreover, seem to grow out of the energetic ornament around them, with the result that they achieve the colorful heraldic character of monarchs in a deck of playing cards. However, the peacocks curving around the inner arch supply the best evidence both of the Portraitist's strong decorative leanings and of his respect for the subject matter. Although the birds descend directly from the creatures on the Lindisfarne carpet page, they have become, as they had been in Early Christian times, emblems of immortality. Perched on grape-laden vines and with a cross-inscribed wafer on their wings, the pea-cocks symbolize salvation through Christ's sacrifice.

The rich and varied art of the formerly barbarian peoples entered into the mainstream of Western art as an essential component of the Romanesque and Gothic styles of the twelfth and thirteenth centuries. The technical virtuosity and fertile imagination of the artists enabled them to produce works of awe-inspiring beauty and vitality. No more fitting summary exists of the style of the Celts and

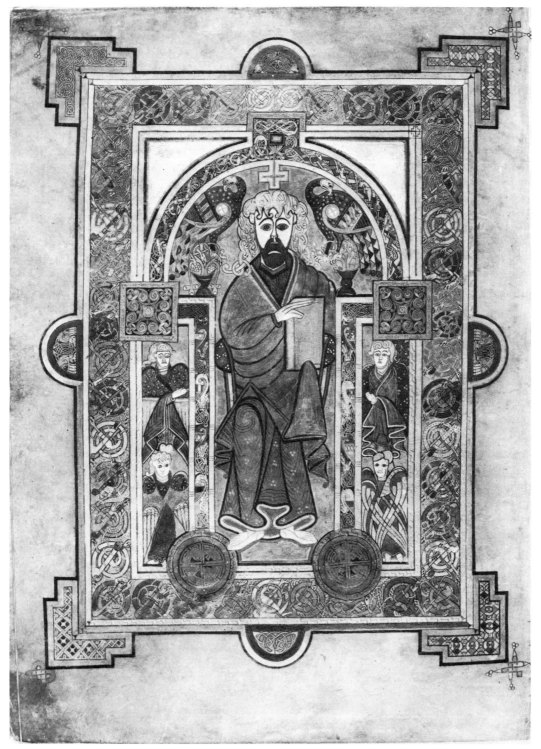

29. Christ, *Book of Kells*, Iona and Kells?, early ninth century. Manuscript illumination,
13″ × 9 1/2″. Trinity College Library, Dublin.

Saxons, and indeed of all the arts of the "Dark Ages," than Giraldus Cambrensis' twelfth-century description of a Gospel book:

Fine craftsmanship is all about you, but you might not notice it. Look more keenly at it, and you will penetrate to the very shrine of art. You will make out intricacies, so delicate and subtle, so exact and compact, so full of knots and links, with colours so fresh and vivid, that you might say that all this was the work of an angel, and not of a man.

Northern and Western Europe, from the Byzantine point of view, was a mere provincial backwater. Certainly, compared to Constantinople, even Rome and Ravenna had a very reduced role in the history of art and architecture by the sixth and seventh centuries. As we have seen, the finest Visigothic and Merovingian stone buildings to survive are small and relatively simple structures, and the quality of their decoration is rather indifferent. Wooden architecture, which must have been much more impressive, is lost. In sculpture and painting human figures have been reduced to stylized symbols of humanity. Nevertheless, the Christian Roman Empire and Mediterranean culture remained as ideals. Early Christian architectural types—the martyr's chapel or tomb, the baptistery, the basilica, the imperial audience hall, and the palace—survived as a reference point and were reproduced simply and at times even crudely. The visual arts, with their potential for didactic statement as well as decoration, were adapted to the taste of artists and patrons with a long heritage of imaginative abstract art and an exceptionally high level of technical skill in minor arts, especially metalwork.

The Goths, Lombards, Franks, Norse, Celts, and Anglo-Saxons brought to Medieval art an abiding preference for dynamic abstract art. By means of color and line the artists sought to create, or to capture, the essence of forms in motion as symbols of pure energy. The artists' love of light and color in the form of gold and jewels or enamel, the complexity of engraved or filigree interlaces, the creative representation of imaginary beasts and birds, and the astonishing metamorphoses of geometric patterns into zoomorphic forms give barbarian art its distinctive character. When these people came into contact with the art of the Greco-Roman Mediterranean world, they adopted individual motifs or types, especially recognizable human figures, and occasionally the static architectonic compositions, but they rejected the Classical artists' attempts at the representation of carefully observed surface reality and modeling in light and color. The ancient Classical artist sought to bring clarity and stability to nature; the barbarian sought to re-create its complexity and shifting diversity.

⟦ CHAPTER V ⟧

Carolingian Art

In the year 800, at the high altar of St. Peter's basilica in Rome, Pope Leo III crowned the Frankish King Charles as Emperor of Rome. When Charles the Great, better known as Charlemagne, accepted the crown from Leo III, he declared himself to be the legitimate heir to the throne of Constantine. The coronation of the emperor by the Pope strengthened both the Church and the state: the Pope reaffirmed his privilege to crown and anoint the ruler, and received military assistance in exchange; the new emperor could claim divine sanction for his acts and by this means gain moral and psychological superiority over his political foes. Theoretically, in 800 the Roman Christian Empire of Constantine was reestablished as people imagined it to have been. The new imperial realm, however, did not extend over Constantine's vast domain, for the Byzantine emperor or empress ruled the East from Constantinople. Furthermore, Charlemagne, with his interest and authority focused on the lands of France, Germany, and Italy, moved the political center of Western Europe from Rome to Aachen in Germany. Still, the dream of a unified, all-embracing European empire took hold of contemporary imagination, and, under the strong hand of Charlemagne, it became a near actuality.

How did a Frankish king, descended from Merovingian warlords, become the emperor of Western Europe? Charlemagne's unrivaled position had its roots in the instability of the Merovingian dynasty after the death of Clovis (511). The successors of the great sixth-century leader, challenged by intriguing, aggressive enemies—and further immobilized by their own sloth and incompetence—relegated more and more administrative duties to court officials. Consequently, the mayor of the palace, at first accountable only for the royal estates, assumed responsibility for the day-to-day management of the kingdom, its finances, and its army. By the time Pepin rose to the office at 697, the mayor of the palace was the virtual ruler of France, and the office had become a hereditary position. Because Pepin left no rightful heirs at his death in 714, the succession passed to his illegitimate son, Charles Martel ("The Hammer," 717–741). Charles not only brought the Merovingian nobility under his sway, but, by defeating the invading Islamic forces at the battle of Tours in 732, he also made Western Europe safe for Christianity.

Charles Martel's son, Pepin the Short (741–768), finally deposed the last survivor of the Merovingian dynasty. To obtain sanction for his act, Pepin called upon the papacy, and in return for political assistance Pope Stephen II reanointed Pepin as King of the Franks in 754 at the Abbey of St. Denis, thus initiating the close association between the Frankish monarchs and the vicars of Christ. When Pepin died in 768, his sons, Carloman and Charles, divided the kingdom, but Carloman died in 771, thereby leaving Charles—Charlemagne—the sole monarch of the Franks.

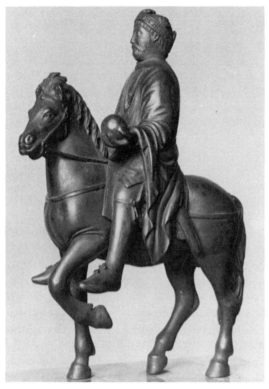

1. Carolingian emperor, Charlemagne or Charles the Bald, ninth century. Bronze. Height, 9 1/2". The Louvre, Paris.

Charlemagne deserved to be called "the Great" [1]. He was exceptionally skilled as a warrior and an administrator, and was a remarkably erudite ruler. He gathered around him the most learned people of Western Europe and within a few short years transformed the imperial court at Aachen into one of the foremost intellectual centers of the Middle Ages. Alcuin of York (d. 804), a great Anglo-Saxon scholar, supervised the palace school until 796, when he retired to Tours and devoted the rest of his life to the completion of a new edition of the Vulgate. Paul the Deacon, the historian of the Langobards, came to Aachen after the defeat of his Italian patrons in 774; Theodulf, a Visigothic theologian, joined the court circle and then served as Bishop of Orleans and Abbot of St. Benoît-sur-Loire. Einhard (d. 840), a scholar and artist

from Fulda, was a pupil of Alcuin at Aachen and succeeded his master as the "minister of culture." In his *Biography of Charlemagne*, Einhard gives us a vivid description of the Carolingian court. Charlemagne's family (eight legitimate and ten illegitimate children) provided him with a loyal group of supporters who played a crucial role in the administration of the Empire and in the patronage of art and architecture. His sons Drogo of Metz and Louis of Aquitaine (later Louis the Pious), along with Ebbo, the son of a serf (Louis's nurse), who was given his freedom by Charlemagne, and Angilbert, the paramour of Charlemagne's daughter, became active patrons of the arts. This extended family carried the authority of the emperor and the culture of the court throughout Europe.

Charlemagne transformed the Church into an administrative arm of his Empire by appointing his children, relatives, and friends to positions of ecclesiastical authority. Drogo, Ebbo, and Angilbert, for example, all became bishops of major dioceses, from which vantage they organized an educated, elite civil service to rule the far-flung territories. To cement relations with the papacy, Charlemagne ordered that the Roman rite introduced by his father, rather than the native Gallican rite, be used exclusively in churches throughout the Empire—an astute move designed to unify Frankish lands through a common liturgy. Charlemagne also supported a revitalized Benedictine monasticism, promulgated by a former member of the court, St. Benedict of Aniane (d. 821).

In 779 St. Benedict of Aniane established a monastic community based on the original sixth-century rule of his namesake, St. Benedict of Nursia. St. Benedict of Nursia (c. 480–550) had founded a monastery at Monte Cassino, Italy, where about 540 he drew up regulations for the monks, a rule which is still the basis for Western Monasticism. At the same time, his sister St. Scholastica (c. 480–543) established a convent for nuns near Monte Cassino,

also following her brother's rule. Monks and nuns had as their principal duty the *opus Dei,* or work of the Lord, including services in the church, private prayer, study, and physical labor. As Benedictine monastic communities became relatively wealthy through improved agriculture and technology, good management of resources, and donations from patrons, they became patrons of the arts, for the Benedictines encouraged the arts as an expression of the glory of God. As missionaries they spread Christian art and learning throughout Western Europe. Louis the Pious in 817 convened a Church synod which established the Benedictine rule, as revised by St. Benedict of Aniane, for all monks and nuns in the Empire.

Side by side with the ecclesiastical administration was the equally well-organized secular government. Charlemagne laid the foundations for medieval feudalism by formalizing the ancient barbarian tradition of blood loyalties and oaths. He divided the Empire into counties, wherein each reigning count swore fealty to Charlemagne and had, in turn, his own lesser vassals. Such a system had numerous administrative and economic benefits, and it also created a ready supply of soldiers for the emperor's military campaigns. Charlemagne personally led at least fifty-three expeditions, and because he always fought in the name of the Church, it can justly be said that he, like Constantine before him, used religion to enhance his political goals, correctly perceiving that a firm bond with the Roman pontiffs would sanction his power. Following his father's precedent, Charlemagne defended Rome against the Langobards and finally destroyed their kingdom in 774.

In the quarter century before Charlemagne's first visit to Rome and his coronation there in 800, the emperor's most dramatic achievements were on the battlefield. His successful wars against the pagan Saxons in northeastern Germany and the Avars, a nomadic people inhabiting the Hungarian plain, removed the most serious threats to the eastern borders of the Empire. Around the borders of his realm Charlemagne established special fontier districts governed by powerful warriors. Among these territories, known as the Marches (from German *Mark,* boundary district), the most famous was the Spanish March. Here Charlemagne, accompanied by his vassal Count Roland of Brittany, led the imperial armies against the Spanish Saracens. The death of Count Roland during the massacre of the emperor's rear guard in 778 provided the nucleus for the later *Song of Roland.* In this masterpiece of French medieval poetry, Charlemagne and his paladins become the heroic ideal of Christian chivalry. To some extent, the literary conceit had a basis in reality, for it was Charlemagne's practice to use force for the conversion of the vanquished people. By thus bringing all the heathen territories into the arms of the Church, he extended that Christian Empire of which he himself was the omnipotent protector.

Charlemagne's seal read "renovatio Romani imperii" (the revival of the Roman Empire). Whatever the political and religious ramifications of the Frankish dream, it also generated a revival of Classical art in its Early Christian guise, to such an extent that both the style and the period are often referred to as the Carolingian Renaissance.

Carolingian Architecture

Unlike the peripatetic Merovingian kings, Charlemagne maintained a fixed capital at Aachen. Not only did the city have a geographically advantageous location, it also boasted of vast game preserves and natural hot springs, where the emperor could indulge his fondness for riding, hunting, and swimming. Hence, although he had other residences, it was at Aachen that Charlemagne commissioned a palace and a chapel for the imperial court. In this endeavor the emperor, ever anxious to give visible form to his avowed lineage, ordered the chief architect, Odo of

Metz, to emulate the buildings of ancient Christian Rome and imperial Ravenna.

Charlemagne's architects designed the Aachen complex on a square grid plan, just as had the builders of Diocletian's palace [2]. Buildings housing the law court, the school, the guards' barracks, and the administrative offices were crossed by two major axes, one running east-west and the other extending from north to south, with a monumental gateway at the point of intersection. The gateway opened into a large forum in the center of which Charlemagne placed an equestrian statue brought from Ravenna. (The miniature equestrian portrait may have been inspired by this sculpture.) Dominating the Aachen complex were the chapel at the southern end and, immediately opposite on the northern flank, Charlemagne's palace and audience hall. This long hall was a large, two-story structure with apses on three sides and a stair tower on the fourth, from which one ascended to the imperial reception chamber on the second floor. From the hall, Charlemagne could proceed by means of the covered, two-storied portico that formed the main north-south avenue directly to the throne room in the Palatine Chapel.

Construction of the Palatine Chapel began about 790, shortly after Pope Hadrian I granted Charlemagne permission to take materials from ancient buildings in Rome and Ravenna, and was completed by 805, when Pope Leo III consecrated the church to the Savior and the Virgin. An atrium surrounded by porticoes and large enough to contain 7,000 people preceded the entrance to the chapel. This entryway is a special Carolingian structure, formed out of a public portal on the ground floor and a throne room in the upper gallery. From the gallery the emperor could participate in the religious services in the chapel or make official appearances from an exterior balcony to the crowds in the atrium below, just as his imperial predecessors in Rome and Byzantium had done. Above the throne room was a reliquary chapel. With the three sections joined by flanking cylindrical stair towers, the Aachen entrance tower became the prototype for an architectural feature known as the westwork.

The actual chapel began just inside the portal as a sixteen-sided structure with an octagon forming the interior core [3, 4]—a centralized conception that admirably fulfilled the building's symbolic and practical functions as a royal house of worship, a martyrium church for Charlemagne's collection of relics, a parish church for members of the court, and, finally, the imperial mausoleum. In designing the Aachen chapel on a central plan, Odo of Metz surely recalled such Roman and Byzantine imperial mausolea as Sta. Costanza in Rome as well as palace chapels such as S. Lorenzo in Milan and S. Vitale in Ravenna. Einhard wrote that the emperor ordered columns and capitals brought from Italy for his church. Even so, the traditional association between the earlier churches and the Carolingian one should not be overstated, for the severe and massive forms of the Palatine Chapel at Aachen are a far cry from the complex, floating shapes of S. Vitale.

The most distinctive feature of the imperial chapel at Aachen—and the building's greatest contribution to the emerging architectural aesthetic of Western Europe—is its emphatic verticality and the clear definition of its component parts. At ground level the portal opens into an ambulatory, or annular aisle, divided into alternating rectangular and triangular bays ingeniously designed to fit into the spaces created by the faces of the inner octagon and the outer, sixteen-sided, wall. In the second story, the room in the entrance tower leads into a gallery that, like the ambulatory below, circles around the octagon to the sanctuary at the chapel's opposite side. The gallery, too, is articulated by bays of rectangular and triangular shape, each bay being separated by a diaphragm arch—that is, a transverse arch carrying a thin upper wall that supports the roof. The core of the chapel receives its octagonal form from eight massive piers and a like

number of plain, wide arches. Above the molding defining this lower story these same masonry piers soar up to support high arches forming the base of the dome. By thus doubling the height of the gallery arches, the builders generated a powerful vertical pull at the center of the chapel, a rising sensation that culminates in a dome once covered with a mosaic representing Christ and the twenty-four elders of the Apocalypse. (The nearly ruined mosaic decorations in the Palatine Chapel, along with many of the moldings and arches, underwent extensive restorations after the church became a cathedral in 1821. Most of the nineteenth-century decoration has now been removed.) The dome, moreover, is not a hemisphere on pendentives, as in Byzantine architecture, but rather it is a cloister vault —a construction that results in a cupola of eight segments precisely echoing the octago-

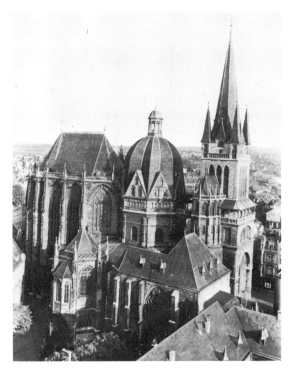

2. ABOVE LEFT: Palatine Chapel, Aachen, late eighth century.

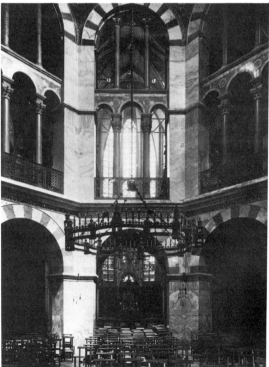

3. BELOW LEFT: Interior, Palatine Chapel, Aachen.

4. BELOW: Plan, Palatine Chapel, Aachen.

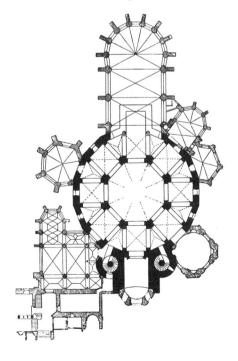

nal elevation of the chapel's center.

The architects designed the chapel to respect the eight-sided character of the inner core and to intensify its heavenward ascent; in addition, they reaffirmed the octagon's function as a structural support. Unlike Eastern buildings, such as S. Vitale or Hagia Sophia, where the central zone seems to expand into the curving space of semidomes and conches, the Carolingian church is enclosed by flat walls. The ground floor at Aachen is articulated not by elegant columns, as at S. Vitale, but by heavy piers, angled to mark off a facet of the octagon. A sharply projecting cornice between the upper and lower stories and richly worked bronze grilles forming barricades at the gallery level further accentuate the wall concept, as do the related lintels above the gallery arcade. The columns within the tall upper arches, which lend so much verticality to the church, also screen the opening and thereby add to the mural effect. By means of such calculations, Charlemagne's builders rejected the open, flowing unity of Byzantine church designs and chose instead to define each architectural unit in terms of its inherent structural character.

When a basilica was to be built, architects turned to Italy. Emulation of Roman buildings began in the reign of Charlemagne's father, who by in effect translating Constantine's Church of St. Peter to Frankish soil sought to legitimize his position as supreme Christian leader. The Abbey Church of St. Denis, begun soon after Pepin the Short's coronation there in 754 and consecrated in 775, was the first foundation to serve his political purpose. The construction of the abbey church as a basilica, with a semicircular apse and a transept continuing out beyond the aisles, speaks clearly for the architects' conscious adaptation of St. Peter's, particularly so because this building type had not been used since the early fifth century. St. Denis was not a slavish copy; for example, it had only three aisles instead of the five used at St. Peter's and it was oriented with apse at the east. The west facade combined portal with a chapel flanked by paired towers; however, within this chapel were placed not the holy relics of saints but the remains of Pepin the Short.

In the Abbey Church of Fulda, built to house the relics of St. Boniface, apostle to the Germans, the builders adopted special features of St. Peter's in Rome with unusual fidelity. St. Boniface himself had supervised the building of the original Fulda church between 744 and 751. Dedicated to the Savior, this church had the form of a simple rectangular structure, terminating in an eastern apse. In 790, thirty-six years after the missionary's death, a campaign to enlarge the building resulted in an aisled basilica, again with an apse at the eastern end. In 802 Abbot Rutger of Fulda decided that the relics of St. Boniface should have as splendid a setting as the tomb of the Prince of Apostles in Rome—and be as nearly identical to the Early Christian structure as differing construction methods, the influence of local style, and the exigencies of the already existent basilica at Fulda would allow. Thus, Abbot Rutger's men, while retaining the three-aisled form of the earlier church, added a continuous transept in order to duplicate St. Peter's tau-cross plan and great length. Indeed, the very dimensions of St. Peter's were sent from Rome at the abbot's request, with the result that, when completed, the Abbey Church of Fulda was the largest of all northern churches. The builders also copied the orientation of St. Peter's by building an apse at the west in their deliberate attempt to re-create on German soil the most revered church in Western Christendom. (Since the fifth century, the orientation of churches had been standardized, with the apse at the east and entrance at the west.) Three years after the Fulda abbey was consecrated in 819, Rutger, again following the model of St. Peter's, added an atrium to the eastern entryway—in the words of a contemporary chronicler, "in the Roman manner." This atrium, however, fronted another semicircular apse, because the abbot had

left the eastern apse of the original church untouched.

Buildings such as the Abbey Church of Fulda demonstrate that Carolingian planners never produced slavish copies of Constantinian monuments, even when they claimed to be doing so. Consequently, it is more accurate to describe the Carolingian revival of Early Christian architecture as a reinterpretation of the older forms—a reinterpretation that, in the process of integrating Classical designs with the northern requirements, laid the foundation for subsequent medieval structures. The originality of Charlemagne's architects stands out most clearly in those churches that were not designed as overt imitations of Roman buildings.

The monastery at Centula in northern France (known through excavations and a seven-teenth-century engraving of an eleventh-century drawing) attests to the inventive character of Carolingian architecture [5]. Built by Angilbert, its lay abbot, and dedicated in 799, Centula was a masterpiece of geometric planning and number symbolism. Modern excavations reveal that the three churches and the cloister with its adjoining walls form a rough triangle and that this shape determined the layout of the entire complex. The triangle gave visual presence to the three-part, indivisible Trinity to which the monastery was dedicated. It is as if the Carolingian architects combined their ancestors' penchant for geometric designs with the Christian interpretation of architecture as symbolic form—an interpretation already encountered in the cross-plan church and in the eight-sided baptistery. One other building at Centula demonstrated the architects' con-

5. Centula Abbey, Church of St. Riquier (reconstruction), Picardy, late eighth century.

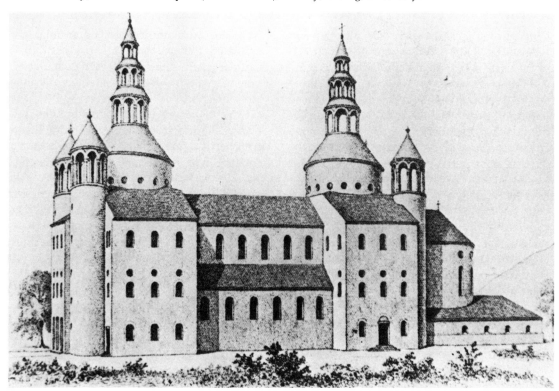

cern for symbolism, a chapel consecrated to the Virgin and the apostles. Modern excavations have shown that this chapel was a dodecagon, or twelve-sided structure, surrounded by an aisle that housed twelve altars—one for each of the apostles.

St. Riquier, the major church at Centula, illustrates an innovative Carolingian church design that continued to be used throughout the Middle Ages. The general silhouette of St. Riquier was remarkable for the vertical quality produced by the tall crossing towers with flanking stair turrets rising from both the eastern and western ends. Resting on round drums, the towers were composed of three stages of open arcades surmounted by spires. These drums and spires were built of timber, perhaps around a central mast. Clearly the desire for soaring heights far outweighed the need for the kind of permanence afforded by masonry construction. St. Riquier was essentially a timber-roofed basilica with an eastern transept, apse, and ambulatory in the Early Christian manner to which a second transept was added at the western end of the church to produce a symmetrically balanced plan. The westwork was not only a monumental entrance block with a vestibule, but it also had an upper chapel designed to create additional space for altars or a choir and—in a church frequented by the court—it could be used as an imperial box with a throne, as we saw at Aachen. Westworks served as reliquary chapels and even as independent parish churches for laymen when the church served a monastic community. Although precedents for the westwork exist in other Carolingian churches, St. Riquier provides us with the first fully developed example of what was to become a characteristic unit in Medieval German achitecture.

The reliquary chapels in Carolingian westworks could not house the growing number of relics arriving in France and Germany. In gratitude to Pepin and Charlemagne, the popes allowed Frankish churchmen to extract relics from Roman catacombs for their own churches. Altars dedicated to the martyrs began to fill the naves as well as the chapels of Carolingian churches—in the St. Gall plan the entire nave is crowded with cross-marked reliquary altars. When many pilgrims began to visit the shrines, new interior arrangements were required to create additional space. At the same time, in order to accommodate an increasingly large clergy, architects found it necessary to expand the overall size of the sanctuary. Inspired by the Early Christian churches in Rome raised over tombs, or martyria, builders found a way to provide both for the relics and for the faithful who came to venerate them. Underneath the sanctuary they built substructures, or crypts, having access from the main level of the church. Because crypts had to support the weight of the apse above, the masons relied on the Roman construction techniques of groin or barrel vaults. Carolingian designers ultimately evolved several crypt forms, of which the annular and the *échelon* designs were the most important. The annular crypt emulated the one built at St. Peter's in the early seventh century, wherein a circular aisle punctuated with openings enabled pilgrims to view the centrally placed relics. On the outer side of the passage, Carolingian builders often added chapels to shelter even more shrines. Another solution, followed at St. Germain at Auxerre, was to build auxiliary chapels placed *en échelon*—that is, laid out in a parallel, stepped format. So efficient were these systems that Romanesque builders of the eleventh and twelfth centuries adopted both the ambulatory and the *échelon* arrangement for use above ground in the sanctuary of the church.

The Carolingian monastery, however, was more than a pilgrimage station. It was designed primarily as a religious center, where people sworn to obedience and poverty lived in a self-sufficient community according to the rule of St. Benedict and worshiped together in a regular sequence of church services. Just as these offices formed the heart of the commu-

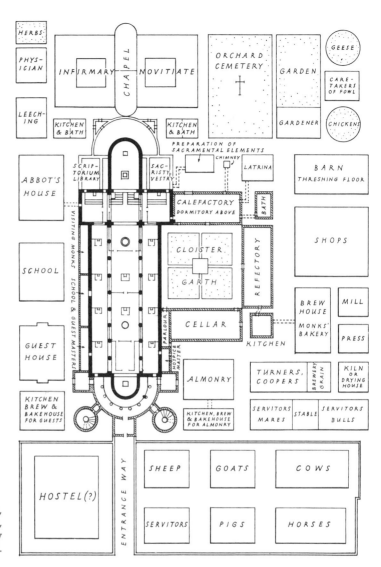

6. Plan for an ideal monastery, early ninth century. Parchment, 44 1/8″ × 30 1/4″. Monastery Library of St. Gall, Switzerland.

nity's spiritual life, so the cloister and scriptorium, where the monks studied and manufactured books, became the nucleus of its intellectual activities. The monastery at St. Gall, Switzerland, preserves in its library the plan for an ideal monastery [6], probably made in 817 on the instructions of the Church synod convened by Louis the Pious. The monastery reflects the orderly planning we noted in Charlemagne's Aachen. A church on the axis, flanked on one side by administrative buildings—the abbot's residence, the school, the hospice for distinguished guests—and on the other side by the monks' lodgings, formed the architectural and spiritual core of the complex. The monks entered the church by the cloister or from the dormitory by means of stairs directly into the choir. The planners surrounded this inner rectangle with auxiliary structures: kitchen, bakery, brew houses, baths and latrines, shops, stables, barns, gardens, and living quarters for lay brothers. The noviitiate and the infirmary, separated by an oblong chapel, lay just east of the main church and immediately north of the cemetery. The plan is completely logical and functional from the

point of view of the residents of the monastery, whose lives revolved around the church and the cloister. The buildings peripheral to the needs of the community are located farthest from the cloister, and the dwellings of the many serfs who would be needed to till the surrounding fields are not represented at all. Thus, the visitor approaching the monastery would be confronted by pig sties, sheep pens, and stables, not by a monumental portal.

As for the ideal church itself, the members of the synod conceived of it as an aisled basilica with an eastern transept and both eastern and western apse. This doubling of apses, first seen at Fulda, provided space for additional altars. Paired cylindrical towers marked the western apse.

As impressive as the logical and functional character of the St. Gall arrangement is the underlying geometry of the plan. Carolingian architects, lacking a standard system of measurement, laid out the buildings with sophisticated surveying techniques based on a geometric conception of architecture inherited from antiquity. Not only was the monastic complex organized, as at Aachen, according to a grid system, but the dimensions of the church and its component parts were calculated by means of circles, squares, and equilateral triangles. Every feature of a Carolingian building, from the length of the nave to the width and proportions of the aisles and transepts, and even the key points in the elevation, could be accurately determined with rod and compass, or a cord and stakes.

Carolingian Painting and Sculpture

What little survives of the extensive monumental painting and mosaic cycles executed during the Carolingian period suggests that, like architecture, architectural decoration was often characterized by an underlying geometric design and by the emulation of Roman Christian programs. The frescoes in the Chapel of St. Stephen in the crypt at St. Germain, Aux-erre, attest to the preference for underlying geometric compositions in the Carolingian era. One of the lunette frescoes, for example, depicts the martyrdom of the saint who was stoned to death at the gates of Jerusalem [7]. At first sight the painting seems loosely ordered and executed with free, vigorous brushwork; then we realize that the artist used a square grid, turned at 45 degrees to form a triangle, to establish the position of the men and the buildings. Just as architects worked with square modules to develop church and palace plans, so the painter employed a similar technique to determine the position of the figures, the city, the drapery folds, and even the hand of God emerging from the clouds at the right. Note, for instance, how the outflung arms of Stephen and his attackers fall along the same diagonal, and how this measured line is laid at a precise right angle to the Lord's extended hand. The two intersecting perpendiculars thus created, echoed as they are in the receding planes of the cityscape at the left, bring to mind the main avenues of the grid construction at Aachen.

The clearest picture of the Carolingian renaissance emerges not from the monumental arts but from a study of manuscript illumination and ivory carving, for it is only in these fields that abundant material survives. The production of books had an essential place in both the self-conscious revival of learning and the missionaries' propagation of the Christian faith. Charlemagne's educational program also required that texts be legible, and the development of a new script based on Roman letters is the imperial scribes' most significant and lasting achievement. Meanwhile, as happened with architecture, painters turned for inspiration to Constantinian Rome, no less than to Byzantium, and the arts of these two regions greatly enriched the Germanic and Celtic art of northern Europe. The ensuing cross-fertilization, although subject to local variations, created a fascinating new style.

The first in a group of books executed by

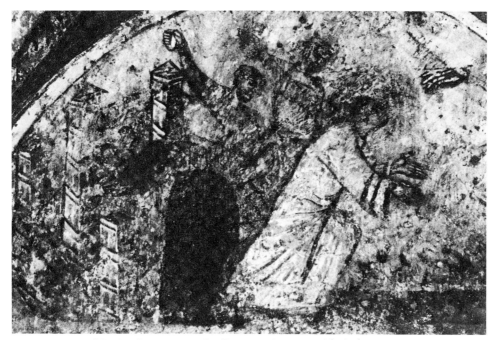

7. The Stoning of St. Stephen, crypt at St. Germain, Auxerre, mid-ninth century.

the palace school at Aachen is a manuscript written between 781 and 783 by Charlemagne's scribe Godescalc to commemorate the baptism of the emperor's son Pepin in Rome. Although usually called the *Godescalc Gospels*, the text in fact is a lectionary—that is, selections, or pericopes, from the Gospels designed to be read at Mass through the liturgical year. Godescalc, following the custom of Early Christian and Byzantine imperial manuscripts, rendered the letters of the texts in gold against a purple vellum ground. Another artist created the full-page illustrations. Given the revival of Classical art urged by Charlemagne, it is interesting to see how the painter tried to reconcile the balance, symmetry, and naturalism of antique forms with the energetic complexity and geometric abstractions traditionally preferred by Germanic and Celtic artists. In the resolution of the conflict between spatial illusionism and surface design, between three-dimensional modeling and linearism, the *Godescalc Gospels* mark an early stage in Carolingian painting. Hence, despite the obvious presence of Italian and Byzantine prototypes,

characteristics of the indigenous northern manner still dominate. The youthful Christ recalls the figure of the Virgin in the Mount Sinai icon, particularly in the attenuated proportions of the body, the round face, and the large eyes [8]. Scholars such as Porcher see a Near Eastern, "Syrian," style in the image and in the painting technique. Straight edges and compasses determine the composition, as they did in the Hiberno-Saxon school. Horizontal lines drawn across the entire surface, although primarily to aid the scribe, become fixed guides for the painter's description of the throne, footstool, and brick wall. Moreover, Christ's cloak falls downward from his left arm in a perfect vertical, the shadows of the cascading folds fanning out in an array of meaningless lines. Such abstract features as these, along with the division of the background into contrasting colored bands, visually ally the inner composition with the scroll and interlace border, thereby reducing the image to a two-dimensional field.

Where the text did not demand the inclusion of human forms, the Godescalc artist rejoiced

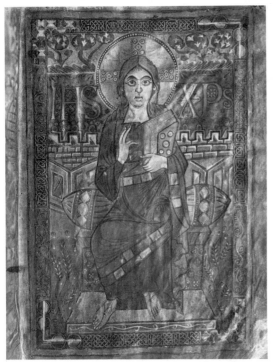

8. Christ, *Godescalc Gospels*, palace school, Aachen, 781–83. Gold, silver, and colors on vellum, 12 1/2″ × 8 1/2″. Bibliothèque Nationale, Paris.

and frame, replete with knots, interlaces, frets, and stepped patterns, derive from the Hiberno-Saxon school of illumination [10].

On another level, however, the Fountain of Life page is as symbolic as it is abstract. The fountain's eight columns suggest an octagonal structure, and therefore a baptistery font. Surely the artist intended a reference to Pepin's recent baptism in Rome, a ritual enacted in the Lateran Baptistery—the very place where, according to legend, Constantine had been similarly received into the Church. Beyond this significant association with Early Christian Rome, the paradisaical setting of birds and plants elevates the fountain as the source of the four rivers of paradise, which are in turn

9. Fountain of Life, *Godescalc Gospels.* Bibliothèque Nationale, Paris.

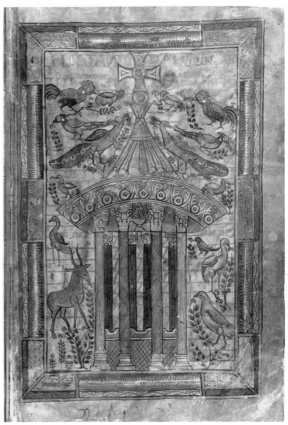

in the display of decorative patterns. The Fountain of Life [9] and its facing folio, with the opening words of the Christmas message in gold, appear remarkably "barbarian," even though the arched curve of the roof line reflects a distant illusionistic source, perhaps Early Christian images of the Fountain of Life or the Holy Sepulchre. The columns and the capitals of the little temple are merely elongated rectangles filled with local color and ornamental motifs, while the horizontal guides seen through the interstices are connected by short diagonals that transform the implicit spatial recession into an abstract zigzag. In addition, the painter has rendered in strict profile almost all the birds and animals inhabiting the leafy branches indicating landscape, and has disposed them one above the other. In the passage on the opposite page, beginning "In illo tempore" (Matt. 1:18–21), initial letters

equated with the four Gospels. The stag becomes humanity thirsting for salvation (Psalm 42); the peacocks are symbols of immortality. Ultimately, the painting stands as a metaphor for eternal life.

After the completion of the *Godescalc Gospels,* the imperial style matured rapidly. A Gospel book written for an otherwise unknown woman, named Ada (once thought to be Charlemagne's sister), contains some of the finest figure painting executed during this phase of the palace scriptorium [11]. St. Mark, like the Godescalc Christ, is a frontal figure enthroned against an architectural setting, but how much more lively and integrated the later composition seems! The evangelist flings his

10. "In illo tempore," *Godescalc Gospels.* Bibliothèque Nationale, Paris.

arms out to display the Gospel in one outstretched hand while he dips his pen with the other. The lion displays a scroll in the lunette above him. Sprays of drapery, which constitute the saint's toga and tunic and cover his throne, end in angular edges that meander in a jagged pattern over torso and legs. So dynamic is the artist's conception of volumes in space that we imagine the feline heads decorating the throne as attached to bodies crouched to leap out from under the draped covering. To this animated field with its brilliant color the architecture contributes a realistic foil. The columns, capitals, and pedestal are reasonably functional, making the background architecture distinct from the throne; and the arched frame forms a theatrical proscenium arch through which we as spectators look into a dramatic presentation.

When Alcuin retired to Tours in 796, Charlemagne's biographer, Einhard, became chief of the palace scriptorium. Under Einhard, Carolingian craftsmen rediscovered the illusionistic painting of imperial Rome as it had been preserved by the Byzantines. Indeed, one or more Greek illuminators may actually have come to Aachen to work at the palace school. The Greek name "Demetrius presbyter" appears on the first page of the Gospel of Luke in the *Coronation Gospels.* What part he played in the execution of the manuscript is not known, but the inscription does document the presence of a Greek at the court.

The extraordinary new style that developed out of the revival of ancient Roman art, no less than from the assistance of Eastern-trained artists, is nowhere more striking than in the so-called *Coronation Gospels,* datable to the period before Charlemagne's death in 814 [12]. (The book was found in the year 1000 by Emperor Otto III, when he opened Charlemagne's tomb and found the Gospels on his predecessor's knees. Thereafter German emperors swore their coronation oaths on this book.) The painter has created portraits of the evangelists that rival the author portraits, such

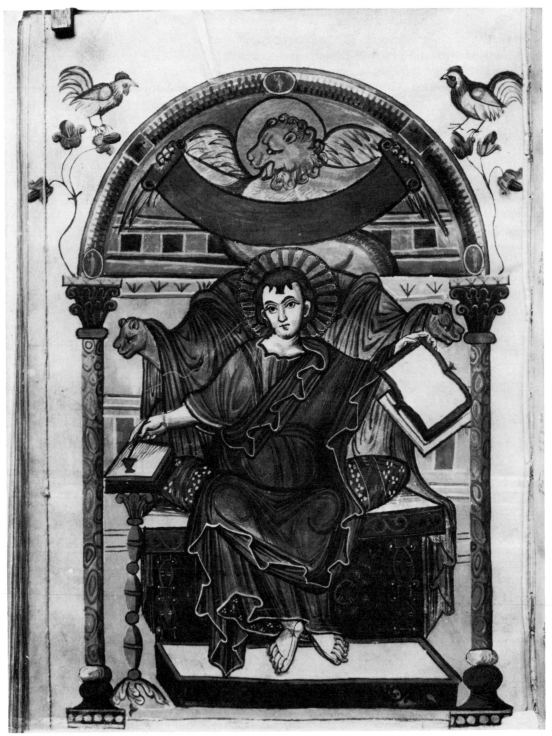

11. St. Mark, so-called *Ada Gospels*, palace school, Aachen, c. 800. 14 1/2″ × 9 5/8″.
Stadtbibliothek, Trier.

as Dioscorides', in Byzantine books. St. John, a full-bodied, white-robed figure, is seated on a crimson-cushioned golden throne isolated against a landscape of hillocks and foliage. This concentration of solid human forms in an impressionistic vista speaks for a dependence on antique illusionism as practiced by Byzantine painters. The artist achieved the effect of chiaroscuro modeling by building up forms with the antique method of impasto— that is, with a thick application of paint (some of which has flaked off over the centuries). One need only compare the *Coronation Gospels'* St. John to the evangelists in the *Ada Gospels* to see the substance and monumentality gained from the Greek influence. A second comparison, with such Byzantine works as the *Rabbula Gospels,* reveals the Carolingian painter's source for the lush forest and pale blue sky behind St. John's throne. His footstool in reverse perspective projects out over the frame into the spectator's space in accord with Byzantine aesthetic theory. The wide frame, with its golden acanthus molding, is yet another classicizing element, for by creating a picture window view it enhances the illusionistic quality of the painting.

With Byzantine painting playing such a vital role in Einhard's palace school, it is not surprising to find that sculptors also fell under the influence of Byzantine art. Thus, when a Carolingian craftsman carved ivory reliefs for the cover of a Gospel book at the Abbey of Lorsch, about 810, he must have known some sculpture from Justinian's court [13]. Even the incorporation of not one but several styles in the Lorsch ivories emulates the variety of styles we have already encountered in such works as the Throne of Maximianus. Indeed, so well did Charlemagne's artists understand their models that the Carolingian book cover was once identified as sixth-century Byzantine. The Lorsch panels, like the Barberini ivory, are divided into five compartments, with medallions held by hovering angels in the upper section and small narrative scenes in the lower

12. St. John, *Coronation Gospels*, palace school, Aachen, early ninth century. Purple vellum, 12 3/4″ × 9 7/8″. Kunsthistorisches Museum, Vienna.

one. The front cover represents the enthroned Virgin and Child, flanked by Zacharias and St. John the Baptist, while the back depicts Christ. Each of the full-length figures appears within a narrow, column-supported arch decorated with molding and foliage patterns, much as in the archangel Michael diptych or the Throne of Maximianus. Below, the stocky figures acting out events from the life of Christ do so in a cramped field yet in an energetic manner reminiscent of the Joseph reliefs. On the whole, the sculptor of the Lorsch ivory, like the painter of the *Ada Gospels*, no less than the carver of the evangelist panels on Maximianus' throne, exploited the two-dimensional decorative possibilities of line rather

13. Virgin and Child, with Zacharias and John the Baptist, Lorsch panels (book cover), early ninth century. Ivory, 14 7/8″ × 10 3/4″. The Victoria and Albert Museum, London.

than its form-defining function. Although the architectural setting is convincingly rendered, the figures themselves occupy little tangible space; their corporeal substance is denied by rich ornamental drapery patterns. Looped and hooked folds and curvilinear designs suggest the roundness of shoulders, thighs, belly, and breasts, but the legs are hidden by an array of straight sharp lines and the figures effectively disappear behind a linear pattern. The sculptor has worked from a model having measurable volumes; however, his attempt to express these volumes by linear means has resulted in a markedly contemporary work. The true Classical style, even as translated by

Byzantine art, always eluded Charlemagne's artists.

The Carolingian Empire did not endure long after the death of the man whose vision created it. Trouble began during the reign of the new emperor, Louis the Pious (814–840), named for his abiding interest in the development of monasteries as the spiritual, artistic, and intellectual centers of Carolingian life. Louis had little political or military ability, however, and he could not control his sons, who attempted to secure for themselves as rich a portion of their father's lands as possible. When Louis died, Lothair I inherited the title of emperor, along with the middle section of

the Empire from the North Sea through Italy. The two younger heirs, Louis the German and Charles the Bald, received, respectively, the eastern and western parts (modern Germany and France). Even if the brothers had lived in peace with each other, Charlemagne's dream of imperial unity was a hopeless cause, since the three kingdoms constituted a patchwork of different nationalities. The internecine quarrels continued unabated until the Treaty of Verdun (843) affirmed the tripartite organization of the Empire and established an uneasy truce. Louis, Charles, Lothair, and their heirs continued to be embroiled in territorial wars that turned the map of Europe into a jigsaw puzzle of small, interlocking holdings. The moral authority of the Church also suffered under these anarchical conditions. In 882 assassins struck down the Pope himself; and so precarious was the political climate that at the very end of the century six different popes reigned within a two-year period.

Adding to the misery of civil wars and the lack of spiritual leadership, the Carolingian Empire, like the Roman Empire it had hoped to revive, was threatened from the outside. In the late eighth century the Vikings began their expeditions around Europe. By 845 the Norsemen had destroyed Angilbert's monastery at Centula. Eight years later they leveled Alcuin's foundation at Tours, and in 885–886 they beset Paris, lifting the siege only when Charles the Fat, son of Louis the German, paid an enormous tribute. As if these incursions from the north were not enough, the Muslims moved into Sicily and then up the Italian peninsula, destroying the famous Benedictine monastery at Monte Cassino in 811 and attacking Rome in 846. At the close of the ninth century, the savage Magyars swept across Europe from the east and plundered Lombardy. Today we recognize that the Vikings, Muslims, and Magyars had viable cultural and artistic traditions of their own, but to contemporaries this second "dark age" of Western Europe seemed more foreboding than the first.

To understand what happened to the Carolingian dynasty, one need only look at the titles of its successive rulers, for such laudatory epithets as Charles the Hammer, Charles the Great, and Louis the Pious gave way in the ninth century to less than flattering nicknames. It is surely a sign of the Empire's debilitated state that among the last of the Carolingian monarchs were kings called Charles the Fat, Louis the Stammerer, and Charles the Simple.

When the warring and harassed kingdoms ceased to function as even a nominally operative Empire, Carolingian art—always a product of imperial patronage and the taste of an educated elite—was doomed. But its death was tolled slowly over the course of fifty years, so that masterpieces continued to be produced throughout the ninth century. Charlemagne had made Aachen the focal point of artistic creativity. During the reign of Louis the Pious, monastic scriptoria and workshops started to supplant the palace school, with the result that Reims under Archbishop Ebbo and Metz under Bishop Drogo, as well as Tours, dominated cultural productivity. All three schools continued on after the Treaty of Verdun—Metz in the kingdom of Lothair, Reims and Tours in that of Charles the Bald. In addition, Charles founded his own palace atelier, probably at the Abbey of St. Denis, where he was titular lay abbot. The problem of identifying the different schools of Carolingian art is a difficult one—all the more so because artistic projects continued to rely on imperial patronage. As a result, styles seemed to emerge as almost accidental products of an individual patron's taste and the models that happened to be available to the artists.

Louis the Pious appointed Ebbo as Archbishop of Reims in 816, and within a short time artists assembled at the new episcopal court. Out of the illusionism of the later palace school, these painters created a remarkable style, exemplified by the Gospel book made for Ebbo himself in the Abbey of Hautevillers near Reims. Although the portrait of St. Mark

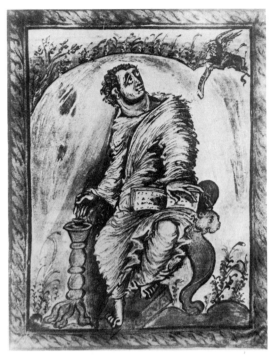

14. St. Mark, *Ebbo Gospels*, Hautevillers, 816–35.
10 1/4″ × 7 3/4″. Bibliothèque, Epernay.

ultimately derives from the evangelist pages in the *Coronation Gospels*, the Classical calm exuded in the early manuscript in the *Ebbo Gospels* becomes a vibrating rhythm of brushstrokes [14]. Rapid, calligraphic flourishes with an overlay of gold replace the impasto modeling of the palace school, since the draftsman focused less on the outward appearance of a man writing than on the inner, spiritual excitement filling an evangelist as he records the Word of God. The consequent expressiveness of faces and gestures sometimes produces grotesque results: Mark's head and neck jut awkwardly out of hunched shoulders; his left hand clumsily grasps the book, while the right seeks out the ink bottle; and the long diagonal slashes that represent the saint's eyelids lend an almost theatrical character to his inquiring upward glance. Even the furniture serves to accentuate the instability of the composition, for only a single leg supports the

lion throne and the inkstand rests on taffy-like mounts.

The most famous of the Carolingian manuscripts is the *Utrecht Psalter*. In the ink drawings here, designed to illustrate the Psalms, the draftsman employed the linear vitality of the *Ebbo Gospels* style as a powerful, expressive instrument—despite the fact that the buildings, the populous setting, and the integration of picture and text into one field betray a source in antique illuminated manuscripts. The Psalms, however, do not lend themselves to literal illustration, being mystic, metaphorical praises and laments rather than narrative descriptions. Thus, the text of Psalm 88 (89) is a blessing to the Kingdom of David and a promise of protection against enemies [15]. God—a youthful, nimbed Christ-Logos in a mandorla—is surrounded by angels and a personified sun and moon. Below but on the right hand of God, David, "the anointed one," enthroned in his palace receives the gifts of kings who arrive in their ships; on God's left one sees the evils of the world—the destruction of war, the plundering of cities, the individual cruelty of men, even the Crucifixion of the Lord. The psalmist cries out for God's help: "like the dead who lie in the grave. . . . the terrors destroy me: they surround me like water all day long; together they encircle me." Fortresses and palaces, hill, rivers, and the sea provide the setting for the energetic figures of kings, warriors, peasants, seamen, prophets. One soul alone (at the upper left) receives a robe and crown of glory from three angels.

The author of the *Libri Carolini* denied the painter's ability to depict the scriptures. The *Libri Carolini* were a protest against the decrees of the Council of Nicaea (787). The author may have been the Visigothic Bishop of Orleans, Theodulf, a sophisticated scholar who decorated his oratory at Germigny-des-Prés with mosaics representing angels adoring the Ark of the Covenant. Clearly Charlemagne and his theologians did not understand the issues confronting the Byzantine Church, with

FURORTUUS·ETOMNESFLUC
TUSTUOSINDUXISTISUPER
ME· DLAPSALMA
LONGEFECISTINOTOSMEUS
AME·POSUERUNTMEAB
OMINATIONEMSIBI;
TRADITUSSUMETNONEGRE
DIEBAR·OCULIMEILANGU
ERUNTPRAEINOPIA;
CLAMAUIADTEDNE·TOTA
DIEEXPANDIADIEMANUS
MEAS;
NUMQUIDMORTUISFACIES
MIRABILIA·AUTMEDICI
SUSCITABUNTETCONFITE
BUNTURTIBI·

NUMQUIDNARRABITALI
QUISINSEPULCHROMISE
RICORDIAMTUAM·ETUE
RITATEMTUAMINPER
DITIONE;
NUMQUIDCOGNOSCENTUR
INTENEBRISMIRABILIA
TUA·ETIUSTITIATUAIN
TERRAOBLIUIONIS;
ETEGOADTEDNECLAMAUI·
ETMANEORATIOMEAPRAE
UENIETTE;
UTQUIDDNEREPELLISORA
TIONEMMEAM·AUERTIS
FACIEMTUAMAME;

PAUPERSUMEGOETINLABO
RIBUSAIUUINTUTEMEA·
EXALTATUSAUTEM HUMILI
ATUSSUMETCONTURBATUS·
INMETRANSIERUNTIRAETU
AE·ETTERRORESTULCON
TURBAUERUNTME;
CIRCUMDEDERUNTMESICUT
AQUATOTADIECIRCUMDE
DERUNTMESIMUL;
ELONGASTIAMEAMICUM
ETPROXIMUS·ETNOTOSME
OSAMISERIA;

LXXXVIII·INTELLEC TUSAETHAN EIZRAHLITAE

15. Psalm 88, *Utrecht Psalter*, Hautevillers or Reims, 816–35. Ink on vellum, approximately 13″ × 10″. University Library, Utrecht.

its iconodules and iconoclasts, for the Carolingian churchmen thought the Byzantine position supported idolatry, and denounced it as heresy. The Western Church took a simple, puritanical position that images have no mystical function, that they are precious only if their material is precious, that they are not holy and not the products of divine inspiration. The Carolingian rebuttal to the Byzantine court contains one of the rare statements on aesthetic principles written in the West during the Middle Ages.

To the Carolingian theologians, art was a worldly endeavor with an important didactic function. Artists, far from being divinely inspired, must learn their craft like anyone else. They should select good materials and good models and work diligently, and the images they produce remain material products whose value lies in the expense of the material. Thus, a gold Virgin is more valuable than a wooden one, although both represent the Mother of God. Quality in art is based on three things: the artists' success in fulfilling their intentions; the intrinsic material worth of the object; and, if the work is an ancient piece, its state of preservation. The point of view—so different from the Neoplatonic aesthetics of the East— probably represents a common attitude toward art and artists in the West during the Middle Ages. Echoes of the *Libri Carolini* still reverberate today.

The *Utrecht Psalter* artists, sufficiently remote from the political climate that had generated this short-lived iconoclasm, overcame the inherent difficulty by designing what Nordenfalk has aptly called "charades," or word-by-word illustrations of the text. This imaginative solution to a nearly impossible pictorial problem is made all the more striking by the unrestrained energy of the drawings—a vigorous style that typifies the northern medieval spirit. Weightless figures, elegant and delicate, stand on tiptoe, gesturing emphatically. The dynamism accorded serpents in Scandinavia or abstract spirals in Ireland is here transferred to human beings and their activities.

The *Utrecht Psalter* style also appears in a series of ivory plaques, known as the Liuthard group (so called because some were reused as covers for books produced by the scribe Liuthard for members of the circle of Charles the Bald, but probably carved by artists working for Louis the Pious). One of these works, now reset into the cover of the eleventh-century *Pericope of Henry II,* transforms antique models, in the manner of the *Utrecht Psalter,* into uniquely Carolingian creatures [16]. The Crucifixion, the Marys at the Tomb, and the Resurrection are disposed in registers within an extended landscape. Despite the patently Christian subjects, Classical personifications define time and place. Above the Cross the

16. Cover of *Pericope of Henry II,* the Crucifixion, Reims, c. 870. Ivory, 11″ × 5″. The setting: before 1014, given by Henry II to Bamberg Cathedral, Byzantine and Ottonian enamels. Gems and pearls on a gold ground. Height, 17 5/8″. Bayer. Staatsbibliothek, Munich.

sun and moon, which had hitherto appeared as natural bodies, are personified by Apollo riding in his chariot and Diana guiding her ox cart. In the lower right of the panel, Gea (Earth) stares intently up at the crucified Savior, while a reclining river god directs his glance toward the spectator. The carver has drawn heavily on Early Christian sources, too, by including Stephaton, Longinus, the cluster of mourners, and the angel addressing the three Marys. In addition, the domed, tower-like sepulchre recalls the tomb seen in the Munich Ascension ivory. Yet the slender figures, with their rippling, shape-defining garments, their heads thrusting out from rounded shoulders, and their intensely assertive gestures, are close kin to the actors in the *Utrecht Psalter*. The undulating ground lines between the zones also suggest the Reims school, but in this three-dimensional presentation landscape becomes a series of overhanging ledges that create space pockets around the depicted events. The architectural elements, meanwhile, although deeply cut in receding planes, sustain a vertical movement over the surface because the tomb and small buildings break through from one area into the next, unifying and energizing the field. Perhaps the most telling sign of the ivory's northern medieval origins is the sharply undercut, classically inspired acanthus frame that nevertheless cannot restrain the forms within. Soldiers, lances, coffins, and rooftops all burst out into the rectangular surround, and in so doing give new life to an ancient convention. Although the panel shares several stylistic features with the *Utrecht Psalter*, some scholars regard it as a product of the school of Metz, the episcopal court presided over by Charlemagne's son Drogo, Archbishop of Metz from 844 to 855.

In the *Sacramentary* made for Archbishop Drogo about 850–855, the illuminator fitted the entire picture into the enlarged opening letter of the text, thereby achieving a new form, the historiated initial, in which the illustration is actually incorporated into the

17. Initial "C" with the Ascension of Christ, *Drogo Sacramentary*, Metz, 844–55. Bibliothèque Nationale, Paris.

text [17]. The crowded figures witnessing the Ascension of Christ and the illusionistic rendering of forms in space again hark back to antique prototypes, such as influenced the Reims painters. The striding image of Jesus assisted into Heaven by the hand of God, the angels, Virgin, and apostles in front of the hill are familiar Early Christian motifs. Drogo's artist rejected the bejeweled or interlaced patterns of his predecessors and chose instead to ornament the initial letters with Classical acanthus leaves. In the final analysis, however, the Metz illuminator remained true to his native tradition, for although the foliage is based on the Classical rinceau, it is completely filled with gold, the better to transform this idealized growth into a flat, decorative design.

In the kingdom of Charles the Bald, several monastic centers became major scriptoria. During the abbacy of Alcuin (798–804), Tours had produced large Bibles that, because they

18. Count Vivian presenting a Bible to Charles the Bald, Tours, 846. 19 1/2″ × 13 5/8″. Bibliothèque Nationale, Paris.

were primarily designed to disseminate Alcuin's edition of the Vulgate, were sparsely decorated, save for some simple Hiberno-Saxon ornament in the initials and canon tables. Under Alcuin's successors, Abbot Adalhar (804–843) and Abbot Vivian (843–851), who was a count and chamberlain to Charles the Bald, lavishly illustrated Bibles were produced. The Tours form of antique realism based on Roman sources can be studied in a Bible presented by Count Vivian to Charles the Bald on the occasion of the king's visit to the monastery in 846 [18]. The dedication page of this so-called *Vivian Bible* (also known as the *First Bible of Charles the Bald*) marks one of the earliest medieval depictions of an actual event. Charles, enthroned beneath a canopy, flanked by courtiers and guards, and blessed by the hand of God, reaches out to accept the book proffered by the monks of St.

Martin's. Which of the figures represents Count Vivian is a matter of some controversy: the ecclesiastic raising his arms at lower center and the crowned man in secular garb at the king's right are both candidates. Despite this uncertainty, we have not encountered a similar attempt at visualizing a contemporary scene since the commemorative reliefs of imperial Rome. The setting, of course, is ethereal, for the king and his retinue hover on a cloud bank, thus elevating the Carolingian monarch to semidivine status; and even though the image of Charles suggests a portrait, the convention of hieratic scale causes him to be larger than his subjects. These symbolic considerations do not, however, affect the depth and near-tangibility of the spatial environment. The painter disposed the participants in a full circle in order to establish an illusionistic recession, and by overlapping each one with the next he created the effect of a crowd. Moreover, a continuous rhythm of gestures and glances accentuates the circular movement and locks the figures into a chain of relationships. An aura of physical reality suffuses this dedication page—even the sky glows in softly shaded colors. In addition, the *Vivian Bible* painter made his figures more active by infusing their forms with a characteristically northern vitality, a product of elongated proportions, looser brushwork, and, above all, a linear and dynamic treatment of drapery.

Charles the Bald, as emperor and as lay abbot of St. Denis, was one of the last Carolingian rulers to patronize the arts on a grand scale. (The bronze horseman [1] may be his portrait.) Charles' painters must have studied antique models with renewed intensity; at the same time the ornamental vigor that once energized Celtic designs revitalizes the Classical vocabulary into compositions that are simultaneously decorative and meaningful. A synthesis of available sources appears in the Gospels produced about 870 by the brothers Berenger and Liuthard. (At the death of Charles the Bald in 877 the manuscript, along

19. The twenty-four Elders adore the Lamb, *Codex Aureus of St. Emmeran,* court school of Charles the Bald, c. 870. Miniature on vellum, 16 1/2″ × 13 1/4″. Bayer. Staatsbibliothek, Munich.

with other items in the imperial treasury, became the property of King Arnulf of the Germans, who then donated his legacy to the monastery of St. Emmeran at Regensburg, for which reason the volume is now called the *Codex Aureus of St. Emmeran.*) The Gospel is quite literally a "golden book," from the bejeweled gold cover to the purple ground with its golden script and acanthus-leaf borders. In a depiction of the Apocalypse [19], which may have been inspired by the dome mosaics of the Palatine Chapel at Aachen, personifications of earth and water flank the circle of the twenty-four elders of the Apocalypse who adore the mystic Lamb (Rev. 5:6–14) standing in a circle of light above a rainbow. The chalice in front of the Lamb recalls Christ's sacrifice and the celebration of the Eucharist. In pictorial terms, the painters conformed to the Byzantine practice of representing the apocalyptic Christ as the *Agnus Dei,* rather than as the human redeemer of the Western tradition. Within the great star-studded disk of Heaven, the elders twist and turn, rising from their thrones and offering golden crowns to the radiant golden Lamb. The resplendence of the pigment here lends an ecstatic tone to the awesome vision of glory. The painters capture the drama of the scene by adapting the dynamic linearism and spirited movements

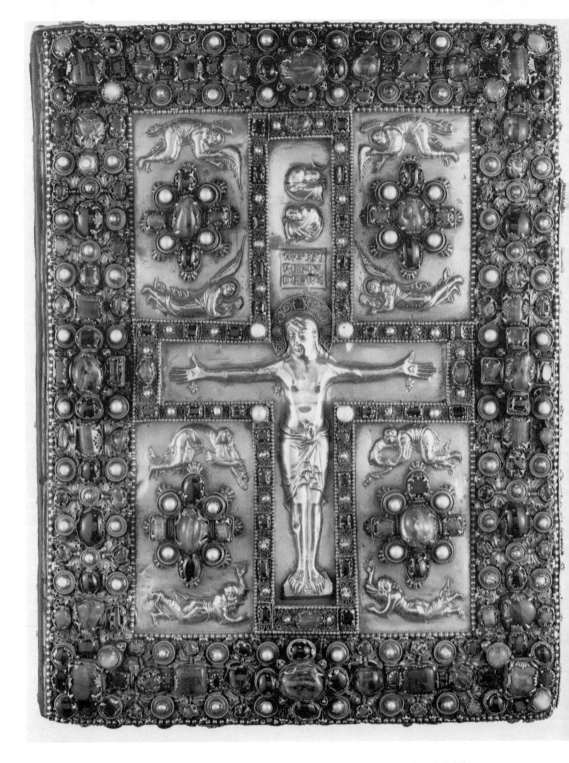

20. Christ on the Cross, cover, *Lindau Gospels*, c. 870. Gold, precious stones, pearls, 13 3/8″ × 10 3/8″. The Pierpont Morgan Library, New York.

used by their colleagues at Reims and Metz while retaining the corporeal solidity and illusionistic modeling of the earlier court schools.

The covers of these manuscripts match the sumptuous quality of the illuminations within. On the cover of the *Lindau Gospels,* made about 870, a jewel-encrusted frame surrounds a jewel-bordered cross bearing the triumphant living Christ [20]. Weeping personifications of the sun and moon with fluttering, gesticulating angels fill the upper quadrants of the field. Below, the Virgin, St. John, and two mourners twist in grief around bosses formed of gems and pearls. The small figures with their hunched shoulders, expressive movements, and fluttering draperies contrast with the serene, idealized Christ. In spite of their patrons' pride in emulating Early Christian and Byzantine representational art, Frankish artists continued to develop the jewelwork and metalwork so beloved by their barbarian ancestors. Delicate arcades and lions' feet support polished gems, and beaded mounts set off pearls from the foliage-encrusted ground. Jewels and pearls attest to an almost barbaric delight in the color and quantity of stones. The effectiveness of the *Lindau Gospels* cover comes from sheer richness and highly skilled craftsmanship as well as from the representation of poignant human images.

In one sense, the term "renaissance" is a misnomer for the Carolingian revival. The arts still flourished during the so-called Dark Ages, the flame of learning had not by any means been extinguished by the barbarians, and furthermore, Carolingian art was more than a mere re-creation of the Classical style. Painters, sculptors, and architects of the later eighth and ninth centuries integrated the antique perception of human forms, of weight and mass, as well as the illusionism and individual motifs of Byzantine work with the highly developed decorative sensibility and the impeccable craftsmanship of Hiberno-Saxon artisans. If Carolingian illuminations and relief sculptures sometimes depict events in a visually convincing manner, accurately representing the human body, landscapes, architecture, or the relationship of figures to their environment, it is only because the designers constantly referred to ancient models. What truly motivated Charlemagne's artists was not so much a penchant for pictorial naturalism as a desire to perpetuate the pictorial tradition established in Early Christian Rome—a tradition, of course, eagerly emulated in another way by the emperor himself. The arts provided a splendid and symbolic setting for the Frankish monarch and served to advance his imperial and ecclesiastic ambitions. Given this role, it is understandable that Carolingian art always remained a relatively exclusive enterprise, never extending beyond the limits of imperial patronage, whether in the secular court or in the monasteries. It is also understandable that the Carolingian renaissance could not endure beyond the dynasty that created and sustained it. Devastating as the Viking and Magyar ravages were, they were not entirely to blame for the second "dark age" that beclouded France and Germany for the next hundred years. The idea of a Holy Roman Empire, the idea of Charlemagne as a Christian hero, became one of the great myths of Western European civilization—so much so that in 1165 this Frankish warlord, who fought campaign after campaign to extend his personal empire, was beatified by the Church.

[CHAPTER VI]

Art Outside the Carolingian Empire

The Art of the British Isles and Scandinavia

According to the ninth-century Anglo-Saxon Chronicle, in 793

... terrible portents appeared over Northumbria and sadly affrighted the inhabitants: these were exceptional flashes of lightning, and firey dragons were seen flying in the air. A great famine followed soon upon these signs, and a little after that in the same year on the ides of [June] the harrying of the Heathen [the Vikings] miserably destroyed God's church in Lindisfarne by rapine and slaughter.

Alcuin, learning of the disaster at Lindisfarne from the safety of Charlemagne's court, believed the Vikings to be instruments of God's wrath and cited Jeremiah 1:14: "Then the Lord said unto me, Out of the north an evil shall break forth upon all the inhabitants of the land." For some time, the invasions indeed appeared to fulfill the old prophecy. By 800, when Charlemagne was crowned emperor in Rome, the Vikings had raided the coast of Northumbria, rounded Scotland to destroy St. Columba's monastery on Iona, ravaged the Isle of Man, attacked Wales and Ireland, and reached the coast of France.

Who were these fearsome people? They lived along the coasts of Denmark, Norway, and Sweden as seafarers, fishermen, and traders; but at the end of the eighth century, they suddenly took to the sea as explorers and pirates. Whether moving as solitary warrior bands with two or three boats, or in flotillas

of 350 ships, the Vikings—named for the *viks*, or bays along the Norwegian coast—terrorized Europe. The shallow draft of their longboats enabled the Scandinavians to sail up the rivers of Europe into the heart of the Continent: no town or monastery was safe [1]. Vikings appeared in Normandy in 814 and on the Seine in 820. Not until the very end of the ninth century did Carolingian armies begin to hold fast against the Scandinavian threat. Nevertheless, in 911 Charles III, the Simple, was forced to cede the northern coast of France to the Viking Hrolf, or Rollo, who became duke of the region, thenceforth called Normandy after the Norsemen.

Meanwhile Viking raids began in the British Isles at the end of the eighth century. Norwegian Vikings settled in Scotland, northern England, and Ireland, and in the second half of the ninth century they began to extend their territories. Not only did Olaf the White found the Kingdom of Dublin in 851, but in 860 his compatriots discovered and colonized Iceland. Little more than a hundred years later, the Vikings sailed on to Greenland, and about 1000 they even reached the North American continent. Crafty Viking leaders subsequently developed into statesmen, among whom the most astute was the Danish Knut, known in English as King Canute the Great (c. 995–1035), who by 1028 had become the ruler of Denmark, Norway, and England.

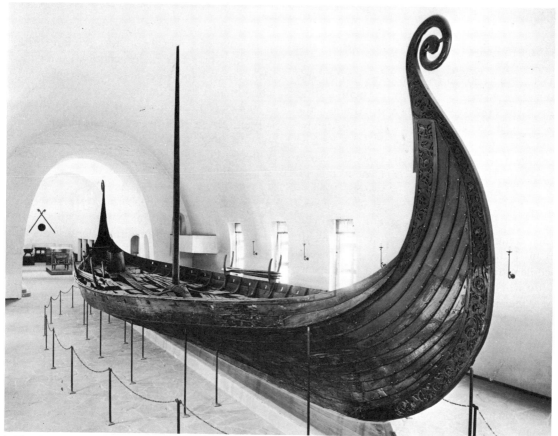

1. The Oseberg ship, Norway, c. 800. 71′ long, 16 1/2′ across. Viking Ship Museum, Bygdoy.

The Swedish Vikings followed a different route, crossing the Baltic Sea and sailing down the Russian rivers into the Black Sea. When they finally arrived in Constantinople, they became mercenaries. In this way, the Vikings became soldiers of fortune, working first as an elite defense corps in the imperial palace and, by 1000, as the Byzantine emperor's personal bodyguard, the Varangian guard.

Although Canute and Rollo accepted Christianity in England and France, the population of Scandinavia remained aggressively pagan well into the tenth century. Odin presided over the Viking pantheon of gods from Valhalla, the Hall of the Slain. To this hallowed place the Valkyries, Odin's messengers and ale bearers, carried warriors who had died in battle to spend eternity fighting by day and drinking by night. Odin also taught his people

to write with runes, the twiglike northern script, which he obtained by sacrificially hanging himself on a tree for nine days. The Vikings believed that the world would end one day in a catastrophic upheaval, but the Fates foretold of a twilight of the gods, a time when the universe would be destroyed in the apocalyptic *Ragnarok*, from which a new earth would arise.

The conversion of Scandinavia came slowly. In the tenth century, Gorm the Old united Denmark, and his son Harald Bluetooth (c. 945–985) accepted Christianity for himself and his people in 960. In Norway, Harald Fairhaired (860–933) brought together under his rule all the people scattered through the valleys and along the fjords, but the Norwegians did not adopt Christianity until 1015, during the reign of Olaf II (c. 995–1030), a

king later canonized as St. Olaf, patron saint of Norway.

The Anglo-Saxon natives of the British Isles had their own heroes, beginning with Alfred the Great (871–899/900), who unified the rival Anglo-Saxon kingdoms in order to defend England against the Vikings. By 878, Alfred had gained firm control over southwestern England. The north and east, nevertheless, remained in Danish hands, in a region thenceforth known as the Danelaw. It was Alfred's aim, as it had been Charlemagne's, to revive and strengthen the cultural and political life of his country. Hence, he invited Continental scholars to England to teach and to translate Latin works into the vernacular. Just as in the Carolingian Empire, the Benedictines provided a bridge to European civilization through their monastic ties. Chiefly responsible for stimulating artistic and scholarly productivity were St. Dunstan (d. 988), Abbot of Glastonbury and later Archbishop of Canterbury (an office that made him primate of England), and St. Ethelwold (d. 984), a monk at Glastonbury, whom St. Dunstan appointed Bishop of Winchester in 963. St. Ethelwold developed such a great scriptorium at Winchester that the old Saxon capital gave its name to an entire school of Anglo-Saxon art.

The eleventh century opened with massacres, reprisals, blackmail, and betrayal—horrors that ceased only in 1013, when Sven Forkedbeard annexed the Anglo-Saxon kingdom of Ethelred to the Danelaw and the Anglo-Saxon dynasty took refuge in Normandy. Sven's son, King Canute, we recall, added Denmark and Norway to this North Sea empire. Canute's own sons were ineffective, thereby enabling Edward the Confessor to return to England in 1042 and rule until his death in 1066. A dispute over the legitimate succession to the throne then gave the Normans under William the Conqueror an excuse to invade the British Isles, a campaign that led to the defeat of the Anglo-Saxon forces at the battle of Hastings.

In spite of political conflicts, the lands ringing the North Sea had become an integrated cultural province. As a result, art historians sometimes cannot determine where a style or a work of art originated. Indeed, English and Viking art in this period, while often manifesting indigenous characteristics, just as often reflects the constant presence of one people on another's soil.

The excavation of a mound at Oseberg, along the western coast of the Oslo fjord, unearthed a ship burial as remarkable as the earlier Sutton Hoo burial in England. Although robbers had made off with precious materials, the wooden vessel and its equipment survived. The ship, anchored to a rock and covered with an airtight mound, contained the remains of two women, together with all the provisions necessary for life in the next world. The burial must have taken place about 850, although the boat itself had been constructed fifty years earlier. A royal barge designed for the calm waters of the fjord rather than for warriors' sea raids, the Oseberg ship measures 71 feet in length and 16½ feet across. Its extraordinarily elegant proportions, technically perfect to reduce water resistance, with strong yet flexible oak construction, had been developed by the Vikings over centuries of seafaring experience. In symbolic terms, the Vikings conceived of the vessel as a huge sea serpent, the rising spirals of the prow and stern representing the creature's head and tail. Such a dragon-like shape was no doubt intended to frighten off other monsters, for similar beasts were carved on houses, tent poles, sleighs, and wagons. The Oseberg ship also had carved decorations. A frieze of interlaced, silhouetted animals runs along the prow and stern in a design that harks back to the Vendel style of earlier Swedish royal tombs. The ninth-century craftsmen, however, introduced a contrast of textures and forms absent in Vendel work. The serpent heads in the Oseberg reliefs move down the center of the panel, while relatively broad bodies with hatched surfaces provide a

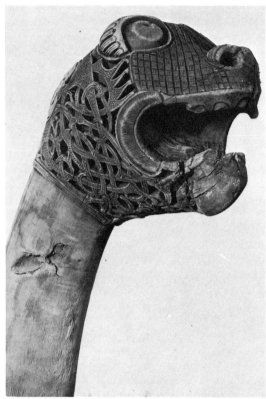

2. Headpost (detail), Oseberg ship. Viking Ship Museum, Bygdoy.

visual foundation for an interweave of thin, curving tails and legs, thus adding variety to the refined Vendel manner. The "gripping beast," as this motif is called, soon became a hallmark of Viking animal ornament.

The later development of this Viking style can be seen in animal headposts, puzzling objects whose use is still uncertain [2]. The headpost by the so-called Academic Master is a round-headed, short-muzzled catlike creature that could be a descendant of the Echternach lion. The Academic Master created an art of balance and restraint, while using the Oseberg motifs. The bulging eyes and snarling mouth of a ferocious beast are countered by the regular checkerboard pattern of the muzzle. An interlace of great delicacy and elegance formed of the same kind of animals that cover the Oseberg ship's prow spreads over the

leonine head, but this head is balanced on the unadorned surface of the post, which rises gracefully from a rectangular base. On the base broad, bead-inscribed squares repeat the rectangular motif of the muzzle. The artist has balanced the patterned and unadorned surfaces, and rectilinear with curvilinear forms in masterly fashion. In contrast, another headpost is an image of horrifying ferocity, a writhing mass of entangled dragons. Indeed, the swarm of contorted creatures that bite and clutch at each other overwhelms the form.

During the tenth century, a new style emerged in Scandinavia and the British Isles, except southwest England, the only region to escape Viking domination. This new phase of Viking art combined simple foliage elements and coarse ribbon interlaces with animals more readily identifiable than the Oseberg gripping beasts. A predominant motif is the so-called great beast, a lion-like creature usually engaged in a vicious struggle with a serpent. The style can be seen clearly in memorial stones from Jelling [3]. The Vikings customarily raised two kinds of commemorative stones, the picture stone and the rune stone—that is, a rock inscribed with runes [4]. About 980 Harald Bluetooth ordered a picture stone, a huge boulder eight feet high, bearing the inscription: "King Harald had this memorial made for Gorm his father and Thyri his mother: that Harald who won for himself all Denmark and Norway and made the Danes Christians." On one face of the Jelling Stone the sculptor carved in low relief the image of Christ robed in the Byzantine manner, with arms outstretched as if crucified. No cross, however, supports him; instead, he is bound to the stone by an intricate system of coarse, double-ribbon interlace. The Savior's presence transforms the great beast on the opposite side into a symbolic Lion of Judah, an Old Testament prefiguration of the militant Christ, and thus wholly appropriate for a royal monument commemorating the conversion of the Danes and Harald's victorious dynasty. The striding

3. Memorial stones, Jelling, Jutland, Denmark, c. 980.

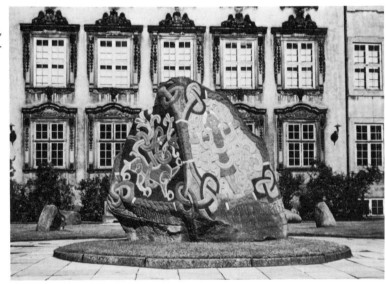

4. Copy of memorial stone, Jelling, with polychrome restored.

creature, resembling a heraldic lion, seems almost realistic when compared to the Oseberg animals, even though the double contours and spiral joints reflect the earlier style. The coarse, loosely twisting double-ribbon interlace covering the surface of the stone must have been inspired by Hiberno-Saxon art. New to the north, however, are the foliage motifs, which begin to spring from the animal forms; the great beast's tail, for example, is a rudimentary acanthus leaf.

The great beast continued to dominate the Scandinavian imagination for centuries. By the eleventh century, in Scandinavia and the British Isles the great beast was still battling serpents, monsters, and even lizard-like birds, but all the warring creatures had become so delicate and elongated that their identities had become obscured. This art has been given the name Urnes style, since the finest examples appear in wood carvings of c. 1050–70 that were incorporated in a twelfth-century church at Urnes in western Norway [5]. While enormous dragons cross above the door lintel, two

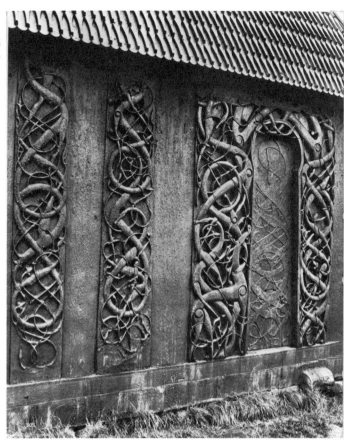

5. Stave church, Urnes. Carved portal and wall planks.

smaller animals and a pair of snakes curl down to bite them. The creatures' energy seems directed against the great beast on the left jamb, defiantly snapping at a monster, or, in symbolic terms, at the forces of evil and darkness crawling over and around the church. The beauty of the Urnes style in Scandinavia, no less than in the British Isles, lies in its aesthetic control—the elegance of drawing and the harmonious balance of thick and thin elements arranged, like the carpet pages in Hiberno-Saxon manuscripts, in a series of figure-eight patterns, but with far greater freedom and vitality.

Sculpture of such complexity and refinement as is found on the Urnes portal could not have been produced had the Vikings spent all their time on the high seas. In fact, they did establish permanent homesteads, cities, seaports, trading posts, and military camps. To-day, these settlements survive only in archaeologists' excavation reports and reconstructions; nevertheless, the cities of Ireland no less than Scandinavia owe their foundation to the Vikings. The reconstruction of the camp at Trelleborg in Denmark enables us to study the Vikings' remarkably efficient planning. Built about 1000 as a staging area for raids against England, the circular plan of the camp permitted a maximum amount of space with a minimum of wall construction. The heavily fortified main camp, over 300 feet in diameter, was surrounded not only by a ditch but by a massive earthwork, 50 feet thick, with a palisade—a fence of upright stakes—on its crest. Four tunnels led into the inner city, and two crossing avenues, more or less oriented toward the cardinal points, divided this area into quadrants.

The buildings within the Trelleborg ramparts

attest to the presence of a disciplined, well-organized military force, for simplicity and practicality determine the plans. In each quadrant, a square, central courtyard was formed by four longhouses. Uniform in size and shape, these structures had three rooms—two small ones flanking a long hall—with a door placed asymmetrically at one end. Palisade-like outer walls, along with interior posts, supported a heavy sod roof, while a stone hearth in the center of the room and earth-filled benches along the perimeter provided heating and insulation.

Wood buildings are perishable, but Norwegian and Swedish country building remained so conservative that seventeenth- and eighteenth-century farmsteads reflect the practices of the Middle Ages [6]. Hence, we know that three types of timber construction prevailed in Scandinavia and the British Isles. In the first, stripped logs notched at the ends to dovetail were stacked horizontally to form a rectangular structure which was roofed with thatch or sod. This is the familiar log cabin introduced by Swedish settlers in North America. In the second method, logs were set vertically into a sill (the horizontal beam) and squared off on the inside; the system was perfected in later Norwegian stave churches and is visible even today in the church at Greenstead, north of London. A third system—cruck construction—was widely used in the north as long as extensive forests could provide large, uniform timbers. Trees of equal height with conveniently angled lateral branches were felled, trimmed, and then halved to form pairs of upright posts and roof supports. A series of crucks, joined by horizontal members (sills and plates) created the skeleton of the building, while thatched roofs and wattle and daub walls—that is, wickerwork branches roughly filled with clay, rubble, and plaster—made the dwelling or shelter reasonably snug.

In the British Isles, builders, inspired by Carolingian structures as well as the indigenous masonry tradition dating back to the Roman occupation, built churches of stone as well as wood. In the Church of St. Lawrence in Bradford-on-Avon, founded in the eighth century and remodeled in the ninth, the long rectangular plan and striking verticality carry to an extreme the proportions characteristic of earlier timber and stone churches. In marked contrast to the wide naves and triumphal arches of Mediterranean basilicas, Anglo-Saxon churches offered the congregation enclosing walls, narrow openings, and soaring height.

European architecture and sculpture exerted a greater influence on the decoration of English ecclesiastical foundations, no doubt because St. Dunstan's revival of Benedictine monasticism brought the insular monasteries into closer contact with the Continent. At St. Lawrence's church, pilaster strips and a blind arcade of short columns joining two horizontal moldings enrich the exterior. Simplified as they are, such Classical references suggest the same desire to emulate the imperial Christian past that motivated the Carolingian builders. The interior of St. Lawrence was once adorned with painting and monumental sculpture [7]. At the top of the west wall facing the altar two carved angels, each almost five feet long, still fly with veiled hands toward a venerated object, probably a painted crucifix or an *Agnus Dei*.

The Anglo-Saxons did not reject the Viking legacy of timber architecture, even when building with stone. The tenth-century tower at Earls Barton, for example, merely translates into stone the basic elements of wood decoration [8]. The pilasters, triangular moldings, arcades, and square string courses have a sticklike quality more appropriate to woodwork than to masonry. The round balusters dividing the windows on the first level were turned on a lathe, while the five-part belfry arcade is supported by cigar-shaped shafts that are equally foreign to the masonry tradition.

In the visual arts, the part of England remaining outside the Danelaw developed a style closely related to Continental art—so

6. Farmstead showing traditional building types. Norwegian Folk Museum, Bygdoy, Oslo.

7. Church of St. Lawrence, Bradford-on-Avon, ninth century.

8. Church tower at Earls Barton, tenth century.

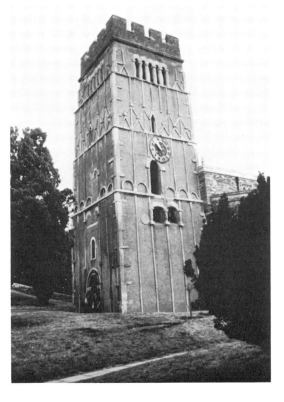

much so that it may even be considered an Anglo-Saxon phase of the Carolingian renaissance. The early ninth-century Easby Cross, for instance, could have been conceived only after a renewed and appreciative encounter with the Classical art of Western Europe, an encounter again due to Benedictine monastic connections. On one face of the two surviving fragments of the cross, bust portraits of Christ and the apostles are arranged within arches

[9]. Although the surface is severely weathered, we can still see the naturalistic proportions of the heads and the depth achieved by the saints' foreshortened, overlapping shoulders. A sense of solidity pervades the deeply cut sculpture, for the artist worked with light and shade to produce the kind of tangible, plastic forms that bespeak a new humanism.

The Anglo-Saxon painters, profoundly affected by Carolingian art but at the same time the heirs of a strikingly different pictorial tradition, created two kinds of illustrated manuscripts: those with fully painted illuminations and those with colored drawings based on the *Utrecht Psalter* style. The *New Minster Charter* exemplifies the first type and shows that willful combination of Hiberno-Saxon and Carolingian art that marks the Winchester style [10], a style characterized by an almost excessive use of curling acanthus foliage and a ragged, fluttering line inspired by Carolingian draftsmanship of the Reims and Metz schools. In 966 King Edgar granted a charter to St. Ethelwold's abbey, or minster, at Winchester. Like the Carolingian alliance of Church and state, the Benedictines' close ties with the Anglo-Saxon royal house fostered the creation of works of art. Thus, St. Ethelwold commissioned a luxurious copy of the charter to be displayed on the abbey altar as a testament to the importance of the Benedictines in England. Written in gold, with three illuminated introductory pages, the *New Minster Charter* rivaled Carolingian imperial manuscripts. The dedication page shows King Edgar presenting the charter to Christ, who is enthroned in a mandorla and supported by angels while the Virgin and St. Peter, patrons of the abbey, look on. The composition recalls presentation scenes in Carolingian work, but the figure of King Edgar is an original Anglo-Saxon creation. The figure is twisted and the head turns back over the shoulder to simultaneously look up at Christ and confront the spectator. The other figures, while not subject to such contortions, also move energetically, creating animated draper-

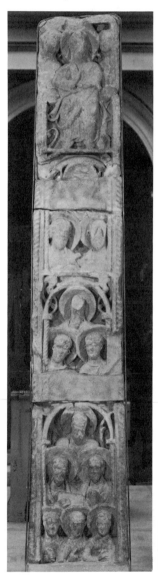

9. Easby Cross, early ninth century. The Victoria and Albert Museum, London.

ies pulled tightly across the thighs that end in crinkly edges or flying folds.

Acanthus leaves winding around golden trellises frame the *New Minster Charter* page in a design characteristic of the fully developed Winchester style. The variegated curling leaves seem to grow from a stem located in the center of each side. In contrast to Carolingian artists, who filled golden letters with acanthus shoots or enclosed the foliage within a geometric border, Anglo-Saxon illuminators followed their Hiberno-Saxon predecessors and let the ornament burst out beyond the frame. Ultimately foliage and trellis frames dominated the page.

Magnificent frames characterize the finest manuscript of the Winchester group, the *Benedictional of St. Ethelwold,* a prayer book used by the bishop during Mass [11]. The *Benedictional* was produced at Winchester about 980 by the scribe Godoman. The flowers that creep beyond the trellis in the *New Minster Charter* here have assumed command of the entire decorative system. Gold, double-banded trellises support a luxuriant growth of acanthus foliage and four outsized rosettes. As the leaves wind around the frame or each other, they seem permeated with energy. More important, however, is the fact that figures inhabit the frame and play a narrative role in the central scene: the Holy Women in the right border face the angel seated on Christ's empty tomb, while at the left the Roman soldiers gaze awestruck at the miracle of the Resurrection. The frame, whose enclosing function is already challenged if not destroyed by foliage, becomes a mere foil for actors in a religious drama, as the actors become visual adjuncts to the border rosettes. The entire narrative seems to take place in front of, rather than behind, the frame. The tomb, the angel, the soldiers, and the women seem to float into the spectator's space—an effect accentuated by the neutral background and the elimination of all ground lines. In the best tradition of Hiberno-Saxon and Anglo-Saxon

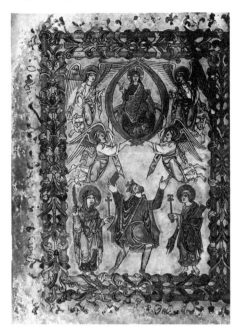

10. King Edgar presenting the charter to Christ, *New Minster Charter,* Winchester, 966. The British Library, London.

11. The Marys at the Tomb, *Benedictional of St. Ethelwold,* Winchester, c. 980. The British Library, London.

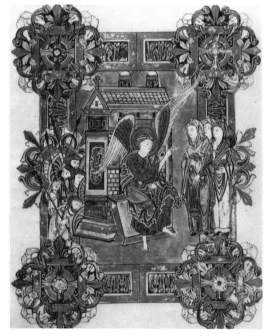

decoration, Godoman and his assistants combined frame, text, and illustrative scenes into a single ornamental composition.

An unfinished page in the *Benedictional* provides an opportunity to study the tenth-century Anglo-Saxon artist's method. The illuminator first rendered the outlines in red, and then filled them in with broad areas of color, over which he applied both light and dark tones. Godoman drew with quick, staccato strokes, especially when representing drapery and foliage. He created heads, with their broad low brows, square jaws, and jutting necks, like those of the Reims school, although the stockiness of his figures bears more relation to the Metz type; but unlike that of the Carolingian models, his drapery becomes so elaborate and excited that the bodies almost disappear. Through the swirling pattern of rippling drapery with fluttering, ragged edges, even a rather static figure gains a nervous energy. When the undulating lines of clouds,

hills, or water are added to the scene, individual elements and sometimes the very narrative are virtually lost.

The visually dynamic appearance of the *Benedictional* owes much to skillful and expressionistic drawing. Indeed, artists in the British Isles had always shown a marked predilection for this medium. Faster and cheaper than painting and gilding, drawing suited active monastic scriptoria that were not sustained by an imperial court. Moreover, books had to be produced rapidly in the tenth and eleventh centuries, for the libraries devastated by Viking raids had to be reestablished. This predilection for drawing was reinforced when the *Utrecht Psalter* was brought to Canterbury about 1000. How and why the manuscript came to England from France remains a mystery.

Scribes at Canterbury copied the *Utrecht Psalter* three times, and in so doing developed a style of draftsmanship unsurpassed in vigor

12. Scenes of daily life: builders, sailors, farmers, prisoners. Psalm 106, copy of *Utrecht Psalter*, after 1000. The British Library, London.

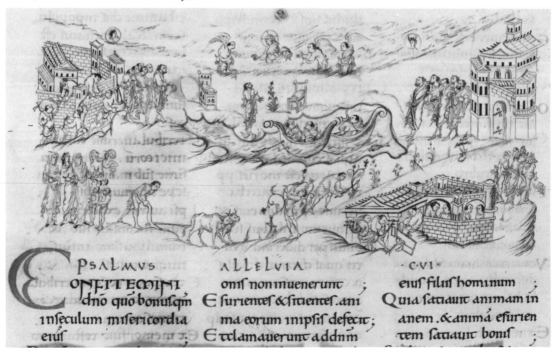

13. Heaven and Hell, *Liber Vitae of New Minster*, Winchester, 1020. The British Library, London.

and eloquence. The version now in the British Library and known, from its catalogue number, as Harley 603 must have been done shortly after the arrival of the *Psalter* [12]. The copyists seem to have understood both the Classical heritage that first inspired the earlier painters and the dynamic linearism with which the Carolingians had reinterpreted their models. Nevertheless, although the Anglo-Saxon draftsmen remained faithful to the iconography and composition of the original, and even transmitted its directness and graphic intensity, they also began the process of changing the Carolingian illusionistic style into abstract and decorative patterns. They simplified the structure of individual forms and, more important, they rejected the uniform brown ink favored by Carolingian scribes, choosing instead to work with red, green, blue, amber, and lavender lines. Such polychromatic drawing, where colors are applied without regard to the actual hue of the object represented, became a specialty of Anglo-Saxon illuminators, and the primary means by which they heightened the expressive quality of the work and

simultaneously achieved quick, inexpensive, ornamental effects. Thus the copy actually denies the Classical illusionistic tradition from which the *Utrecht Psalter* sprang and, through the abstraction of the changing color, created a new aesthetic in which ornamental quality— color and rhythmic line—dominates the image. Classical illusionism, in its Carolingian form, gives way to Medieval expressionism.

The Anglo-Saxon artist's narrative skills are impressively displayed in the drawings in another manuscript of the Winchester school, the *Liber Vitae of New Minster* (a list of benefactors, for whom prayers were to be said, kept on the altar). In the upper register of a highly theatrical Last Judgment [13], St. Peter spiritedly welcomes the blessed into paradise. Below, assisted by an angel holding the book of good deeds, Peter fights for a soul by smashing the devil's face with his huge keys, while an angel triumphantly locks the gate against an enormous demon who pulls the damned by their hair into the gaping mouth of hell. The draftsman's interest in human reactions, his delight in pictorial detail, and

his cavalier arrangement of compositions and figures for the sake of dramatic confrontation became characteristic features of English art.

The *Liber Vitae* was commissioned in 1020 by King Canute for the new minster at Winchester. On the dedication page, the king and his queen, patrons of the abbey, place a cross on its altar while Benedictine monks observe the scene from an arcade below [14]. As in King Edgar's charter, Christ, the Virgin, and St. Peter bless the donation; however, the rulers now actually flank the altar and receive crowns from Heaven-sent angels, making the charter a political document to symbolize the

14. Patrons of the minster, *Liber Vitae of New Minster*, 1020. The British Library, London.

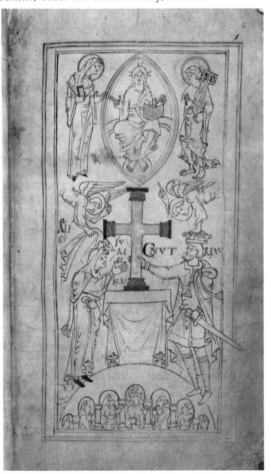

Church's sanctification of the monarchy. The frontispiece also shows the first signs of a stylistic transformation that was to take place in Anglo-Saxon art about the middle of the eleventh century. The symmetrical, architectonic composition, and the quiet figures drawn with relatively firm, regular lines herald the absolute domination of the Western European Romanesque style carried from the Continent in 1066 by the Norman conquerors. Duke William's victory at the battle of Hastings and the consequent supremacy of the Normans in the British Isles brought the Anglo-Saxon phase of English art to a close—at the same time that it set the stage for the development of what we now call Anglo-Norman art.

North Sea art and architecture demonstrate again that pattern of religious and artistic confrontation which so often occurred as Christianity supplanted pagan belief. At first, only the content of art changed. Just as Christ once appeared in the guise of Helios or Orpheus, so missionaries to the Vikings identified the Savior with the great beast. The eventual appropriation of Christian iconography, with its didactic narratives acted out by human figures in architectural or landscape settings, forced artists to abandon the animal style that had held sway in the north since prehistory. Yet these artists never ceased to communicate the sheer energy of the forces of nature, for they expressed the content of their work through drawing, color, and intricate patterns rather than through personifications or literal representations. The result was a revitalized Christian art.

Harald the Ruthless, the "thunderbolt of Norway," invaded England in 1066, only to lose his life and his troops at the hands of the English King Harold. With this defeat, Scandinavian art suffered a mortal blow. Decimated by war, the Vikings subsided into a peaceful backwater. King Harold's victorious forces were weakened and battle-weary, and hence

no match for William the Conqueror, who overwhelmed them three weeks later at Hastings. William was therefore able to unite England with Normandy, and in so doing he created a powerful new political and cultural entity.

The Second Golden Age of Byzantium (867–1204)

When in 843 the Council of Constantinople ended the iconoclastic controversy, the Byzantine emperors embarked on an ambitious program of restoration, rebuilding, and refurbishing the city's palaces and churches. Constantinople again became a city filled with rich treasures and spectacular buildings. This splendid court was supported by the military prowess and administrative skill of the emperors of the Macedonian dynasty. In the ninth century a wily and ruthless player in the game of palace intrigue, Basil I (867–886), established the long-lasting Macedonian dynasty (867–1056). Basil and his successors, Leo VI (886–912) and Constantine VII (912–950), patronized the arts as an imperial policy. Churches, mosaics, icons, illuminated manuscripts, and other ecclesiastical treasures testify to the enduring glory of the Empire. The period became the Second Golden Age of Byzantine art, a period that can be divided into two principal phases: the Macedonian renaissance, 867–1056, and the Comnenian period, 1081–1185.

The creation of art and architecture on a grand scale requires political and economic stability. Although the Macedonian dynasty provided these conditions during the first hundred years of its existence, by the latter part of the tenth century, Muslim armies and marauding bands of Slavs and Vikings threatened the Empire. The Muslim armies were halted by Nicephoros II Phocas (963–969), while the Slavs suffered defeat at the hands of Basil II (967–1025), thenceforth known as "the Bulgar slayer." Meanwhile, the Viking

danger in Russia was eliminated peacefully, for in 989 Vladimir II, Prince of Kiev, accepted Byzantine Christianity, affirming his decision by marrying Basil's sister.

Troubles multiplied after the death of the last Macedonian empress, Zoë, in 1050. In 1054 the abiding conflict between Byzantine and Latin Christianity, this time focused on the definition of the Trinity, resulted in the final separation of the Eastern and Western Churches, with the pope in Rome and the patriarch in Constantinople excommunicating each other. In the West the Normans established a foothold in southern Italy, took the key city of Bari in 1071, and soon turned the former Byzantine territory into the Duchy of Apulia. In the East the Muslim threat increased when the Seljuk Turks rose to power. Sultan Alp Arslan routed the Byzantine army at Manzikert, in Armenia, in 1071 and thereafter conquered most of Asia Minor. During the crisis a new dynasty came to power, headed by Alexius Comnenos (1081–1118) and inaugurating the Comnenian period, 1081–1185. In this time of peril Emperor Alexius turned to the West for help, despite the breach between the two Churches, and his plea to Count Robert of Flanders led Pope Urban II to preach the First Crusade in 1095. Ironically, the Westerners proved to be as dangerous to Byzantium as the Turks, for they could not resist the temptation offered by the wealth of Constantinople. In 1204 they sacked the city and established themselves as rulers, thus ending the Second Golden Age of Byzantine art.

The Constantinople seen in the tenth and eleventh centuries was not the city built by Justinian, nor even that known in Charlemagne's time, for many of the capital's most magnificent monuments had been severely damaged during the iconoclastic controversy. When, in 853, the Council of Constantinople ended that puritan interlude, the Byzantine emperors embarked on an ambitious program of restoration, rebuilding, and refurbishing the

city's palaces and churches. Constantinople again became a city filled with treasures and splendid buildings.

New designs for churches were developed to meet changing liturgical requirements. In the ninth and tenth centuries Christian liturgy, glorifying both God and His imperial vicar on earth, became increasingly complex and mysterious. The rituals of the Church were hidden from the congregation even more effectively than they had been in Justinian's day, for the choir screen grew into a high, solid wall hung with icons, and hence known as an iconostasis. From a door in the iconostasis the clergy emerged but briefly during the greater and lesser entrances, to display the Gospel and the Host. The congregation, while hearing the Eucharist celebrated behind the iconostasis, meditated on the icons and looked upward beyond the tiers of images to mosaics or paintings in the vaults dominated by the imposing image of Christ as Pantocrator, or Ruler of the Universe.

In order to meet the new liturgical requirements and aesthetic preferences, Byzantine architects evolved novel building types based on compact, centralized plans and vertical rising spaces made all the more striking by the reduced size of the churches. Furthermore, a tendency to subdivide spaces and forms and to elaborate details also increased. The architects turned for inspiration to the Greek-cross plan; however, the earlier arrangement of a central dome, rising from the midpoint of an equal-armed cross, diverged into two distinct, albeit related, structural types known as the cross-in-square (or quincunx) and the Greek-cross-octagon. In both designs the central space became the focal point of the architectural composition and the iconographic program. The religious architecture of Greece, the Balkans, and Russia—in fact, the architecture of the Orthodox Church even today—is a variation on these designs.

The eleventh-century churches in the monasteries of Hosios Loukas and Daphnī in Greece illustrate the two most distinctive Middle Byzantine plans: the cross-in-square and the Greek-cross-octagon. The simpler of the two types, the cross-in-square, is illustrated by the Theotokos at Hosios Loukas (tenth century); a central dome on pendentives rests on four columns or piers and is surrounded by four radiating barrel vaults that form a Greek cross [15]. Lower groin vaults between the barrel vaults fill out the square plan. (In Late Byzantine architecture, subsidiary domes replace the groin-vaulted corner bays.) Three tall, projecting apses reiterate the verticality of the central space. The compact plan and steeply rising spaces, from groin-vaulted corner bays to barrel vault to dome, direct the worshiper's attention upward to the central dome, which, with its window-pierced drum, becomes the focal point of the church [16].

The Greek-cross-octagon is seen in the Katholikon (c. 1020) and in the Church of the Dormition at Daphnī (c. 1080) [17]. The Katholikon (dedicated to a local hermit, the Blessed Luke of Stiris) is the principal church at Hosios Loukas. Although a Greek cross in plan, it is converted into a central octagon at the level of squinches, which in turn brace the eight pendentives forming a circular base for the window-pierced drum of the dome. Barrel vaults cover the arms of the cross; a shallow dome, the eastern bay; and a half dome, the apse. This central space s surrounded by aisles and galleries, groin-vaulted and opening into the central space through high narrow arches and arcades. These narrow, compressed spaces contrast with the open naos. The Greek-cross form of the church becomes apparent only as the eye wanders upward above the galleries. Since the vaults over the Greek cross extend from the sides of the octagon of the dome, not the square of the plan, their narrowness enhances the verticality of the design. Light filters into the interior from windows in aisles and galleries and streams directly in from tall windows under the dome. A two-story, groin-vaulted narthex stands across the

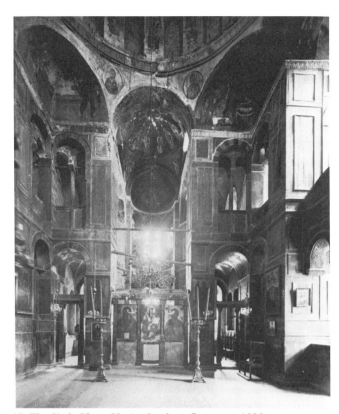

15. The Katholikon, Hosios Loukas, Greece, c. 1020.
Mosaics: Virgin in the apse, Pentecost in the lower dome, c. 1020.

16. Plan, churches of the monastery of Hosios Loukas, Greece, eleventh century.

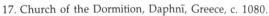

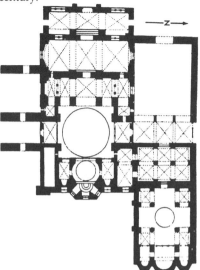

17. Church of the Dormition, Daphnī, Greece, c. 1080.

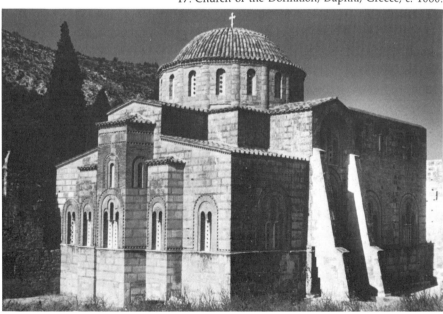

church's western end. This complex architectural design produces a series of forms and spaces subdivided and compartmentalized, yet simultaneously unified by the central dome.

On the exterior of the churches, a sense of ascendant forms is effected by the graduated heights of the apses, the walls and roofs disguising the squinches and vaults, and, the loftiest of all, the drum and central tile-covered dome. Intricate masonry patterns, formed by alternating courses of brick and stone, bond the mural surface. The Greeks often transformed this structural device into pure decoration by outlining the stones with bricks set both vertically and horizontally, a decorative technique known as cloisonné wall work. A lively, two-dimensional ornament of string courses composed of zigzag, curved, and sawtoothed brick moldings further enhances the wall.

18. Virgin and Child, Katholikon, Hosios Loukas, Greece. Apse mosaic, variously dated 1020 to 1100.

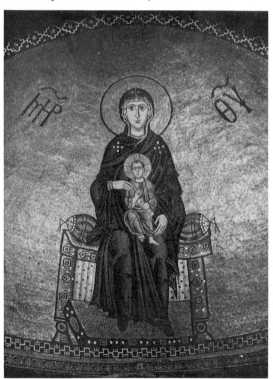

Just as the exterior walls are reduced to a pattern of stone and brick, so the supporting function of the interior walls and piers is denied by the marble and mosaic decoration that overspreads the surface, illuminated by single, double, and even triple windows. Theologians attempted to make the Christian mystery visible in the decoration of the church. The entire building—architecture as well as ornament—became for them a microcosm of the Christian universe. Artists throughout the Byzantine world adhered to the same guidelines, even if they modified the program to provide for the cult of local saints or to conform to the architectural details of a specific church. Following a general principle that the loftier the placement, the greater the honor paid to the image, Byzantine planners reserved the domes and highest vaults for Christ, the Virgin, and the angels. Christ the Pantocrator, Ruler of the Universe, naturally commanded the central dome. His Ascension or the Pentecost might appear in a secondary dome—the Pentecost appears over the sanctuary at Hosios Loukas—while Mary was portrayed in the slightly lower conch of the apse [18]. The next level—the squinches or pendentives and the higher vaults—held scenes from the earthly life of Christ, arranged according to the order of festivals in the Church calendar rather than in historical sequence. At Hosios Loukas, the Annunciation, Nativity, Presentation, and Baptism of Christ fill the four pendentives of the central dome. In the lesser vaults and on the walls were the saints, apostles, and prophets, the superior beings who had once inhabited this world. Finally, the marble-sheathed dado and the floor represented the realm of matter, where living men and women witnessed the mysteries depicted above them.

The viewers' psychological association with the image was of concern to these Byzantine designers. In order to render the image as a sacred icon within a mystical realm and simultaneously establish a direct relationship

with the viewer, artists developed a style that is best termed, in Demus' phrase, "abstract verism." They condensed the scene down to its essential components, eliminating all unnecessary details. Consequently, in the ultimate reduction of setting, as in the image of the Virgin in the apse, the figures seem to float in a golden atmosphere. At the same time, to help the worshiper identify with the images, the depicted figures and events also had to be represented with some degree of realism. To resolve these seemingly contradictory aims, artists turned to the art of the past, to Greco-Roman art and the art of the First Golden Age of Byzantium.

In the first phase of the Middle Byzantine period, the so-called Macedonian renaissance, mosaicists adopted those vast expanses of gold tesserae, as well as the geometric and foliage ornament that had characterized iconoclastic art of the eighth century. With this abstract mode, they blended two kinds of Classicism: the Classical aspect of Justinianic art, particularly accessible in secular works that had survived iconoclasm, and the original Greco-Roman style itself. Unlike the ancient masters, Byzantine artists conceived of their figures as intellectual, rather than physical, ideals. In Plotinus' theory, the image does not exist independently, creating a space of its own within a frame or behind a picture plane, as in Western art. On the contrary, the picture, the beholder, and the zone between them share the same cerebral space, a space articulated by constantly shifting sight rays joining viewer and image. The artist, therefore, in designing a mosaic, had to treat the viewer as an active participant in the composition.

After the triumph of the iconodules (lovers of images) the obliterated images in Hagia Sophia were restored or replaced. The image of the Pantocrator in the central dome has been lost, but that of the Virgin and Child enthroned in the apse has been recovered from under layers of whitewash applied by the Ottoman Turks when they converted Hagia

Sophia into a mosque [19]. In 867 the Patriarch Photios preached on the restoration of the images in the great church. The monumental mosaic of the *Theotokos* must be dated to this time. The massive figures and the idealized faces of Mother and Child demonstrate that the sensitivity to Classical art and the craft of mosaic had not been lost during the two hundred years of iconoclasm. The heritage of Greco-Roman and Justinianic Classicism accounts for these solid, well-proportioned figures, clothed with form-defining garments; however, the garments are always given a separate existence as brittle, linear patterns of small, sharp, angular folds. As the style developed, the tendency toward stylization in

19. Virgin and Child, Hagia Sophia, Constantinople, c. 867. Apse mosaic.

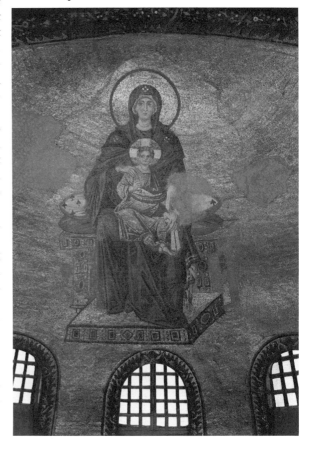

Byzantine art became clear; a comparison of the two representations of the Virgin and Child illustrates the continuity and change in Byzantine art. The artists began to modify the traditional method of modeling through the subtle gradation of colors and began to rely on juxtaposition of rows of light and dark tesserae. The mosaicist counted on the distance between the image and the beholder to blend the colors and create the illusion of forms modeled in light. When studied within a proximity never intended, the images dissolve into a colorful network of cubes. For example, a few dark lines serve to describe facial features, with a row of light tesserae highlighting the bridge of the nose. That the mosaic reads convincingly from the proper vantage point is a tribute to the craftsmen's clever manipulation of optics. In later Byzantine art, these devices became such an inviolable part of the stylistic canon that even in small manuscript illuminations the strongly linear, sharply highlighted manner prevailed.

The splendor of the Macedonian renaissance art has survived best in a series of extraordinarily rich manuscripts, in which painters unite religious expressionism with Classical inspiration. An extreme example of this neo-Classical renaissance is the *Joshua Roll,* a long scroll now cut into thirteen sheets [20]. Even the ancient format has been continued; text and images unwind in a continuous narrative. Joshua appears as commander (5:13–15) and prostrate before the angel. Personifications, illusionistic landscape details, figure types, and details of costume all presuppose an intimate knowledge of ancient models. The crowned seated figure under the tree, personifying the city of Jericho, for example, derives from the well-known Hellenistic sculpture, the Tyche of Antioch. The scroll format precluded the use of heavy paint or gold, which might crack and flake when rolled. Instead, drawings are lightly tinted with blue and brown washes.

In contrast, codices were heavily painted in brilliant colors. The *Homilies of St. Gregory Nazianzus* is such a book, an illuminated manuscript made for Basil I between 880 and 886 [21]. One miniature in this book of sermons presents the Vision of Ezekiel in the Valley of the Dry Bones (Ezek. 37:1–14), an Old Testament prefiguration of the Christian

20. Joshua and the Angel, *Joshua Roll,* Constantinople, tenth century. Height, 12 3/4".
Biblioteca Apostolica Vaticana.

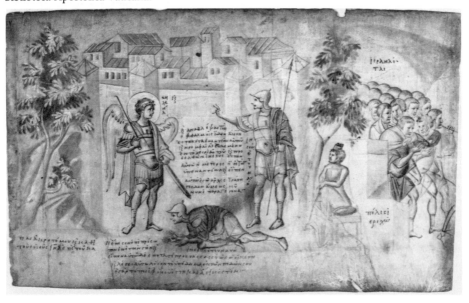

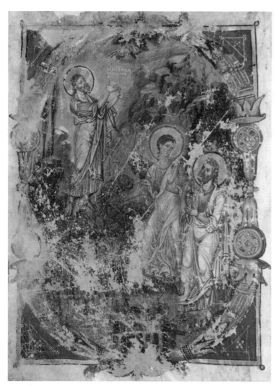

21. Ezekiel in the Valley of the Dry Bones, *Homilies of St. Gregory Nazianzus*, Constantinople, 880–86. 16 1/8″ × 11 3/8″. Bibliothèque Nationale, Paris.

Even more dependent on Classical models are the paintings in the *Paris Psalter*, a book of Psalms produced in the early or mid-tenth century and now in the Bibliothèque Nationale, Paris [22]. Each of the fourteen illustrations occupies a full page. With no text to interrupt the pictorial composition, each image gains an iconic independence. Antique references abound; David playing the harp could have been copied from a Classical Orpheus charming the animals. With the muse Melodia at his back, David strums the harp, while the nymph Echo peeps around a stele. In the background, a rocky, forested landscape opens up to reveal the city of Bethlehem, whose personification reclines like a Classical river god in the lower right corner. Moreover, the painter strictly followed the ancient formulas for achieving realism by modeling his figures in subtly changing tones of light and dark and integrating them within a receding three-dimensional space. Applying the principle of atmospheric perspective, the painter even colored the farthest trees with lighter hues than

22. David the harpist, *Paris Psalter*, Constantinople, tenth century. 14 1/8″ × 10 1/4″. Bibliothèque Nationale, Paris.

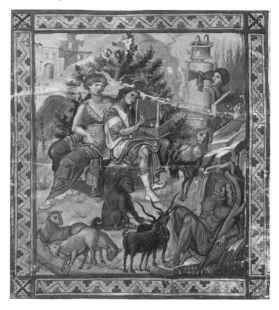

Resurrection. The angel and Ezekiel (the latter shown twice) stand within a landscape where the rosy hues of the horizon fade into blue heavens, creating a feeling of space and atmosphere in spite of the highly stylized mountains. The contrast between illusionism and abstraction appears again in the figures, where well-proportioned forms are articulated by clinging garments, but at the same time that these so-called damp folds mold the body, the drapery falls into a crumpled, linear pattern independent of any realistic movement or shape. Here Byzantine abstraction can be seen to move toward decorative stylization. The ornamental aspects of the Ezekiel folio are reinforced by the heavy oval frame, for its complex sheafs and medallions with simulated jewels have a visual existence quite unrelated to the scene within.

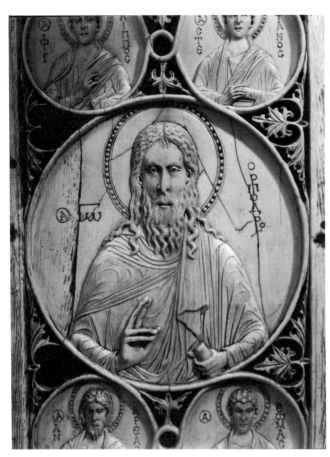

23. St. John (detail), late eleventh century. Ivory. 9 1/8″ × 5 1/4″. The Victoria and Albert Museum, London.

those in the foreground, and at the same time he reduced the size of the town and rocks in a manner suggestive of the ancient Roman artists' window view of the world.

With the advent of the Comnenes in the second half of the eleventh century, Byzantine art turned to elegant refinement but also acquired a new vitality. Once again a Classical canon of form served as a vehicle for this transformation, but it was applied to the entire figural conception rather than to mere details. In the minor arts, Comnenian work is epitomized by a Constantinopolitan ivory panel of John the Baptist surrounded by SS. Philip, Stephen, Andrew, and Thomas [23]. The composition is generated by the circle; as framing bands move from one rondel to the next, accompanied by symmetrical, spiky acanthus leaves in the interstices, the halos repeat the circular forms and accentuate the delicacy and remoteness of the heads. The extremely low relief of the carving here has reached a level of technical perfection that enabled the sculptor to model details of hair and garments with exquisite precision.

Just this combination of gentle elegance and severe artistic control is found in almost all Byzantine art of the late eleventh and early twelfth centuries, even in the rare statuette, carved fully in the round, of the Virgin and Child [24]. Because the Virgin gestures toward Christ, this type of image is known as the *Hodegetria*—that is, the Mother of God "showing the way." The thin, vertical fluting of the Virgin's drapery and the attenuated lines of her mantle, falling in pressed folds from her left arm, elongate the body and give the Virgin a regal and rather cool presence.

The proportions of Christ seem even taller and more slender than those of the Virgin. The Byzantine artist's penchant for linear organization has imposed itself in this three-dimensional work, for the Child's left arm and right leg extend across Mary to repeat the line of her gesturing arm, while His right arm follows the diagonal direction of her cloak.

A respect for impeccable craftsmanship and a refined aesthetic sensibility also guided Comnenian scribes and painters. In the portrait of Emperor Nicephoros III Botiniates (1078–1081), flanked by St. John Chrysostomos and the archangel Michael, found in an illustrated copy of the saint's homilies, the splendid embroidery of the robes turns the figures into flat, hieratic patterns of blue, black, and gold, isolated in a spaceless setting by the unbroken gold background [25]. Into this carefully fashioned imperial epiphany, strikingly naturalistic elements make an unexpected intrusion: the idiosyncratic features of the emperor seem to have been painted from life. Of course, the fourth-century St. John Chrysostomos cannot be a true portrait; nevertheless, the painter rendered a convincing type. Indeed, the saint's emaciated countenance, with deep-set eyes, sunken cheeks, and a prominent jawbone, describes an ascetic nobility wholly fitting for the revered Greek Church Father. The angel's face exemplifies that idealized Greco-Roman type seen in the Macedonian renaissance. In the final analysis, the illumination demonstrates the self-conscious appropriation and integration of styles—decorative abstraction, Classicism, realism, and emotional expressionism—that characterizes the sophisticated Comnenian court.

Comnenian artists could also compose the awe-inspiring images so essential to Byzantine ecclesiastical decoration. The image of the Virgin and Child from Hagia Sophia has already been mentioned in the discussion of the iconographical program of the Byzantine Church. As we have noted, the focal image was the Pantocrator. The mosaic of the Pan-

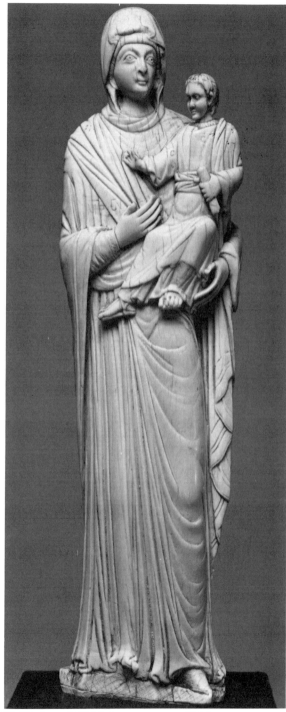

24. Virgin and Child. Ivory statuette. Height, 12 3/4″. The Victoria and Albert Museum, London.

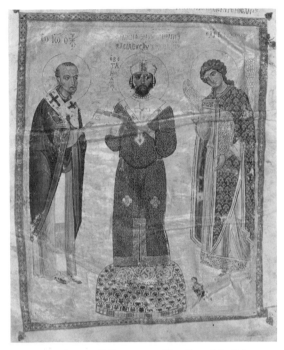

tocrator at Hosias Loukas fell in an earthquake in 1593; however, the image in the central dome of the Church of the Dormition at Daphnī has survived [26]. The artist eliminated all extraneous features from the portrayal of the Pantocrator; for all its striking lifelike power, it is dematerialized into a terrifying and condemning divinity hovering in a vast, golden glory. By building the head on a system of concentric circles and reducing drapery to a series of parallel lines and acute angles, the artist rendered the human form as both a naturalistic shape and a geometric design. Thanks to this combination of the real and the mystical, the omnipotent character of the Pantocrator is revealed. His strong hand and His great, staring eyes truly intimidate—as if the threat of damnation were passing along charged sight lines to the sinner standing below.

25. Nicephoros III Botiniates, *Homilies of St. John Chrysostomos*, Constantinople, 1078–81. 16 1/2″ × 12 1/4″. Bibliothèque Nationale, Paris.

26. BELOW LEFT: Christ the Almighty, Daphnī, Greece, c. 1100. Dome mosaic.

27. BELOW: The Crucifixion, Daphnī, Greece, c. 1100. Mosaic.

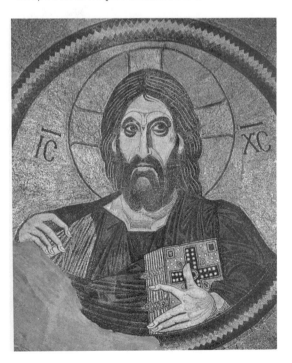

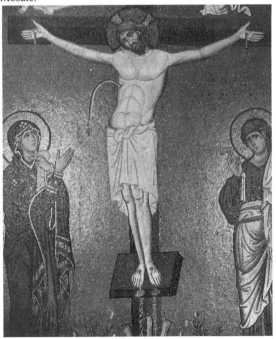

Like the Pantocrator in the dome, the Crucifixion at Daphnī expresses the new emotional content of Comnenian art [27]. An expanse of gold tesserae isolates Christ, Mary, and St. John (and originally mourning angels) and eliminates every indication of time and place. With none of the detail of earlier representations, such as the *Rabbula Gospels,* the scene acquires the timeless concentration of an icon and becomes a symbolic rather than a narrative representation of the Crucifixion. The figures are elongated, their bodies and garments rendered with boldly drawn patterns which only hint at the solidity of Classical models. Christ is represented as *Christus patiens,* the suffering Christ. In contrast to earlier triumphant representations, here He is naked and dying. His blood streams down to Adam's skull on Golgotha (a conflation of the legend of the True Cross and John 19:17). The image is both a reminder of the essence of the Eucharist and a promise of salvation, following Paul's letter to the Corinthians (I Cor. 15:22): "For as in Adam all die, even so in Christ shall all be made alive."

Byzantine art spread through the Balkans and Russia, and was introduced into Western Europe through Venice and Sicily. The ancient Republic of Venice maintained close diplomatic and economic relations with Constantinople and other important cities in the Eastern Empire long after northern Italy had gained independence from Byzantine rule. The prosperity of Venice rested in large measure upon its commercial interchange with the East. Venetian architecture emulated that of Byzantium. Thus, when in 1063 the Venetians began to rebuild the church of their patron, St. Mark, they copied the Greek-cross domical Church of the Holy Apostles in Constantinople [28]. Naturally, they incorporated the changes made during the tenth-century remodeling of the Apostoleion, a project that resulted in the raising of the five domes on drums pierced by

28. Church of St. Mark, Venice, after 1063.

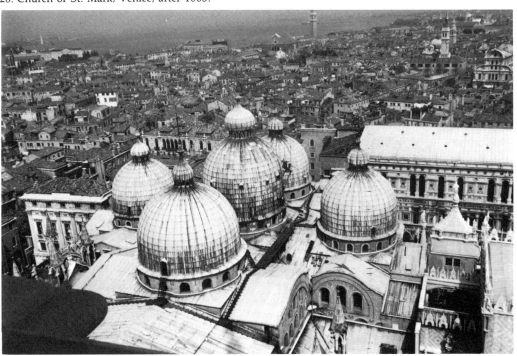

arched windows. The major structural elements, the five great domes with connecting and abutting barrel vaults, interacting as massive hemispheres and tunnels, produce a space reminiscent of Justinianic architecture. Unlike the complex broken views characteristic of Middle Byzantine buildings, St. Mark's is subdivided into large units, repeated and flowing into the next with harmonious grandeur. The eleventh-century mosaics, although restored, still convey the sumptuous effect of the original scheme. The building and ornamentation of St. Marks' went on well into the seventeenth century; thus much of the decoration of the church as we see it today postdates the Middle Byzantine period.

Southern Italy and Sicily were also receptive to Byzantine art and architecture, but for different reasons. The Eastern Empire had reconquered southern Italy about 970, and ruled the territory through a governor based at Bari. Sicily, in the meantime, having been taken by the Saracens in 827, remained in Muslim hands. The Normans, under Count Roger (1061–1101), captured Bari in 1071 and within twenty years controlled Apulia and Sicily. Roger's nephew Roger II (1101–1154) was crowned "King of Sicily, Apulia, and Calabria" in 1130 at Palermo. In this new capital, Norman, Muslim, and Byzantine artistic traditions mingled to form a brilliant and exotic setting in which the Norman kings sought to rival the glory of Byzantium.

At Cefalù, a town on the Mediterranean coast east of Palermo, Roger II founded a church intended to serve as his dynasty's pantheon. In 1132 he commissioned a decorative program in the Eastern fashion and imported material and mosaicists from Constantinople to do the work, which may have been finished in 1148, or may have continued through the 1180s. Despite the king's admiration for Byzantine forms, the cathedral at Cefalù was built on the basilican plan more common to Western architecture. As a consequence, artists had to adapt the iconographical

scheme developed for Middle Byzantine domed buildings to a longitudinal basilica—that is, a church whose aesthetic focal point was the apse rather than a central dome. The image of the Pantocrator filled the conch of the apse; angels appear in the groined vault of the sanctuary [29]. Still adhering to the principle that the larger and higher the figures, the greater their sanctity, the mosaicists placed Mary with the archangels above the apostles in superimposed registers on the curving lower wall. In decorating the sanctuary, the artists compensated for the large area and distance from the spectator by increasing the figure size and intensifying the colors. As they enlarged the forms, the artists simplified shapes and reduced modeling to broad zones of flat color. Such an adjustment was necessary, since several rows of like-colored tesserae now had to fill an area once covered by one, or at most, two rows. With the attempt at tonal modeling almost abandoned, faces and draperies have become, on close examination, a stylized network of color bands. The radiance of gold spreads over architecture and figures alike—from the mosaic acanthus capitals of the framing colonnettes to the gold-shot robe of Christ. The final effect is of static figures, but figures whose very stillness creates a moving serenity and spiritual eloquence. This serenity imbues the Cefalù Christ with a kindly dignity, contrasting with the terrifying Pantocrator of Daphnī. Even His blessing seems more welcoming, and His open book proclaims in Greek and Latin, "I am the light of the World" (John 8:12).

While the Cefalù cathedral was still under construction, King Roger commissioned a palace and chapel in Palermo. The chapel was consecrated in 1140, although the craftsmen did not finish their work until 1189, during the reign of William the Good (1166–1189). The chapel, a small basilican church, is encrusted with Muslim and Byzantine decoration: Muslim patterned marble inlay on the lower walls, and a gilded "stalactite" ceiling and

29. Christ the Lord, cathedral at Cefalù, Sicily, twelfth century. Apse mosaic.

Byzantine mosaics on the upper walls [30]. In the Annunciation forming the sanctuary, the craftsmen gave free rein to their Western taste for incidental detail and explicit narration. The angel points and strides forward; the Virgin accepts her role with a modest gesture of wonder. In the transept, the sheer exuberance of such scenes enables the mosaic cycle to visually dominate the interior in spite of the brilliant stalactite ceiling. The mosaics of Norman Sicily as a group provide a splendid record of late Comnenian art and, by extension, of Constantinopolitan art prior to 1204, when the Crusaders looted or destroyed the treasures of the imperial city.

The Byzantine Contribution to the Art of the West

Byzantine art exerted a profound and continuing influence on the art of the West from the time of Charlemagne to the fourteenth century, as Demus has brilliantly demonstrated. Techniques of painting, modeling, drawing, mosaic, cloisonné enamel, gold, and

30. Palatine chapel, Palermo, mid-twelfth century. Mosaics, second half of the twelfth century. "Stalactite vault" with Fatimid painting, 1142–54.

stained glass were transmitted to the West by artists and later by handbooks. Byzantine iconography and decorative motifs were also adopted by Western artists. At certain key moments in the development of Western style, Byzantine art played an important role. Byzantine models changed the direction of Carolingian painting, and the art and artists who came to the Ottonian court two hundred years later reintroduced Byzantine style to the West, at the beginning of the eleventh century. A Burgundian interpretation of the Comnenian style spread through Europe with the monks of Cluny at the end of the eleventh century. Later, as artists in the Ile-de-France were experimenting with the new forms which we now call Gothic, they had another opportunity to study Byzantine art in the reliquaries brought back by Crusaders after the sack of Constantinople in 1204.

One of the most significant and enduring contributions to the art of the West was the Byzantine concentration on the single religious image or scene—the icon. In the design of an icon, the artist had to organize a unified composition around a single idea, preferably using only a few large-scale figures. To some degree the development of the full-page manuscript illustration and eventually of panel painting in the West have been inspired by the reestablishment of icons in the East.

Constantinople also had the largest collection of ancient art, especially Greek sculpture, available to the artists of the Middle Ages. The city was like a museum, and its artists became the interpreters of the Classical heritage for the West. Western artists gradually absorbed more and more of the ancient humanistic style as abstracted, simplified, and articulated by Byzantine art until, in the thirteenth century, they began to study and assimilate the style of ancient sculpture firsthand. The vital message of ancient art, and one not wholly lost in Byzantine art, was the appreciation of the beauty and dignity of the human figure. If human beings were both matter and spirit, then the body should be shown as motivated by an inner will, not by the fancy of the artist. With this concept came a respect for the human figure and a consideration of drapery as a separate defining and decorative adjunct. Eventually artists learned to depict massive three-dimensional images defined by light and color and inhabiting a landscape or architectural space. Such interests led ultimately to the art of the Italian Renaissance.

Islamic Art

The Byzantine Empire, for all its self-conscious identification with Constantine and imperial Rome, and the papacy, with its claims based on St. Peter's primacy among the apostles, were not alone in their desire for universal hegemony. A third spiritual and political force—Islam—challenged the Christians both in the Byzantine East and in the West. The struggle between Islam and Christianity continued through the Middle Ages. The contact, though usually antagonistic, led to a valuable cross-fertilization of art. No attempt will be made here to trace the history and development of Islamic styles, for such a discussion requires and deserves a special study. A few characteristic buildings and objects, of the kind possibly known to medieval artists, can only hint at the riches of a great culture.

The dramatic rise of a new religion, Islam, in the seventh century suddenly destroyed the uneasy balance of power in the Mediterranean world. Once again, a prophet appeared in the Near East preaching the absolute authority of one God, Allah. Muhammad called on his followers to submit to the will of Allah. The name for the new religion, Islam, is derived from *salam*, meaning the perfect peace that comes when one's life is surrendered to God.

At first Muhammad tried to remain within the Judeo-Christian community, for he claimed to be the successor to the Jewish prophets, to John the Baptist, and to Christ. Jews and Christians saw otherwise, however, and Mu-

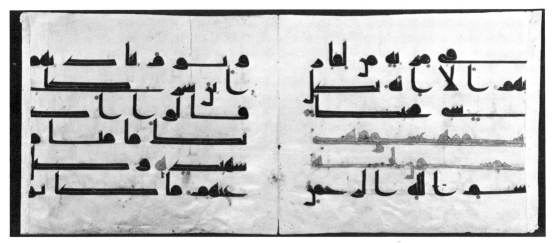

31. Kufic script, ninth–tenth centuries. Black and gold on vellum, 8 1/2″ × 21″. The Nelson-Atkins Museum of Art, Kansas City.

hammad soon abandoned hope of converting them. In 622 he moved from Mecca to Medina, a move known as the *hijrah*, which marks the first year of the Muslim era. In 630 he returned to Mecca with his followers, intending to conquer the world for the true God, and when he died in 632, he was the triumphant leader of a new religion and a theocratic state.

Making no claims to divinity, Muhammad called himself the prophet to whom Allah revealed the truth. These revelations, collected in the Koran, became the sacred scripture of the Muslims. The word of God, as transcribed in the Koran, inspired the finest calligraphy, and scribes developed two great scripts, the angular Kufic [31] and the cursive Neskhi, to create a superb nonfigural art. No definite prohibition against images is found in the Koran, but a strong iconoclastic party existed in Islam, as in Christianity. Nothing in Islam equals the vehemence of Hebrew prohibitions against images (for example, in Isaiah 44:9–20)—perhaps because the Jews had long been in active competition with pagan cults, whereas the Muslims had only to confront Jewish iconoclasm and the Christian ambivalent attitude toward artistic representations. One recalls, for example, that St. John of Damascus, the most ardent Byzantine defender of images, was the Patriarch of Damascus under Muslim

rule, and that his family had been members of the civil service under the caliph.

Islam owed its international success to Caliph Omar, who, like Constantine, combined military and political skill with religious fervor (the caliph, meaning "successor," continued to be both a religious and a political leader, as Muhammad had been). Omar embarked on a campaign of conquest: Damascus fell in 635; Jerusalem in 638; among the great Christian cities of the East, only Constantinople remained in Christian hands. By the time of Omar's murder in 644, the Islamic Empire had spread from Egypt to Iran. After Omar's death, his followers established the Umayyad dynasty. Meanwhile, in the eastern part of the Empire, the Abbasids claimed the leadership of the Muslim world through Abbas, Muhammad's uncle. From Persia they organized a rebellion against the Umayyad caliph, in which they were joined by the followers of Muhammad's daughter and son-in-law, Fatima and Ali, who had always considered the Umayyad caliphs to be usurpers. In 750 the Abbasids toppled the Umayyad dynasty and assassinated the caliph and all but one of his male heirs.

When the Umayyad dynasty fell to the Abbasids, one Umayyad prince, Abd er-Rahman, "the flower of Islam," escaped to Spain,

a land which had been Islamic territory since the victory of the Muslims over the Visigoths in 711. In 756 Abd er-Rahman established a strong centralized government with a capital at Cordova. In this early period, Christians and Jews could practice their religion by paying a tax for the privilege. They made up most of the city population and the artisan and commercial classes, while the Muslims controlled the military and political establishment and owned extensive country estates. Abd er-Rahman, although actually an independent ruler, maintained the fiction of Islamic unity by ruling Spain as an emir, or governor, under the distant and often ineffectual Abbasid caliph. Not until 929 did Abd er-Rahman III finally establish an independent Caliphate of Cordova.

In North Africa, other leaders established independent states in Morocco, Tunisia, and Egypt. The Fatimids from Tunisia gained control of Egypt and established a new capital at Cairo. As we have seen, Sicily, captured in 827, also was a Fatimid province until the late eleventh century.

As the Abbasid caliphs gradually lost political control, they feared for their personal safety and created a bodyguard of Turkish soldiers from the eastern border of the empire. The Seljuk Turks accepted Islam in 956, and by the eleventh century they virtually ruled an empire that lasted until the fall of Baghdad to the Mongols in 1258. The western Seljuks, known as the Seljuks of Rum, led by Alp Arslan, defeated the Byzantine army at the battle of Manzikert, and thereafter they controlled Asia Minor until the rise of the Ottoman Turks in the fourteenth century.

The Muslim place of prayer, or mosque, did not have to be a building; it could be an open space marked out by a ditch or a wall with a sign, the qibla, indicating the direction of Mecca. Islamic religious architecture, the mosque, takes its form from domestic architecture. No mosque from the time of Muhammad himself survives, for the prophet had

no interest in architecture and did not encourage building. His followers gathered in his house, just as early Christians met in houses, and he spoke to them from a portico while standing on a low platform so that he could be seen. When buildings for religious services became desirable, Muhammad's house provided the model—a walled courtyard with an open portico on one side, whose only furniture was the minbar, or pulpit. To this simple scheme the minaret, or tower, from which the faithful were called to prayer, was added later, as well as a special enclosure in front of the mihrab from which the ruler led the Friday prayers. The direction of prayer was indicated by the mihrab, or niche, in the qibla wall.

One of the finest and most characteristic early mosques was built in Spain but now has become the Cathedral of Cordova. Begun by Abd er-Rahman in 785, and built over a period of two hundred years, the Great Mosque of Cordova [32] showed a remarkable uniformity in style (until the Christian additions in the sixteenth century), attesting to the essential conservatism of Islamic architecture.

The Great Mosque of Cordova consists of a prayer hall and a courtyard to which a minaret was added in the tenth century. The original mosque of Abd er-Rahman rose in only six years (785–791), for the builders scavenged columns and capitals from Roman and Visigothic buildings. Almost square in plan, the prayer hall consisted of eleven parallel aisles running perpendicular to the qibla wall. Seemingly endless rows of columns, dimly lit from the courtyard, create a sensation of infinite extension into space. In contrast to the focused processional character of a basilica or the rising enclosing spaces of a domed building, Islamic architecture—and art—achieves its effect through the seemingly endless repetition of units, whether columns in a building or geometric motifs in the decorative arts.

Structural necessity led the builders to create remarkable decorative effects, for in order to

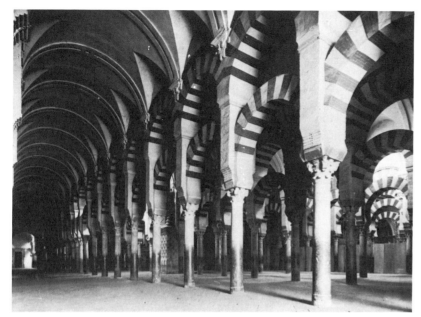

32. Great Mosque, Cordova, begun 785, enlarged in the ninth and tenth centuries.

achieve a uniform height for the scavenged columns they had to add impost blocks and then construct additional piers to support the flat timber ceiling. To stabilize these slender shafts the builders linked them with flying arches, the solution used by Romans in their aqueducts. To adjust the curve of the circular horseshoe arch, stone voussoirs alternated with bricks—three or four red brick courses to each stone voussoir—a solution which did not require sophisticated stonecutting and produced a colorful striped pattern. Bricks set at 45-degree angles—another simple device—frame the upper archivolts. The corbels supporting arches and upper piers are decorated with cylinders which produce roll moldings. The alternating voussoirs, horseshoe arches, zigzag moldings, and rolled corbels all became widely used devices in Islamic and Christian medieval architecture.

Subsequent rulers enlarged and enriched the Mosque of Cordova. Between 961 and 968 Hakam II added to the prayer hall, rebuilt the mihrab, and added elaborate vaults and windows in the bays in front of the mihrab to light the qibla wall [33]. The construction of

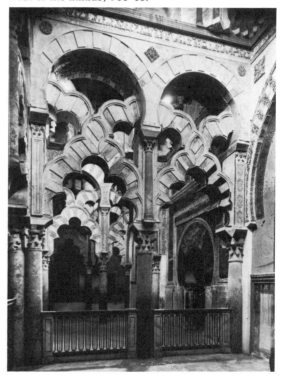

33. Great Mosque, Cordova. Mihrab, 965; bays in front of the mihrab, 961–68.

the vaults and lantern presented a challenge to the architects since the columns and piers, intended to support light wooden roofs, could not bear the weight of the masonry. The builders achieved a remarkable structural and decorative solution to this problem: without breaking the rhythm of the repeated columns, they added shafts and joined columns and piers with screens of interlacing polylobed arches which formed strong, rigid, pierced walls capable of supporting the vaults. They actually used strong pointed arches but disguised this intrusion into the circular horseshoe pattern by building the arches as a series of semicircular cusps following the line of the arch. Above these fantastic walls, four pairs of parallel ribs spanned each square bay, allowing for the insertion of windows in the upper part of the walls and supporting miniature fluted melon domes and other small decorative vaults. Originally the vaults were painted entirely with the interlacing stylized foliage known as arabesques. The architects so completely integrated new forms with the old that innovations, such as the interlacing arches, seem part of the original builders' intention. Thus in spite of a building campaign lasting until 988, the Great Mosque retained a remarkable visual unity.

Hakam II also gave the mihrab (which can be seen through the columns) the most luxurious decoration in the mosque. The mihrab itself is a small octagonal chamber; its entrance is a Cordovan horseshoe arch supported by two pairs of columns. The mihrab portal is framed by a rectangular panel, known as an alfiz, enriched with inscriptions, sculpture, and mosaic. The carved inscription identifies the patron and gives the date, 965. Calligraphy, particularly the angular Kufic script, became an important part of Islamic decoration. Within this calligraphic frame sculptured panels of stylized foliage flow over the surface without regard to structural forms. These arabesques continue into the mosaic-covered voussoirs, where the tesserae (and a workman to set

them) were a gift from the Byzantine emperor.

Religious architecture was conservative in Islamic countries, and, once established, the form of the mosque underwent little change. The need for economy, speed in construction, and large size encouraged builders to use adobe, brick, rubble, and wood with only a veneer of stone or stucco even in the most important buildings. Columns were replaced by brick piers—sometimes simply cruciform in cross section, sometimes molded to look like engaged columns when covered with stucco. The pointed horseshoe arch and the polylobed arch became standard structural forms, although at first the pointed arch was often disguised as a polylobed arch. The simple pointed form, originating in Persia, became widely used only during the eleventh and twelfth centuries, when it occurred from Syria and Egypt to Spain—that is, in Seljuk, Fatimid, and Almoravid territories.

A spectacular decorative form developed by Islamic architects in the eleventh and twelfth centuries is the *mukarnas*, or "stalactite," vault. The *mukarnas* dome or vault is not a true vault but rather an ingenious system of corbels and squinches. Concentric rows of concave cells are corbeled out one above another in an interlocking triple squinch so that the vertical axes of the cells alternate and the upper seem to grow out of the lower. The weight of such a vault does not rest on the corners of the room but on two points along each wall—that is, on the eight points of an octagon inscribed within a square plan. The completed honeycomb-like structure is typically Islamic in its intricate geometric design and disguise of underlying logic by a dizzy multiplication of forms. A *mukarnas* vault covers the Palatine Chapel in Palermo (1132–1140). Roger II, an enthusiastic admirer of Eastern art, imported workmen from Fatimid Egypt, and their paintings on the ceiling (1142–1154) are among the most extensive and finest surviving examples of the Fatimid style. Abstract foliate forms, calligraphy, and stylized scenes of court

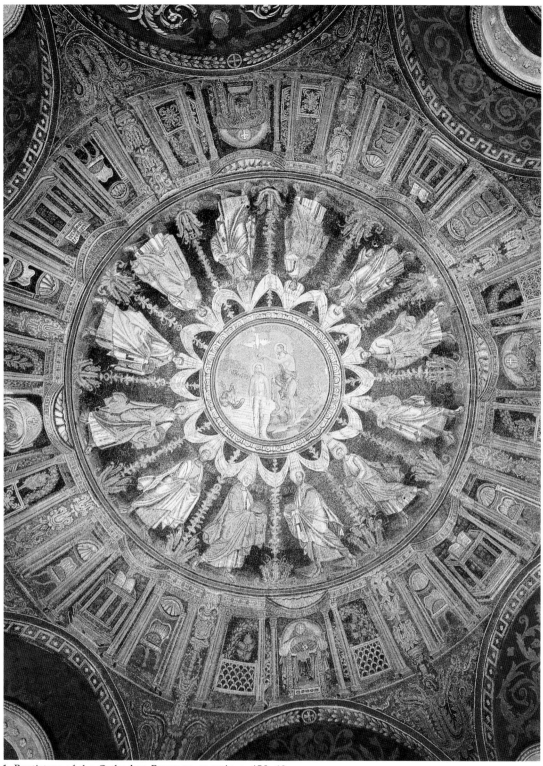

1. Baptistery of the Orthodox, Ravenna, mosaic, c. 450–60.

2. Eagle-shaped fibulae, Spain, sixth century. The Walters Art Gallery, Baltimore.

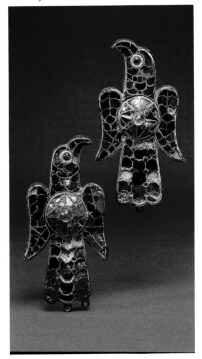

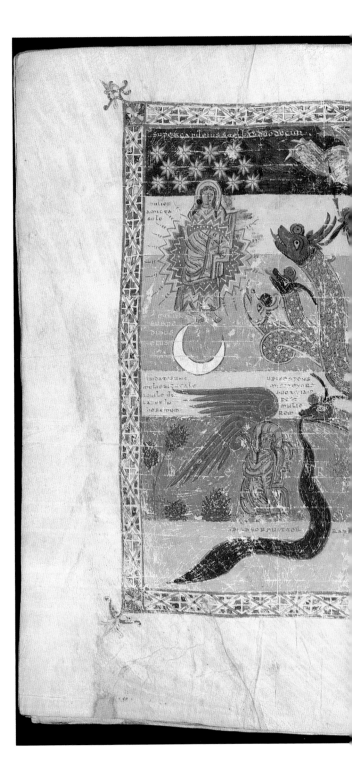

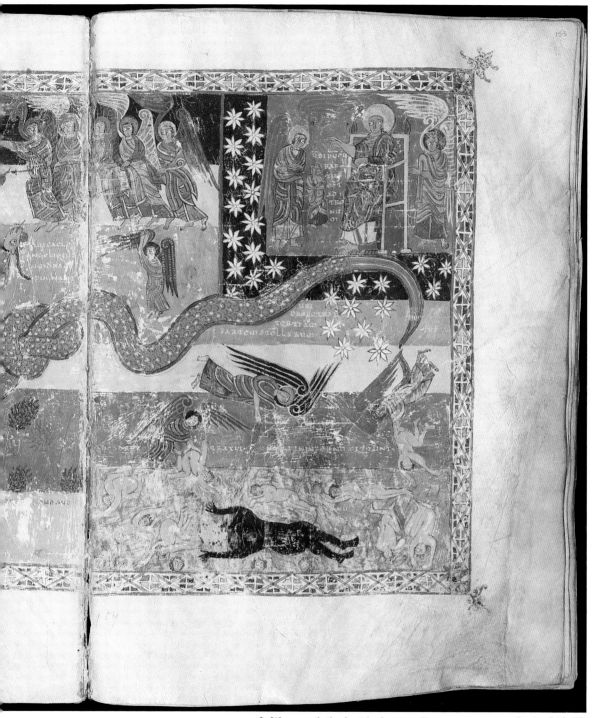

3. Woman clothed with the sun, Beatus manuscript, Spain, 940–45.
The Pierpont Morgan Library, New York.

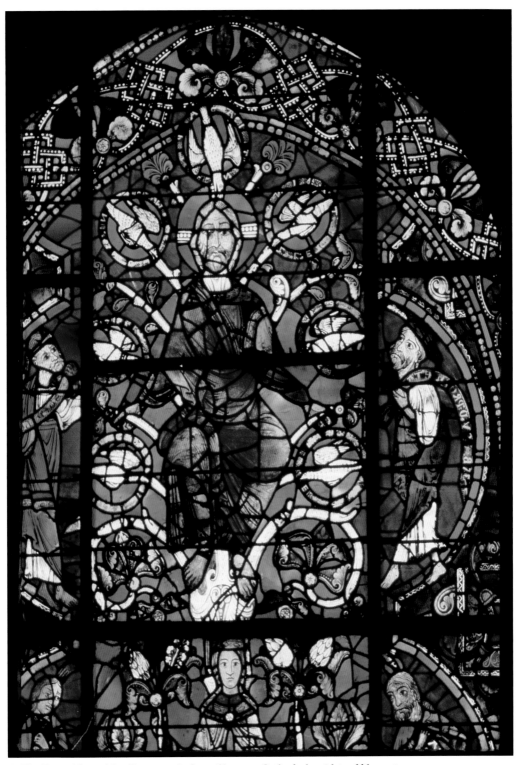

4. *The Tree of Jesse* (detail), west window, Chartres Cathedral, mid-twelfth century.

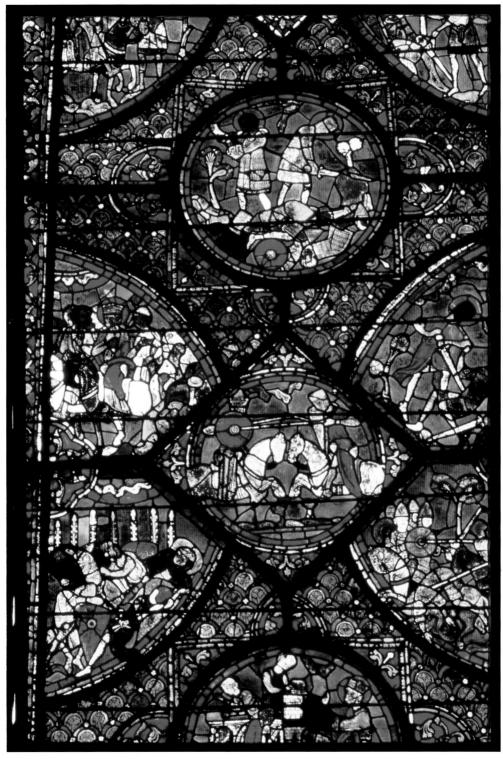

5. Charlemagne window (detail), Chartres Cathedral, thirteenth century.

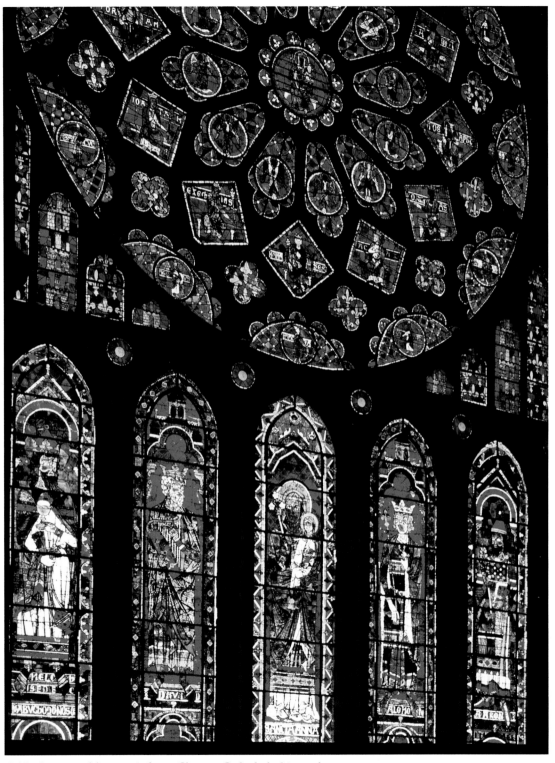

6. North rose and lancet windows, Chartres Cathedral, thirteenth century.

7. *Windmill Psalter*, England, 1270–80. The Pierpont Morgan Library, New York.

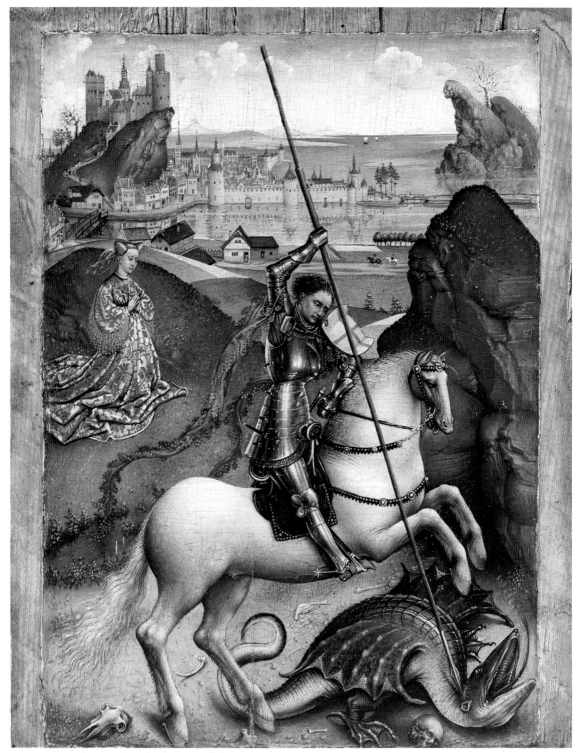

8. Rogier van der Weyden, *St. George and the Dragon,* c. 1432.
National Gallery of Art, Washington, D.C.

life are depicted in symmetrical static compositions of red, brown, purple, blue, green, white, and gold (see page 157).

The mosaics adorning the lower walls of the chapel also reflect Muslim technique and style. Unlike Byzantine mosaics, these mosaics resemble an inlay; black, white, and blue tiles were cut into simple shapes to make angular interlaces and diamond, star, and Greek key patterns. Linear geometric patterns contrast with broad, undecorated surfaces for colorful effects. The transformation of simple materials into objects of delicate beauty, the concentration on the decorative arts, and the elevation of crafts to a position of honor are characteristic of Muslim art.

Muslim artists excelled in the production of utilitarian objects of great beauty and even luxury. Carved ivory and rock crystal, textiles, ceramics, and metalwork were in demand by Christian as well as Muslim patrons. One of the most remarkable achievements of Muslim craftsmen was the development of ceramics. Inspired by Chinese colored glazes and porcelains coming into the Middle East along the trade routes, Muslim artists developed their own distinctive styles [34]. A prohibition against the use of precious metals may have led the patrons to demand a substitute and the potters to invent luster ware. A fine white ceramic body was covered with a transparent glaze and fired; then the decoration, of animals, foliage, and interlaces (in the example illustrated, an ibex in a foliate scroll) was painted on the surface with metallic glazes. A second firing at a low temperature resulted in a shining luster surface. Luster originated in ninth-century Samarra, but by the tenth century it was being produced in Fustat (old Cairo), where it became one of the glories of eleventh- and twelfth-century Fatimid art. Nowhere is the distinction between "fine arts" and "industrial arts" more irrelevant than in the Muslim decorative arts.

No less splendid are the textiles known from literary descriptions and occasionally

34. Bowl with ibex, Fustat, Egypt, eleventh century. Lustre. Diameter, 9 7/8″. The Cleveland Museum of Art.

found in the West in church treasuries where Muslim silks were used to wrap relics. Confronted or addorsed (that is, facing or back to back) figures enclosed in medallions became popular designs; sphinxes attacked by lions, griffins, slim stylized trees, and eight-pointed stars were worked into patterns of repeated

35. Silk, diasper weave. Iranian, Buyid period, tenth–eleventh centuries. Fragment measuring 17 1/2″ × 15 5/8″. The Cleveland Museum of Art.

medallions [35]. Silks with names and dates (the *tiraz*) woven into them were the special prerogative of the caliph. The demand for Eastern textiles in Western Europe meant that merchants carried silks and brocades across the Continent; an inventory from St. Paul's Cathedral, London, in 1245 lists Eastern silks with eagles, griffins, elephants, lions, trees, and birds. Such textiles provided Western artists with a veritable encyclopedia of decorative motifs. Silk weavers continued to use the traditional patterns well into the fourteenth century. In Spain they produced multicolor brocades—green, yellow, and white on a red ground, for example—and the striped silks so often represented in paintings of fashionably dressed people.

Fine metalwork was as prized in the West as textiles. Muslim craftsmen perfected techniques of metal inlay and engraving and produced splendid utensils, such as the so-called Crusader's canteen [36]. Of brass, inlaid with silver, this vessel may have been made in Syria in the thirteenth century. Neskhi calligraphy alternates with interlaces and bird-filled arabesques with Biblical narratives. In the central medallion an enthroned Virgin and Child are adored by angels. The Nativity, Christ in the Temple, and the Entry into Jerusalem are depicted with lively animation dependent on Middle Byzantine models. The interaction of cultures in the decoration of this basin reaffirms the impression of constant interchange between the Christians and Muslims during the Middle Ages.

Objects like the canteen are unusual pieces. Normally Muslim artists concentrated on the development of subtle variations on well-tested themes. Their nomadic heritage had given them few artistic traditions, so they adapted local forms to suit their own functional and aesthetic requirements. Once an idea was

36. Crusader canteen, Syria, thirteenth century. Freer Gallery of Art, Smithsonian Institution, Washington, D.C.

accepted, it became part of a fixed canon, reflecting the essentially conservative nature of Islamic religion. The Koran provided a fixed doctrine, even when subjected to intense analysis in the theological schools. The Koran was the authentic word of Allah, given to Muhammad by the angel Gabriel, and thus not subject to the elaborate reinterpretations the Christians gave the Bible. Islam, with the submission of the individual to Allah as the central belief, required the union of the individual will with a universal, all-pervasive God, achievable through contemplation and the performance of a fixed ritual. This submission to a single authority—Allah and the caliph—created a conservative aesthetic, which is reflected in Islamic architecture and art.

Art expressed Islam through the submergence of individual forms by means of an infinite multiplication of identical elements. The combination of symmetry with the implication of infinite extension in space provides powerful symbolic associations. The geometric basis of architecture and ornament and the subjection of natural forms to mathematical figures became characteristic of Islamic art. Indeed, the culture was characterized by scientific achievements, especially in astronomy and mathematics.

In contrast to this intellectual and spiritual emphasis in Islam, Muhammad promised the faithful eternal bliss in a paradise of masculine fantasy. He described in the most sensual, physical terms a garden of earthly delights in which eternal banquets and beautiful women awaited the conquering warriors of Allah. Just as Islamic religious beliefs emphasize a physical paradise, Islamic artists lavished more attention on secular art and architecture, on material comforts and conveniences, and on worldly display than did their Western contemporaries, who, in theory at least, concentrated on an afterlife where the rewards were those of the spirit rather than of the flesh. The ideal of physical comfort and immediate rewards encouraged patrons and artists to

think in terms of today, not tomorrow. They used inexpensive, impermanent materials—brick, wood, clay, textiles—yet the final effect of the architecture and the arts produced a sense of timelessness by its seemingly infinite extension. Scale, too, is both human and nonhuman—things seem either huge or tiny, and largeness and smallness do not conflict with but rather enhance the perception of both.

Islamic art presents to the Western viewer the appearance of insoluble conflicts. It seems to be at the same time human and nonhuman, rational and anti-rational, earthbound yet otherworldly. Intricacy was appreciated for its own sake. Artists did not aim to re-create the appearance of life; they based their aesthetic principles on geometry. The expression of the complexity of growth from within itself rather than dependence on the observation of external manifestations in nature characterizes the Islamic use of forms. Artists gave their work symmetry without emphasis, controlling and isolating patterns with geometric figures. The Islamic attitude toward the arts is perhaps best shown by the decorative arts. In the decorative arts the ornamentation of the forms converts the simple shape or material into something beyond itself, just as the application of luster glaze transforms humble clay into a shimmering golden object.

Christian Art in Spain and the Western Mediterranean

When they consolidated their holdings in the Iberian Peninsula, the Muslims made the mistake of leaving two isolated pockets of Christian resistance in northern Spain—the tiny kingdom of Asturias on the Cantabrian coast and the county of Catalonia (Charlemagne's Spanish March) in the east. Although the Moors (as the Muslims in Spain came to be known) were generally tolerant of other faiths, and the Christians, if they wished, could live and worship in peace, *reconquista*—"reconquest"—was an ever-present Christian

dream. *Reconquista* had its spiritual leader in the apostle St. James the Greater (Santiago, in Spanish), who—modern evidence to the contrary—was believed in the Middle Ages to have been the missionary to the Iberian Peninsula and to have been buried there after his martyrdom in Jerusalem. His symbol, the scallop shell, was derived from a posthumous miracle on the coast of Galicia.

In 813 a miraculous star led a shepherd to discover St. James's tomb. Bishop Teodomiro and King Alfonso II (791–842) erected a church on the site, now Santiago de Compostela. Shortly thereafter, when Christians fighting under King Ramiro (842–850) were about to be annihilated by the Muslims, the apostle appeared to lead the Christian forces to victory. This miraculous intercession gave the Spanish Christians their battle cry, "Santiago Matamoros" (St. James, slayer of Moors). Thenceforth, the Spanish Christians had a spiritual as well as a geographical rallying point, and the tomb of the apostle became a pilgrimage center, which by the twelfth century rivaled Rome and Jerusalem.

The father of Alfonso II, Alfonso I (739–757), founder of the new dynasty, had extended the Christian territories to encompass the northern coast from Galicia to the Basque country. Asturias, as the new kingdom was called, reached its height of power in the ninth century under Alfonso II, Ramiro, and Alfonso III the Great (866–910), but it remained somewhat isolated from Western Europe. The Asturians retained the Visigothic liturgy, thereby increasing the estrangement from Rome; moreover, Spanish Christians, perhaps as a legacy from Visigothic Arianism, seemed noticeably prone to heretical beliefs. In 782 the bishops of Toledo and Urgel revived an Early Christian heresy known as Adoptionism—the belief that Christ was born a man and was only subsequently adopted by God as His Son. The vehemence of the Roman Church's struggle against the Antichrist, whether Muslim or Adoptionist, is reflected in

the writings of the monk Beatus of Liébana (d. 798), spiritual adviser to the Asturian court. Beatus composed treatises against Adoptionism and commentaries on the Book of Revelations.

A passionate need to defend the faith occasionally surfaced among Christians residing in Muslim territories. In the 850s a zealous group of Mozarabs (from *Mustarib*, "arabicized") in Cordova became voluntary martyrs. Spurred on by their deeds, Christians pushed forward with the reconquest of the peninsula. The Navarrese recaptured Pamplona in 905; Asturias united with León; and in 930 Castilian nobles established a new state with a capital at Burgos. While Christians were redrawing the political map of northern Spain, Abd er-Rahman III declared Cordova an independent caliphate. Soon Christian persecutions began in earnest. Consequently, the population of entire Christian villages migrated to León and Castile, bringing with them a distinctive blend of Christian and Muslim art, the Mozarabic style.

Ferdinand I and Alfonso VI of Castile drove southward and by 1085 they captured Toledo, the ancient Visigothic capital and a northern Muslim stronghold. Alfonso made Toledo the capital of New Castile; as the seat of the primate of the kingdom, the city rivaled Santiago de Compostela.

Meanwhile, in the eastern Pyrenees the Muslim incursion had been short-lived. Although Catalonia fell to the Moors in the eighth century, it was soon retaken by Charlemagne, who established the Spanish Marches with a capital at Barcelona to protect the southern borders of his Empire. Church government nevertheless remained in Narbonne, on the northern side of the Pyrenees. As a result, Catalonia always had close ties to Western Europe—politically to the Carolingian dynasty and ecclesiastically to southern France and Italy—even after the counts of the Spanish March gained complete autonomy. The counts of Barcelona extended their Catalan holdings so successfully that in two hundred years they

controlled territory from Tortosa on the Spanish Mediterranean coast all the way to Nice.

By the twelfth century the entire northern half of the peninsula was permanently in Christian hands. That art and architecture continued to be produced during this long period of incessant warfare must be regarded as testimony to the strength of Spain's artistic traditions and to the energetic patronage of her rulers.

Asturian Art and Architecture

From the exquisite art created for the most sophisticated court in Western Europe, at Cordova, to the "backwoods" of Asturias requires a considerable leap of imagination. The difference between patron's dreams and a craftsman's ability, so often seen in Medieval art, arises again; the patron's will to overcome all obstacles is nowhere more evident than in the architectural projects commissioned by Alfonso II and Ramiro I. It seems remarkable today that, in the remote Cantabrian mountain valleys, masons working for these builder-kings managed to maintain high technical and aesthetic standards. In 793, only thirty-seven years after the Umayyad prince established himself in Cordova and in the very year in which Viking raiders destroyed Lindisfarne, Alfonso II established his capital at Oviedo in northern Asturias. There he built a palace complex composed of residence, church, administrative headquarters, and baths. Even though economic resources prevented the king from emulating the grandiose scale of Charlemagne's capital at Aachen (and no one could rival Cordova), the Church of S. Julian de los Prados (St. Julian of the Meadows, popularly contracted to Santullano) remains Spain's largest pre-Romanesque church [37]. Designed by the court architect Tioda sometime between 830 and 842, Santullano is a three-aisled basilica with a continuous transept and a tripartite sanctuary, all preceded by a western porch. Thus, two aspects of the plan—the basilican arrangement and the transverse

hall—depend on Constantinian churches, such as Old St. Peter's, or later Carolingian adaptations, as at Fulda. In Santullano, however, the enormous transept, as wide as the nave but 6½ feet higher, created an imposing space for the members of the court, who entered through the north door below the royal tribune. Moreover, the very height of the transept seems to be peculiarly Asturian. In contrast, the wooden trussed roof over the nave and transept suggests the architect's evocation of Roman basilicas. The three chambers that constitute the sanctuary, however, derived from the rectangular triple sanctuary of Visigothic churches. They are covered with round barrel vaults and terminate in a flat wall reinforced on the exterior by strip buttresses. In the wall behind the altar a niche may have served as a tabernacle for the display of the consecrated Host. Equally unique to Asturian ecclesiastical architecture is the chamber above the sanctuary's vault, which runs through to the triple window on the exterior wall.

Tioda and his masons used Roman structural and decorative systems. Small cut stones, with relieving arches in brick over windows and doors, make up the walls and vaults, while the arches in the nave arcade are fashioned of brick instead of stone voussoirs. The masonry was then plastered and painted with architectural motifs that recall imperial Roman art and serve as a reminder of the long Roman occupation of Spain [38]. The painters composed each wall symmetrically. They drew buildings and ornament with the help of straight edges and compasses directly in the plaster, then applied the colors: yellow-ocher, rust, blue-gray, dark blue, and white. A fantastic display of imaginary architecture fills the upper zones with palaces, curtained portals, courtyards, and porticoes. We have seen similarly fanciful buildings in the mosaics of Thessalonika and Ravenna; however, unlike the Byzantine mosaics, the Asturian wall paintings include no human figures. Indeed, the only specifically Christian reference in the

37. Tioda (active first half of the ninth century), Church of S. Julian de los Prados (Santullano), Oviedo, Asturias, 830–42.

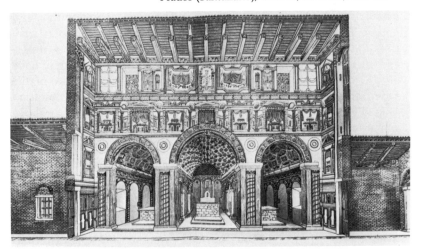

38. Reconstructed painting of transept, Church of S. Julian de los Prados (Santullano).

39. Church of Sta. Maria de Naranco, Oviedo, Asturias, before 848.

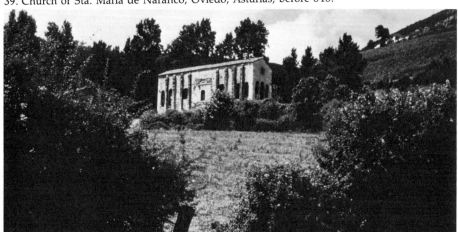

entire decoration is a cross, hung with alpha and omega, painted on the transept wall above the entrance to the sanctuary. The cross may represent either the True Cross of St. Helena or the Cross of Victory, which was carried into battle by the Asturian rulers.

On Naranco, a low mountain outside Oviedo, Alfonso's successor, Ramiro I, built his own residential complex. The present Church of Sta. Maria de Naranco [39] originally may have served as the royal audience hall. This change of function explains the unusual design, for it is a two-story edifice of simple rectangular plan divided internally into three sections at each level. The upper story, twice as high as the lower, is a hall with a loggia at each end. Central doors pierced all four walls. On the north a double stairway gave access to the entrance vestibule, and on the opposite side, corresponding to the vestibule, another chamber once stood, perhaps to accommodate the monarch's throne. The building became a church consecrated to the Virgin in 848.

The Asturian builders worked with excellent masonry for walls and vaults. Barrel vaults reinforced by transverse arches support the windowless central room on the ground floor and the hall and loggias above. From a technical point of view, the upper room, erected as it is on thin ashlar walls, was a daring and ingenious structure for the ninth century. Although exterior strip buttresses, aligned with the transverse arches and the blind arcade of engaged columns on the interior, strengthen the relatively light walls, surely the architects counted on the vestibule and missing throne chamber to support the vault of the hall.

Sculpture at Naranco lacks the finesse of the architectural conception; however, its presence reveals the patron's desire for monumental decoration. Bands in low relief punctuate the face of the loggia and terminate in rondels set within the spandrels of the arches [40]. The columns, inspired by spiral shafts, in the hands of local craftsmen became flaccid ropes, which deny their supporting and stiff-

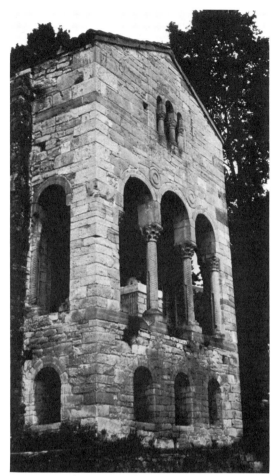

40. Church of Sta. Maria de Naranco.

ening function. Further, while the flat, spatula-like leaves of the loggia capitals retain a distant resemblance to antique art, others inside the building are divided into triangular panels by rope moldings and abandon all reference to a Classical order. The sculptors turned to decorative arts for models; for example, medallions along the upper walls have as their inspiration Islamic textiles and Viking gold discs, both of which could have been acquired through trade or as booty. Even though specific sources cannot be identified, Asturian sculpture demonstrates the wide network of artistic connections existing in the ninth century.

Mozarabic Art in Northern Spain

At the beginning of the tenth century, Alfonso III invited Christians living under Muslim rule to move north and resettle newly conquered lands in León. One of these refugee groups, a Benedictine community from Cordova, founded a monastery at Escalada near the capital city of León. The church, dedicated in 913 to St. Michael, seems at first glance to be a typical Early Christian three-aisled basilica [41]; however, the Mozarabic builders, who were still profoundly influenced by Islamic art, used the Cordovan horseshoe arch in both the plan and the elevation of the building. Not only are the nave arcade, the sanctuary screen, and the exterior porch built with horseshoe arches, the three rooms of the tripartite sanctuary are horseshoe in plan. The timber roof permitted a light, open nave; slender columns support rubble and mortar walls pierced by large clerestory windows. The exterior porch was built about 940.

The present austere appearance of S. Miguel de Escalada is the result of twentieth-century restoration. Originally the interior could have been painted, hung with rich, patterned textiles, and filled with hanging lamps and patterned screens. A sanctuary screen, hung with curtains, functioned like a Byzantine iconostasis, hiding the altar and officiating priests from view, for Mozarabic liturgy resembled the Byzantine in its emphasis on the mystery of the sacraments. *Azulejos*, the glazed tiles popular in Muslim architectural decoration, may have been used by the Christian builders to enrich the exterior of their churches (as they did in later buildings). Some idea of the colorful effect of tenth-century structures can be gleaned from contemporary manuscripts. In the *Tábara Apocalypse*, the scribe and painter Emeterius represented himself and his assistant, Senior, at work in a scriptorium, which is adjacent to a five-story tower [42]. The massive tower we see at S. Miguel dates from the end of the eleventh century, but bell towers were common in Mozarabic monasteries. Emeterius renders the interior and exterior of the monastery simultaneously in cross section, the better to reveal the bustle of activity—the bell ringers, climbing men, and busy scribes—as well as the brilliantly colored tiles affixed to the rafters and walls.

The view of the scriptorium at Tábara bears witness to the importance of book production in Mozarabic monasteries. Escalada once had a great library and was the home of Emeterius' teacher, Magius. Mozarabic monks not only signed their works but included the names of patron and painter, the date of completion, and even brief notes, prayers, and appeals for appreciation. Emeterius wrote, "Thou lofty tower of Tábara made of stone. There, over thy first roof Emeterius sat for three months bowed down and racked in every limb by the copying. He finished the book on July 26th in the year 1008 [that is, 970—the Spanish calendar ran thirty-eight years ahead] at the ninth hour." We are also told that the book was begun by "the chief painter, the good priest Magius," who died in October, 968, and that he, Emeterius, was called in to complete the work.

In the tenth and eleventh centuries there was an extraordinary school of painting, centered in the province of León, where illuminators blended indigenous Western Christian and Visigothic styles with Muslim motifs. In the *Bible of León*, written and illustrated in 920 at the monastery of Albeares, by the monk Vimara and the painter Ioannes, the familiar Carolingian evangelist portrait becomes a fantastic angel amidst wheels of glory supporting the symbolic lion on his shoulders [43]. Just as the *Ebbo Gospels* illustrator reinterpreted solid Classical forms with nervous lines, so the Mozarabic painter conceived the portrait of St. Mark in terms of intense color and pattern. This impulse for decoration derived from both Visigothic and Muslim sources. The Visigothic heritage determined the Moz-

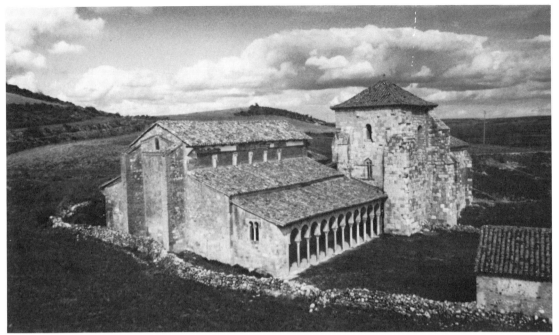

41. Church of S. Miguel de Escalada, near León, before 913. Tower, eleventh century.

42. Emeterius and Senior at work, tower of Tábara, *Tábara Apocalypse*, 970. 14 1/4″ × 10 1/8″. Archivo Historico Nacional, Madrid.

43. Vimara and Ioannes, St. Mark, *Bible of León*, León Cathedral, 920.

arabic designer's segmentation of flat areas of color and his emphasis on bright red and gold. Despite the intervening centuries, the lion and angel of St. Mark, formed as they are of vivid bands of red, yellow, and green arbitrarily juxtaposed for an ornamental effect, constitute legitimate heirs of the eagle-shaped Visigothic brooches. Muslim taste further reinforced the Mozarabic tendency toward compact surfaces, overall patterning, and exotic foliage, birds, and animals. The angel's hands and feet seem to blossom out of colorful stalks, while the arresting conception of the faces punctuates this explosion of colors. If the Tábara illuminator insisted on exposing the interior and exterior of the monastic tower, his colleague at Albeares had to show not only the lion's nose, jaw, and sprouting tongue, but also both of the beast's eyes and ears—even though only one of each would normally be visible in the given profile. Such simultaneous views did not reappear for a thousand years, and then in the work of another Spanish artist, Pablo Picasso.

The tenth-century copies of Beatus' commentary on the Apocalypse (color plate III) provide telling reflections of Mozarabic art and civilization. In the Apocalyptic imagery of destruction, suffering, and final deliverance, Christians could see a direct analogy with the struggle to preserve the Church and to free their co-religionists from the infidel. At the monastery of S. Miguel de Escalada, Emeterius' teacher, Maius, finished a copy of Beatus' commentary in 940 or at least by mid-century. The opening reproduced here [44] illustrates chapter 12 of the Book of Revelations, an allegory of the triumph of the Church over its enemies. In the upper left is "a woman clothed with the sun, and the moon under her feet, and upon her head a crown of twelve stars," confronted by "a great red dragon, having seven heads and ten horns, and seven crowns upon his heads. And his tail drew the third

44. Maius, Woman clothed with the sun escaping from the dragon, *Morgan Beatus*, c. 940–45. 15″ × 11″. The Pierpont Morgan Library, New York.

part of the stars of heaven, and did cast them to the earth. . . . And there was war in heaven: Michael and his angels fought against the dragon; and the dragon fought and his angels, and prevailed not; neither was their place found any more in heaven and the great dragon was cast out, that old serpent, called the Devil. . . . And the serpent cast out of his mouth water as a flood after the woman . . . and the earth helped the woman, and the earth opened her mouth and swallowed up the flood which the dragon cast out of his mouth." In the hand of a master like Maius, the abstract, ornamental Mozarabic style accentuates the dramatic, nightmarish quality of the text, while flights of imagination only enhance the explicitness of the narration. Maius transformed the background into horizontal bands of brilliant colors and suggested landscape with a few foliage patterns. As in the St. Mark from the *Bible of León,* curving brightly hued stripes make up figures that are little more than bundles of drapery. Each face, moreover, dominated by white, staring eyes, is encircled by a colored halo. So thoroughly does the decorative system destroy an illusionistic vision that even the star-covered field of Heaven becomes a frame for frozen activity. By thus reducing the momentous, apocalyptic events to exotic abstractions, Maius rendered a pictorial counterpart to the visionary description of the Last Days. Mozarabic painting, although dazzlingly beautiful as ornament and sometimes persuasive as narrative, exists as an elegant and exotic style outside the mainstream of Western European art.

Lombard-Catalan Art and the "First Romanesque"

At the eastern end of the Pyrenees, in Catalonia, the mountains became more bridge than barrier—the backbone, so to speak, of a rugged kingdom lying in both Spain and France. The link had been forged in Charlemagne's time, when the emperor established the Spanish March. In the tenth century an art and architecture developed under the patronage of the counts of Catalonia that played an important part in the origin of Europe's mature Romanesque style.

Wilfred, the first independent count of Catalonia, founded the dynasty in the late ninth century. A century later one of his successors, Count Oliba of Besalu, known as Oliba Cabreto, traveled through France and Italy, spent a year in the monastery at Monte Cassino, and on his return introduced both the Roman liturgy and the Benedictine order into Catalonia. His son Oliba (d. 1046), Abbot of Ripoll (Spain) and Cuxa (France), and later Archbishop of Vich, kept up this contact with the Benedictines of Monte Cassino, with Cluny, and with the papal court in Rome. Another monk of Ripoll, Gerbert of Aurillac, exemplifies the crisscrossing network of relationships through Europe. Gerbert studied at Ripoll (c. 967) before moving on to Reims, then to the Italo-German court of Otto III (see chapter VII), and finally on to Rome as Pope Sylvester II.

The travels of rulers and churchmen were only partially responsible for the pervasiveness of the Lombard-Catalan style; equally important were the builders themselves. Teams of workmen under master masons journeyed from project to project, where they also taught local masons. Originating in Lombardy about 800, the *magistri comacini*—or *lombardos,* as they were known in Spain—created a school of architecture around the Gulf of Lyons from northern Italy to Catalonia. Because the Lombard builders used Roman and Early Christian building techniques—brick and stone masonry walls and vaults—that had survived in Italy through the centuries, their work is sometimes seen as a final phase of Roman provincial architecture. At the same time their buildings have features that became principal components of the next major architectural movement in medieval history, the Romanesque style. Hence, scholars categorize Lombard-Catalan

45. Monastery and Church of St. Martin-du-Canigou, French Pyrenees, begun 1001.

46. Nave, upper church, Church of St. Martin-du-Canigou, early eleventh century.

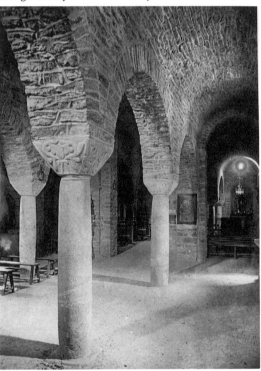

buildings as *le premier art roman,* or the "First Romanesque."

Most of the structures built in Lombardy have been destroyed or thoroughly altered. In Catalonia, however, fine examples still stand. The monastic Church of St. Martin-du-Canigou in the French Pyrenees is a carefully restored edifice begun in 1001 by Count Guiford of Cerdana, another son of Oliba Cabreto, and built under the supervision of Sclua, a monk of Cuxa [45]. In 1009, Guiford's brother, Abbot Oliba, consecrated the church to St. Martin, St. Michael, and the Virgin. This early structure had barrel vaults and massive groin vaults on heavy granite columns. When Sclua became abbot in 1014, he added an upper church, large for its time—eighty-four feet long with a barrel-vaulted nave almost twenty feet high [46]. This Lombard-Catalan architecture is clearly a mason's style, in which the primary concern was not with aesthetic theory or symbolic design, but with the practical, sturdy construction of walls and vaults. The mason's technique, in other words, determined the style.

Lombard-Catalan masons used the most readily available materials—ashlar blocks or small split stones in the Pyrenees, but bricks and even irregular stones or river pebbles elsewhere. They laid up the facing stones set in a very strong mortar simultaneously with a rubble core and so could raise the walls without forms. The rough stone so admired in the twentieth century was invisible, for the finished walls were covered with stucco inside and out. The apse was vaulted with a semi-dome; however, the nave was either wooden-roofed (usual in Italy) or vaulted (in Catalonia). To build the vault, the masons constructed a timber centering supported by the thick walls or, in an aisled hall, short, heavy piers or columns. The removal of the centering sometimes left a distinctive shelflike molding at the springing of the vault. On the exterior, strip buttresses and arched corbel tables helped to strengthen the wall and buttress the outward

thrust of the vault with their additional weight. Early in the eleventh century, builders began to experiment with vault forms. At Canigou they used what may be the first transverse arch to collect the load and concentrate the thrust of the barrel vault. The arch joins rectangular bands, or responds, to produce compound piers and divide the nave into bays.

Masons also used the Roman groined vault (two barrel vaults of equal height intersecting at right angles), which, by concentrating the lateral thrust of the vault at four points, permitted the insertion of windows in the upper walls while maintaining the strength of the support for the vault. Furthermore, the groin vaults, massive masonry piers, and transverse arches produced masonry bays readily adaptable to the square modular system developed by Carolingian builders.

In Lombard-Catalan architecture, an extraordinary visual continuity results from this use of masonry throughout the building and from a decorative system based on masonry construction. The masons had little regard for surface ornament or delicate carving; they established an unbroken plane sweeping from the upper wall to the springing of the arch and on over the vault. In contrast to the Asturian Church of Sta. Maria de Naranco, no sculpture articulates the surface.

The same sense of unity, of vertical division of space, and of an entirely architectonic decorative system, determined the exterior articulation of St. Martin-du-Canigou. The strip buttresses and arches seen in Roman and Early Christian art in northern Italy, at the Tomb of Galla Placidia in Ravenna, for example, run up into an arched corbel table— that is, an additional projecting thickness of wall supported on arches. Then, instead of covering the outside of the vault with a wooden roof, the masons at Canigou built up the interior barrel vault in such a way that it became, on the exterior, a sloping stone roof. The great rectangular bell tower, articulated

with strip buttresses and arched corbel tables, although rebuilt in the nineteenth century, is characteristic of the massive forms of the First Romanesque.

One of the finest examples of the mature Lombard-Catalan style is the Church of S. Vicente at Cardona, begun about 1020 and consecrated in 1040 [47]. The church is vaulted throughout—with barrel-vaulted nave and transept, groin-vaulted aisles, and a dome on squinches over the crossing. The wide, vaulted nave is crossed by three transverse arches, which continue down the piers as responds, the visual and structural flow only momentarily broken by the tiny moldings high up at the springing of the arch. The masons at Cardona elaborated on the system devised at Canigou, for they added masonry bands supported by responds as a strengthening device on the underside of each arch in the nave arcade. The piers thus formed mark the first stage in the evolution of a key element in Romanesque architecture—the compound pier. Whereas at Canigou the system seemed tentative and almost accidental, the masons at S. Vicente deliberately used it to lend an architectonic unity to the entire church. Because the forms were perceived within a series of vertical bays, the builders achieved a simplification and clarification of structure through soaring spaces and continuous walls.

The Lombard-Catalan builders also developed a new kind of exterior church decoration, in which relief sculpture was not merely applied to the portal but integrated into the construction. Like ninth-century Asturian sculptors, these later sculptors depended on the minor arts for subjects and compositions. Thus Lombard-Catalan church portals abound with apocalyptic themes. The marble lintel at St. Genis-des-Fontaines, dated 1020–1021, represents Christ in Glory, held aloft by angels and flanked by six apostles [48]. The use of figures standing within an architectural setting goes back to antiquity; however, the Lombard-Catalan sculptor treated the lintel as a two-

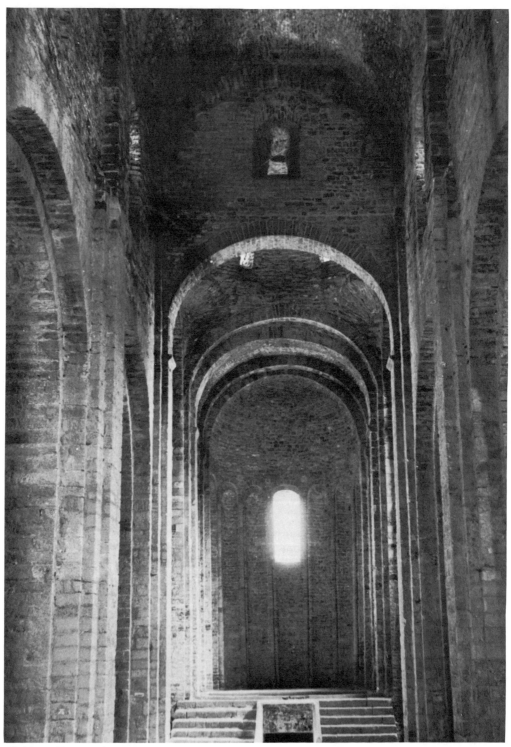

47. Nave, Church of S. Vincente, Cardona, Catalonia, c. 1020–40.

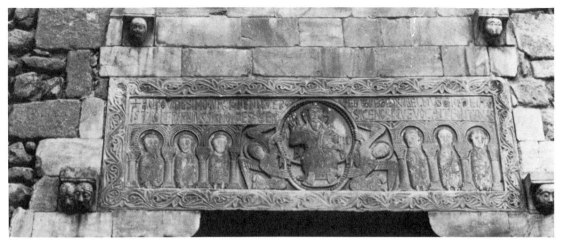

48. Christ and the Apostles, Church of St. Genis-des-Fontaines, 1020–21. Marble, approximately 3′ × 7′.

dimensional field in need of decoration, not as an open arcade housing tangible beings. Indeed, the Mozarabic horseshoe arches of the arcade actually define the contour of the apostles, for with arms clasped about their bodies and enlarged rounded heads, the saints seem designed solely to fill the keyhole shape of the surrounding arcade. Little concerned with three-dimensional effects, the artist tried to imitate the quality of a precious silver reliquary or golden altar by sharp chip-carving. As a consequence, the stone surface of the lintel catches the brilliant Mediterranean light in a manner that is reminiscent of faceted barbarian metalwork. With such work the Lombard-Catalan masters initiated a tradition

of architectural sculpture that, by the twelfth century, resulted in the application of carved programs to the portals and even to the entire western facades of Romanesque churches.

Monastic builders carried the Lombard-Catalan style, with its masonry vaults, architectonic decoration, and modest sculptural programs northward to affiliated monasteries in the territories of the Old Carolingian Empire. The Benedictine monks of Cluny introduced the Lombard-Catalan style into Burgundy and the Loire Valley, while Lombard builders working for patrons in the Holy Roman Empire carried the style and techniques to the imperial cathedrals in the Rhineland.

The Imperial Tradition: Ottonian and Romanesque Art in the Holy Roman Empire

Ottonian Art

The two empires—Byzantine and Ottonian—as far apart in the tenth century as the barbarians and Romans a thousand years earlier, both believed in their own superiority and their God-given right to lead the Christian world in a revival of the Empire of Constantine and in opposition to Muslims and pagan barbarians. Rival emperors considered themselves to be the political heirs of the Roman emperors and the spiritual heirs of the apostles, and they eyed each other warily but with grudging respect.

At the beginning of the tenth century, Saxon kings replaced the Carolingians as rulers of the land now called Germany. They created the political entity known as the Ottonian Empire (after three of the rulers), by 1254 called the Holy Roman Empire. In 911 the German dukes assembled according to ancient custom to elect one of their number king. Conrad, Duke of Franconia, won the election. On his deathbed, only seven years later, Conrad nominated his strongest rival, Henry the Fowler, Duke of Saxony, as his successor, and the Germans duly elected Henry. Thereafter, although the king continued to be formally elected, the office in fact became hereditary. Three powerful men named Otto ruled from 936 to 1002, giving their name in modern times to the historical period and its art and architecture.

Otto I, known as Otto the Great, chose to be crowned at Aachen, thus proclaiming himself the heir of Charlemagne in a revitalized Carolingian state. Otto wisely did not assert a claim to Carolingian West Francia (France), but turned his attention south, where he added northern Italy to his kingdom by marrying the widowed Lombard Queen Adelaide. At the invitation of the Pope, he moved on to Rome as defender of papal lands. Henceforth German and Italian history and politics became inextricably entangled, for German rulers saw themselves as the rightful heirs of Constantine, as well as Charlemagne, and their empire as the Holy Roman Empire.

Italian territories presented a problem: in this age of personal rule, a king could not reside permanently on one side of the Alps and expect to control his subjects on the other side without extraordinary assistance. To administer his diverse and widespread realm, Otto, like Charlemagne, turned to the Church for political as well as moral support. He soon filled important posts with his relatives; for example, his younger brother Bruno became both the Archbishop of Cologne and the Chancellor. Other relatives held the archbishoprics of Trier and Mainz, and women in the family became powerful abbesses. But not even family loyalty could ensure internal stability in an age when might was still usually

right. No sooner had Otto left Germany for Italy than his son, the Duke of Swabia, and his son-in-law, the Duke of Lorraine, allied themselves with the pagan Magyars. In 955 Otto decisively defeated the rebels at Lechfeld, near Augsburg, and Bruno became Duke of Lorraine in addition to his other offices. (The Magyars settled along the Danube in modern Hungary and by 1000 they adopted Christianity under King Stephen and Queen Gisela, Otto's granddaughter.) In 962, Otto the Great achieved his dream of reestablishing Charlemagne's Christian Roman Empire when Pope John XII crowned him emperor in Rome.

Ever the politician, Otto the Great now began to look with interest at the wealth and prestige of Byzantium. The rise of the Ottonians in the West coincided with the Second Golden Age in Byzantium, and the Byzantine court, no longer subject to the strictures of an iconoclastic policy, set the standard for pomp and luxury among Western rulers. Byzantine gold, enamel, ivory, and textiles served as models of taste and craftsmanship. Twice Otto sent an ambassador to the court of his rival emperor, but the missions met with little success. The Byzantine emperor tried to impress the Germans with his God-given power, and the Germans in return despised the Byzantines, whom they considered dirty and effete. Nevertheless, Byzantine luxury goods must have appealed to the Germans, for the ambassador, Luitprand, was caught smuggling silks back to the West. Eventually Otto the Great arranged a marriage between a Byzantine princess and his son, Otto, and in 972 Princess Theophano arrived at the German court with works of art in her dowry and artists in her retinue. She may have been a very minor princess in Byzantium, but she became a powerful force in politics and art.

The year after Otto and Theophano married, Otto the Great died, and the young couple ruled the empire. Politically, Otto II's reign (973–983) was a period of consolidation; culturally, the presence of a Byzantine empress made it one of great importance for art. Otto II, caught up in his father's dream of empire, determined to add all of Italy, including Islamic Sicily, to his empire. He died in 983 campaigning in Italy and was buried in the atrium of the Church of St. Peter in Rome. Otto III was crowned King of the Germans in 983 at the age of three, but his mother and grandmother—the Byzantine Empress Theophano (d. 991) and the Lombard Queen Adelaide—ruled the empire as regents for the child king.

When thirteen years later Otto III (983–1002) began his personal rule, with his coronation as emperor in Rome (996), Italy absorbed his attention. His near obsession with imperial Rome was encouraged by his tutor, Gerbert of Aurillac. Gerbert, whom we have already met in Catalonia (chapter VI), had been head of the cathedral school in Reims; he then served as Abbot of Bobbio, Archbishop of Reims, Archbishop of Ravenna, and finally Pope. Gerbert adopted Sylvester as his papal name, thereby identifying himself with the Pope who baptized Constantine, and, according to documents forged in the eighth or ninth century (the "Donation of Constantine"), received temporal rights over the Church. Gerbert, as Pope Sylvester II (999–1003), abetted the imperial dreams of his young protégé Otto III and hailed him as the new Constantine. Otto built an imperial palace in Rome and adopted elaborate Byzantine etiquette for the German court. Always conscious of the importance of symbolism, in the year 1000 Otto opened the tomb of Charlemagne, and while venerating the imperial relics, he removed Charlemagne's pectoral cross and Gospels for his own use.

Otto III left no heir at his early death in 1002, and the empire passed by election to his cousin Henry, Duke of Bavaria. Henry II (1002–1024), known as Henry the Pious, and his wife, Kunigunde, abandoned the grandiose schemes of the Ottos and devoted themselves to Germany. They enriched the Church, patronized the arts, supported monastic reform,

and became known as such efficient and pious rulers that both were canonized—Henry in 1146 and Kunigunde in 1200. They were buried in Bamberg, in the cathedral they had endowed.

The Saxon line ended with the death of Henry II, and when the electors chose Conrad II (1024–1039), the Empire returned to the Franconians. The new dynasty is called, with equal correctness, Franconian from the duchy located in the original Frankish tribal territory, or Salian, from the Latin name for the subtribe, the Sali. While Conrad II led the Empire to new heights of power and influence, the moral authority of the Church declined. Abuses such as the sale of bishoprics encouraged corruption among the clergy, while Rome became a center of intrigue and vice. Reform was clearly essential. The Benedictine Congregation of Cluny led the reform and, in so doing, became an international organization.

Throughout this unruly age abbots and bishops, emperors and dukes vied in the magnificence of their buildings and their gifts to the Church. The Ottos patronized Trier and Cologne; Henry II endowed Bamberg, Regensburg, and Basel; Henry III, Speyer. The splendor of the Ottonian period survives in the works of art created to be used by these worldly princes of the Church in services they hoped to make worthy of an imperial court.

Fortresses crumble; cities grow or die; vernacular buildings disappear, victims of the fragility of materials. Religious architecture is likely to survive, for it is both well built and preserved, either because of genuine piety or through conservative religious tradition. Nevertheless, Ottonian churches have seemed particularly prone to disaster. The Cathedral of Mainz burned to the ground on the day of its consecration in 1009. Otto the Great's Cathedral at Magdeburg burned in 1008; rebuilt in 1049, it burned again in 1208. Trier, the center of Ottonian imperial art, had its great Benedictine Church of St. Maximin destroyed in 1674; Hersfeld, the major Ottonian

Cluniac monastery, burned in 1761 and was never rebuilt. The churches of Cologne and Hildesheim were rebuilt in the twelfth and thirteenth centuries, only to be destroyed in World War II and rebuilt yet again, in our own time. Still, Ottonian architecture must be studied, even in reconstruction, for it provides a link between the architecture of the Carolingian Empire and the Romanesque buildings of the eleventh and twelfth centuries.

Just as Ottonian rulers sought to reestablish the Carolingian political empire, so too they commissioned their architects to create buildings which would recall the splendors of Charlemagne or Constantine. Naturally, they looked to Carolingian buildings as models: the elevation and central plan of the Palatine Chapel at Aachen, the Constantinian basilican form and double apses of the church at Fulda, the soaring towers of St. Riquier. Ottonian architects borrowed, reinterpreted, and recombined elements into a new imperial style. The Chapel at Aachen, with all its associations— not only as the court chapel but also the tomb of Charlemagne—inspired the design of several chapels and sanctuaries. The Abbess Theophano (1039–1058), granddaughter of Empress Theophano, added a chapel dedicated to St. Peter to the western transept of the church at the imperial Convent of the Trinity at Essen [1]. This western sanctuary, viewed from the nave, appears to copy the Palatine Chapel at Aachen, but actually the central half hexagon, ambulatory, gallery, stair turrets, and lateral bays are intricately interrelated forms unlike the relatively straightforward Carolingian structure that inspired their superficial form. A tower rose two stories above the semidome of the chapel. Flanking turreted stair towers occupying the space between the diagonal outer walls of the ambulatory and the square lateral entrance bays form a triple-towered westwork. This westwork retained its Carolingian imperial associations; as at Aachen, the gallery could be a throne room. Choirs may have sung from the galleries;

certainly in the later Middle Ages the chapel was used as a stage for a Passion play. Details such as pendentives supporting a semidome and capitals with miniature entablatures resembling stilt blocks indicate renewed Early Christian and Byzantine influence.

A magnificent candlestick given by the founder, Abbess Matilda (974–1011), the granddaughter of Otto the Great, copies the seven-branched candelabrum from the Temple of Solomon in Jerusalem, as represented on the Arch of Titus in Rome. The close contact between the Ottonian court and Rome meant that the aristocratic patrons' admiration for ancient Rome was now supplemented by first-hand knowledge of Roman imperial monuments as well as the art of the Byzantine court. The candlestick as well as the church suggest the care and intensity with which Ottonian architects and artists selected, studied, and then reinterpreted their models as they sought to create an austere and monumental imperial style for the German court. In so doing they established the direction taken by German Romanesque and even Gothic building, and influenced Romanesque architecture in Italy, Burgundy, and far-off Normandy.

Another abbey church, St. Michael's at Hildesheim, illustrates the Ottonian adaptation of the basilican form [2]. Archbishop Bernward (993–1022), who was canonized in the twelfth century, began the church in 1001 and consecrated the crypt in 1015. (The church was finished in 1033 but suffered damaging fires and rebuildings in the eleventh, twelfth, and seventeenth centuries. After being severely damaged in 1945, in 1958 the church was restored to its original eleventh-century form.) The Carolingian preference for east-west balance, seen at Fulda and St. Riquier, inspired the Ottonian builders [3]; however, massive low towers at the crossing of the transepts replaced the soaring lantern towers and belfries of St. Riquier, although the stair turrets at the ends of the transepts created additional vertical accents. On the interior, the basilican elevation

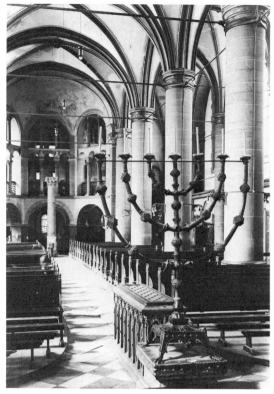

1. Convent of the Holy Trinity, Essen, mid-eleventh century; seven-branched candlestick, Hildesheim?, c. 1000.

is given a rhythmic energy by the alternation of piers and columns, a variation of forms that breaks the otherwise horizontal movement of the clerestory windows and the enclosure of the painted wooden ceiling. Transepts, like the transepts of St. Peter's in Rome or at Fulda, form continuous transverse elements as wide and high as the nave. As in Carolingian architecture, a square grid determined the plan of the building—three squares for the transept, four for the nave—and the placement of the piers and columns continued in the division of the interior space into vertical units. This incipient bay system becomes especially apparent in the demarcation of crossing bays by heavy arches of polychrome masonry. The rhythmic alternation of heavy and light supports, rectangular and round forms, hori-

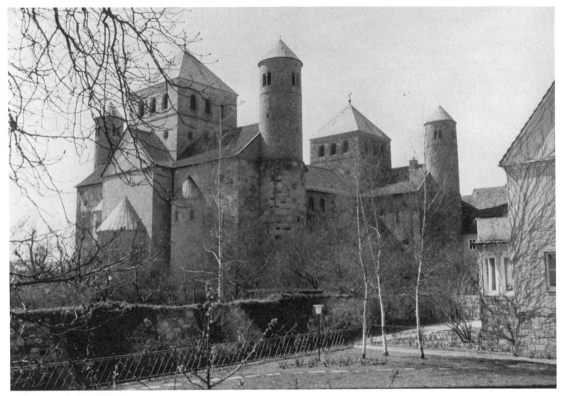

2. Church of St. Michael, Hildesheim, Saxony, 1001–33 (restored, 1958).

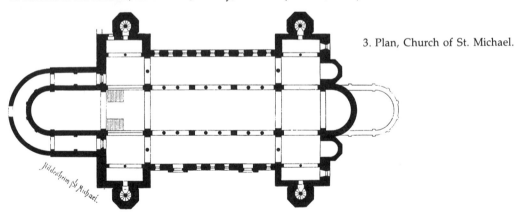

3. Plan, Church of St. Michael.

zontal and vertical movements characterizes the new Ottonian architectural aesthetic, and sets the Ottonian (and later medieval) basilicas apart from their Early Christian prototypes.

The cloister monks and the public entered St. Michael's through side doors; therefore, the aisles functioned as entrance halls and enhanced the divided focus on both east and west ends of the church [4]. The high altar of the church remained in the eastern apse; however, at the west the sanctuary bay and apse were raised over a half-subterranean vaulted crypt whose parallel aisles were surrounded by an ambulatory. The increasing complexity of the liturgy required double choirs, for which the transept galleries, their

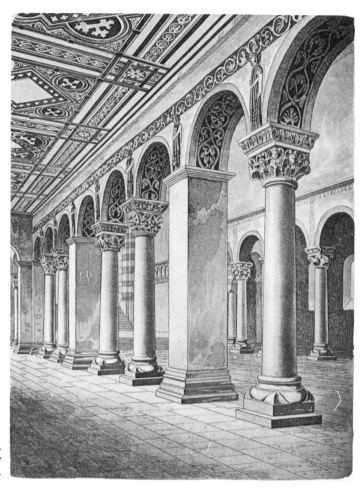

4. Nave and aisles, Church of St. Michael (nineteenth-century drawing).

floors connected by polygonal stair towers, offered ample accommodation. Such clear, simple cubical forms established the precedent for the severe and restrained German Romanesque style of the later eleventh and the twelfth centuries.

Bridging the Ottonian and Romanesque, and its final form a product of both, was the Cathedral of Speyer, built by the Salian (Franconian) kings as their dynastic pantheon. The Cathedral of Speyer was remodeled in 1172–1178 and restored in 1820. A huge crypt extending under both the transept and the sanctuary survives from the building begun in 1030 and dedicated in 1061 [5, 6]. Here the Ottonian tendency toward compartmentalization and subdivision continued; piers divide

the space into square bays, which are then further divided by heavy columns with cubic capitals carrying connecting arches and groin vaults. The cubic capital, an extreme simplification of a Byzantine form, suited the austere German taste so well that it was used throughout the succeeding Romanesque period.

The crypt supported a transept and a raised sanctuary flanked by stair towers and covered by an octagonal tower. This imposing tower complex was balanced at the west by an enormous western wall twenty feet thick, pierced by a double splayed door (door jambs angled both inward and outward) and containing stairs rising above the wall in two towers. Later builders added a galleried porch,

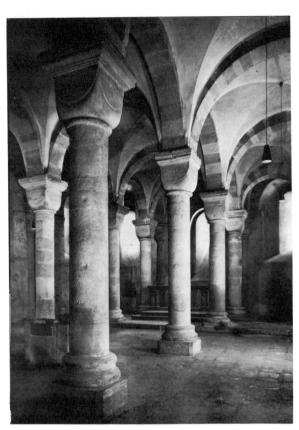

5. Crypt, Cathedral of Speyer.

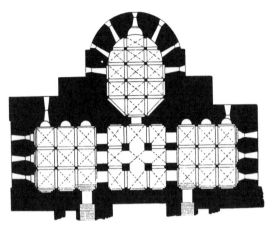

6. Plan, crypt, Cathedral of Speyer, 1031–61.

7. Cathedral of Speyer, 1030–61; second campaign begun 1080, vaulted after 1106.

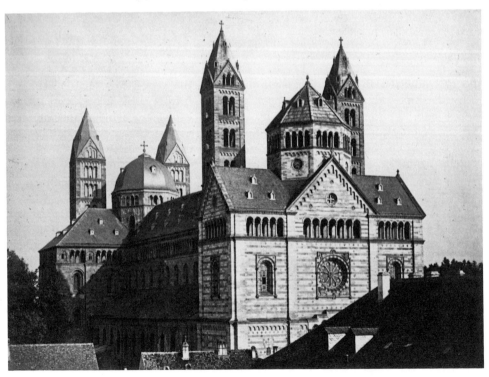

as high as the nave and covered by a central tower, thus forming a kind of westwork. The forms established in Carolingian buildings have been enlarged, made increasingly complex, and at the same time very grand. The completed building was 435 feet long, making it one of the largest churches in Europe [7].

The interior of the first church, Speyer I, must have been very imposing. The timber-roofed nave and groin-vaulted side aisles were carried on rectangular piers having engaged columns on their inner and outer faces. These engaged shafts ran the height of the nave (about 85 feet) and were joined by a series of arches framing the windows of the clerestory. (The design may have been inspired by the giant, continuous blind arcade of the Constantinian hall at Trier.) This system of compound piers and wall arcades was adopted in Romanesque architecture. Clerestory windows were probably large even at Speyer I, for the thick walls easily carried the weight of the light timber roof. As an imperial cathedral, Speyer established the pattern for major German ecclesiastical buildings during the Romanesque period.

In the history of painting as well as architecture, the tragic destruction of monuments through fires and wars complicates the study of Ottonian art. Only fragments or heavily restored paintings bear witness to the murals that made church walls a text for people in an age when even the clergy might be only semiliterate. Illuminated manuscripts—splendid books adorned with gold, gems, and ivory—provide the best visual evidence of Ottonian pictorial arts.

Ottonian artists, like the architects, created a new imperial style by reinterpreting the past, combining elements of Late Antique, barbarian, Byzantine, and Carolingian art. Acceding to their well-traveled patrons' demands, artists copied Roman monuments, whether pagan (the columns of Trajan or Marcus Aurelius), Jewish (the seven-branch candlestick), or Christian (the stories of Christ and the saints on the walls of Roman churches). Furthermore, they saw that Roman artists had depicted both historical events and allegories with human actors in a spatial environment, so they, too, developed a powerful narrative and symbolic art with human figures. Nevertheless, their Germanic, barbarian heritage underlay the expressive content as well as the form of their painting and sculpture. The artists' preference for schematization of natural forms and the intensity of their expression derives from this Germanic heritage, while the patrons' love of gold and jewels and the artisans' great skill in every kind of metal and lapidary work are also part of an artistic tradition going back to the migration period. This love of opulence is as Byzantine as it is barbarian, and contemporary Byzantine art also profoundly influenced Ottonian artists. The presence of a Byzantine empress, Byzantine art objects, and Byzantine artists in the Ottonian court cannot be overemphasized. Byzantine art provided models for imperial and religious iconography, for systems of drawing the human figure, for the depiction of space, and even for details of costume and ornament. Finally, Carolingian art often acted as an imaginative filter for the Byzantine style—and the Roman and barbarian styles as well—and works of art produced for Charlemagne or Charles the Bald could be copied faithfully, as we will see in a codex made for Archbishop Gero.

Ottonian art was not entirely dependent on the emperor, and many secular and ecclesiastical courts were centers of patronage. Regional styles begin to appear, for, although Ottonian rulers might in theory be all-powerful, in practice the great dukes and churchmen held nearly autonomous courts in such scattered centers as Cologne, Hildesheim, Reichenau, Trier, and Regensburg.

Archbishop Gero of Cologne (969–976) was one of these important patrons north of the Alps. A Gospel lectionary belonging to him provides an excellent introduction to Ottonian painting, because in it the artist attempted to

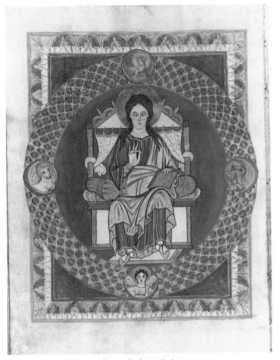

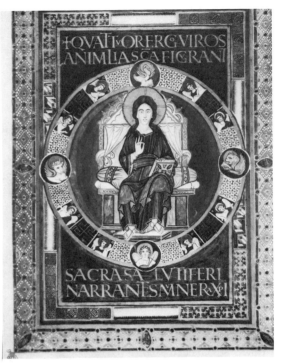

8. Christ in Glory, *Gero Codex*, Cologne or
Reichenau, 969–76. Vellum, approximately 11 3/4″ ×
8 3/4″. Hessischelandesbibliothek, Darmstadt.

9. Christ in Glory, *Lorsch Gospels*, Aachen (Carolingian
palace school), early ninth century. Vellum, 14 1/2″ ×
10 1/2″. Bathyaneum, Alba Julia, Rumania.

copy the *Lorsch Gospels*, an early ninth-century
Carolingian manuscript from Aachen, whose
ivory cover we have already seen. The opening
miniatures of the *Gero Codex* [8] and the *Lorsch
Gospels* [9] have an image of Christ in Majesty
adored by the apocalyptic beasts, who appear
in medallions set in a wide mandorla overlap-
ping a rectangular frame of stylized acanthus
leaves. A comparison of the two paintings
illustrates both the debt and the originality of
the Ottonian artist. He simplified and clarified
the image; focused attention on a broader and
more massive figure of Christ by eliminating
the angels, inscriptions, and outer frames; and
reduced the ornament to only two motifs, the
Byzantine double ax and the acanthus. His
composition is compact and concentrated: the
repeated rectangles of page, frame, and throne
interlock with the circles of mandorla, halo,
medallions, and even Christ's round face and

enlarged eyes. All elements direct attention to
the blessing hand. The image seems pressed
into a series of thin overlapping planes, in
which the lingering illusionism of the Carolin-
gian model is abandoned. This urge to clarify
and control the image extends into the drawing
itself, for the calligraphic quality of Carolingian
drawing has given way to hard, regular out-
lines filled with bright, flat colors, and the
once illusionistic modeling of forms has been
reduced and intellectualized into repeated lin-
ear patterns. We have seen such a system of
shadow and highlight develop in Middle Byz-
antine painting and mosaic; now the Ottonian
artists have turned the Byzantine formulas, as
they did their Carolingian models, into a style
both more severe and more ornamental.

The *Gero Codex* was probably not made in
either Cologne or Lorsch, but in Reichenau (a
peninsula in Lake Constance, where three

monastic churches survive to this day), the principal center of manuscript production in the tenth century, or in Trier, the seat of Archbishop Egbert. Egbert, the son of the Count of Holland, had served as imperial chancellor before becoming archbishop during the reign of Otto II. His abbey of St. Maximin at Trier was a center of scholarship and spiritual renewal. The three manuscripts associated with the archbishop—the *Codex Egberti* (a book of pericopes), the *Registrum Gregorii* (the letters of St. Gregory), and the *Egbert Psalter*—could have been made in Trier; nevertheless, a dedicatory portrait shows the *Codex Egberti* being presented to the archbishop by the monks Kerald and Heribert of Reichenau [10].

In the frontispiece of the *Codex Egberti* (c. 980–985), Egbert sits isolated against a red-purple ground, his head framed by a square halo (indicating that he was alive at the time the portrait was painted) and by a gold inscription. In the compressed space of the painting, his gold lion-headed throne footstool and the painting's frame become a single interlocking golden base for the archbishop. The symbols of Egbert's spiritual and temporal power—the golden crosier and the pallium (the white woolen strip around his shoulders), which denotes his papally endowed authority—are juxtaposed at the center of the figure. The towering, rigid, frontal image of the archbishop and the severity of mood, intensified by the staring eyes, recall the portraits of Constantine or Theodosius. The extreme elongation of the torso suggests either the influence of Byzantine icons or their Carolingian interpretations. Yet, with all these references to earlier art, the artist has unmistakably worked in the new Ottonian style. He constructed the figure of Egbert from geometric forms—the spiral stomach surrounded by four ovals for the knees and chest—and simplified the drawing of the garments to produce an extraordinary clarification of Carolingian and Byzantine drawing.

This stylization of the principal figure con-

trasts with the well-observed depiction of Kerald and Heribert. The two monks are stocky figures wearing recognizable monastic habits, and modeled with some reference to anatomical possibility. The monks stand outside the inner frame of the page—outside Egbert's world—almost becoming part of the frame. In creating these two lively gift bearers, the painter may have looked at Early Christian or Carolingian sources, for the monks have a life and energy reminiscent of the courtiers and monks in the *Vivian Bible*. Countermanding these classicizing sources is the wide gold and purple frame composed of gnawing beasts growing out of masks. Here, the biting animals of the north become confused with, or expand into, coarse tendrils (just as occurred in Scandinavia, on the stone of Gorm the Old), as they undulate symmetrically through a space confined by hard-edged borders. This unbro-

10. Archbishop Egbert with Kerald and Heribert, *Codex Egberti*, Reichenau?, c. 980–85. Vellum, 9 3/8″ × 7 1/4″. Stadtbibliothek, Trier.

ken red and gold frame reinforces the Ottonian emphasis on artistic control.

In 983 Archbishop Egbert gave his cathedral a book known as the *Registrum Gregorii,* illustrated by one of the most brilliant painters in the early Ottonian period [11]. This anonymous artist, known as the Gregory Master, may have directed the scriptorium at St. Maximin's in the 980s. In the cosmopolitan atmosphere of the bishop's court, he evidently had access to Early Christian as well as Carolingian and Byzantine models, from which he developed his own sophisticated, classicizing style. Two miniatures survive from the *Registrum Gregorii*—one of them a portrait of St. Gregory, in which the learned Pope works at his desk, inspired by the Dove of the Holy Spirit, who whispers in his ear. Gregory, like Egbert, towers over lesser men—in this case, his secretary spying on him through the curtains.

11. Pope Gregory, *Registrum Gregorii,* Reichenau?, 983. Vellum, 10 5/8″ × 7 7/8″. Stadtbibliothek, Trier.

The Pope dominates the composition in spite of the distraction created by the elaborate setting the narrative required. Gregory sits on a golden throne under a hanging votive crown, like the Visigothic crown of Recceswinth. In contrast, the curious secretary has become a comic figure, as knotty and twisted as the curtain above him.

In the Pope's study the painter has reduced the architectural forms to a series of thin, superimposed layers with a frame that hints at a Classical bead and reel molding. In simultaneous yet shifting views, we see the interior and exterior of the building and its gable as well as its side wall. At the bottom of the page, columns, bases, throne, footstool, feet, and drapery are all worked into a carefully calculated, two-dimensional, rectilinear pattern that turns perspective systems to nonsense in a dramatic denial of the material world. The unreal, floating quality becomes particularly apparent in the secretary, who neither sits, stands, nor crouches but hovers over his bench. Yet the Gregory Master remains the most classicizing of Ottonian painters. Within the strong outlines characteristic of Ottonian painting, he modeled flesh and drapery with a subtlety unusual in Ottonian art. The sensitive treatment of idealized faces, suggested in turn by a Byzantine Classical revival, avoids the exaggeration characteristic of most Ottonian painting; and in delicate, luminous colors and refined drawing, the Gregory Master found the possibility for personal expression even within the hieratic forms of Ottonian painting.

The Gregory Master had little immediate influence on other painters—in his personal reinterpretation of antique art he was ahead of his time—but ultimately his classicizing style spread into the Rhine and Meuse River valleys and became a source for Mosan artists in the eleventh and twelfth centuries (chapter VIII). More characteristic of Ottonian art are the manuscripts made for Otto III and Henry II.

12. St. Luke, *Gospels of Otto III*, Reichenau?, c. 1000. Vellum, 13 1/8″ × 11 1/8″. Bayer. Staatsbibliothek, Munich.

The political and even transcendental aspirations of the young Otto III and the religious reforms stimulated by monastic orders inspired an art in which a sense of barely suppressed inner turbulence bursts forth in dramatic gestures and often a wild-eyed frenzy—a frenzy deliberately developed, like an imperial policy, by cool, clear-headed artists. The author portraits in the *Gospels of Otto III* (now in Munich) display a striking originality [12]. Instead of depicting the evangelists intent on their writing, the artist represented men in ecstasy to whom the full mystery of their religion is revealed by heavenly messengers. St. Luke sits on a rainbow enclosed by a mandorla, the writings of the prophets in his lap and his inspiration suggested by circles of heavenly fire, from which emerge prophets, apocalyptic beasts, and angels. St. Luke flings out his arms, both supporting the vision above him

and drawing its power into himself. At his feet flows the River of Life, nourishing the flocks—that is, the Christian community. The inscription across the lower edge of the frame reads, "From the source of the fathers the ox brings forth a flow of water for the lambs." A festooned arch supported on porphyry columns frames the page; any architectural quality is denied by flickering brushwork and an imaginative combination of plants, birds, and ribbons. The painter has eliminated the lingering classicism of the Gregory Master and his followers, as a comparison of the heads of St. Luke and Pope Gregory shows. A reference to the evangelists of the *Ebbo Gospels,* furthermore, suggests that the religious excitement now resides in the image itself, not in its creator. St. Luke explodes in the emotion of the moment, but the artist remained aloof,

13. Storm on the Sea of Galilee, *Gospels of Abbess Hitda,* Cologne?, eleventh century. Vellum, 11 3/8″ × 5 5/8″. Hessische Landesbibliothek, Darmstadt.

14. Detail, Christ on the Cross (Gero crucifix), Cathedral of Cologne, c. 970. Polychromed wood. Entire figure, 6' 2" high.

drawing clear, hard, and controlled outlines and filling them with brilliant and unnatural colors.

The charged emotional content of the evangelist portraits in the *Gospels of Otto III* continues in the justly famous eleventh-century *Gospels of Abbess Hitda* (d. 1042), given by the abbess to the Convent of St. Walburga, Meschede, in the diocese of Cologne [13]. Religious fervor rather than imperial ceremony seems to have motivated the Cologne artist, who, like his Carolingian predecessors in Reims or Metz, painted with an urgency that enabled him to capture the drama of salvation. Otto-

nian artists created original illustrations for New Testament narratives. The painter of the *Hitda Gospels* was a wonderful storyteller: the boat, with its sail whipping in the wind and its oars useless, plunges through sky and water right over the painting's heavy frame, like an animated sea creature with a dragon-head prow and a lashing tail. With agonizing expressions the apostles cast their eyes up to Heaven—and to the sail—while one of their number grasps Christ's shoulder in an effort to shake Him awake. Meanwhile Christ sleeps in their midst, resting His head on a drapery-covered arm and hand; the long folds of the

drapery draw our attention to Him and provide a stable element in the slipping, tilting composition. The artist has drawn with color—pinks, reds, white—and the halos resemble a heap of golden discs. He has abandoned the stability and monumentality of the Ottonian court school for a more personal expression and freer brushwork, which recalls the illusionistic technique of some Carolingian and Early Christian painting.

Intense emotional content as well as monumentality and formal clarity characterized sculpture as well as painting in Cologne. A polychromed wood sculpture, over six feet high, of the crucified Christ presented to the Cologne cathedral about 970 by Archbishop Gero exemplifies these qualities [14]. Functioning as both sculpture and reliquary, the *corpus Christi* (body of Christ) held the Host in a receptacle in the head; thus the wooden body literally held the presence of Christ. Not a symbolic sacrificial Lamb of God, not a Byzantine emperor alive and crowned in front of a cross, not even a young hero, as in some Early Christian or Carolingian images, but a stripped and broken martyr appears before the worshiper. To the solemnity and grandeur of the image, the sculptor added a new emotional intensity, for he dwelt on the anguish of Christ, inducing in the worshiper feelings of pity as well as awe. The horror of the Crucifixion rather than the triumph of the Resurrection suffuse this huge, gaunt figure, a horror that abstraction of the musculature and the geometry of the golden drapery cannot dispel. The sagging stomach, chest, and hands, the bony arms and legs, the drawn flesh of the face so effectively capture the sensation of dead weight that their beauty as formal elements only heightens the horror. At last, nearly a millennium after the event, an artist has portrayed the material fact of Christ's death by torture. In content and form the Gero crucifix played an important role, as Western artists began to create a more personal vision of Christ.

If religious fervor distinguishes art in Cologne, learned sophistication, material splendor, and technical refinement characterize work produced in Regensburg, a city which rose to importance at the beginning of the eleventh century, during the reign of Henry II and Kunigunde. Regensburg artists also had important Carolingian models available; the imperial regalia of the Carolingian house, including reliquaries and the Carolingian *Codex Aureus,* lay in the Abbey of St. Emmeram. Goldsmiths worked beside painters and scribes to create an art of equal refinement and material splendor with which to surround the Word of God. When Henry II ordered a book of pericopes for Bamberg Cathedral, before his coronation as emperor in 1012, he must have given the goldsmiths items from his imperial treasury to incorporate into the cover [16, p. 126]. Thus, the artist literally combined rather than reproduced elements from different sources: a Carolingian ivory, Byzantine enamels, and his own enamels, gems, and pearls. The round-headed Byzantine cloisonné prophets and apostles (which are probably from a votive crown), three on a side, alternate with large rectangular stones surrounded by smaller gems and pearls. The jewels are set on a gold ground on arcades of pearled wire to raise them in order that the light will enhance their luster. Enamel roundels with the four evangelists, perhaps made in Regensburg or Trier, fill the corners, and a niello inscription on the inner frame names Henry II as the donor. Just as in painting, strict frames within frames visually bind and control the heterogenous elements; each part is exquisite—the whole is magnificent.

Although the incorporation of ancient and exotic treasures into a new work associated it with older empires and thus gave it added context, Ottonian jewelers had no need to borrow Carolingian ivories. Skillful carvers worked in their shops; one such artist, of unusual imagination and skill, carved an image of the Doubting Thomas [15]. The inscription

15. Doubting Thomas (detail), Trier or Echternach, variously dated tenth or eleventh century. Ivory. National Museum, Berlin.

carved on the ivory comes from the Gospel of John (20:27): "Then saith he to Thomas, Reach hither thy finger, and behold my hands; and reach hither thy hand, and thrust it into my side: and be not faithless, but believing." With remarkable realism for the age, the sculptor abandoned the normal Ottonian hieratic scale and instead literally elevated the risen Christ on an octagonal pedestal. He then attempted to show St. Thomas from the back, stepping and looking upward at Christ, his head dramatically and accurately foreshortened. The intensity of the gaze establishes a psychological as well as physical interdependence, as the heavy muscular figures with their enormous hands and feet seem to interlock. The juxtaposition of the hands—the searching finger and clutching fist of St. Thomas and the passive grace of Christ— capture the spirit of the whole in a detail. Yet

for all the psychological potency of the moment, the artist also escapes into an Ottonian love of ornamental display—Christ and St. Thomas both wear patterned cloaks, the rich Eastern silks so admired by the Ottonian courtiers. The contrast between the monumental figures and the surface decoration reinforces the tension between surface and form, form and space, created by the compression of huge figures into a shallow roundheaded niche and wide acanthus-filled frame. This ivory, and others by the same master, were carved either in Trier or Echternach. Scholars disagree on their date, some suggesting the end of the tenth century, others the early eleventh, and recently Lasko has called the ivories Romanesque work of the mid-eleventh century. Whatever the authorship and date, Doubting Thomas is a powerful image.

More than the ivory or wood carver, the smith had always been an important and mysterious figure in the north. Ottonian smiths, with their roots deep in local tradition, were daring and innovative in the technical perfection of their silver and gold work and in the audacious scale of their bronzes. They rapidly developed the intellectual and technical means to fulfill the most demanding patrons. The candlestick at Essen or the cover of Henry II's pericopes for Bamberg Cathedral are examples of their brilliant work.

The monumental quality inherent in the imperial style does not depend on the actual size of the piece, and for this reason Ottonian artists working within their own versions of Byzantine formulas could enlarge or reduce the scale without losing the imposing character of the work. The portable altar given by Countess Gertrude to the Cathedral of Brunswick about 1040 is only four inches high, and yet the tiny figures of Christ, Mary, and the apostles, and of Constantine and St. Helena adoring the True Cross, have all the presence of a Romanesque apostolado (college of apostles) [16]. The portable altar is actually a

16. Gertrudis Altar, the Guelf Treasure, Brunswick, Lower Saxony, c. 1040. Gold, enamels, precious stones. The Cleveland Museum of Art.

simple oak box containing relics wrapped in precious scraps of cloth. The golden figures stand under an exquisite cloisonné arcade. A porphyry slab forms the altar table and precious stones alternating with pearls and filigree once framed the top and bottom. A niello inscription around the stone reads, "In order to live happily in Him, Gertrude presented to Christ this stone, glistening with gold and precious stones." Later, as we shall see, Romanesque sculptors translated the forms developed by Ottonian goldsmiths and bronze casters into stone and marble sculpture.

If the altars represent an imperial style of Reichenau and Trier at its most imposing, then the bronze casters of Hildesheim working under the direction of Bishop Bernward represent the more popular and dramatic narrative style seen so memorably in the Carolingian *Ebbo Gospels* and *Utrecht Psalter* two hundred years earlier. Bernward and his men created the first truly monumental bronze sculpture in the north—a door 16½ feet high and a column 12½ feet high—for the Church of St. Michael [17]. The door and column have been called "retrospective," and to be sure the bishop

looked back to the monuments of imperial Rome as he challenged his artists to do as well for the new Christian empire. The form of the monuments is Late Antique. Bernward saw carved doors and commemorative columns when he accompanied Otto III to Rome for the coronation. On his return to Germany in 1001, Bernward ordered his artists to cast a set of bronze doors covered with scenes from the Old and New Testaments. The doors were ready for the consecration of St. Michael's choir in 1015.

A remarkable achievement in bronze casting for any age, the doors, each wing of which was cast in one piece, are a near miracle in the eleventh century. Earlier bronze doors had been either simple sheets of plain metal, such as the doors at the Palace Chapel at Aachen, or they were constructed of small panels nailed to a wooden frame. At Hildesheim, the artisans used the lost-wax process, which they reintroduced to the Continent from Anglo-Saxon England (where the technology, used on a small scale, had never been lost). In the lost-wax process the artist modeled his sculpture in wax over a core; then the casters made a

17. Old and New Testament scenes, doors of St. Michael's Church, Hildesheim, 1015. Cast and chased bronze. Height, 16' 6". Cathedral of Hildesheim.

mold with vents top and bottom so that, as they poured in the molten metal, the wax melted and ran out at the bottom. When they broke away the mold, if they were successful the metal had the same form as the original wax sculpture. The process is more difficult in practice than its description implies, and the Hildesheim bronze foundry made a significant contribution to the history of technology as well as the history of art.

The intellectual content of the doors matches the audacity of their physical creation. St. Bernward must have designed the iconographical program himself, for only a scholar thoroughly familiar with both art and theology would have conceived of combining this clear narrative history with such subtle interrelationships. The chronological history of the Fall of Man and his salvation through Christ is so arranged that paired scenes from Old and New Testaments become a mutually interdependent explication and justification of each other. The left-door wing has eight scenes from Genesis [18], beginning at the top with the creation of Adam, moving downward, and ending with the murder of Abel. The right wing, beginning at the bottom of the door and running upward, illustrates the New Testament from the Annunciation to the appearance of Christ to Mary Magdalen after the Resurrection (*Noli me tangere*). A wide frame with a dedicatory inscription divides the narrative sequence into groups of four scenes. On the Old Testament side, events in paradise ending with the discovery of Adam and Eve lie above the inscription, and events in the world beginning with the expulsion lie below; on the New Testament side, the first four scenes depict the life of Mary and the childhood of Christ; the upper four, His Passion, beginning with His trial before Pilate.

That a scholar designed the program for an educated, theologically sophisticated audience is apparent in the typological comparisons established by each horizontal pair of scenes. Here the theological and moral significance of events is amplified by comparison between the Old and New Testaments. The theme of the two Eves, a theme that became widespread in Medieval art, runs through several scenes: Eve who caused the fall and expulsion from paradise and whose son committed the first murder is contrasted with the "new Eve," Mary, through whose son salvation was granted. Juxtaposed at the center of the door, Eve and Mary are almost identical figures,

18. The expulsion of Adam and Eve from Paradise (detail of doors cast for St. Michael's Church), Hildesheim, 1015. Bronze, 22″ × 42″. Cathedral of Hildesheim.

each holding her firstborn son—Cain, the murderer; Jesus, the savior. As part of the chronological narrative, Eve belongs to the scene of man's labors after the Fall, while Mary is glorified in the Epiphany. Just as Eve's name in Latin, EVA, reversed—spelled backwards—becomes AVE, the first words of the angel's greeting to Mary at the Annunciation, so too God reversed the consequences for humankind of Adam and Eve's Fall at the moment of the Incarnation. Sin—Cain's slaughter of Abel—is paired with the Annunciation at the bottom of the doors. This wiping away of sin through Christ becomes a recurring theme: the expulsion of Adam and Eve from paradise is paired with the purification of Mary and the presentation of Christ in the temple; Adam and Eve accused by God, with Christ accused before Pilate; the Fall, and the Resurrection. In this monumental public art every pair of scenes becomes the subject for private meditation and public homily.

Such sophisticated intellectual content is expressed in forms of childlike simplicity and directness, composed by an artist more at

home with the pen than the chisel. Small lively figures with a few plants and bits of architecture in open uncluttered space suggest the drawings of the *Utrecht Psalter.*

The jutting heads and gesticulating figures of the Reims school have been re-created by tilting the upper parts of the figures out until the heads emerge entirely free from the ground. This partial freeing of the actors from the setting produces an exciting surface composition, and an emphatic concentration on human emotions and reactions.

The joy and eagerness with which Adam and Eve greet each other, the shifting of blame from one to the other and finally to the serpent in the Fall, the simpering argument of Eve in the expulsion, the surprise of Mary at the Annunciation, the weakness of Pilate and his men, or the wonder of Mary Magdalen all relate immediately to the human condition and produce a unique and powerful work of art.

The iconography and style of the doors owe a debt to Carolingian manuscripts, but the column, where the life of Christ unfolds in a

continuous spiral in twenty-four individual scenes, introduces a new phase of German art [19]. The spiral column, probably completed before Bernward's death in 1022, stands as the Ottonian challenge to the monuments of ancient Rome. After seeing the triumphal columns carved with the feats of the Roman emperors, Bernward must have decided to create just such a monument to record Christ's earthly life, from His baptism to His entry into Jerusalem—precisely the scenes omitted from the bronze doors. (The column lost its capital and surmounting cross in the seven-

19. Spiral column with scenes from the Life of Christ, Hildesheim, 1015–22. Cast bronze. Cathedral of Hildesheim.

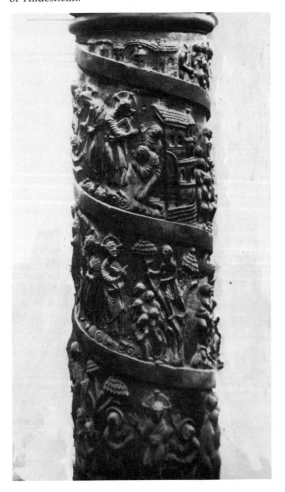

teenth century.) In contrast to the retrospective aura surrounding the doors, the column returns to an aggressively Ottonian style—to dense compositions in which large, intensely emotional figures are compressed into a narrow space. Line dominates the sculpture as it had painting, and the artist, using a direct casting technique rather than reworking the surface, built his images with repeated linear patterns notable for their expressionistic quality and raw strength. A new artistic personality has joined the Hildesheim shop, one more attuned to Ottonian power than Carolingian refinement. The splendid, opulent art of the Ottonian court disappears here, as it did in the *Hitda Codex*, to be supplanted by the almost brutally rugged and even exaggerated forms which presage the future direction of much German art. German expressionism—brutal, intense, relying on the power of line to define mass in a compressed space—is born in St. Bernward's column at Hildesheim.

Ottonian art is an aristocratic art of great splendor. The artists served the Empire, although they also served a religion that held spiritual values above the material world and questioned the possibility of expressing truth in tangible form. Taking their direction from earlier imperial styles, they created monumental compositions by means of hieratic images, symmetrical compositions controlled by jeweled frames, and massive figures acting in a compressed space. Abstraction based on geometry rather than on observation adds to the rigidity and solemnity of the figures, which become schematized symbols designed to convey a message or to express an emotional state through exaggerated gestures and huge eyes with widely dilated pupils. Ottonian artists concentrated on their human actors and eliminated distracting accessories and settings; they went beyond Byzantine or Carolingian artists in their simplification of drawing and modeling. Their work sometimes may seem excessively didactic, but, as in architecture, apparent directness and simplicity can hide a complex

and subtle inner form or meaning. The hard drawing, clear colors, and balanced composition in a painting—like the walls and cubical spaces in a building—may be combined with exceedingly intricate interlocking forms and spaces controlled by the artist's strong sense of the frame or the boundary wall.

Ottonian artists could be conservative, turning back to the arts of imperial courts of the past—Rome, Byzantium, and Aachen—and they could be equally innovative as they created a Western imperial style. The arts glorified and justified the combined secular and religious authority of God-like emperors and aristocratic, worldly clerics, but also, in the hands of masters and thoughtful scholars, they had a potent spiritual and intellectual impact. An art of contrasts, Ottonian art combines simple narration and complex metaphor, severe form and intricate interlocking spaces, a denial of the flesh in the ecstatic saints and adulation of material goods in the gold and jeweled sumptuary arts. It is a figurative art in which the people fill ornamental as well as narrative purposes. It is an art which draws into itself, like St. Luke in the *Gospels of Otto III,* the inspiration of the past and, like St. Luke, digests and then flings forth new forms. In their synthesis of old and new, East and West, Ottonian artists created a severe monumental style for a holy German-Roman Empire, and, in John Beckwith's apt phrase, "Ottonian art provided an imperial gateway to the Romanesque."

Romanesque Art

From Europe's Roman and barbarian heritage an art and architecture emerged in the eleventh and twelfth centuries which is both international and regional, sophisticated and brutal—an art for monks and emperors, pilgrims and Crusaders, peasants and nobles. Romanesque art reflects the dichotomy of an age when the ideal of a universal Christian church confronted a feudal, manorial society.

Clergy, nobility, and peasants had assigned places in a social system which recognized, in theory, the supremacy of God and His vicars. The Pope, as the leader of the Western Church, claimed dominion over all Christendom. The Patriarch of Constantinople, not surprisingly, refused to submit to the claims of the Latin Church, and as we have seen, the final break between the Latin and Greek Churches came in 1054. Secular rulers could be equally resentful of papal claims. For all the formal deference paid to the authority of the Church, secular power remained more than an equal partner.

The question arose, could secular and papal empires co-exist? Reforming Popes Leo IX (1048–1054) and Gregory VII (1073–1085, formerly the Cluniac monk, Hildebrand) exacerbated the inherent conflict between spiritual and temporal power. The controversy came to a head in Germany when both the Pope and the emperor claimed the right to invest new bishops with the ring and staff of office. Emperor Henry IV (1056–1106) wished to maintain the power held by his Ottonian predecessors to make ecclesiastical appointments as part of his economic and political power base; therefore, when he tried to reaffirm his authority over the German bishops not only by nominating candidates but also by performing the symbolic public ceremony of investiture, the very principle of Church freedom was at stake. Henry came into direct conflict with Gregory VII's vision of the Pope as an all-powerful ruler who controlled the Church and also had the right to recognize or depose monarchs and emperors. Although Gregory won in principle by humiliating Henry in 1077 at Canossa, Henry retained his political control, and the investiture controversy lingered on into the twelfth century.

In the twelfth century Germany was a loose federation of states held together by personal ties, feudal oaths, and self-interested alliances sealed by marriages. Two great families, the Welfs of Saxony and the Hohenstaufens of

Swabia, struggled for power. Although in 1138 Conrad III, Duke of Swabia, emerged victorious as the first Hohenstaufen emperor, the Welfs through prudent marriages secured Saxony and Bavaria, and their leader, Duke Henry the Lion, cemented an Anglo-Norman-Welf alliance by marrying the English princess Matilda. The Hohenstaufens still controlled the elections, and when Conrad III died in 1152 his nephew Frederick Barbarossa (1152–1190), rather than Henry the Lion, became emperor. Frederick Barbarossa, determined to play the successor to Constantine and Charlemagne, was the first ruler to call his lands the Holy Roman Empire.

Historians have seen the near obsession of the German emperors with Italy as a serious defect in their policy. Had the emperors concentrated their energy and resources on their homeland (as did the Anglo-Norman and Capetian kings), they might have formed a unified German nation; however, they inherited imperial aspirations from their Ottonian predecessors, and they yielded to the temptation offered by the rich lands over the Alps. The determination of the Holy Roman emperors to control Italy led to cultural exchange, reflected in architecture and the arts. Lombard masons had worked in Germany in the eleventh century (chapter VI); in the twelfth century the Italo-Byzantine style also spread with renewed vigor into Germanic lands.

German architecture found its definitive expression in the Cathedral of Speyer: *Kaiserdom*, imperial pantheon, and symbol of the Holy Roman Emperor's power and authority [20]. Henry IV began the rebuilding of the eleventh-century church after his defeat of his rival, Rudolph of Swabia, in 1080. Henry's great church stood as a symbol of his triumph over the nobles, Rudolph, and Pope Gregory VII. In the original building, the nave had been composed of a series of uniform bays defined by piers with engaged pilasters supporting blind arches [21]. In the new scheme, since two nave bays were to be combined

under one vault, only alternating piers required additional masonry reinforcement. The second team of architects reinforced every other pier by adding engaged columns and responds running the full height of the nave. This system divided the nave into square bays, and since the side aisles were half the width of the nave, following the time-honored system of surveying based on circles, which produced square modules, two of the groin-vaulted side aisle bays equaled one nave bay. The alternation of heavy and light piers created a rhythmic movement down the length of the nave. Thus, the bay system begun by Ottonian architects developed into a mature functional composition.

In 1106 a third building campaign began at Speyer. A new master, probably from Como in northern Italy, built the soaring domical groin vaults, which rise 107 feet from the pavement of the nave. He also added an exterior Lombard dwarf gallery to the top of the nave, transept, and choir walls, using this exterior gallery, along with arched corbel tables and pilasters, to create a play of solid and void, of light and shade, that changed the walls from flat enclosing planes into three-dimensional forms. The massing of towers, which rise like exclamation points at each end of the long nave, enhance the balanced composition adopted from Ottonian architecture by emphasizing both the sculptural quality and the remarkable height and length of the cathedral. Nevertheless, even when all its excellent qualities are recognized, sheer size makes Speyer Cathedral a symbol of the imperial challenge to the rest of the Christian world.

The conservative imperial style dominated German Romanesque building. The Abbey Church of Maria Laach (1091/3–1156) still presents a complete and harmonious picture of a German monastic church [22]. The double-ended silhouette of the church with its six towers dominates its rural setting by the Laacher Sea much the way St. Riquier must

20. Plan, Cathedral of
Speyer, 1030–61; second
campaign begun 1080;
vault, after 1106.

21. Nave, Cathedral of Speyer.
Height of vault, 107'.

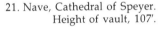

have risen over the countryside in Carolingian France and St. Michael's at Hildesheim in Ottonian Saxony. The architect has simply refined and adapted the forms of St. Michael's and added Lombard arcades, strip buttresses, and arched corbel tables. The arcading and strip buttresses, of black volcanic stone, emphasize the structural integrity of the building and create a strong independent rhythm against the creamy yellow of the walls. An atrium, added in 1230, enhanced the resemblance to the ideal monastic church of the St. Gall plan. The open arcades of the atrium create a disquieting impression of a great weight supported on an inadequately light colonnade and suggest, with its interest in movement and light, the direction taken by German Gothic architecture.

German Romanesque sculpture and painting, like the architecture, adopted themes and techniques from Carolingian and Ottonian art and in so doing created a style of unprecedented clarity, severity, and magnificence. Artists worked with a finesse associated with goldsmithing, and their drawing and choice of colors—gold, green, blue—suggest the inspiration from *champlevé* enamel, a technique that reached new heights of elegance and beauty in the Rhineland and Mosan regions.

Just such an interdependence of the arts can be seen in the lectionary made for the Benedictine monastery of Siegburg about 1130

22. Abbey Church of Maria Laach, 1091/3–1156.

23. St. Maurice or St. Panteleon, *Siegburg Lectionary*, Cologne or Siegburg, mid-twelfth century. Vellum, The British Library, London.

[23]. The martyred patron of the monastery (St. Maurice or St. Pantaleon) stands in the center of the page, framed within the frame, a frontal, hieratic, isolated image reminiscent of a Byzantine icon. The background panel of blue and green (where a Byzantine painter would have used gold) enhances the tinted drawing and causes the saint to stand out like a reserved metal figure against an enamel background. The saint seems immobilized in his sheathlike cloak and holds the palm of his martyrdom like a scepter. Subtle variations relieve the rigid balance established by the vertical fall of his cloak and the horizontal bands of orange embroideries: the tunic hem, the position of the feet, the tossed fold at the hem of the cloak balancing the palm and repeating the slight movement of the raised blessing hand.

The Byzantinizing tendencies seen in the *Siegbert Lectionary* become even stronger in Austrian art. At Kloster Nonnberg in Salzburg (c. 1150) the loss of paint in the lifesize, half-length figures of saints in the vestibule of the monastery reveals underdrawings that permit an examination of the Westerners' adaptation of Byzantine designs [24]. The artist laid out figures meticulously with straight edge and compasses using a method described in handbooks as follows: the area was divided in half by a vertical line; then a perpendicular line was constructed at the point judged by the artist to be the center of the face. From this point, with the length of the nose as the module, the painter swung a series of three concentric circles which then defined the outline of the face, hair, and halo. The bridge of the nose lay at the center, and the pupils of the eyes, on the horizontal line halfway between the center and the first circle; the mouth crossed the vertical line halfway between the

first and second circles. This scheme could be modified, as it was at Kloster Nonnberg, to produce a less bulbous forehead by reducing the second and third circles to half a length each, thus placing the mouth on the second ring and shortening the height of the hair. Over this geometric base the painting could be executed with considerable freedom. At Kloster Nonnberg, the modeling was done with particular subtlety, giving the austere, hieratic images of the saints a grace and delicacy that mitigates the austerity of the Ottonian or Byzantine ideal.

The reliance on formulas, which existed for the entire figure or composition as well as for details, is one of the secrets of the exportability of Byzantine art. The schematic geometry of the conventions as well as the simplicity of the recipes enabled provincial artists, both Western and Eastern, to produce competently designed images. The more imaginative artists added their own variations.

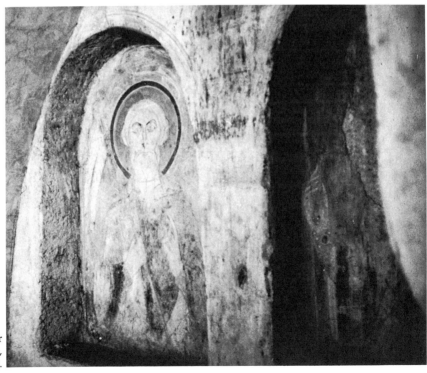

24. Saint, Kloster Nonnberg, Salzburg, c. 1150. Mural painting.

A handbook for artists, written by one of the finest metalworkers of the day, Roger of Helmarshausen, has come down to us. *De diversis artibus* (On the Diverse Arts), written under the pseudonym Theophilus about 1100, contains specific instructions on techniques of goldsmithing, bronze casting, painting, enameling, and stained glass as well as principles of composition and even a description of the ideal arrangements for a large workshop. Theophilus wrote as an artist for other craftsmen, not for philosophers and patrons. He saw the creation of a work of art as a straightforward, step-by-step process of design and construction—not a mystical experience. His approach reflects the point of view expressed centuries earlier by the author of the *Libri Carolini:* works of art should be well made, be of fine materials, and should fulfill a practical or didactic function. Theophilus' book, and others like it, transmitted techniques, images, and styles from region to region and generation to generation.

The illustrated book as an educational tool as well as a glorification of the Word appeared in the eleventh and twelfth centuries. The symbols and narratives of earlier Christian art seem relatively straightforward in comparison with the complex allegories devised by Ottonian and Romanesque churchmen, but the intricate interrelationship of meaning so difficult to follow in philosophical argument could be explicated in drawings. Hundreds of tinted drawings illustrated the brilliant twelfth-century compendium of human knowledge, the *Hortus Deliciarum* (a book destroyed in 1870 and recently reconstructed on the basis of nineteenth-century copies). *The Garden of Pleasures* was composed for her nuns by Abbess Herrad (1167–1195) of the Alsatian nunnery of Ste. Odile. She wrote, "Like a small active bee, I have extracted the sugar of the flowers of divine and philosophical literature . . ." for "my sisters in Jesus." The Abbess's ambitious goal was to produce a universal history, from the Creation to the Last Judg-

ment, into which all human knowledge could be incorporated. For example, to the story of the star which guided the Magi, she added a discussion of astronomy and astrology. Such scholarly works not only stimulated the design of complex iconographical programs in their own day, but now guide the scholar in decoding the intellectual content and the significance of medieval subject matter today.

Byzantine formulas and complex iconographical programs were revitalized and adapted with exceptional effectiveness by artists in the Meuse River Valley, in the territory lying in the heart of Carolingian Lotharingia and including the great cities of Aachen, Trier, Metz, Verdun, and Liège. Inspiration from Byzantine art, and with it a rediscovery of the antique, as interpreted by their Carolingian forebears, enabled Mosan artists to achieve a uniquely humanistic style. Liège, a center of Classical learning in northern Europe, was called the "Athens of the North" in its day. The interest of its scholars must have permeated the cultural atmosphere, for the art associated with the valley of the Meuse is truly "Classical" in its harmony, simplicity, and dignity. Mosan artists, and their neighbors in the Rhineland, became masters of enamel and of metalwork. One of the first was Rainier, from Huy, south of Liège, who created a personal style profoundly indebted to Classical art as interpreted and preserved by his Lotharingian forebears. Between 1107 and 1118 he cast a bronze baptismal font for Notre-Dame-des-Fonts in Liège (now in the Church of St. Barthélemy) [25]. The font literally reproduces the "molten sea" standing on twelve oxen in Solomon's temple (I Kings 7:23–24). This iconography may have been suggested by the Benedictine philosopher Rupert of Deutz, who wrote a treatise, *De Trinitate* (Liège, 1117), in which he identified the twelve oxen with the twelve apostles. On the sides of the basin the traditional images of St. John baptizing Christ and St. John preaching are extended and enriched by the inclusion of New

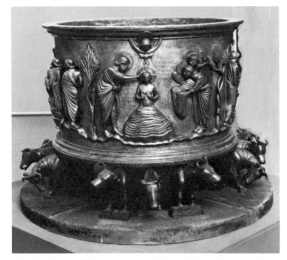

25. Rainier de Huy, baptismal font, Notre-Dame-des-Fontes, Liège, 1107–18. Bronze. Height, 23 5/8"; diameter, 31 1/4". Now in the Church of St. Barthélemy, Liège.

Testament parallels, St. Peter baptizing Cornelius and St. John the Evangelist baptizing the philosopher Crato. Rainier has rendered his singularly beautiful figures as sturdy idealized bodies whose softly rounded forms, whether nude or covered with heavy clinging drapery, convey tangible reality. Strong outlines establish each figure or group as an independent unit, yet each relates to the others through movement and gesture—the man who turns his back and steps away from the scene, or the cluster of ministering angels. In these complex poses and gestures Rainier has demonstrated his remarkable intuitive understanding of human anatomy. Figures, rather than setting, convey a sense of space, and landscape is reduced to a few miniature trees, rippling ground lines, and discreetly rising waves of water. Rainier de Huy has shown that the Classical and humanistic tradition survived in the north through the Middle Ages. To find such classically inspired work south of the Alps would not be so surprising. The presence of ancient Roman monuments inspired artists whenever their eyes—and the culture—were attuned to accept them.

Italian Romanesque Art

The political and cultural bond between Germany and Italy, established in the Ottonian period, continued in the eleventh and twelfth centuries. The power struggle in Germany between the Welfs of Saxony and the Hohenstaufens of Swabia spread into Italy, where Welfs were known as Guelfs (and usually supported the Pope) and the Hohenstaufens became the Ghibelline, or imperial, party. The Italian Peninsula was even further divided by the papal states lying in the center, the rise of the semi-autonomous cities in the north (the Lombard league and the seaports of Genoa, Pisa, and Venice), and the Norman Kingdom of the Two Sicilies in the south. In such circumstances it is not surprising to find that there is no single Italian twelfth-century style but instead many local variations within the general rubric of Romanesque art. Such unity of ideal and style as exists amid the complex crosscurrents in Romanesque art can be attributed in part to the international religious community.

St. Benedict had founded a monastery at Monte Cassino, south of Rome, in the sixth century. Lying on a strategically important site commanding the route between Rome and Naples, Monte Cassino has been destroyed and rebuilt repeatedly (most recently in World War II). Barbarian Lombards burned St. Benedict's monastery in the sixth century; Carolingian rulers rebuilt it in the eighth, only to have Muslims destroy it in the ninth and the Byzantine emperors rebuild it in the tenth century. In the eleventh century a remarkable person became abbot. Abbot Desiderius, a nobleman from northern Italy, ruled the abbey from 1058 to 1086. In 1086 he became Pope Victor III, and then spent the last year of his life in Rome attempting to control the raging conflicts the Church had inherited from Pope Gregory VII.

Desiderius, one of the most remarkable me-

dieval patrons of art and architecture, followed a conscious policy of reviving the arts, and he introduced Byzantine craftsmanship to the West. He rebuilt his abbey church on a large scale beginning in 1066. The church was consecrated in 1071 by Pope Alexander II (1061–1073), assisted by his archdeacon, Hildebrand, who was later Gregory VII. Like so many churchmen, Desiderius took Old St. Peter's as his model; however, he made important variations on the Roman basilica. The monastery church did not have to accommodate crowds of laymen and pilgrims, so single aisles and a transept which did not extend beyond the line of the aisle walls provided sufficient space. The transept and three apses, not just the sanctuary, were raised eight steps above the nave in order to accommodate the tomb of St. Benedict, which Desiderius had found during the excavations for the foundations of the new larger church. This plan, with raised east end and important structural innovations (such as Muslim pointed arches and catenary vaults in the narthex and atrium), was transmitted from Monte Cassino to Western Europe. The prestige of the abbey church as the center of Benedictinism made it a model followed by monastic builders throughout Europe.

Leo of Ostia, Desiderius' biographer, enthusiastically recounts the decoration and furnishings of the church. Even before Desiderius began his rebuilding campaign, he had ordered bronze doors from Constantinople. Later he brought mosaic workers to decorate the apse and narthex and to pave the floor with inlaid marble patterns. Leo of Ostia wrote, "One would believe that the figures in the mosaics were alive and that in the marble of the pavement flowers of every color bloomed in wonderful variety." Then Desiderius began to train young artists. Monks who showed interest and aptitude were given instruction in the working of "silver, bronze, iron, glass, ivory, wood, alabaster, and stone." After the church was completed and the walls and ceiling were

painted, Desiderius continued to add to its splendid appointments. From Constantinople he ordered a gold altar frontal decorated with gems and enamels representing stories from the New Testament and miracles of St. Benedict. He paved the steps to the altar with marble and added a choir screen of red, green, and white marble. A purple pulpit decorated with gold, six candlesticks of silver, a gilded silver column for the Easter candle, and a huge silver chandelier with thirty-six lamps are but a few of the items with which he enriched the sanctuary. These treasures are lost, but their beauty inspired visitors, including St. Hugh, the abbot of Cluny (chapter VIII), who visited Monte Cassino in 1083 before he began his own church.

A contemporary view of a well-furnished church can be seen in the illustration of the blessing of the paschal candle from an eleventh-century *Exultet* roll from Monte Cassino [26]. The artist has represented a church interior, where a deacon prepares to read a scroll from the ambo, beside which stands a towering paschal candle. Another deacon swings a censer. In the eleventh and twelfth centuries, Monte Cassino and Bari were centers for the production of liturgical rolls used for the Easter services. These manuscripts are known as *Exultet* rolls, from the hymn "Exultet iam angelica turba coelorum" (Let the Angelic Hosts of Heaven Exult), which is sung on Holy Saturday after the blessing of the candle and before the blessing of the baptismal font. The deacon read the liturgy from a roll which was illustrated with large pictures placed upside down in the text. As the deacon read, he let the roll fall forward over the lectern so that the pictures appeared upright to the congregation, and the images passed in front of them in sequence. The text, with indications of tones for singing, appears between the scenes. The rolls are very large, as much as three feet wide, so that their illustrations could be seen at a distance. The use of art in the edification of the public and the justification

26. Church interior with the Easter Candle, *Exultet* roll, Monte Cassino, c. 1060. The British Library, London.

of art on the basis of its educational function are typically Western.

Abbot Desiderius' elevation to the papacy symbolizes the link between Monte Cassino and Rome in the arts. Cassinese conservatism appealed to the Romans, where ancient and Early Christian monuments provided models for artists and patrons. Even at its nadir Rome remained the center of Christendom, but it had not been the center of Christian art. After all, Rome was already filled with churches, and the Popes had neither resources nor desire to commission "modern" art. By the later years of the eleventh century, however, churches had to be built or refurbished, and Monte Cassino provided craftsmen, technical knowledge, and models.

Nowhere is this revival more apparent than in the Church of S. Clemente, which was rebuilt after the Norman sack of Rome in 1084 [27]. (The Normans had been invited into Rome by the Pope in one of his many altercations with the German emperor, but they looted the city instead of defending it.) S. Clemente, a basilica with a nave arcade of Ionic columns, mosaic-covered apse, and splendid furniture, was consecrated in 1128; an earlier church with paintings and a Mithraic shrine still exist below the present buildings. The church was oriented to the west in emulation of St. Peter's. Unlike the Early Christian basilicas, however, S. Clemente had three apses, like Monte Cassino, and piers which added a dynamic rhythmic pulse to the stately basilican elevation by interrupting the continuous movement of the arcade.

The furnishings of S. Clemente provide a vivid illustration of the kind of interior described by Leo of Ostia and illustrated in the *Exultet* roll. The choir extended into the nave as far as the piers, its low parapet marking the areas reserved for the clergy. Marble inlay and sculpture salvaged from the chancel built by Pope John VIII in 872 were reused here.

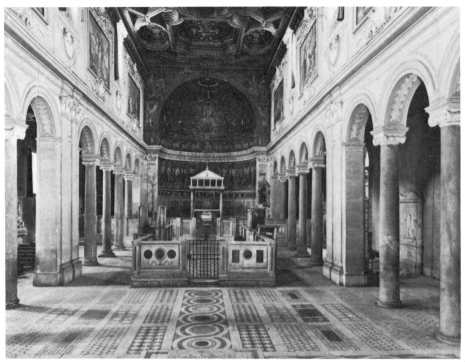

27. Nave with choir and Cosmatesque pavement, Church of S. Clemente, Rome, rebuilt after 1084, consecrated 1128.

The raised lectern, a large paschal candlestick, and the baldacchino over the altar are all in an ornamental style called Cosmati work after craftsmen of that name. In *opus alexandrinum*, the ancient Romans had set slabs and discs of white and colored marble and porphyry in geometric patterns; the Cosmati workers inlaid white marble panels with fine geometric patterns made up of small pieces of colored glass and stones. Supported by the prestige of Monte Cassino and Rome, Cosmatesque decoration spread throughout Italy and continued to be used well into the fourteenth century.

Behind this brilliant furniture the apse mosaic, glittering with gold tesserae, reaffirmed in its complex symbolism the Christian faith in the Resurrection [28]. Christ on the cross, flanked by the mourning Virgin and St. John, forms the central composition. The twelve white doves symbolizing the apostles join Christ on the cross, for "whosoever doth not bear his cross, and come after me, cannot be

my disciple" (Luke 16:27). The rest of the complex symbolism revolves around the triumph of the cross. The cross emerges from an acanthus vine scroll which deliberately recalls such imperial monuments as the Church of Sta. Costanza. This vine, filled with birds, animals, and human beings, to indicate that it embraces all life, is associated both with the ancient pagan cosmological tree and with the Old Testament Tree of Knowledge, whose fruit caused the Fall. According to one legend, seeds from this tree were placed in Adam's mouth after his death, and from these seeds out of Adam's skull grew a tree whose wood was used to make the True Cross. The cross is indeed the Tree of Life, for man was saved and given eternal life through Christ's sacrifice. Thus the acanthus scroll suggests both pagan antiquity and the Old Testament, while the cross is, of course, the symbol of the New Testament and salvation.

At the root of the acanthus-cross a stag

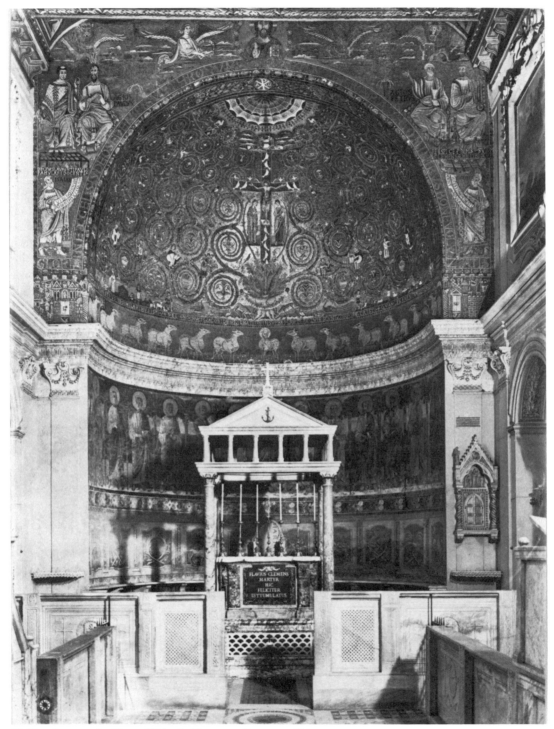

28. The Cross as the Tree of Life, S. Clemente, Rome, twelfth century. Mosaic.

seems to attack a jeweled ribbon (the ribbon should be a snake). Here the craftsman has misunderstood the image of the stag and serpent, another symbol of the Resurrection. According to medieval belief, the stag renews its antlers each year by eating a snake and thus becomes a symbol of rebirth. The serpent at the foot of the cross is also a Resurrection symbol in its own right, for the brazen serpent of the Old Law held the candle or light of the New Law—an idea represented literally in the Middle Ages when the processional candlestick used at Eastertide was given the form of a serpent. Below this complex symbol other stags drink from the four rivers of paradise, a motif seen earlier in the Tomb of Galla Placidia and later in Ottonian painting. The apostles appear as sheep flanking the Lamb of God, again recalling Ravenna. The cross reaches from the heart of the acanthus to the canopy of the heavens, where the hand of God holds the ultimate Classical symbol of triumph, the victor's wreath. Thus the designer of the S. Clemente mosaic combined Early Christian and Byzantine themes and symbols into an elaborate Romanesque decoration which must have recalled to the twelfth-century worshiper the imperial splendor associated with the early Church.

The mosaic, for all its Early Christian associations, is clearly twelfth century in technique and style. The roughness of the work can be seen as a decline from Byzantine standards of craftsmanship; on the other hand, the irregular setting of the tesserae in rough plaster actually increases their glitter and heightens the effect of the gold. The hard outlining and dry modeling that turn the central figures and the doves into patterns are characteristically Romanesque, while the representation of the suffering of Christ and the pathos of the mourners recall Middle Byzantine art and become typical of the Gothic style.

North of Rome, in Tuscany, the Late Antique and Early Christian heritage of Italy also determined the special character of Romanesque

art, in spite of the very different history and atmosphere of the emerging commercial cities. Florence under the Countess Matilda (1046–1115) had a prosperous and enlightened citizenry, and Matilda herself was an educated woman, a patron of the arts, and a friend of Pope Gregory VII, whom she sheltered in her castle at Canossa during his confrontation with Emperor Henry IV. The excellence of building during her reign reflects the flourishing Tuscan environment. Pisa on the west coast was an even more aggressive commercial city, competing with Genoa and Barcelona for control of shipping and trade in the western Mediterranean. In 1062 the Pisan navy defeated the Muslims near Palermo, assuring Pisan control of the maritime trade, and thus the city's wealth and ability to support the arts.

Florence and Pisa became commercial and political rivals, for, as we have noted, conflicts within the Holy Roman Empire extended across the Alps. Florence became a Guelf city, and Pisa, Ghibelline. Competition extended into the arts as splendid Romanesque churches rose in both cities. The typical Tuscan church remained basilican in form; however, unlike the Early Christian basilicas, the exterior as well as the interior was richly decorated with marble sheathing—white and green geometric and architectural patterns at S. Miniato in Florence, and blind and false arcades at Pisa.

The cathedral complex at Pisa [29], begun in 1063 immediately after the great Pisan naval victory, is a tribute to civic pride and Pisan commercial success—as well as to the Virgin, to whom it was dedicated. The cathedral is part of a complex that retains the Early Christian separation of functions in different buildings. Besides the cathedral, a separate baptistery, following time-honored custom, was built (begun in 1153 and finished in the Gothic style). The famous "leaning tower of Pisa," begun in 1174, goes back to the freestanding cylindrical bell towers of the Byzantine exarchate; the Gothic Campo Santo,

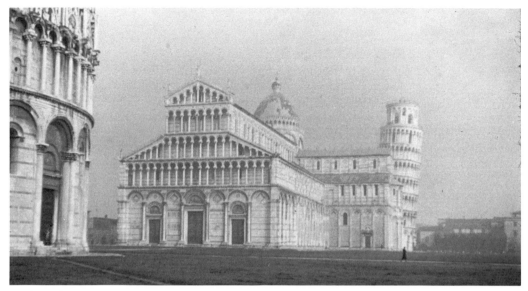

29. Cathedral complex, Pisa. Cathedral begun 1063; baptistery, 1153; tower, 1174; Campo Santo, 1278–83.

30. S. Michele, Lucca.

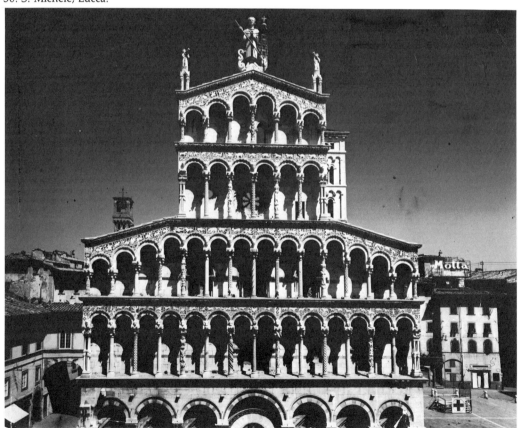

or burial ground, was added in 1278–1283.

The first architect at Pisa had a Greek name, Busketus, and may have come from Thessalonika, for the cathedral's nave and transept resemble the Church of Hagios Demetrius in that city. The cathedral is a Latin cross with double nave and choir aisles and extended aisled transept ending in apses. (The elliptical dome over the crossing is later.) Work progressed slowly on the cathedral; the high altar was consecrated in 1118, but work continued throughout the twelfth century, and reached the facade in the thirteenth (1261–1272). The most distinctive feature of the building is the exterior encrustation with a veneer of pale marble enriched with pilasters and row upon row of blind arcades. This system of decorative horizontal bands created by colored marbles or galleries characterizes Tuscan Romanesque and Gothic architecture. The churches of Lucca present a dazzling display of colonnaded and arcaded facades [30].

Following Early Christian and Byzantine precedent, the bronze doors of the Porta S. Raniero at the Cathedral of Pisa carried a narrative and decorative program [31]. Bonanno, the architect of the "leaning tower," evidently designed the doors, although he did not sign this work, for a similar door at Monreale has an inscription reading "Bonanno, citizen of Pisa, made me in the year of the Lord 1186." The fifteen-foot door valves are divided into twenty-four panels by broad rope borders and wide bands punctuated by large rosettes. Scenes from the life of Christ and the Virgin, from the Annunciation to the death of Mary, lead to the Madonna Enthroned and Christ in Glory. At the bottom of the doors, and thus supporting the New Testament events, twelve Old Testament prophets sit under palm trees. These bronze doors provide an instructive contrast to the Ottonian Hildesheim doors. Heavy frames establish clear boundaries, and frames and figures have a

31. Bonanno of Pisa, Porta S. Raniero, Cathedral, Pisa, late twelfth century. Bronze. Door, 15' 2" × 9' 10".

new simplicity and sculptural solidity. The broad modeling of the figures, the reduction of the setting to a few essential descriptive elements, and the brief explanatory inscriptions all produce a straightforward narrative based, to be sure, on Byzantine iconographical conventions but Romanesque in their decorative clarity.

Bonanno had worked in Norman Sicily, where ancient, Byzantine, and Muslim art could be studied firsthand. Apulia and Sicily became a fertile source of ideas and models and an early leader in the revival of monumental sculpture in the West. Bari, the former Byzantine capital on the east coast, became the regional capital of the Norman Kingdom of the Two Sicilies, and here one of the first schools of Romanesque art appears. As usual, the needs of the Church stimulated artistic activity. A great new church had to be built when in 1087 Bari acquired the relics of one of the greatest eastern saints, St. Nicholas, bishop of Myra in Anatolia (Turkey). Within two years the monks had begun to build a church to accommodate pilgrims coming to venerate the saint. The Church of S. Nicola, soon the principal church of Apulia, illustrates the creative eclecticism of southern Italy. The basilica, begun in 1089 and essentially completed by 1132, had a raised choir and nave divided into bays by diaphragm arches. A Norman two-tower facade, bronze doors, and a gabled porch supported by columns resting on the backs of lions had been added by the time of the final dedication in 1196.

The apse at S. Nicola, originally visible only to the monks in the choir, followed the Early Christian arrangement with seats around the lower wall and a throne on the axis of the church. In 1098 Pope Urban II gave a marble throne to Archbishop Helias, at the time of the synod of Bari [32]. The date of the throne is established both by an inscription and by an account of Helias's reign. Such specific documentation is rare in the eleventh century and adds to the importance of the throne in

32. Throne of Archbishop Helias, Church of S. Nicola, Bari, 1098. Marble.

the history of Italian Romanesque sculpture. In the synod, Helias led the papal party, which asserted the power of the papacy and the Western Church over the predominantly Byzantine-oriented clergy in southern Italy. The throne, itself a symbol of the authority of the bishop, has other overt symbols of power, for it rests on the shoulders of three men who represent the different people of the world (the Ethiopian with his curly hair; the Oriental with his peaked cap) and on the backs of lions chewing human heads. The seat is a simple massive form decorated with low relief and pierced patterns.

To conclude an all-too-brief overview of Italian Romanesque art we must return to northern Italy, to Lombardy and the work of the mature Lombard-Catalan school. The influence of Lombard architecture on Germany, especially in the Rhineland, has already been noted. In the see of Milan, the original home of the *magistri comacini*, the Lombard-Catalan

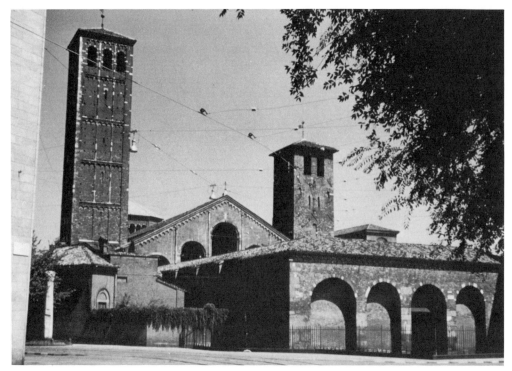

33. Church of S. Ambrogio, Milan, eleventh and twelfth centuries.

34. Nave, S. Ambrogio. Vaults, after 1117; baldacchino, early eleventh century.

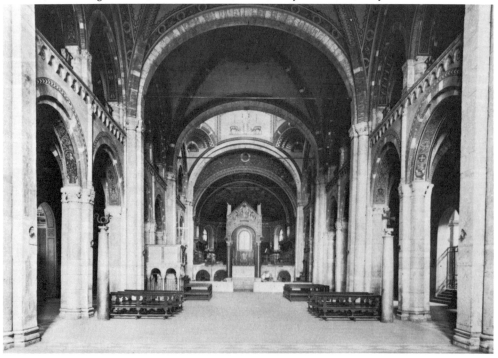

style is exemplified by the Church of S. Ambrogio, Milan, St. Ambrose's own basilica and, not incidentally, the coronation church of the German emperors as kings of Italy.

The present Church of S. Ambrogio is a red brick, aisled basilica of four bays ending in a raised sanctuary which incorporates fragments of earlier buildings into its structure [33]. Some ninth-century masonry remains in the choir, and parts of the nave and aisles may belong to the early eleventh century. The present building was begun about 1080 and grievously damaged by an earthquake in 1117. After the earthquake, domical ribbed vaults of stuccoed rubble and brick were built over the nave [34, 35]. (These vaults have been the subject of prolonged scholarly debate, for if—as was once thought—they had survived the earthquake, they would have been among the earliest ribbed vaults in the West.) The structural importance of the diagonal ribs has been

questioned; aesthetically, however, the unmolded ribs rising from compound piers function effectively. They divide the vault into compartments and at the same time draw the segments into a series of similar units. Groin vaults supported on light intermediate piers cover the square bays of the aisles. Since the square module was used throughout the building, the structural requirement for the support of two aisle bays for one in the nave produced the same alternating system of supports used at Speyer after its twelfth-century remodeling [36]. In spite of the relative stability of the domical ribbed vault, the builders kept the walls heavy and the openings small, and buttressed the nave with vaulted galleries, producing a relatively dark, two-story building. Later they rebuilt the bay in front of the sanctuary as a lantern tower to bring direct light into the nave.

S. Ambrogio has an unusually severe exte-

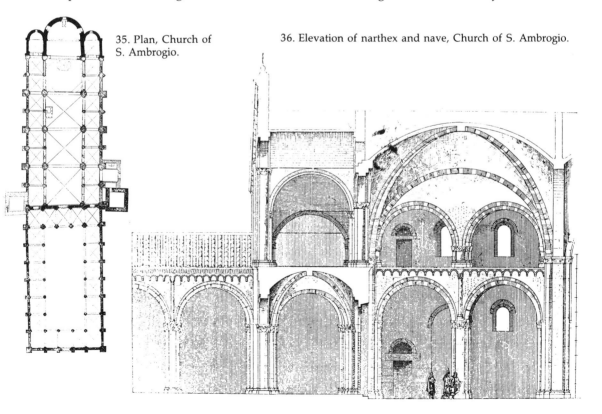

35. Plan, Church of S. Ambrogio.

36. Elevation of narthex and nave, Church of S. Ambrogio.

rior. Many Lombard church facades were decorated with bands of sculpture, sometimes extending the full height of the facade, as at S. Michele, Pavia, and they often were entered through portals guarded by huge marble lions or griffins.

The Cathedral of Modena, in Emilia, had both sculptured friezes and lion portals. The friezes, by the master sculptor Wiligelmo, are among the earliest examples of monumental stone sculpture in Italy [37]. Lanfranco began the cathedral in 1099, and work had progressed so that the relics of the patron, S. Gimignano, could be transferred to the crypt in 1106. The facade must have been begun after the transfer of the relics; therefore Wiligelmo's sculpture can be dated to the first decade of the twelfth century with some assurance. M. F. Hearn has suggested that Wiligelmo may have been trained as a goldsmith and that Ottonian metalwork played as important a role as Late Antique sculpture in the formation of his style.

Wiligelmo's sculpture now flanks the Cathedral's central portal. Four horizontal panels with scenes from Genesis formed a continuous frieze on each side of a door whose jambs

were carved with vine scrolls and prophets. Individual dedicatory panels were also inserted in the facade (two of the narrative reliefs were reset above when side doors were added in the thirteenth century). The idea of a continuous narrative relief on a great public monument came from ancient Rome, and Wiligelmo, like St. Bernward, must have been inspired by Roman sculpture; however, St. Bernward's adaptation of a Roman triumphal column to Christian use remained within the tradition of the decorative arts rather than architectural sculpture. In Wiligelmo's facade reliefs at Modena, Old Testament scenes from the Creation to the story of Noah band the facade like a Romanesque interpretation of a Roman historical frieze. A contrast of the Modena reliefs with those at Hildesheim is, however, more instructive than a comparison with Constantinian art. Both sculptors used Classical models; both created dramatic narrative compositions, but where the Ottonian artist worked with a loose, open composition and an illusionistic rendering of forms, the Romanesque sculptor was both detached and intense, creating an intricately balanced and compressed composition.

37. Wiligelmo (active, early twelfth century), Cain and Lamech, Noah, relief from the west facade, Cathedral of Modena, c. 1100. Height, about 36".

The relief, reset over the right portal—Cain shot by the blind Lamech, Noah's Ark, and the departure of Noah and his family from the Ark—illustrates Wiligelmo's narrative skill. Wiligelmo contrasted the blindness of the archer Lamech with the blindness of death in Cain's face; Cain falls, grasping a branch in a strangely poignant gesture. In creating these ponderous figures, Wiligelmo exaggerated the Late Antique qualities of mass and stance in compositions so dense that even in the dramatic forest scene the figures seem compressed into the panel. The framing arcade, carried on foliate corbels, hints at a narrow stage on which the dramatic action may proceed. Recent restoration of the sculpture (1975–1980) has revealed traces of the original brilliant colors, which would have increased the visual impact of the sculpture. Variations of Wiligelmo's style were widely copied in northern Italy, and friezelike compositions appear in Catalonia as well as the lands of the Holy Roman Empire.

Catalan Romanesque Art

Politically and economically Catalonia maintained close contact with Italy and the Empire. By the second decade of the twelfth century the counts of Barcelona had extended their territories to include Provence, on the very borders of the Holy Roman Empire. Furthermore, Catalonia increased its contacts and competition with northern Italy as it developed into a maritime and commercial force in the western Mediterranean. Northern Italy and Catalonia in the eleventh and twelfth centuries continued to be a closely related cultural province and the First Romanesque (chapter VI) style persisted well into the twelfth and thirteenth centuries in the Pyrenees.

Reliefs from the retable of the Cathedral of Vich illustrate the close connection of Catalonia and northern Italy. (The sculpture served as fill and pavement when the Romanesque cathedral was rebuilt in the eighteenth century. Apostles and prophets from the retable are now scattered in museums abroad.) Three apostles (now in the Nelson-Atkins Museum of Art, Kansas City) [38] have the short proportions; large heads, hands, and bony feet; and drapery arranged in sharp-pressed folds which we saw in Wiligelmo's work. Rather than being compressed on a narrow stage, the figures seem to emerge from a background plane. The sculptor's awareness of the figure in the round is suggested by the three-quarter view of heads, in which only half of the eye is carved. Inlaid lead pupils enliven the impassive features. The sculpture was once brilliantly painted, and examination reveals traces of red, blue, black, and white. Polychromed sculpture, painted altar frontals, and murals survived in Catalan mountain churches; now, moved to the safety of museums, they provide a rich source for the study of Romanesque art.

Regardless of the ideals of the rulers and patrons, few churches could afford elaborate

38. St. Paul, St. Andrew, and St. James, Cathedral of Vich, Catalonia, twelfth century. Limestone, 31″ × 27 1/2″. The Nelson-Atkins Museum of Art, Kansas City.

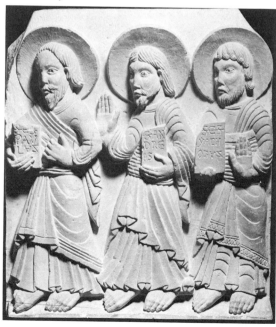

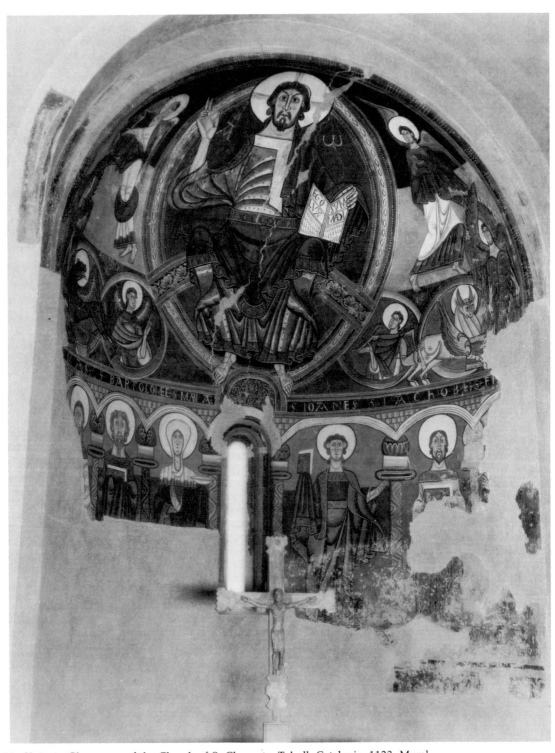

39. Christ in Glory, apse of the Church of S. Clemente, Tahull, Catalonia, 1123. Mural painting. Museo de Arte Catalan, Barcelona.

and costly mosaic decoration, and few Westerners had the requisite technical skill to make mosaics. Paintings replaced mosaics in the apses and on the walls of churches, and Catalan paintings (although once only a cheap substitute for mosaic) now stand among the prime examples of Romanesque art. Ever since the days of Oliba Cabreto's visit to Monte Cassino, Catalan art had been open to Italo-Byzantine influences. However, Spanish Romanesque paintings could never be confused with Italo-Byzantine decoration, for in Spain formal geometric conventions resulted from a blend of the imported style with native Mozarabic qualities.

The masterpiece of the Catalan school is the apse of the Church of S. Clemente in Tahull (now in the Museum of Catalan Art in Barcelona) [39]. The consecration of the new church is recorded in a painted inscription of 1123. The apse contains the apocalyptic vision of Christ in Glory surrounded by the symbols of the evangelists, with the hand of God reaching down in blessing from the keystone. In His left hand is an open book on which is written "Ego sum lux mundi," (I am the light of the world). The alpha and omega, suspended on four threads, swing from a pearled glory surrounding the image. Four extraordinarily vivacious angels grasp the symbolic beasts, even by the foot. Below, a painted portico of seven arches on foliate capitals frames the Virgin and five apostles. From the extraordinary drapery patterns, in which the Byzantine formulas for highlights become an independent pattern of lines and circles, emerge memorable faces whose Mozarabic heritage is apparent in their elongated oval shape, wide eyes with enormous pupils, and long pointed noses. Hair and beards have become symmetrical, linear, decorative patterns, completely unreal but completely elegant. Mozarabic too is the painter's use of wide horizontal bands of color as a background against which the figures are drawn in heavy black outlines, just as they were in Mozarabic

manuscripts. The deep colors—blue, green, red, carmine, ocher, earth colors, black, and white—have a very high intensity. The skill of the artist in drawing with these colors revitalized the often dry Byzantine formulas.

Artists in the Holy Roman Empire and the lands associated with it were able to subordinate the northern styles to an imperial ideal. They adapted Classical and Byzantine iconography and style, in which the human figure was the vehicle for communication, to the taste of a people only recently under the spell of an abstract animal art. As a result they brought imperial monumentality, dignity, and grandeur to the art of the West. Through their reinterpretation of ancient Roman and "foreign" Byzantine art, German and Italian artists made that art visually and psychologically available to Western artists working in places as far apart as France, Spain, and England. Among their contributions to architecture can be numbered the development of masonry construction, the bay system, and the early use of rib vaults. The austere majesty of their buildings, and the sheer size and height, constitutes part of the medieval architectural aesthetic; the soaring verticality of the interior space, or the exterior silhouette with its clusters of towers and spires at both ends of the building, produced a distinctive German Romanesque architecture. In Lombardy the red brick basilicas and sculptured stone facades and in Tuscany the marble-sheathed basilicas created a new exterior richness in an architecture which once limited decoration to the interior. When monumental stone sculpture began to reappear in the Western churches, sculptors turned to Ottonian gold and bronze work, as well as to manuscript illumination, for inspiration. Finally, conservative as its arts may seem in retrospect, the Holy Roman Empire commanded enormous respect, artistically as well as politically, and its artists reaffirmed the value of art and architecture to

carry a message of secular power and universal God-given dominion.

A word should be added about the designation "Romanesque" for the arts of the late eleventh and twelfth centuries. It will already have occurred to the reader that Romanesque art has no closer connection with Rome than did the Byzantine, Carolingian, or Ottonian imperial styles. Nineteenth-century scholars saw the development of Medieval art and architecture as parallel to the emergence of the Romance languages from Latin; the French historian Michelet coined the term "Romanesque" and applied it to architecture and art as well as to literature. Roman-like or not, the art has been called Romanesque ever since.

⟦ CHAPTER VIII ⟧

Romanesque Art in Western Europe

he balance of power among Christian states and, with it, leadership in the arts shifted westward at the end of the eleventh century. In France the longevity and political acumen of the Capetian kings enabled them eventually to meld the French lands into a true monarchy. Meanwhile the Normans, beginning with the brilliant, efficient, and brutal William the Conqueror, turned their interests away from the North Sea kingdom of their Viking ancestors and created a powerful Anglo-Norman state.

In theory a kingdom belonged to its ruler, but when distant kings could not meet the minimal requirements of their people—the need for security and a rule of law—a political structure arose known as feudalism (from *feudum*, or fief, a parcel of land). Feudalism was a system of landholding in return for personal service in which the parties to the agreement were bound by personal oaths. As feudalism evolved, especially in France and England, the system formed a pyramidal social structure, with the king at the pinnacle, nobility and warriors below, then free peasantry and artisans, and finally serfs tied to the land. The ruler promised his people justice and protection; the vassal owed military service, assistance in the administration of justice, and a share of the produce of the land. Originally, every able-bodied man fought his leader's battles and cultivated his own land, but as such hastily assembled mobs proved unreliable and inefficient, a specialized class of mounted

warriors emerged. These knights devoted their lives to perfecting little other than their military skills. Improvements in agriculture created a modest surplus to support the community. Because under feudalism actual ownership of the land was only as real as the lord could enforce, or as the vassal chose to honor, in practice landholding became hereditary. Gradually, even the knights developed a landholder's mentality—that is, they became more concerned with the preservation and extension of their holdings than with the conduct of the king's wars.

Europe at the beginning of the Romanesque period was still rural. Individual manors where peasants cooperatively cultivated strips of land formed the basis of the economy. A manor might extend over a thousand or even two thousand acres and include crop land, pasture, and timber. At the center stood the lord's manor house with its mill, forge, brewery, and wine or cider press. The manor house and its out-buildings, the church, and a cluster of peasant houses formed a manorial village, which could vary in size from a dozen to fifty or sixty families. Living on their manors, the lords held court, administered justice, and collected revenues in kind.

Some people never fitted into this feudal, manorial scheme. Free peasant landholders appeared in the eleventh century, and by the thirteenth century they had become the dominant agricultural class. They could have gained their own land by participating in the recla-

mation projects, clearing forests and draining swamps, or they could have gone as pilgrims to Spain or the Holy Land and remained as settlers. The opening of new land meant an increase in productivity, and as the possibility of agricultural surpluses became a reality, trade revived, population increased, and villages grew into towns. Agricultural workers lured by the freedom and new opportunities to be found in towns moved to the cities.

The pilgrimages and Crusades, as well as the revival of trade and industry and the growth of towns, undermined and ultimately destroyed feudalism and manorialism. Pilgrimages and the Crusades sponsored by the papacy and the monastic orders crossed geographical, social, and political boundaries. Inspired pilgrims traveled to shrines of local saints, the Holy Sepulchre in Jerusalem, the tombs of SS. Peter and Paul in Rome, and the tomb of St. James in Spain.

Throughout the period, the Iberian Peninsula and the Holy Land remained battlegrounds between Christians and Moors. When the caliphate of Cordova began to disintegrate in 1034, the Christians took the offensive, and by 1085 the Muslim stronghold of Toledo fell to Alfonso VI, the Castilian king. In the East the Seljuk Turks had conquered most of Asia Minor and all of Syria, but at the end of the eleventh century the Byzantine emperors attempted to mount an offensive against the Muslims. When Emperor Alexius Comnenos appealed to the Pope for help, in 1095, Pope Urban II rallied the French nobles at the Council of Clermont, and soon crusading armies marched on the Holy Land. The first Crusaders captured Jerusalem and set up states in Palestine and Syria; however, unlike the Spanish Crusade, the Crusades in the Holy Land had no firm political or economic basis. St. Bernard's Second Crusade (1147–1149), led by Louis VII of France and Conrad III of Germany, failed dismally. Then in 1187 the great Muslim general Saladin recaptured Jerusalem. Ironically, bloodshed could have been

avoided—Saladin had been willing to grant Christians free passage to their shrines—but the Crusades had aroused both Muslim and Christian fanaticism. The Third Crusade (1189–1192) pitted three kings—Frederick Barbarossa of Germany, Richard the Lion-Hearted of England, and Philip Augustus of France—against each other as well as against Saladin. Only Philip Augustus profited, for he steadily improved his position at home and extended his own holdings at the expense of his less practical colleagues. Political leaders could be brutal and rapacious, but at best they had the energy and the will to accomplish great projects.

The Crusades brought the West into contact with Muslim and Byzantine culture. Before the eleventh century luxury goods had been rare in the West, but the establishment of Western kingdoms in Syria and Palestine opened the East to trade. This international trade required a new economic system to finance expeditions, the construction of ships, and the organization of caravans. Merchants cooperated for mutual protection and developed a money economy eventually leading to capitalism. Meanwhile villages located on the trade routes grew into towns, and local market towns became cities where trade fairs held on saints' days in conjunction with local pilgrimages combined business, pleasure, and religion. Artisans as well as merchants settled in the towns and manufactured furniture, pottery, and iron utensils for the local markets; and in England and Flanders weavers produced textiles for sale at home and abroad.

Increasingly complex government and economic organization required persons of intellectual ability rather than merely hereditary right or military might. The Church still attracted and educated men and women who showed ability and energy, but in the twelfth century universities in towns such as Bologna, Paris, and Oxford began to challenge the educational monopoly of the Church. The Church, the state, and the town all provided

opportunities for intelligent and ambitious people to improve their lot. Church, state, and town all eventually supported artists and architects.

The Pilgrimage Style in Languedoc and Northern Spain

Masons and artists followed the Christian Crusaders and pilgrims from southern France across northern Spain in the eleventh and twelfth centuries. Ever since the work of Arthur Kingsley Porter at the beginning of the twentieth century, the pilgrimage to Santiago de Compostela has been recognized as an important unifying force in Romanesque art. The tomb of St. James had been discovered in Galicia in the ninth century, and by the eleventh century it rivaled that of St. Peter and the Holy Sepulchre as a pilgrimage center. Four roads linked Compostela with the important cities of France. From Paris a road passed through Tours, Poitiers, and Bordeaux; a second road joined Vézelay and Limoges; a third, Le Puy, Conques, and Moissac. These three roads joined to cross the Pyrenees at Roncesvalles (Roncevaux), the site of the massacre of Charlemagne's rear guard under the command of Roland, the event immortalized in *The Song of Roland*. The fourth road, from St. Gilles, Arles, and Toulouse, followed eastern mountain passes and joined the others at Puente La Reina. From there a single road crossed northern Spain through Burgos and León. The French Road, as it was called, became legendary, for it was said to be marked out in the sky by the stars of the Milky Way. On the ground, pilgrims trod a reasonably well-built road maintained by the guild of bridge builders and policed by the Knights of Santiago. Monasteries along the road provided lodging and assistance for pilgrims. In the 1130s a French priest, Aymery Picaud, wrote a guidebook for the pilgrims, describing the route and the most important shrines along the way.

The Cathedral of Santiago de Compostela rose over the tomb of St. James, and a similar pilgrimage church stood on each of the four principal roads in France—the churches of St. Sernin at Toulouse, St. Foy at Conques, St. Martial at Limoges, and St. Martin at Tours. Of the five, only the churches at Compostela, Toulouse, and Conques have survived more or less in their Romanesque form. They illustrate a remarkably unified style in architecture and sculptural decoration. All were being built at the same time, and masons could have traveled from one to another; nevertheless, modern partisans of Santiago and Toulouse vie to demonstrate the priority of their buildings. Conques, with its fine setting and great treasury, gives the most complete view of a medieval pilgrimage church [1, 2].

The counts of Toulouse were the patrons of a church dedicated to the first bishop of Toulouse, St. Saturnin, apostle to Languedoc, who was martyred about 250. The Church of St. Sernin could have been started as early as the 1060s and certainly was well under way in the 1070s [3, 4]. In 1096 Pope Urban II consecrated the altar, a table of St. Beat marble carved by the sculptor Bernardus Gelduinus. Raymond Gayrard, a canon of the church who was master of works until his death in 1118, must have seen most of the building completed [5]. At the same time in Santiago de Compostela, Bernard, the treasurer of the chapter, and his assistant Robert were responsible for building a new church. An inscription on the south transept portal bears the date July 11, 1078, but work progressed slowly and the main body of the church was not yet finished in 1117, when citizens revolted against the bishop and set fire to the scaffolding and roof. Aymery Picaud described the church in *The Pilgrim's Guide:* "In the church there is indeed not a single crack, nor any damage to be found; it is wonderfully built, large, spacious, well-lighted; of fitting size, harmonious in width, length, and height; held to be admirable and beautiful in execution. And furthermore it is built with two stories like a

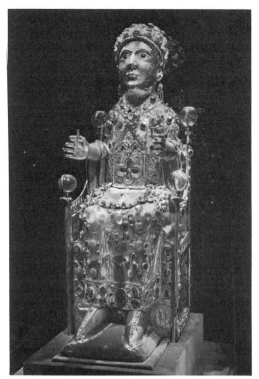

1. Treasure of the Church of St. Foy, Conques, eleventh and twelfth centuries. Gold, filigree, and jewels over wood. Height, 33 1/2".

2. Church of St. Foy, Conques.

royal palace. For he who visits the galleries, if sad when he ascends, once he has seen the preeminent beauty of this temple, rejoices and is filled with gladness [6]."

The practical necessity of housing relics safely in impressive shrines but at the same time permitting large numbers of people access to these shrines determined the essential character of the pilgrimage churches [7]. The architecture itself marked out a processional path through the building. The pilgrim entered the church and by moving through the aisles and ambulatory visited chapels built in the transept and around the apse without disturbing services at the high altar. At St. Sernin's double side aisles, influenced no doubt by St. Peter's in Rome and Cluny, increased the congregational space. Nave, aisles, galleries, transepts, crossing tower, choir bays, apse, ambulatory, and chapels—all appear as simple, geometric forms which express on the exterior

the internal arrangements of the church. Each unit was separate and distinct but added to the next to create, in the French scholar Henri Focillon's apt term, the "additive" character of Romanesque art.

Practicality (fireproofing and solidity) and aesthetics (appearance and acoustics) required that the builders use masonry throughout the church, even in high tunnel-like nave and transept vaults. The elevation has only two parts, nave arcade and gallery, a reduction of the usual three-part elevation, necessitated by the masons' concern for the stability of the vault. Groin-vaulted aisles supported full galleries covered by quadrant (half-barrel) vaults, which in turn carried the thrust of the high vault to massive outer walls strengthened by wall buttresses. Compound piers and transverse arches divided the barrel vault into a succession of rectangular bays which emphasize the processional character of the interior.

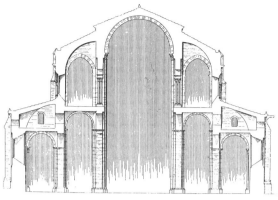

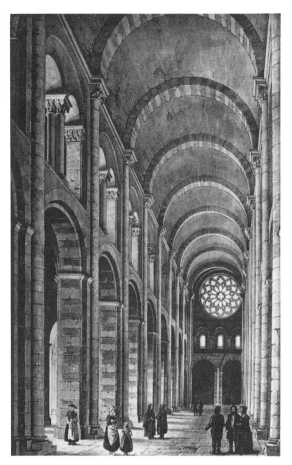

3. ABOVE: Section, Church of St. Sernin, Toulouse, c. 1070, altar consecrated 1096.

4. LEFT: Interior (in the nineteenth century), Church of St. Sernin, Toulouse, c. 1070.

5. BELOW: Exterior from the southeast, Church of St. Sernin, Toulouse.

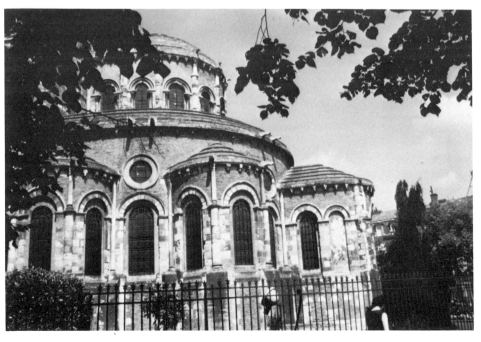

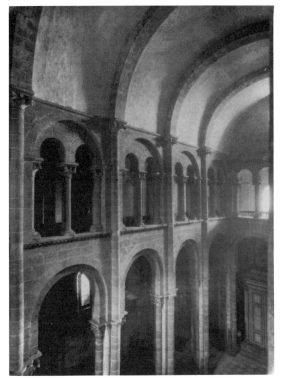

A subtle verticality enhanced by the engaged columns, the stilted arches of the arcade, and the close spacing of the piers counter the otherwise heavy enclosing effect of the barrel vault. The repetition of the round arch in the gallery, where paired arches supported by slender columns are enclosed by larger round arches, unifies the design. To ensure the sta-

6. LEFT: Transept interior, Cathedral of Santiago de Compostela, c. 1070–1120.

7. BELOW LEFT: Plan, Cathedral of Santiago de Compostela.

8. BELOW: Puerta de las Platerías, south transept, Cathedral of Santiago de Compostela.

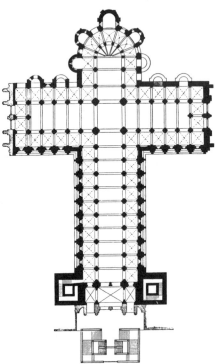

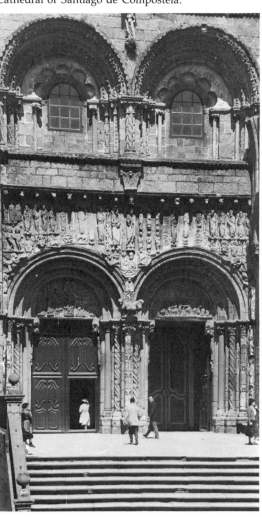

bility of the vault, the clerestory was eliminated and windows were confined to the outer walls of galleries and aisles; however, dramatic lighting effects could be produced by constructing a crossing tower as a lantern to bring light directly into the building in front of the altar. Severe, grand, and fortress-like, the pilgrimage churches are conservative, utilitarian structures, in which the builders worked within a well-tested architectural canon based on First Romanesque style principles.

The internal structure of the church required a distinctive portal design. When aisles and galleries crossed the ends of the transepts, the heavy central supporting pier interfered with a single entrance; so the architects built a double door, an arrangement which can still be seen in the Puerta de las Platerías (the Silversmiths' Portal) in the south transept at Santiago [8] or the door of the counts at St. Sernin. Lesser entrances opened into the aisles. Such a portal is the Miégeville door (the door to the city) in the south aisle at St. Sernin. The portals had to be practical entrances with large openings for easy movement of crowds and provide fields for impressive didactic statements in sculpture. The sculptural program had to make an immediate impact on pilgrims, who would see it only once or twice, in contrast to the cloister arts intended to stimulate the monks' lifelong contemplation.

Monumental sculpture developed early in southern France and northern Spain. Sculptors attempting to make Christian history understandable to the common people created a forceful narrative style. Inspired by their Mediterranean Roman heritage, they learned to capture the mass and weight of the human figures, although they often lacked the Classical artists' feeling for the articulation of the body. Certainly, they did not make a scientific study of human beings moving in a vast terrestrial environment—for that we had to wait three hundred years—but they did create bulky figures who seem to act out a story in a narrow plane.

The Languedoc school of sculpture began with an altar table, signed by Gelduinus and consecrated in 1096, and a series of marble reliefs of Christ, the apostles, and angels, now set into the ambulatory wall at St. Sernin [9]. M. F. Hearn has recently suggested that these reliefs once formed part of the shrine of St. Sernin in the crypt, a shrine which included the sarcophagus of the saint, an altar table, and the marble reliefs placed like a retable in the apse wall. Gelduinus could well have been inspired by fifth-century sarcophagi when he carved his reliefs, for his figures look like sturdy, secular athletes with the thick necks, low brows, heavy chins, and caps of curling hair characteristic of Late Antique figures. Draperies imitate a heavy fabric with folds indicated by thick double lines. The relatively low relief, simplified silhouettes, reduction of three-dimensional forms to linear patterns,

9. Gelduinus, Christ in Glory, Church of St. Sernin, Toulouse, c. 1096. Marble. Height, 49 1/2".

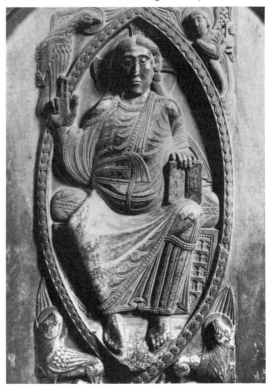

and compression of compositions within heavy architectural frames created an abstract style in sculpture as strong and distinct as Romanesque architecture.

This experimental eleventh-century style matured in the Miégeville door (c. 1115) in the south aisle at St. Sernin [10, 11]. In the tympanum Christ ascends into Heaven assisted by angels; in the lintel, apostles witness the event. St. Peter and St. James flank the scene in the spandrels above the door. Each element is an isolated form; each figure is clearly contained within a single block of stone— even the angels' wings fit around their halos and into the rectangular panels. The repeated curved edges of folds engraved and raised into double rolls, the almost metallic surfaces, and the severe horizontal terminations of the garments folded into repeated box pleats reflect the style created by Gelduinus in the ambulatory reliefs; however, the dancelike, cross-

10. Miégeville door, south aisle, Church of St. Sernin, Toulouse, c. 1118.

11. Miégeville door, Church of St. Sernin, Toulouse.

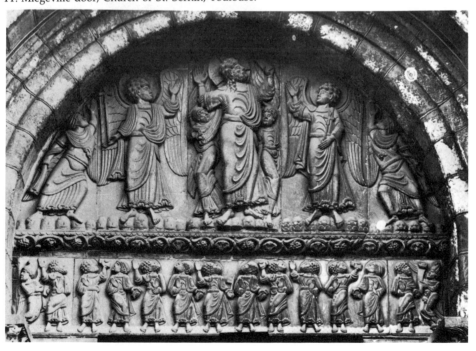

legged poses and a greater subtlety in modeling faces characterize this new work. Row upon row of heavy cylindrical moldings frame the tympanum; their sturdy simplicity harmonizes with the ponderous human forms. A hint of Muslim influence intrudes into the ornamental corbels alternating with large flowers framing the portal, a reminder that artists moving along the pilgrimage road had ample opportunity to study Moorish art.

The pilgrimage roads enhanced cultural exchange between Christians and Moors, between France and Spain. Sculpture of a similar style can be found from Conques in central France to Santiago de Compostela in northwestern Spain.

In Santiago de Compostela the Puerta de las Platerías on the south transept of the cathedral has become, through the centuries, a veritable museum of sculpture. In the now jumbled program, individual pieces of great beauty illustrate the variations within the Pilgrimage style. King David, inserted beside the door [12], repeats the mannerisms found in later Toulouse sculpture such as the "twins." David, here playing a viol instead of a harp, wears a cloak whose repeated folds resemble architectural moldings, so strong are the three-dimensional effects. The tympana on the portal, with scenes from the Passion of Christ, resemble the sculpture of Conques. Here genre narratives present the didactic message of man's inhumanity to man and his failure to recognize truth and virtue. The sculptors, although carving in relatively low relief, produced massive architectonic figures. Their art seems strangely earthly for the Middle Ages.

Isolated on the borders of the mountainous Auvergne, the Church of St. Foy in Conques has preserved a huge carved and painted tympanum of the Last Judgment [13]. Sturdy figures with impassive faces act out the drama. The narrative skill of the twelfth-century sculptors dramatizes the scene, and inscribed and painted banderoles and gables clarified the message for those who could read. Christ

the judge is enthroned beneath a huge cross, inscribed "The sign of the cross will appear in the heavens when the Lord comes to judge humanity." Christ signals the judgment, and the banderoles read, "Come, Blessed of my Father, receive the Kingdom prepared for you." Led by the Virgin, St. Peter, a king, and a cleric, under angels proclaiming their charity and humility, "The assembly of saints stand happy before Christ the Judge. Thus are given to the elect, united forever in the joy of Heaven, glory, peace, repose, and days without end. The chaste, the peaceful, the gentle, the pious receive happiness and security, free from fear." Christ's down-turned left hand emphasizes the command, "Depart from me, cursed ones," while demons drag the sinners

12. King David, Puerta de las Platerías, south transept, Cathedral of Santiago de Compostela, 1078–1103.

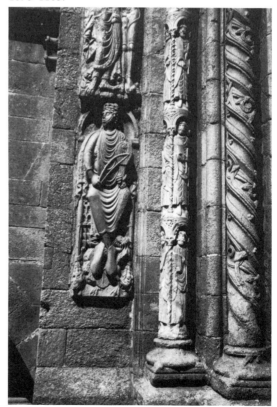

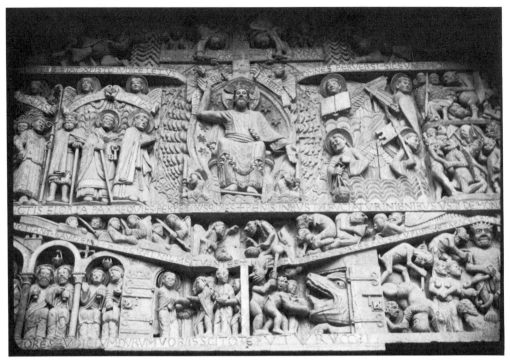

13. The Last Judgment, tympanum of western portal, Church of St. Foy, Conques, twelfth century.

off to hell, again under inscriptions: "The perverse are thrown into the Inferno. The wicked suffer tortures; burned by flames, tortured by demons, they tremble and groan endlessly. Thieves, liars, deceivers, misers, rapists are all condemned. Oh sinners, if you do not change your ways, know that a terrible judgment awaits you." Reader, be warned.

Burgundy: Cluniac and Cistercian Art

Burgundy, the homeland of the Frankish tribe of Burgundians, lay in the very heart of Western Europe, where its fertile lands were relatively secure from the invasions of Magyars and Vikings. The eleventh century found the territory divided between a kingdom which Rudolf III bequeathed to the Ottonian emperor and the duchy of Burgundy, nominally part of France. Nevertheless, in spite of Burgundy's ties to the Holy Roman Empire and proximity to modern Switzerland and Italy, the history of Burgundian art is tied to the patronage and

inspiration of the congregation of Cluny, which stood foremost among the patrons of learning and the arts in the eleventh and twelfth centuries. In 909 William, Count of Auvergne and Duke of Aquitaine, gave land and a Roman villa at Cluny in Burgundy to a group of Benedictine monks who wanted to follow the strict rule of St. Benedict of Aniane. William waived all his feudal rights and decreed that the abbot of Cluny be subject only to the Pope. As the reform spread, and Cluny established new monasteries and reformed older houses, the abbots of Cluny created a new, centralized form of government in which all the houses became priories of Cluny as a congregation ruled by a single abbot. Cluny provided a unifying force in the fragmented society of the eleventh and twelfth centuries.

While adhering to the Benedictine motto, "To work is to pray," Cluniac reformers emphasized scholarly rather than manual labor. Led by scholarly abbots, such as Abbot Odo (927–942), a poet and musician as well as an

administrator, Cluniac monks became famous for their music and art and the perfection of the liturgy. The intellectual level of the congregation also rose rapidly as Cluniac monasteries attracted the brightest youths into the novitiate. Abbots Odilo (994–1048), St. Hugh (1049–1109, canonized in 1120), and Peter the Venerable (1122–1156) enhanced Cluny's temporal power as well. The congregation grew wealthy both from gifts and through its own effective land management for, like secular lords, the monastery ruled vast estates worked by lay brothers and serfs. The growth of Cluny in power, prosperity, and numbers (from seventy monks to about three hundred during the sixty-year abbacy of St. Hugh) inspired vast building campaigns. Fortunately Cluny had the imaginative, technical, and financial ability to build splendid edifices. Romanesque art is the art of a feudal age, but it is also an art profoundly influenced by Cluny.

Within thirty years of its foundation, Cluny had outgrown its first church, a simple barnlike structure. Between 940 and 960 the monks began a new church, which in 981 they dedicated to SS. Peter and Paul. Because of the destruction and rebuilding on the site, the details of the building remain conjectural. Built in the First Romanesque style, Cluny II, as it is known now, had a basilican nave with transept leading to an elongated choir, from which projected three apses in staggered fashion, known as the apse *en échelon,* or Benedictine, plan [14]. At the west end of the church stood a two-story narthex, or Galilee porch, flanked by a pair of towers rising from the second story. The name "Galilee" was given to the portal because the procession of monks stopped there during the Easter service before they entered the heavenly Jerusalem symbolized by the church, like apostles walking through Galilee to Jerusalem. Laymen stood in a second-floor gallery, where they could observe without obstructing the procession.

Just as the House of God was the center of the spiritual life of the community, the cloister was the center of domestic activity. The plan established in the Carolingian period (chapter V) evolved into a masterful arrangement of large, well-built halls. The intellectual activities of the monks were centered in the church, where they celebrated the Christian rites day and night, and in the library and scriptorium. The scriptorium at Cluny probably lay along the south wall of the church adjacent to the north walk of the cloister. Convenient to the choir was the dormitory of the monks, in the second story of the east range. Below, in the east walk, were the chapter house for meetings, the parlor, and the monastic archives. Across from the church in the south range stood the refectory, pantry, and calefactory (warming room), while the west range contained kitchen and cellar, distant from the choir and library but convenient to the refectory. The public approached the monastic complex from the west; therefore the almshouse, where public charity was dispensed in the form of food and shelter, stood in the west range near the kitchens. At first all the members of the community lived together; later, even when the abbot had his own house, he lived near his fellow monks (rather than north of the church, as in the St. Gall plan). Eventually a novitiate, guest facilities, and a hospital were added to the central core of church and cloister buildings.

Only some foundations of the eleventh-century church at Cluny survive, but the development of the First Romanesque architecture in France can be studied in churches related to Cluny II, such as the Church of St. Benigne of Dijon or St. Philibert's at Tournus. Certain important features characterize the group: a basilican nave; the massing of transept, tower, and chapels at the east; and a western entrance with square towers and porch-narthex.

The monk William of Volpiano was instrumental in forging a connection between Bur-

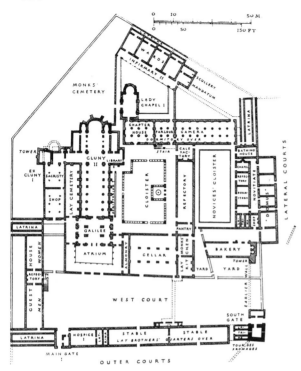

14. Cluny: plan of the early monastery (Cluny II).

gundy and Lombardy, when in 987 he came from northern Italy to Cluny and then proceeded to Dijon, the capital of the duchy of Burgundy, to reform the monastery of St. Benigne. The church William built in Dijon, between 1001 and 1018, was a large double-aisled basilica, in emulation of St. Peter's in Rome but constructed of masonry like a Lombard building. To the basilica William added an elaborate east end composed of transept and staggered apses surrounded by a passage that led to a great rotunda. The plan of the church with its basilica and rotunda was inspired by the Church of the Holy Sepulchre in Jerusalem, which of course William had never actually seen.

Other builders on the borders of Burgundy also experimented with new church plans. In the Loire River Valley, the Merovingian Church of St. Martin at Tours underwent a reconstruction that had wide repercussions for the subsequent development of medieval ar-

chitecture. In 903–918 a corridor had been built around the apse joining a series of semicircular chapels slightly below the level of the apse. In the rebuilding of the church after a fire in 997, this corridor became a true ambulatory at ground level. The chevet—as this scheme of apse, ambulatory, and radiating chapels is called—was to have a long history in medieval building. We have already seen the result in the pilgrimage church plan, and St. Martin was a principal church on the western route.

Like Cluny, little remains of the experimental eleventh-century churches at Dijon and Tours; however, at Tournus the Church of St. Philibert stands as a reminder of the severe, dignified architecture of early-eleventh-century Burgundy [15]. Originally erected to house the relics of St. Valérien, a second-century martyr, the church received its present dedication when monks from western France, fleeing Viking attacks, brought the remains of St. Philibert to Tournus in 875. Rebuilding of the church began after a fire in 1007–1008 and a new chevet was consecrated in 1019 [16]. To accommodate the relics of two saints and the pilgrims coming to venerate them, the architects built a crypt with the shrine of St. Philibert in the center and an ambulatory with radiating chapels, the central of which contained the shrine of St. Valérien. The chevet arrangement, like St. Martin's at Tours, was repeated on the ground level to house the altars; and since the crypt was entirely underground, the floor of the church could be on a continuous level from the entrance through to the sanctuary. The logic and clarity of this plan are matched by the logic of the building techniques, and the simplification and clarification of all the components heralded a new era in ecclesiastical architecture.

The design of the narthex and nave of St. Philibert evolved from First Romanesque experiments. Arched corbel tables and strip buttresses articulate the exterior walls of the two-story narthex and towers. On the interior,

each story has two different vaulting systems in a display of ingenuity that produced a veritable dictionary of eleventh-century engineering techniques [17]. Large, cylindrical piers on the ground level support three groin vaults over the center aisle, which are abutted by transverse barrel vaults over the side aisles. Cylindrical piers on the second story carry a barrel vault; however, quadrant vaults over the upper side aisles were too low to support the upper wall and vault, so the builders inserted tie beams across the central space at the springing of the main vault. This additional support enabled the masons to place modest

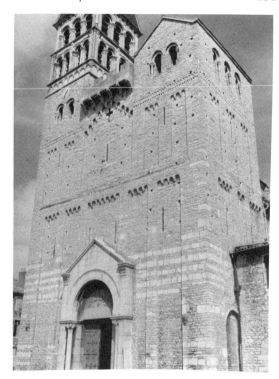

15. RIGHT: Facade, St. Philibert, Tournus, early eleventh century.

16. BELOW RIGHT: Plan, St. Philibert, Tournus.

17. BELOW: Nave, St. Philibert, Tournus, 1060s.

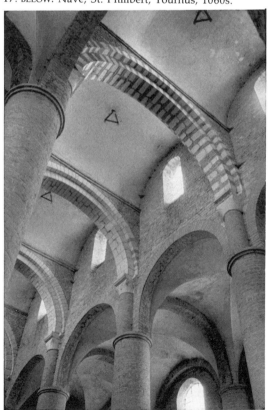

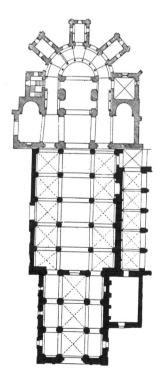

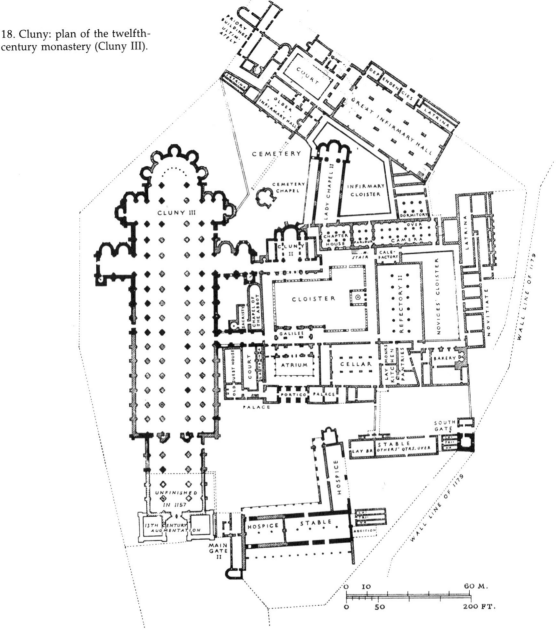

18. Cluny: plan of the twelfth-century monastery (Cluny III).

clerestory windows under the vault and in this way create a lighted interior that speaks more for the northern heritage of the Burgundians than for their Lombard-Catalan legacy. Still, the masonry walls rising unbroken into a barrel vault, divided as they are into vertical bays by tall transverse arches, recall the mature Catalan style at Cardona.

The nave of St. Philibert also boasts a variety of vaulting methods. As completed in the 1060s, colossal cylindrical piers hold up the groin vaults of the side aisles and the diaphragm arches of the nave. On the diaphragm arches the builders raised a series of transverse barrel vaults. Consequently each barrel vault buttresses the next down the

length of the nave, and the whole is abutted at either end by the narthex and the choir. Since such a system exerts little outward thrust on the walls, large windows could be pierced through the upper walls to achieve brilliant illumination. While this combination of columnar piers and large windows lends an almost fragile appearance to the nave, the structure is in fact remarkably stable. Ultimately, the visual effect of the pier-arch-vault organization is one of excessive subdivisions, and this nave design was never repeated. Regardless of the visual effect, the masonry improved the acoustics in the church, an important consideration for the music-loving Benedictines.

These eleventh-century churches soon paled beside the renewed building activity at Cluny [18]. In 1088 St. Hugh began a third church. A nobleman, St. Hugh applied to his relatives for financial contributions toward the building campaign; thus King Alfonso VI of Castile and León and his queen, St. Hugh's niece Constance, made Cluny the recipient of huge offerings of thanks after the capture of Moorish Toledo. St. Hugh needed vast resources, for he planned his church to rival the Roman basilicas of St. Peter and St. Paul and to challenge the imperial Cathedral of Speyer in size and magnificence. Although St. Hugh did not live to see his dream realized, the great church, dedicated in 1130, eventually fulfilled his ambition. It had a finished length of 555 feet, double aisles, a double transept, and a cluster of towers. As an inspiration for succeeding generations, and as a school for masons and sculptors during its construction, the church and monastery at Cluny exerted a profound influence on the development of Christian art.

Two Cluniac monks supervised the construction of the church. Gunzo, a Spaniard, had been a notable musician and head of the house at Baume, east of Cluny. According to legend, St. Peter himself designed the church and appeared in a dream to instruct Gunzo.

The actual building project was carried out by Hezelo, a mathematician. The monks began their new church September 30, 1088, and Pope Urban II, passing through Cluny on his way to preach the First Crusade, consecrated the high altar on October 25, 1095.

In the twentieth century archeologists, led by Kenneth John Conant, have traced the plan and studied the fragmentary remains of the great church known as Cluny III [19]. To

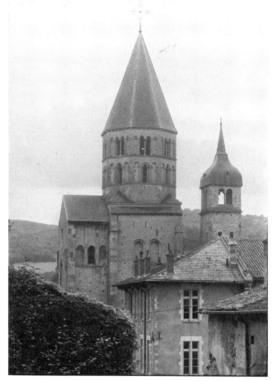

19. Surviving south transept (Cluny III), 1088–1130.

accommodate the congregation of monks, an ambulatory with semicircular radiating chapels surrounding the apse was combined with double transepts having chapels on their east walls. Since Cluny was not a pilgrimage church, little provision had to be made for the needs of lay pilgrims, but ample space had to be built for the monks in the choir. The dramatic pyramidal design of the east end includes an ambulatory and radiating chapels,

double transept, and octagonal towers over both crossings and over the center bay in each arm of the west transept. Around the high altar, six Roman columns and two slender cylindrical piers crowned by Corinthianesque capitals supported the upper wall and conch of the apse. There a representation of Christ in Glory dominated the choir. Later the Pantocrator with the twenty-four elders and SS. Peter and Paul was carved on the west facade of the church.

The nave with its double aisles and three-part elevation emulated Old St. Peter's; however, classicizing details such as engaged columns, pilasters, capitals, and moldings could have been inspired by the ancient Roman

20. Nave (Cluny III), as reconstructed by K. J. Conant and drawn by Turpin Bannister, 1088–1130.

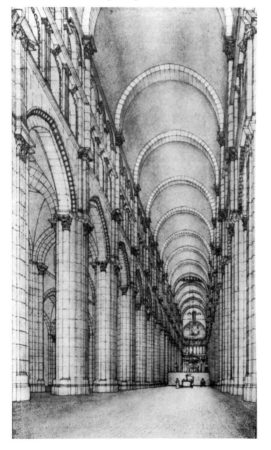

21. Nave, Paray-le-Monial.

monuments still standing in Burgundy [20]. An idea of the appearance of the church can be gained at Paray-le-Monial, where the Church of the Virgin copied Cluny III on a reduced scale [21]. Structurally the architects at Cluny abandoned their Roman models and built the thinnest possible catenary barrel vault, reinforced with transverse arches, rising to a daring height of 98 feet in the nave and 119 feet at the crossing. Tall compound piers enriched with pilasters supporting pointed arches emphasized through their vertical lines the actual height of the building. To counter the outward thrust of the high vault, the masons reduced the width of the nave by almost two feet at the springing of the vault. At the lower level they further stabilized the building with double, groin-vaulted aisles. The catenary arches and vaults also helped to reduce the

thrust of the vault for, although rounded at its apex, the catenary arch approaches the steeper and more stable slope of the pointed arch. The Muslim pointed arch had already been introduced into Europe through Spain and Italy. Other Muslim elements appear in Cluniac decoration—for example, the horse-shoe-shaped polylobe arches and pearled moldings in the upper stories of the church.

The church was consecrated again in 1130, but work continued at Cluny throughout the twelfth century. A western narthex, begun in 1125, was finished only at the end of the twelfth century, in an early Gothic style.

The Romanesque church at Cluny served as a model for builders, sculptors, and painters throughout Burgundy. Burgundian Romanesque churches fall into three groups: buildings directly inspired by Cluny; experimental buildings loosely associated with Cluny; and Cistercian churches built as a reaction against Cluny. The first group of builders, while continuing the structural techniques, the plan, and proportions of Cluny, concentrated on perfecting elegant proportions and classical details. Notre-Dame at Paray-le-Monial and the Cathedral Church of St. Lazare at Autun reflect this essentially conservative architecture. The second group, such as the Church of the Magdalene at Vézelay, combined Cluniac themes and local building traditions in an attempt to solve engineering problems posed by vaulting and lighter masonry. The Cistercian reaction to Cluniac luxury can be seen at the Abbey of Fontenay.

The original cathedral dedicated to St. Nazaire was replaced by a Romanesque building dedicated to St. Lazarus, whose relics were brought to Autun from Marseilles in 1079. Construction began about 1120; the church was consecrated in 1130, and again in 1146. Masons by this time had perfected their building techniques and were now refining the details of the structure and its decoration. They applied fluted pilasters with historiated capitals to the piers of the nave, thereby

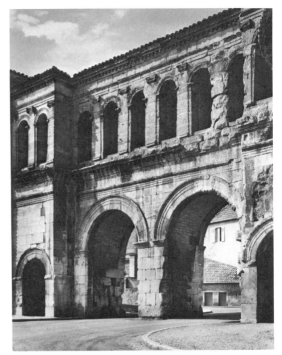

22. Roman city gate, Autun.

23. Nave, Cathedral, Autun, c. 1120–30.

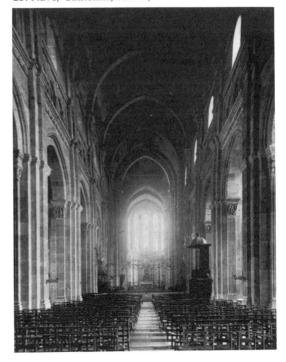

creating a rising linear movement reinforced by the pointed arches of the nave arcade and vault. The fluted pilasters, the Classical moldings, and the proportions used in the blind arcade and the clerestory could have been inspired by Roman gates to the city, which survive to this day [22]. Above this elegant wall, transverse ribs divided the pointed barrel vault into bays. The rising, pointed shape of the vault continues the verticality of the elevation, uniting pilasters, arches, and vault into a coherent design [23]. The ingenious adaptation of Classical motifs in the moldings and sculpture, enhanced by fine proportions and masonry of superior quality, make Autun one of the most successful Romanesque buildings.

In contrast, the builders of the Abbey Church at Vézelay were heirs of the energetic, experimental tradition of buildings such as St. Philibert of Tournus. In 1050, when Pope Leo IX confirmed the existence of the relics of St. Mary Magdalen at Vézelay, pilgrimages to the shrine began. After a fire in 1120 the monks rebuilt in stone and consecrated a new church in 1132. (The choir was rebuilt in the Gothic style.) Vézelay was the site of dramatic events: St. Bernard preached the Second Crusade there in 1146, and a generation later Philip Augustus and Richard the Lion-Hearted met at Vézelay to leave for the Third Crusade. The church was a worthy site for twelfth-century spectacle, for its builders had been fearless in their innovations.

To create a light, open effect, the builders of Vézelay used widely spaced compound piers, eliminated the triforium, and inserted large clerestory windows. In order to build a stable masonry vault on such widely spaced supports, they erected a slightly flattened groin vault reinforced with concealed iron rods. (The vault suggests a series of transverse vaults intersecting the longitudinal barrel-vaulted nave at a slightly lower level.) The structural solution is sound, but, like the experimental vaults at Tournus, not entirely satisfactory visually. Pilaster-backed engaged columns support transverse arches with alternating reddish-brown and white voussoirs, a decorative feature characteristic of Islamic architecture but also recalling Carolingian polychrome masonry; these arches dramatize the division of the space and give the building an exotic flavor [24, 25].

The building of Cluny III provided an impetus for the development of monumental stone sculpture as well as architecture. Fortunately, some of this sculpture survived the destruction of the church. The capitals from the columns of the ambulatory behind the high altar, capitals which Conant believed to have been in place for the dedication of 1095, illustrate the intellectual and cultural aspirations of the Cluniac monks and the emerging Burgundian style [26]. Cluniacs sought redemption through intellectual and spiritual labor as well as through religious ritual. In the sculptured capitals the monastic life was represented allegorically by the rivers of paradise, the eight tones of the plainsong, and the cardinal and theological virtues. Even damaged, as they are, the capitals illustrate the high quality of early Cluniac art. Like the marble reliefs of St. Sernin, the capitals stand at the beginning of a great school of monumental stone sculpture.

Roman Corinthian capitals inspired the capitals' underlying design: spiky acanthus leaves and ribbon-like volutes spring free from an inverted bell shape to support a wide abacus. Suspended in front of and scooping into the vigorous three-dimensional composition, platter-like aureoles frame independent, isolated figures. Their graceful poses animate clinging sheaths of "plate" drapery, which end in wind-tossed folds. Their eyes (with drilled pupils) in round, doll-like faces sparkle; their large hands gesture expressively. The sculptors achieved a remarkable crispness, clarity, and linearity by undercutting forms so that edges are sharpened by shadows.

The harpist representing the third tone of the plainsong, like all these figures, is carved

in such high relief that he approaches sculpture in the round. His energetic movement contrasts with the vertical growth of the acanthus leaves and the static aureole. The musician hunches over his instrument, his fingers actually plucking a string, and his stockings crumpling unnoticed around his ankles, so completely is he absorbed in his music. The Cluniac sculptor

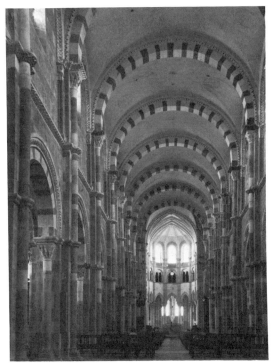

24. Nave, Church of the Madeleine, Vézelay, 1120–32.

26. Third tone of the plainsong, ambulatory capital, Abbey Church, Cluny, c. 1095.

observed human beings carefully, even though he was not committed to reproducing the outward appearance of the material world.

The Cluny capitals seem closely related to the cloister crafts of manuscript illumination, ivory carving, and goldsmithing. Stylistic comparisons have been made with Mosan and Ottonian art, especially with figures from Werden in Germany. Romanesque sculpture did not develop in a Darwinian fashion from technically crude to skilled execution or from

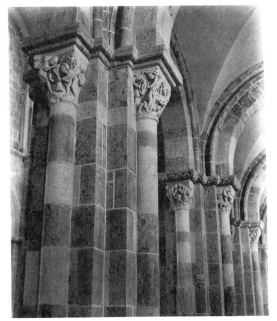

25. Detail of piers and aisle capitals, Church of the Madeleine, Vézelay (first capital: St. Paul grinding grain, the Mill of the Lord), 1120–32.

formally simple to complex compositions. As we see at Cluny (and in other monasteries, such as Silos in Spain), work of extraordinary sophistication appeared in very early monuments.

Two uniquely gifted sculptors learned their art at Cluny: Gislebertus of Autun and the anonymous master of Vézelay. Gislebertus may have worked on all three buildings, but the full range of his talent can best be seen in the Cathedral of St. Lazare, where he carved or directed the carving of capitals and the sculpture of the north and west portals. He signed his work "Gislebertus M [agister?] hoc fecit," by placing his own name directly under the feet of Christ in the center of the western tympanum.

Gislebertus, according to G. Zarnecki, began his career at Cluny, then worked on the original west facade at Vézelay, and c. 1120 moved to Autun, where he began the capitals. The acanthus capital remains a constant reference point, but Gislebertus reinterpreted it into a closely knit, two-dimensional linear composition. The foliage—a flat split-leaf reduction of the acanthus—curls upward into volutes, establishing an architectural frame for narrative scenes in which the figures and the foliage become a decorative symmetrical composition. When he depicted the suicide of Judas, he captured the horror of Judas's betrayal and disgusting death in the grimacing face and limp, dangling figure [27]. Two demons string up Judas with a wrestler's belt, the symbol of brutal, worldly, physical strength. The demons' scrawny limbs, flaming hair, contorted faces, and gnashing teeth make them convincingly energetic embodiments of evil, who defy even the architectonic requirements imposed on the sculptor.

After finishing the capitals, Gislebertus turned his attention to the portals. Only a fragment of the north portal lintel, with a beautiful depiction of Eve, survives; however, on the west facade his monumental tympanum is almost intact [28]. The huge tympanum

rests on a two-part lintel and thus requires both door jambs and a trumeau (central post) for support. In the tympanum Gislebertus depicted humanity's final accounting; serene in the center of the swirling activity, Christ renders judgment. The twenty-four elders (destroyed in the eighteenth century and replaced by a plain molding) and signs of the zodiac filled the archivolts. Human touches abound: two men carry wallets with the cross and scallop-shell badges of the pilgrim to Santiago; one angel juggles the scales and another boosts a soul through the under-croft of the Heavenly Jerusalem; gigantic hands snatch one fellow away. Gislebertus contrasts the drama of the event with the regularity of the composition— the symmetrical figure of Christ, the horizontal registers, and inscribed bands. Furthermore, although he actually worked in high relief, his elongated and interlocking figures produce an effect of two-dimensional linearity. This space-denying pattern is enhanced by the

27. Gislebertus, Suicide of Judas, nave capital, Cathedral, Autun, c. 1125.

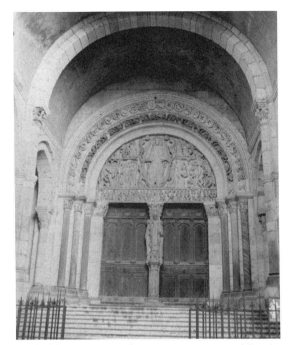

28. Gislebertus, Last Judgment, tympanum and lintel, west portal, Cathedral, Autun, c. 1125–35. Limestone, 11' 4" × 21'.

delicate multiple-fold drapery, whose weblike engraving creates a refined surface texture. Gislebertus combined the overall pattern of fine parallel lines ("multilinear") with sheath-like overlapping of sharply pressed folds ("plate" drapery) at Cluny. The clinging drapery covers slender bodies and twiglike limbs, and flutters freely around ankles and at edges of cloaks. The small, round heads with gentle faces—with the exception of the demons, of course—act as human points of reference.

When Gislebertus left for Autun, a new master began a sculptural program at Vézelay, unique in Romanesque art. In the central tympanum of the western portal, set within a narthex and leading directly into the church, he represented Christ's mission to the apostles [29]. The subject is singularly appropriate for a church which was both a center of pilgrimage and a staging point for Crusades.

The sculptural styles at Vézelay and Autun are as different as the architecture. Whereas

Autun is balanced, restrained, and even gentle, at Vézelay dynamic angular forms fill the tympanum, and figures seem to writhe with energy. Christ becomes both the motivating force and a figure caught up in His own unearthly power as He twists into a compressed zigzag position, a pose enhanced by the spiral patterns of drapery at hip and knee joints. The sculpture suggests the dynamic energy of barbarian art. As though conscious of the need to exert an architectonic control, the sculptor has surrounded the tympanum with ornate archivolts. The inner archivolts have signs of the zodiac and the outer moldings are covered with the luxuriant foliage which became a hallmark of later Burgundian art.

In a way unusual in Romanesque art, the sculpture at Vézelay impinges on the spectators and draws them into the drama. Curving backgrounds and high relief create a dramatic play between the linear surface composition and three-dimensional forms. Sometimes the background actually curves, and sometimes the sculptor has created an optical illusion of space. For example, the trapezoidal frames are scooped out to form concave half cylinders, and the mandorla surrounding Christ is a

29. Christ's mission to the apostles, tympanum and lintel, west portal, Church of the Madeleine, Vézelay, 1120–32.

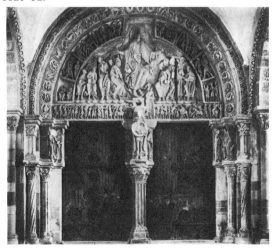

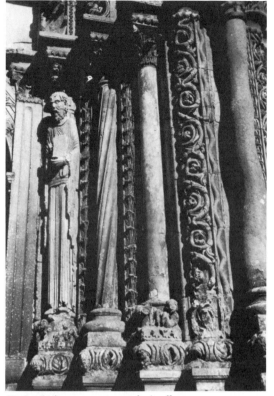

saucer-like plaque in an exaggeration of the floating discs of the Cluny capitals. On the other hand, the rippling clouds above Christ and the undulating molding between lintel and tympanum cast shadows which make the background plane appear to move. The halos of the apostles tip and slant, creating shifting planes within the shallow stage provided by the architecture. The master of Vézelay, like Gislebertus of Autun, has retained the dramatic linearity of Cluny. Both tympana were carved in such high relief that parts of figures are actually detached from the background; yet both tympana remain surface compositions of great intricacy—brilliant drawings in stone. By the middle of the twelfth century, at churches like St. Julien-de-Jonzy, Charlieu, Anzy-le-Duc, or Avallon, this dynamic linear movement became mere restlessness [30, 31]; the study of the effects of light and shade turned into a fascination with surfaces, and the delight in ornament led to a near obsession with detail, already hinted at in the Vézelay sculptor's masterpiece.

30. Jamb figure, west portal, Avallon.

31. Christ in Glory, west portal, Abbey Church, St. Julien-de-Jonzy, twelfth century.

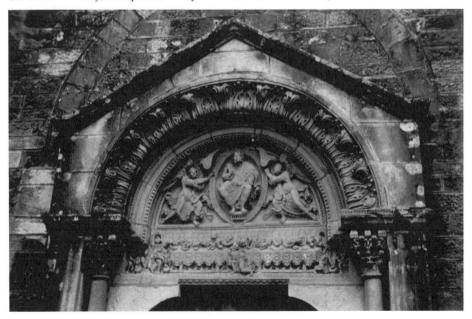

So beautiful is the stone, even when subject to the vicissitudes of modern pollution and cleaning, that sometimes it is difficult to remember that most medieval sculpture was painted. A few mural paintings survive to give us an idea of the true medieval color sense. At Berzé-la-Ville, a grange of Cluny only seven miles from the abbey, a regal Christ giving the law to St. Peter fills the apse, and scenes of martyrdom fill the walls [32]. The painting may copy the apsidal decoration of Cluny III, which in turn could have been inspired by Roman basilicas. The paintings have been dated as early as the abbacy of St. Hugh—that is, before 1109, and as late as 1140. The rich colors—a dark blue ground with rust brown and olive green—were applied in *fresco secco*—paint over remoistened plaster. Forms are built up in superimposed layers of color and finished with a fine linear net of highlights derived from the Byzantine practice of indicating folds of drapery with sprays of white or gold highlights. Nevertheless, this painting could never be confused with Byzantine work. The free drawing, the loose yet dense composition in which figures seem to jostle for position, and even the multilinear drapery style are akin to the sculptured tympanum at Vézelay. With painted walls and sculpture, Romanesque buildings must have been dazzling and, to our eyes, even garish.

A single figure from a manuscript suggests the quality of painting that was done in the Cluny scriptorium. The library was destroyed during the French Revolution, and not enough manuscripts survive for us to be able to describe a school of Cluniac painting. One cannot but hope that the scriptorium equaled the masons' workshops in the quality of its products. The figure of St. Luke, the sole remaining fragment of a Bible made about the same time as the Berzé murals, illustrates both the use of Byzantine sources and the originality of Cluniac painting [33]. The evangelist type—a mature scholar seated at his desk holding a scroll, and observed by his symbolic ox—as

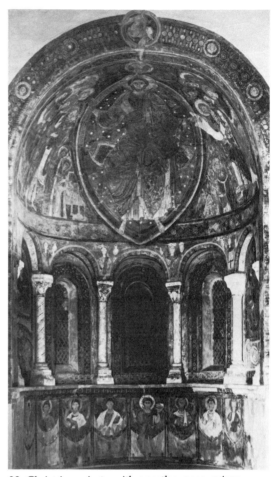

32. Christ in majesty with apostles, apse, priory chapel, Berzé-la-Ville, early twelfth century. Mural painting.

well as the modeling of the figures in the so-called damp-fold drapery style—is based on Byzantine prototypes probably transmitted through Rome. The monumentality of the figure, the firm drawing, the subtle color harmony of blue, mauve, green, and gold, and the elegant linear modeling within the forms are all Romanesque. Details, such as the throne, reflect the decorative devices found in the sculpture of the abbey church. The leaf was probably painted by the master of the Cluny lectionary, now in the Bibliothèque Nationale, Paris (nouv. acq. lat. 2246.)

Manuscript illumination inspired many

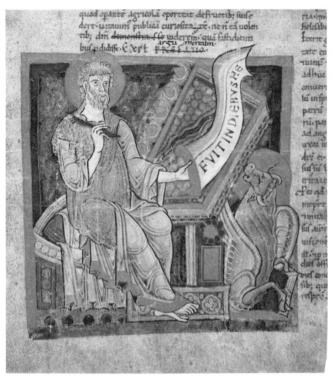

quad opatte agricola oportet defruerib; suise
dere untuum publici curiositaze ne n ta uolen
tib; dm domenfraffe usderein qua fastidieru
bus pdidisse. Exrt prefatio.

33. St. Luke, detached miniature from a Bible, Cluny, c. 1100. Tempera, gold, and silver on parchment, 6 3/4″ × 6 3/8″. The Cleveland Museum of Art.

34. Durandus, cloister pier, Moissac, c. 1100.

sculptors, as they sought to create a monumental art after generations of dedication to the cloister crafts. The many currents in Romanesque art come together outside Burgundy in the sculpture of the Church of St. Peter at Moissac, a Cluniac priory on the road to Santiago. Ruled by Durandus, who came from Cluny in 1047 and later became bishop of Toulouse, Moissac stood second in importance to Cluny. Abbot Durandus built a new church, dedicated in 1065, and when he died in 1072, he was buried in the cloister. There on a pier relief is his memorial portrait, a sculpture of uncompromising frontality and symmetry [34]. The figure completely fills the arched panel, and the vestments repeat the arch of the frame and the rectangle of the pier. Crisp and delicate carving turns three-dimensional forms into flat patterns. Sheaths of drapery with edges marked by parallel engraved lines create a delicate graphic quality related to manuscript illumination or ivory carving.

Later, during the reign of Abbot Roger (1115–1131), a new church was built. Here in

the tympanum the illuminated Beatus manuscripts popular in the region inspired the sculptor [35]. Christ in Glory, surrounded by seraphim and the symbols of the evangelists, is adored by the twenty-four elders, who, divided by the rippling sea of glass, turn to look at the Pantocrator. St. Peter and St. Paul and the prophets Jeremiah and Isaiah on the door jambs and trumeau symbolically (as representatives of the Old and New Testaments) and literally (as architectural elements) support the vision.

An almost feudal hierarchy determines the composition of the tympanum. A regular, grid-like scheme of horizontals and verticals controls the figures, whose size is determined by hieratic scale. Christ, a gigantic, seated Pantocrator, extends through three registers, while the seraphim fill two registers and the elders only one. The composition suggests an unyielding static quality, but the vigor of individual figures challenges the controlling grid. Each theme is stated and restated with variations; every movement has its counterpart in reverse. The sculptor worked in a series of beveled planes, building the total work in a series of layers, yet the tympanum remains a surface composition—a rich tapestry sweeping over the surface of the building. Ornamental patterns abound: jeweled borders and crowns, foliate archivolts and lintels, a starry mandorla, and exotic cusped jambs and trumeau.

Prophets and apostles on the jambs and trumeau are truly architectonic compositions in which the lines of the body are coordinated with the lines of the building [36, 37]. The prophet in the trumeau is elongated to fill the narrow space, yet steps forward in a cross-legged pose popular in the south. He fits perfectly into the unusual cusped pattern of the trumeau, for his feet, knees, hips, shoulders, and head follow the outward movement of the cusps. On the front face of the trumeau, diagonally crossing and interlacing pairs of lions and lionesses nearly hide the rosette pattern which continues from the lintel. The cusping, the heraldic beasts, the flat decorative rosettes, the pristine technique and taste for

35. Apocalyptic vision, tympanum, south portal, Church of St. Peter, Moissac, 1125–30.

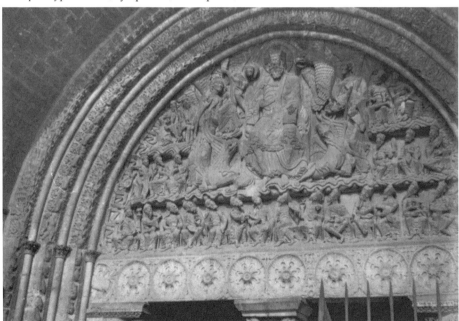

36. Prophet and lions, trumeau, south portal, Church of St. Peter, Moissac, 1125–30.

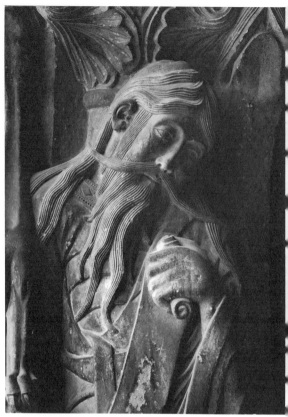

37. Detail of head of prophet.

flowing tapestry-like decoration are all part of the Eastern heritage of Romanesque art, reinforced by renewed contact with Islamic culture through the Crusades. The sculpture of Moissac influenced the masters of Souillac and Beaulieu, where an undercurrent of social protest, and even heresy, adds to the fascination of this southwestern sculpture.

Not all churchmen cared to enter a church through such richly sculptured portals. Disillusioned by Cluniac worldly success, Robert of Molesmes in 1098 established a new monastic community at Cîteaux near Dijon. (The swampy land gave the name to the place, from the medieval Latin word for reeds, *cistel*.) Another member of the original founding group, the Englishman Stephen Harding, abbot from 1109 to 1134, wrote the constitution, which a Cluniac Pope, Calixtus II, confirmed

in 1119. In 1112 a young Burgundian nobleman, Bernard de Fontaines, and thirty-two companions requested admission to the order. When Bernard found even Cîteaux too liberal, he established another reformed monastery, at Clairvaux. Abbot there for twenty-eight years and one of the leading figures of the twelfth century, St. Bernard died in 1153 and was canonized in 1174.

Unlike Cluny, with its strongly centralized government, each Cistercian monastery was independent within the limits of the rule. Although an individual Cistercian lived in poverty, the monastery itself could become a wealthy landholder with splendid buildings. Cistercians established their self-sufficient communities in the wilderness, where they dedicated themselves to manual labor as well as to prayer; they cleared forests, drained

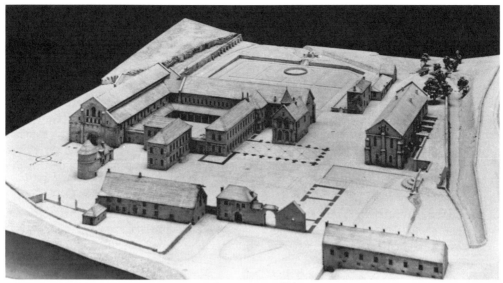

38. Plan and model, Cistercian monastery, Fontenay, twelfth century.

swamps, improved their flocks, and developed the wool industry. From Scotland to Italy— from Fountains Abbey in Yorkshire, to Maulbronn in Germany, to Poblet in Catalonia— Cistercian monastic plans and building techniques vary only slightly.

The Burgundian Abbey of Fontenay, founded in 1119, is typical of Cistercian architecture [38]. Naturally, the church with its adjoining cloister remained the focal point of the complex, and other buildings were related to it in a practical, integrated plan. The dormitory joined the transept of the church, and stairs directly into the choir provided access for night services. The refectory, library, and scriptorium stood perpendicular to the cloister walks and parallel to the dormitory, so that if the community grew, these buildings could be extended in length without disrupting other buildings around the cloister. In front of the entrance to the refectory was a lavatory and fountain. The monastery depended on lay brothers, *conversi,* rather than serfs to perform much of the manual labor on the land and in the workshops. The lay brothers' dormitory was usually built above the cellar on the west side of the cloister. A guest house and chapel stood by the gate.

The Church of Fontenay, begun in 1139, and consecrated in 1147 by Pope Eugene III, is a typical Cistercian church [39]. A rectangular sanctuary flanked by square chapels

39. Interior, north transept, Abbey Church, Fontenay, 1130–47.

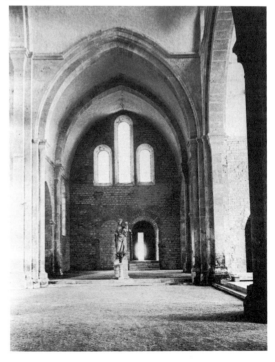

opens into a transept and thence into a long nave and aisles. The monks' choir, enclosed by a choir screen, extended into the first two bays of the nave. The church has neither clerestory nor gallery, but is lit by windows in the west wall, the upper east wall, and the sanctuary. The church was vaulted throughout with pointed barrel vaults. The high nave vault was buttressed by vaulted aisles, where in each bay a transverse vault springs from diaphragm arches. This austere interpretation of Burgundian forms characterizes Cistercian work wherever it is found.

Cistercian architecture emphasized perfect proportions as well as excellent masonry. At mid-twelfth century it expressed a tendency strong in Christian thinking since the Early Christian period. St. Augustine had used mathematics to provide a theory of the universe, whose perfection could be expressed in music as consonances, octaves, fifths, and fourths, ratios which could be reproduced in architectural proportions. At Fontenay the perfect ratios of 1:1, 1:2, 2:3, and 3:4 determined the plan and the elevation of the church. For example, the nave ends with a transept whose ratio of width to length is a musical fifth (2:3), while the musical fourth (3:4) determines the relationship of nave and aisle to transept and chapels, and the octave the proportions of the aisles. These perfect ratios produced visual as well as musical harmony, and such harmony, according to St. Bernard (and St. Augustine before him) could lead the soul to God.

St. Bernard, like the Byzantine philosophers, believed that light provided the trained and sensitive intellect with a method of transcending the mundane world. He compared the union of the soul with God to the illumination of the air by sunlight. The visual arts, on the other hand, were anathema to him; he banned "those unclean apes, those fierce lions, those monstrous centaurs" from churches and cloisters. He would not permit figured pavements, stained glass, or elaborate liturgical vessels,

and even prohibited bell towers, other than low wooden gables just strong enough to hold two small bells. He wrote, "We are more tempted to read in the marble than in our books, and to spend the whole day in wondering at these things rather than in meditating the law of God. For God's sake, if men are not ashamed of these follies, why at least do they not shrink from the expense?"

Yet the Cistercians, before St. Bernard's passionate puritanism infected them, produced superb illuminated manuscripts. Large ornamental initials exemplify all that St. Bernard came to protest. "Those fighting knights, those hunters winding their horns," "these four-footed beasts with a serpent's tail," "the fish with a beast's head" filled the letters of Cistercian manuscripts just as they filled the capitals and voussoirs of the churches and cloisters at Cluniac priories. At first, the Cistercian desire for austerity was satisfied by eliminating full-page paintings and using only line or wash drawings confined to initials. Eventually, the Cistercians banned even historiated initials.

At Cîteaux during the reign of Stephen Harding, English monks and perhaps the abbot himself copied St. Gregory's *Moralia in Job* [40]. In the salutation, "Reverendissimo" of the letter from St. Gregory to Leandro, Bishop of Seville, the letter R becomes St. George fighting the dragon, and the remaining letters alternate in blue, red, and green. The page is bordered by a trellis and foliage inspired by Anglo-Saxon manuscripts such as Ethelwold's *Benedictional*. The elongated energetic figures, the representation of the drapery by repeated arcs of colors, the jagged termination of folds, and the rhythmic movement throughout the composition relate the painting to Burgundian sculpture.

St. Bernard had a special devotion to the Virgin Mary; the Cistercian order and all its churches were dedicated to her. The idea of the Virgin as an essential link in the genealogy of Christ finds artistic expression in the Tree

of Jesse, a theme developed in Cistercian painting. A tree springs forth from the sleeping Jesse, whose reclining figure provides a horizontal base for rising branches that culminate in a Virgin and Child surmounted by the dove of the Holy Spirit. Among the earliest representations of the Tree of Jesse are those in the manuscripts from Cîteaux, which are now in the Dijon municipal library. The elegance and tenderness of these paintings suggest the advent of a gentler mood and a new style at mid-century. Byzantine art, now better known from pilgrimages and Crusaders' booty, brought a new dignity to the representation of human beings in the West.

Western France

The fertile lands of Carolingian Aquitania supported a flourishing civilization in the Romanesque period. Music, poetry, and the visual arts could thrive under the patronage of the troubador William IX of Aquitaine (1071–1127), who, with his fellow poets, gave the language of the people literary form by writing in French as well as Latin. In literature, the rude warriors of the epics became the perfect knights of romance who dedicated their arms to unattainable ladies and to the Virgin Mary, *Notre-Dame.* The troubadors idealized the illicit and frustrated romantic love of the knight for the wife of his suzerain: Guinevere, Lancelot, and King Arthur; Yseult, Tristan, and King Mark. The game of love, bounded by elaborate rules, became a knightly duty.

From this environment came one of the most brilliant women in French history. The granddaughter of William IX, Eleanor of Aquitaine, after the death of her brother and father, refused to go into pious retirement at the wealthy Abbey of Fontevrault and instead ruled her domain with a political skill equal to that of her two husbands and far surpassing that of her sons. In 1137 Eleanor married the King of France, Louis VII (1137–1180), and thus joined her vast lands to those of the

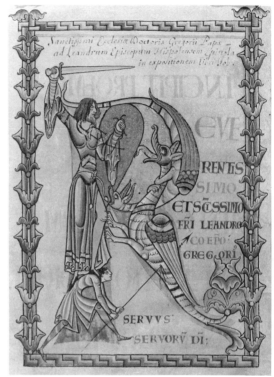

40. Initial "R," St. George, *Moralia in Job*, Cîteaux, early twelfth century. Dijon Bibliothèque Municipale.

Capetian house. Eleanor divorced Louis in 1152, after returning from the Second Crusade, where she had enjoyed the company of her uncle, Count Raymond of Toulouse. Only two months after her divorce she married Henry Plantagenet, the dashing young count of Anjou. Henry inherited Anjou, the rich province watered by the lower reaches of the Loire River, from his father, Geoffrey Plantagenet, and claimed Normandy and Brittany through his mother. He joined his lands to Aquitaine when he married Eleanor, and in 1154, at the death of his cousin Steven, he claimed the English throne. Henry and Eleanor held court in Poitou, Normandy, Anjou, and England, but Fontevrault and Poitiers were Eleanor's favorite residences and the Abbey of Fontevrault became her pantheon [41]. The abbey had been founded in 1099 by Robert of Arbrissel as a five-part establishment ruled by

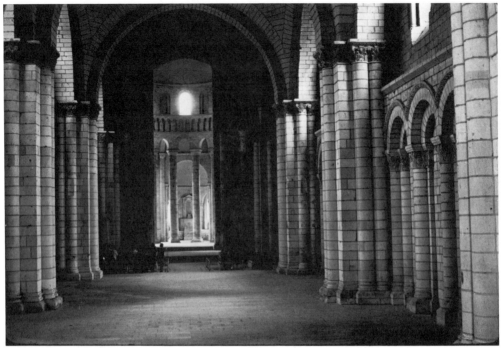

41. Nave (c. 1125), abbey church, Fontevrault, twelfth century.

42. Plan, abbey church, Fontevrault, twelfth century.

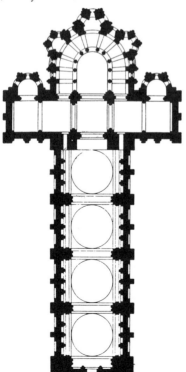

an abbess: nuns, noble ladies, monks, lepers, and the sick each had a chapel, cloister, and conventual buildings. Patronized by the nobility and especially by the Angevin rulers of England, the community grew into a small but wealthy independent order. When Henry II died in 1189, Eleanor buried him in the abbey church. Tomb figures (*gisants* in French) of Henry II, Eleanor (d. 1204), their son Richard the Lion-Hearted (d. 1199), and Isabelle of Angoulême (wife of King John) still lie in the vaulted transept of the nuns' church.

The domed church of the nuns, dedicated to the Virgin, is typical of the rich and varied architecture of western France [42]. Regardless of superficial differences, the builders strove for generous space and light in churches, which they built of excellent ashlar masonry. The church at Fontevrault was built in two stages. The chevet, transept, and a crossing covered with a dome on pendentives were dedicated in 1119. Then, about 1125, builders constructed a wide, aisleless nave covered with four domes on pendentives supported

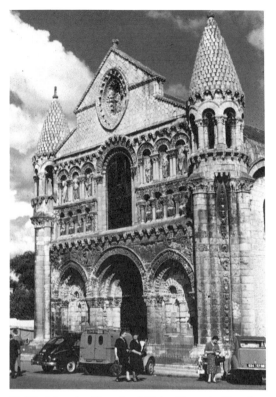

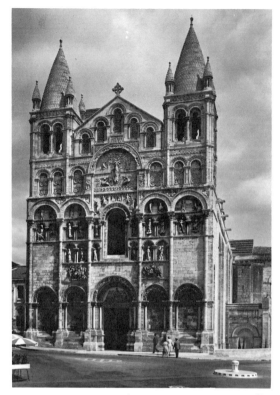

43. West facade, Church of Notre-Dame-la-Grande, Poitiers, second quarter twelfth century.

44. Cathedral of Angoulême (upper section restored).

by walls reinforced by massive engaged piers. Domical architecture was popular in the area, and domed churches still stand at Périgueux, Angoulême, Cahors, and Souillac. The Romanesque dome on pendentives in general differed only slightly from the Byzantine. The domes are balanced on slightly pointed arches which require pendentives of irregular form, unlike the spherical triangles of Byzantine building. The Romanesque builders seem to have emphasized these structural forms— piers, walls, vaults, pendentives, and dome— as distinct units clearly separated from each other; however, the effect could have been quite different when the interiors were painted. (The western dome at Cahors retains its later painting.)

The facades of these western churches screen the nave with blind arcades, which often do not reflect the interior arrangement of the building. Among the most elaborate Poitevin facades are those found on the Church of Notre-Dame-la-Grande in Poitiers [43], which dates from the second quarter of the twelfth century, and the Cathedral of Angoulême [44]. At Poitiers the horizontal lines established by superimposed ranges of sculpture continue even into the design of the towers, which flank and frame the composition. Engaged columns around a cylindrical core turn the towers into bundles of shafts supporting drums, open arcades, and conical roofs capped by distinctive inverted scale patterns. The sculptors' evident delight in patterns extends from individual elements, such as the towers, to the entire wall surface in an elaborate iconographical program glorifying the Virgin.

The facades of Poitiers and Angoulême were too elaborate to be copied widely, but the actual portal design without tympana but with repeated radiating archivolts, in which

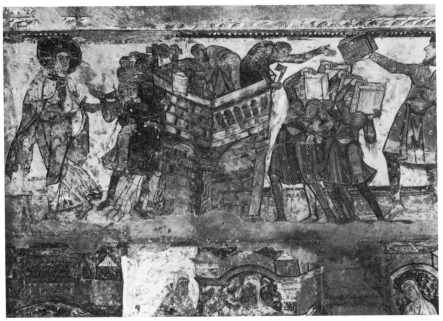

45. Building the Tower of Babel, vault, Abbey Church of St. Savin-sur-Gartempe, c. 1100.

each voussoir was carved with a single motif, became popular in abbey and parish churches in the southwest and along the pilgrimage road. A splendid effect could be achieved with limited artistic or intellectual skills, for the pattern of voussoirs, once established, could be repeated over and over again. The elders of the Apocalypse, whose number might be increased or reduced to fit the portal, the Massacre of the Innocents (with mothers, children, and soldiers each occupying a voussoir), the Wise and Foolish Virgins, birds, animals, grotesques, palmettes, and vines were all popular motifs at Saintes, Parthenay, and Aulnay in France or Soria in Spain. That such portals continued to be carved long after the Gothic style appeared in the Ile-de-France is testimony to the popular appeal of the Romanesque style in the West.

The urge to enrich the House of the Lord continued on the interior of the churches, where domed or barrel vaults provided broad fields for the mural painter. The most extensive cycle of Romanesque painting extant in the west of France is in the Abbey Church of St. Savin-sur-Gartempe [45]. As usual, the paint-

ings form a didactic program aimed at instructing the viewer as well as decorating the building. Scenes from the Old Testament fill the barrel-vaulted nave; the infancy of Christ is depicted in the transept; the Passion, in the tribune over the porch; scenes from the lives of the saints, in the chapels and crypt; and finally the Apocalypse and the second coming of Christ cover walls and vault of the porch. The nave vault, where the stories from the Old Testament unfold in four continuous registers, was built between 1095 and 1115, so the paintings must date from the same time, for they would have been done while the masons' scaffolding was still in place. A harmony of earth tones—ocher, sienna, white, and green—produces a warm, light tone throughout the building.

The paintings were expected to do more than provide an effective decoration; since the Carolingian period art had been justified for its didactic value. The painters of the nave vault, therefore, intended that their painting would be intelligible from a distance. They worked on a large scale, emphasized outlines and broad color areas, and simplified internal

modeling of figures. They may have had a Carolingian or Anglo-Saxon manuscript in the abbey library as a model, for their compositions and figure style suggest the lively two-dimensional patterns and expressionistic drawing that we saw first in the *Utrecht Psalter* and the *Liber Vitae* Last Judgment. Such models inspired the energetic figures with the round heads jutting forward on long necks, pot bellies emphasized by horizontal banding of torsos, round shoulders, and long, thin arms and legs. The painting, however, is clearly Romanesque in style, in the tight, simplified drawing, the broad decorative use of color, and the organization of individual units into an additive composition. The Tower of Babel (Genesis 11:1–10), for example, rises amid hectic building activity. Geometric patterns determine the placement and movement of the figures—the triangle formed by the three stone masons emphasized by the giant's capstone, the masons standing back to back in the tower, the swing of fanlike folds emphasizing the swaying stance of the figures. The Romanesque "law of the plane" remains unbroken; however, under inspiration from their classicizing sources, the painters created figures who seem to operate on a new, wider stage. That the masons work *in* the tower and the crowd *surrounds* it suggests the beginning of a new awareness of an inhabited spatial environment. The subsequent history of painting and sculpture records the artists' continued search for effective means to represent an even clearer vision of the world.

Normandy and England

North of Anjou and Maine lay the duchy of Normandy; from its port of Dives William the Conqueror set out for England in 1066. Even before the conquest, artists and masons had traveled between the Norman and Anglo-Saxon courts, but after William and his men gained the day at Hastings, Norman nobles and church dignitaries had castles and churches rebuilt. As Normans imposed their rule and their taste on the country, Anglo-Norman architecture evolved from structurally innovative but severe buildings to huge, lavishly decorated churches and palace halls.

The Normans, through their extensive military, commercial, and political contacts, had firsthand knowledge of most architectural styles and technical developments made during the tenth and eleventh centuries. The Norman dukes were enthusiastic patrons of Cluny beginning in 1002, when Duke Richard invited William of Volpiano to reform the monasteries of Normandy. William of Volpiano in turn brought Lanfranc (a Lombard from Pavia who in 1045 had established a great school at the monastery of Bec) to head a new monastic foundation under the patronage of Duke William at Caen. (Lanfranc, with characteristic mobility, eventually became Archbishop of Canterbury.)

Many new monasteries and nunneries were founded or rebuilt in the eleventh century, from Mont St. Michel and Jumièges in Normandy to Durham in northern England. The ruins of the Abbey Church of Jumièges, built between 1037 and 1067, attest to the innovative architecture created by Norman builders [46, 47]. The facade, with its soaring flanking towers, resembled a massive westwork, while the long, aisled nave led to a crossing marked by another great tower, and then continued in an extended choir with ambulatory. Alternating compound piers and columns divided the three-story elevation into bays. The continuous applied half columns on the piers supported a timber roof, although groin vaults covered the aisles.

The architectural logic as well as structural innovation combined with an aesthetic based on soaring height and good if not brilliant illumination that was to characterize Norman architecture is already apparent in its early stages at Jumièges. It reached maturity in the churches built by William the Conqueror and Matilda at Caen [48]. In Caen the rulers estab-

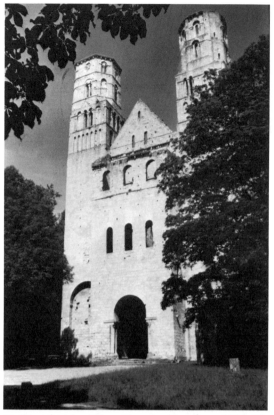

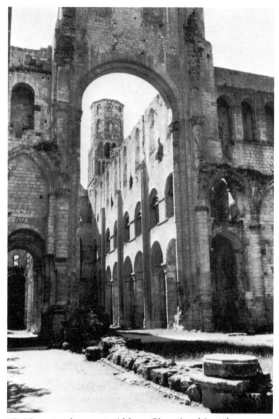

46. West facade, Abbey Church of Jumièges, 1037–67.

47. Nave to the west, Abbey Church of Jumièges.

lished two monastic communities, the Abbaye-aux-Hommes, with its church dedicated to St. Stephen, for men, and the Abbaye-aux-Dames, with the Church of the Trinity for women. St. Etienne was begun in 1064 and completed as far as the two eastern bays in the nave for a consecration in 1077. The nave was finished by 1087, in time for William the Conqueror's burial, and the facade was completed by the end of the century [49]. In two subsequent campaigns the nave was vaulted (by 1120) and the choir was rebuilt (1202). Massive compound piers with half columns running the full height of the three-story elevation divided the nave into bays and emphasized the verticality of the composition, and the addition of moldings on alternate piers created a subtle rhythmic movement down the nave

[50]. As at Jumièges, originally a timber roof covered the nave, although vaults were used in the aisles and galleries. In the clerestory, between an arcade facing the nave and the outer windows, a passage within the thickness of the wall provided access to the upper areas.

In spite of the actual thickness of the walls, the Norman builders conceived of the interior as a skeletal framework of piers and arches which permitted wide openings filled with windows, arcades, or a skin of masonry. To visually lighten the masonry, supporting arches were given additional moldings and subsidiary arches, supported by engaged columns. If moldings were multiplied, so were the supports, until piers might have a very complex cross section, as is already apparent in the primary piers in the nave at Caen.

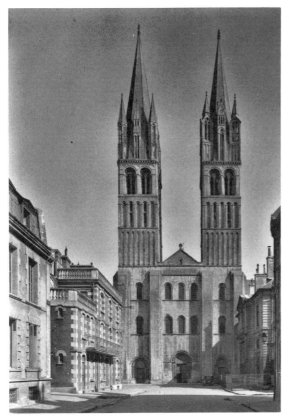

48. West facade, Abbey Church of St. Etienne, Caen, 1064–77.

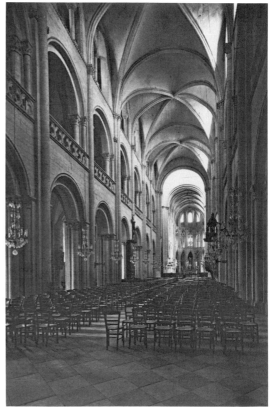

49. Nave, Abbey Church of St. Etienne, Caen; vaulted c. 1120.

The grid design of the elevation, with strong vertical accents at the columns dominating the horizontal pull of the round arched arcades, was repeated in the facade of St. Etienne. Enormous buttresses run unbroken the entire height of the facade to divide the wall into three vertical sections, while small string courses at the window sills mark the three horizontal stories of the elevation. Tall towers (finished with Gothic spires) reinforce the essential verticality of the design. The severe rising forms of St. Etienne's facade stand in marked contrast to the horizontal composition and richly sculptured facade of Notre-Dame-la-Grande, Poitiers. The facade at Caen reflects the arrangement of the three-part plan and three-part elevation, the divisions indicated by the buttresses and string courses, whereas

50. Section of nave, Abbey Church of St. Etienne, Caen.

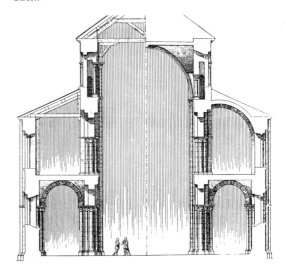

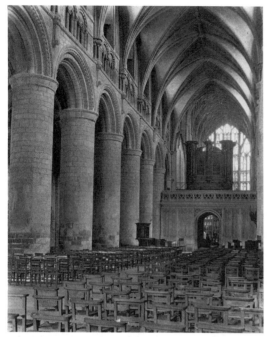

51. Gloucester Cathedral; nave, c. 1190, vaulted
c. 1240; choir rebuilt, 1337–51. Height of the nave
piers, 30' 7".

at Poitiers a reredos-like screen hides the
interior arrangements. At Caen the facade is
stripped to the essentials; at Poitiers, all is
lavish sculpture. Even St. Bernard might have
approved of Caen's severity, fine masonry,
and harmonious proportions, although he
would have disapproved of the tall towers
and Gothic spires.

By far the largest number of fine Norman
buildings are in England, where the new
Norman clergy tried to outdo each other, and
their Anglo-Saxon predecessors, in the size
and splendor of their architecture. Many
churches, which we will return to in our study
of English Gothic art, were founded or rebuilt
by the Normans and have features derived
from buildings in the many lands with which
the Normans had contact: Cluny's double
transepts appear at Canterbury; the rare tran-
sept towers found in the Holy Roman Empire
at Exeter; the screen facade of Aquitaine at
Ely. The Abbey Church of St. Peter in

Gloucester, begun in 1087, with its massive
columnar piers and the upper stories enriched
with a barbaric chevron ornament, its ranges
of square and circular moldings, is unlike
anything in Normandy [51]. Of all the Norman
churches, the most important for the future
development of medieval architecture is the
Cathedral of Durham [52, 53]. Set on a cliff
where the oxbow of the River Weir provides
natural defenses, the cathedral and castle
shared the site, for Durham was the military
as well as the religious headquarters for the
north, and one man was both secular and
ecclesiastical lord.

An aggressive builder like his fellow Norman
churchmen, Bishop William de Carlief deter-
mined to replace the Saxon church at Durham.
He began in 1093 and finished the vaulted
choir in 1104; the vaulting of the nave was
completed in 1133. Following the alternating
system of nave design used at Jumièges but
embellished beyond that generation's imagi-
nation, enormous primary piers of the tall
nave and choir arcade have become clusters
of vigorously projecting engaged columns,
while the intermediate piers are cylinders equal
in height and circumference and decorated
with engraved chevrons, spiral fluting, and
diaper patterns. Multiple rolled moldings and
chevron ornament decorated the soffits of
arches springing from huge scalloped cushion
capitals [54]. On the second story, which is
more like a triforium than a gallery, paired
arches open into the nave, but the outer wall
is low and has only small windows. The
clerestory, too, has a colonnade to screen wall
passages and windows.

Above this vigorous wall design rise vaults
which mark an important step on the way to
the development of the Gothic structural sys-
tem [55]. The vaults of the double bays are
separated by transverse arches and divided
into seven parts by two pairs of diagonal ribs.
In the choir, these ribs spring from columns,
but in the nave they were altered to rest on
corbels. They seem aesthetically independent

of the web of the vault. The segmental arches of the ribs enabled the architect to maintain a level crown for the vault and thereby to create a more unified interior space than the domical groin vaults of Speyer or S. Ambrogio, Milan. At Durham the great internal piers and stiffening exterior wall buttresses support and stabilize the vault; hidden buttresses in the galleries (imperfectly weighted arches in the choir and quadrant arches in the nave) suggest the future development of flying buttresses.

The innovative vaults at Durham had little immediate effect on architecture in England, where buildings continued to be roofed with timber. In Normandy, however, in the second decade of the twelfth century the architects reconstructed St. Etienne at Caen with a six-part ribbed vault. The early wall system of alternating heavy and light supports suited sexpartite vaulting, for it provided a logical correspondence between nave elevation and major and minor transverse ribs. To accommodate the vault, however, the clerestory had to be altered to the awkward arrangement of double windows and ribs seen today.

Architects in England developed the decorative rather than the structural possibilities of themes established at Durham. Incised patterns, roll and chevron moldings, interlaced arches (visible on the lower aisle wall at Durham), and some figure sculpture appeared in the later Anglo-Norman buildings. The Viking and Anglo-Saxon style could not be entirely expunged from the folk memory. When sculpture appeared on capitals at Canterbury, in small tympana, such as Southwell, or on door jambs, as at Kilpeck, the Scandinavian heritage of the artist sometimes had reemerged.

The traditional skills of the metalworker flourished in Norman England. Here the Romanesque fascination with men and monsters

52. Plan, Cathedral of Durham, 1093–1133.

53. Cathedral of Durham.

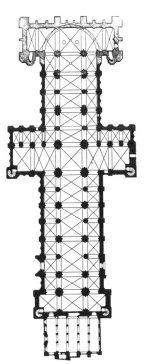

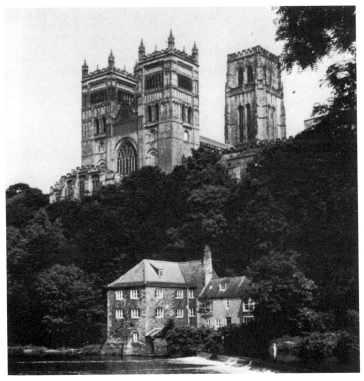

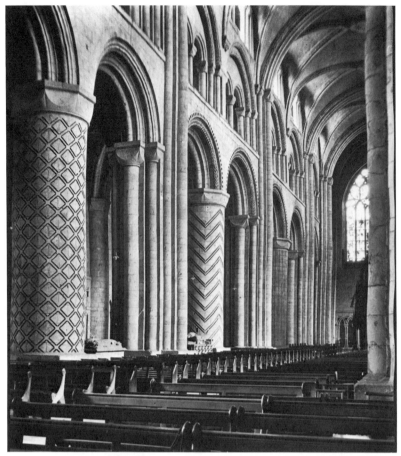

54. Nave, Cathedral of Durham (south elevation, from crossing), 1093–1133.

55. Elevation, choir, Cathedral of Durham.

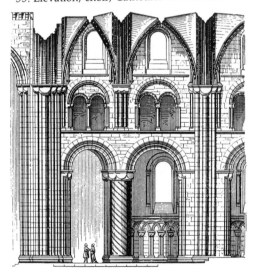

appears in the magnificent gilt bronze Gloucester Candlestick, an offering of Abbot Peter (1104–1113) to his monastery [56]. The small scale of the work did not lessen the monumentality of its conception—nothing less than humanity's struggle against the forces of evil and darkness to reach the true light of Christ. Through a twisting, writhing mass of monsters and foliage, loosely controlled by an encircling band, tiny figures struggle and scramble upward, first to the symbols of the evangelists half way, at the knop, and then to the light itself. Not only is the candlestick a masterpiece of bronze casting, but the conception of the figure in motion, and the depiction of the tension of bitter struggle and the eventual joyous victory demonstrate an acute awareness of human inner nature.

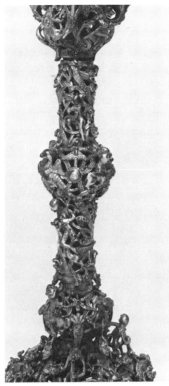

56. Gloucester Candlestick (detail), 1104–13. Gilt bronze. Height, 23″. The Victoria and Albert Museum, London.

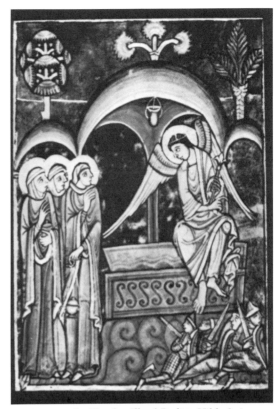

57. Marys at the Tomb, *Albani Psalter.* Hildesheim Bibliothek.

English scribes also played a role in the twelfth-century revival of the figurative arts. Carolingian, Anglo-Saxon, and Ottonian manuscripts were available to the scribes in monastic scriptoria such as St. Albans. The great Benedictine monastery just north of London had one of the finest libraries in England at the beginning of the twelfth century. By the time the Gloucester Candlestick was cast, a painter in the scriptorium of St. Albans was at work on a cycle of Biblical illustrations in the *St. Albans Psalter* (or *Albani Psalter*), which provide as radical a break with the Anglo-Saxon past as did the vaults of Durham [57]. The psalter opens with forty full-page illustrations encompassing Christian history from the Fall to the Pentecost. In addition, there are tinted drawings, full-page paintings, and historiated initials. The inspiration for the art seems to have come from increased contact with Ottonian art and, through Germany and Italy, with Byzantium (although scholars have not identified specific models). The influence of imperial art, with its architectural compositions, articulated human figures, deep colors, simplified drawing, and above all emphatic monumentality, changed the direction of English art, and the painters of the *Albani Psalter* established this new style.

Several scribes and painters worked on the manuscript, but the master painter of the Biblical cycle supervised and controlled the project. His revolutionary style dominates the work. Strong, severe, even somber, with hard drawing and deep, full-bodied colors—dark brown, green, blue, and purple—the new style stands in sharp contrast to the lively, tinted drawing or the exuberant foliage and figures of the late Anglo-Saxon *Benedictional of St. Ethelwold* (page 141). A comparison of

the same scene, the Marys at the tomb, as treated by the two painters, dramatizes the remarkable change which has occurred between the Anglo-Saxon style and the Anglo-Norman Romanesque. Gone are the fluttering draperies, the intricate internal modeling of the forms, the relaxed poses and luxuriant foliage of Anglo-Saxon art. In the *Albani Psalter* the acanthus and trellis frame has been replaced by linear borders and foliage patterns as severe and controlled as Ottonian art. Only four tiny feet break the inner frame, and no elements extend beyond the outer border. The triple vault of the Holy Sepulchre, with its supporting piers below and the three trees above, establishes a symmetrical composition scarcely relieved by figures who play out the Easter drama in a shallow space. The three Marys stand in a compact group, like tall, narrow posts, confronting the seated angel and four knights. Even the tomb of Christ,

inspired undoubtedly by marble sarcophagi, is a pattern of wavy lines and S curves. Trees, conventionalized beyond any imaginable foliage, become decorative patterns, while the earth is reduced to fat spirals. The facial types, with their large noses and staring eyes, the prominence given to gestures, the use of dark colors and heavy outlines all suggest Ottonian art; nevertheless, the extreme elongation of the figures, the insistence on parallel verticals, and the love of geometric ornament reflect native English taste.

Closely related to the manuscript production of the scriptoria was the production of fine embroidered textiles, for patterns and scenes were drawn by scribes and then worked by needleworkers. The most famous of all English embroideries is the so-called *Bayeux Tapestry* [58], which records the conquest of England by William. Ordered by William's half brother Odo, Bishop of Bayeux, and probably worked

58. Storming of Dinant, *Bayeux Tapestry*, c. 1070. Wool embroidery on linen. Height, 20″; length of entire tapestry, 229′ 8″. Ville de Bayeux.

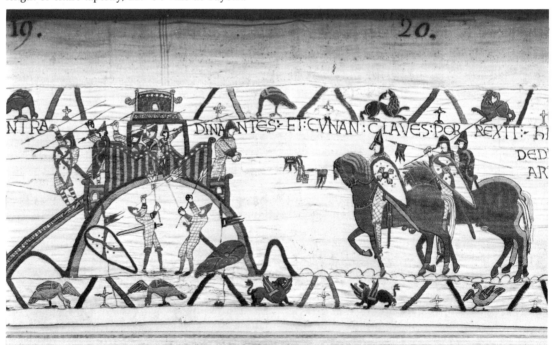

in southern England, the tapestry is actually wool embroidery on linen. As a political document it justifies the conquest, authenticates William's claims to the kingdom, and recounts the preparation for the invasion, the course of the battle leading to the death of Harold, and the establishment of the new Anglo-Norman dynasty. No detail escaped the attention of the artist. In the siege of Dinant, the conformation of the land, the burning of the palisades, and the surrender as the keys are passed out from lance to lance are depicted in an energetic style which is closer to late Anglo-Saxon drawing than to the new Romanesque style of the *Albani Psalter*. Accuracy in reporting is prized over calculated composition, specific details over idealized views, energy over elegance. Furthermore, the *Bayeux Tapestry* provides a fascinating source of visual information, not only of an important historical event but of daily life in the eleventh century.

Secular Art

The most characteristic secular art of the Romanesque period—castles, arms, and armor—has survived only in battered condition. No later ruler could afford to have his realm dotted with private fortifications and arsenals, so if the castles survived medieval sieges they were "slighted" (that is, destroyed) by later royal decree.

The *Bayeux Tapestry* provides one of the best views of the Norman motte-and-bailey castle. Easily and rapidly built, the wooden tower on an artificial earth mound (motte) was vulnerable to fire. As soon as possible the wooden palisades around the bailey had to be converted to stone, and the keep, as the tower was called, strengthened to withstand a prolonged siege. A fine example from the early twelfth century is the Norman keep at Rochester in southern England [59]. The keep was reinforced at its base as protection against mining and battering rams. Corner buttresses continued up above the level of the roof in

turrets, which, since they project beyond the line of the walls, add to the effectiveness of the archers, who could then defend the walls with a raking fire of arrows and missiles. Crenelated battlements (permanent stone shields behind which the defender could step

59. The Keep, Rochester Castle, early twelfth century.

for protection) surround the roof and turrets. A windlass on the roof and a series of openings in the center of the inner floors provided an effective elevator system to lift supplies to the roof when the tower was under attack. A single door high on the wall, and defended by a forebuilding, was the only entrance to the keep. Today's wide lawns around the keep were once the walled bailey, or courtyard, where troops, animals, and populace could take refuge. The internal arrangements of the keep were simple. The ground floor provided storage space and could be entered from the upper floors but not from outside. The great hall on the principal floor could be two stories

high, with chambers in the thickness of the walls at the second story. Spiral staircases in the corner turrets and passages in the walls provided access to the chambers, upper floors, and the roof. Inconvenient and uncomfortable as a dwelling, this relatively simple building soon became impractical also as a fortress.

As military architecture became more sophisticated, the rectangular form gave way to circular towers, against which battering rams moved with less devastating effect. The bailey increased in size, and the surrounding curtain wall was strengthened. More comfortable living quarters, as well as quarters for troops, could be built in the bailey. Additional walls and fortified gatehouses added to the strength and flexibility of the defenses. Castle building reached a climax in the Holy Land during the period of the early Crusades, where such an intermixture of style and technique took place that it is often fruitless to attribute parts of buildings to either Christians or Moors. During the Crusades, both camps learned to increase the effectiveness of walls and towers with crenelations, loopholes, barbicans, vaulted towers, and passages. Towers of various shapes were designed as siege techniques and offen-

sive devices were perfected and fire power improved. Throughout the Middle Ages the walls of Constantinople stood as a model of defense technique.

In Western Europe, King Richard the Lion-Hearted had learned his lessons as a Crusader well, and his castle, Château Gaillard, built between 1196 and 1198 on a cliff above the Seine on the border of Normandy, incorporated all the latest developments in both Christian and Muslim military technique [60]. The site was nearly perfect, for the castle could be approached only by a narrow ridge of land, which was easily cut by a strong independent fortification [61]. A series of three massive walls, towers, and ditches ensured that, should the outer walls be breached and the towers captured, the enemy would find himself facing yet another, even stronger, bastion. The walls of the inner bailey and keep formed a continuous row of semitowers. Living quarters, great hall, kitchens, chapel, and other buildings were constructed in the inner courtyard. Château Gaillard fell to the French king after a long siege, and after the death of Richard. Such was the fate of many castles—eventually they were taken by pro-

60. Château Gaillard, 1196–98, Les Andelys.

61. Château Gaillard.

longed sieges, treachery, starvation, or disease. Nevertheless, many proved impregnable and stood until dismantled or destroyed in modern times.

In the eleventh and twelfth centuries dwellings clustered for protection near castle walls; other villages arose near religious establish-

ments and at crossroads, fords, or ports. By the twelfth century these villages had become real towns. Avila in Spain was founded at the end of the eleventh century by Raymond of Burgundy, who came to Spain as a Crusader and stayed to marry Urraca, daughter and heiress of Alfonso VI of Castile [62]. Intended

62. Avila, late eleventh and twelfth centuries.

as a Christian outpost against the Moors, even the cathedral choir was fortified. The city wall, built like a castle's curtain wall, was reinforced by many D-shaped, battlemented towers joined by a wall walk. Pyramidal crenelations, a Moorish innovation to deflect missiles, protected open firing platforms at the top of the towers. The city wall was necessarily broken by more gateways than were desirable in a castle, and the largest of these were defended by huge double towers. Open spaces outside these gates provided an area for produce and livestock markets. Within, houses crowded around the central marketplace with its community well, ovens, market hall, parish churches, and finer houses.

The finest twelfth-century houses, such as those which have survived in Cluny [63] or Lincoln, were built of masonry around courtyards. They were two or three stories high, with commercial quarters and stables on the

63. House in Cluny, twelfth century.

ground floor and living quarters above. Facing the street, the town house often had a large, arched opening closed by a shutter, which was lowered during the day to form a counter for a shop. On the upper floor, a row of windows, with carved colonettes and capitals, lit a spacious hall, while private rooms and workrooms were placed at the back of the house and under the roof. The prosperous burgher in the twelfth century had his factory, warehouse, sales room, and home all in one compact building.

In the eleventh and twelfth centuries an international style sponsored by the papacy and the monastic orders was modified by local artists and patrons to suit their own materials and techniques, artistic traditions, and needs. Romanesque art developed as a style with marked regional variations, thereby illustrating the diversity suggested by the religious, political, and social organization of Western Europe in the eleventh and twelfth centuries.

Romanesque architecture is a model of clarity in planning, construction, and symbolic content. Towers, which stood like city gates as symbols of authority and temporal power, often dramatize the facade, while sculpture, whose narrative content further emphasized the sanctity and the importance of the Church as the House of the Lord, enriched the portal. A lantern tower on a cupola could give additional distinction to the crossing of the nave and transept by introducing a vertical element into the building. Such a tower also served as a reminder that every church was a martyrium and that the altar on which Mass was celebrated was both table and tomb. Beyond the crossing, a complex choir provided space for the participating clergy and chapels to house the relics of saints. In their exterior massing, Romanesque buildings define the interior functions and spaces; the distinction between mass and void, solid form and enclosed space, was never blurred. Simple geometric shapes

and clearly distinguishable individual units produced the total architectural composition. The great French medievalist Henri Focillon called the "additive composition" the single most important element in the definition of Romanesque style. The impression given by the buildings is of solid, massive, uncompromising strength—the architectural expression of an essentially hierarchical and military society.

Architecture dominated the arts of the eleventh and twelfth centuries and determined the form of sculpture, painting, and the cloister crafts. An aesthetic tension arose between the architecture and its decoration when the sculptured forms began to challenge the limiting plane of relief and the rigorously defined limits of the frame. The wall established the limits of the relief and, although figures might extend over more than one block of stone in the great tympana, they remained enclosed by the framing archivolts. In painting, too, the illusion of three-dimensional space was reduced or eliminated through the use of strong outlines in uniformly brilliant color. In painting and sculpture the rhythmic and symmetrical repetition of abstract patterns gave the forms an essentially decorative character enhanced by the underlying geometry of individual elements. Each became a self-contained composition in an enclosed world. The minor arts also took on architectural compositions; even manuscript illustrations had a geometric clarity and monumentality appropriate for mural decorations. The exquisite refinement of the decorative arts imported from the Byzantine and Muslim East reinforced the desire for superior craftsmanship that was already part of the northern heritage. At the same time artists looked again at the antique tradition of realism/humanism as distilled by Byzantine artists. This selection and combination of elements, as well as the submission to an architectural discipline, gave Romanesque art its distinctive character. Romanesque artists created a world independent of nature.

Painters and sculptors had an additional impetus to seek formal clarity, for their work had a didactic as well as a decorative purpose. The strong suspicion that images led to idolatry induced a feeling that art should be justified as educational. St. Bernard's concern over the ostentatious decoration of churches expressed a common Christian fear of graven images and a puritanical disgust with the expense of art. St. Bernard considered the decoration of cloisters a distraction, but even he admitted the usefulness of narrative and symbolic art for instruction in parish churches. Art was produced for the edification of two distinct audiences: on the one hand the illiterate masses and on the other an educated community. For the populace, simple, lively stories or overwhelming hieratic images were painted on the walls or carved on the portals of the churches. These images could be self-explanatory but could also provide subject matter for homilies, moral tales, and instruction in the faith. The more sophisticated viewer could appreciate intricate and intellectually challenging themes with esoteric references and many levels of meaning intelligible only to the initiated scholar. The visual arts became a system of signs and symbols, less erudite than script to contemporaries, but often difficult to unravel in the twentieth century, when the common language of belief and folklore has been forgotten. Complex allegories and typological comparisons provided subjects for meditation in the cloister, but even the most didactic art was intended to decorate a surface as well as to instruct the viewer.

Patrons and artists during the eleventh and twelfth centuries were united in their intention to represent the splendor of the Heavenly Jerusalem on earth and to prepare humanity for the life hereafter with art that was both didactic and magnificently decorative. They hoped to represent the perfect beauty of the wisdom of God rather than the accidents of nature and, through images, to lead the imperfect human mind to an understanding of

the invisible and perfect beauty of God. This perfection underlying, or overreaching, earthly forms could be expressed only in the generalizations of a conceptual art. Unlike the Byzantines, however, the Western philosophers did not develop a complete and coherent theory of art. Certain aesthetic principles determined the art work: compartmentalization, whether in the division of architectural space into units or the human figure into segments, the rhythmic organization of these forms, and then the addition of these clearly defined units into new entities. In short, the Romanesque artist, through imaginative intellectualization of organic forms, created a new conception of human beings and the world they inhabit.

❲ CHAPTER IX ❳

The Origins of the Gothic Style

ailed as "King of the Aquitainians, of the Bretons, of the Danes [Normans], of the Goths, of the Spaniards and Gascons, and of the Gauls," and elected because he posed little threat to the great nobles who actually held these lands, Hugh Capet, Count of Paris, became King of France in 987, and the Capetian dynasty began its 340-year rule. The Archbishop of Reims crowned and consecrated Hugh Capet and so established the moral authority of the Capetian house. The new king's political authority was dependent on his own personal holdings around Paris—the Ile-de-France—and those feudal dues he could exact from his vassals. In theory, the king defended the realm and dispensed justice; in fact, at the time of Hugh's succession the title of king carried with it powers of moral suasion and very little else.

The Capetians, blessed with long lives and competent heirs, gradually turned a loose system of allegiances into a powerful, centralized monarchy. Remarkably enough, from the days of Hugh Capet until 1316 there was always a son of age to inherit the throne. Hugh Capet, Robert the Pious, Henry I, Philip I, Louis VI (the Fat) and Louis VII succeeded each other; thus, when Philip Augustus began his rule in 1180, only six kings had ruled in nearly two hundred years. The prestige and wealth of the monarchy had grown slowly and steadily. The arts reflected this situation and the local, or regional, styles of the Romanesque gave way to the Gothic style of Ile-de-France.

Philip Augustus was a brilliant and determined ruler who combined the skills of politician, lawyer, and economist. He realized the importance of the fact that the kings of England were his feudal vassals, and he used his legal skills to break their power on the continent. His son Louis VIII (1223–1226), daughter-in-law Blanche of Castile (regent 1226–1236), and grandson Louis IX (St. Louis, 1226–1270, canonized 1297) extended the territory held by the French monarchy in the north almost to the present borders. Just as the kings had formed a nation from many feudal counties, so around Paris, the Capetian capital, architects and artists wove together the many strands of Romanesque art to create the new Gothic style. Two great churchmen, Abbot Suger of St. Denis and Archbishop Henri Sanglier of Sens provided patronage and inspiration; Suger's abbey church north of Paris and the Cathedral of Sens seventy-five miles south inaugurated the new Gothic style. In its own day Gothic architecture was called *opus francigenum,* "French work," in clear recognition of its origin. The Gothic style dominated the arts from 1150 to 1450 and in some places lasted into the sixteenth century.

Gothic art has nothing to do with the barbarian Goths. Italian writers in the fifteenth and sixteenth centuries called the art of the Middle Ages the *maniera dei Goti,* for they considered all art from the fall of Rome to their own day as crude and barbaric, or "Gothic." In the eighteenth and nineteenth

centuries, French, German, and English scholars, looking through romantic and nationalistic eyes, saw in Gothic art an anti-Classical style expressive of the native genius of the people of the north and turned the adjective from a pejorative to one of high praise.

Within a generation, Gothic buildings rose in Paris, Laon, Chartres, Poitiers, and Canterbury under the patronage of kings, nobles, and a new urban middle class. In fifty more years Gothic art spread from the Ile-de-France throughout Western Europe, ranging from Scotland and Scandinavia to Spain and Italy. The pointed arches and flying buttresses, the rib vaults and clustered colonnettes, the traceried windows and diaphanous walls of stained glass became the easily recognizable hallmarks of the new French work in cathedrals, parish churches, palaces, and market halls. Architects of genius created a new structural technique based on an articulated skeleton of masonry rather than massive walls and vaults or the time-honored post and lintel system. Sculptors and painters were equally innovative as they attempted to capture the appearance of the material world as well as its spiritual essence.

The First Gothic Architecture

The Gothic period in contrast to the Romanesque was an age of city churches rather than rural monasteries. Patronage moved to lay and ecclesiastical courts; learning, to the universities; and gradually wealth, if not prestige, from landed nobility to the manufacturers and merchants in the cities. Cities rivaled each other in the magnificence of the churches they provided for communal worship, and the cathedrals became symbols of civic pride. Of course, the monastic orders continued to play a role in the formation of Gothic art. Abbot Suger began the rebuilding of the Abbey Church of St. Denis [1] while Abbot Peter the Venerable of Cluny enriched his abbey, and St. Bernard thundered against ostentation.

Abbot Suger himself represents the new Gothic age: a man of humble origins nurtured by the Benedictines, he identified himself with the Abbey of St. Denis and the fortunes of the French monarchy. The material splendor and visual beauty that he loved he sincerely justified as a path to the understanding of God. The twentieth-century student, looking at the twelfth century with perfect hindsight, may see St. Bernard as an embodiment of the ideals of an earlier age while Abbot Suger belongs to a new age of monarchs, cities, self-made men and women, and the rich art and architecture of the Gothic world.

Abbot Suger served Louis VI and remained as Louis VII's adviser, chancellor, and friend, but Suger was no royal sycophant. In his eyes the abbey could claim precedence over the royal court: the church sheltered the relics of St. Denis, the apostle to the Franks who was martyred in the third century on Montmartre. The abbey had been one of the seats of the court as early as the reign of Charles the Bald; it was the pantheon of the Capetian royal house; and in the twelfth century it housed the royal crowns and the *Oriflamme*, the war banner carried by the king. Suger saw the fortunes of the abbey and the kingdom as inextricably linked. Indeed the abbey symbolized France for people for whom a symbol was reality. In short, religious, political, and personal goals made Suger's aggrandizement of St. Denis a just cause.

When the Benedictine monks of the Abbey of St. Denis elected Suger abbot in 1122, they still worshiped in a Carolingian church lacking the grandeur which the new abbot believed commensurate with the role of the abbey in the kingdom. Suger reformed the monastery, reorganized its finances, and soon received royal patronage to rebuild the church. Out of respect (and a shrewd analysis of human nature) Suger left the Carolingian church standing when he began his building campaign. He began at the west, the building was well under way by 1137, and the narthex was

consecrated in 1140 [2]. Then, the rebuilding of the choir was completed in three years and three months, a success attributed by Suger in part to miraculous intervention. Seventeen bishops dedicated the altars of the choir in the presence of King Louis VII and Queen Eleanor of Aquitaine on June 14, 1144.

The new facade and narthex, with its St. Michael's chapel, recalled a traditional Carolingian westwork, but Norman influence, especially from St. Etienne of Caen, is apparent both in the design and in the structural details. Continuous vertical wall buttresses divide the square mass of the facade into three sections, and lofty towers reinforce this vertical subdivision. Sculptured portals like those of Burgundy and Languedoc were added to this Norman composition. The components of the Gothic facade—towers, an essentially vertical composition organized in units of three, sculptured portals, and a round window—are used together here for the first time. The figure of Christ dominated the facade from its position in the Last Judgment of the central tympanum, while flanking the entrances figures were carved on the columns of the splayed door rather than on the jambs (known in French by the descriptive term "statue-column"). The experimental quality of the facade would have been even stronger when the gold mosaic still adorned one of the tympana.

Behind the facade stood a narthex covered with rib vaults supported on piers whose elaborate cross sections recall the complex new pier designs developed in Anglo-Norman architecture. These clustered colonnettes reinforce the diagonal movement of the expanding and contracting space of square and rectangular bays. The sheer mass of masonry used by the builders is a reminder of the experimental character of the building.

Beyond the Carolingian church, but perfectly aligned with the tomb and altar of St. Denis, Suger's masons built a new choir, the first Gothic chevet [3]. The continuous flowing movement and the interpenetration of spaces

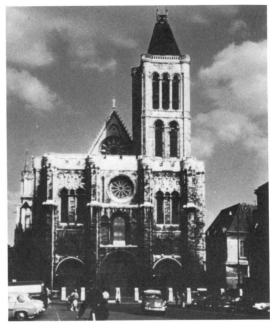

1. West facade, Abbey Church of St. Denis, 1135–40.

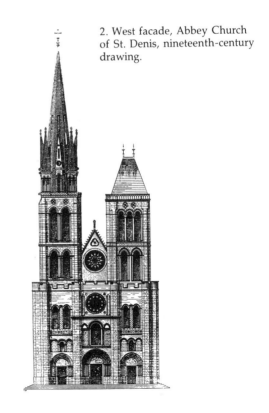

2. West facade, Abbey Church of St. Denis, nineteenth-century drawing.

3. Interior of choir, ambulatory, Abbey Church of St. Denis, 1140–44.

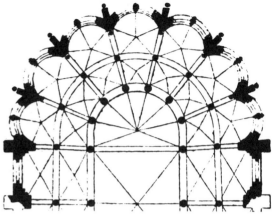

4. Chevet, Abbey Church of St. Denis.

in the sanctuary is such that the ambulatory and seven radiating chapels surrounding the apse seem to merge, in contrast to the clearly defined elements of a Romanesque choir. Supporting walls are reduced to columnar piers from whose foliate capitals rise ribs supporting the web of the inner ambulatory vault [4]. The ambulatory bays are united with the chapels by five ribs joining in a common keystone to form single units. The chapels resemble a continuous series of bay windows divided by buttresses. As Suger wrote in *De consecratione* (chapter IV), they are "... a circular string of chapels, by virtue of which the whole [church] would shine with the wonderful and uninterrupted light of most sacred windows."

Suger's masons carried the skeletal structure developed by Norman builders to its logical conclusion; they reduced the walls to massive piers and buttresses and sheathed the whole in colored light from stained-glass windows.

By using rib vaults with pointed arches they had the flexibility in construction to enclose the complex plan. Carved moldings further reduced the visual impression of weight. Individual elements designed and developed by Anglo-Norman builders were brought together in a new structure to achieve a light-filled, flowing space—the ribbed vaults of Durham, the skeletal frame and linear quality of the wall of Caen, the emphasis on light and space in the Angevin buildings. In short, an architectural aesthetic of light, space, and line replaced one based on continuous planes and cubical forms.

Suger intended to complete his church with a new nave and began work on the foundation, but his duties as regent for the absent king at the time of the Second Crusade consumed his energy, as the Crusade did the wealth of the monarchy. Abbot Suger died in 1151, shortly after the return of King Louis and Queen Eleanor, and his church waited one hundred years to be completed with a Gothic nave and transept. As Sumner Crosby, who devoted his life to the study of the abbey, believed, the western narthex was "a symbol of the monarchy and terrestrial power. By contrast the choir, with the lightness of the structure, evoked the immaterial universe of the celestial hierarchy. The transept and nave, envisioned and begun by Suger but never finished, would have provided the symbolic link effected by the Papacy between the celestial and terrestrial

realms" (Blum and Hayward, *Gesta*, XXII/1, 1983).

Gothic art, the art of the "cathedral age," began in a Benedictine abbey church. Abbot Suger wrote its *apologia*, or philosophical justification, at least in part to answer the criticism of another abbot, St. Bernard of Clairvaux. Suger's account of his administration and of the building of St. Denis, unfortunately for the modern scholar, leaves many of our questions unanswered—for example, enamelers and metalworkers are mentioned but never architects and sculptors. Suger's hidden concern was to justify the building and to immortalize himself as the founder abbot; thus, he described the effect of the church, the miracle of its construction, and his gifts—altar, cross, and the jewels and gold which went into these lavish fittings, but he left our desire to know something about the builders, who in effect invented the Gothic style, unfulfilled.

In his justification for the enrichment of the abbey, Suger provided an exposition of Gothic aesthetic theory. As he wrote of the relationship of light and color to the Christian's search for perfection and union with God, Suger reformulated Byzantine aesthetics. Suger had studied the writings of Pseudo-Dionysius, which he found in the abbey library, and whom he (and other twelfth-century scholars) thought was the same Denis whose relics his abbey housed. The Pseudo-Dionysius provided a basis in Neo-Platonic philosophy for Gothic architectural aesthetics: through the colored light created by walls filled with stained glass, the interior of the church could take on the mystical essence of, the One and provide a path for mortals to rise to union with God. Architectural structure, no matter how ingenious, was simply a means to create the spatial and lighting effects which would re-create for this world the celestial light of Heaven. We can turn to Suger's own words for a description of his intentions and of the effects which he was determined to achieve:

Thus, when out of my delight in the beauty of the house of God—the loveliness of the many-colored gems has called me away from external cares, and worthy meditation has induced me to reflect, transferring that which is material to that which is immaterial, on the diversity of the sacred virtues; then it seems to me that I see myself dwelling, as it were, in some strange region of the universe which neither exists entirely in the slime of the earth nor entirely in the purity of Heaven; and that, by the grace of God, I can be transported from this inferior to that higher world in anagogical manner (Suger, *De administratione*, ch. XXXIII, translated by Panofsky).

On the doors in the west facade, Suger wrote,

Whoever thou art, if thou seekest to extol the
 glory of these doors,
Marvel not at the gold and the expense but
 at the craftsmanship of the work,
Bright is the noble work; but being nobly
 bright, the work
Should lighten the minds, so that they may
 travel, through the true lights,

To the True Light where Christ is the true
 door,
In that manner it be inherent in this world
 the golden door defines:
The dull mind rises to truth through that
 which is material
And, in seeing this light, is resurrected from
 its former subversion. (Suger, *De administratione*, ch. XXVII)

While Suger was building St. Denis, seventy-five miles southeast of Paris, Archbishop Henri Sanglier (1122–1142) was at work on the first Gothic cathedral, the Cathedral of Sens. He may have begun the church in the 1130s, even before Suger began St. Denis, and certainly construction was well underway in 1140. By 1164 work on the cathedral had progressed to the extent that Pope Alexander dedicated an altar in the choir. The nave must have been built soon thereafter, for it was repaired after a fire in 1184. Jean Bony's studies indicate the subtle crosscurrents in Anglo-Norman and Early Gothic architecture; however, in a brief

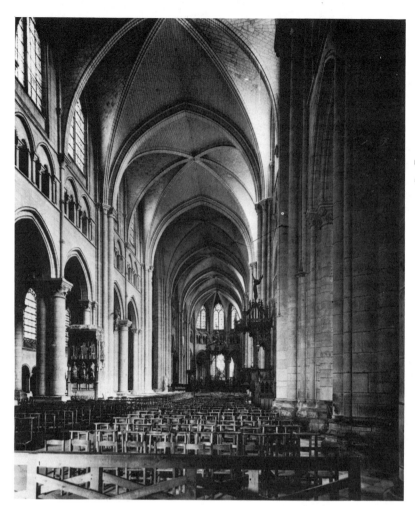

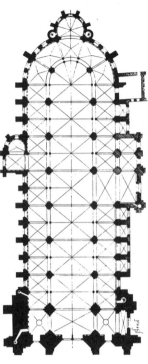

5. ABOVE: Nave, Cathedral of Sens, begun before 1142. Height of vault, about 81'.

6. ABOVE RIGHT: Plan, Cathedral of Sens.

7. RIGHT: Reconstruction of original elevation, Cathedral of Sens.

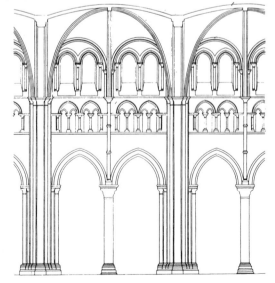

overview these two buildings—the Cathedral at Sens and the Abbey Church of St. Denis—must represent for us the Gothic style as created in mid-twelfth-century France.

Henri Sanglier's cathedral had a compact plan—the transept was reduced to chapels and the side aisles of the nave extended around the apse to form an ambulatory without chapels. The nave was vaulted with six-part ribbed vaults over square double bays like those of Normandy [5], while the three-part elevation of the nave could have been inspired by nearby Burgundian buildings such as Autun [6]. Massive compound piers formed by engaged columns running through two stories carried the transverse and diagonal ribs of the vaults, while paired cylindrical piers supported the intermediate arches. As seen today, the illumination is much lighter than in the original twelfth-century building. The simple lancet windows of the choir were enlarged in 1230, and those of the nave in 1310, and were rebuilt again in the eighteenth century.

The remarkable geometric quality of the early Gothic design becomes apparent in the cross section of Sens [7], as Von Simson, who argues that symbolic geometry was an essential element of the Gothic style, has pointed out. Master masons used the equilateral triangle to establish key points in the elevation and cross section. To emphasize this triangular form they abandoned the Anglo-Norman gallery and clerestory passage and used instead a narrow false triforium and a relatively thin clerestory wall. (This single plane of stone and glass had to be supported with flying buttresses when the windows were enlarged.) The compact plan, the union of the Burgundian nave elevation with Norman sexpartite vault, and alternating system of piers at Sens provided later architects with an important alternative to the late Romanesque style.

In the 1160s a second generation of architects in the Ile-de-France and neighboring territories experimented with the techniques and forms found at Sens and St. Denis. The cathedrals of Laon, Paris, and Poitiers, begun in the decade after mid-century, represent three dramatically different approaches to Gothic structure and aesthetics.

Whereas St. Denis was identified with the Capetian dynasty and the king, and Sens with the archbishop and conservative St. Bernard, Laon can be seen as the prototypical "new town," a cloth-making and trading center lying northeast of Paris on the road to Flanders. Townspeople and bishop were in conflict and construction was slow. A new cathedral was begun shortly after 1150, and by 1170 the choir and transept were nearly complete. Construction continued in the nave for the rest of the century, with western bays and facade finally built between 1190 and 1215 [8]. The eastern arm was extended with a long rectangular choir before the end of the twelfth century [9]. The new eastern wall with its triplet lancet windows surmounted by a rose provided a fitting climax to one of the finest early Gothic interiors. The lantern tower, a Norman feature which focused attention at the crossing, reinforced this drama of light.

Whereas the Cathedral of Sens seems compact and calculated, the Cathedral at Laon, with its nave, extended aisled transepts, two-story chapels, and soaring towers appears to spread over the hilltop and thrust into the sky. On entering the nave one is immediately impressed by the space—the height and changing quality of light [10]. The narrow proportions (79 × 35 feet, as compared to Sens's 81¼ × 49½ feet), narrow bays, multiplication of engaged shafts running through the upper three stories, and the actual reduction of the wall surface make the nave appear to be much taller than it actually is. Each of the four stories—the nave arcade, gallery, triforium, and clerestory—has a different height, depth, and intensity of light. The sculptural quality of the wall design, with its implication of walls behind walls, creates a shifting movement as the eye follows the wall shafts up to the vault. The sexpartite ribbed

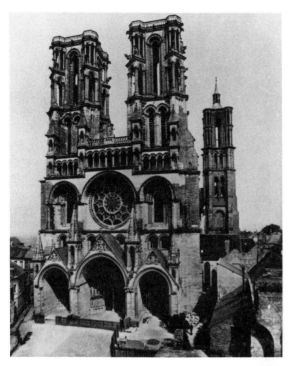

8. LEFT: Cathedral of Laon, begun 1160s (west facade, 1190–1215).

9. BELOW LEFT: Plan, Cathedral of Laon, 1165–1205.

10. BELOW: Nave, from tribune in crossing, Cathedral of Laon. Height of vault, about 79′.

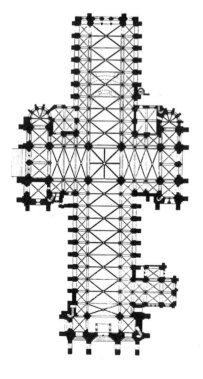

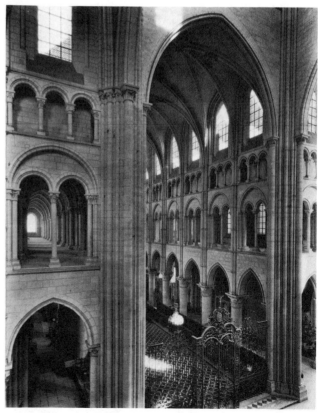

vault spanning the nave is stabilized by quad-ripartite vaults over the aisles and galleries, a thick-wall triforium, and hidden buttressing under the gallery roofs. This vault determined the details of the elevation from the alternating square and octagonal bases and abaci of the cylindrical piers to the wall shafts in bundles of five or three responding to the ribs of the vault. Even the new crocket capitals, in which simplified foliage emphasizes the form and function of the capital, accords with the early Gothic architects' concern with the definition of structure and proportion.

Paris, the Capetian capital, was not to be outdone by Sens and Laon, or Noyon, or Mantes. The Cathedral of Notre-Dame, the largest early Gothic cathedral, was over 400 feet long and rose 108 feet to the keystone of the nave vault, a worthy rival to the huge Romanesque churches of Cluny and Speyer [11]. Bishop Maurice de Sully, like Abbot Suger, seems to have identified himself with the church. The son of a peasant, educated by the Benedictines, he became a clerk and then subdeacon of the cathedral chapter in Paris. Elected bishop in 1160, he began at once to plan the construction of a new cathedral. Building began in 1163, with a grandiose design that required the sites of two older churches: one dedicated to the Virgin lay under the choir of the present cathedral and the other, St. Etienne, under the western bays of the nave and the facade.

The architects of Notre-Dame of Paris repeated the compact plan of Sens but added a transept included within the line of the aisle buttresses [12]. The large choir of two and a half bays allowed the keystone of the ribs of the high vault of the choir to be abutted by two additional ribs—that is, half a sexpartite vault. Double aisles and a double ambulatory surround the nave and choir. The architects solved the problem of the trapezoidal form of the encircling ambulatory bays through an ingenious system of diagonal ribs (suggested by the doubling of the piers between the **nave**

and the outer aisles) which divide the ambulatory bays into triangular forms. The chevet must have been finished by 1182, when Pope Urban consecrated the high altar.

In the original design for the nave, built between 1180 and 1200, the architects adopted the four-story elevation we have seen in Laon rather than the three stories of Sens, but they replaced the implied wall shaft support for a sexpartite vault with uniform bundles of three shafts rising from cylindrical piers [13]. The alternating support system was not abandoned entirely by the Parisian builders, however, for the piers dividing the double aisles alternate between clustered shafts and columns. Above the arcade a vaulted gallery opened into the nave through triplet arches; then a range of oculi (bull's-eye openings) at the triforium level and simple lancets in the clerestory completed the four-part elevation. In the thirteenth century the nave was "modernized" by combining the lancets and oculi into single large windows. (In the nineteenth-century restoration, Viollet-le-Duc restored the bay next to the crossing to record the original design.) The repeated circular oculi would have broken the verticality of the individual bays and enhanced the longitudinal movement toward the altar established by the regular repetition of the massive cylindrical piers. By the time the nave was nearing completion, however, the desire for verticality led to a greater articulation of the piers. In the western bay of the nave, built by a new master in the 1190s, colonnettes were added to the piers in the new High Gothic mode of Chartres Cathedral.

The piers of the western nave bay are the work of new builders with a new sense of form. The architect of the nave, however, had already made a daring technical innovation, which was to revolutionize building practice and make possible soaring vaults and light walls with huge windows in the thirteenth century. He devised a sophisticated system of abutment, in which a buttress under the triforium roof and a second flying buttress

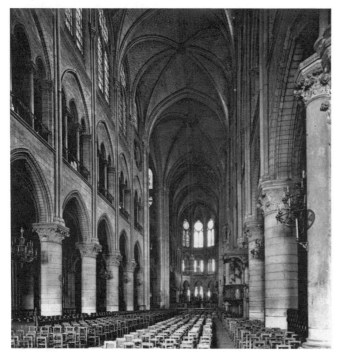

11. Nave, Cathedral of Notre-Dame, Paris, begun 1163; nave, 1180–1200. Height of nave vault, 102'.

12. Plan, Cathedral of Notre-Dame, Paris.

standing free above it carried the thrust of the high vault over the gallery to intermediate pier buttresses and then in a second series of struts to the wall buttresses beyond the aisles. These flying buttresses became one of the principal technical and aesthetic features of Gothic construction. Weighted with soaring pinnacles, these strong but light, elegant struts fulfill an aesthetic as well as structural role, for they seem to merge form and space, creating the interpenetrating solids and voids, the dematerialized architectural forms so congenial to later medieval taste.

On the exterior of these two cathedrals, Laon and Paris, the facades built at the beginning of the thirteenth century provide a dramatic contrast. Panofsky, in his essay "Gothic Architecture and Scholasticism," demonstrated that the pattern of thought typified by Abelard's rationalism, the balance of opposites, *Sic et Non*, permeated architectural thinking. He contrasts the spreading plan of Laon, which also surges upward in towers, with the compact, enclosed form of Paris. The architect

at Laon thought in terms of sculptured mass and void; the builders of Paris, of mural surfaces. The facade of Laon is a composition of interpenetrating forms—towers, turrets, deep porches, projecting wall buttresses, and windows set within great arches. The Paris facade [14] is a perfectly proportioned surface—balanced, with all its forms moving within a shallow plane, and calculated in modular units based on the diameter of the great rose. In its emphasis on wall, Paris is a strangely retrospective building.

The towers at Laon are one of its most memorable features; even in their own day they were considered masterpieces. The thirteenth-century architect Villard de Honnecourt marveled at them and included drawings of the towers in his handbook for builders. He wrote, "I have been in many lands but nowhere have I seen a tower like that of Laon." Seven towers were planned: a lantern tower at the crossing, a pair of towers at the west facade, and pairs at the transept facades. Although the towers were built in the thir-

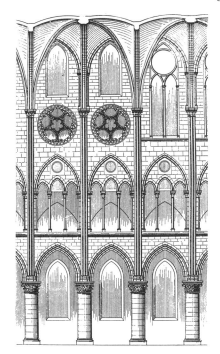

13. Elevation (showing original twelfth-century design and thirteenth-century remodeling), Cathedral of Notre-Dame, Paris.

teenth century, they continue the rich sculptural treatment of architecture we have seen in the nave and the west facade. From the massive heavily buttressed bases, to octagonal belfries, the towers become lighter as they soar into the sky—their slender elongated galleries abutted by diagonally placed corner turrets, which are also reduced to openwork, niche above niche. Space seems to penetrate every stone, for such masonry walls as remain are carved as a series of moldings and enriched with detached colonnettes. The architect has denied the weight of the stone as he creates a fantasy of light and space. In comparison, the towers of the Cathedral of Paris seem almost Romanesque in their cubical mass, although twin lancet openings and crocketed edges diffuse their clear outlines.

Not every experiment and every school led directly to the High Gothic style of the thirteenth century. One of the most interesting regional Gothic styles outside the Ile-de-France can be found in the Angevin lands. The builders looked to different Romanesque

14. West facade, Cathedral of Notre-Dame, Paris, first half of thirteenth century.

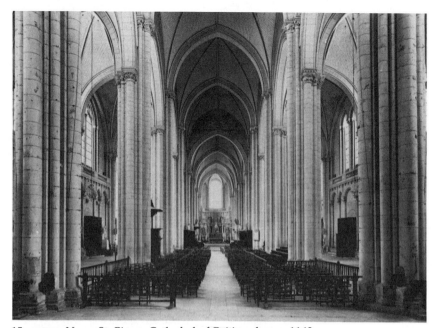

15. ABOVE: Nave, St. Pierre, Cathedral of Poitiers, begun 1162.
16. ABOVE RIGHT: Plan, Canterbury Cathedral, twelfth–fifteenth centuries.

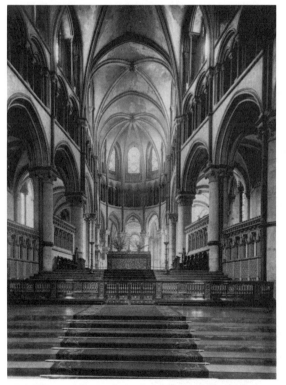

17. William of Sens, choir, Canterbury Cathedral, after 1174.

sources; they continued the western preference for wide, open aisleless naves (Fontevrault) or the so-called "hall church," in which a high vaulted nave was flanked by almost equally tall side aisles (St. Savin-sur-Gartempe). Inspired by their Norman neighbors, Angevin architects also experimented with ribbed vaults. Their eight-part ribbed vaults are steeply pointed, so that the domed-up form recalls the shape of earlier Romanesque domes. St. Pierre, Cathedral of Poitiers, begun in 1162, is a masterpiece of the Angevin Gothic style [15]. Ribbed vaults supported on slender piers cover three aisles of nearly equal height. The vaults buttress each other, and the outer walls became sheaths for a cubical space. English architects soon adopted this hall church form on a small scale for chapels—for example, in the Cathedral of Salisbury (page 337). The light, open rectangular building did not suit the taste of Ile-de-France builders, however, and not until the fourteenth century was the hall church widely adopted.

Across the channel in England, Henry II at first had as dynamic, powerful, and loyal a churchman in Thomas à Becket as the French

kings had in Suger. Becket, however, soon began to oppose the king. The murder of Becket in Canterbury Cathedral in 1170 gave England a new martyr and saint. Then, on the night of September 5, 1174, the cathedral burned to the ground. A vivid eyewitness account of the fire survives in the chronicle of Gervase of Canterbury, who described the rebuilding of the cathedral under the direction of William of Sens. Reconstruction began in 1174 in the choir, where William salvaged the old crypt as the foundation for the new building. This Norman structure gave the new church its curiously pinched plan and diagonally placed chapels [16]; however, the sexpartite vault, the molded ribs, the foliate capitals, and the three-part elevation of the new work are all typical of French early Gothic architecture. The passage in the thick clerestory wall, the detached colonnettes on the piers, and the increasing elaboration of the design, especially the addition of Purbeck marble shafts, whose dark brown and black color contrasted dramatically with the white Caen stone, are all English characteristics. William of Sens fell from a scaffold in 1178 and returned to France. His place was taken by William the Englishman, who finished the building of the choir, and the eastern chapel in 1184 [17].

The chronicle of Gervase of Canterbury provides an insight into medieval building practices. We learn that the architect was responsible for the design, and for relations with the patrons (the cathedral chapter), for the organization of the masons, for acquiring material (William brought stone from Caen), and for direct supervision of the work. The personal quality of Gervase's narrative provides us with some of the useful and homely detail we miss in Abbot Suger's account of his building campaign. These two accounts could serve as an adequate introduction to the Gothic age, but as Gervase wrote, "All may be more clearly and pleasantly seen by the eyes than taught in writing."

Early Gothic Sculpture

Sculptors at mid-twelfth century, like the architects, built on the past to create a new art. Changes appear in the iconographical programs, in the relationship of the sculpture to the architecture, and in the style of individual works of art. These changes derive in part from the patrons' desire for more effective communication of ideas and in part from the artists' attempt at greater integration of content, function, and form. A new conception of human beings and their place in the world, a new vision of the terrestrial world in relation to the world of the spirit, pervades sculpture and painting.

The sculpture of the west facade at St. Denis, like the architecture which supported it, established a new style in the Ile-de-France. In the huge central typanum the Last Judgment was witnessed both by the apostles and the elders of the Apocalypse. Although recently Blum and Crosby have demonstrated that much original twelfth-century sculpture remains at St. Denis, the problems resulting from eighteenth-century destruction and nineteenth-century restoration complicate a study. Early sculpture at Chartres and Paris provides a clearer introduction to the early Gothic style. The Royal Portal of Chartres Cathedral has survived fires, pilgrims, tourists, and even twentieth-century atmospheric pollution; and some of the sculpture from the St. Anne portal at Paris, broken up at the time of the French Revolution, has recently been recovered.

The west facade of the Cathedral of Chartres was rebuilt after a fire in 1134. Work began on the north tower at once and on the south tower about 1142 [18]. The sculptured portals between the towers must have been carved between 1140 and 1150. When, in 1194, lightning struck the cathedral and the building burned to the ground, the Royal Portal survived, protected by the masonry of the towers. Sculpture does not spread over the facade as

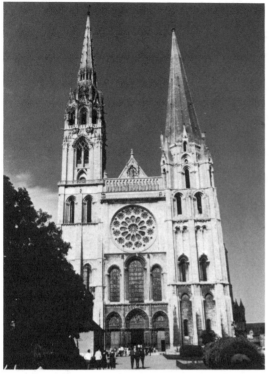

it does in the nearly contemporary Roman-esque Notre-Dame-la-Grande, Poitiers. Gothic masons determined that certain architectural members were most appropriate for sculptural enrichment—door jambs, lintels, tympana, and archivolts. Furthermore, the sculpture is not compressed or controlled by the architecture, as it had been in the Romanesque style, but instead conforms naturally to the shape of the architectural member and even visually reinforces it. The figures carved on the engaged columns of the entrance, for example, are columnar figures, in contrast to the lively jamb figures at Vézelay or Moissac. Vertical elements dominate the composition; thus in the voussoirs, figures follow the line of the arches, rather than radiating out from a center, the better to harmonize with the vertical lines of the statue columns. Horizontal lintels might be filled with standing figures under an arcade, which both reinforces the horizontal shape of the lintel and establishes a pattern of verticals within the horizontal block. Within the lunette

18. West facade, Chartres Cathedral, after 1145 (north spire, sixteenth century).

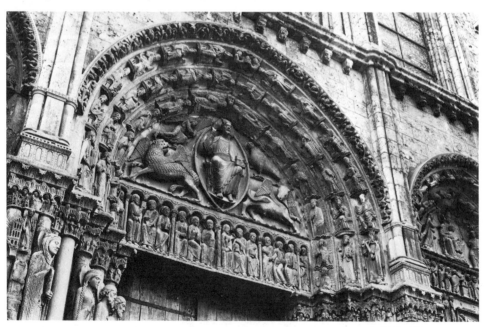

19. Christ in Glory, central tympanum and west facade, Chartres Cathedral, 1145–55.

of the tympanum, through the continued use of hieratic scale, the central figure of Christ naturally rises to fill the apex while apocalyptic beasts fit gracefully into the remaining triangular sections [19]. The number of figures is reduced and their relationship to each other and to the architecture is clarified so that—in contrast to the intricate interlocking forms of Autun, Vézelay, or Moissac—the tympana of Chartres are composed of self-contained and balanced units.

The sculpture serves as more than decoration. With the exception of some ornamental patterns on subsidiary colonnettes and moldings around the portals, the sculpture was clearly intended to convey a message. The Old Testament kings and queens of Judea—the precursors—support Christ, the Virgin, and the vision of the Second Coming. The idea that the Old Testament supported the New is clearly stated in the actual physical relationship of jambs and archivolts; furthermore, as jamb figures, the kings literally lead the worshiper into the House of God. (The philosopher Bernard of Chartres had described the relationship of contemporary scholars to their predecessors as one of dwarfs standing on the shoulders of giants in order to see farther, and the idea was extended to describe the evangelists as literally standing on the prophets.) As the kings and queens of Judea lead to Mary and Jesus, so too the shafts of the columns which they adorned lead to capitals bearing the message of the New Testament. The sculptured capitals form a continuous arcaded frieze filled with scenes from the life of Christ. Then higher still in the tympana, Christ is glorified with His mother, as He ascends to Heaven, and as He appears again at the end of time.

The right-hand portal depicts Mary and the early life of Christ [20]. In the scene of the Nativity on the lowest lintel, the Virgin reclines on a bed which is at the same time an altar on which the Christ Child lies, adored by the ox and the ass. The shepherds at the right balance the Annunciation and Visitation at the left so that Christ and the Virgin appear in the precise center of the lintel. On the second lintel, the Presentation in the Temple, Christ stands on the central altar. In the tympanum He is enthroned on the lap of Mary, who becomes the *sedes sapiente,* or the Throne of Wisdom. (The tabernacle over their heads is lost but the bases of the columns which would have supported the baldacchino are still visible at each side of the throne, and the line of the gable roof and arch can still be traced.) Since the narrative progresses logically from left to right and bottom to top, the adjustment of the three representations of Christ (lying, standing, and then sitting in the center of the composition) seems almost accidental instead of carefully calculated. Furthermore, in each case He is, in a sense, enshrined (a point effectively made by Katzenellenbogen). Jesus is not a living child but a cult object. In the voussoirs the personifications of the liberal arts and philosophers working at desks surround Mary, their patron. The dedication of an entire portal on the principal facade of the Cathedral to Mary has been seen as a significant change in her status (and through her, that of other women) in the twelfth century.

On the left-hand side of the portal Christ ascends heavenward in a cloud, adored and supported by angels [21]. In the lintels below, more angels and seated apostles witness the miracle. Surrounding the Ascension in the voussoirs, signs of the zodiac and works of the months symbolize earthly time, which comes to an end in the glory of the Second Coming. This vision of glory fills the central tympanum. Christ as the Pantocrator of the Apocalypse, with the four beasts and twenty-four elders and choirs of angels (in the voussoirs), rises over the twelve apostles (in the lintel).

Thus the Chartrain theologians have organized all of Christian history on the facade of their cathedral, and the master sculptor, known as the Head Master, has created a logical and

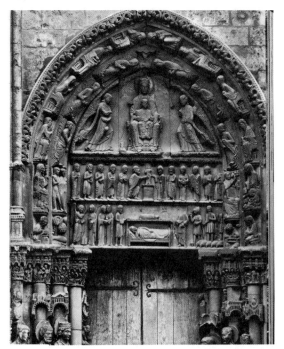

20. Virgin portal, west facade, right bay, Chartres Cathedral.

21. Ascension, west facade, left bay, Chartres Cathedral.

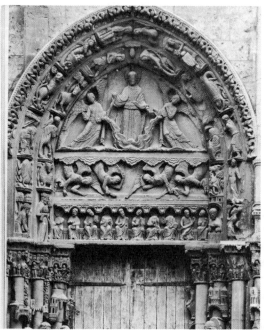

convincing architectonic composition in fulfillment of their wishes. Later masters had only to expand on the themes of the Royal Portal. Indeed, even at Chartres, elaborate portals added to the transepts in the High Gothic period are but an extension of the theme established on the west facade.

Sculpture on the facade at Chartres heralds the new style of the Early Gothic period. Perhaps the most characteristic new element introduced at mid-century is the column figure, or statue-column [22]. At Chartres the extremely elongated proportions of the figures are emphasized by long sleeves and silky pleated garments, which reinforce the verticality of the shafts like the fluting on a column. Figures almost disappear beneath the sheaths of drapery. Then, emerging from these columnar bodies are heads of astounding beauty and hands raised in blessing or lightly holding books and scrolls. In spite of the essentially architectonic quality of the figures, they seem to express a new, sensitive interest in physical appearances. The modeling of the heads, in which a bone structure supports soft flesh, in which hair forms a delicate linear pattern against skin, in which eyes lie under the lids rather than stand forth as jewels in frames, contrasts with the strict geometric forms of earlier Romanesque figures. Even the swelling bosom of the queen suggests life, not the patterned anatomy of the Romanesque.

The west facade of Chartres influenced sculpture in Burgundy, Languedoc, and Provence, as well as the Ile-de-France. Among the finest examples of the school of Chartres are to be seen at Le Mans, Angers, Bourges, and St. Loup-de-Naud. The lovely statue of St. Stephen at Sens, the statue columns from St. Ayoul in Provins, and the figure added to the portal at Avallon (chapter VIII) all attest to the power of the Chartrain vision. Even the portal at St. Trophime in distant Arles still copied the central portal of Chartres. Followers never quite reached the Head Master's quality, for he established the standard of sculpture

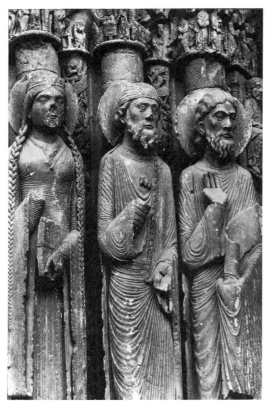

22. Ancestors of Christ, west facade, Chartres Cathedral.

of the second half of the twelfth century; others could only follow him to the best of their ability.

Parisian sculptors provided yet another variation of Chartrain themes. The Portal of Ste. Anne, now on the right side of the west facade at the Cathedral of Notre-Dame, copied the iconography and composition of the Virgin's portal at Chartres. The dramatic discovery in 1977 of fragments of figures from the jambs provides new evidence that innovative sculptors carved the work now on the Ste. Anne portal at the very time the Head Master was creating the Royal Portal at Chartres. Scholars suggest that since Etienne de Garland had begun to restore the ancient church of St.Etienne before his death in 1150, sculpture intended for that facade may have been sal-vaged and reused in the facade of Maurice de Sully's Notre-Dame.

The head of King David, now in The Metropolitan Museum of Art in New York, came from the St. Anne portal [23]. The sculpture has a crisp, polished appearance, and a decorative quality associated both with Romanesque art and with the courtly elegance of the later Parisian sculpture. King David's imperious expression, an impression created by the highly arched brows and staring eyes (originally inlaid with lead) makes him seem a more worldly colleague of the king at Chartres. Only a small fragment of King David's body, a piece of drapery around his feet, was recovered; however, large pieces of other figures permit an examination of the early Parisian style. The figure of St. Paul, identifiable from eighteenth-century drawings, is one of the most complete column figures found in the 1977 excavations [24]. Broken into large fragments and missing head, hands, and feet, the figure nevertheless is an impressive example of the Parisian sculptor's ability to maintain the severe verticality appropriate to a column figure and at the same time to suggest a living, moving being under the restraining drapery.

Sculpture from Chartres and Paris is similar in its subtle and sophisticated precision, in its still decorative organization of draperies, in the elegance and refinement of proportions and details, and in the emphasis on a spiritual rather than a tangible visible world. Sculptors working in eastern France, nearer the region artistically dominated by Mosan bronze casters, were more concerned with natural appearances. The sculpture from the Cathedral at Senlis, a royal residence lying within the Ile-de-France but in the direction of the Meuse Valley, established an alternative to the Chartrain tradition in the second half of the twelfth century.

The western portal of the Cathedral of Senlis glorifies the Virgin Mary [25]. The sculpture is usually dated about 1170, the work of the next generation of artists after St.

23. ABOVE: King David, St. Anne portal, west facade, Cathedral of Notre-Dame, Paris, 1165–70. The Metropolitan Museum of Art, New York.

24. ABOVE RIGHT: St. Paul, three fragments of the body, from right jamb of St. Anne portal, west facade, Cathedral of Notre-Dame, Paris, c. 1150. Limestone. Height, 52" (with filler). Cluny Museum, Paris.

Denis, Chartres, and Paris. The entire portal is dedicated to the Virgin: her Coronation in the tympanum, prophets and precursors below in the jambs, and the Tree of Jesse winding around the voussoirs above. For the first time Mary is represented as crowned and enthroned beside her Son. Her Dormition, with the miraculous gathering of apostles, and her Assumption, assisted by angels, fill the lintel. Mary is more than a receptacle or throne for Christ, for she is now elevated above all other human beings to be crowned by God Himself. Once established at Senlis as an appropriate theme for monumental church portals, the Coronation of the Virgin appears often in French art.

The Senlis master captures a world in which figures and objects occupy a narrow but clearly defined stage—a space with definite limits, but limits that have been expanded beyond Romanesque planar control. In the Assumption, for example, the Virgin lies on an arcaded bed surrounded by a flight of angels. One

angel even pushes aside the wings of another in order to get a better view. The very idea that an angel's wing was a tangible object occupying space is new; a charming detail today was a revolutionary concept in the twelfth century.

The new spatial consciousness continues in the tympanum sculpture. Christ and Mary are surrounded by a swelling arcade punctuated by circular openings from which angels lean out while other angelic acolytes sit and stand under the arcade. The artist has carefully depicted the relationship of architecture and figures: the angels are within the arch; their wings overlap it. Christ and Mary are blocky figures of relatively normal proportions who seem to sit firmly on the thrones. The looping folds and almost metallic modeling of their robes recalls Rainier de Huy and Mosan art. Even more complex poses are found in the kings seated in the rich scroll which forms a Tree of Jesse in the voussoirs. This concern with space and form continues in the sculpture

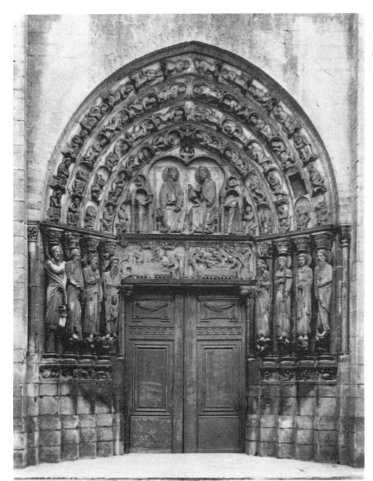

25. Dormition, Assumption, and Coronation of the Virgin, west facade, Cathedral of Senlis, c. 1170.

of the cloister of Châlons-sur-Marne and at the Cathedral of Laon, where the deep portals and porches themselves establish a three-dimensional framework for the sculpture.

Sculpture in southern France remained essentially Romanesque in style throughout the twelfth century, even when the sculptors were well aware of the innovations occurring in the Ile-de-France. In Provence, for example, the facade at St. Gilles-du-Gard is contemporary with Suger's work at St. Denis; the portal at St. Trophime, Arles, was inspired by the Royal Portal at Chartres [26, 27]. But the Romanesque conception of sculpture as a low relief decorating a flat wall surface and the strict architectonic organization and control of all the elements remain in force. Naturally the mon-

uments of Classical antiquity in the region also exerted a profound influence on the design of the portals. The columns and pilasters of the facade at St. Gilles could have been inspired by monuments such as the triumphal arch and Roman theater at nearby Orange. The standing figures of saints remain flat relief panels inserted between pilasters and behind Corinthianesque columns. They do not suggest the animation or the sense of the inner life which had already entered the Gothic sculpture of the north. Superficial mannerisms of Classical style were adopted without an understanding of the underlying structure which gave life to the forms. Most skillfully adapted was Classical architectural decoration—fluted pilasters, Corinthian capitals, acanthus deco-

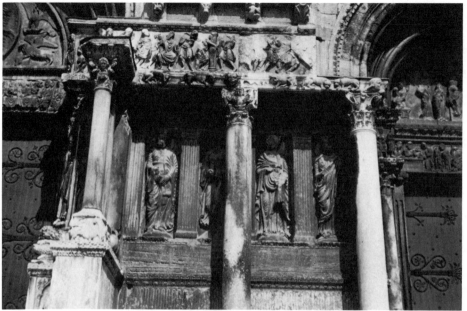

26. West facade, Abbey Church of St. Gilles-du-Gard, second half of twelfth century.

27. Portal, west facade, Church of San Trophime, Arles, second half of the twelfth century.

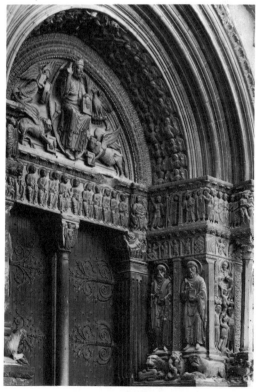

ration of lintels. These antique forms appear beside two-dimensional textile-like patterns of interlocking circles enclosing imaginary beasts and ferocious Romanesque lions gnawing people and animals. Even at the end of the century, when the sculptors had seen the Early Gothic innovations, they continued to work in the rich and beautiful but essentially conservative Provençal Romanesque style.

Other sculptors and architects working in the 1170s and 1180s were inspired by the Ile-de-France. In Italy, Benedetto Antelami in Parma, as early as 1178, the date of his Deposition relief, and after 1196 in the Parma baptistery, introduced the new Gothic humanism into Lombardy and Emilia. In Spain the Cámara Santa in Oviedo, the Church of S. Vicente, Avila, the later cloister piers at Silos, and the Cathedral of Santiago de Compostela provide a transition from the Late Romanesque to the Early Gothic style. In Santiago a magnificent narthex, the Pórtico de la Gloria, was constructed by Master Matthew, who signed and dated his work 1188 [28]. His vision of the Apocalypse, combined with a Last Judg-

28. Master Matthew, Pórtico de la Gloria, West Portal, Cathedral of Santiago de Compostela, 1168–88 and later.

ment as it was at St. Denis, also included apostles and prophets standing on the jambs, angels trumpeting from the vaults, and the twenty-four elders playing harps and viols, notable for the accuracy of their representation. On the trumeau, above one of the earliest Trees of Jesse in sculpture, a seated St. James leans on his pilgrim's staff. The adjustment of the seated figure to the pier is but one example of Master Matthew's acute observation and skill. He even captured fleeting smiles and spontaneous gestures; yet he and others of his shop used ornament with Romanesque profusion: folded and crinkled hems, engraved borders imitating jeweled embroideries, corkscrew curls. Matthew, more than many artists of his generation, blended accurate observation with decorative abstraction. The Pórtico de la Gloria, together with Oviedo, Avila, and Silos, ends the Romanesque and begins the Gothic style in Spain but did not lead to a national High Gothic style. Consistent patronage to support generations of artists made northern France and England, not the south, the center for the development of High Gothic art.

The Pictorial Arts

Abbot Suger considered monumental stone sculpture hardly worthy of mention; he preferred stained glass, the pictorial and decorative arts. The abbot, and people of his time, saw the church as a luminous Heavenly Jerusalem and wrote of it in metaphors of light and jewels—rubies and pearls, sapphires and jasper. The architecture became a mere skeleton to support stained-glass windows. These windows were walls of glowing color which, with the movement of the sun and clouds in the sky, changed the interior of a building into shifting waves of red, blue, and purple light.

Great care and expense went into making a stained-glass window, and a consideration of the technique involved makes the final aesthetic effect all the more admirable. Theophilus (chapter VII) included instructions for stained-glass windows, from the original drawing, to the making of glass, the painting, and the final construction of the full window. The glass was blown either into spheres, which

could be opened into circular panes, or into cylinders, which would be slit lengthwise and rolled open to make rectangular panels. The best glass blowers dipped their rods into pots of different shades of color or else swirled colored and clear glass together to produce a layered cross section which would refract light. Although the artists planned the windows carefully because the materials were very precious, this blown glass varied in color and thickness, and sometimes the final color was not the one the master wanted. Theophilus advised the glass workers to save all accidental pieces—yellows, lavenders, and off-whites—to use for special effects. The designs for the window were drawn full scale on a board. Then colored glass pieces were cut to fit the figures drawn on the pattern board, and painters added the details of draperies, anatomy, faces, and ornamental designs in brownish-black enamel (iron or copper oxide). After glass was refired to fix the drawing, the pieces were joined with lead bands, known as cames. In the finished window, the lead cames would appear black against the light and enhance the intensity of the color of the glass by preventing the colors from visually blending at a distance. After finishing all the individual panels, the artist assembled the leaded panes, supported on a grid of iron bars. This iron framework, or armature, strengthened and stiffened the window and also had an important role in the final aesthetic effect because it, too, became a black pattern against which the brilliant colors vibrated. At last the window was set into the opening in the masonry wall. Early Gothic window openings were of simple lancet form, but in later Gothic art elaborate stone tracery added another decorative element. By the time the window was in place, it could be so far from the spectator that only the colors and the pattern of the cames and armature, and later the tracery, were seen easily. In order that the fine painting of the individual scenes would not be lost, large-scale objects of single figures were often placed in the clerestory windows, while the narrative compositions of many small scenes were used in the aisles and chapels.

Abbot Suger, in his description of the building of St. Denis, took special care to mention the stained-glass windows in the new choir. He brought in specialists for the work and arranged for a curator to care for the windows. The windows were to him the epitome of art used in the service of religion, for they led the worshiper to God, "urging us onward from the material to the immaterial in an anagogical fashion." One window, for example, began with an allergory on the relationship of the Old and New Testaments in which the prophets carried sacks of grain to be ground into flour by St. Paul (as we have seen at Vézelay) and continued in the series of "types," culminating in God's gift of the law to Moses. Twelfth-century scholars revived, restudied, and explicated the allegories found in Early Christian art, and their systematization of events, known as typology, gave depth and meaning to human action through perceiving relationships to events in the past. In the complex system of typological comparison and contrast, events and people of the Old Testament foreshadow events in the New Testament. Typology differs from allegory in that historical references are never forgotten and give to events a cosmic significance.

The St. Denis windows can be studied only in fragments in museums and in heavily restored panels in the church. At Chartres Cathedral, however, twelfth-century windows still survive in place. In the west wall above the Royal Portal three great lancet windows—representing the Life of Christ, His precursors in the Tree of Jesse (color plate IV), and His Passion—expand on the themes of the west facade sculpture. The elegant, painted figures sensitively recall the Chartrain sculptural style, while the wide borders of clasping leaves and beaded vines—like the rich ornament underlying the facade sculpture—enhance the decorative quality of the windows. The designer

29. Initial for Jeremiah, *Winchester Bible,* c. 1160–70. Initial, 4 3/8″ × 5″. Cathedral Library, Winchester.

30. Morgan leaf, scenes from the life of David, Winchester (possibly *Winchester Bible*), third quarter of the twelfth century. 22 5/8″ × 15 1/4″. The Pierpont Morgan Library.

organized his narratives in a series of alternating circular or square frames and also alternated the background colors between red and blue. (This simple color pattern was also used to heighten the carrying power of designs in heraldry and is referred to as heraldic alternation.) The famous "celestial" blue of Chartres and a lively sapphire blue dominate the ruby red, although normally blue, as a "cool" color, recedes. Since stained-glass windows control the interior light, they affect the worshipers' perception of the architecture. The subdued but brilliant Chartrain glass makes the interior seem to be simultaneously dark and luminous; and the windows are essential to the creation of the Gothic ideal—a continuous and unified interior space.

Stained glass did not supplant mural painting altogether, as the many surviving fragments of painting attest; however, as is so often the case in the study of Medieval art, manuscripts provide the richer source of visual information. The *Winchester Bible* [29], for example, has been related to murals (Sigena) and mosaics (Palermo) as well as to the cloister crafts of the second half of the twelfth century. Made in England by several different artists working over a period of about fifty years, the *Winchester Bible* is a veritable repertory of transitional painting styles. Among the later artists working on this Bible was the Master of the Morgan Leaf, so called from a detached page now in the Pierpont Morgan Library in New York (ms. 619). The Morgan leaf depicts the story of David [30]: David slaying Goliath, playing the harp for Saul, anointed by Samuel, and finally mourning Absalom. Well-proportioned figures enhanced by flowing form-revealing draperies act out the drama within the kind of shallow space we have seen in the sculpture at Senlis. This interest in the representation of three-dimensional forms in a very limited spatial environment suggests a renewed contact with Roman and Byzantine art, probably through Norman Sicily. In the second half of the twelfth century

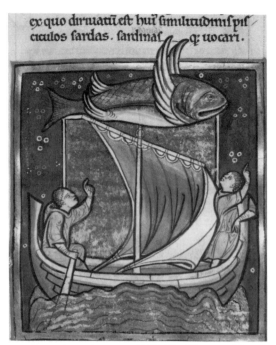

ex quo dir'nratū est huī similitudinis pis
cīculos sardas. sardinas̄ q̄ uocari.

31. Flying fish of Tyre, c. 1185. The Pierpont Morgan
Library.

artists began to restudy aesthetic and technical
problems posed by the reevaluation of the
humanistic tradition of the ancient world.

This budding interest in the physical world
is suggested by the popularity of books known
as bestiaries, which combine descriptions of
both real and imaginary creatures with mor-
alizing, theological allegories. The flying fish
of Tyre, which followed ships only until it
grew tired, came to represent sinners who
lacked the faith and stamina to follow the
rigorous path to salvation [31]. In an English
illustration of the monstrous fish (Morgan,
ms. 81, f. 69), two sailors gesture vigorously
while the fish flies above their billowing sail.
The painter uses large blocks of clear, brilliant
color bounded by strong outlines to produce
a balanced, decorative pattern; however, he
allows the wings of the fish to sweep through
the frame and also models the men and sail
with fine repeated lines. During the last de-
cades of the twelfth century painters rendered

observable nature with ever-increasing enthu-
siasm and realism.

A medical treatise from Liège, dated about
1160 (BL, Harley 1585, f. 13), contains scien-
tific information and the likenesses of phy-
sicians [32]. The figures are no longer rep-
resented as merely an assemblage of in-
dependent geometric shapes, characteristic of
Romanesque art, but are rendered with a new
sense of space and mass. The doctor sits on a
jeweled bench which, like the thrones in the
Senlis coronation tympanum, suggests the art-
ists' awareness of the optical effects of reces-
sion in space. Heavy waving hair frames the
well-modeled face, and full drapery in many
fine folds stretching smoothly over projecting
limbs emphasizes the bulky figure. This new
tangibility is further developed in the metal-
work and enamel of Nicholas of Verdun.

Nowhere is the reinforcing Byzantine style
and the revitalized humanism of the ancients
more apparent than in the art of the goldsmith

32. A physician, Liège, c. 1160. Miniature on vellum.
The British Library, London.

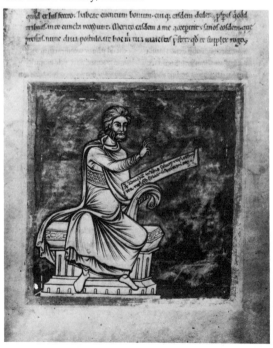

and enameler. In the twelfth century two important centers of enameling arose: a southern school, popularly known as Limoges, and the Mosan school in the Rhine and Meuse River valleys. A large enameled cross, probably the work of the Master of the Grandmont Altar, c. 1189, illustrates the Limoges style of champlevé enamel [33]. In champlevé enamel the designs are formed by metal cells gouged into a copper plate, then filled with colored glass and fused by heat. The plaque could also be engraved and gilded. The Limoges cross recalls the precious jeweled True Cross venerated in Jerusalem, for the cross within the cross rises on Golgotha, literally identified as "the place of the skull" by Adam's skull resting on the ground beneath Christ's feet. The still-living Christ seems stretched rather than hung on the cross; however, the slight sway of His body and the droop of His head, as in the Daphnī Christ, suggest a pathetic rather than a triumphant figure. Of course, the stylized musculature of the body and limbs is based on artistic convention, not observation; however, the contrast of the pale pink face with the white flesh of the torso hints at the artist's awakening concern for nature. The artist gave his work an extraordinarily delicate finish by stippling the metal walls which hold the enamel pastes with tiny punch marks and then gilding these contour lines. As the cross is moved, the contours catch the light, and the image appears to be a golden drawing on a field of glowing color.

When Abbot Suger wanted enamel and gold fittings for his church, he turned to Mosan artists, who, since the beginning of the century, had produced the very finest metalwork, enamels, and manuscripts. Artists from the Mosan region, from Rainier de Huy to Nicholas of Verdun, had been inspired by Byzantine and Carolingian interpretations of ancient art. As heir to the Mosan artistic tradition—and a draftsman, sculptor, and enameler of unique achievement—Nicholas seems particularly sensitive to the more real-istic, humanistic art of the earlier Christian world. His masterpiece is a pulpit for the Benedictine Abbey of Klosterneuburg near Vienna. According to the inscription, Nicholas made the pulpit in 1181; after a fire in 1320, the enamels were reassembled into an altarpiece.

Nicholas combined niello and enamel techniques; he engraved, encrusted with enamel, and gilded his figures. To heighten their effect he normally used a plain blue background. This flat ground-color, together with the elimination of setting, removed the scenes from the material world. Elaborate inscriptions and intricate ornamental frames reinforce the decorative quality of the work as a whole.

The iconography of the Klosterneuburg altar is based on the writings of Honorius of Autun

33. Grandmont Altar, Christ on the Cross, Limoges, c. 1189. Champlevé enamel. The Cleveland Museum of Art.

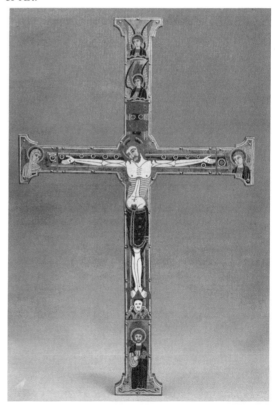

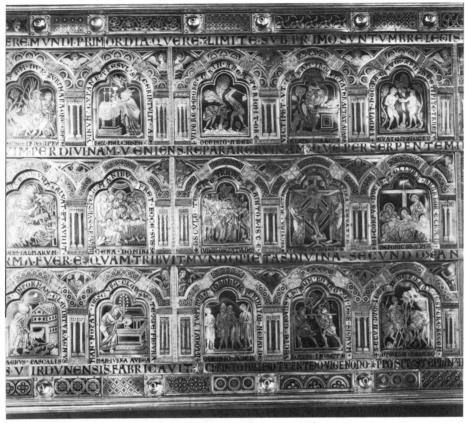

34. Nicholas of Verdun, altarpiece, 1181. Gold and enamel. Stiftsmuseum, Klosterneuburg.

and consists of typological comparisons between the life of Christ and events in the Old Testament [34]. Scenes from the New Testament fill the middle register of the altarpiece and are framed above and below with appropriate Old Testament parallels. In the center are the Crucifixion, the sacrifice of Isaac, and the spies bringing grapes from Canaan (Num. 13). Obedient to God, Abraham prepares to sacrifice his son, just as God sacrificed Christ. The drama of the event is expressed in the contorted figures; Abraham grips Isaac by the hair and raises his sword; Isaac lies bound hand and foot on the altar while the sacrificial substitute, the ram, stretches to nibble some oak leaves. The intercession of the angel, who grasps Abraham's upraised sword, adds to the immediacy of the image. Equally energetic are the triumphant spies who stride along bearing

an enormous bunch of grapes, their muscles bulging and their drapery flying.

The Crucifixion as depicted by Nicholas [35] contrasts with the Limoges master's cross, for Nicholas dramatized the suffering of Christ and the sorrow of Mary and St. John to a degree far beyond the cool stylizations of the Grandmont Master. Human reactions to events concerned him, and like an ancient sculptor, he used the entire figure to convey the heavy sense of grief. Sagging postures are as telling as gestures and facial expressions, although Mary and John stand firmly on the ground and their solid figures are rendered more massive by rippling classicizing drapery. Christ is an idealized athlete, even though Nicholas followed Byzantine conventions in the decorative stylization of muscles. The explosive emotional quality of the scene is reduced by

the sumptuousness of the ornament, the intense color, the gold. Nicholas has backed the cross with a diamond pattern in repeated enamel bands. This unique device focuses attention on the central place of the Crucifixion, both in the work of art and in the Christian faith.

During the twelfth century artists began to think of the human figure as an independent and majestic form worthy of representation in art. They could justify this interest because man had been given the outer appearance adopted by God while on earth; thus Father and Son, and even the ranks of angels, had to be represented in human form. Even in Gothic art, however, the human figure continued to be treated in a religious context and not as an admirable object in itself. The renaissance of the twelfth century lacked the humanistic celebration of man found in the Italian Renaissance of the fifteenth and sixteenth centuries. A distinction also can be drawn between Western and Byzantine figural representations. Whereas in Byzantine art images of Christ and the saints became icons to be venerated, in the West figures usually had a didactic role. Whereas Romanesque artists had adopted Byzantine figure conventions and compositions, Early Gothic artists assimilated the Byzantine lessons and then looked at the world afresh when they had to create actors in the sacred drama. Both Romanesque and Gothic art still make a powerful impact on the mind and the emotions of the viewer. However, the final impression created by Romanesque art is one of naked power; that of the Early Gothic, of humanized force. The Romanesque artist seemed to expect the Apocalypse; Gothic artists hoped for salvation and the joys and splendor of paradise.

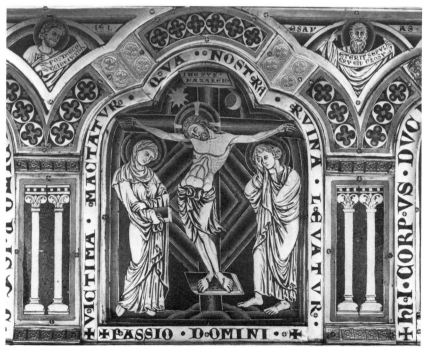

35. Nicholas of Verdun, Crucifixion (detail), 1181. Enamel; size of plaque, 5 1/2″ × 4 1/2″. Stiftsmuseum, Klosterneuburg.

CHAPTER X

High Gothic Art in France

nd even as the scribe that hath made his book illumineth it with gold and blue, so did the said King illumine his realm with the fair abbeys," wrote John, Lord of Joinville, about St. Louis as a patron of the arts (Book 2, ch. CXLVI). The reign of King Louis IX (1226–1270, canonized in 1297) coincides with the mature Gothic style in art. Louis IX owed the strength of his realm and the peace and the resources which enabled him to patronize the arts to the skillful politics of his grandfather, Philip Augustus. The wars between Philip Augustus and King John of England ended in 1204 with Philip's victory, and ten years later a French-Hohenstaufen coalition defeated the English-Welf alliance at the battle of Bouvines (1214), assuring French political, economic, and cultural dominance on the Continent.

Under St. Louis's successors, Philip III the Bold (1270–1285) and Philip IV the Fair (1285–1314), France became an absolute monarchy. The crown passed to Philip's son and then from brother to brother in turn, each of whom died after a short reign without an heir—Louis X (1314–1316), Philip V (1316–1322), and Charles IV (1322–1328). In 1328, Philip of Valois, a cousin, ascended the throne, ending 340 years of Capetian rule and establishing the House of Valois. During this time the French kings established a strong centralized government with a staff of civil servants dependent on royal favor, and from their court in Paris they defended their realm with

professional mercenary troops hired with the income they received from their towns.

The crusading spirit remained strong throughout the thirteenth century. The Fourth Crusade (1201) proved profitable when Venetian merchants and French knights turned the campaign into raids against Christian cities. In 1204 these Western hoodlums sacked and looted Byzantium itself. They installed one of their number as emperor and ruled the city until driven out by the Paleologues in 1261. When in 1244 Jerusalem fell again, this time to the Turks, St. Louis sailed from Aigues Mortes to Egypt on a Crusade. Near Cairo the king was taken prisoner, ransomed, and after fortifying a few ports in the Holy Land, returned to France in 1254. In 1270 St. Louis took up the cross again, and for the last time the Western Crusaders sailed for the Holy Land. This time they landed in Tunis, where the king died and his army abandoned the campaign.

For all their bellicose claims, Christians and Muslims maintained relatively good relations most of the time. This association of Western Europeans with the Byzantine and Muslim East had a profound impact on Europe. Scholars gained access to Eastern and Classical science: astronomy, astrology, mathematics (including Arabic numerals and the concept of zero), and the rudiments of biology and medicine; also, they could study the work of ancient Greek and Arabic philosophers in the universities. The Crusaders perfected military

engineering but they also learned about chimneys, clocks, and windmills. With travel, knowledge of geography improved and so did mapmaking and navigation. Trade fairs became clearing houses for native and imported products, and as markets expanded banking developed to finance trade with the East. New products appeared in Europe: rice, lemons, melons, apricots, sugar, sesame, cloves, incense and sandalwood, cotton and damask, fine ceramics and glass, carpets, gold and enamel work.

The Capetian kings had been generous to the towns; they granted privileges to old towns and founded new ones. Philip Augustus had granted seventy-eight charters to towns. City and state both profited: city wealth made the king independent of the nobility and feudal dues; meanwhile townspeople had a stake in the success of the monarchy because they needed the peace which a strong central government could ensure in order to operate their business ventures successfully. With the growth of commerce and industry, artisans and merchants formed guilds, which became virtual monopolies. Guild members controlled production and prices of goods, but they also ensured that their members maintained high standards of quality, and they kept careful watch on the education and welfare of members. After a seven-year apprenticeship, a youth became a journeyman—that is, a laborer who worked by the day, or *journée*. After an examination and the creation of an acceptable "masterpiece," the new master could practice his trade and train apprentices himself. Women could become guild members if they carried on their deceased husbands' business. Guilds also provided important social services: members looked after each other's physical and spiritual welfare, and provided suitable burials. They often formed confraternities under the patronage of a saint, whose chapel they maintained.

This growing middle class needed far more spiritual guidance than the guilds and the older rural monastic communities provided, and new monastic orders, the Franciscan and Dominican friars (from the Latin *frater*, brother) were founded, dedicated to work in the cities. Once known as Grey Friars from the color of their robes, later Franciscans could be recognized by their brown habits and rope belt, whose three knots symbolized their vows of poverty, chastity, and obedience. Their founder, St. Francis of Assisi (c. 1182–1226, canonized 1230) preached a life of poverty, service, and love; Franciscans became renowned preachers, missionaries, and teachers. Among their most illustrious members was Roger Bacon (c. 1214–1290), "Doctor mirabilis" and defender of the study of experimental sciences. Another, Duns Scotus (c. 1265–1308), challenged scholastic philosophers by his insistence on the importance of St. Augustine's thought, and others, such as Thomas of Celano, the biographer of St. Francis, became poets and men of letters.

St. Francis was motivated by a passionate love of Christ so intense that the stigmata, or wounds suffered by Christ on the cross, appeared in his own body. Franciscan emphasis on the emotional aspects of religion found expression in a renewed dedication to the Virgin—to Mary as an earthly mother rather than queen of Heaven. The theme of pity, *pietà* in Italian, appeared in sculpture and painting and in the Franciscan Latin hymn, "Stabat Mater Dolorosa":

> Next the cross with tears unceasing,
> Worn by sorrow aye increasing,
> Stood the mother 'neath her Son . . .

The most moving of all Latin hymns, "Dies Irae," possibly written by Thomas of Celano, remains a worthy equivalent in verse to the Last Judgment tympana of the cathedrals.

> Dreaded day, that day of ire
> When the world shall melt in fire . . .

Another order of Friars, the Dominicans, was established in 1206 by a Castilian nobleman, Domenico Guzman (1170–1221, canon-

ized 1234). Members of the order of Friars Preachers were also known as the Black Friars because they wore a black cloak over their white tunics. The Dominicans became a teaching order, determined to combat heresy by combating ignorance. In 1233 the Pope put the Inquisition into their hands and, in a pun on their name, the Dominicans became known as the watchdogs of the Faith, *Domini canes.*

Dominicans number among their members some of the greatest scholars and theologians of the thirteenth century: Vincent of Beauvais (c. 1190–1264), Albertus Magnus (c. 1200–1280), and Thomas Aquinas (c. 1225–1274). Vincent of Beauvais organized human knowledge into a huge encyclopedia, the *Speculum Maius* (The Greater Mirror). Eighty books and 9,885 chapters form the *Speculum Naturale,* the *Speculum Doctrinale,* and the *Speculum Historiale.* (A fourth "mirror," the *Speculum Morale,* is a later addition.) Albertus Magnus applied the intellectual discipline of Aristotle and the Arabic philosophers to theology, and his student, Thomas Aquinas, carried his work to its logical conclusion by balancing the conflicting claims of Christian faith with scientific reason in the *Summa Theologica (The Summary of Theology),* the "crowning achievement of scholastic philosophy."

St. Thomas Aquinas, born of a noble family near Monte Cassino, began his studies there with the Benedictines; however, he joined the Dominican order and traveled to Paris and Cologne to study with Albertus Magnus. His *Summa Theologica* remains the basis for Roman Catholic theology to this day. In a comprehensive system of propositions and arguments, St. Thomas summarized and harmonized Greek and Christian philosophy and reconciled the conflicts between natural law and revealed truth. He insisted on the compatibility of human knowledge and divine revelation, since both natural law and revealed truth came from God, and while human logic attempts intellectual understanding, faith illumines the truth. In 1328 the Church recognized the

Summa as a miracle and canonized its author. The *Summa Theologica,* like the Gothic cathedral, stands as an enduring achievement of the thirteenth century.

Gothic Architecture

At the beginning of the thirteenth century builders, sculptors, and painters achieved a synthesis of form and content which we see today as the complete statement in stone of Western Christendom's aspirations. Early Gothic artists had experimented with structural and decorative features—ribbed vaults supported by a variety of wall and buttress systems, complex interior elevations with tribunes, triforia, and clerestories, regularized iconographical and compositional programs in sculpture and stained glass. Now thirteenth-century masters resolved the technical and aesthetic problems posed by their twelfth-century predecessors and in so doing they created a style whose order, harmony, and balance was recognized, to use Grodecki's phrase, for its "exemplary" quality. The builders of the High Gothic cathedrals expressed Western Christian ideals just as seven centuries earlier Anthemius, Isidorus, and Justinian had made the Church of Hagia Sophia a visible symbol of Byzantine culture and belief.

The Cathedral of Notre-Dame at Chartres stands at the beginning of the thirteenth-century as a model to be challenged at Bourges and emulated and perfected in the cathedrals of Reims and Amiens [1, 2]. Built on the foundations of the church destroyed by fire June 10, 1194, a new cathedral rose on the site in a remarkably short time: the nave was finished about 1210 and the chevet by 1220, when the first dedication took place. The nobility and the townspeople poured their resources into the rebuilding campaign after inspired preaching had convinced them that the fire was not a punishment for their sins but a sign from the Virgin that she wanted a new church. The work of rebuilding began

behind the Royal Portal, which, with its precious sculpture and stained glass, had survived.

The architect of Chartres Cathedral adopted elements from the twelfth-century buildings of northern France; however, in creating his own masterpiece he simplified, clarified, and regularized his predecessors' designs [3, 4]. He combined the long nave and wide, aisled transepts of Laon Cathedral with the compact double ambulatory and radiating chapels of St. Denis and Paris. In the elevation, he adopted the three-part scheme of Sens in preference to the four-part elevations of Paris and Laon. Alternating cylindrical and polygonal compound piers articulated by contrasting shafts divide the nave into vertical bays. Then, quadripartite vaults cover both the rectangular bays in the nave vault and the flanking square aisle bays. Pointed arches permit the keystones of transverse and diagonal ribs to be set at the same height in order to produce a level

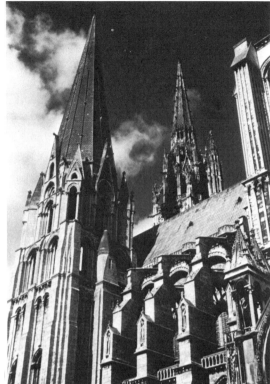

2. South wall and spires, Chartres Cathedral, thirteenth century (north spire sixteenth century).

1. Chartres: Cathedral from the town.

vault that, with the arcade of the triforium, creates a continuous horizontal movement toward the altar. In contrast to this horizontal movement the verticality of the tall arcade and clerestory and the upward linear thrust of compound piers and clustered wall shafts of diminishing diameter carry the eye into the high ribbed vault. Structurally the piers, vaulting ribs, and the exterior flying buttresses form an independent architectural skeleton. Aesthetically this system of piers and wall shafts, contrasting with the horizontal lines of the arcade of the triforium and the string course moldings, becomes a rectilinear pattern. Unlike earlier buildings, the wall is not a series of discrete units but a continuous, subdivided, arcuated frame for stained glass. By balancing a nave arcade and a clerestory of equal height above and below an arcaded triforium passage,

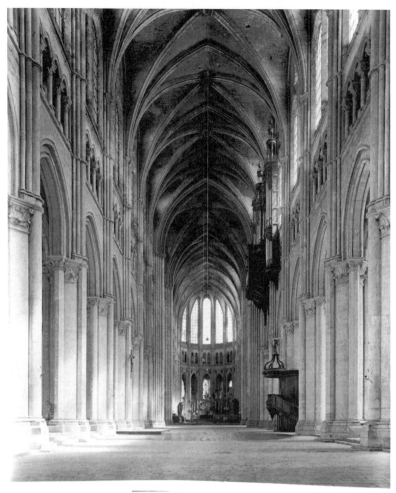

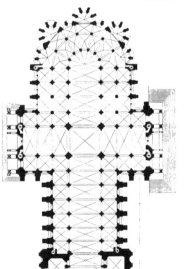

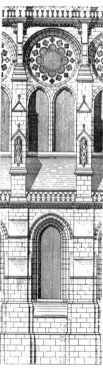

3. ABOVE: Nave and choir, Chartres Cathedral, after 1194. Height of vault, approximately 122'.

4. LEFT: Plan, Chartres Cathedral.

5. ABOVE RIGHT: Interior elevation of nave, Chartres Cathedral.

6. RIGHT: Exterior elevation of nave, Chartres Cathedral.

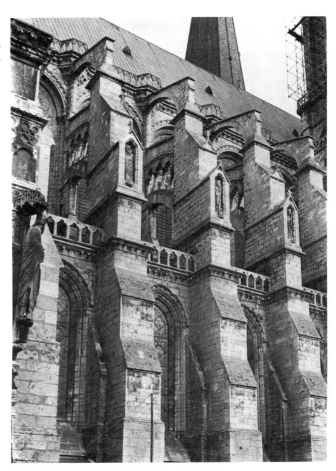

7. North wall, buttresses, Chartres Cathedral.

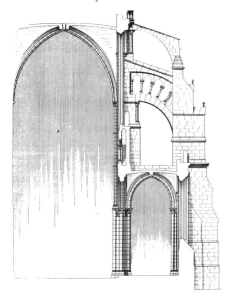

8. Section, Chartres Cathedral, thirteenth century.

the designer created an impression of almost Classical harmony in the interior.

The upper wall reads as a plane, not as masonry mass [5, 6]. Inside, it becomes a sheet of glowing color and on the exterior, a tone of shimmering gray behind the arches of the buttresses. In each bay two lancets and a rose pierce the wall to form clerestory windows forty-five feet high, an enlargement of the window made possible by double strutted buttresses. Double arches joined by arcades of round arches on short columns carry the weight of the vault over the aisle roofs to buttresses so massive that even today one senses the architect's determination as he created a building of extraordinary size and height [7, 8].

On reaching the choir the architect subtly modified the elevation. The triforium continued around the hemicycle with paired arches, while above in the clerestory a single lancet fills each bay. The engaged columns on the compound piers become single shafts on the altar side of the pier (removed in later remodeling). In the high vault, ribs radiate out from a central keystone, and their lines are continued in lower trapezoidal ambulatory bays and polygonal chapels. Double flying buttresses support the hemicycle and carry the thrust of the vault over double ambulatories to massive buttresses set wall-like between the chapels. So completely are buttresses and chapels integrated and so delicate do the struts of the flyers appear that the vault and the exterior roof seem to float weightlessly over the enormous lancets of the clerestory.

The continuous ring of chapels with stained-glass walls in Suger's St. Denis must have inspired the builders of Chartres. Proof lies in the third and fifth chevet chapels which copy St. Denis's double lights and vaulting system. However, at Chartres, the builders had to incorporate the foundations of the original crypt, with its three strongly projecting chapels; therefore, when they built a chevet with seven chapels, they designed three different chapel forms. Three strongly projecting, separately vaulted chapels (the second, fourth, and sixth) alternate with shallow chapels vaulted together with the outer ambulatory bays. The Chartres master increased the number of windows from two to three in the larger chapels, so that a window stands on the axis of the chapel, enhancing the effectiveness of the stained glass. The ring of chapels formed an aureole of colored light around the high altar to realize at last Abbot Suger's ideal of luminosity.

The architect's intention for the complete cathedral is difficult to imagine today, even while we admire the rich sculpture of the deep porches and contrast the pure lines of the soaring Gothic spire with the flamboyant tracery of the northern spire (built in the sixteenth century). The original designers planned nine towers—a pair for each facade—west, north, and south—another pair at the beginning of the choir and a great tower over the crossing. Nine spires should have pierced the heavens above the church of the Virgin. The towers and the ingenious plan of the chevet with its circular and rising forms create a Gothic equivalent of the symbolic Heaven of the Early Christian martyrium.

The builders of Chartres achieved a solution, comparable to that found in sixth-century Byzantium at Hagia Sophia, to the Christian architectural dilemma: how to combine the vertical and horizontal axes of martyrium and hall? At Chartres the worshipers' gaze might rise upward into vaults [9], or to the heights

9. Interior, crossing vault, Chartres Cathedral, thirteenth century.

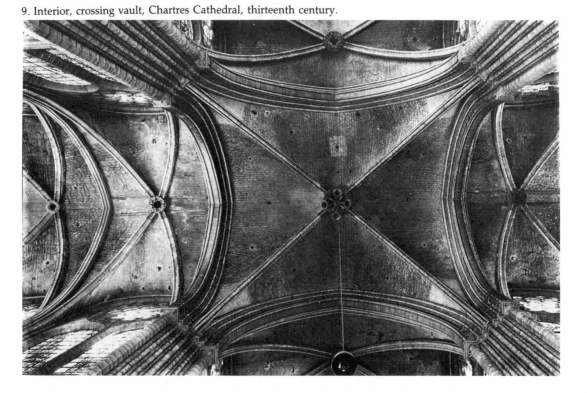

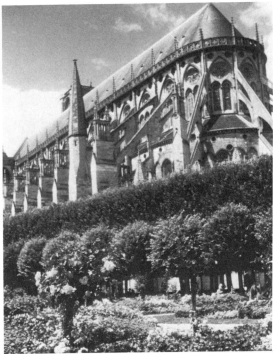

10. Exterior from southwest, Bourges Cathedral, begun 1195.

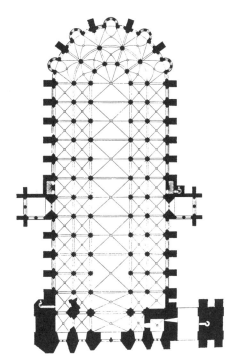

11. Plan, Bourges Cathedral.

of towers and spires outside, but their attention was directed to the sanctuary. In other words, architects maintained the dramatic focus on the altar found in the Early Christian basilica, in contrast to Byzantine churches, where billowing spaces seem to circle upward. At Chartres the crossing of nave and transept becomes a baldacchino supported on huge piers adorned with shafts; the choir, a light-filled rotunda surrounded by a ring of subsidiary chapels. Christian fascination with light and color became a near obsession in French Gothic architecture. Not content with the Byzantine glitter of reflected light from gold mosaics, the Western artists turned the entire church interior into colored light by replacing masonry walls with colored glass.

Contemporary with the Cathedral of Chartres but inspired by different models, a cathedral dedicated to St. Etienne was built between 1195 and c. 1225 in Bourges, 140 miles south of Paris [10]. Here the architect created a building whose spatial complexity

and lateral extension appealed to southern taste. The compact plan with double aisles and ambulatory, and sexpartite vaults over double bays, has been compared to Notre-Dame, Paris; however, the builders emphasized space and light rather than mass, line rather than surface [11]. At Bourges, in spite of the divisive effect of the sexpartite vault, the eye moves rapidly down a nave and choir uninterrupted by a transept. Contrarily, attention may be distracted laterally into the double aisles. Relatively light piers in the nave arcade articulate the space, their slender verticality enhanced by eight thin surrounding colonnettes [12, 13]. The triforium and clerestory, squeezed between this tall arcade and the vault, have bays subdivided into narrow units—the triforium into six arches under a relieving arch and the clerestory into triplet windows. So high are the flanking aisles (59 feet) that they too have triforia and clerestories, and their arcades open into yet lower side aisles lit by lancet windows [14]. Thus three

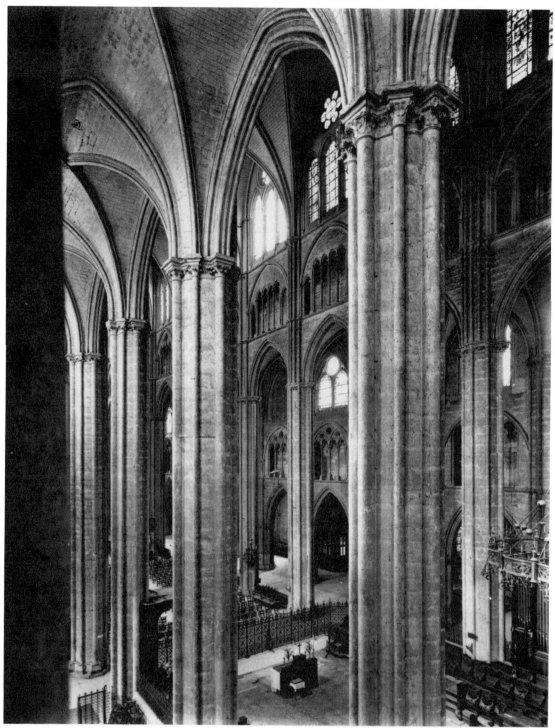

12. Nave, Bourges Cathedral, from south choir aisle triforium, begun 1195.

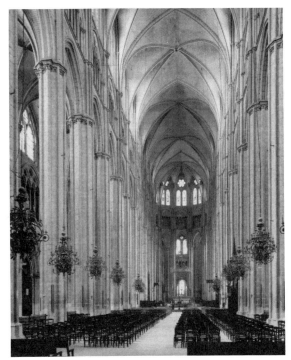

13. Bourges Cathedral, begun 1195; choir, 1195–1214; nave, 123', 1225–c. 1250.

14. Section of nave, Bourges Cathedral.

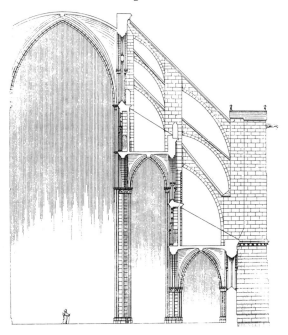

ranges of windows, alternating with two triforia, form bands of stained glass and shallow arcading, which, as they rise and approach at the same time, create diagonal sight lines contradicting the primary focus on the sanctuary. This remarkable expansion of the interior space contrasts with the controlled verticality of Chartres. The Bourges High Gothic design was less flexible and consequently was followed less than the Chartres plan, but it did influence the cathedrals at Tours, Le Mans, and Coutances in France and Burgos and Toledo in Spain.

In the northeast, Chartres, not Bourges, inspired the builders of Champagne and Picardy when they began their magnificent cathedrals in the cities of Reims and Amiens. Reims holds pride of place [15]. A Roman and then a Merovingian stronghold, Reims was the site of the baptism of the Frankish king Clovis in 496 and thereafter came to be identified with the monarchy. As seat of an archbishop and the coronation church of the Capetian kings, the cathedral could claim precedence. Of course, many churches had stood on the site: in 817 a Carolingian church, similar to St. Riquier, replaced the Merovingian building; this church was rebuilt in 976 and again in the middle of the twelfth century. After fire destroyed the city and the cathedral in 1210, the architect Jean d'Orbais laid the first stones of the Gothic cathedral.

Work on the cathedral, begun in 1211, progressed slowly. During the thirteenth century the cathedral chapter, the citizens, and the archbishop did not enjoy the good relations that existed in Chartres. Open rebellion flared, and funds for the building often became scarce. In the course of the thirteenth century, five architects directed the work, and a labyrinth in the pavement (destroyed in 1776) recorded their names and accomplishments. Jean d'Orbais adapted the overall design from Chartres and oversaw the building of the lower part of the choir and transept. He was followed about 1220 by Jean le Loup, who continued the

choir and transept, built aisle walls and piers in the nave, and began the west facade. From 1233 to 1236 urban uprisings stopped construction. A third architect, Gaucher de Reims, finished the eastern part of the church so that the canons could be reinstalled in the choir in 1241. In the second half of the century Bernard de Soissons finished the nave (1289), and Gaucher and Bernard must have worked on the portals and sculpture of the west facade, for it had reached the level of the rose window by 1260. Robert de Coucy, who died in 1311, finished the facade but never completed the proposed seven towers and spires.

A comparison of the plans of Chartres and Reims shows that Jean d'Orbais altered the Chartrain scheme by lengthening the nave, shortening the transept, and improving the geometric regularity of the choir [16]. The Reims hemicycle is half a decagon, from whose sides the bays of the ambulatory and the five chapels project in regular wedge-shaped sections. The ambulatory continues the inner aisles of the choir while the chapels abut the outer aisles to unite chevet, choir, and transept in a compact yet spacious plan. The chevet reaffirms the Early Christian ideal of a church which combines basilica and martyrium, for both inside and out the chevet appears to be a centralized structure attached to the nave [17]. The circular movement of the ambulatory and polygonal chapels is enhanced by the

15. Chevet exterior, Reims Cathedral, 1211–60.

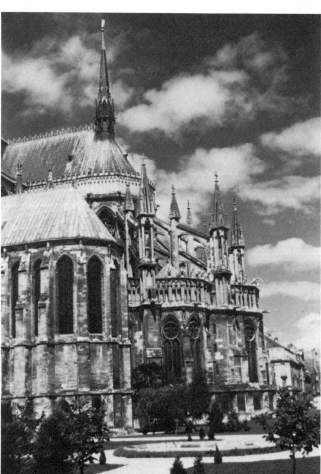

16. Plan, Reims Cathedral.

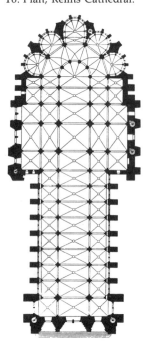

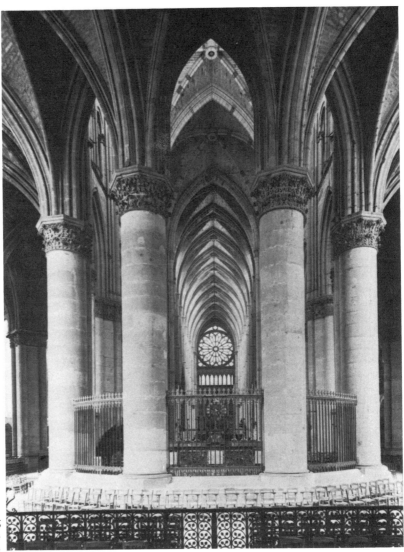

17. Interior, choir looking west, Reims Cathedral. Height of nave vault, 125′.

rippling movement of windows and the radiating flying buttresses. Even the sculptured angels in the buttresses ringing the choir seem appropriate to a martyrium church.

The logic and clarity inherent in Gothic architecture becomes even more apparent in the nave at Reims [18]. The ideal of soaring height is achieved through actual size (125 feet to the crown of the vault, as compared to Chartres's 122 feet), through proportion (Reims's 2.8 to 1 as compared to Chartres's 2.2 to 1), and through an emphasis on the vertical lines of projecting wall shafts and sharply pointed arches. Identical compound piers at Reims replace the subtle variation of cylindrical and polygonal elements in the Chartrain arcade. Capitals which are doubled on all four attached colonnettes wrap the piers with broad bands of almost naturalistic foliage. The capitals interrupt the upward surge of the compound piers and wall shafts and create a unique horizontal element in the nave elevation. Meanwhile the triforium loses its horizontal continuity, for it lies behind the ag-

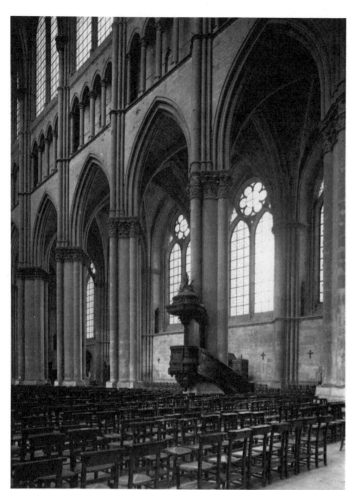

18. Nave, Reims Cathedral.

gressively sculptural wall shafts. Furthermore, the slight thickening of the central colonnette in the triforium arcade suggests a relationship with the double lancets of the clerestory and even hints at the merger of these two elements.

In the clerestory and aisle, the Reims masters revolutionized window design by turning the clerestory wall into giant windows subdivided by masonry mullions, which support the enclosing panels of stained glass. In each bay of the aisle and clerestory, these mullions rise into pointed arches to form a pair of lancets supporting a delicate rose. The aisle windows seen through the arches of the nave arcade repeat the pattern of the clerestory windows and further relate the upper and lower stories. In short, the elevation is now composed of

bands of colored light, joined and divided by a dark triforium. The masons' skillful use of flying buttresses made the enlarged windows possible [19]. Profiting from generations of experience, the builders calculated thrusts and loads with great accuracy, and they stabilized vaults and roofs with slender struts and arches attached to massive, tower-like buttresses. Every buttress terminates in a pinnacle-weighted tabernacle housing a sculptured angel. Had the full complement of seven towers and spires been completed, the cathedral would have seemed to soar into the clouds, a Heavenly Jerusalem guarded by flights of angels.

The architects of the Cathedral of Amiens refined the solutions reached by the builders of Chartres and Reims, and by the end of the

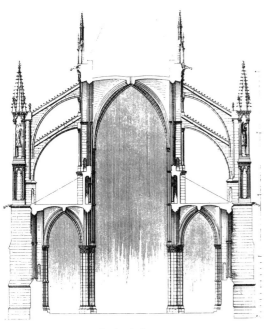

19. Section, Reims Cathedral.

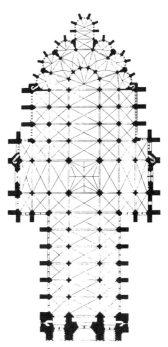

20. Plan, Amiens Cathedral, begun 1218.

21. Amiens Cathedral.

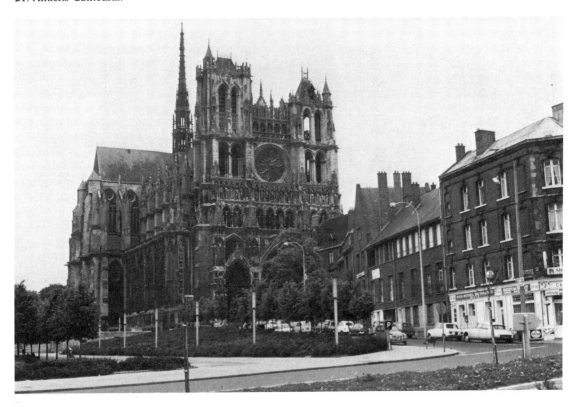

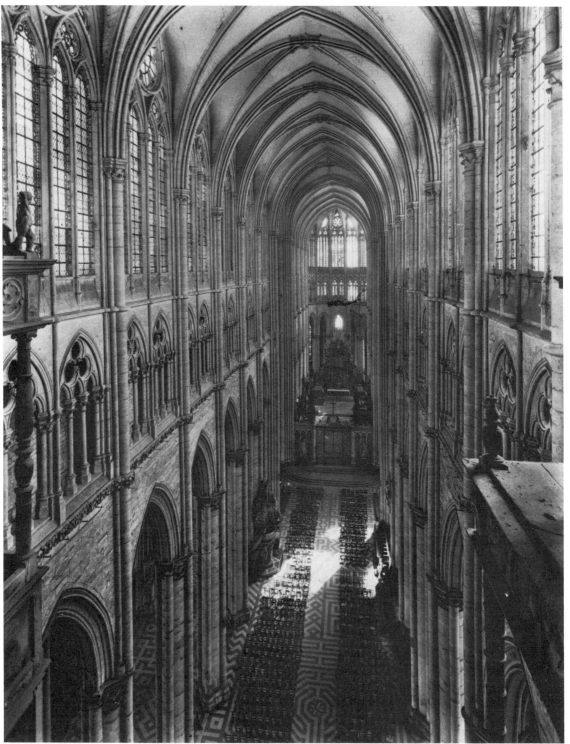

22. Nave looking east, Amiens Cathedral. Height of nave vault, 139′.

building campaign they inaugurated a new phase of Gothic art, known as the Rayonnant [20, 21]. The city of Amiens in the thirteenth century had become a rich textile manufacturing town and trading center. A Romanesque cathedral and a church dedicated to St. Firmin, the first bishop of Amiens, stood on the site of the present cathedral. The Romanesque cathedral burned in 1218; and Bishop Evrard de Fouilloy, the chapter, and the townspeople seized the opportunity to rebuild their cathedral on a scale they deemed appropriate to the importance of their city. The architect, Robert de Luzarches, began building at the west so that during the construction of the nave St. Firmin's church could be used for services. Robert built the west facade to the height of the kings' gallery, and the nave (completed in 1236), and began work on the transept and choir. His successors, Thomas and Regnault de Cormont, finished the choir. When work ended in 1288, a labyrinth was set in the nave giving the names of the architects and of Bishop Evrard de Fouilloy. Robert de Luzarches was the guiding genius, for just as the builders of Reims respected the intentions of Jean d'Orbais, so the Cormonts continued Robert's plans.

The Gothic builders' passion for height and light should have been satisfied in the Cathedral of Amiens (they did try to outdo themselves yet again at the Cathedral of Beauvais, with a vault 154 feet high). The Amiens nave is much higher than Reims's (139 feet in comparison with Reims's 125 feet), while the width remains about the same; and these proportions as well as the increased vertical subdivision of the elevation and the steeply pointed arches of the vault give an appearance of height that matches the real space [22]. Furthermore, the extraordinary sixty-foot-high nave arcade and aisles dwarf the spectator. (The addition of chapels between the outer wall buttresses in the fourteenth century changed these remarkably tall proportions. Today the impression of lateral extension in

the nave approaches that of Bourges.) Again, uniform compound piers line the nave and, as in Chartres, the shaft that supports the transverse arch runs the full height of the elevation uninterrupted by a capital. Unlike Chartres and Reims, the elements in the shaft bundle increase in number at each stage. One shaft engages the pier and continues through to the transverse rib. Above the capital two more shafts are added to join the diagonal ribs of the vault; at the triforium level still more shafts for the lateral arches appear; and finally at the clerestory tracery dominates the composition of wall and window.

"Creation by division" characterizes the design of the triforium and clerestory. The triforium arcade is composed of two large arches enclosing triple arcades and trefoils, and in the clerestory pairs of lancets and roses are subdivided into identical repeating motifs. The mullions of the clerestory extend down to

23. Elevation, Amiens Cathedral.

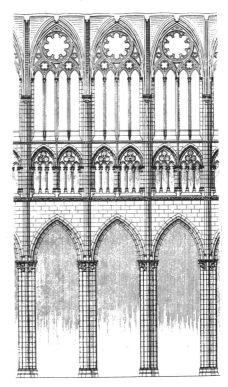

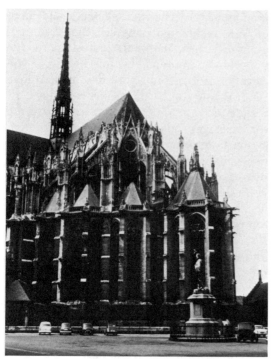

24. Choir from southeast, Amiens Cathedral, mid-thirteenth century.

form wall shafts in the triforium uniting the upper two registers into a single unit, and dividing each bay into narrow segments. One horizontal element intrudes into this essentially vertical composition: at the base of the triforium, a molding carved with a continuous band of idealized curling foliage completely encircles the main vessel of the church. The molding emphasizes the horizontal continuity of the triforium and provides an enrichment comparable to the capitals at Reims [23]. Panofsky likened the design of Amiens to the insistent subdivision and classification of parts found in scholastic philosophy. He even suggested that the tracery of Gothic windows was a tangible rendition of the schoolmen's logical outline. Into the logic and mathematical precision of the architecture, the foliage of Gothic cathedrals brings an enriching and lightening note.

In the choir at Amiens the Cormonts began a new architectural mode, which developed into the Rayonnant style. At the crossing they subdivided the clerestory lancets into eight narrow fields, and in the choir they eliminated the last horizontal band of darkness by placing windows in the triforium. The choir suggests a two-story building: a united triforium and clerestory above a spacious ambulatory and chapels. The chevet becomes a mysterious, luminous space within and an intricate composition of open spiky forms without [24]. On the exterior even the arches of the flying buttresses are filled with open tracery resembling that of the windows; traceried gables over the windows break the juncture of roof and wall and the steep roofs over the chapels rise unmasked. The seven polygonal, triple-windowed chapels opening into a single ambulatory create a regularized chevet undisturbed even by the enlargement of the axial chapel. From the exterior, Amiens seems more compact and balanced than either Chartres or Reims; even the slight projection of the transept beyond the choir does not break the continuity of its silhouette.

Because of the order of the construction of the two cathedrals, the facade of Amiens precedes that at Reims by a generation [25]. The facade at Reims, like the choir at Amiens, brings to a close the High Gothic and introduces the new Rayonnant style. Deep porches lavishly decorated with sculpture emphasize the entrance and provide a stable base for the intricate spatial composition above. Stained glass, with its impressive interior effect, supplants sculptured tympana; and inside the nave the west wall becomes a giant trellis of niches filled with sculptured figures punctuated by rose windows. Sculpture unites the portals and porches on the exterior as well; porches disguise wall buttresses; and gables filled with tracery and relief sculpture cover the buttresses of the outer walls and extend up into the range of the arcade and rose. At the level of the rose, the buttresses become spired tabernacles, and the towers are pierced with open traceried lancets through which the diagonal

lines of the flying buttresses of the nave can be seen. The facade becomes almost incredible reaffirmation of Gothic delight in complex linear articulation of space and interpenetrating forms. The rose window seems to float above and behind the central gable, where under a filigree of turrets, Christ appears to crown His mother. The kings' gallery above the rose masks the gable of the nave and also ties the towers into the composition by providing a dense, horizontal element. Had spires been completed over the tall open towers, the verticality and apparent weightlessness of the design would have made the stabilizing breadth of the base provided by the sculptured portals essential to the harmony of the composition. This calculated balance of elements makes Reims a great High Gothic facade; the new relationship of form and space leads us to the Rayonnant style.

25. West facade, Reims Cathedral, 1211–60.

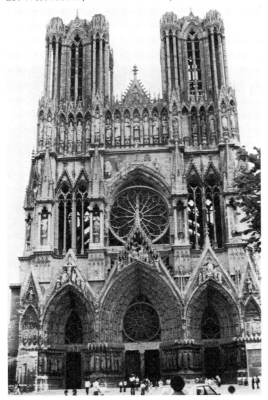

The Rayonnant Style in Architecture

No sooner had architects reached perfection in the cathedrals of Chartres, Reims, and Amiens, than they began to move in new directions, first by refining traditional elements, and then by experimenting with new relationships of solid and void, structure and ornament. They created a new style, called Rayonnant. In the Rayonnant style, masonry walls seem to disappear, to be replaced by sheets of stained glass framed by clusters of colonnettes, while stone and glass alike are united by an overlying pattern of moldings and tracery. As befits a style developing around a royal court, an ideal of elegance permeates the architecture, and the sculpture and painting as well. Subtlety and refinement together with technical virtuosity give to all the arts of the period an intellectual as well as a sensuous appeal. The new style falls into two periods: Robert Branner dubbed the first the Court style because of the intimate association of its major monuments—St. Denis, Ste. Chapelle, and the additions to Notre-Dame—with the Parisian court of St. Louis. The second, Grodecki's "mannerist" phase, is exemplified by the Church of St. Urbain at Troyes.

One of the first projects to be executed in the new style was the upper choir and transept of St. Denis, where the logic of Amiens was carried to a final point of intellectual refinement [26]. In 1231, work began again on the choir, and the completed church was dedicated in 1281. So beautifully does the thirteenth-century work harmonize with the twelfth-century narthex and choir that today the viewer is hardly aware of the intervening century.

The court architects also modernized earlier buildings, such as the cathedral of Paris, which must have seemed dark and old-fashioned. Beginning about 1225, the clerestory of the nave at Notre-Dame was enlarged by combining the oculi and lancets of the four-story

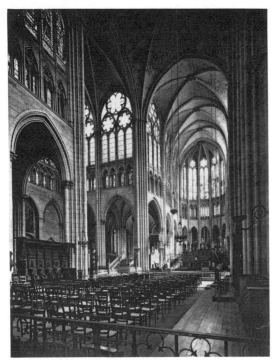

26. Choir and crossing, Abbey Church of St. Denis, rebuilt 1231–81.

begun as a palace chapel for relics of the Crucifixion: the crown of thorns, a bit of the lance that pierced Christ's side, the sponge, and a fragment of the True Cross. St. Louis had purchased these treasures in 1239 from his cousin Baldwin of Flanders, who was then ruling as emperor in Byzantium. The building consisted of two parts: an upper chapel [27] connected with the king's private apartments reserved for royal use and for the exposition and protection of the relics, and a lower chapel dedicated to the Virgin used as a parish church by members of the royal household. With its jewel-like encrustation of sculpture, painting, gilding, and glass, the chapel must have been the epitome of courtly elegance when it was completed in 1248. Robert Branner justly likened it to a giant reliquary "turned outside in."

The upper chapel is a simple, open room twice as high as it is wide and having a polygonal east end. Above a blind-arcaded base, piers with clustered shafts lead up to the

27. Interior of upper chapel, Ste. Chapelle, Paris, 1243–48.

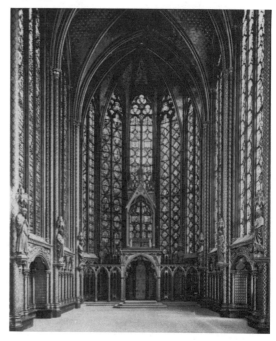

elevation into traceried windows, thereby increasing the level of illumination and converting the interior into a three-part elevation. Chapels were added between the buttresses (1236–1245) and around the choir (1270s) and the transept facades were rebuilt by Jean de Chelles at mid-century. In 1265 Pierre de Montreuil took over the position of master of works for the cathedral.

Pierre de Montreuil's role in architectural projects in and around Paris and the relation of his work to that of the Cormont family from Amiens has been the subject of lively debate among scholars. At one time Pierre was thought to be the leader of the Parisian Court school, and St. Louis' Ste. Chapelle was attributed to him. However, Branner argued that Thomas de Cormont left Amiens to work for the French court and that the Ste. Chapelle is his creation. Certainly the court chapel and the Amiens choir have much in common.

In 1243 the exquisite Ste. Chapelle was

ribs of the vault. Together they form a skeletal network supporting the glass of the walls and the web of the vault; in other words, the wall has become a translucent screen of tracery and stained glass. Sculptured figures of the twelve apostles on the piers link the painted and gilded lower wall to the stained-glass windows above. The windows are glazed with deep-red and blue glass, whose juxtaposition fills the space with violet light. Small scenes set in elaborate geometric panels against dia-pered backgrounds are framed with heraldic devices, such as the castles of the Queen Mother, Blanche of Castile. Although the rapid construction of the windows encouraged rep-etition of motifs and scenes, as a composition in colored light and as a sensual experience the Ste. Chapelle is an unqualified success.

On the exterior, large stepped buttresses terminating in pinnacles articulate the walls of the tall, narrow structure. Each window is framed by a gable, which in turn breaks through the roof line. This interpenetrating pattern of gables and arches became a popular decorative device among painters and sculptors as well as architects. The chapel, with its original rose window of radiating fields of tracery, can be seen in the miniatures of the *Très Riches Heures*, painted for the Duke of Berry (the king's brother) in the early fifteenth century.

The Ste. Chapelle popularized the new Ray-onnant style, which soon spread through Western Europe. New cultural centers such as Troyes arose in France. The year after his election as Pope, Urban IV (1261–1264) founded a church on the site of his birthplace in Troyes in honor of his patron saint [28]. Jean Langlois (John the Englishman?) built the choir and transept between 1262 and 1265, although the work had to be rebuilt after a fire in 1266. Jean inaugurated a new phase of Rayonnant architecture in Troyes, a style char-acterized by unified interior spaces richly dec-orated with painting and sculpture and bril-liantly illuminated by huge windows filled

28. St. Urbain, Troyes, 1262–65, rebuilt after 1266.

with light-colored glass. Grodecki has called the style "Gothic mannerism." At St. Urbain Jean designed a simple three-aisled church with a square transept and a choir of two bays ending in a polygonal apse flanked by polygonal chapels [29]. Above a plain masonry base two stories of glass enclose the apse: the first story is a traceried passageway, the outer range of which is glazed; the second is a huge

29. Interior, St. Urbain, Troyes, begun 1262, rebuilt after 1266.

clerestory. Continuous repeated tracery patterns unite the two stories and provide continuity between masonry walls and glazed openings. Piers formed of many engaged shafts seem mere clusters of rippling moldings; their insignificant capitals allow the channeled shafts to flow unbroken into the ribs of the vault. Light-colored glass permits the appreciation of the crisp carving and metallic quality of the tracery and moldings. Like the Ste. Chapelle, the choir of St. Urbain is a glass cage, but the color and quality of the light has changed from a mysterious royal purple to the silvery light of day.

Stained Glass

Light, so essential to the symbolic aesthetic effect of the interior of a Gothic building, is dependent on the quality of the stained-glass windows. Today, when most of the buildings have lost their medieval glass, the cathedrals in northern France have a cold, austere quality never intended by their creators. The linear pattern of colonnettes and moldings rising to the network of the ribbed vault is too dominant when it is seen in the harsh brilliance of clear glass. The study of Gothic architecture can become an exercise in engineering, or drawing-board aesthetics, without a consideration of the color that once infused the space.

At the Cathedral of Chartres and in the Ste. Chapelle the full effect of a completely glazed interior can be appreciated. Not only are the walls rich and colorful luminous sheaths trapping the space, but the space itself is animated by beams of colored light slanting down through the air and transforming walls, piers, and even the people moving through the aisles. The beams shift and move, and the quality of light and color change depending on the time of day and the movement of clouds across the sun. Thus sunlight and weather unite with the artists' handicraft to create the truly awe-inspiring Gothic interior. As Pierre de Roissy wrote, "The paintings on the windows are Divine writings, for they direct the light of the true sun, that is to say God, into the interior of the church, that is to say the breasts of the faithful, thus illuminating them."

In the Cathedral of Chartres superb twelfth-century glass survived in the west facade. Between 1215 and 1240 most of the other windows were glazed, and the entire program was finished for the consecration in 1260 [30]. The production of the glass itself, followed by painting, leading, and setting the panels, involved a large team of artists and craftsmen. The simple lancets in the aisles and chapels, which were low enough to be easily seen, had complex narratives from Christian history. Many small scenes were arranged in geometric panels, whose frames of iron showed as a black pattern across the rich colors of the glass. The high clerestory windows had single figures of saints, prophets, and apostles, which, because of their increased size, simple drawing, and brilliant color carry well at a distance.

In the north transept lancets and a rose window (over forty-two feet in diameter) are filled with deep-blue and ruby-red glass and emblazoned with golden lilies of France and the castles of Castile (color plate 6). (The windows may have been a royal commission of Blanche of Castile.) The iconography represents a well-thought-out statement on the relationship of the Old and New Testaments. The Virgin and Child surrounded by four doves (the Gospels) and eight angels in the heart of the rose replace the image of Christ in majesty as the focus of the heavenly host. Old Testament kings and prophets, the ancestors of Christ, sit in the circle of lozenges, and quatrefoils display the golden *fleur-de-lis*. In the semicircles around the rim of the rose, medallions bearing prophets float in a red-and-blue diapered (checkered) ground. In the lancets St. Anne holding the infant Virgin Mary stands in the center over the royal coat of arms.

Artists and patrons gave St. Anne the place

30. Upper wall of nave, Chartres Cathedral, thirteenth century, glazed before 1260.

of honor in the iconographical program of the north transept because the Count of Blois had presented a precious relic, her head, to the cathedral when he returned from the Fourth Crusade in 1204. St. Anne and Mary are flanked by Old Testament prefigurations of Christ: Melchizedek, David, Solomon, and Aaron. Melchizedek and Aaron prefigure the priesthood of Christ and David and Solomon are his royal ancestors. Melchizedek and Solomon triumph over the idolatry of Nebuchadnezzar and Jeroboam represented in panels below their feet, while David stands above the suicide of Saul, and Aaron, Moses' brother, presides over the destruction of Pharaoh in the Red Sea. All these vivid figures emerge as glowing panels in the dark mass of the wall.

In the choir, the guild of furriers donated a window with scenes from the story of Charlemagne, who had been the original Western owner of the Virgin's tunic (color plate 5). At the bottom of the window, they depicted one of their number selling a cloak to a customer. (The furriers' gift was not unique; about seventy guilds paid for windows in the cathedral and many included scenes showing their members at work or their products.) The exploits of Charlemagne and his knights are depicted in elaborate interlocking compositions of geometric figures. The artists demonstrated a remarkable skill in adjusting narrative to the armature of the window. In a circular medallion at the summit of the lancet, for example, the charge of Roland against the Moor and the violence of combat, as the lance breaks, are caught within a delicate red and blue frame. Color clarifies and emphasizes the scene—the red of Roland's tunic and the glittering yellow of his helmet against the blue ground are picked up again in the red disc of the Moor's shield. Only the essentials of the armor, drapery, and horses' heads are rendered in detail. The vigor and at the same time the economy of the composition demonstrate a very sophisticated sense of color and composition.

The brilliant art of Chartres makes more regrettable the loss of so much stained glass elsewhere. A considerable amount of high-quality thirteenth-century glass remains at Bourges. At Reims a few of the kings of France and the archbishops of Reims who anointed them survive in the clerestory windows. The invention of bar tracery at Reims and the concomitant expansion of the fields of glass had a profound impact on the glazers' art. The western wall with the rose, glazed triforium, and glazed tympana, although heavily restored, gives some idea of the artists' original intention.

In the Ste. Chapelle the solemn classical style of the High Gothic was transformed into the more intricate and intimate Court style. Purple, green, and yellow combined with red and blue to produce a sparkling violet light. The nineteenth-century English aesthetician John Ruskin recalled the effect of the windows:

The true perfection of a painted window is to be serene, intense, brilliant like flaming jewellery; full of easily legible and quaint subjects, and exquisitely subtle, yet simple in its harmonies.

Later Rayonnant architecture, as we have seen at St. Urbain in Troyes, demanded a new kind of stained glass [31]. The expectation of patrons and the skills of artists linked with new technical achievements to produce dramatically different stained-glass windows. Grisaille—that is, clear glass painted with geometric patterns or foliage—became increasingly popular in northeastern France in the thirteenth and fourteenth centuries. Grisaille had been used by Suger's artists at St. Denis and was even approved of by the Cistercians. When windows had to be glazed rapidly and economically, it had been used in the great cathedrals. In the later years of the thirteenth century, however, artists and patrons chose grisaille glass to complement interiors enriched with tracery and sculpture. Artists in Champagne and Burgundy combined the traditional techniques of glazing by in-

31. Interior of choir, St. Urbain, Troyes, begun 1262, rebuilt after 1266. Glass.

serting stained-glass panels into grisaille windows, and this mixed technique was chosen for the windows at St. Urbain. The colored panels, surrounded by delicately patterned light, satisfied the desire for stained glass while they increased the amount of light in the interior.

The discovery that silver oxide could produce a wide variety of shades of yellow revolutionized the craft and the aesthetic requirements of the glaziers. Silver stain had the further advantage of being able to be painted on the glass; therefore, the amount of leading could be reduced, and fewer dark lines broke up the surface of the window. The development of flashed glass, in which one color could be coated with another to lighten, darken, or change the original color, made further variation possible. New, brighter colors could be made easily—pinks by coating clear glass with ruby red, or brilliant greens from

blue glass flashed with yellow. Pale silvery whites and lemony golds replaced the deep-colored light which had made twelfth- and thirteenth-century interiors so mysterious. The spacious, well lit, and richly decorated interiors of the late Rayonnant style provided in turn a new impetus for independent sculpture and painting.

Monumental Sculpture

The sculpture of Chartres, Amiens, and Reims demonstrates the underlying logic and the all-encompassing nature of the iconographical program of Gothic cathedral decoration. Scholars rather than masons must have devised this vision of the world, for the sculpture encompassed all medieval learning. As Emile Mâle wrote, the sculpture of a cathedral resembles an encyclopedia in stone, the *Speculum* of Vincent of Beauvais.

At the Cathedral of Chartres, where the

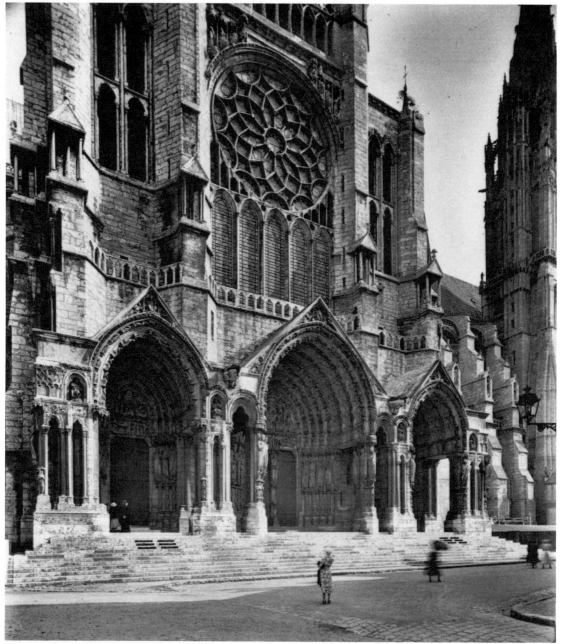

32. North transept, Chartres Cathedral, thirteenth century.

west facade already illustrated human history from the Incarnation to the Apocalypse, the north and south transept portals expanded and commented on the earlier program [32]. The north transept held the precursors and prefigurations of the Christ in the Old Testa-ment, as well as the life of the Virgin—in short, the world before Christ's ministry. The triple portal has as its center the coronation of the Virgin with St. Anne as the trumeau and the Old Testament ancestors of Christ in the statue columns, the theme elaborated in

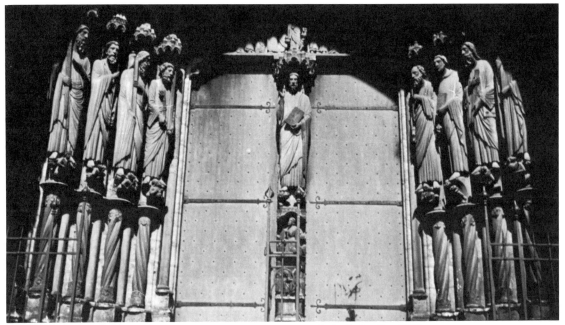

33. Christ and apostles, central portal, south transept, Chartres Cathedral, after 1205.

34. Christ, trumeau, central portal, south transept. Chartres Cathedral.

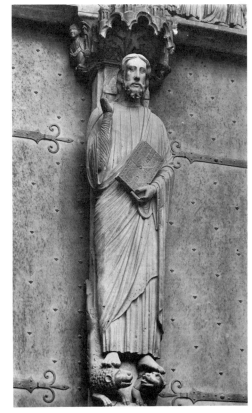

the stained-glass windows above. To the left are scenes from the infancy of Christ and on the right, allegories of virtue in the Old Testament as seen in the stories of Job and the Judgment of Solomon. The south transept was dedicated to the New Testament, the saints, and the Last Judgment—that is, to events after the Incarnation [33]. Christ and the apostles on the trumeau and jambs lead to the Last Judgment in the tympanum. Themes from the historical church fill the flanking portals— martyr saints at left, confessor saints at right.

The sculpture of the central portal on the south transept focuses on the trumeau figure of the teaching Christ holding a book whose jeweled cover suggests the rich housing given the word of God by Carolingian goldsmiths [34]. Christ is the door and as teacher He welcomes the worshiper to His house. As St. Augustine wrote, "He stood in the door because by Him we come unto the Father and without Him we cannot enter the City of God." The figure of Christ is a worthy suc-

cessor to the column figures of the Head Master on the Royal Portal. The elongated rounded form and the sweeping, almost metallic drapery encompass both human figure and architectural structure. The college of apostles in the jambs (by a lesser master) and the Last Judgment, personalized by intercessors and angels with the instruments of Christ's passion in the tympanum, establish a theme to be developed by generations of artists.

In the tympanum, the sculptor has simplified and idealized forms in an effort to express the humanity as well as the divinity of Christ [35]. Theologians no longer insisted on the dual nature of man, glorifying the spirit while denying the flesh, but instead wrote of the union of body and soul. Sculptors and architects, too, desired an integration which at the same time recognized and maintained the distinctness of the individual parts. Sculptors, like architects and churchmen, built their images on a concept of totality, which gave equal place to both physical appearance and intangible inner life. They balanced observable appearances and intuited essences to create figures which exist on a spiritual or symbolic plane as well as on a material level. A frame of clouds and angels establish a shallow stage and give a tableau-like quality to the scene. The overlapping of elements—wings over clouds, cross over angels—suggest the artist's cautious but determined approach to the physical world.

About 1217 the decision was made to enlarge the sculptural program by giving the transepts triple portals. The flanking portals on the south transept portal, dedicated to the saints, illustrate the more mundane approach taken by the new sculpture [36]. On the right portal are St. Martin, the missionary priest; St. Jerome, the Biblical scholar; and St. Gregory, the Pope and administrator. The consoles provide narrative extensions: St. Martin stands on the pair of hounds he commanded to stop chasing a rabbit; St. Jerome holds the Bible he translated and tramples on the Synagogue;

and St. Gregory, with the dove of the Holy Ghost perching upon his shoulder, is spied upon by his secretary. The confessor saints represent a moment when the rival goals of architectonic quality and realism demand attention. The sculptor tries to record every aspect of the material world; faces are wrinkled; the vestments and draperies are displayed with rippling folds, rich embroideries, and jewel work. Seduced by their own skill in representing surfaces, the sculptors lost sight of the underlying structure of both figures and architecture. That they carved the saints standing on flat platforms marks a significant step in the conception of human beings as unique entities in a spatial environment. These Chartrain masters take an irrevocable step away from earlier idealism and toward realism of types, if not of individuals.

35. Last Judgment, south portal, central bay, Chartres Cathedral.

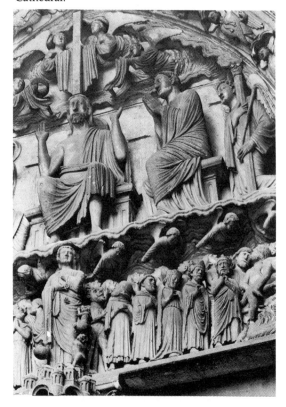

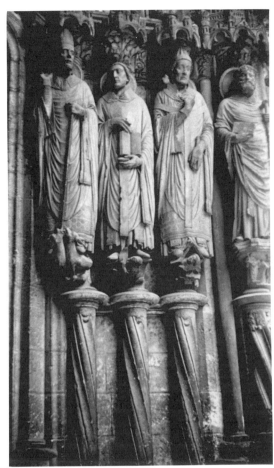

36. Church fathers, south transept, Chartres Cathedral.

By 1224 the Chartrain architects were planning porches and additional figures for the portals, and the grand program was finished at mid-century. The High Gothic canon is maintained to the end. Among the finest of these later figures is St. Theodore, who represents the ideal of Christian chivalry [37]. The sculptor's attempt to render a complex pose, firm stance, and body clad in chain mail under drapery suggests an increased awareness of, and ability to represent, the material world, while the delicate flowing drapery maintains the vertical lines appropriate to an architectural figure, a statue-column. A new individualism pervades the design, and yet the sculp-

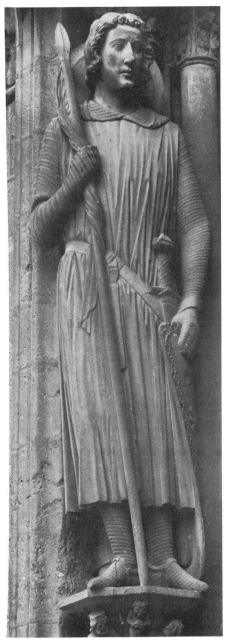

37. St. Theodore, south portal, Martyrs' bay, Chartres Cathedral.

ture retains the idealism and reserve of High Gothic art.

The elaborate sculptural program at Chartres, spreading over nine portals, was not

repeated. Instead a distillation of the scheme, on the west facade at Amiens, became the most popular model [38]. At Amiens the central portal repeated the central portal of the south transept at Chartres, the Last Judgment with Christ and the apostles. The left entrance was dedicated to local saints; at Amiens St. Firmin, whose church had been destroyed to make way for the new cathedral, stands as the trumeau. The right-hand portal, like the north portal at Chartres, had the Coronation, Dormition, and Assumption of the Virgin, although the Virgin with the infant Christ replaced St. Anne and Mary on the trumeau. Deeply splayed portals filled with sculpture—statue columns, tympana, and a broad expanse of figured voussoirs—are set within shallow porches. Sculpture spreads across porches and wall buttresses, and these columnar figures and bands of quatrefoil reliefs unite and enrich the three portals. Above the gable of the porches, the plain wall of the nave and the arched windows of the side aisles are visible, while higher still two galleries, one with figures

38. ABOVE: Christ and apostles, Last Judgment, central portal, west facade, Amiens Cathedral, 1225–35.

39. RIGHT: Portals of west facade, Amiens Cathedral.

of kings, fill the space between the porches and the rose window.

The large figures of Christ and the apostles at Amiens are so uniform in style that the saints can be distinguished only by their (heavily restored) attributes [39]. They are framed by projecting bases and canopies defining a space in front of the columns of the facade, and their weighty stance belies their architectural role. Nevertheless, the columns with bases and capitals still exist; capitals provide yet another rippling horizontal movement across the facade. Each figure becomes a vertical accent within the processional horizontality of the whole.

The impression created by the sculpture at Amiens is of a surface composition organized into horizontal registers balancing the verticality of the architecture. Figures in three tympana become repeated vertical elements placed symmetrically within horizontal registers. The statue columns provide vigorous relief, but their very number, their colossal size, and their placement in a continuous line around the buttresses as well as in the jambs denies their individuality and turns them into horizontal bands uniting the three portals. The quatrefoil frames, enclosing lively narratives and energetic figures, because of their decorative form and repetition become a textile-like pattern over the base of the portals.

The sculptural program at Amiens was completed within the years 1220–1236. In order to produce so many figures so rapidly the sculptors developed a formula that came to characterize the High Gothic style [40]. The geometric simplifications were easy to learn and copy. Broad folds of drapery conceal the anatomy, and the rising movement within the drapery denies the real weight of the stone and the sensed weight of the person. The arrangement of the cloak, which at first seems so natural, follows a pattern which becomes a formula for Gothic figures. Vertical folds enlivened by cascading curvilinear borders at one side of the figure contrast with diagonals

at the other, so that the drapery leads the spectator's eye upward to the attribute and then on to the head. This geometric pattern directs the viewer's attention to the significance of the figure; it does not try to describe a tangible human being. Other sculptors may have been more refined, sophisticated, or profound but the broadly conceived, idealized style of Amiens inspired sculptors from Reims to Bourges, provided the basis for the Parisian court style, and spread to southern France, Spain, and Italy.

Gothic sculptors still saw the world as God's creation, to be contemplated but not dissected; they studied neither anatomy nor botany but they observed the world with care and sympathy. To be sure, artists continued to define figures through attributes, to emphasize gestures and facial expressions, and to arrange

40. Christ, "Le Beau Dieu," trumeau, central portal, west facade, Amiens Cathedral.

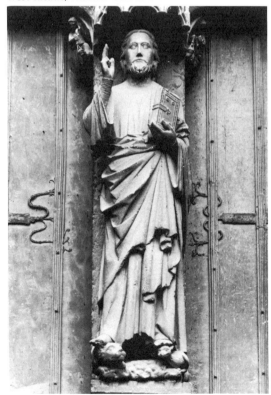

drapery in architectonic patterns. While drapery might suggest the movement of the body, it has an aesthetic and expressive function of its own, and its geometric composition continues to integrate the figures into the complex overall design of the building. Even in narrative reliefs or painting, the artist aimed for a compromise between the tapestry-like architectonic qualities of the Romanesque style and the ancient Roman concept of a window frame through which the spectator looked at the world. Interested as they might be in the organization and representation of figures in space, thirteenth-century artists worked within a narrow stage space in which the figures could move within the limits set by distinct frontal and background planes. Gothic artists left the development of a systematic linear and aerial perspective to the fifteenth century.

The sculpture of the Cathedral of Amiens did not emerge full-blown from the mason's yard. A generation of experimentation preceded the development of High Gothic sculpture, as it had High Gothic architecture. While Chartrain sculptors were carving the north transept, artists in Paris were also at work on the west facade there. From the coronation portal on the left of the west facade an extraordinary head of an angel found only in 1977 has survived [41]. The delicate carving of the head, the subtle planes of the face, the gentle smile playing over the lips, the soft curls of the fluffy hair are the work of genius.

The Cathedral of Reims, with its changes of plans, masters, and sculpture shops, illustrates the variety possible within the Gothic canon [42]. On the west facade alone four distinct styles and many variations can be studied. Sculptors from Chartres, Paris, and Amiens all may have been at work there, together with the distinctive Classical Shop and the highly individual Joseph Master. Shortly after 1230 some of the sculptors who had worked at Amiens and Paris evidently moved to Reims, where they produced much of the sculpture for the west facade of the cathedral. Delicate faces and broad drapery, generalized forms and simple surface movements characterize their work. The Virgin of the Annunciation and Mary and Simon in the Presentation are the work of these masters [43]. (Later sculptors changed the order of the figures at the left; the maid was intended to be the third figure from the right paired with St. Joseph, while Mary and Simon would have been a pair next to the door.) The idealism of the Paris shop, the elegance of Amiens, and a growing interest in nature are here joined.

Elements of ancient Roman sculpture inspired another group of sculptors, whose work is found on the north transept and whose leader has been called the Master of the Antique Figures. The master must have been profoundly influenced by Roman ruins, still to be seen in Reims, as well as by the art of Nicholas of Verdun and early Gothic sculpture of northeastern France. The style at Reims is characterized by exceptionally bulky figures whose broad shoulders and firmly planted feet emphasize their tangibility. In the Visitation on the west facade, Mary could have been inspired by a Roman Juno, for her full face and mature features, gently waving hair, and heavy mantle reflect an antique beauty [44]. The drapery, too, resembles Roman illusionistic drapery, or the so-called Muldenstil used by Nicholas of Verdun. However, the trough-like folds do not reveal the figure as they would in antique art but instead they follow the Gothic formula. Mary and Elizabeth seem extraordinarily tangible, and the sculptor's realization of mass, weight, and movement in space is remarkable for the thirteenth century. The women turn toward each other in a spiral motion created by contrasting relaxed and supporting legs and a slightly swaying hip-shot pose. For all their classicism, however, the figures remain part of the architecture; the shafts and capitals of the columns which form part of their bodies rise above their heads as a reminder of the architectural function of the portal figures.

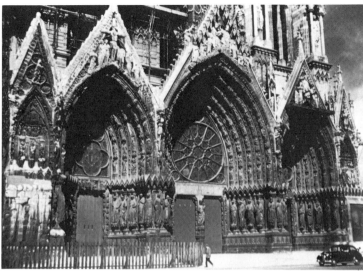

41. ABOVE LEFT: Head of an angel from the left jamb of the portal of the Virgin, Cathedral of Notre-Dame, Paris, c. 1230. Limestone. Height, 15". Cluny Museum, Paris.

42. ABOVE RIGHT: West portals, Reims Cathedral, 1211–60.

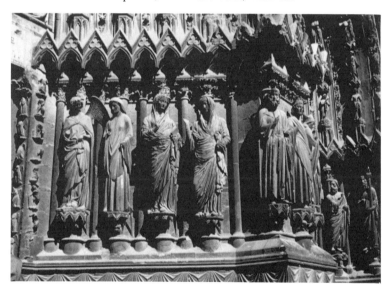

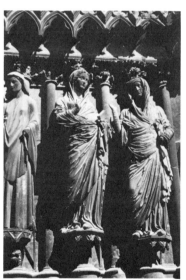

43. ABOVE LEFT: Annunciation and Visitation, central portal, right jambs, west facade, Reims Cathedral, c. 1230–50.

44. ABOVE RIGHT: The Visitation, central portal, right jambs, west facade, Reims Cathedral, c. 1230.

Occasionally a strikingly individual style emerged from the shop traditions of Medieval art, to remind us that even when the artist and the events of his life remain obscure, individuals, not shops, established the direction of future developments. The Master of the

Antique Figures was not the only remarkable individual working at Reims. A second distinct personality appears in the shop, known today as the Joseph Master [45]. The Joseph Master turned the statue column into an autonomous figure imbued with self-conscious, courtly

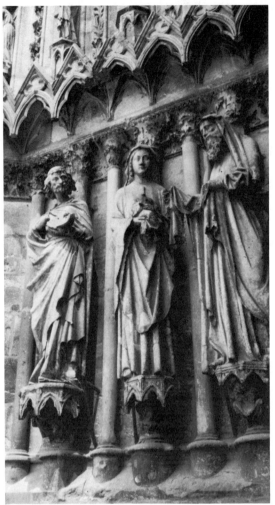

45. The Joseph Master: St. Joseph, the Presentation, left jambs, west facade, Reims Cathedral, c. 1250.

quiet smile of the Paris angel into a piquant expression of amusement as well as pleasure and affection. His St. Joseph, with a cocky stance and twirling mustache, is not a dignified saint but an elegant dandy.

St. Joseph's focused gaze, jaunty pose, and voluminous drapery can also be seen in the servant girl of the Presentation and the angel of the Annunciation. The smile flickering over the thin, oval, adolescent face of the angel seems merry and sad at the same time. In this figure the formal elegance of the drapery pattern and the subtle gesture raise the sculpture to the highest level of sophistication. Like the Mannerist artists of the sixteenth century, the Joseph Master sought a new kind of abstraction, an anti-natural style characterized by elegant formalism and sharpness of expression. In so doing he rejected not only the basic premise of architectural sculpture but in a sense all the styles which preceded him.

46. *Vierge Dorée*, trumeau, south transept, Amiens Cathedral, c. 1260.

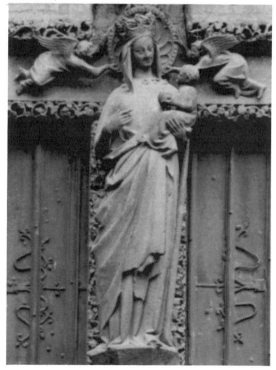

elegance. From the Paris-Amiens school he adopted heavy drapery, deep folds, and undulating borders; however, he dramatized the folds of cloaks and made even more elaborate their curling edges. From the Classical Shop he learned to create a substantial figure, but he exaggerated the shifting weight, hip-shot pose, and spiral twist of the body. Perhaps inspired by Parisian sculpture, he invented a facial type with delicate features, almond eyes under arched brows, and broad forehead framed by short, curly hair. He turned the

The Rayonnant Style in the Figurative Arts: Sculpture and Manuscripts

Mature Gothic sculpture, such as the work of the Joseph Master, can be seen as the product of a new humanistic spirit in Gothic art even while the visual arts remained subordinate to the logic and the forms of architecture. The worldly grace of mid-century sculpture from Reims pervades the art of northern France and the Joseph Master's courtly style inspired the sculpture on the south transept of the Cathedral of Amiens. The justly famous Golden Virgin, the *Vierge Dorée* (c. 1260), reflects Franciscan piety, for Mary is a youthful mother admiring her baby, rather than a severe regal figure [46]. This Gothic princess, with her oval face, high forehead, small sharp features, and almond eyes, could be a beauty from the Parisian court. The sculptor exaggerated the formula of hipshot stance, smiling tilted head, and billowing drapery, and enhanced the S curve of the figure with such sweeping folds that the drapery alone seems to support the Child. The architectural function of the figure as a trumeau all but disappears.

When the original gilding still covered the stone, the *Vierge Dorée* must have resembled goldsmith's work. The sculpture reminds us that in the thirteenth and fourteenth centuries Paris was the center of the production of luxury items for the secular and ecclesiastical courts of Western Europe. Gold and silver, enamels and gems, ivory, and illuminated manuscripts all demonstrate the high level of French taste and craftsmanship. For example, a masterpiece of fourteenth-century metalwork in France, the gilded silver statue of the Virgin and Child presented to the Abbey of St. Denis by Queen Jeanne d'Evreux, the wife of Charles IV, and identified by the inscription with the date 1339 on the base, has the power and dignity of monumental sculpture.

The Master of the Virgin of Jeanne d'Evreux

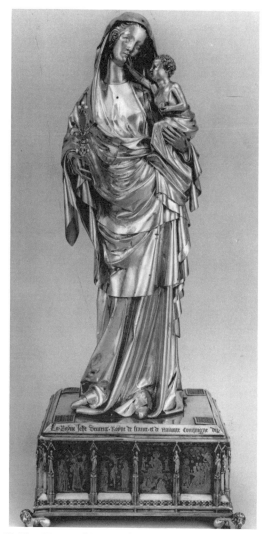

47. The Virgin of Jeanne d'Evreux, Paris, 1339. Silver gilt with *basse-taille* enamel. The Louvre, Paris.

has created an image in which Mary appears as a loving earthly mother as well as a majestic queen of Heaven [47]. Mary's delicate features shine with timeless beauty, yet their melancholy cast suggests that she contemplates her Son's fate on earth, even as the Child reaches up to caress her face. Mother and Child seem isolated by the enveloping folds of the mantle and veil, an effect of enclosure perhaps felt less before the loss of the Virgin's crown. Originally she wore a golden crown adorned

with sapphires, garnets, and pearls, and she still carries a jeweled *fleur-de-lis*, the lily of France. This symbol of the French monarchy, as well as of the Virgin's purity, is a reliquary container for strands of the Virgin's hair.

A rectangular base, resting on four crouching lions and bearing the dedicatory inscription and the royal arms, supports the statue. Miniature buttresses, decorated with tiny figures under gables, divide the sides of the base into fourteen rectangular panels enameled with scenes representing the life and Passion of Christ. The familiar story begins on the right side with the Annunciation, Visitation, and Nativity, continues on the back with the shepherds, the Magi, the Presentation, and the flight into Egypt; then the massacre of the innocents, the resurrection of Lazarus, the arrest of Christ; and finally, on the front, it concludes with Christ carrying the Cross, the Crucifixion, Resurrection, and descent into Limbo. Delicate figures, whose appearance owes much to painters like Jean Pucelle, act out the sacred drama against a blue ground of translucent enamel enlivened and enriched with opaque reds. The artist achieves an aesthetic effect allied to the grisaille paintings in the queen's book of hours by reserving the figures, engraving them, encrusting them with enamel, and then gilding them to create the appearance of drawing in color on gold. A new enamel technique, known as *basse-taille*, for the silver plate is worked in very low relief, became popular in the fourteenth century. The translucent enamel is applied over the modeled surface of the plate and appears deeper in color where it collects in the recesses. The technique produces an effect which is both rich and delicate, subtle yet brilliant.

The elegance and small scale of work in precious materials—gold, silver, enamel, ivory—appealed to aristocratic private patrons. Objects for secular use, such as pendants, belts, clasps, goblets, ewers, basins, and knives, were decorated with translucent enamel. Ivory carvers produced mirror backs, combs, and jewel boxes as well as devotional images. Often these deluxe objects were carved with scenes from the ever-popular tales of intrigue and romance, such as the story of Tristan and Iseult, the *Romance of the Rose*, or the tragic love of the Chatelaine de Vergi [48]. On a panel from an ivory box, the meeting of the Chatelaine and her knight is witnessed by the Duke of Burgundy, and later the jealous duchess pries the secret from the duke. In the ivory carver's shorthand the representation of a few trees indicated a forest or orchard, and a swag of drapery the private apartments of the duchess. Such condensed narratives were possible,

48. La Chatelaine de Vergi, first half of the fourteenth century. Ivory, 3 1/2" × 9 1/2". Spencer Museum of Art, University of Kansas.

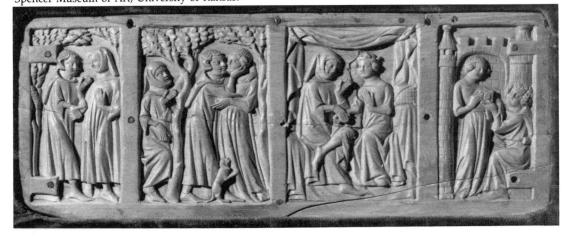

for these were well-known tales.

Parisian workshops were also producing splendid illustrated books for secular patrons, and noble and royal bibliophiles assembled great private libraries. These splendid illuminated manuscripts came from Parisian workshops rather than monastic scriptoria. In order to supply the increased demand for fine books, masters hired scribes and painters who took responsibility for only one aspect of work. We have seen a similar development in sculpture, where at Amiens specialization answered the needs created by the vast sculptural program of the west facade; and like the sculptors, these painters might have lacked the evanescent quality of genius, but they maintained a uniformly high standard of quality.

The relationship of figures and narratives to the exigencies of book illustration can be seen in the *Evangeliary of the Ste. Chapelle*, a collection of readings from the Gospels made about 1255–1260. In readings from Luke, each passage begins "In illo tempore" (At that time), and each letter "I" is composed of a series of superimposed scenes [49]. The letter "I" is easy to work into such a composition; even so, the initials seem incidental to the stories. In the first "I" Christ calls Levi the tax collector to follow Him and takes supper at Levi's house (Luke 5:27–29), and in the second "I" Christ and St. John the Baptist preach to the multitudes (Luke 7:24–29). These events are depicted on a narrow stage in which the gold or the red-and-blue diapered backgrounds deny the three-dimensionality suggested by the modeling of the figures' cloaks. Like other Gothic artists, the manuscript illuminators worked within architectural constraints; figures lie as clearly within the frame and on the plane of the vellum folio as do statue columns in the architecture of the portal. They may move and gesture gracefully within a setting established by miniature landscape and architectural elements, but even the delicate tiptoeing over the lower frames does not establish a feeling of space. Architecture is merely an

49. "In illo tempore" (St. Luke 5:27–29 and 7:24–29), *Evangeliary of the Ste. Chapelle,* 1255–60. Vellum, 12 1/2″ × 9″. Bibliothèque Nationale, Paris.

assemblage of gables, lobed arches, and traceried windows. Like the workers in stained glass, the painters used a reduced palette of primary colors—vermillion and carmine, azure and burnished gold, with a little green and white. Finally, the artist reaffirmed the relationship of the initial to the spiky Gothic script by extending the corners of the letters into foliage bars, whose sharp, brittle, cusped shapes bear only a distant relationship to the forms of nature; yet these strange plants bind together the text, ornament, initials, and narrative illustration. We have seen just such integration of forms in the thirteenth-century cathedrals.

The hint of realism in the foliage sculpture of Amiens and Reims, the conception of a

three-dimensional figure inhabiting space in the statue columns of the cathedrals, the courtly elegance of St. Joseph and the angels at Reims all appear in manuscript illuminations by the end of the century. Influences from abroad, especially England and Italy, sped the development of one of the most sophisticated painting styles in the history of art. The masters, unlike the anonymous monks of earlier scriptoria, were secular artists whose careers can be traced in legal and business records of Paris and the French court—tax rolls, contracts, sales, and inventories.

Master Honoré, for example, was an artistic entrepreneur with a shop near the University of Paris. Between 1288 and 1296 he paid his

50. Master Honoré: Anointing of David, David and Goliath, *Breviary of Philip the Fair*, c. 1296. Miniature on vellum, 7 7/8″ × 4 7/8″. Bibliothèque Nationale, Paris.

taxes and sold books to the king and other customers; in 1296 Philip the Fair bought a breviary from him. The breviary for the clergy and the books of hours for the laity became the most popular devotional books in the late Middle Ages. Both contained prayers for the canonical hours, the seven penitential psalms, and a calendar of saints' days. The books could be personalized by the addition of prayers to saints for whom the owner had a special devotion. In the *Breviary of Philip the Fair* the historiated initials and the single full-page illumination show a vigorous and elegant new style. Solid figures energetically act out the dramatic events of the anointing of David by Samuel [50] and the victory of David over Goliath. Gothic still are the swaying hip-shot poses, splayed feet with pointed toes, sharp elbows, and angular gestures. Houses, trees, and hills are still mere symbols indicating the locale, and gold-and-blue diapered backgrounds close off the recession in depth. Comparison with the same scenes from the life of David by the Master of the Morgan Leaf dramatizes the changes that have taken place over the century. The figures themselves have a new tangibility; they fill the space with their bulk and their voluminous draperies. Saul and Goliath are worthy companions of the noble knight at Reims, and blue-and-red-cloaked figures at the right of the crowd recall the sculpture of the Joseph Master at Reims and the *Vierge Dorée* of Amiens.

Other artists soon simplified this elegant linear style to mannered formulas; nevertheless, in the 1320s and 1330s another great individual artist, Jean Pucelle, again revitalized Parisian book illustration [51]. Pucelle's masterpiece is a tiny book of hours made for Queen Jeanne d'Evreux as a gift from her husband Charles IV. The book can be dated between 1325, when Jeanne and Charles married, and 1328, when Charles died. The queen's will mentions the book with Pucelle's name as painter. In addition to the usual contents, this book of hours contains the

hours of St. Louis, a popular saint with the ladies of the French court.

Pucelle, in making an extraordinarily luxurious prayerbook, worked in a modified grisaille technique, using ink washes, but adding flesh tones and background colors and picking out a few details in red, blue, or pink. He painted both folios of an opening with scenes from the life of the Virgin and the Passion of Christ. By juxtaposing Christ's childhood with His torture and death, Pucelle created a somber atmosphere consonant with his choice of the grisaille technique. In one opening, the Annunciation and the arrest of Christ introduce the prayer for matins. The Virgin receives the angel Gabriel in her home as the dove of the Holy Ghost flutters through an opening in the paneled ceiling and angels rejoice from the upper windows. The initial letters are also historiated: in the initial the queen kneels with her book, guarded from unwanted visitors by a youth with a club or, in another interpretation, a man with a candle. Both the guarded door and the lighted way would be appropriate for a queen praying to the Virgin Annunciate. The letter "D" sprouts foliage and supports a musician and a monkey. In the lower margin the joy of the angels seems to spread to the children playing "Froggy in the Middle," a taunting children's game, which in the Middle Ages symbolized the mocking of Christ. Thus the lower marginal scene, known as a *bas-de-page*, relates to the opposite page, where Judas and the Roman soldiers crowd around Christ and the apostles. In that *bas-de-page*, figures riding goats mock knightly jousts.

51. Jean Pucelle (1325–88): Annunciation, Betrayal, *Hours of Jeanne d'Evreux*, Paris, 1325–28. Miniature on vellum. The Metropolitan Museum of Art, the Cloisters Collection, New York.

Pucelle borrowed widely but selectively, and by assimilating ideas from England, Italy, and his own French predecessors he created a distinctive, harmonious personal style. The mixture of religious narrative with secular allegory, the fantasy of the grotesque and foliate borders, and the supplementary *bas-de-page* came from England. The new spaciousness, especially the architectural interior rendered in linear perspective, was Italian in origin, and may be traced to Duccio's *Maestà* altarpiece of 1308–1311. Inspired by Italy, Pucelle increased the depth of modeling in his painting, although he still retained the linear surface patterns characteristic of Gothic art. He adopted Master Honoré's figure style, in which subtly modeled, voluminous draperies gathered up into swags of elegant rippling folds hide graceful, swaying bodies. Queen Jeanne d'Evreux's book of hours brings the review of French Gothic art to an elegant and royal conclusion just before the ravages of the Black Death (beginning in 1348) and the Hundred Years War (1337–1453) temporarily stifled French creativity. At the end of the Middle Ages new artistic centers in England, Italy, Spain, and Germany challenged French leadership in the arts.

NOTE: Studies and Definitions of the Gothic Style

Scholars have defined and redefined the Gothic style. Inspired by Johann Wolfgang von Goethe's praise of Strasbourg Cathedral, Romantics saw in the Gothic cathedral an architecture whose vertical proportions, accented by pointed arches, colonnettes, and tracery, created a soaring space and engendered in human beings intuitions of the sublime. Nationalists found in the Gothic style a northern German aesthetic, a will-to-form inspired by the vast northern forests. In contrast, architects and engineers such as Eugène Viollet-le-Duc and later Camille Enlart and Marcel Aubert looked at the masonry of the buildings and saw the pointed arches and ribbed vaults stabilized by flying buttresses weighted by pinnacles as the epitome of rationality.

While archaeologists excavated foundations and engineers calculated thrusts and wind resistance, historians such as Hans Hahnsloser and Robert Branner searched archives to document financial and workshop organization and the careers of patrons and builders. Art historians Hans Sedlmayr, Henri Focillon, and Jean Bony wrote of skeletal structure created to mold space, and Paul Frankl, in a brilliant reversal of Focillon's definition of the Romanesque "additive" aesthetic, suggested that the Gothic style was one of "creation by division." The Gothic cathedral was seen as a complete statement of Christian history and belief: for Emile Mâle it was a *Summa Theologica*, and a *Speculum* in stone and glass; for Hans Sedlmayr, the House of God and the New Jerusalem. To Erwin Panofsky, the Church was not only a Bible for an illiterate populace but also a demonstration of Scholastic principles and methodology in tangible form, while Otto von Simson found in its geometric proportions and luminosity the expression of Augustinian mysticism. Individual buildings received detailed study from Robert Branner at Bourges and Reims to Sumner Crosby at St. Denis and William Clark at Laon.

The dematerialization of the architecture—recognized by Viollet-le-Duc but analyzed further by Focillon, Bony, and Max Dvorak as a key to Gothic aesthetics—became in Hans Jantzen's felicitous phrase the principle of "diaphanous structure." Scholars, from von Simson and Panofsky to Sedlmayr and Grodecki, agreed that "light as form and symbol" remained essential to the definition of the High Gothic style. As Louis Grodecki wrote, "Gothic space is not merely an enclosed volume to be geometrically defined. It is a function of light; it is transfigured by light. . . . The notion of 'light-space' [interprets] the medieval church as the material realization of spiritual ideas, religious or philosophical" (Grodecki, *Gothic Architecture*, p. 20).

[CHAPTER XI]

National Styles in Gothic Art

How kings and bishops must have envied the luminous soaring buildings of France! In spite of civil and foreign wars, men like Henry III in England and Alfonso the Wise in Castile tried to compete with Louis IX as patrons of the arts, and they even commissioned French masters to replicate the Gothic splendors of Paris, Amiens, and Reims in London and León. Their own artists and craftsmen from Wells to Cologne, Lincoln to Burgos, accepted the *opus francigenum* with unabashed enthusiasm, but used local materials and building techniques, to create new regional styles within the Gothic idiom. By the middle of the thirteenth century ducal, royal, and episcopal courts all over Europe emerged as centers of patronage. In an age that began with the futile and vicious Fourth Crusade and ended with the disastrous Black Death, men and women found the courage, resources, and faith to build magnificent churches and to fill them with treasures.

Gothic Art in England

"Lackland" and "Soft Sword," the nicknames of King John, remind us that the thirteenth century did not open auspiciously for England [1]. King John lost his French lands to Philip Augustus, his control over the church to Pope Innocent III, and his royal prerogatives to his own barons. During his reign (1199–1216) the English strengthened the right of self-government and the power of common

law over the whim of a monarch. Baronial power culminated in the king's acceptance of the Magna Charta, or the Great Charter of Rights, which remains to this day the basis of English democracy.

Important as it was for political development, King John's unstable reign was not

1. Matthew Paris, map of Britain in the thirteenth century. The British Library, London.

331

conducive to the completion of great building programs. His successor, Henry III (1216–1272), inaugurated a new period of royal patronage of the arts when he rebuilt Westminster Abbey in self-conscious emulation of Louis IX in France. Meanwhile work continued on the cathedrals of Canterbury and Wells, and the building of a new cathedral at Salisbury in the early years of Henry's reign assured the widespread acceptance of the Gothic syle in England.

Henry's son Edward I (1272–1307) welded the people of the British Isles into a nation. Known as "the Hammer of the Scots," Edward I was a great warrior who conquered the Welsh but died fighting the Scots. He administered his realms efficiently, reformed the central administration, and substituted the rule of law and parliament for that of the autocratic local barons. To further incorporate Wales into the kingdom, he made his young son Prince of Wales, the title still held by the heir to the throne. The death in 1290 of his beloved Queen Eleanor inspired Edward to erect a series of monuments to her—the Eleanor crosses—in a new, luxurious style now known as the Decorated style.

Edward II (1307–1327) failed to live up to his father's or his country's expectations. Defeated by Robert the Bruce at Bannockburn in 1314, he gave up the dream of conquest and retired to London, where he lived in luxury, only to be deposed and later murdered at Berkeley Castle. After the monks of Gloucester courageously accepted Edward's body for burial in their Norman abbey church, Edward III (1327–1377) found it expedient to treat his father as a royal martyr. Gifts made possible a splendid tomb and, as a cult arose around the monarch, the influx of pilgrims stimulated the rebuilding of the church. The tomb, the choir, and later the cloisters built in the Perpendicular style embody English taste in the later Middle Ages.

Local traditions as well as political events determined the pattern of English Gothic art.

In Canterbury, as we have seen, the master builders William of Sens and William the Englishman adapted French Gothic architecture to local practices and taste. The determination of the chapter there to preserve as much of the old building as possible after the fire in 1174 led to the building of double transepts, and the murder of Thomas à Becket caused the chapter to add an axial chapel for his shrine. Other models also influenced the evolution of a distinctive English Gothic style. Cistercian buildings reinforced the Norman preference for rectangular plans, fine masonry vaulting, and geometric or foliate decoration. Furthermore, the tradition of fine carpentry dating back to the Anglo-Saxons and Vikings meant that timber construction remained important, and many Gothic buildings had timber roofs. Finally, the monastic influence on the English church remained strong. The cathedrals served by canons living under monastic discipline required cloisters, chapterhouses, and other appurtenances, and as the buildings are set in extensive grounds they still retain a rural, monastic character today.

The cathedrals at Wells and Salisbury are typical English Gothic buildings. Shortly after William of Sens and William the Englishman began the reconstruction of Canterbury, Bishop Reginald (1174–1191) began a new church dedicated to St. Andrew at Wells [2]. Documents of 1184 and 1191 refer to funds raised for work in the choir. Bishop Jocelin (1206–1242) pushed the work forward and consecrated his church in 1239. The choir was rebuilt in the fourteenth century and the towers were added in the fourteenth and fifteenth centuries in the Perpendicular style.

The nave at Wells demonstrates the English preference for horizontal extension, for length rather than height. The vault of the nave, only 64 feet from the pavement, is lower than the side aisles of the tallest French cathedrals [3, 4]. The thick walls, low proportions, and relatively small lancet windows in the clerestory enabled the masons to build ribbed vaults

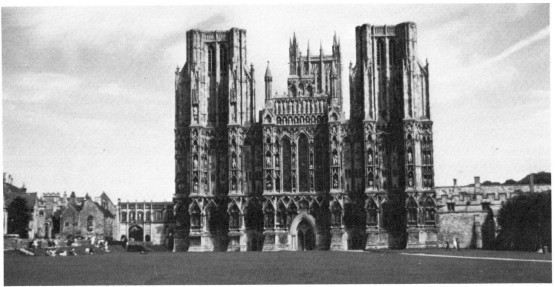

2. West facade, Wells Cathedral, begun after 1184; consecrated 1239. 147′ wide.

3. Nave and crossing, Wells Cathedral, begun after 1184; nave, thirteenth century; strainer arches, 1338.

4. Plan, Wells Cathedral, begun after 1184; consecrated 1239; chapter house, 1293–1319; choir rebuilt, c. 1325.

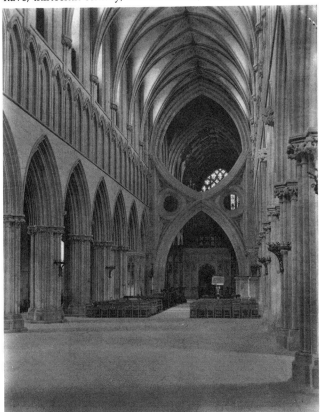

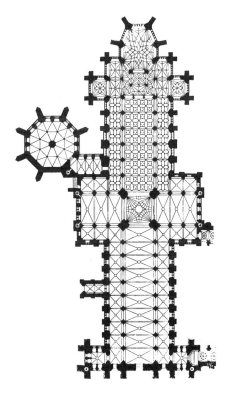

without flying buttresses; arches concealed under aisle roofs stabilize the vault. Furthermore, the English builders emphasized the horizontal quality inherent in the three-story basilican elevation. In the nave arcade, piers composed of clusters of twenty-four shafts support deeply splayed and molded arches. The zigzag movement they create down the nave is speeded in the second story, where a continuous arcade eliminates any reference to bays. Colonnettes springing from elaborate foliate corbels and framed by moldings resting on human heads support the vaulting ribs.

The builders of the nave at Wells used sculpture lavishly in capitals, corbels, and as terminations for the moldings which frame the arches. English builders continued to use ornament exuberantly; for example, the dog tooth pattern—a three-dimensional, pointed quatrefoil—gives a staccato accent to the smooth, repeated curves of an arch. The "stiff leaf" foliage of the capitals recalls the lively and luxurious Anglo-Saxon Winchester school acanthus ornament, and the introduction of figures and grotesques among the leaves, such as the man with a toothache or the fellow

pulling a thorn from his foot, is also distinctively English.

The nave at Wells seems austere in comparison to the rich facade of the cathedral. In contrast to the cathedral facades at Reims or Amiens, the designer of the Wells facade dramatized sweeping horizontality in his composition. He increased the breadth of the facade to 147 feet by setting the western towers outside the line of the nave walls. Then with row upon row of moldings, arcades, gables, and bands of quatrefoils he reduced the wall and its six huge buttresses to a surface pattern. The quatrefoils bend around the corners of the buttresses in a fashion which would have struck the French as illogical but on the English facade enhance the complex geometric pattern and the continuous horizontal movement. Slender lancet windows and insignificant western doorways replace the French rose windows and great gabled portals. The architecture becomes a mere scaffold for sculpture [5]: figures have the serene, idealized faces, delicate features, and tightly curled hair seen in the Paris angel, and their draperies fall in finely pleated parallel channels recalling

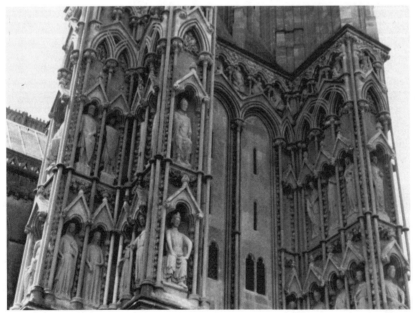

5. Sculpture on north tower, Wells Cathedral, early thirteenth century.

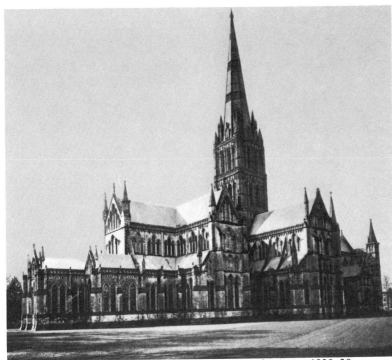

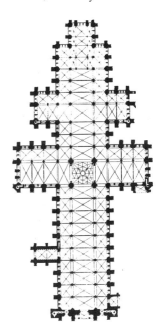

6. Salisbury Cathedral, 1220–58; crossing tower and spire, c. 1320–30.

the transept sculpture of Chartres; however, the crisp linearity and the elongation of the figures are typically English. Red, green, and black paint, gilding, and metal fittings as well as contrasting colored stones turned the west front at Wells into a dazzling replication of an altarpiece. If the French facade suggests a triumphal gateway, then the English screen facade becomes the glittering jeweled wall of the Heavenly Jerusalem on earth.

The choir at Wells was rebuilt in the fourteenth century; therefore, to see an Early Gothic plan with choir and axial chapel we must turn to the Cathedral of St. Mary at Salisbury [6]. Set in a broad close and dominated by the soaring fourteenth-century tower and spire, Salisbury has long been considered the prototypical English Gothic cathedral. In the thirteenth century Bishop Richard Poore asked permission to relocate his cathedral in the valley of the Avon for, he argued, the winds howled so loudly around the church at

Old Sarum that the clergy could not hear themselves sing the mass. Permission was granted, and, unlike most cathedrals, Salisbury was built on a new site and in a single campaign from 1220 to 1258 [7]. By 1256 the west front was finished. No preexisting structures determined the form of the thirteenth-century church, although Canterbury may have inspired the axial chapel and double transepts, and Cistercian architecture the spreading rectangular plan [8]. Massive walls and simple lancet windows permitted the builders to construct a ribbed vault without flying buttresses (although such buttresses had to be added to support the tower and occasionally to reinforce the upper walls).

Master Nicholas of Ely built the eastern chapel, dedicated to the Trinity and All Saints, between 1220 and 1225 [9]. United to the sanctuary by the ambulatory which forms its western bay, the open, rectangular space formed by three aisles of equal height seems

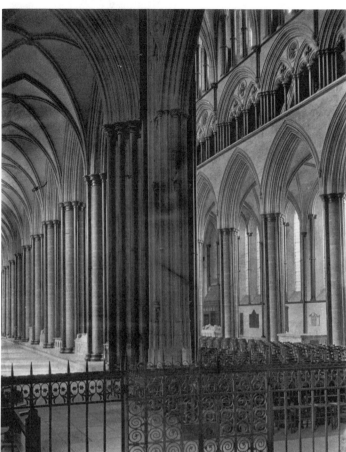

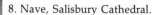
8. Nave, Salisbury Cathedral.

only incidentally broken by the slender Purbeck marble shafts which carry the vault. Although the architect may have been inspired by reports of building in western France, where the English held extensive territory, technically and aesthetically the chapel is a new building type in England.

A new wave of French influence came into England with the accession of Henry III. In 1245, only two years after Louis began to build the Ste. Chapelle in Paris, Henry started rebuilding Westminster Abbey to house the shrine of Edward the Confessor [10]. The architect, Henry of Reynes, introduced French elements into the plan and elevation by replacing the Norman apse of the abbey with an ambulatory and radiating chapels, the first French chevet in England, and by using flying buttresses to support thin clerestory walls and vaults. He divided the interior space into vertical bays with continuous wall shafts and filled the openings with bar tracery in the manner of the Cathedral of Reims. As a builder in England would, Henry retained the tribune gallery, added a ridge rib to the vault, and enriched the interior with colored stone and Purbeck marble. The lavish sculptured and painted decorations, such as the angels in the spandrels of the arches in the transepts, may have been inspired by the richness of the interior of Ste. Chapelle. Originally the walls had a diapered pattern in gold on a red ground. Red, green, and gold highlighted the foliate capitals, moldings, and carved angels. Then, as though to illuminate and emphasize the polychromed sculpture, the windows were

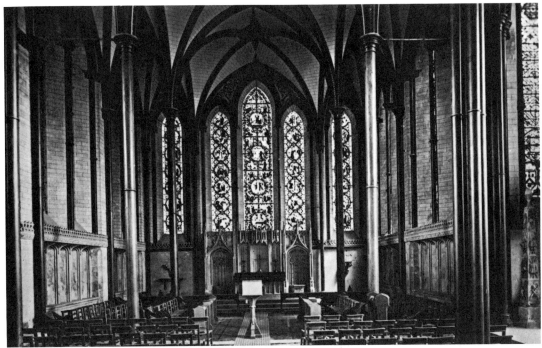

9. Master Nicholas of Ely: eastern chapel, Salisbury Cathedral, 1220–25.

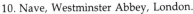

10. Nave, Westminster Abbey, London.

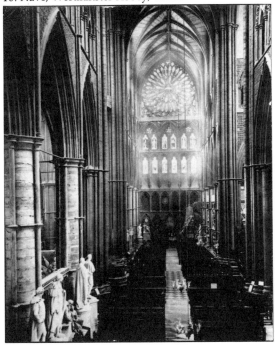

glazed with grisaille glass. Henry III, consulting with the court goldsmiths, intended Westminster Abbey to resemble a magnificent jeweled shrine for the Confessor.

Westminster Abbey introduced the Parisian court style into England; the Angel Choir at Lincoln acclimated the style [11]. By 1256, when the axial chapel at the east end of Lincoln Cathedral was begun, English architects were creating the Decorated or Curvilinear style. The chapel had the nave and side aisles, three-part elevation, and ribbed vault of early English Gothic, but the close spacing of piers and the steep pointing of the arches in the arcade create a sense of verticality, which in spite of profuse decoration leads the eye to the vault, where additional ribs, known as tiercerones, rise to the ridge rib from short colonnettes supported by elaborate foliate corbels. Polished Purbeck marble enhances the linearity of the design. In the second story, the wall disappears behind the decorative overlay of moldings, foliage, and the carved angels, which give the chapel its name. The

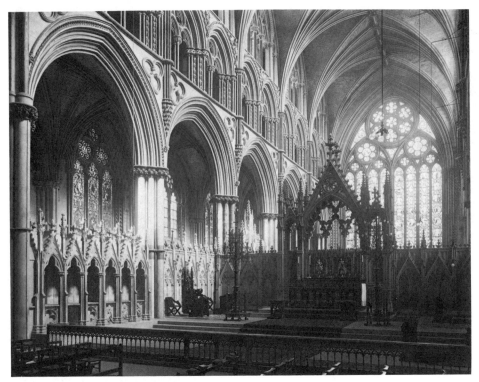

11. Angel Choir, Lincoln Cathedral, 1256.

idea of enriching spandrels with trefoil tracery and angels was borrowed from Westminster Abbey. New at Lincoln is the reduction of the double wall construction in the clerestory to a diaphanous Gothic screen of double tracery. And new, too, is the way in which foliage creeps out around marble shafts and even moldings seem to flower. All this exuberant decoration was meant to be appreciated, for the building is brightly illuminated by a huge eastern window, 59 by 29 feet, whose tracery doubles the motif of cusped arches and oculi established in the clerestory (the stained glass was replaced in 1885). Edward I and Eleanor of Castile witnessed the solemn transfer of the relics of St. Hugh to the completed chapel in 1280.

The Angel Choir stands at the beginning of an experimental phase in English art, a period characterized by lighter construction and increased ornament and named for the flowing tracery of the large windows. Designers turned vaults into intricate nets by adding extra ribs,

or lierns, to the already complex tiercerone vaults. They made piers into diamond-shaped clusters of slender shafts; then by eliminating galleries or reducing them to simple balustrades, they developed two-story elevations. They covered the surfaces of their structures with complex shallow moldings, tracery, foliage, and figure sculpture. Three new architectural ornaments added a lighthearted elegance: "bubble foliage," the ball flower, and the "nodding ogee" arch. Bubble foliage (a wonderfully descriptive name coined by Lawrence Stone) looks like seaweed; ball flowers are tightly closed, stylized rose buds; and the flamelike ogee arch moves outward as well as upward to produce the "nodding" effect which makes a wall seem to ripple. By the fourteenth century this ornamental, curvilinear style took on even more extravagant forms. The Decorated style was decorated indeed!

Some of the most beautiful sculpture and architecture at the end of the thirteenth century was inspired by the memory of Eleanor of

Castile. After she died in 1290, Edward ordered monumental crosses erected to mark the resting places of her bier on its journey from Lincoln to Westminster. The crosses, with their tiers of cusped ogee arches, bubble foliage, crockets and finials, roses, fret work, naturalistic foliage, and idealized portraits of the queen, popularized the new style, which reached its apogee in the Cathedral of St. Peter in Exeter.

Rebuilding of the Norman Cathedral of Exeter began about 1270 [12]; a new master mason, Roger, headed the shop by 1299. The nave vault was completed only in the 1360s, after the country began to recover from the ravages of the Black Death. The effect of the interior is startling; every surface, whether wall, pier, or vault, has been reduced to line. Diamond-shaped piers whose surfaces are concealed by thin, sharply molded shafts, speed the zigzag movement toward the altar. A tiercerone vault runs uninterrupted the length of the nave and choir; eleven vaulting ribs in each bay spring from shafts supported

on richly carved corbels and spread to meet bosses on the ridge rib only sixty-nine feet above the pavement. An arcade of cusped arches in the second story and a continuous quatrefoil balustrade along the clerestory passage emphasize the horizontality of the building. Four-light clerestory windows have complex tracery heads, whose very inventiveness invites the eye to wander over painted and gilded surfaces. Finally, in the east window of the choir, a combination of grisaille and stained glass produces a silvery gold light similar to that in Troyes and Evreux.

In the choir the bishop's throne, with its towering canopy (1312), demonstrates the appropriateness of the style to wood [13]. Tiers of pinnacles seemingly set on slender piers are united by arcades of nodding ogee arches carved with angels and foliage. Every surface seems to undulate; bubble foliage ripples over the surface while the arches twist in and out in the flamelike forms. The serpentine forms disguised the actual mechanics of the structure.

12. Nave, Exeter Cathedral, 1270–1366.

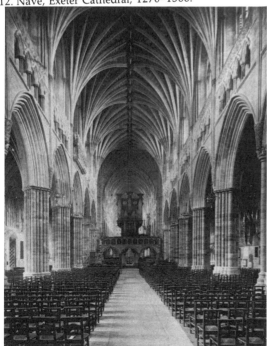

13. Choir and bishop's throne (1312), Exeter Cathedral.

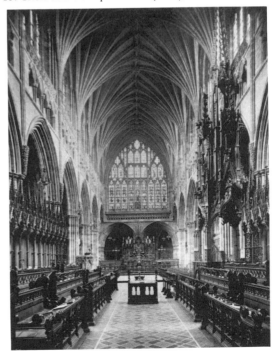

Such a technique is diametrically opposed to the rationality and explicit statement of function found in French Gothic art.

Many thirteenth-century buildings were completed with splendid towers and spires in the fourteenth century. At the Cathedral of Wells, a crossing tower built in 1315–1322, and larger and heavier than the original builders had intended, caused the masonry to crack. In 1338 the architect inserted strainer arches (masonry braces, like tie beams) formed by four pairs of inverted arches between the piers on all four sides of the crossing. These sweeping arches turned dire necessity to aesthetic advantage by dramatizing the entrance to the choir.

At Salisbury, too, the builders added a grand tower to the thirteenth century cathedral. About 1320–1330 Master Richard of Farleigh built a crossing tower with a spire rising to the extraordinary height of four hundred feet. He divided his tower horizontally into two stories and vertically with four pairs of tall lancets on each face. Massive buttresses at each corner support the structure; and a double tier of pinnacles at each corner and gable in the center of each face lead the eye from the square tower to the octagonal spire. Far higher than anything visualized by the original builders, the spire has such harmonious proportions that it seems the logical, and indeed inevitable, focal point of the architectural composition.

The most brilliant of the series of crossing towers, erected before the Black Death brought major building campaigns to a halt at mid-century, is a timber octagon at Ely [14]. When the Norman crossing tower of the Cathedral at Ely collapsed, the chapter decided to rebuild it at once. Alan of Walsingham, the sacristan, brought the king's carpenter, William Hurley, from London to design and supervise the construction of a tower and lantern (1328–1347). Instead of restoring four piers and a square tower, William constructed eight masonry piers, which form an octagon seventy-two feet in diameter. They carry a wooden superstructure having a tiercerone vault and octagonal lantern closed by a star vault. Oak timbers sixty-three feet long and over three feet thick at the base form the vertical members of the lantern. These huge posts were supported on hammer beams cantilevered out from the walls and hidden by the tiercerone vault. The octagon is more than a technical achievement; it is one of the finest spatial designs produced in a period famed for the ingenuity of its builders. The tiercerone ribs literally shape the space, sweeping the viewer/worshiper through the streaming light from the lantern into the star of the vault. The effect is spectacular.

The repetitive linear quality of the Exeter nave and choir and the Ely octagon suggests the emergence of a new aesthetic, based on the forms of carpentry as well as on the mannered French Rayonnant. The new style, known as Perpendicular, is a court style which appeared first in London and in monuments closely related to the royal court—for example, the tomb of Edward II in Gloucester (1329–1334) [15]. Edward III established a cult around his murdered father (just as Edward I had for Queen Eleanor) and only two years after the murder he ordered an elaborate freestanding tomb. The effigy is not a portrait but rather an image based on the traditional representations of God the Father. The tranquil gaze of Edward's engraved eyes, and the elegant stylization of his waving and curling beard and hair idealize the king. Using alabaster for monumental figure sculpture for the first time, the artist exploited his material to produce undulating forms and a translucent surface finish that suggest an almost decadent luxury. The canopy over the tomb has nodding and cusped ogee arches, battlemented string courses, gables framed by gables, and a veritable forest of buttresses and pinnacles. The sharp angularity of the forms and the rectilinearity of the composition produce a brittle effect which contrasts with the soft, idealized

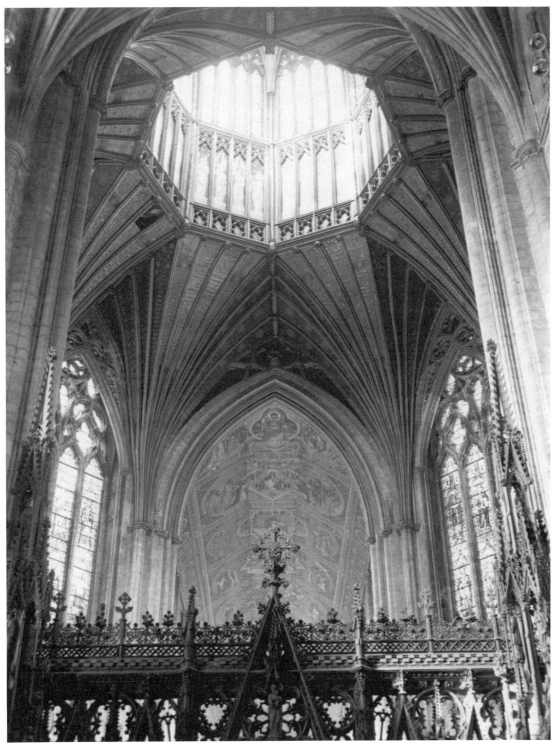

14. Ely Cathedral, lantern, 1328–47.

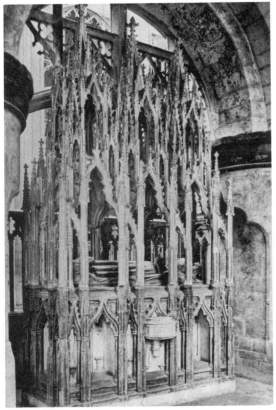

15. Gloucester Cathedral, Tomb of Edward II.

composition, enlarged many times over, could have served as the cartoon for a stained-glass window. More rondels in a horizontal panel at the bottom of the page continue the story from the Fall of Man to the sacrifice of Isaac. The remainder of the letters of the opening words form another narrow vertical composition, foliate scrolls, winged beasts, and blue-and-pink panels overlaid with delicate and varied geometric patterns frame and ornament the text. The ambitious narrative forced the artist to reduce the size of individual scenes. Tiny figures are too small to allow for three-dimensional modeling; thus the reader notes brilliant colors, burnished gold, and fine drawing—in short, an enriched page—rather than the expressive content of any individual scene or figure.

The flowering of English Gothic manuscript

figure. The Perpendicular style used here in miniature architecture appears in full-sized buildings throughout the late Gothic period in the British Isles and in time became England's national style.

England produced fine painters as well as sculptors and builders. Scriptoria in both France and England excelled in the production of fine illuminated manuscripts in the thirteenth and fourteenth centuries. A Bible made for Robert de Bello (d. 1235), Abbot of St. Augustine's Abbey, Canterbury, is as fine as anything produced for the French court [16]. The artist, like his compeers in France, used a repertoire of models available to painters of stained glass as well as manuscripts. In the "I" of *In principio*, the opening words of Genesis, the artist contains the vast panorama of creation within overlapping rondels; his

16. Initial "I" (*In principio*) with scenes from Genesis, *Bible of Robert de Bello*, Canterbury, before 1235. Miniature on vellum, 10 5/8″ × 7 7/8″. The British Library, London.

17. *Beatus vir qui non abiit: Windmill Psalter*, England. 12 3/4″ × 8 3/4″. The Pierpont Morgan Library, New York.

18. *Beatus vir qui non abiit: Windmill Psalter*, England. 12 3/4″ × 8 3/4″. The Pierpont Morgan Library, New York.

illumination coincided with the Decorated style in architecture, and the supreme skill of English draftsmen shines in the *Windmill Psalter* [17, 18] and the *Queen Mary Psalter*. In English Gothic psalters scenes from the Old and New Testaments in historical sequence were followed by a calendar with signs of the zodiac and labors of the months. Then a large initial "B" indicated the beginning of the Psalter proper, with the opening words of the first Psalm, *Beatus Vir*, "Blessed is the man." The Beatus initials interlaced with acanthus vines filled the entire page. In the *Windmill Psalter* (c. 1270–1280) the great "B" holds the Tree of Jesse, wherein Jesse, King David, the Virgin and Child, and God the Father are adored by saints and prophets (color plate VII). The heavy colorful painting contrasts with the following page, where King Solomon—in line of succession in the genealogy of Christ—

renders judgment. The king is enthroned on the cross bar of the letter "E" and the child is at the terminal, with the contending mothers above and below. An angel swoops down toward the text holding a pennant containing the remaining letters, *atus vir qui non abiit*, in gold on blue. A windmill, which gives the psalter its name, and an equally realistic pheasant perching on a tree add lively genre elements, and as if to complete the repertory of ornament, an elderly male grotesque with a winged serpentine body whose tail ends in a bird's head fills the end of the line. The page is framed and the "E" filled with a filigree of ivy leaves in pale olive green against red and blue and surrounded with scribal flourishes of the most energetic and elegant sort. Perhaps the illustrator is still thinking in the literal terms like the draftsman of the *Utrecht Psalter*, for "the blessed man" who

19. Christ in the temple, *Queen Mary Psalter*, England, c. 1310. 7″ × 4 1/2″. The British Library, London.

takes delight in the law of the Lord is exemplified by Solomon the just judge, and he is likened to the tree whose leaf does not wither, justification enough for the evergreen ivy leaves.

The initial "E" does not frame the scene. Instead it lies over the transparent leafy background and establishes a forward plane behind which the figures move. The swordsman hooks his toe under the "E"; the angel somersaults over the text; Solomon's position remains ambiguous; the windmill makes no "sense" whatsoever; the ornament spreads like tracery over the page. Skilled draftsmanship has been

characteristic of the British Isles since the Hiberno-Saxon period, and the pen work of the *Windmill Psalter* is a worthy successor to the interlaces of the *Lindisfarne Gospels*.

In the *Queen Mary Psalter*, produced in East Anglia about 1310, narrative supplants fantasy [19]. To illustrate the text the youthful Christ teaching in the temple sits on a tall columnar stool under a round tower while the disputants stand or sit under an arcade and an amazed Mary and Joseph look in the door. These elegant figures occupy a narrow stage space established by architectural canopies, like figures in the tympana of sculptured portals.

Diapered gold backgrounds close off any suggestion of movement into a deeper space. The *bas-de-page* is a tinted drawing completely unrelated to the Biblical narrative above: two ladies and a gentleman on spritely horses hunt ducks with falcon. The well-observed bird of prey, the escaping ducks, the energetic activity of the falconer, and the fluttering veils of the ladies create a vivid scene. The delicate drawing and well-observed natural detail made such *bas-de-page* illustrations brilliant heralds of a new age.

Closely related to painting is English pictorial embroidery. In the thirteenth and fourteenth centuries English needleworkers so dominated the art that fine embroidery in colored silk and gold thread came to be known as *opus anglicanum*. The English perfected the technique of covering a linen base with fine satin stitches, which modeled faces and draperies. Couching stitches with gold thread reproduced the appearance of the burnished gold backgrounds of manuscript illuminations. The Syon Cope, c. 1300, for example, has as its principal

themes the Coronation of the Virgin, the Crucifixion, and St. Michael fighting the dragon [20]. The cope, an all-enveloping cape worn by the bishop, presented an especially difficult problem for the designer. Not only did the composition have to fit the semicircular shape of the garment but the figural scenes had to be distributed so that they presented an effective picture when the cope was worn. In addition, the artists of the Syon Cope had to adapt figures to the shape of medallions and interlocking barbed quatrefoils and to arrange the figures so that they would appear upright. Since the figures radiated from the wearer's head, some of the apostles and angels had to be embroidered on a slant within their frames. Well-designed vestments turn the celebrating clergy into semi-architectural elements aesthetically harmonious with the surrounding choir. In the fourteenth century English artists created vestments, altar frontals, retables, liturgical vessels—and buildings—which achieve a rare unity and continuity of form.

20. St. Michael, Syon Cope, England, c. 1300. *Opus anglicanum* (embroidery in silk and gold thread). The Victoria and Albert Museum, London.

Gothic Art in Germany

The Holy Roman Empire in the thirteenth and early fourteenth centuries stands in striking contrast to France and England. Whereas the latter kingdoms emerged as strong monarchies, the Holy Roman Empire became a decentralized conglomeration of independent counties, bishoprics, and towns under the nominal but often ineffectual rule of an emperor. The brilliant scion of the Hohenstaufens, Frederick II, crowned king in Aachen in 1212 and emperor in Rome in 1220, spent most of his time in Italy. After his death in 1250, Germany existed in a state of near anarchy until, by 1273, even the fractious German nobles realized that they needed a central organization. They elected Rudolph of Hapsburg to be their emperor. The Holy Roman Empire survived as an ideal, even though, in Voltaire's famous phrase, it was "neither holy nor Roman nor an empire," until Napoleon delivered the *coup de grâce* in 1806. In spite of political turmoil, patronage of the arts continued, and the German spirit and style seems stronger and more consistent than the history of the country would suggest.

Nowhere was initial resistance to the new French Gothic art more resolute, and later adoption of the style more enthusiastic, than in the Rhineland. In the eleventh and twelfth centuries German masons and patrons had built huge Romanesque churches, and throughout the Empire this emphasis on monumentality, solidity, and geometric purity satisfied the patrons' desire for grandeur. Just as Ottonian art lived on in the churches of the twelfth century, so in turn the Romanesque style survived well into the thirteenth century. To approach the Cathedral of Worms from the west, for example, is to experience a sense of slipping back into an earlier age [21]. Soaring towers at east and west, joined by a long nave, could have been conceived by a Carolingian architect. The Romanesque eastern transept with its massed towers and choir was begun in the 1170s, but the nearly matching western choir complex was finished in the third decade of the thirteenth century. The arcaded galleries at the top of the walls and the blind arcades around the lower story, the strip buttresses and arched corbel tables are all traditional elements of Romanesque architecture in the Rhineland, yet this choir is contemporary with the facades of Paris and Amiens. Perhaps the rose windows of the French cathedrals inspired the Worms architect to design his great circular windows, but the idea of surrounding the rose with three subsidiary roses is evidence of a late Romanesque taste for repetitive geometric forms and exuberant decoration. The emphatic mural surfaces of the German building are very different from the diaphanous quality of French facades or the linear, trellis-like designs of England.

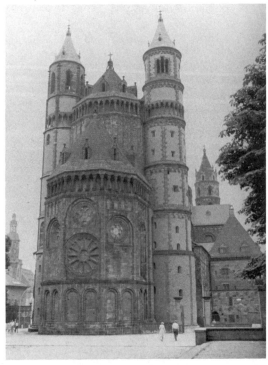

21. Western choir, Worms Cathedral, early thirteenth century.

Imperial taste triumphed again in the west choir of Worms cathedral.

The conservative character of German art in the early years of the thirteenth century is as apparent in the visual arts as it is in architecture. Imperial artists had looked to Byzantium for inspiration since the days of the Ottos, and thus it is not surprising to find German painters in the early thirteenth century maintaining contact with Byzantine art. In the hands of the German painters—for example, at Hildesheim, where a Tree of Jesse was painted on the wooden ceiling c. 1230—the ornamental, domesticated Byzantine style became more mannered and emotion-charged. Characterized by jagged zigzag lines, especially in drapery, the style combines the dynamic linearism of northern drawing and the figure and drapery styles of Byzantine and Imperial Romanesque art. In the second quarter of the thirteenth century the Zackenstil, or zigzag style, reached a peak of sophistication in the altarpiece of the Trinity at Soest and a lively folk-art quality in manuscripts such as the *Westphalian Bible* leaves now in the Cleveland Museum of Art [22]. The style has become intricate and angular, as though the painter had redrawn Byzantine icons with a straight-edge and compass. The painter observed some of the conventions of Byzantine drawing and modeling but turned every element into a harsh pattern. Brilliant colors against a gold ground enhance the decorative quality of the miniatures.

Slowly French art and architecture came to be accepted by German patrons and artists. Masons understood the structural advantages of French building; however, not until mid-century did patrons demand the aesthetic effect produced by increased light and height. Once

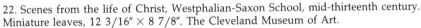

22. Scenes from the life of Christ, Westphalian-Saxon School, mid-thirteenth century. Miniature leaves, 12 3/16″ × 8 7/8″. The Cleveland Museum of Art.

they adopted the principles of French architecture, German architects carried the style to an extreme, dematerializing form beyond anything attempted in France. Acceptance of the new art may have been stimulated by a change in religious attitude. The inspired preaching by the friars turned people toward private meditation, and personal mystical experience became as important as communal celebration of the mass. The idealized geometry and diaphanous quality of French Gothic art became an instrument for the expression of the new mysticism, and the architects looked to build-

ings like the choir at Amiens, the Ste. Chapelle, and St. Urbain at Troyes for inspiration.

The rebuilding of the Cathedral of Cologne provided a splendid opportunity to introduce the French style into the Rhineland. When Master Gerhard drew up the first plan for the new church in 1248 [23], the choir of Amiens served as a model for the five-aisled choir, three-aisled transept, and chevet. The seven radiating chapels, unlike those in Amiens, are all of equal size, and the double-aisled nave could have been derived from Paris or Bourges, but details of the decoration and the super-

24. Cologne Cathedral in the fifteenth century: Hans Memling, *Shrine of St. Ursula*, (detail), Flanders, 1489. Museum of the Hospital of St. John, Bruges.

23. Plan, Cologne Cathedral, begun 1248; choir finished, 1322; work ended, 1560; completed, 1880.

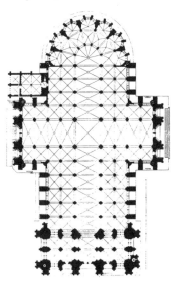

structure reflect both Amiens and the Ste. Chapelle. The thin wall of the choir, supported by the first flying buttresses in Germany, seems to dissolve; the windows of the clerestory are supported by a glazed triforium and the windows of the chapels below also illuminate the ambulatory. Extremely pointed arches are used throughout, and slender shafts running the height of the building emphasize the elongation of the arcade piers. Finally, inspired by the interior sculpture used on the walls of the Ste. Chapelle, the Cologne sculptor suspended canopied figures in front of the piers of the arcade.

Work progressed slowly, and not until the fourteenth century could Nicholas of Verdun's shrine of the three Magi be moved to its place of honor and the tombs of former archbishops be placed in the radiating chapels. The choir was dedicated in 1322, but Cologne was not finished in the Middle Ages. Hans Memling recorded its appearance in the fifteenth century in his painting of the legend of St. Ursula [24]. By that time the unfinished nave and the huge wheel and lifting apparatus on the tower had become a permanent part of the Cologne skyline. In 1560 work came to a halt. The discovery of the plans of the cathedral in the nineteenth century stimulated the already growing German romantic identification with the Gothic as the national style of northern Europe, and the burgers of Cologne finished their Cathedral in 1880. In spite of the dry, repetitive style of the nave, gigantic size and mathematical precision make Cologne Cathedral a masterpiece of Rayonnant architecture in Germany.

Had it been completed, the west facade of Strasbourg Cathedral [25] would have been the finest piece of Rayonnant architecture in either France or Germany (and claimed by both). In 1277 Erwin von Steinbach designed a new facade for the cathedral [26]. Although he must have studied French Rayonnant buildings, he created an entirely new and daring facade, conceived of as a gigantic trellis,

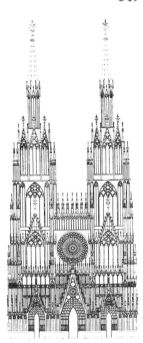

25. Nineteenth-century drawing of proposed facade based on a contemporary drawing, Strasbourg Cathedral, begun 1277.

26. Erwin von Steinbach: west facade, Strasbourg Cathedral.

a "harp work" in stone, two feet in front of the old facade and hiding the original wall behind a delicate screen of vertical columns. The High Gothic balance between vertical and horizontal elements is eliminated by breaking every horizontal line with a series of steeply pointed gables, tabernacles, or pinnacles. The facade was built to the height of the rose in the Middle Ages, and the existing tower and dwarf spire only hint at the elegance of the original conception—a pair of open towers supporting slender spires. Erwin intended to create a triumph of Gothic transparency in stone. Erwin's plans undoubtedly were widely known, for the architect of the Cathedral of Freiburg-im-Breisgau (c. 1330) adopted elements of the design for his church.

German sculpture and painting followed a similar course of resistance to, and then adoption of, the new French art, a pattern observable in the sculpture cathedrals of Strasbourg, Bamberg, and Naumburg. Bamberg cathedral's portals and choir screen (c. 1230) are late survivals of an early Gothic style, while individual sculptures on the inner piers—the Visitation and the mounted knight—show the influence of Reims. Strasbourg masters, too, knew Reims but here the Joseph Master rather than the Classical Shop was followed.

At Naumburg a church was built on the site of the castle of Margraves Hermann and Ekkehard, whose idealized portraits stand in the western choir of the church. Their descendant, Bishop Dietrich II of Wettin (1244–

27. Choir and screen, Naumburg Cathedral, c. 1240–60.

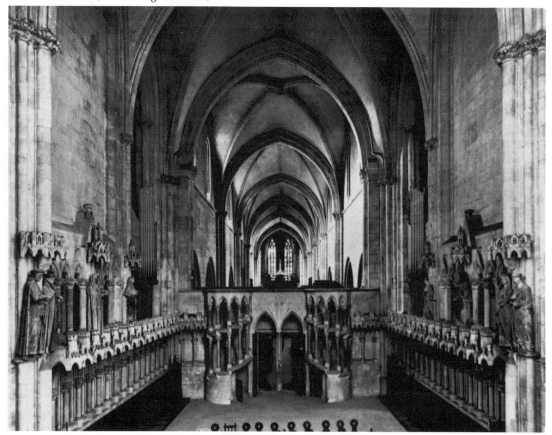

1272), built this choir as an expiatory chapel for his ancestors. Inspired by the Ste. Chapelle, the Naumburg choir [27] differs from its model in important ways: in the increased proportion of masonry to glass, in the frank statement of weighty mass in the base and supporting piers, in the emotional content of the iconographical program, and in the realism of the sculptured figures.

Architecture, sculpture, and stained glass have been united in a single theme of sin and atonement. On the choir screen the Passion and Crucifixion of Christ face the nave as a constant reminder of the sins of mankind, the sacrifice of Christ, and the coming Last Judgment. The worshiper walks into the choir under the very arms of the crucified Christ and so seems to join the grieving Virgin and St. John. Within the chapel sculptured members of the houses of Billung and Wettin seem to observe and participate in the Mass, and the stained-glass windows portray the heavenly host, which surely the bishop hoped he and his ancestors would join. Directly opposite the entrance stand the two men most in need of intercession—Ditmar, a traitor who died in ordeal by combat, and Thimo, a murderer. Some members of the family turn away in dismay; others simply await judgment. At each side of the chapel stand the original founders of the church and their wives— Margrave Ekkehard of Meissen and his wife Uta: Ekkehard the proud, doughty warrior; Uta, the epitome of feminine grace and elegance [28]. Uta draws her cloak up to her face in a simple, telling gesture. She has too much dignity to shrink from the judgment which awaits her, but still she shields herself with her garment as she gazes on some private vision. The broad, heavy folds of her cloak, grasped with delicate fingers into a Gothic cascade of mannered folds, represents the most mature and elegant version of Gothic sculpture in Germany, comparable to the art of the Joseph Master in Reims.

On the choir screen, in the narrow, com-pressed stage space formed by columns and spiky gables, large figures act out the drama of the Passion [29]. They resemble actors in a Passion play; the gestures of the jostling, whispering, greedy figures seem observed from life. German realism often borders on caricature, but here it is still restrained. In the grim Crucifixion, the dignity of the Virgin and the pathos of the dead Christ give way to an almost hysterical grief in St. John. His twisting figure and grimacing face foreshadow the excesses of emotionalism into which German art so easily falls in the late Gothic period.

The melodrama inherent in the Naumburg sculpture is still restrained by the dignity and idealism of the High Gothic period and the elegance of the courtly Rayonnant style; however, by the fourteenth century the visual arts

28. Ekkehard and Uta, choir, Naumburg Cathedral.

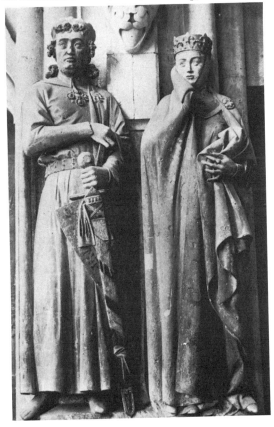

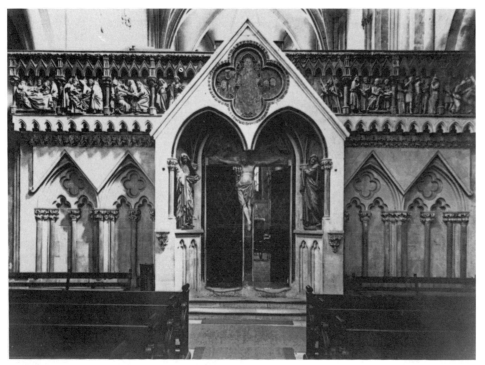

29. Choir screen, Naumburg Cathedral.

30. The Crucified Christ, Cologne, fourteenth century. Height, 16 3/8". The Cleveland Museum of Art.

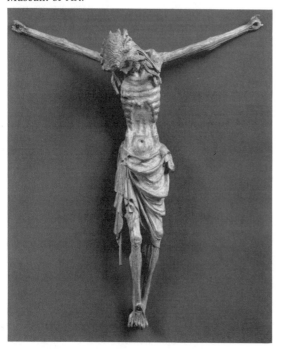

abet the impact of the new mysticism through the depiction of the suffering of death, the horrors of decay, the agony of survival. Art spoke directly to a people beset by disease, warfare, and starvation. The crucified Christ was no longer triumphant or pathetic but a hideous, emaciated figure, a victim of man's viciousness, an image of torture and physical destruction [30].

To make the horror of the death of God all the more poignant, the scenes of public lamentation were reduced to a very private scene of mourning. Images of the Virgin holding the body of her Son tenderly in her lap replace the joyous Madonna and Child as the image for private devotions. Known as the *Vesperbild* in Germany—that is, an image for meditation at evening prayers—the powerful new theme spread from the Rhineland across Europe. In Italy it is known as the *pietà*. Such images were not the sole prerogative of Germany; equally powerful and poignant figures were produced in the Lowlands and Scandinavia, in Central Europe and in Spain, where the

constant threat of plague and starvation made the promises of the Church the chief consolation of the populace.

Gothic Art in Spain

Five kingdoms shared the Iberian Peninsula: Christian Castile, Navarre, Portugal, Aragon-Catalonia, and Moorish Granada. The Castilian kings Ferdinand III (1217–1252) and Alfonso the Wise (1252–1284) consolidated their power and reconquered the southern half of the peninsula from the Moors. The Christians won a great victory at Las Navas de Tolosa in 1212 and in 1236 the center of Muslim culture in Spain, Cordova, fell to St. Ferdinand. Seville was taken in 1248, leaving only the tiny kingdom of Granada as an outpost of Islamic culture in the west.

Close personal ties existed between the royal houses of Castile and France; Ferdinand III was the nephew of Queen Blanche of Castile, thus making the two royal saints, Ferdinand and Louis, cousins. When Bishop Maurice of

Burgos was entrusted with the task of escorting King Ferdinand's fiancée, Beatrice of Swabia, to Spain, he refreshed his memories of Gothic building by also visiting Paris, where he had been as a student. King Ferdinand and Beatrice were married in the old cathedral of Burgos in 1219, and not surprisingly in 1221 they donated money for a new building [31]. Bishop Maurice and his first architect, Martin (who may have come from Paris), intended to build a French Gothic cathedral in Castile. Their plan [32] called for three aisles with projecting transept, a three-bay choir with ambulatory, and five radiating chapels of equal size. The building was vaulted throughout in the French fashion with rib vaults and flying buttresses. Work moved along swiftly; the bishop celebrated mass in his new choir in 1230 and was buried there in 1238.

In Burgos, as in Bourges, the broad proportions of the building are countered by low side aisles, which create an impression of height in the nave. Cylindrical piers with eight engaged shafts support the arcade, and the

31. Burgos Cathedral, thirteenth–sixteenth centuries (begun 1221).

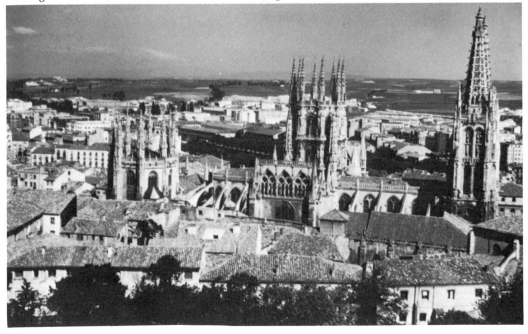

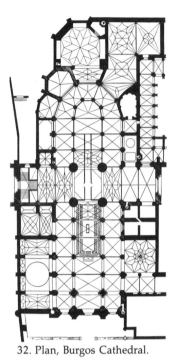

32. Plan, Burgos Cathedral.

33. Portal, south transept, Burgos Cathedral.

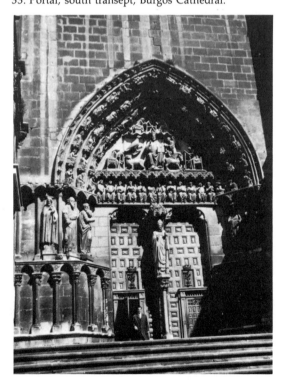

triforium opens into the nave through wide arcaded arches. Bourges, however, was not the only model used by the builders of Burgos. Reims inspired the tracery of the clerestory windows, and Anglo-Norman Gothic architecture, the ridge rib. Evidence of Mudejar influence appears in the trefoil-headed openings of the second-story overall decoration. Mudejar art—that is, the art of Moors working for Christian patrons—pervades Spanish taste in the later Middle Ages.

Even in Burgos, the most French of Spanish cathedrals, national characteristics emerge in the short, wide plan and the cubical, horizontal composition. Gone are the steep roofs of France, for here the climate permitted roofs to be built with only a moderate slope or with tiles laid directly on the vaults. Decorative emphasis on the tops of walls added to the horizontality of the external composition. Originally exterior decoration was limited to portals; however, today chapels, towers, and spires mask the original exterior. Decoration was lavished on the interior in *retablos* (altarpieces), *rejas* (iron grilles), tombs, and choir stalls. The choir stalls, as in early Christian usage, filled the first bays of the nave west of the crossing. Spanish churches often appear dark, mysterious, and cluttered with accumulated offerings.

Sculpture for the Cathedral of Burgos was also inspired by the Paris-Amiens-Bourges style. The south transept portal (1221–1230) followed the French High Gothic arrangement with sculptured tympanum, voussoirs, trumeau, and jambs [33]. The iconography is conservative and based on the Apocalypse, not the Last Judgment. In the tympanum Christ is surrounded by working evangelists, supported by apostles in the lintel, and adored by angels in the voussoirs. The trumeau figure of the bishop resembles the *Beau Dieu* of Amiens. (The figures in the jambs are later replacements.) The nobility of the faces, the quiet dignity of the figures, the broad sculptural drapery defining and disguising the fig-

ures at the same time are so close to the Paris-Amiens style that scholars have suggested that a master came to Burgos from Amiens. The interpretation of the theme, however, already suggests a Spanish fascination with realistic genre detail; for example, the artist was not content with generalized figures and symbols of the evangelists, and he represented the authors as scholars seated at desks with all their equipment, actively engaged in writing the Gospels.

Masters from Burgos moved on to León later in the century. On the west facade of the cathedral (a building begun in 1254 in the French Rayonnant style) the sculptors brought together the idealism of Burgos sculpture and a new strain of elegance and realism which could have been inspired by Reims and the Joseph Master [34]. This contradictory combination of decorative idealism and specific realism became a hallmark of Spanish art. At León, the Virgin and Child on the trumeau and the blessed souls in the lintel are just such extraordinary figures. The Virgin, known as *Nuestra Señora la Blanca* because of original painting and gilding, must have resembled an ivory figure. She is erect, dignified, bundled in angular draperies; her full veil and crown almost overshadow her handsome face. Above her in the lintel (c. 1270–1285) the scene of the blessed becomes an earthly fiesta: a happy group of people chat and listen to the organ as they wait their turn to be welcomed by St. Peter into paradise. The genre treatment of the subject, the variety of types, and the details of the angel organists, together with the pictorial quality of the relief, suggest that the artist knew the later sculpture of Reims but that he carried Gothic realism even further. Like the thirteenth-century encyclopedists, the Leónese masters are concerned with all the details of the natural world.

In contrast to Castile, Catalonia became a major commercial power in the Mediterranean in the thirteenth century. King Jaime I (1213–1276) extended his power by conquering Ma-

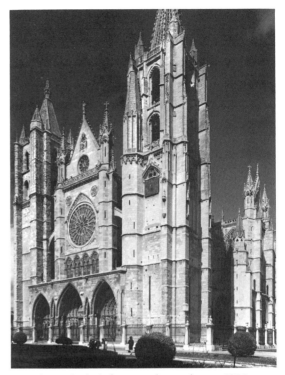

34. León Cathedral, from southwest, begun 1254.

llorca in 1229 and Valencia in 1238. A distinctive Catalan Gothic style developed, inspired by southern French buildings, Cistercian monastic architecture, and only indirectly by the Gothic of the Ile-de-France. Parish churches and secular buildings as well as cathedrals rose in the prosperous cities.

In 1298 building began on the Cathedral of Sta. Eulalia in Barcelona under the direction of Bertrand Riquer, and by 1318 the famous Mallorcan architect Jaime Fabre had begun to give the cathedral its distinctive character. The east end was completed in 1329 [35]; however, work continued for another one hundred years [36]. The builders combined the wide, aisleless, internally buttressed hall of Languedoc with the Cistercian use of severe masonry and transverse vaulted aisles and French ribbed vaults and tracery. New is the spatial unity achieved by raising the aisle vaults almost to the height of the nave while still suggesting

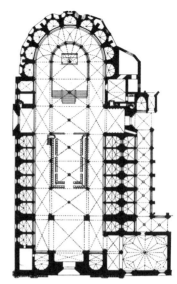

35. LEFT: Choir, from northeast, Cathedral of Sta. Eulalia, Barcelona, begun 1298.

36. ABOVE: Plan, Cathedral of Sta. Eulalia, Barcelona, fourteenth century.

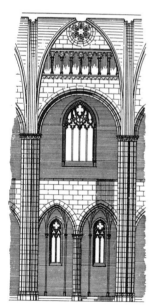

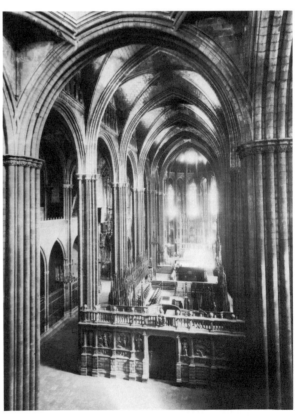

37. ABOVE: Elevation, Cathedral of Sta. Eulalia, Barcelona.

38. RIGHT: Nave and choir, Cathedral of Sta. Eulalia, Barcelona.

the basilican three-part elevation, although the triforium and clerestory oculi seem squashed between the high arcade and the vault [37, 38]. Clustered colonnettes with tiny capitals form piers almost fifty feet high, which support the ribs of both the nave and the aisle vaults. Enormous internal buttresses form the lateral walls of double chapels (whose windows are now blocked by *retablos*). Windows in the outer wall above the chapels are too distant to light the aisles and nave effectively, and this reduced light, and the dark stone fabric, turn the cathedral into a mysterious space illuminated by flickering candlelight reflected off the glittering *retablos* seen through attenuated iron *rejas*. The sculptured bosses of the vault are lost in shadow.

The many parish and convent churches of Catalonia are simplified versions of the monumental architecture of the cathedral [39]. Often a single nave flanked by unconnected chapels between deep buttresses ends in a

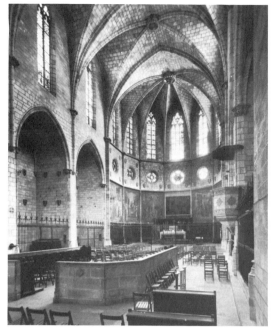

39. Convent church, Sta. Maria de Pedralbes, Barcelona, founded 1326.

40. Ferrer Bassa (active 1320–48): Chapel of St. Michael, cloister, Pedralbes, Barcelona, 1346. Fresco.

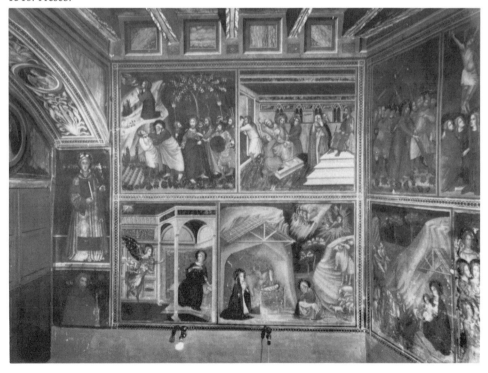

polygonal apse, having a double ring of oculi and lancet windows. The preference for flat mural surfaces and simple ribbed vaults reflects the taste of the merchant bankers of Catalonia as well as the monastic orders.

The expanses of masonry wall encouraged the efforts of mural painters rather than makers of stained glass. In 1346 the Barcelona artist Ferrer Bassa painted the chapel of St. Michael in the cloister at Pedralbes [40] with scenes from the life of Christ and portraits of Franciscan saints. Bassa's activity in Catalonia is well documented between 1320 and 1348, but earlier he must have traveled and studied in Italy. Only there could he have learned to represent such monumental figures in a coherent space or to break with the traditional Gothic subordination of painting to architecture. He simply divided the chapel wall into rectangular panels and created a series of stagelike spaces into which he set his actors. Ferrer Bassa's work, so deeply imbued with the style of Giotto and Tuscany, established the direction of Catalan painting for the rest of the century.

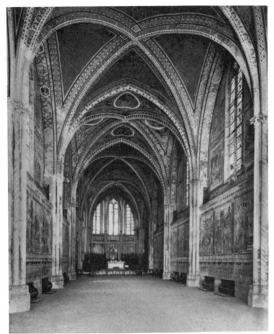

41. Interior, upper church of St. Francis, Assisi, 1228–53.

Gothic Art in Italy

The Italian peninsula, although a clearly defined geographic entity, did not become a single political unit in the Middle Ages. Southern Italy, where the Normans had established a strong central government in the twelfth century, might have become a modern state; however, after the death of Frederick II in 1250, conquest first by Charles of Anjou and then by Pedro III of Aragon turned the south into a political and cultural backwater. In central Italy the papacy provided little artistic or political direction, especially in the fourteenth century, when the papal court resided in Avignon, France. Conditions existed for effective patronage of the arts principally in the northern city-states from Tuscany northward. There powerful families had behind them a long tradition of municipal freedom

and commercial rivalry, a heritage that stimulated artistic development. Even the Black Death, beginning in 1348, could not long halt progress in that region.

Gothic architecture in Italy reflects the needs of the preaching friars. The single nave church of St. Francis at Assisi (1228–1253) [41] (or the more traditional three-aisled Sta. Croce, and Sta. Maria Novella in Florence) illustrate solutions to the problem of providing an impressive hall with good acoustics, uninterrupted sight lines, and broad expanses of wall for didactic mural paintings.

The Church of St. Francis at Assisi, although unusual in that it is a two-storied church with a crypt, illustrates the special features of Italian Gothic architecture. The upper church, which is the principal congregational hall, is a single open space divided into bays by clustered engaged shafts and ribbed vault. The heavy walls are set back at the window level to provide for a wall passage running the length of the building, and the upper section of the

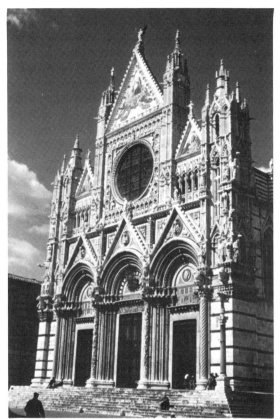

42. Giovanni Pisano and others: west facade, Siena Cathedral.

wall is pierced in each bay with tall, two-light windows. Painted imitations of architecture and textiles divide the lower wall into a drapery-covered dado and narrative panels, while the extension of the painting over the upper wall and vault turns the actual architecture into an ornamental fantasy.

The decoration of the Church of St. Francis was one of the most important artistic undertakings at the end of the thirteenth century. Defying their founder's own insistence on austerity, the Franciscans began an extensive program of mural decoration which eventually covered the walls of both the upper and lower churches. Gothic unity of the arts—that is, the subservience of painting and sculpture to an all-embracing architecture—begins to break down as the paintings within semi-indepen-

dent rectangular panels gain an independence from the architecture. Sculpture too often becomes an addition to, rather than an integral part of, the structure. Although splendid cathedral facades were built at Siena [42] and Orvieto, many churches were left incomplete. The most innovative Gothic sculpture in Italy was, in fact, done for marble pulpits and bronze doors.

Gothic sculpture in Italy begins with the work of Nicola Pisano. Perhaps Nicola came from southern Italy, for twice documents refer to him as Nicola of Apulia. If so, he could have worked at the court of Frederick II, a center of Classical studies and experimental science. (Frederick himself was a brilliant man of wide-ranging interests, called *Stupor Mundi*, "the wonder of the world," by his contemporaries.) In a self-conscious revival of Roman art, Frederick ordered a Classical portal added to a castle and a triumphal arch with appropriately classicizing sculpture raised in Capua. His own portrait shows a remarkable understanding of ancient Roman sculpture on the part of the sculptor [43]. The massive head with deep-set eyes and furrowed brow indicates a close study of Classical models. The presence of Roman antiquities and of patrons who appreciated ancient art and commissioned work in the antique style reinforced the Italian predilection for tangibility.

Nicola's first documented work is the pulpit in the baptistery at Pisa [44]. It is inscribed, "In the year 1260 Nicola Pisano carved this noble work. May so gifted a hand be praised as it deserves." The pulpit is indeed a magnificent creation worthy of the confidence expressed in the inscription. The Corinthian-esque columns, three of which stand on the backs of lions, support a hexagonal pulpit. Columns and moldings, individual figures and faces, architectural backgrounds, even carving techniques are based on Roman models. On the other hand, the heavy, angular draperies falling in repeated V folds and camouflaging the figures are medieval. On the body of the

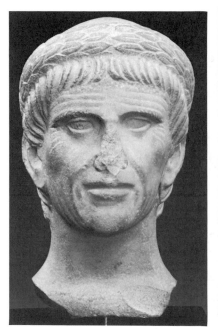

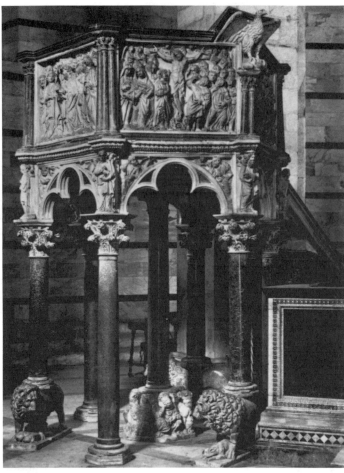

43. ABOVE: Portrait of Frederick II, d.
c. 1250. Marble. Height, 17".

44. RIGHT: Nicola Pisano (active 1250–
78): pulpit baptistery, Pisa,
1259–60. Marble.

45. BELOW: Giovanni Pisano (active
1265–1314): prophet, west facade, Siena
Cathedral, after 1284.

pulpit each panel is an independent, self-contained unit and each has a dense, friezelike composition. Nicola indicated a series of narrow planes in depth, the first occupied by the chief actors in the drama, the next by the crowd, and the last by the cornices and roof lines of the buildings. In spite of this definition of a stage on which the actors move, the sense of almost intolerable compression of the figures remains to enhance the emotional quality of the scenes. Thus, in spite of his debt to ancient Roman art, Nicola Pisano remains a Gothic artist.

Nicola Pisano's son Giovanni Pisano, a leading sculptor during the later years of the thirteenth century [45], designed the facade of Siena Cathedral. Giovanni was born about 1250 in Pisa, learned his trade from his father, and may have finished his education with a trip to France about 1270. After 1284 he was employed as sculptor and architect for the Cathedral of Siena. In spite of his French studies, Giovanni conceived of the facade as independent from the cathedral, as a splendid and richly ornamented screen. He substituted classicizing moldings, columns, and capitals for the intricate narrative sculpture on French portals, set blind tympana under round arches over the portals, and framed this Classical composition with steep, crocketed Gothic gables set against rectangular panels. Although Giovanni placed his sculpture high up on the facade, he conceived of his prophets and sibyls as part of an overall architectural scheme. Strong three-dimensional modeling and energetic movement (which seems so exaggerated when the figures are placed in a museum) compensate for optical distortion created by their position on the facade, and the dramatic gestures and expressions permit relationships to be established across the facade. Few Italian churches had such distinguished sculpture. Instead, Italian Gothic sculpture is to be found on pulpits, tombs, monuments, and fountains.

The simplicity, or directness of statement,

intensification of emotion, and refinement of drawing and color already present to some degree in Italian art were reinforced by Byzantine art and artists who came to Italy after the fall of Constantinople to Western Crusaders. Just as Byzantine art reinvigorated northern art in the years about 1200, so too it revitalized Italian art in the later years of the thirteenth century; however, by 1300 Byzantine art was no longer seen as a revitalizing force but rather as the old-fashioned "Greek" manner. In the eyes of later writers the young Giotto di Bondone (active 1300–1337) came as the savior of painting.

Giotto's education and early career are conjectural. However, we do know that he was in Florence by 1301, and he may have visited Rome earlier, during the jubilee year of 1300. By 1303 he was working in Padua in the Church of St. Anthony, and by 1305 in the Arena Chapel. Much is known about his later work in Florence, and recently discovered documents also refer to work in Assisi by "Giotto of Florence" in 1309.

While Giotto was in Padua, Enrico Scrovegni commissioned him to decorate the walls of a family chapel known as the Arena Chapel [46] because of its location near an ancient Roman arena. Giotto transformed this modest building into a testament to the Virgin Mary, whose coronation he represented over the arch leading into the chancel. Ignoring the building's structural features, he used ornamental bands to divide the walls and vault to suit his own compositional scheme: a grid of simple rectangular panels in which he painted scenes from the life of the Virgin and Christ beginning in the upper register. The Annunciation flanks the opening into the chancel and an awesome Last Judgment fills the western wall. Kneeling among the blessed is Enrico Scrovegni with his chapel. The theme of expiation and salvation is further personalized in a series of allegorical figures of the virtues and vices painted in grisaille in the dado.

Giotto's strength as an artist comes from

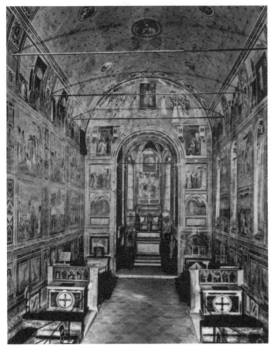

46. Giotto (active 1300–37): interior, Arena Chapel, Padua, after 1305. Fresco.

his ability to distill a complex narrative into a single telling moment. In the Lamentation over the body of Christ he focused the elements of the composition and thus the viewer's attention on one intimate detail, the juxtaposed heads of the Virgin and Christ. The barren ledge and the standing mourner's sleeves direct the attention to the mother and Son, while a grieving woman's raised arms and clasped hands form a tabernacle over the Virgin's head. The viewer, identifying with the seated figures as if they were in his space, becomes involved in the dramatic experience; thus the painting appeals on both an emotional and a rational level.

Giotto revolutionized art through the technique as well as the content of his paintings. He deepened the stage space devised by his predecessors, and although he continued to use miniature landscape and architectural elements like stage properties, he defined his space almost entirely by means of his figures.

These figures are truly monumental creations, each of which, through its simple contours and sculptural modeling, creates its own space [47]. Giotto rendered figures as color masses, painting the darkest areas with the most intense color and modeling toward white so that the final effect is of high-keyed color even in a somber scene like the Lamentation. Figures normally fill the lower part of the scene, with the center of interest at one side in a perfectly balanced but asymmetrical composition. In the Lamentation, however, the sky is filled with angels, whose extravagant grief provides a counterpoint to the heavy, doleful notes below. Faceless seated mourners turn their backs on the spectator and in so doing frame the central figures and establish a functional space. Giotto balances the decorative effect of the chapel as a whole with the intellectual and emotional impact of the individual scenes to produce a narrative art unsurpassed in any age. The Arena Chapel was finished by 1313, and Giotto returned to Florence, where he and his assistants painted chapels in the Church of Sta. Croce. Giotto also worked for the French court in Naples and finally, with the versatility characteristic of the medieval artist, became head of building operations for the Cathedral of Florence.

In the rival city of Siena, Duccio di Buoninsegna (active 1278–1318/19) had become the principal painter. His masterpiece, the altarpiece of the Virgin in Majesty, is known simply as the Maestà—Majesty. When the altarpiece was finished in 1311, it was carried from Duccio's workshop to the Cathedral through the streets of the city in solemn procession. The huge altarpiece is made up of many smaller panels: on the front Mary is enthroned as Queen of Heaven; scenes from her life fill the predella; and the life and Passion of Christ cover the back. Several of the smaller panels are now in museums.

The Nativity with the prophets Isaiah and Ezekiel in the National Gallery, Washington, D.C., illustrates Duccio's mature style [48].

Duccio combined elements of thirteenth-century Italo-Byzantine art with painting as practiced by the artists of the court of St. Louis in Paris. Much of the iconography—for example, the representation of the Nativity in a cave where the Virgin lies on a pallet—as well as the concentration on single, dominant figures against a gold ground were derived from the art of the icon painters. On the other hand, the delicate, graceful figures and miniature landscape and architecture, which never quite establish a spatial environment in spite of a tentative approach to linear perspective, seem inspired by Parisian art. The decorative quality of the light, intense colors, especially the pinks and blues, the meticulously rendered details, and the calligraphic quality of the line all suggest the art of manuscript illumination. Through his own sensitivity to gesture and feeling, to nuances of color and subtle modeling of drapery and figures, Duccio achieves a convincing interrelationship of figures to each other and to their settings. The grace, even the gentleness, of his art and its lingering courtly elegance contrasts with Giotto's severe monumentality. While Giotto inspired artists like Ferrer Bassa in Catalonia, Duccio influenced Jean Pucelle and the painters of France and Flanders. Duccio's art became an important component of the International style at the end of the century.

From the Ile-de-France Gothic art spread throughout Western Europe. Whether they accepted the new style enthusiastically or cautiously, artists and patrons soon absorbed and then subtly changed the French style to suit their native traditions. At the end of the twelfth century England rivaled France as a

47. Giotto (active 1300–37): The Lamentation, Arena Chapel, Padua, 1305–06. Fresco, 6' × 6'.

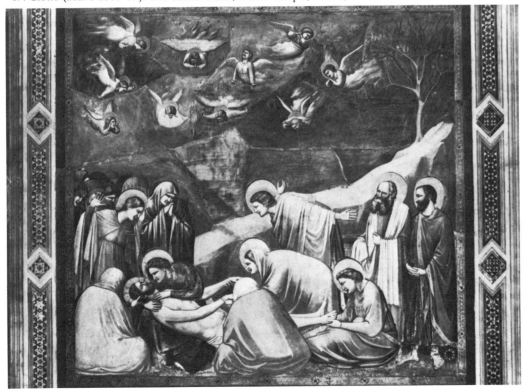

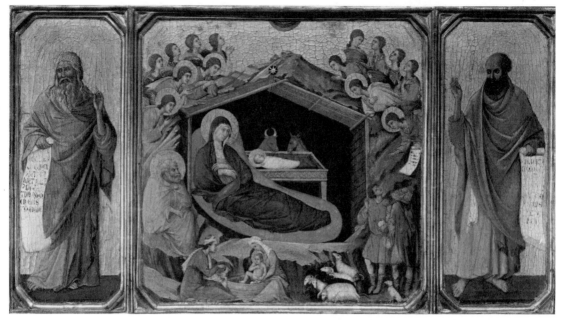

48. Duccio (active 1278–1311): The Nativity, the Prophets Isaiah and Ezekiel, from the *Maestà* altarpiece, Siena Cathedral, 1308–11. Tempera on panel, 17 1/4″ × 17 1/2″, 17 1/4″ × 6 1/2″.

center of Gothic art; the rest of Europe followed more slowly, learning from both France and England. New styles arose in Spain and Germany in the later years of the thirteenth century, and Italian artists, although resistant to French Gothic art at first, by 1300 combined elements of the Gothic, Roman, and Byzantine styles to lay the foundations for the Renaissance of the fifteenth century.

Gothic art remained didactic and symbolic in content. Inspired by the scholastic philosophers—even if unconsciously—artists organized their compositions into clear hierarchies and relationships. The elaborate allegories and esoteric symbolism of Romanesque art never entirely disappeared, but clear didactic narratives gained importance as the churchmen ordered visual sermons in stone and glass for their churches. The Gothic iconographical program aimed not only to expound Christian truths but to be encyclopedic in nature, and in this intuitive understanding and love for all of God's works the Gothic artist differed from his predecessors. Gradually a new realism crept into Gothic art—a realism of specific

observable details, a record of surfaces, not an attempt to understand and organize the world in human terms. God remained the one and only creator; the artist, His humble acolyte; the worshiper, God's creature who might attempt understanding through reason or through emotional identification.

Gothic art began, and remained, an abstract style in which forms were based on an ideal geometry rather than observed proportions. Early Gothic art was, like Romanesque art, stylized, linear, and two-dimensional. Even when external appearances of a man or a plant might be lovingly depicted, little attempt was made to understand the underlying physical structure or to place the figures in a mundane spatial environment. At best, delicate figures move gracefully through their miniaturized environment, acting on a narrow stage surrounded by a symbolic architecture and landscape. Calligraphic line dominated the emerging three-dimensional forms and the light, brilliant colors. But as the scholars of the Church found justifications for the study of the natural world, artists too began to

represent not only abstracted drapery forms and expressive gestures but also individualized faces, the weight and fall of garments, tangible forms and spatial settings. When artists realistically rendered the details of creation, they still sought the immaterial essence of the form. Even in scenes of high seriousness or great brutality, the Gothic ideal in art remained one of cool elegance. Generous use of gold translated painting and sculpture out of this world into an ideal atmosphere; light and color conveyed the mystical experience of Heaven.

Painting and sculpture submitted to the overall control of a greater entity, be it the page of the manuscript, the tracery of a window, or the overall architecture of the church. Architects, too, attempted to create a luminous abstraction of an ideal, Heavenly Jerusalem. The Gothic builders concentrated on the interior effects of their churches, on a mysterious darkness or jewel-like brilliance, on the changing quality of color and light. They disguised walls and vaults, dematerialized them, and turned them into luminous sheaths of color, into diaphanous screens, or enclosing linear nets. Pointed arches, ribbed vaults, flying buttresses, pinnacles, piers with engaged colonnettes, and tracery windows are all technical innovations whose purpose was to create a soaring space. Increasingly the builders blended the separate elements into a visually unified whole, until in the fourteenth century architects strove for architectural unity rather than articulation. They lightened walls, reduced support visually if not actually, and turned vaults from surfaces into linear patterns. Thus, although Gothic art constantly evolved and every region created its own variations on the French theme, certain general characteristics remained constant. In all the arts, artists sought to balance the real and the ideal, reason and imagination, observation and fantasy in an effort to capture the cosmic quality of the religion they served.

[CHAPTER XII]

Late Gothic Art

The late Gothic period, from the middle of the fourteenth century to the beginning of the sixteenth, was no mere postscript to the Middle Ages. As Western Europe recovered from the ravages of the Black Death (1348–1349) the very dislocations caused by the decimation of population and leadership permitted new institutions to emerge. The Church, torn by heresy and the claims of papal factions, lost its preeminence as a patron of the arts. From 1305 until 1377 the Popes lived in Avignon in southern France (Petrarch called the period the "Babylonian Captivity"), and when finally an Italian Pope was elected, Avignon remained the home of the French and Spanish anti-Popes. Rival Popes struggled for power, condemned each other, and excommunicated each other's adherents until 1417, when the Council of Constance confirmed Roman authority. Heresies flourished: led by John Wycliffe (d. 1384) in England and John Huss (d. 1415) in Bohemia, radical thinkers prepared the way for the Protestant Reformation of the sixteenth century.

Religious struggles were reflected in the political alliances and changing fortunes of the wars between France and England, lasting from c. 1337 to 1453, and known as the Hundred Years War. After the schism in the Church, Scotland, Castile, and Aragon supported France and the French Popes in Avignon, while Flanders, Scandinavia, Hungary, and Poland supported England and the Pope in Rome. The German princes and northern Italian towns were divided in their allegiances. In spite of this turmoil, by the end of the fifteenth century Louis XI in France, Henry Tudor in England, and Ferdinand and Isabella in Spain had united their territories under effective centralized governments. Their official bureaucracies were joined by modest representative bodies, parliaments, and councils in ruling the new nation-states.

As manufacture and trade flourished, towns and villages grew into great cities, and bankers and merchants joined the princes of the Church and state as patrons of the arts. The newly wealthy city dwellers looked at the world with hard, cautious eyes, for plague, fire, theft, and commercial disaster, as well as warfare and treachery, were omnipresent. Those who survived the Black Death had seen virtuous people struck down, families and fortunes destroyed without reason, but they also noted and took advantage of the new opportunities for skilled workers and shrewd entrepreneurs. Not surprisingly, their architecture varies from the severely functional to the ostentatious, their painting and sculpture from genre realism to an emotional mysticism profoundly influenced by the preaching friars.

The ideal of chivalry became more important in the fourteenth and fifteenth centuries than ever before, just as the knight in armor was rendered forever obsolete by the English archers at the battles of Crécy (1346), Poitiers (1356), and finally Agincourt (1415). When the Turks used cannon against Constantinople

and in 1453 breached the mighty land walls at last, a new age in warfare began. The nobility, nevertheless, engaged in spectacular tournaments and pageantry as if to reaffirm their importance in the face of the reality of their diminished role [1]. A military roster made for Sir Thomas Holmes, Clarenceaux King of Arms (1476–1494), is illustrated with jousting knights whose arms are displayed on shields, tabards, and horse trappers. New knightly orders were founded—the Order of the Golden Fleece in Burgundy, the Order of the Star in France, and the Knights of the Garter in England. While lip service was paid to a chivalric code, Charles VII let Joan of Arc, to whom he owed his crown, burn at the stake (1431), and Louis XI (1461–1483), the "spider king," schemed for the downfall of his cousins in Burgundy. Across the Channel, in England, the baronial revolts known as the Wars of the Roses (1455–1485) pitted family against family, the white rose of York against the red rose of Lancaster, until the victorious Henry Tudor defeated Richard III at Bosworth Field and established a powerful new dynasty. Finally, even the Crusades came to an end, when in 1492 Ferdinand and Isabella captured Granada, the last Muslim kingdom in the West. In that year Spanish ships reached America and inaugurated the great age of exploration and expansion that would change every aspect of European life.

Art and architecture could not remain isolated from such ferment. Some artists, writers, and philosophers began to study the physical world in minute detail, while others turned inward to a contemplative mysticism. The most brilliant artists did both and combined objective realism with personal emotional expression to create a new art and architecture.

Secular architecture gained stature in the late Gothic period, and an idea of the appearance of these towns can be gained from their representation in painting as well as from extant buildings. The use of cannon had rendered traditional castles all but obsolete. Pro-

1. *Book of Arms,* Sir Thomas Holmes, Clarenceaux King of Arms (1476–94).

longed sieges gave way to battles in open fields, and the castle became garrison headquarters, a supply depot, and as much a symbol of power and authority as an actual bastion. In Rogier van der Weyden's painting *St. George and the Dragon,* a castle with high walls, bristling towers, and an elegant residence rises atop an imaginary, stylized rock formation [2]. At the base of the crag the painter has depicted a prosperous city, with walls and towers protecting houses, churches, and a city hall or merchants' exchange. (Such an arrangement can be seen in a survey drawing of Windsor [3].) In the town center, the towers, spires, buttresses, and transept facade of a large church contrast with the heavy square tower and simple walls and windows of a nearby older building. Houses are crowded together, with their steep gable fronts facing the street, their roof lines broken by stepped

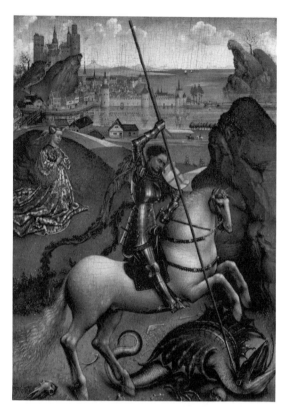

gables, chimneys, and dormer windows. Masonry construction and tile or slate roofs reduced the danger of fire in cities; in contrast, the farmsteads lying outside the walls have large half-timbered buildings and wattle fences. Two bridges lead into the city, and by one a tavern or inn with red and white signs stands ready to sustain the traveler. This peaceful view of prosperous domestic economy contrasts with the fantasy of the princess in her blue-and-gold brocaded gown and St. George, a knight in plate armor. (Incidentally, his impossibly long scalloped sleeves, elegant as they are, would have rendered him nearly helpless in battle or in his confrontation with this nasty but not very frightening dragon.)

2. LEFT: Rogier van der Weyden (1399/1400–64): *St. George and the Dragon,* Flanders. Panel, painted surface, 5 5/8″ × 4 1/8″. National Gallery of Art, Washington, D.C.

3. BELOW: Castle, town, and gardens, John Norden, plan of Windsor Castle, England, 1607. The British Library, London.

Less fantasy and greater realism pervade Pol Limbourg's painting of the Ile-de-la-Cité in Paris in the *Très Riches Heures* of the Duke of Berry [4]. Again neat fields tended by peasants surround the city, while behind the city walls, with the River Seine forming a natural moat, rise the buildings of the Royal Palace and the Ste. Chapelle. From the palace, stairs lead down from the private apartments to a pleasure garden whose trellis and bower of lattice and vines are visible behind the walls. Such paintings suggest that domestic and civic architecture reached unprecedented magnificence in the fifteenth century.

Avignon in southern France and York in England retained some of their medieval character: city walls and medieval domestic and civic buildings are dominated by the minster in York and the papal palace in Avignon [5, 6, 7]. Low city walls, punctuated by salient towers and many gateways and defended by barbicans, are topped with elaborate turrets, crenelations, and machicolations. At Avignon the stepped and modeled corbels joined by pointed arches seem to have been multiplied at least in part for their decorative effect. The papal palace, built by Benedict XII between 1335 and 1342 and enlarged with the addition of the so-called new palace by Clement VI between 1342 and 1352, typifies the southern preference for severe, clifflike walls articulated by buttresses and broken only by a few lancet windows or arrow slits. Large audience halls and small private apartments grouped irregularly around courtyards are secured by a massive outer wall and paired towers, battlements, and fortified entrance.

Very little remains of the once sumptuous decoration of palaces. In a few smaller rooms in the papal palace at Avignon murals depict scenes of courtly life [8]. Falconers and fishermen work in the forest, while tough mastiffs or elegant greyhounds leap over the patterned grass in stylized, graceful abandon. The red, blue, and white costume of the falconer and his companion, together with the white mas-

4. The Limbourg Brothers (active 1390–1416): June, Royal Palace with Ste. Chapelle, *Très Riches Heures* of the Duke of Berry, France, c. 1415. 11 1/2″ × 8 1/4″. Musée Condé, Chantilly, France.

tiffs and red roses, birds, and cherries, create a startlingly decorative effect against the varied greens of the airless landscape. The dense dark-blue and green foliage resembles *mille-fleurs* tapestry. Here a courtly style, combining the elegance of Paris and the incipient realism of England and Flanders with the new humanism of Italy, appears in what later art historians have called the International style.

On a much smaller scale well-to-do merchants and craftsmen built comfortable, well-furnished houses. Fifteenth-century paintings of the Virgin and Child illustrate the comforts available to a carpenter such as St. Joseph was assumed to be. Petrus Christus, for example, placed the Virgin in a room with glazed and shuttered windows opening on a walled garden and cityscape and surrounded her with fine furniture, including a curtain-hung bed, benches piled with pillows, and an elaborate brass chandelier [9].

The newly affluent members of the middle

5. City walls, Avignon, fourteenth century (modern restorations).

6. Barbican and gate, city walls, York.

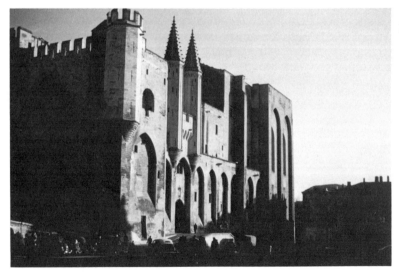

7. Papal palace, Avignon.

class also erected guild halls, markets, town halls, and other civic architecture. They modernized their churches and built new chapels and parish churches whose soaring towers are evidence of civic pride of the parishioners. The broad windows of St. Cuthbert, Wells, remind us that innovative architecture continued to be commissioned for the glory of the Church [10].

Ravaged by plague and war, France lost its position as the premier art center in the West. Artists in England, Flanders, and the Holy Roman Empire produced imaginative buildings and filled them with sumptuous arts. In England the Perpendicular style (a term coined by Thomas Richman in 1817) and in Germany *Parlergothik* (so called from the surname of a family of master masons and architects) dominate late Gothic architecture with their technical and aesthetic innovations. Only in the fifteenth century, and then perhaps influenced

8. Hunting scene, papal palace, Avignon, fourteenth century.

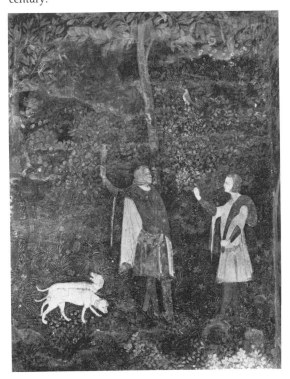

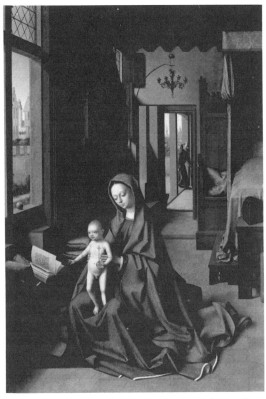

9. Petrus Christus (c. 1415–72/73): *The Holy Family,* Flanders, 1472. Oil on wood panel, 27 3/8″ × 20″. The Nelson-Atkins Museum of Art, Kansas City.

by the English Decorated style, did France develop the brilliant new style known as Flamboyant, from the flamelike twisting of the ogee arches which characterize its decorative details.

The Perpendicular style, as we have noted in chapter XI, was the court style of England. Its characteristic forms—the rectilinear composition contrasting with huge windows, and a spare linear ornament spreading over flat mural surfaces—evidently originated with architects building the royal chapel of St. Stephen in Westminster (begun 1292) and St. Paul's Cathedral, London. These buildings are gone—St. Paul's replaced by Wren after the great fire of 1666, and St. Stephen's by the Houses of Parliament in the nineteenth century. (St. Stephen's served as the House of

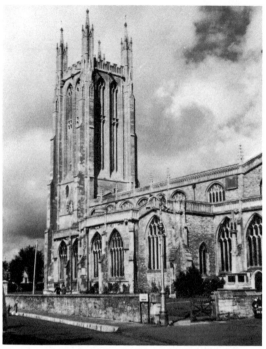

10. Parish church of St. Cuthbert, Wells, fifteenth century.

Commons from 1547 until it burned in 1834.) The style practiced by masons and carpenters working for the crown in London or on royal projects in the provinces survives splendidly in such places as the Cathedral at Gloucester, the towers added to the Cathedral at Wells, the nave at Canterbury, and the university chapels.

At the Abbey of St. Peter at Gloucester (elevated to cathedral status and rededicated to the Trinity after the Reformation), a new building campaign, stimulated by the popular cult of Edward II, began in the south transept (1330) and choir (1337). The builders preserved the stonework of the Anglo-Norman choir, where the heavy walls and piers of the Romanesque arcade and tribune can still be seen behind a screen of tracery. They added a clerestory, east window, and vault in the Perpendicular style (page 254). Old and new work, walls and windows are united by tracery in repeated rectangular panels formed by mul-

lions and transoms in the windows and extended as a blind tracery over wall surfaces. Straight lines and slender vertical moldings replace the flowing curves of the Decorated style, although tracery in the head of each rectangular tracing frame relieves the austerity.

At Gloucester the east window, an enormous tripartite wall of glass measuring 72 by 38 feet, was in place by 1349. The side walls are canted to accommodate even more glass, so that when the choir is viewed from the west, no wall is visible. The great window rises like a glowing altarpiece dedicated to the Coronation of the Virgin. Around the central Virgin and Christ stand witnesses, a single figure in each light of the window, their tall canopies becoming as extension of the stone tracery at the head of the panel. The elegant, slouching "hip-shot" figures swathed in voluminous draperies form decorative patterns created almost entirely in line. The grisaille figures and architecture silhouetted against colored glass backgrounds become at a distance alternating bands of red, blue, and gray and thus reinforce the rectilinear pattern of mullions and transoms. The linear quality of the design continues into the vault, where a pointed barrel vault is disguised by decorative netlike ribbing. The unity of the elements, seen earlier in the English denial of the French bay system at Exeter, here produces a vault which seems to float over piers and windows.

The English masons in the second half of the fourteenth century invented yet another variation on the rib vault, known as the fan vault. The earliest surviving fan vault was built in the cloister at Gloucester between 1351 and 1377, and the entire cloister was finished by 1412 [11]. The structural principle of the fan vault is simple: curving half cone-shaped corbels laid up in horizontal courses support a series of flat panels along the crown of the vault. The ribs, each with the same curvature and same length, seem to spring from each pier; however, they are not structural but instead are a tracery carved out of

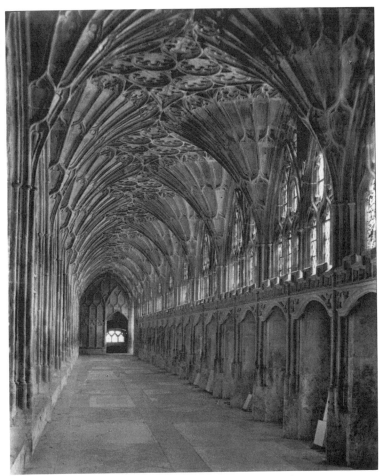

11. Cloister, south range, Gloucester Cathedral, 1351–1412.

the solid corbels. The handsome form of the fan vault and the rich ornamental pattern of moldings are heightened by the silvery light from large windows. The new architectural aesthetic seemed to play on the contrast of walls and windows, but at the same time bound opposing masses and voids behind a delicate screen of rectilinear tracery.

By the time many cathedral chapters were ready to finish their churches, taste had changed, and thus many churches are graced with towers in the later style. At Wells Cathedral, for example, beautifully proportioned towers designed by William of Wynford and built between 1365 and 1440 provide a severe but handsome foil to the vivid color and texture of the thirteenth-century facade. The parish church of St. Cuthbert, in the same

city, embodies these characteristics of clarity and balance, juxtaposition of horizontal and vertical, mass and void. The architects stated and restated the verticality of the towers but tempered the severity of the structure with delicate vertical moldings, cusped headings, and narrow gables.

One of the most characteristic building complexes, and one for which the Perpendicular style proved to be especially satisfactory, was the university. The oldest colleges of Oxford and Cambridge provide excellent examples of the secular and religious architecture of the later Middle Ages. Cloister-like quadrangles surrounded by living quarters, assembly rooms, refectories and kitchens, and of course the library and chapel, illustrate the essentially functional character and the adapt-

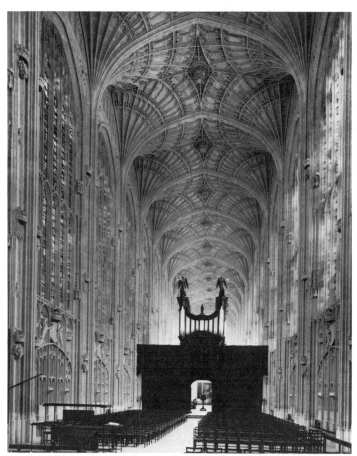

12. Interior, King's College Chapel, Cambridge, 1446–1515.

ability of the style. One of the most beautiful of these collegiate buildings is King's College Chapel at Cambridge, built by Reginald Ely and John Wastell between 1446 and 1515 [12]. The chapel is a large, rectangular hall lighted by enormous windows filled with sixteenth-century Flemish stained glass and covered by a fan vault. The vault is almost flat and on the exterior is masked by a parapet to emphasize the horizontality of the building. Massive walls are enriched on the interior by Tudor roses and portcullises in high-relief sculpture. This heraldic decoration also surrounds the entrances. The opposition of horizontal and vertical lines, which gave the style its popular name, Perpendicular, produces a building that heralds the Renaissance style in its regularity, its horizontal lines, and its sheer wall surfaces. When Tudor monarchs intro-

duced a form of the Renaissance into the British Isles, builders did not have to rethink the form and structure of their buildings; they simply changed the decoration from Gothic to Classical ornament.

English medieval styles lingered on in the Tudor period. Henry VII, the founder of the dynasty, ordered a new Lady chapel at Westminster Abbey which would also function as a mausoleum and a chantry chapel for himself (a chantry is an endowment for perpetual masses for the soul of the founder). Between 1503 and 1519 William Vertue built an exquisite monument, having yet another variation on the theme of the rib vault, known as the pendant fan vault [13]. The underlying structure of the vault consists of enormous transverse arches, but these arches early disappear under a filigree of stonework. About a

third of the way around the arches, Vertue elongated the voussoirs into pendants eight feet long, from which fan vaults spring. Close inspection reveals that these pendant fans are actually openwork and that the transverse arches are visible through the tracery. To enliven the rich surface of the vault still further, additional pendant fans drop from the flat panels along the crown. The building is a master mason's tour-de-force! The central lights of the windows are canted to form sharp projections and the wall is reduced to octagonal piers which on the exterior rise as turrets above the level of the roof. Once they provided the bases for heraldic beasts carrying gilded weather vanes. Inside, the walls and windows are bound together by trellis-like rectangular paneling and a broad band of sculpture beneath the windows. The stall and banners of the Knights of the Bath, whose chapel this has become, now add the final touch of fantasy to a building as sumptuous and extravagant as late medieval chivalry itself.

Germany, like England, saw a change in emphasis in religious architecture, from the early focused directional scheme to the hall church in which spatial unity and an even, pervasive light were made possible by elevating the side aisles to the height of the nave and enlarging the windows in the outer walls. This architectural type had been confined to crypts (Speyer), chapels (Salisbury), and secular halls; however, in the fourteenth century German architects, led by the Parler family, gave the form new monumentality and dignity. Heinrich Parler, head of a large and prolific family, established an architectural dynasty in southern Germany and Bohemia. His son, Peter (c. 1330–1399) at age twenty-three became court architect to Charles IV (1316–1378) in Prague, the new capital of the Holy Roman Empire.

Peter's earliest work may be the choir of the Church of the Holy Cross at Schwäbisch Gmünd [14, 15]. Heinrich Parler began the church with the nave in 1317 and in 1351 he

13. Henry VII chapel, Westminster Abbey, London, 1503–19.

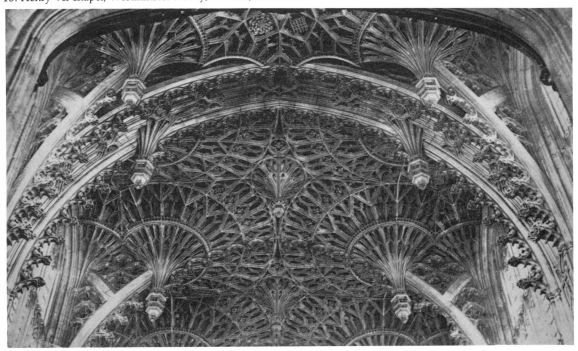

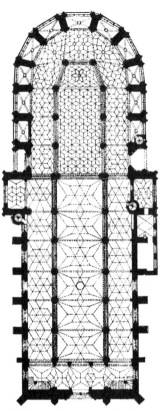

15. Plan, Church of the Holy Cross, Schwäbisch Gmünd.

14. Heinrich and Peter Parler (c. 1330–99): Choir, Church of the Holy Cross, Schwäbisch Gmünd, begun 1317; choir, 1351.

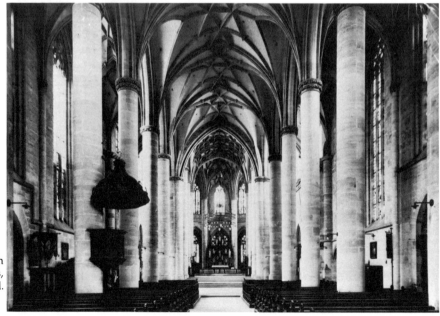

16. Interior, Church of the Holy Cross, Schwäbisch Gmünd.

was joined by his son in the design of the choir, a hall church enlarged by a ring of low chapels between the buttresses. The unity so important to the artists of the later Middle Ages controls the light-filled interior space and the exterior design, where the choir appears as a single polygonal unit under a steep roof. Flat tracery-headed panels disguise the buttresses, and heavy pierced balustrades emphasize the horizontal continuity of the exterior. Large, traceried windows in two stages light the choir directly and through the chapels.

Peter Parler proved to be one of the most inventive designers of the century. Like the English architects, whose work he must have known, Peter experimented with vaults, elevations, and lighting [16]. He elaborated on such technical devices as flying ribs and open-work tracery; and he designed the first net vaults built in the Germanic lands. The contrast between nave and choir vault at Gmünd makes readily visible the increasing complexity of the vault pattern. By increasing the number of ribs and eliminating the ridge rib and transverse arches, vaults could be turned into intricate, decorative nets.

Peter Parler's influence spread throughout central Europe after he was called to Prague by Charles IV in 1353 to complete the Cathedral and Imperial Pantheon (begun in 1344). In the upper stories of the choir, begun in 1374 and vaulted in 1385, he combined French and English construction techniques with his own design of canted walls and windows on each side of the supporting piers. When he died, in 1399, he had introduced nearly every innovation found in later German Gothic architecture. His ideas were adopted in the new choir Charles IV added to the Carolingian Palatine Chapel at Aachen (begun 1355), in the Cathedral of St. Stephen in Vienna (begun 1359, vaulted 1446), in the Frauenkirche at Nürnberg (1355), and at the Cathedral of Ulm built under the direction of Heinrich Parler II, Michael Parler II, and Heinrich Parler III. Dazzling effects became the stock-in-trade

of German architects in the fifteenth century. The eastern choir of St. Lorenz, Nürnberg, begun by Konrad Heinzelman (c. 1390–1454) in 1439, copied Schwäbisch Gmünd [17, 18]. The three-aisled hall church choir is surrounded by lower chapels, and the division into two stories is emphasized by a projecting cornice and pierced parapet. Hexagonal piers with engaged shafts rise unbroken by capitals to merge with the vaulting ribs. Konrad Roriczer (c. 1410–1475) designed an extraordinarily complex star-patterned vault (1472–1477). Huge aisle and chapel windows light sculpture, church furniture, and the painted decorations. In the view into St. Lorenz's choir, Viet Stoss's *Annunciation* seems to float in the center of the sanctuary, and Adam Kraft's flamboyant, open-work tabernacle for the reserved sacrament (1493–1496) stands by a pier at the left so tall that its spire bends to follow the line of the vault. The intricate wooden tracery is the ultimate enlargement of the towered reliquary, with all its associations of martyrium, a spire within rather than outside the church.

The Flamboyant style appeared in the late fourteenth century and continued well into the sixteenth century. It was pervasive in northern France and Flanders, lands under the control of the English regent, the Duke of Bedford, or closely connected with England through the cloth trade. The flamelike tracery, which gave the style its name, may have been derived from the English Decorated style. In Flamboyant architecture and decoration the visual dissolution of the architecture in an intricate play of space and form reached its climax. The transparency of the Reims facade has been intensified, and every element is made up of open tracery; ogee arches form *soufflets* (daggers) and *mouchettes* (curved daggers known also as "fish bladders"), as can be seen in the rose windows in Amiens or Ste. Chapelle. Ultimately, what was once Gothic structure became mere applied decoration.

Pinnacles, traceried gables, and ogee curves

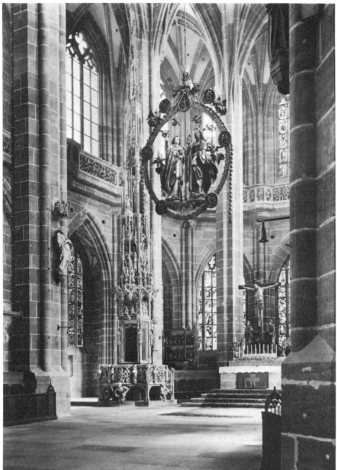

17. Konrad Heinzelman (c. 1390–1454) and Konrad Roriczer (c. 1410–75): Church of St. Lorenz, Nürnberg, begun 1439; vaulted, 1472–77. Adam Kraft (c. 1440–1509): Tabernacle, 1493–96. Viet Stoss (c. 1440–1533): The Annunciation, 1518.

18. Plan, Church of St. Lorenz, Nürnberg.

even in the flying buttresses created the finest tracery spire in France, designed by Jehan de Beauce in 1507 for the twelfth-century north tower at the Cathedral of Chartres. The profusion of geometric and natural ornament seems to merge the stone structure with the surrounding atmosphere. Such a tracery spire has no practical use—instead it is symbolic architecture and totally irrational; yet, with its final dissolution of the solid mass of the building, it is a telling expression of the late Gothic spirit.

That this Flamboyant style appealed to Spanish patrons and architects is apparent at once at Burgos, where Spanish bishops, returning from the Council of Constance (1417), brought with them architects who were trained in the new style. Hans of Cologne, known in Spanish as Juan de Colonia, added tracery spires to the west facade of the Cathedral of Burgos; his son Simon built a lantern tower at the crossing and a chapel for the Constable of Castile; and his grandson Francisco rebuilt the crossing tower in spectacular Plateresque ("silversmith") style in the sixteenth century.

In the fifteenth century a truly national style also developed in Spain, a style fascinating in its own right but also important because of its

profound influence on the architecture of Latin America and southwestern United States. This late Gothic style can be seen at its most grandiose in the Cathedral of Seville and at its most ornate in the Church of S. Juan de los Reyes in Toledo, 1477–1492.

The Spanish builders desired spreading horizontal spaces. Inspired perhaps by the rectangular plans of mosques, churches became short and wide, even rectangular, and almost square in plan. The cathedral built on the site of Seville's Great Mosque followed the latter's rectangular plan, although the orientation had to be changed from north-south to east-west to make it suitable for the Christian liturgy [19]. The Patio of Oranges of the mosque became the Christian cloister, and the minaret was turned into a bell tower, the famous Giralda [20]. The forbidding building appears to be a series of cubical blocks with heavy walls built up like terraces, and the unroofed vaults increase the horizontal effect of the exterior. Portals may be enriched with horse-

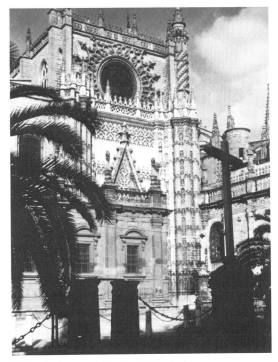

19. South transept, Seville Cathedral.

20. Vaults, from the Giralda Tower, Seville Cathedral.

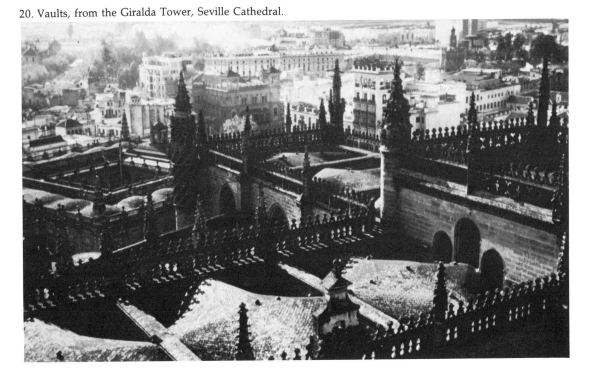

shoe arches, framing panels, and polylobed interlacing arches. Occasionally large windows were filled with colorful Flemish stained glass, but usually openings were tiny, making interiors very dark. Choir stalls, iron or bronze grilles (*rejas*), and huge altarpieces lead the eye upward through the dim interior to elaborate vaults, inspired by Moorish eight-pointed star vaults. Moorish influence is everywhere apparent in the rich and colorful surface patterning and in the use of luxurious textiles, ceramics, and metalwork. In a style known as Mudejar, created by Moorish craftsmen working for Christian patrons, exterior as well as interior walls could be covered with colorful ceramic tiles, molded stucco, and geometric patterns in brick. Measuring 454 feet long and 295 feet wide, the Cathedral of Seville is the largest medieval church and second in size only to Michelangelo's new St. Peter's in Rome, among Christian buildings. The building gives the sensation of an enormous spreading space, although the vault of the nave rises to 121 feet.

Not all late Gothic Spanish architecture was built on the scale of the Cathedral of Seville. Monastic and parish churches built during the reign of Ferdinand and Isabella could be modest in size, although often richly decorated. These Isabellan churches became the Spanish mission type built in the Americas by the *conquistadores*. The Church of S. Juan de los Reyes, in Toledo, founded in 1477 by Isabella and Ferdinand and designed by Juan Güas, became the model [21, 22]. This new Isabellan church type has a single nave flanked by unconnected lateral chapels between the buttresses, a raised choir over the western entrance bay, raised pulpits at the crossing, and a low lantern tower over a crossing whose transept extends no farther than the outer walls of the lateral chapels. This compact and efficient design allowed ample space for altars, pulpits, and tombs (if the church was intended as a burial chapel), a nave free for the congregation, and wall space suitable for an educational or propagandistic decorative program. Lavish interior decoration at S. Juan honored the Catholic sovereigns. Heraldry became a principal decorative feature, and the royal coats of arms seem more prominent than the assembly of saints. To saints standing under flamboyant canopies were added friezes of tracery and foliage, where the artists' attention to the accurate representation of detail rivals manuscript illumination. Insects, birds, and animals climb in vines that sometimes seem entirely independent of the buildings. Other prominent features, stalactite corbels and inscriptions in continuous friezes, were inspired by Moorish art. The Church of S. Juan de los Reyes never served its intended purpose as a royal pantheon, for when Granada fell in 1492 the Catholic sovereigns decided to make the cathedral they established in the former Moorish capital their final resting place.

Years of contact with Moorish art had predisposed the Spaniards to appreciate extravagant surface decoration, which they used to good effect in the glorification of the valor of the monarchs and the power of the state. The sculpture of S. Juan de los Reyes, with its delight in realistic detail, combined with an equal enthusiasm for abstract or geometric ornament, indicates the direction late Gothic art had taken throughout Europe: on the one hand it was decorative and elegant, and on the other, it was a meticulously realistic rendering of surfaces. This dichotomy had begun a century earlier, when, at the end of the fourteenth century, patrons demanded and artists produced a richly ornamental and graceful style that combined the characteristics of Parisian and English court styles with Italian, especially Sienese, art. The papal court at Avignon was the creative center of this so-called International style. Attracted by papal patronage, Duccio's pupil Simone Martini (c. 1284–1344) [23] had moved from Siena to Avignon about 1335, and at the same time northern artists also flocked to the new court. The synthesis of the art of Paris and Siena

21. Juan Güas (active 1459–96): Church of S. Juan de los Reyes, Toledo, Spain, begun 1477.

22. Plan, Church of S. Juan de los Reyes.

that took place in southern France spread and flourished through Europe from about 1380 until about 1430.

The International style was first and foremost an art of royal and ducal courts: Paris, London, Prague, Burgundy, Berry, and Anjou. Superb abstract design of bright colors and rhythmic lines enhances the detailed rendering of textiles, plants, and surface textures. Inspired by Sienese painting, northern artists learned to represent spacious architectural settings, although they still saw the landscape as a tapestry-like collection of plants and fantastic rocks. They left the study of mathematical,

linear perspective to their Italian colleagues while they concentrated on capturing the ephemeral quality of light and atmosphere.

Traveling artists and portable works of art—tapestries, manuscripts, and panel paintings—carried the International style from Avignon throughout Europe. The earliest surviving suite of Gothic tapestries is known as the *Angers Apocalypse*, made between 1376 and 1381 for the Cathedral at Angers [24]. Jean Bondol designed the cartoons, following an illuminated manuscript of the Apocalypse, and Nicolas Bataille supervised the weaving. Rectangular panels alternate between blue and red,

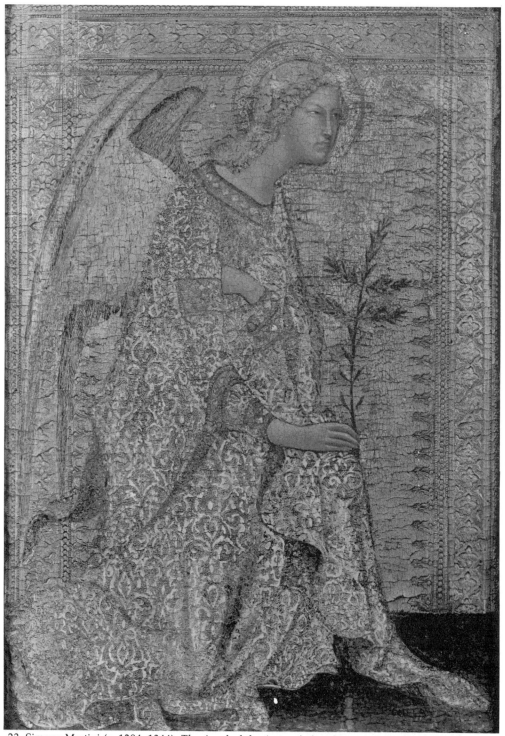

23. Simone Martini (c. 1284–1344): *The Angel of the Annunciation*. Siena and Avignon. Panel, 12 1/8″ × 8 1/2″. National Gallery of Art, Washington, D.C.

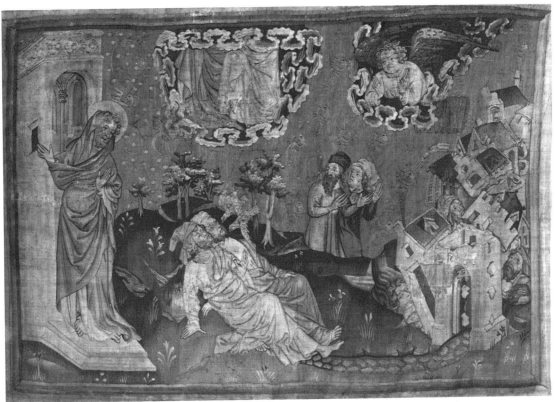

24. *Angers Apocalypse* tapestries, 1376–81. Caisse Nationale des Monuments Historiques et des Sites.

enriched with vine scrolls or diapered with *fleur-de-lis*; they provide backgrounds for elegant, courtly figures, miniature architecture and trees, and impossible charming beasts. Images that could be merely pretty or decorative are saved by the solemnity of the theme, the catastrophic events at the end of the world, and by the monumental size of the hangings, the subtlety of the painters' drawing and shading, and the abstract quality inherent in the medium.

In the fifteenth century tapestries brightened the dreary winter days in northern Europe by turning halls into imagined flower-strewn meadows. Baggage trains carried suites of tapestries from one residence to another to provide appropriately luxurious state rooms for the owner. Tapestries not only created sumptuous, warmly insulated inner rooms, but were seen as major investments and therefore appropriate royal gifts and sought-after booty. The typical *mille-fleurs* tapestry, inspired by murals such as those that decorated the walls of the papal palace in Avignon, or by the custom of fastening bunches of flowers and branches to walls on festive occasions, had plants of recognizable species scattered over a field of dark blue or vermillion. Depending on the cartoons in the workshop, the depiction of individual plants varied from realistic studies to a dense pattern of highly stylized daisies, pinks, columbines, Solomon's seal, and strawberries. The entire tapestry could be packed with flowers, or the plants could function as a background for other images. Animals and birds were often placed at random, with no attempt to reproduce realistic relationships in space even in figural scenes.

Tapestries were woven in both France and Flanders. A series attributed to the Loire Valley, made in the first decade of the sixteenth

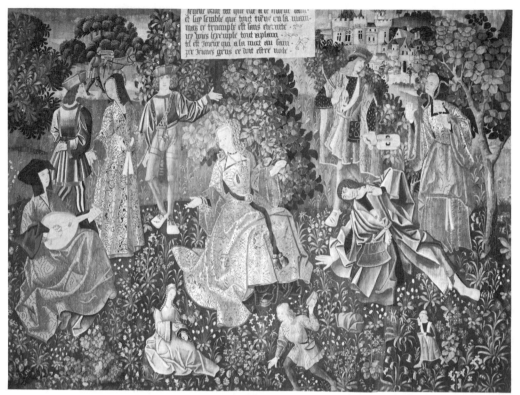

25. *Youth*, Loire Valley, 1500–10. Wool and silk tapestry, 10′ 11″ × 15′ 2″. The Cleveland Museum of Art.

century for the château of Charles d'Amboise (d. 1511) at Chaumont, illustrates the continuity of medieval themes and the *mille-fleurs* tradition [25]. Against a rich floral background figures of Youth, Love, Death, Time, and Eternity present an allegory on the fleeting nature of the world. In a succession, related to Petrarch's Triumphs, only Eternity survives. Youth and Death read:

> Youth triumphs while its heart is healthy,
> And when it seems to hold all in its hand.
> But this triumph is without eternity.
> Here one sees the example full well;
> Those who are happy hid death
> in their heart,
> Let the young heed this warning.

(Translated by Remy G. Saisselin)

The theme reflects the dire warnings of the mystics but also looks ahead to Renaissance allegories on worldly fame.

Working on a smaller scale, but more innovative visually than the weavers, were the painters of illustrated books and altarpieces. Painters working for the dukes of Berry and Burgundy studied the visual appearances and captured effects of light, space, and atmosphere; at the same time they painted in an elegant, linear, ideal mode inherited from the Gothic world. Luxury book production culminated in the manuscripts created for the bibliophile Duke Jean de Berry. Among his leading painters were Pol, Jean, and Herman Limbourg. The Limbourg brothers appeared first about 1390 in Paris as goldsmiths, but in 1401 or 1402 Pol was in Burgundy and by 1413 all three were working in Berry for Duke Jean. The brothers died of the plague in 1416, leaving their masterpiece, the *Très Riches Heures*, unfinished.

Like other books of hours, the *Très Riches Heures* contained a calendar and the prayers

for the canonical hours. The Limbourgs illustrated the calendar with the labors of the months represented as scenes of daily life and set in specific landscapes. For example, in June peasants mow the fields outside the walls of Paris (see page 369). Not only is the architecture of the Ile-de-la-Cité depicted with meticulous detail but the very quality of the light, color, and atmosphere of a northern early summer was captured by the painters. Such a study of the French countryside is remarkable, although, true to the traditions of their art, the Limbourgs thought in terms of the manuscript page. Even when the principal miniature presents a window on the world, the artists used a decorative frame to bring the eye back to the surface. Part of the success of a manuscript illumination depends on this respect for the page, and when the representation of three-dimensional space overshadows the unity of the page, the illustration no longer belongs to the art of the book.

Most painters were more conservative than the Limbourg brothers, and they continued to surround text and illustrations with a tangle of golden leaves whose spiky forms echo the angular Gothic script. Into this glittering foliage realistic images of flowers, birds, and insects as well as curling stylized acanthus begin to intrude. Such a border surrounds the prayer to the Virgin in a book of hours from northeastern France [26]. The initial letter forms a border for the image of the Madonna of Humility. Humility, as the root from which all other virtues grew, was seen as an especially appropriate attribute of the Virgin, not only because of her maidenly modesty and humility before God but because she was the root (the earthly mother) from whom Christ, like the virtues, grew. A trellis behind her supports a dense blooming rose, the archetypical Marian flower, and creates a walled enclosure suggesting the traditional enclosed garden of the Song of Solomon, another Marian image. The *Vosper Hours* may have been made in Langres, because it contains prayers to the local saints

26. The Virgin and Child, *The Vosper Hours,* France (Langres?), second half of the fifteenth century. Miniature on vellum, 9 1/4″ × 6 1/4″. Kenneth Spencer Research Library, University of Kansas.

Mammes and Desiderius, but its style of painting originated in Paris in the middle of the fifteenth century.

The fourth of the great royal patrons, the Duke of Burgundy, gained more fame as a politician than a patron of the arts, yet his commissions are among the most grand and enduring. Philip the Bold (1363–1404) commissioned painting and sculpture that changed the course of art history. He inherited the duchy of Burgundy from his father, John the Good, in 1363. When six years later he married the heiress of Flanders, he became one of the wealthiest and most powerful rulers in Europe, surpassing his brothers—the King of France, Charles V, and the dukes of Anjou and Berry. His capital city, Dijon, became one of the cultural centers of the north. In 1385 Philip

27. Claus Sluter (c. 1360–1406): Portal, chapel, Carthusian monastery of Champmol, Dijon, 1385–93.

established a ducal pantheon in the Carthusian monastery near Dijon, the Chartreuse de Champmol [27]. He entrusted the project first to Jean de Marville and then, on Jean's death in 1389, to Jean's assistant, the Netherlandish sculptor Claus Sluter (c. 1360–1406). Sluter worked continuously on the pantheon, leaving the tombs unfinished at his own death in 1406; nevertheless, in his relatively short career Sluter created a memorable and influential new style.

On the jambs and trumeau of the portal of the chapel at Champmol (1385–1393) the patron saints John the Baptist and St. Catherine introduce kneeling figures of the duke and duchess to the Virgin and Child. In sculpture at once monumental and human, Sluter combined realistic portraiture with massive figures enveloped in voluminous, sweeping draperies. He created images of living beings so strong that the spectator feels that he or she is standing in their very presence. To create his effects Sluter combined intense surface realism and dynamic movement with a carefully calculated light and shade pattern. Sluter ob-

served the world so acutely and carved so deftly that he could capture the essence of his subjects without the scientific anatomical study that had begun to captivate his Italian contemporaries. (The climax of the entire complex was to have been the ducal tombs. Unfortunately, Sluter died before he could complete the commission. Broken up during the French Revolution, the tombs have now been restored and are in the Dijon museum.)

Sluter's finest conception, the so-called Well of Moses (1395–1406), now stands in the cloister [28]. From the bottom of the well rose a pier bearing a complex sculptured group consisting of Old Testament prophets supporting the scene of the Crucifixion. The prophesies painted on the scrolls were taken from a contemporary Mystery play, *The Judgment of Jesus,* in which Mary pleaded the cause of her Son before the great men of the Old Testament, and each replied that Christ must die to save mankind. Sluter could have seen the play, and the theatrical quality of the Moses Well may not be simply a product of a modern imagination.

Moses is justly considered the masterpiece of the group. His sad old eyes blaze out from a memorable face entirely covered by a fine filigree of wrinkles. A mane of curling hair and huge beard cascade over his heavy figure and an enormous cloak envelops him in deep horizontal folds. The painting and gilding of the sculpture by Jean Malouel must have enhanced its impact. Sluter's mastery of dramatic representation and volumetric breadth completely transformed the contemporary

ideal of sculpture. Under Sluterian influence brutal realism, bordering at times on caricature, took the place of the sophisticated and often superficial elegance of the court schools and International style.

The carved and gilded Dijon altarpiece by Jacques de Baerze, made for the Chartreuse de Champmol [29], is relatively modest in size (especially considering that in Spain retables might rise the full height of the choir). In the Dijon altar saints in elaborate flamboyant tra-

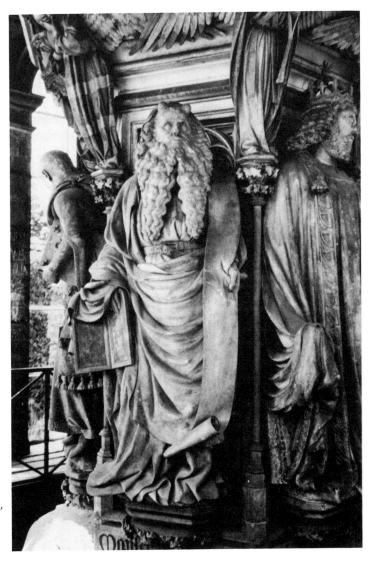

28. Claus Sluter: The Well of Moses, cloister, Carthusian monastery of Champmol, Dijon, 1395–1406. Height of figures, 5′ 8″.

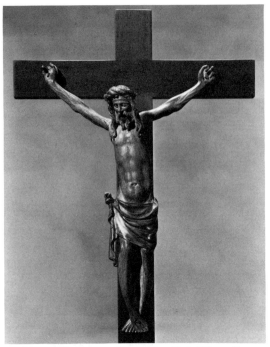

29. Jacques de Baerze: Christ Crucified, Dijon altar, 1390–91. Wood.

cery settings, whose richness makes the spire at Chartres seem simple, frame scenes from the life of Christ (the figure of crucified Christ is now in the Chicago Art Institute). Elegant proportions and stance, idealized faces, and intricate draperies contrast with intimate homely details to produce an effect at once lyrically idealistic and domestic. In little stage-like boxes, religious dramas were presented by figures and settings from daily life. Such understandable, emotional storytelling, combined with the impressively florid architectural settings, appealed to popular taste. Altarpieces grew in importance and size in the fourteenth and fifteenth centuries and combined architecture, sculpture, and painting in a sumptuous and didactic glorification of the sacraments and the saints.

The protective wings of the altarpiece were painted by Melchior Broederlam (active c. 1378–1409), the leading panel painter at the beginning of the fifteenth century and

court painter to Philip the Bold [30]. The painter composed scenes from the early life of Christ within the decorative frames of the Gothic altarpiece (1394–1399). In these paintings he demonstrated his mastery of three-dimensional modeling, warm rich tempera colors, and light-filled space. To create this space, Broederlam worked within a convention known as axial perspective, in which parallel lines seem to converge on a central axis rather than at a single vanishing point, and he enhanced the effect of spatial recession by placing buildings on the diagonal. An even light from a single source further unifies the composition. Into this convincing space Broederlam placed massive figures, like the archetypical peasant St. Joseph, whose healthy earthiness leads northern art toward a new genre, realism. Of course Broederlam retains

30. Melchior Broederlam (active c. 1378–1409): *Presentation and Flight into Egypt,* wings, Dijon altarpiece, 1394–99. Oil on panel, 64″ × 51″. Dijon Museum.

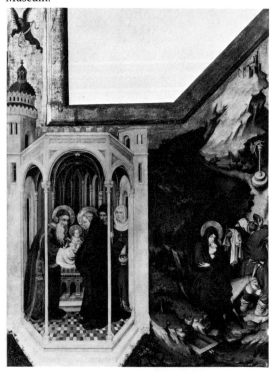

many medieval devices, such as stylized rock forms for mountains, miniature trees and castle, and a gold background. The conflict in Broederlam's style, as so many writers have noted, is epitomized by his depiction of a realistic hawk flying in a golden sky over the "Byzantine" mountains behind Mary and Elizabeth.

Sculptors and painters still reflected the deep piety of the Middle Ages. They and their patrons sought an underlying significance in natural objects and everyday activities. Only gradually did visual problems, the representation of space, and the appearance of nature become as important to them as the symbolic meaning inherent in a subject. The court of the dukes of Burgundy, where painters like Melchior Broederlam were joined by the sculptors Jean de Marville and Claus Sluter and later by Jan van Eyck, became the center for this new art.

Artists after Broederlam and Sluter continued to explore the visual and symbolic possibilities of an art based on the observation of nature. In their desire for ever greater and finer detail in the rendering of the surfaces of objects, the painters developed a new painting technique, using oil as a medium for the pigments. Oil dried slowly, allowing the artists to blend colors and to produce subtle variations in tone. Colors built up in a series of semitransparent glazes had a greater intensity and luminosity than possible in tempera painting. Jan van Eyck has been called the inventor of oil painting, but no single artist invented the technique. Painting in oil had been used earlier where durability was required—for example, when a painting might be exposed to the weather. Jan mastered, extended, and popularized the medium, and during the fifteenth century painters readily adopted his technique.

Jan van Eyck (c. 1380/1400–1441) is the acknowledged leader of the Flemish school. He is first recorded working in The Hague in 1422. He moved to Bruges in 1424 and on May 19, 1425, he went to Lille as painter and

valet de chambre to Philip the Good of Burgundy. In 1427 and 1428 he traveled to Spain and Portugal for the duke, and on his return he settled in Bruges. Jan van Eyck was a man of affairs, a skilled diplomat, and a courtier as well as an artist, whose paintings capture the imagination today just as they did in the fifteenth century. While recording and analyzing every detail of a world seen as though through a magnifying glass, Jan could still create a coherent pictorial whole. Furthermore, his meticulously rendered objects carry symbolic meanings and wide associations. Jan's painting of the Annunciation [31] has levels of meaning which would have been clear to contemporaries, even though the interpretation may be obscure or difficult today. The event takes place in a church rather than the Virgin's room. Gabriel speaks the words of greeting (painted in gold) and the Virgin, half kneeling, raises her hands like an orant as the dove of the Holy Ghost descends in beams of light. (This interpretation may have been inspired by a religious drama in which two youthful clerics took the parts of Gabriel and Mary and the dove was a Limoges enamel ciborium.) Homely details like the prayer desk and pot of lilies are meant to be understood as symbols of the Virgin's humility, chastity, and perfection, while the architecture, through its combination of "old" Romanesque and "new" Gothic elements, symbolizes the Old and the New Law, the Old and the New Testaments. On the back wall are paintings of the story of Moses and in the stained-glass window, of the *Salvator mundi*; scenes in the floor tiles prefigure the coming of Christ. In Jan's interpretation, the observable world of the Church is turned into the spiritual world of Gabriel and the Virgin. To contemporaries, the two figures suggested more than the means by which God became flesh; the Virgin is actually equated with the Church as the Bride of Christ and the Beloved of the Song of Songs. This subtle iconography and amazing visual record of an unseen happening characterizes Jan van

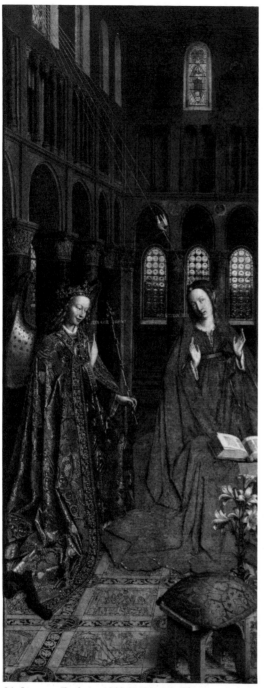

31. Jan van Eyck (c. 1380/1400–41): *The Annunciation,*
Flanders, c. 1425–30. Transferred from wood to
canvas, 36 1/2″ × 14 3/8″. National Gallery of Art,
Washington, D.C.

Eyck's art. Also characteristic is his suppression
of physical action and emotion, to achieve a
monumental quality in the composition. In
short, Jan juxtaposes the secular and religious,
the real and ideal worlds, and in his emphasis
on the symbolic significance of individual ob-
jects and the painting as a whole, he remains
a medieval artist.

Jan's contemporary Rogier van der Weyden
(1399/1400–1464), as the official painter for
the city of Brussels, worked for the community
rather than the aristocracy. His easily under-
stood subject matter and gracious style gained
wide popular appeal, and he became the most
copied of all Flemish masters. After an ap-
prenticeship with Robert Campin, he became
a master in 1432 and Brussels' official painter
in 1436. Unfortunately Rogier neither signed
nor dated his paintings; however, *St. George
and the Dragon* is clearly an early work (perhaps
as early as 1432), for the courtly International
style still pervades the painting of the elegant
knight and princess, the rearing white horse,
and fantastic dragon (color plate 8). Rogier
seems to have taken delight in every detail,
from the brocades of the princess's gown to
the scales of the dragon, from the swirling
lines of St. George's trailing red sleeves to the
glittering highlights of his armor. The land-
scape rises in a series of flat, sharply defined
planes from the narrow foreground stage, on
which the confrontation of saint and dragon
takes place, to fantastic rock formations and
a high horizon line. In his painting of the
distant city, however, Rogier achieved an effect
of sweeping landscape, which foretells his
later mastery of light, color, and atmosphere.
The reason for Rogier's popularity is apparent;
he was an excellent storyteller, a superb drafts-
man and colorist, and his people have about
them a quality of idealized nobility—making
him unsurpassed as a portrait painter as well
as a painter of religious themes.

By the middle of the fifteenth century, so
many young artists had adopted the styles
and techniques of Jan and Rogier that a school

of Flemish painting can be said to have been established. Petrus Christus (active 1444–1473) is typical of this second generation. At first he borrowed themes and figures from Rogier, although he simplified compositions; later he came to depend more and more on the paintings of Jan, until after the middle of the fifteenth century his style became totally Eyckian. (He is only documented in Bruges, from 1444 until his death in 1472/3, so he probably never actually met Jan van Eyck.) His *Virgin and Child,* painted near the end of his life ("1472" is painted on the clasp of the Virgin's book), shows his abiding concern with the study of spatial relationships and the integration of figures into an environment. His precisely drawn, solid geometric forms existing in a definite, believable space are the work of a superb still-life painter. The traveling case may suggest preparations for the Flight into Egypt, and the apple in the window holds connotations of paradise, the Fall, and Mary as the new Eve, but the brass chandelier, complete with ropes and pulley for lowering it, the stacked red and green cushions, the chamber pot, and the three-legged stool surely hold no subtle iconographical messages. Such genre details establish a mundane setting for the activities of the Holy Family and so bring the religious figures into association with the daily life of the owners of the panel.

During the fifteenth century, the style and painting technique developed in Flanders spread throughout Europe. While local artists adopted the luminous colors and careful realism of Flemish painting, they seldom mastered the intricate religious symbolism. Artists outside Flanders learned to record a sitter's physical appearance but only rarely did they suggest personality. In painting landscape, the artists tended to concentrate on details of nature in a way reminiscent of the International style, but they showed less interest in the study of space and light and the organization of the visual world into a coherent composition. In short, the fifteenth-century

artists of Germany, France, or Spain retained elements of the local Late Gothic art in their adaptation of the Flemish style.

German painters, for example, preferred to emphasize expressive lines and abstract colors to the detriment of coherent spatial relationships. Influenced by German mystics, they were concerned for the emotional impact of their subjects rather than for the accuracy of a record. Stefan Lochner's *Madonna of the Rose Garden* [32] becomes an iconic image of Mary, who sits eternally in a heavenly rose arbor against a golden sky, as the epitome of renunciation of personal will, just as German mysticism advocated the renunciation of reason and the dependence on subjective personal feelings to unite the soul with God. This mystical attitude, as expressed in the Cologne school by Lochner (1405–1451) and his fellow painters, aimed for perfect harmony by placing forms symmetrically in the simplest possible composition and limiting colors as much as

32. Stefan Lochner (1405–51): *Madonna of the Rose Garden,* Cologne, c. 1440. Oil on panel, 20″ × 16″. Wallraf-Richartz Museum, Cologne.

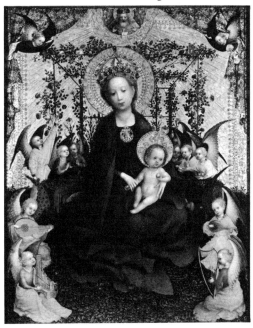

possible to the primary hues. Lochner creates a timeless world peopled with gentle figures who seem to float in a golden space.

A need to identify with interceding saints and a longing for personal revelation even influenced the design of reliquaries. Relics were no longer concealed in miniature tombs but displayed in monstrances. Encased in crystal vessels and glorified by precious metals and jewels, the relic was made visible to the worshiper as tangible proof of the presence of the saint. In the reliquary made for St. Bernward's paten (c. 1400) [33] the silver niello twelfth-century paten is displayed in a gilded silver architectural setting, elevated on a tall stem. Behind a crystal cover are relics of St. Bernward. Such a reliquary, in its elegant simplicity and devout expression of belief, captures the spirit of late Gothic art in northern Europe, where the art was profoundly influenced by the spirit and philosophy of mysticism.

The desire for a personal communion with the Deity led artists to concentrate on themes having highly emotional content, such as the Virgin mourning her dead Son. In an Austrian sculpture of the Pietà [34], the Gothic idealism in the Virgin's face and the elegance of her gestures and massed curling drapery contrast with the rigor mortis of the body and limbs of the dead Christ. The once vivid polychromy over the cast stone added to the immediacy of the figures. Dramatic visual effects were also achieved in architecture through the manipulation of light and space. The builders intended to create a sublime environment in which meditating worshipers, with the help of realistic paintings and sculpture, might achieve an intense personal religious experience. As subjectivity rather than rationality became an ideal, worshipers hoped to transcend the senses by means of the senses. Master Eckhardt and other mystics advised that a subjective mysticism was the only possible way to achieve understanding and union with God. The *Andachtsbilder*—dramatic religious images for use as inspiration during meditation—became a distinctive new type.

Mysticism inspired the representation of the joys of Mary as well as her sorrows. Tilmann Riemenschneider (c. 1460–1513) carved figures of the Virgin and Child [35] in which idealized faces, realistic details, and a lingering Gothicism in the stance and sharply creased angular drapery patterns produce a deeply felt religious fervor. The Virgin remains a sweet, solemn princess who holds her child protectively and at the same time seems to offer Him as a sacrifice. Such sculptures are not meant to be studied as isolated objects but are part of a total visual and emotional experience created by the controlled space of the great altarpiece and shifting light of the church interior.

Such a setting is provided by the Church of St. Lorenz, where a second great sculptor, Veit Stoss (c. 1440–1533), carved the Annunciation (1518) in the choir. Here Mary and the angel Gabriel are surrounded by a garland of roses interspersed with scenes from Mary's life [36]. Stoss has modified the Germanic love of realism by treating draperies as crisp, entirely decorative forms, and then has further removed the image from the everyday world by gilding the sculpture. The interpenetration of space and solids, combined with the moving light and shadow, produced a sculpture which literally floats over the altar—an object for contemplation and adoration. Such sculpture is a mystical experience made tangible.

Jan van Eyck, Rogier van der Weyden, Stephen Lochner, Claus Sluter, Tilmann Riemenschneider, and Veit Stoss are only a few of the hundreds of painters and sculptors who bridge the years between the Middle Ages and the modern world. Along the Rhine, in Mainz and Strasbourg, other artists and craftsmen with new techniques were working over their printing presses, unknowingly destroying the medieval world. Before Jan van Eyck had finished his *Annunciation,* or Rogier his *St. George,* unknown printers began to cut and stamp out woodblock prints to satisfy the

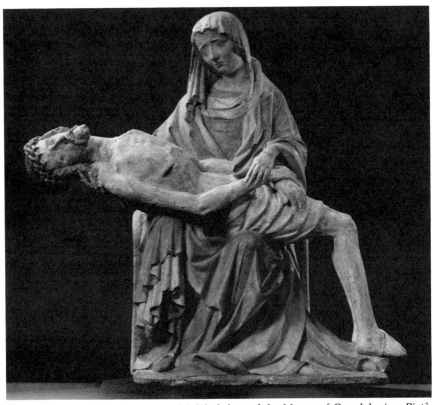

34. Workshop of the Master of Grosslobming: Pietà (Vesperbild) Steiermark, Austria, c. 1420. Painted cast stone, 37″ × 36 1/2″ × 15 1/2″. The Cleveland Museum of Art.

33. Master of the Oswald Reliquary: paten of St. Bernward, Hildesheim, twelfth century. Silver and niello. Monstrance, c. 1400, Lower Saxony. Silver gilt. The Cleveland Museum of Art.

desire of the common people to own a sacred image. St. Dorothy, to whom Christ appeared bearing roses, becomes a maiden with a mundane basket of flowers [37], while the Christ Child, now a toddler, supports himself in a baby walker. The saints have become personalized indeed.

While manuscript illuminators still painted exquisite books of hours, Johann Gutenberg (c. 1396–1468) had six presses, each manned by several workmen, printing so many copies of the Bible that over forty so-called Gutenberg Bibles, printed in Mainz in 1456, still exist. In 1476 the first English printer, William Caxton (c. 1422–1491), set up his press in Westminster,

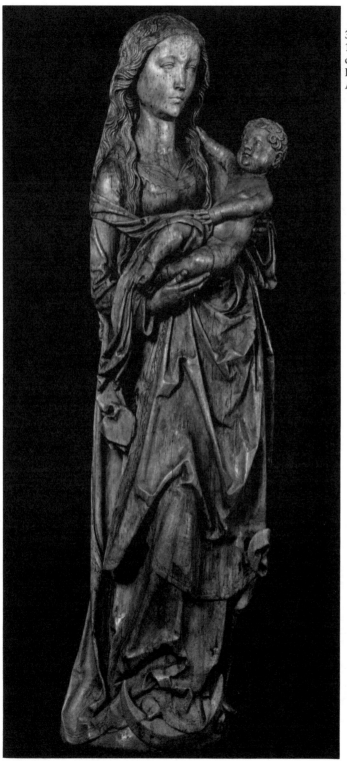

35. Tilmann Riemenschneider (c. 1460–1531): Virgin and Child, Germany, c. 1499. Lindenwood. Height, 48 1/4″. Helen Foresman Spencer Museum of Art, University of Kansas, Lawrence.

36. Veit Stoss (c. 1440–1533): The Annunciation, Church of St. Lorenz, Nürnberg, 1518.

37. St. Dorothy, Germany, fifteenth century. Woodcut. National Gallery of Art, Washington, D.C.

where he produced both secular and religious texts, including Chaucer's *Canterbury Tales* (1484). The printing press did to the scribe and manuscript what the English longbowmen did to the French knights at Crécy; and the introduction of relatively inexpensive printed books produced a knowledge explosion comparable to the computer revolution in the twentieth century. The intellectual and spiritual life of the West, and with it the arts, changed forever.

GLOSSARY

abbey A monastery; a community of men or women living under religious vows; the buildings, especially the church, used by the community.

addorsed Two figures placed symmetrically back to back.

Adoptionism The heretical belief that Christ was born a man and subsequently adopted by God as His Son.

aedicule A shrine or niche framed by columns or pilasters and surmounted by a gable or entablature and pediment.

affronted Two figures placed symmetrically facing each other.

Agnus Dei Lamb of God; a name given to Jesus by St. John the Baptist (John 1:29); a symbol of Christ; a prayer in the Mass.

aisle Corridor or passageway; in a church the aisles flank and run parallel to the nave.

alb A long, white, sleeved linen tunic worn by the celebrants of the Mass under the other vestments. See also **vestments.**

alfiz A rectangular panel framing an arched opening, especially in Islamic architecture.

alpha and omega First and last letters of the Greek alphabet, thus the beginning and the end; in Christian art, associated with the representation of Christ as judge to indicate eternity and infinity.

altar frontal A carved, painted, embroidered or otherwise decorated panel covering the front of an altar.

ambo A raised platform for a reader in a church, later replaced by the pulpit. Often two ambos were used, one on the north from which the Gospel was read and one on the south for the reading of the Epistle. (The phrases "Gospel side" and "Epistle side" make clear the location in churches without an east-west orientation.)

ambulatory A walkway; the passage around the apse in a basilican church.

amice A square of white linen worn by a priest on his neck and shoulders. See also **vestments.**

anastasis Greek: resurrection. A church dedicated to the Resurrection of Christ; the rotunda built over the tomb of Christ in Jerusalem.

Andachtsbild A devotional image. See also *Vesperbild.*

angels Intelligences not united to bodies, serving as messengers between God and the world. Angels are ordered into three "hierarchies" of three "choirs": seraphim, cherubim, and thrones; dominions, virtues, and powers; principalities, archangels, and angels.

annular Ring-shaped, as in annular vault or annular crypt (a crypt in which a circular aisle surrounds the chamber housing the relics). See also **crypt, relics.**

antependium See **altar frontal.**

antiphons Sentences from scripture sung alternately by two choirs.

Apocalypse The Book of Revelation; the last book of the New Testament, attributed to St. John the Evangelist.

Apocrypha Early Christian writings rejected by the editors of the New Testament; thus of questionable authenticity.

apostles The disciples of Christ: Sts. Peter, Andrew, James, John, Philip, Bartholomew, Matthew, Thomas, James son of Alphaeus, Jude (Thaddeus), Simon Zelotes, and Judas Iscariot. After the betrayal and suicide of Judas, Mattheas was chosen as his replacement. In art, St. Paul and the Evangelists St. Mark and St. Luke are sometimes substituted for Sts. Jude, Simon Zelotes, and Mattheas, but the number of figures remains at twelve.

Apostoleion Church dedicated to the twelve apostles.

apse A vaulted semicircular or polygonal structure; in a church it faces the nave and houses the altar. A large church may have additional apses in the transepts.

aquamanile A water pitcher, often in the shape of an animal, for handwashing at meals or at the altar.

arcade A series of arches, often supporting a wall, as in the nave arcade of a church. See also **blind arcade.**

archangel The eighth order of angels. The archangels are Michael, Gabriel, Raphael, and Uriel. See also **angels.**

archbishop A bishop having jurisdiction over an ecclesiastical province which includes several dioceses.

architrave The lowest element in the entablature; a horizontal beam supported by columns or piers.

archivolt The molding following the contour of the arch and framing the opening. **Voussoirs** are sometimes referred to as archivolt blocks.

arcuated lintel A lintel which breaks upward into a central arch.

Arianism A Christian heresy which denied the doctrine of the Trinity and the eternal divinity of Christ. Expounded by Arius of Alexandria (ca. 256–336). Declared heretical at the Council of Nicaea in 325 but accepted by the barbarian Goths and Lombards.

armature A supporting framework, as in the iron bars supporting stained glass in a large window opening.

articulated Divided into units.

ashlar masonry Masonry of squared, even-faced blocks laid in horizontal courses.

Assumption The taking up of the Virgin Mary into heaven, body and soul.

atrium An open courtyard; in Christian architecture, the court in front of a church.

Augustinian Canons Also known as Austin, Black, or Regular Canons; priests living under the rule of St. Augustine.

azulejos Glazed, colored tiles.

bailey The open courtyard in a castle. See also **motte-and-bailey.**

baldacchino, baldachin A freestanding or suspended canopy over an altar, throne, or tomb.

ball flower Architectural decoration of carved, tightly closed, stylized rose buds.

baluster A short post supporting a railing, forming a balustrade.

baptistery A building, or a room, set aside for baptismal rites.

barbican Defensive structure in front of a gate.

barrel vault An arched masonry ceiling or roof; a continuous vault which must be buttressed its entire length and may be divided by transverse arches into bays.

bar tracery See **tracery.**

bas-de-page Drawing or painting at the bottom of the manuscript page often with humorous or genre subjects.

basilica Greek: *basilikos,* royal. In Christian architecture, a church of longitudinal plan consisting of a high central nave lit by clerestory windows, lower side aisles, and an apse at one end of the nave.

bay A compartment, or unit of space, bounded by architectural members.

beakhead Decoration consisting of animal, bird, or human heads biting a roll molding.

Beatus manuscript A copy of Beatus' commentary.

Beatus of Liébana A Spanish theologian (ca. 730–98) who wrote treatises against Adoptionism and a commentary on the Apocalypse.

bema A speaker's platform; the raised apse in an Early Christian church.

Benedictines Also known as Black Monks; persons who live by the rule drawn up by St. Benedict of Nursia (ca. 480–ca. 550) for the monks of Monte Cassino in Italy. The first responsibility of the Benedictine is prayer; the Divine Office was called *opus Dei,* the work of God.

benedictional A book of blessings used by a bishop when celebrating the Mass.

Bible The sacred writings of the Christians, comprising the Old Testament (the Jewish scriptures) and the New Testament. St. Jerome's Latin translation, the *Vulgate,* forms the basis for the Roman Catholic Bible. An English translation of the *Vulgate,* the *Douay Bible,* was made at Douai, France, 1582–1610. Protestant editions of the Bible include the King James version of 1611, and Martin Luther's German translation in the early sixteenth century.

billet molding A series of cubical or cylindrical projections.

blind arcade An arcade placed against a wall as decoration.

Book of Hours An abbreviated version of the Divine Office used primarily by the laity for private prayer; it includes a liturgical calendar, the Little Office of the Blessed Virgin, the litany of saints, Penitential Psalms, Office of the Dead, and additional personal prayers.

boss Decorative projection covering the intersection of the ribs in a vault.

breviary A liturgical book containing the psalms, hymns, prayers and readings to be recited during daily devotions.

bubble foliage Stylized foliage resembling seaweed.

buttress A mass of masonry built to strengthen a wall and to counter the thrust of a vault. In Gothic architecture, **flying buttresses** carry the thrust of the nave vault over the side aisles through masonry struts and arches to massive piers and buttresses along the outer walls.

cabochon A round or oval, unfaceted, polished stone or gem.

caesaropapism A political system in which an absolute ruler assumes both secular and religious authority.

calligraphy The art of penmanship.

came The thin lead strip used to hold pieces of glass in a stained glass window.

campanile Latin: *campania*, bell. A bell tower, usually free standing.

campo santo Italian: holy field. Burial ground.

canon A clergyman on the official staff of a cathedral or collegiate church; a system of ideal proportions.

canon of the Mass The fixed elements in the Mass; the Eucharist or commemorative sacrifice of bread and wine.

canon table A concordance of the four Gospels; parallel passages arranged in columns.

capital The decorative upper part of a column, pier, or pilaster, which creates a transition from the vertical support to the horizontal lintel, entablature, or arcade. A **Corinthian capital** has acanthus leaves and corner volutes around a bell-shaped core. **Cushion, cubic,** or **block capitals** are cubes whose lower corners have been rounded off to fit a circular shaft. A **crocket capital** is decorated with small stylized leaves.

carpet page Full page of intricate geometric decoration, especially in Hiberno-Saxon manuscripts.

Carthusians Strict contemplatives living in individual cells under a vow of silence and meeting only for the Office, Mass, and a meal on feast days. Founded by St. Bruno (ca. 1030–1101) in 1084. The order takes its name from the original monastery, the Grand Chartreuse, near Grenoble in France.

cartoon A full-scale drawing made as a guide for painters or weavers.

catacombs Subterranean burial places consisting of multi-level galleries and small rooms for memorial services. See also **loculi.**

catechumen A person being instructed in the Christian religion.

catenary arch or vault Theoretically having the curve or shape of a cable suspended from two points.

cathedra The bishop's official chair or throne.

cathedral The church containing the bishop's **cathedra,** thus his principal church.

cell A compartment, as in a vault or in cloisonné enamel; individual monastic habitation.

cenotaph A monument to a dead person, but not his or her tomb.

cense To perfume with incense.

censer An incense burner, usually on chains so that it can be swung; also called a thurible.

centering The frame built to support an arch or vault during construction.

chalice A cup; used in the Mass to contain the Eucharistic wine.

chamfer Bevel, cut at an angle.

champlevé See **enamel.**

chancel See **choir.**

chantry chapel A chapel endowed for perpetual celebration of Masses for the soul of the founder.

charger A large plate or dish; a war-horse.

Chartreuse A Carthusian monastery.

châsse A house-shaped reliquary.

chasuble The outermost garment worn by the priest celebrating the Mass. See also **vestments.**

cherubim The second highest of the nine orders of angels. See also **angels.**

chevet The apse, ambulatory, and radiating chapels of a church.

chevron A V-shape.

choir The part of the church reserved for the

clergy and singers, also known as the chancel; the entire eastern end of the church beyond the crossing. See also **chevet**.

choir screen A screen between the choir and the nave separating the clergy and the congregation; in England called a **rood screen** when it supports the "rood," or cross. Hung with icons in a Byzantine church, it is known as an **iconostasis**.

Christ in majesty Christ enthroned; often surrounded by symbols of the four evangelists.

Christus patiens Latin: suffering Christ. A cross with a representation of the dead Christ.

Christus triumphans Latin: triumphant Christ. A cross with a representation of the living Christ.

church council See **ecumenical council**.

ciborium A baldacchino. A vessel for the consecrated host.

cinquefoil A five-petal shape.

Cistercians Reformed Benedictines; an austere order founded in 1098 by St. Robert of Molesme at Cîteaux in Burgundy. Its most famous member was St. Bernard of Clairvaux.

clerestory Literally a "clear story;" the upper story of basilica pierced by windows.

cloisonné See **enamel**.

cloister A monastery or convent; an open courtyard surrounded by covered passageways connecting the church with the other monastic buildings.

cloister vault A cupola rising in curved segments from a square or octagonal base; also known as a **domical vault**.

Cluny, the congregation of Cluny Reformed Benedictines who emphasized strict adherence to the founder's rule and a life focused on the Divine Office; famed for their use of the arts to enhance the splendor of the church services. Founded in 910 by William I at Cluny in Burgundy, eastern France. The entire international congregation was ruled by a single abbot at Cluny.

codex (pl. **codices**) A manuscript in book form rather than a scroll.

collects Short prayers said or sung during the Mass.

collegiate church A church which has a chapter or college of canons, but is not a cathedral.

colobium The long robe worn by Christ in Byzantine and Byzantine-inspired art.

colonnette A small column.

colophon Information about the production of a manuscript, placed at its end (comparable to the title page in a modern book).

column A cylindrical, vertical element supporting a lintel or arch and usually consisting of a base, shaft, and capital. A column may stand alone (as a monument), or as one of a series (a colonnade), or may be attached to a wall (engaged column).

column-figure or **statue-column** A human figure carved as part of a column.

compound pier A pier with attached columns, pilasters, or shafts, which may support arches or ribs in an arcade or vault.

conch Shell-like in shape. A half-dome covering a semicircular structure such as an apse or exedra.

confessio An underground chamber, near the altar, containing a relic.

confessor saints Christians who have demonstrated extraordinary service to the Church through their exemplary lives, especially as scholars and interpreters of scripture, but who did not suffer martyrdom.

cope A cape worn by a bishop.

corbel An architectural support; a bracket.

corbel table A row of brackets, supporting a molding.

cornice Uppermost element of the entablature; crowning element in a building.

corpus Christi Latin: the body of Christ. The figure of Christ on a crucifix; the consecrated bread (the host) in the Eucharist; the feast commemorating the institution of the Eucharist (Thursday after Trinity Sunday).

Cosmati work Marble inlay and mosaic used as pavement and on church furniture, originating in Italy.

couching An embroidery technique in which threads laid on the face of the material are tacked down by threads carried on the back.

crenelated battlements, crenelation A technique of fortification in which the upper wall has alternating crenels (notches) and merlons (raised sections) forming permanent shields for the defenders.

crocket Stylized leaves used as decoration along angles of spires, pinnacles, gables, and around capitals.

crosier, crozier The staff carried by bishops, abbots, and abbesses; in the West having a spiral termination or the form of a shepherd's crook, and in the East, a cross and serpent.

cross Roman instrument of execution; the cross on which Christ was crucified became the principal Christian symbol.

 ankh Egyptian looped cross, a symbol of eternity.

 Constantinian cross Combined with the monogram of Christ.

 cross-standard A long-handled cross with a flag, a symbol of triumph.

 crucifix The cross with the figure of Christ.

 Greek cross Cross with four equal arms.

 Latin cross Cross with three short and one long arm.

 St. Andrew's cross Diagonal, X-shaped cross.

 tau cross T-shaped, or three-armed cross.

 wheel cross Celtic form in which the arms are joined by circular bracing.

crossing In church architecture, the intersection of nave and transepts.

crucks Pairs of timbers in which the shape of the natural tree trunk and branches forms the posts and rafters of a timber-framed building.

crypt A vaulted chamber usually beneath the apse and choir, housing tombs or a chapel.

cubiculum (pl. **cubicula**) Chamber in a catacomb.

curtain wall Outer wall of a castle.

cusp The pointed projection where two curves (foils) meet. See also **foil.**

dalmatic Knee-length tunic worn by deacons and occasionally by bishops at High Mass. See also **vestments.**

damp-fold Clinging draperies, represented as if wet.

deacon Greek: servant, minister. A cleric who assists a priest, acts as reader, leads prayers, distributes communion, receives offerings, and distributes alms. An archdeacon is the principal administrative officer in a diocese.

Deësis Greek: supplication. Christ enthroned between the Virgin Mary and St. John the Baptist, who act as intercessors for mankind at the Last Judgment.

diaconicon In Early Christian and Byzantine architecture, a chamber beside the sanctuary where the deacons kept vestments, books, and liturgical vessels.

diaper All-over decoration of repeated lozenges or squares.

diaphragm arch A transverse arch carrying an upper wall supporting the roof and dividing the longitudinal space into bays.

diocese The district and churches under the jurisdiction of a bishop.

diptych Two-leaved, hinged plaques containing painting, carving, or wax on which to write. In the early church, they were used to record the names of donors and others for whom special prayers were to be offered. Later they were used as portable altarpieces. See also **triptych.**

Divine Office Daily public prayer. Monastic communities celebrated seven day hours (Laudes, Prime, Terce, Sext, None, Vespers, and Compline) and one night hour (Matins) as fixed by St. Benedict, who called it *opus Dei,* the work of God. In cathedrals and parish churches a simpler office consisted of morning and evening prayers. See also **hours.**

dogtooth molding Architectural ornament consisting of square, four-pointed, pyramidal stars.

dome A hemispherical vault; to erect a dome over a square or octagonal structure, the area between the walls and base of the dome is filled with pendentives or squinches. See also **pendentive, squinch, vault.**

Dominicans A preaching and teaching Order founded at Toulouse in 1206–16 by the Spaniard Domenico Guzmán (ca. 1170–ca. 1221, canonized 1234); also known as the Black Friars from the black cloak worn over a white habit. The great scholar St. Thomas Aquinas (1225?–1274), author of the *Summa Theologica,* was a Dominican friar. See also **friars.**

domus Latin: house. *Domus Ecclesiae:* House church. *Domus Dei:* the House of the Lord, the Church.

donjon The keep or principal tower stronghold of a castle.

dorter Dormitory.

double-shell octagon A church plan in which a central octagon is surrounded by an ambulatory and gallery.

dowel A pin used to hold two pieces of material together.

drôleries French: jokes. Marginal decorations in Gothic manuscripts.

drum The cylindrical or polygonal wall supporting a dome.

ecumenical council (also **oecumenical**) A worldwide council of bishops, called by the Pope, to decide doctrinal matters to be confirmed by the Pope and thenceforth binding on the Church.

elevation The side view of a building. The raising of the host and chalice during the Mass.

enamel Powdered colored glass fused to a metal surface and then polished.

> **champlevé enamel** French: raised ground. The area to be enameled is cut away from the plate.
> **cloisonné** French: partition. The cells or compartments for enamel are formed by strips of metal fused to the surface.

enceinte The outer fortified castle wall or the space enclosed by the wall.

entablature The horizontal structure carried by columns or piers; in Classical architecture, it consists of the architrave, frieze, and cornice.

epigraphy The study of inscriptions; compare **paleography,** the study of ancient written documents.

Epiphany The manifestation of Christ to the Gentiles, first through the Magi, the wise men from the East, who brought gifts to the newborn King of the Jews (Matthew 2:1–12). The gifts of the Magi were gold (royalty), frankincense (divinity), and myrrh (suffering and death). The Feast of the Epiphany is January 6.

Epistles Apostolic letters; 21 books of the New Testament, 14 of which are attributed to St. Paul.

Eucharist Greek: thanksgiving. The central act of Christian worship; the commemoration of Christ's sacrifice on the cross by the consecration and taking of bread and wine, signifying the body and blood of Christ (the actual nature long debated by the Church). See also **Host.**

evangeliary A liturgical book containing selections from the Gospels to be read by the deacon during the Mass.

evangelists The traditional authors of the four Gospels, St. Matthew, St. Mark, St. Luke, and St. John. The evangelists' symbols are the winged creatures from Ezekiel's vision (Ezek. 1:5–14, Rev. 4:6–8): the winged man or angel for St. Matthew, the lion for St. Mark, the bull or ox for St. Luke, and the eagle for St. John.

exarchate A province of the Byzantine Empire, as for example Ravenna.

exedra (pl. **exedrae**) A semicircular recess, apse, or niche covered by a conch.

facade The face of a building, usually the front but also applied to the transepts of a church.

fald-stool Folding seat, like a modern camp stool; as a throne it may be claw-footed and lion-headed and covered with drapery and a large cushion.

fan vault A Late Gothic form in which solid, semi-cones, nearly meeting at the apex of the vault and supporting flat panels, are decorated with patterns of ribs and tracery paneling to give the appearance of an ornamental rib vault.

Fathers of the Church Scholars and teachers of the early Church.

> **The Latin Fathers** St. Jerome, St. Ambrose, St. Augustine, St. Gregory.
> **The Greek Fathers** St. John Chrysostom, St. Basil, St. Athanasius, St. Gregory Nazianzus.

feast A religious festival commemorating an event or honoring the Deity or a saint. The Feasts of the Church are of three types: (1) Sundays—weekly commemoration of the Resurrection, declared a general holiday by Constantine in 321; (2) Movable Feasts—Easter and Pentecost (seventh Sunday after Easter), the annual commemoration of the Resurrection and the Descent of the Holy Ghost; (3) Immovable Feasts—Christmas, Epiphany, and the anniversaries of martyrs (saints' days). **The Twelve Great Feasts,** in the order of the liturgical calendar, are: Epiphany (Jan. 6), Presentation of Christ in the Temple (Feb. 2), Annunciation to Mary (March 25), Palm Sunday, Ascension Day, Pentecost, Transfiguration (Aug. 6), Death and Assumption (Dormition) of the Virgin (Aug. 15), Nativity of the Virgin (Sept. 8), Holy Cross (Sept. 14), Presentation of

Mary in the Temple (Nov. 21), and Christmas (Dec. 25). Easter, as the Feast of Feasts, is in a class alone and is not counted as one of the twelve.

fibula Metal fastener, on the principle of the safety pin, with ornamented foot and head plates and spring fastener.

filigree Intricate ornament made from fine, twisted wire, hence any delicate fanciful decoration.

finial Ornamental terminal, especially at the peak of a gable or spire.

flèche A tall slender spire.

fleur-de-lis French: lily flower. Stylized flower of the iris. In heraldry a three-petal form; the royal arms of France.

foil The lobe formed by cusps making a leaf-like design. The prefix designates the number of foils, hence the shape of the figures, as trefoil, quatrefoil, cinquefoil; a thin sheet of metal, used as backing for translucent enamel or garnets.

font A receptacle for baptismal water.

Franciscans A mendicant Order founded in 1209 at Assisi by St. Francis (Giovanni di Bernardone, ca. 1182–1226, canonized 1230); also known as Grey Friars from the color of their robes (later, habits were brown and tied with knotted cord).

fresco Mural painting in which pigments in water are applied to wet plaster which absorbs the colors. In *fresco secco* the dry plaster is remoistened so that the pigments adhere to the wall surface.

friar A member of a mendicant Order, such as the Dominicans or Franciscans.

frieze The middle element in the entablature; a horizontal band of carvings or paintings.

frontal See **altar frontal.**

Galilee In architecture, a large entrance porch or vestibule; a narthex.

gargoyle A waterspout often carved as a monster or animal.

garth The open space within a cloister.

gesso Plaster of Paris used as a ground for painting or gilding.

gisant The effigy of the deceased on a tomb.

glory The light emanating from a figure indicating sanctity; a **halo** or **nimbus** surrounds the head; a **mandorla** surrounds the entire figure.

gloss Commentary on a text.

Golgotha Aramaic: skull. "The place of the skull;" the site of the Crucifixion outside Jerusalem, also called Calvary from the Latin for skull.

Gospels Old English: Godspel, "good news." The term came to be used for the first four books of the New Testament in which the evangelists record the life of Christ. Since the "good news" (the "glad tidings of redemption") is the same in all the Gospels, the proper form is "the Gospel according to Matthew," etc.

gradual Choir book; antiphons from the Psalms.

Greek cross See **cross.**

grisaille Monochromatic painting or stained glass.

groin The edge of two intersecting vaults. See also **vault.**

guilloche Interlacing bands forming a braid; used as a decorative form of molding.

habit Monastic dress.

hall church From German, *Hallenkirche.* A church with nave and aisles of equal height.

hammerbeam A horizontal beam projecting at right angles from the top of a wall, carrying arched braces and posts and thus reducing the span of a timber roof.

Harrowing of Hell or **Descent into Limbo** According to the Apocryphal Gospel of Nicodemus, between Christ's Entombment and Resurrection He descended into Limbo where souls waited to be admitted into Heaven. Christ is often represented rescuing Adam, Eve, and other souls from Hell (a misunderstanding of Limbo).

haunch In an arch or vault the point of maximum outward thrust.

hemicycle A semicircular structure.

heresy A belief contrary to established doctrine. See **Adoptionism, Arianism, Monophysitism, Nestorianism.**

Hetoimasia The throne prepared for the second coming of Christ, as foretold in Revelations.

hieratic Sacerdotal, hence conventionalized art governed by priestly tradition; formal; stylized.

hieratic scale A convention in which the size of a figure indicates its relative importance.

historiated Decorated with a narrative subject, as historiated capitals or historiated initials.

Hodegetria Greek: showing the way. The Virgin holding and gesturing toward the Infant Christ.

Holy Ghost Third Person of the Trinity. **Gifts of the Holy Ghost:** Wisdom, Understanding, Counsel, Fortitude, Knowledge, Piety, Fear of the Lord (Isaiah 11:2); often represented as seven doves.

homily A lecture or sermon.

hood molding A projecting molding over a window or door to throw off rain. Also called a label or dripstone.

horseshoe arch An arch of horseshoe shape which, however, can be pointed as well as round.

hospice Lodging for guests.

Host Latin: *Hostia*. The sacrificial victim; thus the consecrated bread in the Eucharist; the body of Christ.

hours Cycle of daily prayers: Lauds (morning prayer, on rising), Prime (6 AM), Terce (9 AM), Sext (noon), None (3 PM), Vespers (originally variable but before sunset, now about 4:30 PM), Compline (variable, said just before retiring), and Matins (2:30 AM). The hours varied with the season, depending on time of sunrise and sunset. The liturgical day was composed of nine services, that is, the eight hours and Mass which was said between Terce and Sext.

icon An image of Christ, the Virgin Mary, or saint venerated in the Eastern (Orthodox) Church.

iconography The study of the meaning of images.

iconostasis A screen separating chancel and nave in a Byzantine church; by the fourteenth century a wall covered with icons and pierced by three doors leading to the altar, the diaconicon, and the prothesis.

impost The element below the springing of an arch; the blocks on which the arch rests.

impost block A downward tapering block, like a second capital, above the capital of a column.

inhabited initial or scroll Entwined foliage and small figures.

Instruments of the Passion See **Passion.**

intaglio Designs cut into a surface.

jamb The side of a door or window; often splayed and decorated with column-figures.

Jesse, Tree of A genealogical tree showing the descent of Christ from the royal line of David according to the prophesy of Isaiah (11:1–2).

Kaiserdom German: Imperial Cathedral.

katholikon The principal church of a Byzantine monastery.

keep The principal tower of a castle, provisioned to withstand siege. See also **donjon.**

keystone The wedge-shaped central stone of an arch or vault.

knop A decorative knob, part of the stem of a candlestick, chalice, or similar item.

Koran Muslim sacred writings.

Kufic script An angular written Arabic script, often used as decoration.

label See **hood molding.** Sculptured ends of labels are called label-stops.

Lady, Our Lady *Domina nostra, Nôtre Dame,* the Virgin Mary.

Lady Chapel A chapel dedicated to the Virgin Mary forming part of a larger church; in England often a large chapel east of the high altar.

Lady Day The Feast of the Annunciation, March 25; in the Middle Ages considered to be the first day of the civil year.

lancet window A tall pointed window without tracery.

lappet A ribbon-like extension from the lip or the back of the head of a human or fantastic animal.

Latin cross See **cross.**

lauratron The image of the emperor; the symbol of the imperial presence.

lavabo A wash basin.

lectern A reading desk in a church, often having the form of an eagle.

lectionary A liturgical book containing selections from scripture to be read during the worship service, organized according to the church calendar. Sometimes divided into epistolaries and evangeliaries, and finally supplanted by the missal.

Liberal Arts The Medieval educational system of the trivium (grammar, rhetoric, and logic) and the quadrivium (arithmetic, music, geometry, astronomy). Often personified and associated with the Virgin Mary.

Liber Pontificalis Latin: the Papal Book. The official collection of Biographies of the Popes.

Liber Vitae Latin: Book of Life. List of benefactors.

Libri Carolini Latin: Caroline Books. Carolingian treatise attacking the work of the Council of Nicaea (787) and the restoration of the veneration of icons.

lierne A tertiary rib; a rib springing from neither a main springer nor a central boss but running from one rib to another to decorate the vault.

linenfold Decorative paneling evoking a conventionalized pattern of vertically folded fabric.

lintel A horizontal element spanning an opening.

liturgical calendar. See **feast, The Twelve Great Feasts.**

liturgy The public services or rites of worship in the church, the principal one of which is the Mass or Eucharist; also written texts giving the order of service.

loculi Niches in the walls of a catacomb to hold the dead.

loggia An arcaded gallery.

lunette A flat semicircular surface.

lustre A shining surface on ceramics produced by metallic glazes fired at a low temperature.

machicolation A gallery supported by brackets on the outer face along the top of fortified walls. Openings in the floor permit missiles to be dropped on attackers.

Maestà Italian: majesty. The Virgin in majesty; an altarpiece with a representation of the Virgin enthroned, adored by saints and angels.

magistri comacini Traveling masons working from Lombardy to Catalonia in the ninth and tenth centuries.

Magus (pl. **Magi**) Persian priest. The three wise men who paid homage to the Infant Christ, representing the recognition of Christ by the Gentiles.

majuscule Upper-case letter.

mandorla See **glory.**

maniple A narrow strip of cloth worn over the left arm by the celebrant of the Mass. See also **vestments.**

Maria Regina Latin: Mary Queen of Heaven.

marquetry Inlay of thin pieces of colored wood, ivory, mother-of-pearl.

martyr Greek: witness. One who has suffered death for the faith. The anniversary of a martyr's death was celebrated by the church (saint's day). A relic of a martyr had to be placed in every consecrated altar (until 1969).

martyrium (pl. **martyria**) A church built over the tomb of a martyr.

martyrology The official register of Christian martyrs; at first simply a list of names and dates of martyrdom; later writers added stories. (A **Passion** described the death of an individual martyr in detail.)

Mass Latin: *missa*, referring to the dismissal of the congregation after the service, *Ite, missa est,* "Go, you are dismissed." The central rite of the Christian Church. See also **Eucharist.**

mausoleum (pl. **mausolea**) A tomb, so-called after the fourth-century B.C. tomb of Mausolus at Halicarnassus.

meander A fret or "Greek key" pattern.

medium The material out of which the work of art is made.

mihrab In a mosque, the niche in the qibla wall indicating the direction of Mecca.

millefiori Italian: thousand flowers. Enamel patterns produced by fusing rods of colored glass and then slicing off thin sections to set in the field.

mille-fleurs **tapestry** French: thousand flowers. An overall, repeated pattern of plants which may be highly stylized or quite naturalistic.

minaret In Islamic architecture, a tower from which the faithful were called to prayer.

minbar A pulpit or reader's platform in a mosque.

miniature From *minium,* a red pigment. A painting or drawing in a manuscript, hence tiny.

minster Once any monastery or its church; later applied to some cathedrals and churches especially in England and Germany.

minuscule Lower-case letter.

miracle A fact or event transcending the normal order of things, produced through divine intervention.

misericord A bracket on the underside of the seat of a choir stall which, when the seat is tipped up, provides support for the occupant.

missal A liturgical book containing the text and instructions for the celebration of the Mass throughout the year; combines the lectionary and sacramentary.

missorium A commemorative dish.

miter A cap with two points and lappets, worn by bishops and some abbots. See also **vestments.**

moat Defensive ditch around a castle or town.

molding A projecting or recessed decorative strip.

monastery A community of monks or nuns; the buildings housing the community. In addition to the church, a large self-sufficient monastery had a cloister, chapterhouse, scriptorium and library, dormitory, refectory, kitchen, hostelry or guesthouse, infirmary, novitiate, and supporting farm buildings, workshops, and storerooms.

monograms and symbols of Christ

Chi Rho (XP) The first two letters of the Greek word for Christ, *Xpictoc*, combined to form a cross.

IHC, IHS The first three letters of the Greek word for Jesus (*Ihcuc* or *Ihsus*).

IC XC The first and last letters of Jesus Christ (*Ihcuc Xpictoc*).

INRI (*Iesus Nazarenus Rex Iudaeorum*) Latin: Jesus of Nazareth, King of the Jews (tablet on the cross).

ichtus The sign of the fish, *ichtus* in Greek, comes from the initial letters of the Greek phrase, "Jesus Christ, Son of God, Savior." The fish symbolizes Christ and also the rite of baptism.

Monophysitism Greek: one nature. The doctrine of the single divine nature of Christ; as opposed to the Orthodox belief in the dual nature (human and divine, dyophysite) of Christ after the Incarnation; condemned as heretical by the Council of Chalcedon in 451; the belief continued in Syria, Egypt, Armenia, and Georgia.

monotheism Belief in one God. The three great monotheistic religions are Judaism, Christianity, and Islam. In Christianity the three Persons of the Trinity remain one Godhead.

monsters, fabulous beasts

basilisk Bird's head and body with serpent's tail; kills with a glance.

dragon Gigantic reptile with four legs, lion's claws, serpent's tail, and scaly wings and skin; often fire breathing.

griffin Lion with eagle's head and wings.

harpy Woman's face and body with bird's wings and claws.

quadruped Unidentifiable four-legged beast.

unicorn Horse or deer-like animal with a single horn.

wyvern Two-legged dragon.

mosaic A surface decoration composed of small colored stones or glass cubes laid in cement or plaster forming figurative or abstract designs.

mosque Prayer hall.

motte-and-bailey Fortification consisting of a central earthen mound (motte) supporting a wooden tower and an encircling open yard (bailey) all enclosed by a ditch and earthen bank with timber palisade.

mukarnas The stalactite dome or vault; an ornamental ceiling formed of corbeled squinches usually of brick or timber; as a decorative form may be used on capitals.

Muldenstil German: trough. Trough-like depressions represent folds of drapery.

multiple-fold drapery Drapery surface covered by fine, parallel lines.

naos Greek: the principal room in a temple. The sanctuary; the space in which the liturgy is performed. In a Byzantine church the naos includes apse, choir, and nave.

narthex The vestibule of a church; a transverse hall in front of the nave.

nave Latin: ship. Central vessel of a church, extending from the entrance to the crossing or choir.

Necropolis City of the Dead.

Neskhi Cursive Arabic script. See also **Kufic.**

nested V-fold Drapery represented as forming a series of V-shapes, one inside the other.

Nestorianism From Nestorius (d. ca. 451), a Syrian priest. The belief in two separate Persons of Christ

(human and divine) as opposed to the Orthodox doctrine of a single Person at once God and man; emphasis on Christ's human nature and thus the denial of the title "Mother of God" to Mary. Condemned as heretical by the Council of Ephesus in 431. The belief continued in Persia.

net vault A vault with lierne and tiercerone ribs arranged in an intersecting, net-like pattern.

niello Metal decoration in which incised designs are filled with a sulphur alloy and fused by heat to form a dark pattern.

nimbus See **glory.**

nodding ogee arch Ogee arches curving outward as well as upward.

nook shaft A shaft set in the angle of a pier, respond, or jamb.

Octateuch The first eight books of the Bible; the Pentateuch plus the books of Joshua, Judges, and Ruth.

oculus (pl. **oculi**) Latin: eye. A round window.

Office See **Divine Office.**

ogee An S-shaped curve; in an ogee arch the two S-shaped curves are reversed to meet in a central point.

opus alexandrium Marble laid in geometric patterns.

opus anglicanum The elaborate figurative embroidery, used especially for vestments, produced in England in the Gothic period.

opus francigenum Medieval term for the new architectural style and technique of northern France; later to be known as Gothic.

opus reticulatum A form of Roman masonry, lozenge-shaped stones forming a net-like pattern.

orant Latin: praying. A figure with hands raised in prayer.

oratory A chapel; a small building for prayer.

orb A sphere symbolizing the earth.

order (architectural) In Classical architecture, the style of building as determined by the proportions and form of the total structure, columns, and entablature; in Romanesque architecture, the recessions of an arch, in a doorway or arcade.

Order (ecclesiastical) A group of people united

by a rule or aim; thus, a monastic institution. A choir of angels. Grades in Christian ministry.

Orders or **Holy Orders.** The sacrament of ordination; thus, the clerical status (priests, deacons, and subdeacons).

Palatine Chapel Palace chapel.

paleography The study of ancient written documents.

pallium A strip of white wool with front and back pendants decorated with black crosses worn around the shoulders, given by the Pope to archbishops as a symbol of authority.

palmette A stylized palm frond.

paradise Persian: enclosed park. The Garden of Eden; the heaven of the Blessed. An open court or atrium in front of a church (Parvis). A monastic garden or cemetery, especially in the cloister.

parapet Low, protective wall.

parchment Treated animal skin used for books and documents. See also **vellum.**

parish Greek: district. A subdivision of a diocese under the care of a priest.

Pasch Jewish: Passover. Christian: festival of Easter. **Paschal lamb:** lamb eaten at Jewish Passover after being sacrificed in the Temple, thus Christ as the sacrificial lamb. **Paschal candle:** a candle lighted during the Easter season.

Passion Latin: suffering. The Passion refers to the last days of Christ, His suffering, and Crucifixion. The events of the Passion begin with the Entry into Jerusalem and the Last Supper and include Christ washing the feet of the Disciples, the Agony in the Garden, the Betrayal by Judas, the Denial of Peter, Christ before Pilate, the Flagellation, the Crowning with Thorns, Christ Carrying the Cross, the Crucifixion, the Descent from the Cross, the Pietà or Lamentation, the Entombment, the Descent into Limbo, the Resurrection, the Ascension. Also, the account of a martyrdom. **Instruments of the Passion** as represented in art take three forms: (1) instruments used in the torture of Christ, such as column, whips, crown of thorns, (2) objects recalling the events of Christ's last hours on earth, such as the wash basin (Pilate), purse (Judas), and crowing rooster (St. Peter), and (3) objects specifically associated with the Crucifixion, such as ladder, hammer, dice.

paten A platter on which the bread is offered and the consecrated Host is placed. See also **chalice**.

patriarch Head of an ecclesiastical province in the Eastern Church, comparable to an archbishop in the West.

pectoral cross A cross worn on the chest.

pediment The triangular area enclosed by the entablature and raking cornice.

pendentive A spherical triangular section of masonry making a structural transition from a square to a circular plan; four pendentives support a dome.

Penitential Psalms Vulgate 6, 31, 37, 50, 101, 129, and 142; King James 6, 32, 38, 51, 102, 130, 143.

Pentateuch Greek: five books. The first five books of the Bible, that is, Genesis, Exodus, Leviticus, Numbers, and Deuteronomy.

Pentecost Greek: Fiftieth day after Passover (the Jewish Feast of Weeks). The Descent of the Holy Ghost (Acts 2:1–4); hence, the beginning of the apostles' mission.

pericope Greek: section. Selected passages of scripture to be read at church services.

peristyle An open court surrounded by columns.

perspective A system for representing three-dimensional objects on a two-dimensional surface. **One point linear perspective:** parallel lines at right angles to the picture plane appear to vanish at a single point on the horizon; thus, figures and objects appear to grow smaller in the distance. **Aerial or atmospheric perspective:** distant objects are represented as lighter and grayer in color and less distinct in outline than nearby figures. **Reverse perspective:** lines diverge as they recede, and objects appear to tip up and grow larger.

pier A solid masonry support.

pietà Italian: pity. The mourning Virgin seated with the body of the crucified Christ in her lap.

pilaster A flat vertical element projecting from a wall or pier; often divided into base, shaft, and capital.

pilgrimages Journeys to holy places made as acts of piety or penance; the great pilgrimages of the Middle Ages were to Jerusalem, Rome, and Santiago de Compostela.

pinnacle A small turret, usually ornamental but also used to load a buttress.

piscina Latin: fishpond. At first a pool for baptism; later a niche near the altar with a drain for the disposal of water used in the ceremonies.

plate drapery The representation of cloth as a series of superimposed, sheath-like layers.

plate tracery See **tracery**.

plinth The projecting base of a column or wall.

polychromy The use of colors on architecture and sculpture.

porphyrogenitus Greek: born in the purple. The birth room in the Byzantine Imperial Palace was decorated with porphyry, a reddish-purple stone.

precentor The leader of the church choir.

predella Italian: kneeling-stool. The base of a large altarpiece, often painted or carved.

presbyters Overseers and administrators of the church.

priory A monastic house, or community dependent on an abbey; ruled by a prior or prioress.

propylaeum Monumental entranceway.

prothesis The chamber, in a Byzantine church, used for the storage and preparation of the bread and wine used in the Mass. See also **diaconicon**.

psalter Book containing the Psalms. Benedictine monks recited all the Psalms every week.

pulpit A raised stand for a reader; it replaced the ambo in the late Middle Ages.

pulpitum A choir screen.

putto (pl. **putti**) A small, winged boy.

pyx A container for the reserved sacrament, that is, a consecrated Host saved for later use.

qibla The wall in a mosque indicating the direction of Mecca.

quadripartite vault A vault divided into four cells or compartments.

quatrefoil A design having four lobes or foils; a four-leaf clover shape used in ground plans and as a decorative motif.

quincunx Five objects (such as domes in a Byzantine church) arranged in a square with one in the center and one in each corner.

rampant In heraldry, an animal standing on its hind legs.

recension The revision of a text, or a revised text.

reconquista Spanish: reconquest. The crusade against the Moors in Spain.

refectory Dining hall.

regalia Symbols of royalty such as the crown and sceptre.

reja Spanish: a grill.

relics The venerated remains of saints or objects associated with saints.

relieving arch An arch built into a masonry wall over an opening to disperse (and thus to relieve) the weight above.

reliquary A container for relics.

repoussé A metal relief made by pounding out the design from the back.

reredos A sculptured or painted screen behind the altar. Also known as a **retable** or *retablo* (Spanish).

reserved To save for future use, as in the reserved sacrament. In enameling the raised area of polished, often gilded, metal without enamel.

respond A shaft or pilaster attached to a wall to support an arch.

retable See **reredos.**

rib An arched, molded band dividing and supporting the cells of a vault.

rib vault A vault built on a framework of arched ribs.

rinceau Ornament composed of scrolls of foliage.

rite The prescribed form for conducting a religious service; a ceremonial act; the liturgy.

roll molding A semicircular, convex molding.

rood A cross or crucifix, often placed above the screen at the entrance to the choir.

rubble masonry Rough building stones laid in irregular courses.

rule The regulations drawn up by the founder of a religious order to govern the life and observances of its members as, for example, the Benedictine Rule.

rune Twig-like northern script.

rune stone A commemorative stone inscribed with runes.

sacramentary A liturgical book containing the canon of the Mass and prayers but not the Epistles and Gospels (see **lectionary**) or the sung portions (see **gradual**) in use until the thirteenth century for the celebration of the Mass. Replaced by the missal.

Sacraments Rites of the church: Baptism, Confirmation, the Eucharist, Penance, Matrimony, Holy Orders, Extreme Unction.

sacrifice The offering of a gift, often a living creature, to a deity. In Christianity the Eucharist symbolizes or re-enacts the sacrifice of Christ.

sacristy A room in a church near the altar where liturgical vessels and vestments are kept.

sarcophagus (pl. **sarcophagi**) A large stone coffin.

scriptorium (pl. **scriptoria**) A place where manuscripts are written.

sedilia Seats for the celebrating clergy in the south wall of the choir (usually three seats, for priest, deacon, and subdeacon).

see Latin: *sedes*, seat. The official seat of a bishop. The town where the throne and cathedral are located and by extension the jurisdiction of the bishop. See also **diocese.**

seraphim The highest order of angels.

sexpartite vault A vault divided into six cells or compartments.

soffit The underside of an arch, lintel, or cornice.

solar The upper living room in a medieval house.

spandrel The triangular space formed by the curve of arches in an arcade.

spire A tall, pyramidal, polygonal termination rising over a tower.

springers The stones supporting the arc of an arch.

squinch A corbeled arch or niche across the corner of a square bay serving to convert the space to an octagon on which a dome or vault can be raised.

stalactite vault See *mukarnas.*

star vault A vault with ribs (see **lierne** and **tiercerone**) arranged in a star pattern.

Stations of the Cross Popular devotions commemorating the Passion of Christ, based on the Way of the Cross in Jerusalem, developed by the Franciscans in the later Middle Ages.

stave church A Norwegian timber church supported by vertical timber posts.

stele A commemorative stone carved with reliefs and inscriptions.

stole A strip of material worn over the shoulders by priests and deacons.

strainer arch An arch inserted between two walls or piers to prevent them from leaning.

string-course A horizontal molding on a building.

stucco Fine plaster, often used decoratively.

synod An ecclesiastical council.

tabernacle A receptacle for the Holy Sacrament or relics; often a decorated, freestanding canopy.

tau cross A T-shaped cross. See also **cross.**

terracotta Italian: baked earth. Used for building, sculpture, and ceramics.

tessera (pl. **tesserae**) Small cubes of stone or glass making a mosaic.

tetraconch A building consisting of four conch-covered exedrae enclosing a cubical central space. See also **conch, exedra.**

tetrarchy Four-man rule.

theophany The temporary and immaterial appearance of God in visible form, in contrast to the Incarnation in which God and man were permanently and completely united.

Theotokos Greek: Mother of God. The Virgin Mary was proclaimed *Theotokos* at the Council of Ephesus. See also **Nestorianism.**

tiercerone Secondary rib springing from a main springer and leading to the ridge rib.

timber framing A construction technique in which timber framework is filled with wattle and daub, brick, or plaster to form walls; also known as half-timbering.

torque A neck ornament, usually twisted bars or strands of gold.

tracery Ornamental stone work applied to wall surfaces or used to fill the upper part of windows. In **plate tracery** openings are cut through the stone spandrels above the arched lights. In **bar tracery** mullions divide the window into lights and continue to form decorative patterns in the head of the window.

transept The transverse element of a basilican church, often as high or higher and as wide as the nave.

Transfiguration The revelation of the Divinity of Christ to the Apostles Peter, James, and John. Christ appeared in glory with Moses and Elias on Mount Tabor (Mat. 17:1–13, Mark 9:2–13, Luke 9:28–36).

transom A horizontal cross bar in a window.

trefoil A three-lobed shape. See also **foil, cusp, quatrefoil.**

tribune An arcaded gallery above the aisle and open to the nave of a church.

triclinium Dining room in a Roman house.

triforium In the elevation of a basilican church, the space at the height of the aisle roofs between the nave arcade and the clerestory; an arcaded passage in that position.

triptych Three hinged panels; the narrower outer panels can be folded over the inner panel to protect it. See also **diptych.**

triquetra An ornament of three interlaced arcs.

triskele A three-legged, running figure found in Celtic ornament.

triumphal arch In ancient Rome, a freestanding monument in the form of a gateway to commemorate a military victory. In the Christian church, the transverse wall at the end of the nave pierced by an arched opening into the sanctuary.

trumeau The central post of a portal supporting a lintel and tympanum.

truss The timber framework forming rigid triangles to support the roof; may be left open or covered with a wooden ceiling.

tympanum The area between the lintel and the arch of a portal.

typology The Old Testament prefiguration of events in the New Testament; Old Testament types are paired with New Testament antitypes, for example Abraham's sacrifice of Isaac with the Crucifixion of Christ, the story of Johan with the death and Resurrection of Christ.

uncial A Roman alphabet with rounded letters.

vault A masonry covering built on the principle of the arch; the two simplest forms are the **barrel vault,** a tunnel-like extension of the arch, and the **groin vault** in which two barrel vaults of equal size intersect at right angles. In a **ribbed vault**

masonry ribs are constructed to concentrate the load and thrust and to reduce the amount of centering needed for construction. See also **groin, ribs.**

vellum A fine parchment prepared for writing and illumination.

vermicule Foliate scroll or wormlike patterns engraved as a background for enamel and on masonry.

Vesperbild German. An image for meditation at evening prayers.

vestments The distinctive dress worn by the clergy when performing the services of the church. See also **alb, amice, chasuble, miter, cope, stole.**

vestry A room for the storage of vessels, vestments, and other liturgical equipment. See also **diaconicon.**

vices The seven deadly sins, usually pride, covetousness or avarice, lust or unchastity, envy, gluttony, anger, and sloth. Folly, inconstancy, injustice are also often represented among the vices. Vices are often paired with virtues.

Victory As a personification or deity, usually represented as a winged female holding a laurel wreath.

virtues The theological virtues are faith, hope, and charity; the cardinal virtues are prudence, justice, fortitude, and temperance. The combat of virtues and vices (Psychomachia) is a popular theme in Medieval art.

Visitation The visit of Mary to her cousin Elizabeth, mother of St. John the Baptist, after the Annunciation (Luke: 36, 41–42).

volute A spiral or scroll form, as on Corinthian capitals.

voussoir A wedge-shaped block used in the construction of an arch. The central voussoir is known as the keystone.

Vulgate St. Jerome's Latin translation of the Bible.

wattle and daub Interwoven laths or branches plastered over with clay.

westwork A complex structure at the west end of a church consisting of superimposed entrance, a chapel, and often a throne room flanked by towers or stair turrets.

Zackenstil German: zigzag. A convention in which angular drapery folds end in a zigzag pattern.

zodiac The path of the sun, moon, and planets around the earth, divided into twelve parts marking the times of the year; used in Christian art to suggest the extension of time of God's dominion. The signs of the zodiac are named after the constellations: Aries (the ram), Taurus (the bull), Gemini (the twins), Cancer (the crab), Leo (the lion), Virgo (the Virgin), Libra (the scales), Scorpio (the scorpion), Sagittarius (the archer), Capricorn (the goat), Aquarius (the water carrier), Pisces (the fishes).

zoomorphic The use of animal forms as decorative and symbolic devices.

SUGGESTIONS FOR FURTHER READING

The following list is not intended to be a comprehensive bibliography.
It includes well-illustrated books found in most undergraduate libraries.

I. History and Culture

Adams, Henry, *Mont-Saint-Michel and Chartres*, Boston and New York, first published 1904; many later editions.

Bishop, Morris, *The Middle Ages*, New York, 1970.

Brooke, Christopher, *The Monastic World, 1000–1300*, London, 1974.

———, *The Structure of Medieval Society*, London, 1971.

———, *The Twelfth Century Renaissance*, London, 1969.

"The Cloister," *Gesta*, 12 (1973), special issue with articles by Wayne Dynes, Alfred Frazer, Jane Hayward, Walter Horn, Paul Meyvaert, and Leon Pressouyre.

Colvin, H. M., *The History of the King's Works*, London, 1963.

Delort, Robert, *Life in the Middle Ages*, London, 1974.

Downy, Glanville, *Constantinople in the Age of Justinian*, Norman, Oklahoma, 1960.

Duby, Georges, *The Making of the Christian West, 980–1140; Europe of the Cathedrals, 1140–1280; Foundations of a New Humanism, 1280–1440*, Geneva, 1966–67.

Durandus, William, *The Symbolism of Churches and Church Ornaments: A Translation of the First Book of the Rationale Divinorum Officiorum*, John Mason Neale and Benjamin Webb (trans.), London, 1893.

Egbert, Virginia W., *The Medieval Artist at Work*, Princeton, 1967.

Evans, Joan, *Life in Medieval France*, London, 1925; rev. ed., 1957; 3rd ed., London, 1969.

Harvey, John H., *Medieval Gardens*, London, 1981.

Haskins, C. H., *The Rise of Universities*, New York, 1923.

Husband, Timothy, *The Wild Man:*

Medieval Myth and Symbolism (exhibition catalogue, The Metropolitan Museum of Art), New York, 1980.

———, and Jane Hayward, *The Secular Spirit: Life and Art at the End of the Middle Ages* (exhibition catalogue, The Metropolitan Museum of Art), New York, 1975.

McLean, Teresa, *Medieval English Gardens*, New York, 1980.

Plummer, John, *Liturgical Manuscripts for the Mass and Divine Office* (exhibition catalogue, The Pierpont Morgan Library), New York, 1964.

Previté-Orton, C. W., *The Shorter Cambridge Medieval History*, 2 vols., Cambridge, 1952.

Stokstad, Marilyn, *Santiago de Compostela in the Age of the Great Pilgrimages*, Norman, Okla., 1978.

———, and Jerry Stannard, *Gardens of the Middle Ages* (exhibition catalogue, Spencer Museum and Dumbarton Oaks), Lawrence, Kan., 1983.

Sullivan, Richard, *Aix-la-Chapelle in the Age of Charlemagne*, Norman, Okla., 1974.

Theophilus: De Diversibus Artibus, C. R. Dodwell (trans.), London, 1961; *On Divers Arts: The Treatise of Theophilus*, John G. Hawthorne and Cyril S. Smith (trans. and ed.), Chicago, 1963.

Tyler, William, *Dijon and the Valois Dukes of Burgundy*, Norman, Okla., 1971.

White, Lynn, Jr., *Medieval Technology and Social Change*, Oxford, 1962.

White, T. H., *The Bestiary: A Book of Beasts*, New York, 1954.

II. General Studies

Alexander, J. J. G., *The Decorated Letter*, New York, 1978.

——— (ed.), with E. Temple, C. M. Kauffmann, N. J. Morgan, and L. F. Sandler, *A Survey of Manuscripts Illuminated in the British Isles*, 5 vols., Oxford, 1975–84.

Anthony, Edgar W., *A History of Mosaics*, Boston, 1935.

Aubert, Marcel, *La sculpture française au moyen âge*, Paris, 1947.

———, *Le vitrail en France*, Paris, 1946.

Baltrusaitis, Jurgis, *Le moyen âge fantastique*, Paris, 1955.

Baum, Julius, and Helga Schmidt-Glassner, *German Cathedrals*, London, 1956.

Beckwith, John, *Early Medieval Art*, New York, 1964.

Bevan, Bernard, *A History of Spanish Architecture*, London, 1938.

Bony, Jean, and Martin Hürlimann, *French Cathedrals*, London, 1951.

Braunfels, Wolfgang, *Monasteries of Western Europe: The Architecture of the Orders*, Princeton and London, 1972.

Calkins, Robert G., *Illuminated Books of the Middle Ages*, Ithaca, N.Y., 1983.

———, *Monuments of Medieval Art*, New York, 1979.

———, *Programs of Medieval Illumination*, Lawrence, Kan., 1984.

Conant, Kenneth John, *Carolingian and Romanesque Architecture: 800 to 1200* (Pelican History of Art), Harmondsworth, 1959.

Davis-Weyer, Caecilia, *Early Medieval Art, 300–1154* (Sources and Documents in the History of Art), Englewood Cliffs, N.J., 1971.

Dehio, G., and G. von Bezold, *Die Kirchliche Baukunst des Abendlandes*, 7 vols., Stuttgart, 1884–1901.

Demus, Otto, *Byzantine Art and the West*, New York, 1970.

de Winter, Patrick M., *The Sacral Treasure of the Guelphs,* Cleveland and Bloomington, Ind., 1985.

Dominguez Bordona, J., *La miniatura española,* Florence and Barcelona, 1930.

Enlart, C., *Manuel d'archéologie française,* 2nd ed., 5 vols., Paris, 1919–1932.

Evans, Joan, *Art in Medieval France, 987–1498,* Oxford, 1948, 1969.

——, *Dress in Medieval France,* Oxford, 1952.

——, *The Flowering of the Middle Ages,* New York, 1966.

Farquhar, James D., and Sandra Hindman, *Pen to Press,* Baltimore, 1977.

Fillitz, Hermann, *Das Mittelalter,* I: *Propyläen Kunstgeschichte,* vol. 5, Berlin, 1969.

Focillon, Henri, *Art d'Occident, le moyen âge, roman et gothique,* Paris, 1938; *The Art of the West in the Middle Ages,* Jean Bony (ed.), Donald King (trans.), New York and London, 1963; Ithaca, N.Y., 1980.

Forsyth, George, Jr., *The Church of St. Martin at Angers: The Architectural History of the Site from the Roman Empire to the French Revolution,* 2 vols., Princeton, 1953.

Gardner, Arthur, *French Medieval Sculpture,* Cambridge, 1931; reprint, New York, 1969.

Garrison, Edward, *Studies in the History of Mediaeval Italian Painting,* 4 vols., Florence, 1953–62.

Gauthier, Marie-Madeleine, *Émaux du moyen âge occidental,* Fribourg, 1972.

——, *Émaux limousins des XIIe, XIIIe, et XIVe siècles,* Paris, 1950.

Gómez-Moreno, Carmen, *Medieval Art from Private Collections* (exhibition catalogue, The Metropolitan Museum of Art), New York, 1968.

Grodecki, Louis, *Ivoires français,* Paris, 1947.

——, *Les vitraux des églises de France,* Paris, 1948.

——, *Vitraux de France du XIe au XVIe siècle,* Paris, 1953.

Harvey, John H., *The Cathedrals of Spain,* London, 1957.

——, *The Gothic World, 1100–1600,* London and New York, 1950, 1969.

——, *The Master Builders: Architecture in the Middle Ages,* New York, 1972.

Hayward, Jane, and Walter Cahn, *Radiance and Reflection: Medieval Art from the Raymond Pitcairn Collection* (exhibition catalogue, The Metropolitan Museum of Art), New York, 1982.

Henry, Françoise, *L'art irlandais,* 3 vols., Zodiaque, La Pierre-qui-Vire, 1963–64; English ed., Ithaca, N.Y., 1965–70.

——, *Irish Art,* London, 1940.

——, *La sculpture irlandaise pendant les douze premiers siècles de l'ere chrétienne,* 2 vols, Paris, 1933.

Holt, Elizabeth Gilmore, *A Documentary History of Art,* vol. 1: *The Middle Ages and the Renaissance,* Garden City, N.Y., 1957.

Horn, W., "On the Origins of the Mediaeval Bay System," *Journal of the Society of Architectural Historians,* 17 (Summer 1958), 2–23.

Johnson, Paul, *The National Trust Book of British Castles,* New York, 1978.

Katzenellenbogen, Adolf, *Allegories of the Virtues and Vices in Mediaeval Art,* New York, 1939, 1964.

Kidson, Peter, *The Medieval World,* New York, 1967.

——, Murray, P., and P. Thompson, *A History of English Architecture,* London, 1965.

Kraus, Henry, *The Living Theater of Medieval Art,* Philadelphia, 1972.

Krautheimer, Richard, *Rome, Profile of a City, 312–1308,* Princeton, 1980.

——, *Studies in Early Christian, Medieval and Renaissance Art,* New York, 1969.

Lacy, Norris (ed.), *The Arthurian Encyclopedia,* New York and London, 1985.

Lasko, Peter, *Ars Sacra: 800–1200* (Pelican History of Art), Harmondsworth, 1972.

Lasteyrie, R. de, *Etudes sur la sculpture française au moyen âge: Monuments Pio,* 8 (1902).

Lavedan, Pierre, *French Architecture,* English ed., Harmondsworth, 1956.

Mâle, Emile, *Religious Art from the Twelfth to the Eighteenth Century,* English ed., New York, 1949.

Millar, Eric G., *English Illuminated Manuscripts from the Tenth to the Thirteenth Centuries,* Paris and Brussels, 1926.

Morey, Charles R., *Medieval Art,* New York, 1942.

Nordenfalk, Carl, and Gary Vikan, *Medieval and Renaissance Miniatures from the National Gallery of Art,* Washington, D.C., 1975.

Oakeshott, Walter, *Classical Inspiration in Medieval Art,* London, 1959.

——, *The Mosaics of Rome from the Third to the Fourteenth Centuries,* London, 1967.

Oursel, C., *L'art de Bourgogne,* Grenoble, 1953.

Panofsky, Erwin, *Die deutsche plastik des elften bis dreizehnten jahrhunderts,* Munich, 1924.

——, *Renaissance and Renascences in Western Art,* Stockholm, 1960; New York, 1969.

——, *Tomb Sculpture,* New York, 1964.

Pevsner, Nikolaus, *The Buildings of England* (vols., by county, in progress) Harmondsworth, 1951–.

——, *An Outline of European Architecture,* Harmondsworth, 1943; 7th ed., 1974.

Porcher, J., *Les manuscrits à peintures en France du VIIe au XIIe siècle* (exhibition catalogue, Bibliothèque Nationale), Paris, 1954.

——, *Medieval French Miniatures,* New York, 1959/60.

Porter, Arthur Kingsley, *Lombard Architecture,* 4 vols., New Haven, 1915–17.

——, *Medieval Architecture: Its Origins and Development,* 2 vols., New Haven, 1912.

Post, Chandler Rathfon, *A History of Spanish Painting,* 12 vols., Cambridge, Mass., 1930–58.

Prior, Edward S., and Arthur Gardner, *An Account of Medieval Figure-Sculpture in England,* Cambridge, 1912.

Randall, R., Jr., *Masterpieces of Ivory*

from the Walters Gallery, New York, 1985.

Réau, Louis, *Iconographie de l'art chrétien*, 3 vols., Paris, 1955–59.

Rhin-Meuse, Art et Civilisation, 800–1400 (exhibition catalogue, Kunsthalle, Cologne, and Musées royaux des beaux-arts), Cologne and Brussels, 1972.

Rickert, Margaret, *Painting in Britain: The Middle Ages* (Pelican History of Art), Harmondsworth, 1954; 2nd ed., 1965.

Robb, David M., *The Art of the Illuminated Manuscript*, New York and London, 1973.

Saalman, Howard, *Medieval Architecture*, New York, 1965.

Salmi, Mario, *Italian Miniatures*, 1954; English ed., New York, 1956/57.

Salvini, Roberto, *Medieval Sculpture*, English ed., Greenwich, Conn., 1969.

Saxl, Fritz, and Rudokf Wittkower, *British Art and the Mediterranean*, Oxford, 1947.

Schapiro, Meyer, *Late Antique, Early Christian and Medieval Art*, New York, 1979.

Schiller, Gertrud, *Ikonographie der chistlichen Kunst*, 1966; first American edition, *Iconography of Christian Art*, 2 vols., Janet Seligman (trans.), Greenwich, Conn., 1971–72.

Simson, Otto von, *Das Mittelalter*, II: *Propylaen Kunstgeschichte*, vol. 6, Berlin, 1972.

Stoddard, Whitney, *Monastery and Cathedral in Medieval France*, Wesleyan, 1966; reissued as *Art and Architecture in Medieval France*, New York, 1972.

Stone, Lawrence, *Sculpture in Britain in the Middle Ages* (Pelican History of Art), Harmondsworth, 1955.

Taralon, Jean, *Les Trésors des églises de France* (exhibition catalogue, Musée des arts decoratifs), Paris, 1965; English ed., *Treasures of the Churches of France*, New York, 1966.

Thoby, Paul, *Les Croix limousines de la fin du XIIe siècle au début du XVIe siècle*, Paris, 1953.

———, *Le Crucifix, des origines au Concile de Trente*, Nantes, 1959.

Toesca, Pietro, *Storia dell'arte italiana*, 3 vols., Turin, 1927–51.

Toy, S., *Castles: Their Construction and History* (Dover edition), New York, 1985.

Tristram, Ernest, *English Medieval Wall Painting*, 3 vols., Oxford, 1944.

Verdier, Philippe, *Le couronnement de la vierge*, Montreal, 1980.

Violett-le-Duc, E., *Dictionnaire raisonné de l'architecture française du XIe au XVIe siècle*, 10 vols., Paris, 1854–68.

Watson, A., *The Early Iconography of the Tree of Jesse*, Oxford, 1934.

Webb, Geoffrey, *Architecture in Britain: The Middle Ages* (Pelican History of Art), Harmondsworth, 1956.

Wixom, William, *Treasures from Medieval France* (exhibition catalogue, The Cleveland Museum of Art), Cleveland, 1967.

Zarnecki, George, *Art of the Medieval World*, Englewood Cliffs, N.J., 1975.

Gesta, the semiannual journal of the International Center of Medieval Art, contains articles on all areas of Medieval art. It is the only English language journal devoted exclusively to Medieval art. Articles on Medieval art appear frequently in the *Journal of the Society of Architectural Historians* and in the *Art Bulletin.* Museum bulletins, such as the *Bulletin* of the Cleveland Museum of Art, and the *Bulletin* of the Metropolitan Museum of Art, publish articles on works of art in their own collections.

III. Early Christian and Byzantine Art

Beckwith John, *The Art of Constantinople: An Introduction to Byzantine Art*, London, 1961; New York, 1968.

———, *Early Christian and Byzantine Art* (Pelican History of Art), Harmondsworth, 1970.

Bianchi-Bandinelli, R., *Rome: The Center of Power, 500 B.C. to A.D. 200* (Arts of Mankind), New York, 1970.

———, *Rome: The Late Empire, A.D. 200–400* (Arts of Mankind), New York, 1971.

Butler, Howard C., *Early Churches in Syria*, Princeton, 1929.

Byzance et la France Médiéval (exhibition catalogue), Paris, 1958.

Byzantine Art: An European Art (exhibition catalogue), Athens, 1964.

Dalton, O. M., *Byzantine Art and Archaeology*, Oxford, 1911; reprinted, 1965.

———, *East Christian Art*, Oxford, 1925.

Davies, J. G., *The Origin and Development of Early Christian Church Architecture*, London, 1952.

Delbrück, Richard, *Die Consulardiptychen und verwandte Denkmäler*, 2 vols., Berlin and Leipzig, 1926–29.

Demus, Otto, *Byzantine Mosaic Decoration: Aspects of Monumental Art in Byzantium*, London, 1948.

———, *The Mosaics of Norman Sicily*, London and New York, 1950.

———, *The Mosaics of San Marco in Venice*, Chicago and London, 1984.

———, and E. Diez, *Byzantine Mosaics in Greece: Hosios Lucas and Daphni*, Cambridge, Mass., 1931.

Forsyth, George H., and K. Weitzmann, *The Monastery of Saint Catherine at Mount Sinai: The Church and Fortress of Justinian*, Ann Arbor, Mich., 1973.

Goldschmidt, Adolph, and Kurt Weitzmann, *Die byzantinischen Elfenbeinskulpturen*, 2 vols., Berlin, 1930–34.

Gough, Michael, *The Origins of Christian Art*, New York, 1974.

Grabar, André, *The Art of the Byzantine Empire*, New York, 1966.

———, *Christian Iconography: A Study of Its Origins*, Princeton, 1968, 1980.

———, *Early Christian Art, from the Rise of Christianity to the Death of Theodosius* (Arts of Mankind), New York, 1968.

———, *The Golden Age of Justinian,*

from the Death of Theodosius to the Rise of Islam (Arts of Mankind), New York, 1967.

———, *Martyrium, Recherches sur le culte des reliques et l'art chrétien antique*, 3 vols., Paris, 1943–46.

———, *Sculptures byzantines de Constantinople, IVe–Xe siècle*, Paris, 1963.

———, and Carl Nordenfalk, *Early Medieval Painting*, Geneva, 1957.

Haussig, Hans W., *A History of Byzantine Civilization*, London, 1971.

Kitzinger, Ernst, *The Art of Byzantium and the Medieval West*, W. Eugene Kleinbauer (ed.), Bloomington, Ind., 1976.

———, *Byzantine Art in the Making: Main Lines of Stylistic Development in Mediterranean Art, 3rd–7th Century*, Cambridge, 1977.

———, *Early Medieval Art in the British Museum*, London, 1940; Bloomington, Ind., 1964; London, 1983.

Krautheimer, Richard, *Corpus basilicarum christianarum Romae* (*The Early Christian Basilicas of Rome*), 5 vols., Vatican City, 1937–77.

———, *Early Christian and Byzantine Architecture* (Pelican History of Art), Harmondsworth, 1965, 1975.

———, *Three Christian Capitals: Topography and Politics*, Berkeley, 1983.

Lawrence, Marion, *The Sarcophagi of Ravenna*, New York, 1945.

L'Orange, H. P., *Fra Principat til Dominat*, Oslo, 1958; English ed., *Art Forms and Civic Life in the Late Roman Empire*, Princeton, 1965, 1972.

———, *Studies in the Iconography of Cosmic Kingship in the Ancient World*, Oslo, 1952.

———, and Per Jonas Nordhagen, *Mosaikk*, Oslo, 1958.

MacDonald, William, *Early Christian and Byzantine Architecture*, New York, 1965.

Maclagan, Michael, *The City of Constantinople*, London, 1968.

Mango, Cyril, "The Apse Mosaics of St. Sophia at Istanbul," *Dumbarton Oaks Papers*, no. 19, Washington, D.C. (1965), 113–151.

———, *The Art of the Byzantine Empire, 312–1453* (Sources and Documents in the History of Art), Englewood Cliffs, N.J., 1972.

———, *Byzantine Architecture*, New York, 1976.

Mathew, Gervase, *Byzantine Aesthetics*, New York, 1963–64; Icon edition, 1971.

Morey, Charles Rufus, *Early Christian Art*, Oxford, 1942.

Natanson, Joseph, *Early Christian Ivories*, London, 1953.

Rice, David T., *The Appreciation of Byzantine Art*, London, 1972.

———, *The Art of Byzantium*, London and New York, 1959.

———, *Art of the Byzantine Era*, New York, 1963, 1967.

———, *The Beginnings of Christian Art*, New York, 1957.

———, *Byzantine Art*, Oxford, 1935; revised and expanded, Harmondsworth, 1954, 1968.

Ross, M. C., *Early Christian and Byzantine Art* (exhibition catalogue, Walters Art Gallery), Baltimore, 1947.

Rostovtzeff, M. I., *Dura-Europos and Its Art*, Oxford, 1938.

———, *The Excavations at Dura-Europos . . .* , Preliminary Reports I–IX, New Haven, 1929–46.

Runciman, Steven, *Byzantine Style and Civilization*, Harmondsworth, 1975.

Simson, Otto von, *The Sacred Fortress*, Chicago, 1948.

Tronzo, William, *The Via Latina Catacomb*, CAA Monograph XXXVIII, University Park, Pa., and London, 1986.

Vikan, Gary, *Illuminated Greek Manuscripts from Armenian Collections* (exhibition catalogue, Princeton Museum of Art), Princeton, 1973.

Volbach, W. F., *Early Christian Art*, New York, 1961.

———, *Elfenbeinarbeiten der Spätantike und des frühen Mittelalters*, 2nd ed., Mainz, 1952.

———, and M. Hirmer, *Early Christian Art*, Munich, 1958; New York, 1961/62.

———, and Jacqueline Lafontaine-Dosogne, *Byzanz und der christliche*

Osten: *Propylaen Kunstgeschichte*, vol. 3, Berlin, 1968.

Weitzmann, Kurt, *Ancient Book Illumination*, Cambridge, Mass., 1959.

———, *Le grand Livre des icones*, 1980.

———, *The Icon: Holy Images, Sixth to Fourteenth Century*, New York, 1968.

———, *Icone*; English ed., *The Icon*, New York, 1982.

———, *Illustrations in Roll and Codex*, Princeton, 1947; new ed., with addenda, 1970.

———, *Late Antique and Early Christian Book Illumination*, New York, 1977.

———, *The Monastery of St. Catherine at Mount Sinai: The Icons*, Princeton, 1976.

———, et al., *The Age of Spirituality* (exhibition catalogue, The Metropolitan Museum of Art), New York, 1978–79.

———, editor, *The Age of Spirituality: A Symposium*, New York, 1980.

———, et al., *A Treasury of Icons: Sixth to Seventeenth Centuries*, New York, 1967.

Wilpert, Josef, *Le pitture delle catacombe romane*, Rome, 1903.

———, *I sarcofagi christiani antichi*, 5 vols., Vatican City, 1929–36.

IV. Islamic Art

Art of the Arab World (exhibition catalogue, Freer Gallery), Washington, D.C., 1975.

Arts de l'Islam des origines à 1700 (exhibition catalogue), Paris, 1971.

Burckhardt, Titus, *Art of Islam: Language and Meaning*, London, 1976.

Creswell, K. A. C., *A Short Account of Early Muslim Architecture*, London, 1958.

Du Ry, Carel, *Art of Islam*, New York, 1970.

Ferber, Stanley, *Islam and the Medieval West* (exhibition catalogue, University Gallery), Binghamton, New York, 1975.

Gómez Moreno, Manuel, *Ars Hispaniae*, vol. 3: *Arte Español hasta los Almoravides: Arte Mozárabe*, Madrid, 1951.

Grabar, Oleg, *The Alhambra,* Cambridge, Mass., 1978.

——, *The Formation of Islamic Art,* New Haven, 1973.

Hill, Derek, *Islamic Architecture and Its Decoration, A.D. 800–1500,* Chicago, 1964.

Hoag, John, *Western Islamic Architecture,* New York, 1963.

Jones, Dalu, and G. Michell, *The Arts of Islam* (exhibition catalogue, Hayward Gallery), London, 1976.

Rice, David, *Islamic Art,* New York, 1965, 1975.

Torres Balbas, L., *Ars Hispaniae,* vol. 4: *Arte almohade; Arte nazarí; Arte mudéjar,* Madrid, 1949.

Periodicals devoted to Islamic art: *Ars Islamica, Muqarnas.*

V. Pre-Romanesque Art

Aaberg, Nils, *The Occident and the Orient in the Art of the Seventh Century,* 3 vols., Stockholm, 1943–47.

À l'aube de la France (exhibition catalogue, Musée du Luxembourg), Paris, 1981.

Backes, Magnus, and Regine Dölling, *Art of the Dark Ages,* Baden-Baden, 1967; English ed., New York and London, 1970.

Beckwith, John, *Ivory Carvings in Early Medieval England,* London, 1972.

Brailsford, John, *Early Celtic Masterpieces from Britain in the British Museum,* London, 1975.

Braunfels, Wolfgang, and Hermann Schnitzler (eds.), *Karl der Grosse, Wirk und Wirkung* (exhibition catalogue, town hall and cathedral, Aachen), Düsseldorf, 1965.

——, et al., *Karl der Grosse: Lebenswerk und Nachleben,* 5 vols. (vol. 3, art), Düsseldorf, 1965.

Brown, G. Baldwin, *The Arts in Early England,* 7 vols., London, 1903–37.

Brozzi, Mario, et al., *Les Lombards,* Zodiaque, La Pierre-qui-Vire, 1982.

Bruce-Mitford, Rupert, *The Sutton Hoo Ship-Burial: A Handbook,* 2nd ed., London, 1972.

De Wald, Ernest, *Illustrations of the Utrecht Psalter,* Princeton, 1933.

Dodwell, C. R., *Anglo-Saxon Art: A New Perspective,* Ithaca, N.Y., 1982.

——, and D. H. Turner, *Reichenau Reconsidered: A Reassessment of the Place of Reichenau in Ottonian Art,* 2, Warburg Institute Surveys, London, 1965.

Farkas, Ann, *From the Lands of the Scythians* (exhibition catalogue, The Metropolitan Museum of Art and the Los Angeles County Museum), New York, 1975.

Focillon, Henri, *L'an mil,* Paris, 1952; English ed., *The Year 1000,* New York, 1969.

Fontaine, Jacques, *L'art mozárabe,* Zodiaque, La Pierre-qui-Vire.

——, *L'art préroman hispanique,* Zodiaque, La Pierre-qui-Vire, 1973.

Foote, P. G., and D. M. Wilson, *Viking Achievement,* 2nd ed., London, 1973.

Fox, Cyril, *Pattern and Purpose,* Cardiff, 1958.

The Gauls: Celtic Antiquities from France (exhibition catalogue, British Museum), London, n.d.

Golden Age and Viking Art in Sweden (exhibition catalogue, Historiska museet), Stockholm, 1964–65.

Goldschmidt, Adolph, *Die deutschen Bronzetüren des frühen Mittelalters,* 3 vols., Marburg, 1926–32.

——, *Die Elfenbeinskulpturen aus der Zeit der Karolingischen und Sächsischen Kaiser,* 4 vols., Berlin, 1914–26.

——, *German Illumination,* Leipzig and Florence, 1928.

Gómez Moreno, Manuel, *Ars Hispaniae,* vol. 3: *Arte Español hasta los Almoravides: Arte Mozárabe,* Madrid, 1951.

——, *Iglesias mozárabes,* 2 vols., Madrid, 1919.

Grabar, André, and Carl Nordenfalk, *Early Medieval Painting,* Geneva, 1957.

Graham-Campbell, James, and Dafydd Kidd, *The Vikings* (exhibition catalogue, British Museum and The Metropolitan Museum), London and New York, 1980.

Grodecki, Louis, *L'architecture ottonienne,* Paris, 1950, 1958.

——, F. Mütherich, J. Taralon, and F. Wormald, *Le Siècle de l'an mil,* Paris, 1973.

Haseloff, Arthur, *Pre-Romanesque Sculpture in Italy,* New York, 1931.

Henderson, George, *Early Medieval,* Harmondsworth, 1972.

Henry, Françoise, *The Book of Kells,* New York, 1974.

——, *Irish High Crosses,* Dublin, 1964.

Hinks, Roger, *Carolingian Art,* London, 1935; Ann Arbor, 1962.

Holmquist, Wilhelm, *Germanic Art During the First Millenium A.D.,* Stockholm, 1955.

Horn, Walter, and Ernest Born, *The Plan of St. Gall,* 3 vols., Berkeley, 1979; Leona Price, *The Plan of St. Gall in Brief: An Overview Based on the Three-Volume Work by Walter Horn and Ernest Born,* Berkeley, 1982.

Hubert, Jean, *L'art pré-roman,* Paris, 1938.

——, Jean Porcher, and W. F. Volbach, *The Carolingian Renaissance* (Arts of Mankind), English ed., London and New York, 1970.

——, ——, and ——, *Europe of the Invasions* (Arts of Mankind), English ed., London and New York, 1969.

Ivory Carvings in Early Medieval England, 700–1200 (exhibition catalogue, Victoria and Albert Museum), London, 1974.

Jantzen, Hans, *Ottonische Kunst,* Munich, 1947; 2nd ed., Hamburg, 1959.

Jope, E. M., and P. Jacobsthal, *Early Celtic Art in the British Isles,* 2 vols., Oxford, 1984.

Kendrick, Thomas D., *Anglo-Saxon Art to A.D. 900,* London, 1938.

——, *Late Saxon and Viking Art,* London, 1949.

Koehler, Wilhelm, *Die Karolingischen Miniaturen,* I: *Die Schule von Tours,* 3 vols., Berlin, 1930–33.

——, *Die Karolingischen Miniaturen,*

II: *Die Hofschule Karls des Grossen*, 2 vols., Berlin, 1958.

Krautheimer, Richard, "The Carolingian Revival of Early Christian Architecture," *Art Bulletin*, 24 (1942), 1–38.

Lasko, Peter, *The Kingdom of the Franks: North-West Europe Before Charlemagne*, London, 1971.

Metz, Peter, *The Golden Gospels of Echternach, Codex Aureus Epternacensis*, New York, 1957.

Mütherich, Florentine, and Joachim E. Gaehde, *Carolingian Painting*, New York, 1976.

Nordenfalk, Carl, *Celtic and Anglo-Saxon Painting: Book Illumination in the British Isles 600–800*, New York, 1977.

Palol, Pedro de, and Max Hirmer, *Arte hispánico de la epoca Visigoda*, Barcelona, 1968.

———, and ———, *Early Medieval Art in Spain*, New York, 1967.

Paor, M. de, and L. de Paor, *Early Christian Ireland*, London, 1964.

Paris Mérovingien (exhibition catalogue, Musée Carnevalet), Paris, 1981–82.

Puig i Cadafalch, Jusep, *Le premier art roman*, Paris, 1928.

Rice, David T. (ed.), *The Dawn of European Civilization: The Dark Ages*, New York and London, 1965.

———, *English Art, 871–1100*, Oxford, 1952.

Romans and Barbarians (exhibition catalogue, Museum of Fine Arts), Boston, 1976–77.

Ross, Marvin C., and Philippe Verdier, *Arts of the Migration Period in the Walters Art Gallery*, Baltimore, 1961.

Schlunk, H., *Ars Hispaniae*, vol. 2: *Arte Visigodo, Arte Asturiano*, Madrid, 1947.

Schramm, P. E., and Florentine Mütherich, *Denkmäler der deutschen Könige und Kaiser*, Munich, 1962.

Speake, George, *Anglo-Saxon Animal Art and Its Germanic Background*, Oxford, 1980.

Taylor, Harold, and Joan Taylor, *Anglo-Saxon Architecture*, 3 vols., Cambridge, 1965–78.

Treasures of Early Irish Art (exhibition catalogue, The Metropolitan Museum of Art), New York, 1977.

Tschan, Francis J., *Saint Bernward of Hildesheim*, 3 vols., South Bend, Ind., 1942–52.

Varagnac, André, Bavrielle Fabre, and Monique Mainjonet, *L'art Gaulois*, Zodiaque, La Pierre-qui-Vire, 2nd ed., 1956.

Verzone, Paolo, *The Art of Europe: The Dark Ages from Theodoric to Charlemagne*, Baden-Baden, 1967; English ed., New York, 1968.

Williams, John, *Early Spanish Manuscript Illumination*, New York, 1977.

Wilson, David M., *The Anglo-Saxons*, London, 1960.

———, and O. Klindt-Jensen, *Viking Art*, London, 1966.

Wormald, Francis, *English Drawings of the Tenth and Eleventh Centuries*, London, 1952.

VI. Romanesque Art

Ainaud de Lasarte, Juan, and E. Junyent, *Catalogne romane*, 2 vols., Zodiaque, La Pierre-qui-Vire, 1960–61.

Anker, Peter, and Aron Andersson, *The Art of Scandinavia*, 2 vols. (English ed. of *L'art Scandinave*, Zodiaque, La Pierre-qui-Vire, 1968–69), New York, 1970.

Anthony, Edgar W., *Romanesque Frescoes*, Princeton, 1951.

Armi, C. Edson, *Masons and Sculptors in Romanesque Burgundy: The New Aesthetic of Cluny III*, University Park, Pa., and London, 1983.

El arte románico (exhibition catalogue, Museo de Arte de Cataluña and Cathedral Museum), Barcelona and Santiago de Compostela, 1961.

Aubert, Marcel, *L'art roman en France*, Paris, 1961.

———, *Cathedrales abatiales, collegiales, prieures romans de France*, Paris, 1965.

———, *La sculpture romane*, Paris, 1937.

Avery, Myrtilla, *The Exultet Rolls of South Italy*, 2 vols., Princeton, 1936.

Aymard, O., et al., *Touraine roman*, Zodiaque, La Pierre-qui-Vire, 1957; new ed. by Charles Lelong, *Val de Loire roman et Touraine roman*, 1965.

Barasch, Moshe, *Crusader Figural Sculpture in the Holy Land*, New Brunswick, N.J., 1971.

Barral i Altet, Xavier, *La Catedral romànica de Vic*, Barcelona, 1979.

Barruol, Guy, and Jean-Maurice Rouquette, *Provence romane*, 2 vols., Zodiaque, La Pierre-qui-Vire, 1974; 2nd ed., 1977.

Baudry, J., et al., *Bourgogne romane*, Zodiaque, La Pierre-qui-Vire, 1958, 1962.

Baum, Julius, *Romanesque Architecture in France*, London, 1928.

Beigbeder, Olivier, and Raymond Ousel, *Forez-Velay roman*, Zodiaque, La Pierre-qui-Vire, 1962.

Bertrand, Simone, *La Tapisserie de Bayeux et la manière de vivre au Xie siècle*, Zodiaque, La Pierre-qui-Vire, 1966.

Blindheim, Martin, *Norwegian Romanesque Decorative Sculpture, 1090–1210*, London, 1965.

Boase, Thomas, *English Art, 1100–1216*, Oxford, 1953.

Borg, Alan, *Architectural Sculpture in Romanesque Provence*, Oxford, 1972.

Bouffard, P., et al., *Suisse romane*, Zodiaque, La Pierre-qui-Vire, 1958; 2nd ed., 1982.

Brooke, Christopher, Richard Gem, George Zarnecki, et al., *English Romanesque Art, 1066–1200* (exhibition catalogue), London, 1984.

Cabanot, Jean, *Gascogne romane*, Zodiaque, La Pierre-qui-Vire, 1978.

Cahn, Walter, *Romanesque Bible Illumination*, Ithaca, N.Y., 1982.

———, *Romanesque Sculpture in American Collections*, vol. 1, New York, 1979.

Canellas-López, Angel, and Angel San Vicente, *Aragon roman*, Zodiaque, La Pierre-qui-Vire, 1971.

Chamoso Lamas, Manuel, et al., *Galice*

romane, Zodiaque, La Pierre-qui-Vire, 1973.

Chierici, Sandro, *Lombardie romane,* Zodiaque, La Pierre-qui-Vire, 1978.

———, and Cuilio Citi, *Piémont-Ligurie roman,* Zodiaque, La Pierre-qui-Vire, 1979.

Clapham, Alfred, *Romanesque Architecture in Western Europe,* Oxford, 1936.

Collin, H., et al., *Champagne romane,* Zodiaque, La Pierre-qui-Vire, 1981.

Collon-Gevaert, Suzanne, Jean Lejeune, and Jacques Stiennon, *A Treasury of Romanesque Art: Metalwork, Illuminations and Sculpture from the Valley of the Meuse,* London, 1972.

Conant, Kenneth John, *Cluny: les églises et la maison du chef d'ordre,* Cambridge, Mass., and Mâcon, 1968.

———, *The Early Architectural History of the Cathedral of Santiago de Compostela,* Cambridge, Mass., 1926; Gallegan edition, with introduction by Serafín Moralejo Alvarez, *Arquitectura Románica da catedral de Santiago de Compostela,* Santiago de Compostela, 1983.

Cook, Walter, and Jusep Gudiol i Ricart, *Ars Hispaniae,* vol. 6: *Pintura románica; Imaginería románica,* Madrid, 1950; 2nd edition (entirely revised), 1979.

Craplet, B., *Auvergne romane,* Zodiaque, La Pierre-qui-Vire, 1958; new ed., 1972.

Crighton, George, *Romanesque Sculpture in Italy,* London, 1954.

Crozet, René, *L'art roman en Berry,* Paris, 1932.

———, *L'art roman en Poitou,* Paris, 1948.

———, *L'art roman en Saintonge,* Paris, 1971.

———, and Yvonne Labande, *Poitou roman,* Zodiaque, La Pierre-qui-Vire, 1957, 1962.

Daras, C., *Angoumois roman,* Zodiaque, La Pierre-qui-Vire, 1961.

Decker, Hans, *Romanesque Art in Italy,* New York, 1959.

Defarges, Benigne, *Val-de-Loire roman,* Zodiaque, La Pierre-qui-Vire, 1956; new revised edition, Jean-Marie Berland, 1982.

Demus, Otto, *Romanesque Mural Painting,* English ed., New York, 1970.

Deschamps, Paul, *French Sculpture of the Romanesque Period,* Florence and Paris, 1930.

———, *Terre Sainte romane,* Zodiaque, La Pierre-qui-Vire, 1964.

———, and Marc Thibout, *La peinture murale en France,* Paris, 1951.

Dillange, Michel, *Vendée romane,* Zodiaque, La Pierre-qui-Vire, 1976.

Dimier, Anselme, *L'art cistercien, hors de France,* Zodiaque, La Pierre-qui-Vire, 1971.

——— and Jean Porcher, *L'art Cistercien, France,* Zodiaque, La Pierre-qui-Vire, 1962.

Dodwell, C. R., *The Canterbury School of Illumination, 1066–1200,* Cambridge, 1954.

Dubourg-Noves, Pierre, *Guyenne romane,* Zodiaque, La Pierre-qui-Vire, 1969.

Dupont, Jean, *Nivernais-Bourbon,* Zodiaque, La Pierre-qui-Vire, 1976.

Durliat, M., "L'atelier de Bernard Gilduin a Saint-Sernin de Toulouse," *Anuario de Estudios Medievales,* 1, Barcelona, 1964.

———, *Haut-Languedoc romane,* Zodiaque, La Pierre-qui-Vire, 1978.

———, *Roussillon roman,* Zodiaque, La Pierre-qui-Vire, 1958.

———, and Victor Allégre, *Pyrénées romanes,* Zodiaque, La Pierre-qui-Vire, 1978.

Evans, Joan, *Cluniac Art of the Romanesque Period,* Cambridge, 1950.

———, *Monastic Life at Cluny, 910–1157,* Oxford, 1931.

———, *The Romanesque Architecture of the Order of Cluny,* Cambridge, 1938.

Eygun, François, *Saintonge romane,* Zodiaque, La Pierre-qui-Vire, 1970.

Favière, Jean, and Jacques de Bascher,

Berry roman, Zodiaque, La Pierre-qui-Vire, 1970.

Fergusson, Peter, *Architecture of Solitude: Cistercian Abbeys in Twelfth-Century Europe,* Princeton, 1984.

Focillon, Henri, *L'art des sculpteurs romans,* Paris, 1931, 1964.

Forsyth, Ilene H., *The Throne of Wisdom: Wood Sculptures of the Madonna in Romanesque France,* Princeton, 1972.

Francovich, Geza de, *Benedetto Antelami, architetto e scultore, e l'arte del suo tempo,* 2 vols., Milan, 1952.

Gaillard, Georges, *Les débuts de la sculpture romane espagnole,* Paris, 1938.

———, *La sculpture romane espagnole,* Paris, 1946.

———, et al., *Rouergue roman,* Zodiaque, La Pierre-qui-Vire, 1963.

Gantner, Joseph, and Marcel Pobé, *Romanesque Art in France,* London, 1956.

Garrison, Edward B., *Italian Romanesque Panel Painting,* Florence, 1949.

Gómez Moreno, Manuel, *El arte románico español,* Madrid, 1934.

Grabar, André, and Carl Nordenfalk, *Romanesque Painting from the Eleventh to the Thirteenth Century,* New York and Geneva, 1958.

Grivot, Denis, and George Zarnecki, *Gislebertus, Sculptor of Autun,* Paris, 1960; English ed., New York, 1961.

Gudiol i Ricart, Jusep, and Juan Antonio Gaya Nuño, *Ars Hispaniae,* vol. 5: *Arquitectura románica,* Madrid, 1948.

Haskins, Charles Homer, *The Renaissance of the Twelfth Century,* Cambridge, Mass., 1927.

Hearn, M. F., *Romanesque Sculpture,* Ithaca, New York, 1981.

Henderson, George, *Early Medieval* (Style and Civilization Series), Harmondsworth, 1972.

d'Herbécourt, P., and J. Porcher, *Anjou roman,* Zodiaque, La Pierre-qui-Vire, 1959.

Hutton, Edward, *The Cosmati,* London, 1950.

Katzenellenbogen, A., "The Central

Tympanum of Vézelay: Its Encyclopedic Meaning and Its Relation to the First Crusade," *Art Bulletin*, 26 (1944), 141–51.

Kubach, H. E., *Romanesque Architecture*, New York, 1975.

Lasteyrie, R. de, *L'architecture religieuse en France à l'époque romane*, 2nd ed. (edited by Marcel Aubert), Paris, 1929.

Leisinger, H., *Romanesque Bronzes: Church Portals in Medieval Europe*, New York, 1957.

Lojendio, Luis-María, *Navarre romane*, Zodiaque, La Pierre-qui-Vire, 1967.

————, and Abundio Rodríguez, *Castille romane*, 2 vols., Zodiaque, La Pierre-qui-Vire, 1966.

Lugand, Jacques, et al., *Languedoc Roman (Le Languedoc Méditerranéen)*, Zodiaque, La Pierre-qui-Vire, 1975.

Mâle, Emile, *L'art religieux du XIIe siècle en France*, Paris, 1922; new English ed. (edited by Harry Bober), *Religious Art in France: The Twelfth Century*, Princeton, 1978.

Maury, J., M.-M. Gauthier, and J. Porcher, *Limousin roman*, Zodiaque, La Pierre-qui-Vire, 1960.

Mendell, E., *Romanesque Sculpture in Saintonge*, New Haven, 1940.

Mesplé, Paul, *Les Sculptures romanes: Toulouse, Musée des Augustins*, Paris, 1961.

Moracchini-Mazel, Geneviève, *Corse romane*, Zodiaque, La Pierre-qui-Vire, 1972.

Müller-Wiener, *Castles of the Crusaders*, English ed., London, 1966.

Musset, Lucien, *Normandie romane*, vol. 1: *La Basse-Normandie*; vol. 2: *La Haute-Normandie*, Zodiaque, La Pierre-qui-Vire, 1967; 2nd ed., 1974.

Naesgaard, Ole, *Saint-Jacques de Compostelle et les débuts de la grande sculpture vers 1100*, Aarhus, 1962.

d'Onofrio, Mario, and Valentino Pace, *Campanie romane*, Zodiaque, La Pierre-qui-Vire, 1981.

Oursel, Charles, *L'art roman de Bourgogne*, Dijon, 1928.

————, *Bourgogne romane*, Zodiaque, La Pierre-qui-Vire, rev. edition, 1968.

————, *Haut-Poitou roman*, Zodiaque, La Pierre-qui-Vire, 1975.

————, *Miniatures cisterciennes (1109–1134)*, Mâcon, 1960.

Oursel, R., and A. M. Kres, *Les églises romanes de l'Autunois et du Brionnais: Cluny et sa region*, Mâcon, 1956.

Pacht, Otto, *The Rise of Pictorial Narrative in Twelfth-Century England*, Oxford, 1962.

————, C. R. Dodwell, and F. Wormald, *The St. Albans Psalter*, London, 1960.

Porter, Arthur Kingsley, *Romanesque Sculpture of the Pilgrimage Roads*, 10 vols., Boston, 1923 (Hacker reprint in three volumes).

————, *Spanish Romanesque Sculpture*, 2 vols., New York and Florence, 1928.

Prandi, Adriano, et al., *Ombrie romane*, Zodiaque, La Pierre-qui-Vire, 1980.

Quintavalle, Arturo Carlo, *La Cattedrale di Modena*, Modena, 1964.

————, *Wiligelmo e la sua scuola*, Florence, 1967.

Rey, Raymond, *La sculpture roman Languedocienne*, Toulouse, 1936.

Ricci, Corrado, *Romanesque Architecture in Italy*, London, 1925.

Romanische Kunst in Oesterreich (exhibition catalogue, Minoritenkirche), Krems, 1964.

Salet, Francis, *La Madeleine de Vézelay*, Melun, 1948.

Salmi, Mario, *Romanesque Sculpture in Tuscany*, Florence, 1928.

Salvini, Roberto, *Il Duomo di Modena*, Modena, 1966.

————, *Wiligelmo e le origini della scultura romanica*, Milan, 1956.

Saxl, Fritz, and Hanns Swarzenski, *English Sculptures of the Twelfth Century*, London, 1954.

Schapiro, Meyer, *The Parma Ildefonsus: A Romanesque Illuminated Manuscript from Cluny and Related Works*, New York, 1964.

————, *Romanesque Art* (collected essays), New York, 1976.

Scher, K., *The Renaissance of the Twelfth Century* (exhibition catalogue, Rhode Island School of Design), Providence, 1969.

Secret, Jean, *Périgord roman*, 2nd ed., Zodiaque, La Pierre-qui-Vire, 1968.

Stenton, Frank (ed.), *The Bayeux Tapestry: A Comprehensive Survey*, London, 1957.

Stopani, Renato, *Toscane romane*, Zodiaque, La Pierre-qui-Vire, 1982.

Sunderland, E. R., "Symbolic Numbers and Romanesque Church Plans," *Journal of the Society of Architectural Historians*, 18 (October 1959), 94–103.

Swarzenski, Hanns, *Monuments of Romanesque Art*, 1954; 2nd ed., Chicago, 1967.

Thirion, Jacques, *Alpes romanes*, Zodiaque, La Pierre-qui-Vire, 1980.

Tournier, René, Willibald Sauerlander, and Raymond Oursel, *Franche-comté romane—Bresse romane*, Zodiaque, La Pierre-qui-Vire, 1979.

Turner, D. H., *Romanesque Illustrated Manuscripts*, London, 1966.

Vallery-Radot, J., *Saint-Philibert de Tournus*, Paris, 1955.

Vidal, M., J. Maury, and J. Porcher, *Quercy roman*, Zodiaque, La Pierre-qui-Vire, 1959.

Vielliard, Jeanne (ed.), *Le guide du Pèlerin de Saint-Jacques de Compostelle*, Mâcon, 1938; 2nd ed., 1960.

Viñayo González, Antonio, *Leon roman*, Zodiaque, La Pierre-qui-Vire, 1972.

Voelkle, William, *The Stavelot Triptyche: Mosan Art and the Legend of the True Cross* (exhibition catalogue, The Pierpont Morgan Library), New York, 1980.

Whitehill, Walter, M., *Spanish Romanesque Architecture of the Eleventh Century*, Oxford, 1941; reprinted, 1968.

Will, R., and H. Haug, *Alsace romane*, Zodiaque, La Pierre-qui-Vire, 1965.

Zarnecki, George, *English Romanesque*

Sculpture, 1066–1140, London, 1951.

——, *Later English Romanesque Sculpture, 1140–1210*, London, 1953.

——, *Romanesque Art*, New York, 1972.

VII. Gothic and Late Gothic Art

Andersson, Aron, *English Influence in Norwegian and Swedish Figure Sculpture in Wood, 1220–70*, Stockholm, 1949.

Antal, Frederick, *Florentine Painting and Its Social Background*, London, 1948.

Arano, Luisa C., *The Medieval Health Handbook: Tacuinum Sanitatis*, New York, 1976.

Aubert, Marcél, *Art of the High Gothic Era*, Baden-Baden, 1963; English ed., New York, 1965.

——, *Cathedrales et Trésors Gothiques de France*, Paris, 1958; English ed.: *Gothic Cathedrals of France and Their Treasures*, London, 1959.

——, *French Sculpture at the Beginning of the Gothic Period, 1140–1225*, Florence and Paris, 1929.

——, L. Grodecki, et al., *Le Vitrail Français*, Paris, 1958.

——, ——, Je. Lafond, and J. Verrier, *Les Vitraux de Notre-Dame et de la Sainte-Chapelle de Paris*, Paris, 1959.

Avril, François, *Manuscript Painting at the Court of France: The Fourteenth Century (1310–1380)*, New York, 1978.

Baldass, Peter, et al., *Gotik in Österreich*, Vienna, 1961.

Baxandall, Michael, *The Limewood Sculptors of Renaissance Germany*, New Haven and London, 1980.

Blanch, Montserrat, *Arte gótico en España*, Barcelona, 1972.

Bony, Jean, *The English Decorated Style*, London and Ithaca, N.Y., 1979.

——, *French Cathedrals*, Boston, 1951.

——, *French Gothic Architecture of the 12th and 13th Centuries*, Berkeley, 1983.

——, "The Resistance to Chartres in Early Thirteenth-Century Architecture," *Journal of the British Archaeological Association*, 3rd ser., 20–21 (1957–58), 35–52.

Borsook, Eve, *The Mural Painters of Tuscany*, London, 1960.

Bowie, Theodore, *The Sketchbook of Villard de Honnecourt*, Bloomington, Ind., 1959.

Branner, Robert, *Burgundian Gothic Architecture*, London, 1960.

——, *La cathédrale de Bourges et sa place dans l'architecture gothique*, Paris and Bourges, 1962.

——, *Chartres Cathedral*, New York, 1969.

——, *Gothic Architecture*, New York, 1961.

——, "The Labyrinth of Reims Cathedral," *Journal of the Society of Architectural Historians*, 21 (March 1962), 18–25.

——, *Manuscript Painting in Paris during the Reign of St. Louis*, Berkeley, 1977.

——. "Paris and the Origins of Rayonnant Architecture Down to 1240," *Art Bulletin*, 49 (1962), 39–51.

——, *St. Louis and the Court Style in Gothic Architecture*, London, 1965.

——, "Westminster Abbey and the French Court Style," *Journal of the Society of Architectural Historians*, 23 (March 1964), 3–18.

Breiger, Peter, *English Art, 1216–1307*, Oxford, 1957.

Bruzelius, Caroline A., *The Thirteenth Century Church at St.-Denis*, New Haven and London, 1986.

Calkins, Robert G., "Stages of Execution: Procedures of Illumination as Revealed in an Unfinished Book of Hours," *Gesta*, 17 (1978), 61–70.

Calmette, J., *The Golden Age of Burgundy: The Magnificent Dukes and Their Courts*, New York, 1963.

Carli, Enzo, *Sienese Painting*, Greenwich, Conn., 1956.

Cathédrales (exhibition catalogue, Musée du Louvre), Paris, 1962.

Caviness, Madeline, *The Early Stained Glass of Canterbury Cathedral, 1175–1220*, Princeton, 1978.

——, *The Windows of Christ Church Cathedral, Canterbury*, Oxford, 1981.

Christie, A. G. I., *English Mediaeval Embroidery*, Oxford, 1938.

Courtens, André, and Jean Roubier, *Romanesque Art in Belgium*, Liège, 1969.

Crosby, Sumner McK., *L'abbaye royale de Saint-Denis*, Paris, 1953.

——, *The Abbey of Saint-Denis (475–1122)*, New Haven, 1942.

——, *The Apostle Bas-Relief at Saint-Denis*, New Haven and London, 1972.

——, Jane Hayward, Charles Little, and William Wixom, *The Royal Abbey of Saint-Denis in the Time of Abbot Suger (1122–1151)* (exhibition catalogue, The Metropolitan Museum of Art), New York, 1981.

Cuttler, Charles, *Northern Painting from Pucelle to Breugel: Fourteenth, Fifteenth and Sixteenth Centuries*, New York, 1968.

David, H., *Claus Sluter*, Paris, 1951.

Deschamps, Paul, and Marc Thibout, *La peinture murale en France*, Paris, 1951, 1963.

Deuchler, Florens, *Gothic Art*, English ed., London, 1973.

——, *Der Ingeborgpsalter*, Berlin, 1967.

Dupont, Jacques, and Cesare Gnudi, *Gothic Painting*, Geneva, 1954.

Durán Sanpere, Agustín, and Juan Ainaud, *Ars Hispaniae, VIII: Escultura Gótica*, Madrid, 1956.

Dvorakova, V., et al., *Gothic Mural Painting in Bohemia and Moravia, 1300–1378*, London, 1964.

Erlande-Brandenburg, Alain, *L'art gothique*, Paris, 1983.

L'Europe Gothique XIIe–XIVe siècles (exhibition catalogue, Musée du Louvre), Paris, 1968.

Evans, Joan, *English Art, 1307–1461*, Oxford, 1949.

Les Fastes du Gothique, le siècle de

Charles V (exhibition catalogue, Grand Palais), Paris, 1981.

Fitchen, J., *The Construction of Gothic Cathedrals,* Oxford, 1961.

Forsyth, W. H., "The Virgin and Child in French XIVth Century Sculpture: A Method of Classification," *Art Bulletin* (1957), 171–82.

Frankl, Paul, *Gothic Architecture* (Pelican History of Art), Harmondsworth, 1962.

———, *The Gothic: Literary Sources and Interpretations Through Eight Centuries,* Princeton, 1960.

Frisch, Teresa G., *Gothic Art 1140–ca. 1450* (Sources and Documents in the History of Art), Englewood Cliffs, N.J., 1971.

Gall, Ernst, *Die gotische Baukunst in Frankreich und Deutschland,* Leipzig, 1925.

Gimpel, Jean, *Les batisseurs de cathedrales,* Paris, 1958; English ed., *The Cathedral Builders,* New York, 1961.

Gómez-Moreno, Carmen, *Sculpture from Notre-Dame, Paris: A Dramatic Discovery* (exhibition catalogue, The Metropolitan Museum of Art and the Cleveland Museum of Art), New York, 1979.

Gothic Art, 1360–1440 (exhibition catalogue, the Cleveland Museum of Art), Cleveland, 1963.

Gotick in Österreich (exhibition catalogue), Krems an der Donau, 1967.

Grodecki, L., *Chartres,* New York, 1963.

———, *Gothic Architecture,* 1976; English ed., New York, 1977.

———, and Catherine Brisac, *Gothic Stained Glass: 1200–1300,* Paris, 1984; English ed., Ithaca, N.Y. 1985.

Gudiol i Ricart, Jusep, *Ars Hispaniae,* vol. 9: *Pintura gótica,* Madrid, 1955.

Harthan, John, *The Book of Hours,* New York, 1977.

Hartt, Frederick, *History of Italian Renaissance Art,* Englewood Cliffs, N.J., 1969; 2nd ed., 1980.

Harvey, John, *Gothic England: A Survey of National Culture, 1300–1550,* London, 1947.

Hayward, Jane, and M. Caviness, *Stained Glass Before 1700 in American Collections,* vol. 1: *New England and New York State,* Washington, D.C., 1985.

Henderson, George, *Chartres,* Harmondsworth, 1968.

———, *Gothic* (Style and Civilization Series), Harmondsworth, 1967.

Hofstatter, Hans, *Art of the Late Middle Ages,* Baden-Baden and New York, 1968.

Huizinga, Johan, *The Waning of the Middle Ages,* London, 1924; New York, 1954.

Hunt, John, *Irish Medieval Figure Sculpture, 1200–1600,* 2 vols., Dublin and London, 1974.

Janke, R. Steven, *Jehan Lome y la escultura gótica posterior en Navarra,* Pamplona, 1977.

Jantzen, Hans, *High Gothic: The Classic Cathedrals of Chartres, Reims, Amiens,* English ed., New York, 1962.

Johnson, J. R., *The Radiance of Chartres: Studies in the Early Stained Glass of the Cathedral,* New York, 1965.

Katzenellenbogen, Adolf, *The Sculptural Programs of Chartres Cathedral,* Baltimore, 1959.

Koechlin, Raymond, *Les ivoires gothiques français,* 2 vols., Paris, 1924.

Kren, Thomas (ed.), *Renaissance Painting in Manuscripts: Treasures from the British Library* (exhibition catalogue, The Pierpont Morgan Library), New York, 1983.

Lambert, Elie, *L'art gothique en Espagne aux XIIe et XIIIe siècles,* Paris, 1931.

Lane, Barbara G., *The Altar and the Altarpiece,* New York, 1985.

Lasteyrie, R. de, *L'architecture religieuse en France à l'epoque gothique* (2nd ed.), 2 vols., Paris, 1929.

Lemoisne, Paul A., *Gothic Painting in France,* Florence and Paris, 1931; reprinted, New York, 1973.

Lillich, Meredith P., *The Stained Glass of Saint-Pere de Chartres,* 1978.

Lognon, J., and R. Cazelles, *The "Très*

Riches Heures" of Jean, Duke of Berry, New York, 1969.

Mâle, Émile, *L'art religieux de la fin du moyen-âge en France,* Paris, 1908, 1949.

———, *L'art religieux en France au XIIIe siècle* (Paris, 1898); first English ed., 1913; published as *The Gothic Image,* New York, 1958. New English ed.: Harry Bober (ed.), *Religious Art in France: The Thirteenth Century,* Marthiel Matthews (trans.), Princeton, N.J., 1986.

———, *Chartres,* English ed., New York, 1985.

Marks, R., and N. J. Morgan, *The Golden Age of English Manuscript Painting, 1200–1500,* New York, 1981.

Martindale, Andrew, *Gothic Art from the Twelfth to the Fifteenth Century,* New York, 1967.

Masterpieces of Tapestry from the Fourteenth to the Sixteenth Century (exhibition catalogue, The Metropolitan Museum of Art), New York and Paris, 1973.

Mather, Frank Jewett, *The Isaac Master,* Princeton, 1932.

Meiss, Millard, *French Painting in the Time of Jean de Berry: The Late Fourteenth Century and the Patronage of the Duke,* London, 1967.

———, *French Painting in the Time of Jean de Berry: The Limbourgs and Their Contemporaries,* 2 vols., New York, 1975.

———, *Giotto and Assisi,* New York, 1960.

———, *Painting in Florence and Siena After the Black Death,* Princeton, 1951.

Millar, Eric G., *English Illuminated Manuscripts of the XIVth and XVth Centuries,* Paris and Brussels, 1928.

———, *The Parisian Miniaturist Honoré,* London, 1959.

Miner, Dorothy, *The Walters Art Gallery: Illuminated Books of the Middle Ages and Renaissance* (exhibition catalogue, Baltimore Museum of Art), Baltimore, 1949.

Morand, Kathleen, *Jean Pucelle,* Oxford, 1962.

Morgan, Nigel J., *Early Gothic Manuscripts*, Oxford, 1984.

Natanson, Joseph, *Gothic Ivories of the 13th and 14th Centuries*, London, 1951.

Oakeshott, Walter, *The Artists of the Winchester Bible*, London, 1945.

———, *Sigena: Romanesque Paintings in Spain and the Winchester Bible Artists*, London, 1972.

Oertel, Robert, *Early Italian Painting to 1400*, London, 1968.

Opus Anglicanum: English Medieval Embroidery (exhibition catalogue, Victoria and Albert Museum), London, 1963.

Panofsky, Erwin, *Abbot Suger on the Abbey Church of St. Denis and Its Art Treasures*, Princeton, 1946; rev. ed., Gerda Panofsky-Soergel, Princeton, 1979.

———, *Early Netherlandish Painting: Its Origin and Character*, 2 vols., Cambridge, Mass., 1953.

———, *Gothic Architecture and Scholasticism*, New York, 1957.

Die Parler und der Schöne Stil, 1350–1440 (exhibition catalogue, city museum), Cologne, n.d.

Pevsner, Nikolaus, *The Leaves of Southwell*, Harmondsworth, 1945.

———, *Ruskin and Viollet-le-Duc: Englishness and Frenchness in the Appreciation of Gothic Architecture*, London, 1969.

———, "The Term 'Architect' in the Middle Ages," *Speculum*, 17 (1942), 549–62.

Plummer, John, *The Hours of Catherine of Cleves*, New York, 1966.

———, *The Last Flowering: French Painting in Manuscripts, 1420–1530* (exhibition catalogue, The Pierpont Morgan Library), New York, 1982.

Pope-Hennessy, John, *Italian Gothic Sculpture*, London, 2nd ed., 1972.

Porcher, J., *Medieval French Miniatures*, New York, 1959.

Randall, Lilian, *Images in the Margins of Gothic Manuscripts*, Berkeley, 1966.

Randall, R., Jr., "Frog in the Middle," *The Metropolitan Museum of Art Bulletin*, 16:10 (1958), 269–75.

———, *Ivories* (exhibition catalogue, The Walters Gallery), Baltimore, 1986.

Raguin, Virginia Chieffo, *Stained Glass in Thirteenth-Century Burgundy*, Princeton, 1982.

Reinhardt, H., *La cathédrale de Reims: Son histoire, son architecture, sa sculpture, ses vitraux*, Paris, 1963.

Rey, R., *L'art gothique du Midi de la France*, Paris, 1934.

Röhrig, F., *Der Verduner Altar*, 3rd ed., Vienna, 1955.

Saalman, Howard, *Medieval Cities*, New York, 1968.

Saint Louis à la Sainte-Chapelle (exhibition catalogue, Ste-Chapelle), Paris, 1960.

Salet, F., "Saint-Urbain de Troyes," *Congrès archéologique de France*, vol. 113 (1955), 96–122.

Sandler, Lucy Freeman, *The Peterborough Psalter in Brussels and Other Fenland Manuscripts*, Oxford, 1974.

———, *The Psalter of Robert de Lisle in the British Library*, Oxford, 1983.

Sauerlander, Willibald, and Max Hermer, *Gothic Sculpture in France, 1140–1270*, New York, 1972.

Sherman, Claire Richter, *The Portraits of Charles V of France (1338–80)*, New York, 1969.

Simson, Otto von, *The Gothic Cathedral: Origins of Gothic Architecture and the Medieval Concept of Order*, Chicago, 1956; New York, 1967.

Smart, Alistair, *The Assisi Problem and the Art of Giotto*, Oxford, 1971.

Snyder, James, *Northern Renaissance Art*, New York, 1985.

Stoddard, Whitney S., *The West Portals of Saint-Denis and Chartres*, Cambridge, Mass., 1952.

Stubblebine, James, *Assisi and the Rise of Vernacular Art*, New York, 1985.

———, *Giotto: The Arena Chapel Frescoes*, New York, 1969.

Swaan, Wim, *Art and Architecture of the Late Middle Ages*, New York, 1977.

———, *The Gothic Cathedral*, New York, 1981.

Temko, Allan, *Notre-Dame of Paris*, New York, 1955.

Thomas, Marcel, *The Golden Age: Manuscript Painting at the Time of Jean, Duke of Berry*, New York, 1979.

Tintori, Leonetto, and Millard Meiss, *The Painting of the Life of St. Francis at Assisi*, New York, 1967.

Torres Balbas, Leopoldo, *Ars Hispaniae*, vol. 7: *Arquitectura gótica*, Madrid, 1952.

Transformations of the Court Style: Gothic Art in Europe 1270 to 1330 (exhibition catalogue, Rhode Island School of Design and Brown University), Providence, 1977.

Les trésors des églises de France (exhibition catalogue, Musée des Arts Decoratifs), Paris, 1965.

Verdier, Philippo, *Art and the Courts: France and England from 1259 to 1328* (exhibition catalogue, National Gallery of Canada), 2 vols., Ottawa, 1972.

———, *The International Style: The Arts in Europe around 1400* (exhibition catalogue, Walters Art Gallery), Baltimore, 1962.

Vitry, P., *French Sculpture During the Reign of Saint Louis, 1226–1270*, New York, n.d.

Von der Osten, Gert, and Horst Vey, *Painting and Sculpture in Germany and the Netherlands: 1500–1600* (Pelican History of Art), Harmondsworth, 1969.

Weigelt, Curt H., *Sienese Painting of the Trecento*, New York, 1930.

White, John, *Art and Architecture in Italy: 1250–1400* (Pelican History of Art), Harmondsworth, 1966.

The Year 1200 (exhibition catalogue and background essays, The Metropolitan Museum of Art), 2 vols., New York, 1970.

INDEX